R

WOMEN DESIGNERS IN THE USA
1900–2000

Jacqueline M. Atkins

Whitney Blausen

Eileen Boris

Cheryl Buckley

Leslie R. Close

Edward S. Cooke, Jr.

Jeannine Falino

Toni Greenbaum

Judith B. Gura

Ella Howard

Wendy Kaplan

Pat Kirkham

Pamela Kladzyk

Deborah Nadoolman Landis

Ellen Lupton

Mary Schoeser

Eric Setliff

Penny Sparke

Shauna Stallworth

Valerie Steele

Lynne Walker

Women Designers in the USA

1900 | 2000

DIVERSITY AND DIFFERENCE

Pat Kirkham | EDITOR

PUBLISHED FOR THE

BARD GRADUATE CENTER FOR STUDIES IN THE DECORATIVE ARTS

NEW YORK

BY YALE UNIVERSITY PRESS

NEW HAVEN AND LONDON

This catalogue has been published in conjunction with the
exhibition "Women Designers in the USA, 1900–2000:
Diversity and Difference" held at The Bard Graduate Center
for Studies in the Decorative Arts, Design, and Culture,
from November 15, 2000 to February 25, 2001.

Project director: Pat Kirkham
Curator: Pat Kirkham
Project assistants: Ella Howard and Ronald Labaco
Catalogue editors: Martina D'Alton, New York, and
Sally Salvesen, London
Design director: Ellen Lupton; designer: Patrick Seymour,
Tsang Seymour Design, Inc.
Catalogue production: Tsang Seymour Design, Inc.

Director of Exhibitions: Nina Stritzler-Levine

Library of Congress Card Number: 00-108610

On the front cover: Paula Scher. Poster (detail) for *Dancing on
Her Knees* at the Public Theater, New York, 1996. Private col-
lection. *Checklist no. 201*

On the back cover: Claire McCardell. Dress, 1993. The
Metropolitan Museum of Art, New York, Gift of Claire
McCardell, 1949 (CL49.37.41).

Eva Zeisel. "Museum" teapot, ca. 1942–43. Collection of
Bernard and Felicisimo Labaco. *Checklist no. 79*

Dorothy Torivio. Vase (Acoma Pueblo), 1995. Collection of
Andrea Fisher Fine Pottery, Santa Fe, New Mexico.
Checklist no. 195.

On the halftitle page: Claire Falkenstein. Brooch, ca. 1955.
Collection of Sheryl Gorman. *Checklist no. 103*

Women Designers in the USA, 1900–2000: Diversity and Difference
was made possible by

Elise Jaffe and Jeffrey Brown

Additional funding for this catalogue and
the exhibition has been provided by

Barbara and Richard Debs
Barbara Goldsmith
Judith Leiber
Grace and Shepard Morgan
Tiffany & Co.
Murray Weber
CAP Foundation
The Charles Engelhard Foundation
Laura and Nick Microulis
Pfizer Inc
Daniel and Joanna S. Rose
Reba Judith Sandler Foundation
TIMEX®
Linda Van Kooy
Anonymous Donor

CONTRIBUTORS

JACQUELINE M. ATKINS—Adjunct associate professor, New York University. Publications include *Shared Threads: Quilting Together Past and Present* (1994) and (co-author) *Folk Art in American Life* (1995). Ph.D candidate, Bard Graduate Center, New York.

WHITNEY BLAUSEN—Independent textile historian, writer, and researcher. Frequent contributor to publications, including *Fiber Arts, Contemporary Fashion* (1995), and *The Dictionary of Women Artists* (1997).

EILEEN BORIS—Professor, Studies in Women and Gender, University of Virginia; Charlottesville, and coordinating editor of *Iris: A Journal About Women*. Publications include *Art and Labor* (1986) and *Home to Work* (1995). Editorial board: *Journal of Women's History*.

CHERYL BUCKLEY—Reader in Design History, University of Northumbria, England. Publications include *Potters and Paintresses* (1990) and "Made in Patriarchy," in *Design Issues 3* (1986).

LESLIE ROSE CLOSE—Landscape historian. Founding director, Program in American Landscape History, Wave Hill, New York (1980–88). Publications include "A History of Women in Landscape Architecture" in *The Gardens of Ellen Biddle Shipman*, edited by Judith Tankard (1996).

EDWARD S. COOKE JR.—Charles F. Montgomery Professor of American Decorative Arts, Yale University. Publications include *New American Furniture* (1989) and *Making Furniture in Pre-Industrial America* (1996).

JEANNINE FALINO—Carolyn and Peter Lynch Curator of Decorative Arts and Sculpture, Museum of Fine Arts, Boston. Publications include "Circles of Influence, Metalsmithing in New England" in *Inspiring Reform: Boston's Arts and Crafts Movement* (1997).

TONI GREENBAUM—Independent art and design historian and curator. Publications include essay and catalogue for *Messengers of Modernism: American Studio Jewelry* (1996) and the jewelry and metalwork sections of *Design 1935–1965: What Modern Was* (1991)

JUDITH GURA—Assistant professor, Pratt Institute, Brooklyn; professor, New York School of Interior Design. Publications include *Edward Wormley: The Other Face of Modernism* (exhibition catalogue, 1997).

ELLA HOWARD—Ph.D. candidate, American and New England Studies, Boston University; master's degree, Bard Graduate Center, New York. Co-editor of *Studies in the Decorative Arts* (Fall/Winter 2000–2001), a special issue on women designers.

WENDY KAPLAN—Associate director for exhibitions and cultural affairs, Wolfsonian Foundation and Florida International University, Miami Beach. Publications include (editor) *"The Art That Is Life": The Arts and Crafts Movement in America* (1987) and *Leading "The Simple Life": The Arts and Crafts Movement in Britain* (1999).

PAT KIRKHAM—Professor, Bard Graduate Center, New York; Visiting Professor, The Southampton Institute, England. Publications include *Charles and Ray Eames* (1995) and (co-editor and contributor) *A View from the Interior: Women and Design* (1989 and 1995).

PAMELA KLADZYK—Adjunct professor, Parsons School of Design, New York. Recipient of grant from Parsons to develop a new course on Native American art, design, and craft. Publications include (project research editor) *Through Indian Eyes* (1996).

DEBORAH NADOOLMAN LANDIS—film costume designer and dress historian. Film credits include *Raiders of the Lost Ark* (1981), *Coming to America* (1988), and *The Blues Brothers* (1980).

ELLEN LUPTON—Adjunct curator of contemporary design, Cooper-Hewitt, National Design Museum, Smithsonian Institution, New York, and chair of the graphic design program, Maryland Institute, College of Art, Baltimore. Publications include *Mechanical Brides: Women and Machines from Home to Office* (1993).

ERIC SETLIFF—Gansevoort Gallery, New York. Master's degree, University of Toronto, and (in progress) Bard Graduate Center, New York. Publications include *The Nordic Modern Movement* (exhibition catalogue, 1998) and an essay in *Gendered Parts: Historical Essays* (1999).

MARY SCHOESER—Decorative arts writer, curator, broadcaster, archivist and consultant. Regular contributor to *Crafts*. Recent publications include textile entries in *Materials and Techniques of the Decorative Arts* (2000)

PENNY SPARKE—Dean and Professor, Faculty of Design, University of Kingston, England. Publications include *As Long as It's Pink: The Sexual Politics of Taste* (1995) and (editor) *The Plastic Age: From Modernity to Post-Modernity* (1990).

SHAUNA STALLWORTH—Executive director, Organization of Black Designers, Washington, D.C. Creative director of the design firm LUHF & LUMM. Regular contributor to *Interior & Sources*.

VALERIE STEELE—Chief curator, Museum at the Fashion Institute of Technology, New York, and editor of *Fashion Theory: The Journal of Dress, Body and Culture*. Publications include *Fifty Years of Fashion* (1996) and *Fetish: Fashion, Sex, and Power* (1996).

LYNNE WALKER—Architectural and design historian, curator, and broadcaster, London. Publications include *Drawing on Diversity: Women, Architecture and Practice* (1997). Former editorial board member of the *Woman's Art Journal* and *Art History*.

CONTENTS

DIRECTOR'S FOREWORD

SUSAN WEBER SOROS

THE BARD GRADUATE CENTER is honored to present *Women Designers in the USA, 1900–2000: Diversity and Difference*. This groundbreaking project considers—and celebrates—the multifaceted and largely underrecognized contributions of women designers to American culture in the twentieth century. Encompassing a broad definition of design that extends from industrial design to film costumes, the exhibition and its accompanying catalogue bring together the richly varied work of designers from many different social and ethnic backgrounds. They not only created objects of beauty and originality, but together they also helped shape the design professions and redefine the concept of "women's work." By focusing on diversity and difference, this project challenges the hierarchy of the arts and the eurocentrism of scholarship surrounding them. It is our hope that *Women Designers in the USA* will help elucidate women's roles in twentieth-century design while stimulating additional exploration of this exciting field of study.

ACKNOWLEDGEMENTS

The idea for *Women Designers in the USA* was first proposed by Shelby White of the Bard Graduate Center Executive Planning Committee. She deserves a large measure of credit for its coming to fruition, as do Barbara and Richard Debs, who sponsored the initial research that launched the project. I am most grateful to Elise Jaffe and Jeffrey Brown for underwriting this beautiful catalogue and to all the other sponsors of this project: the CAP Foundation, The Charles Engelhard Foundation, Barbara Goldsmith, Judith Leiber, Grace and Shepard Morgan, Laura and Nick Microulis, Pfizer Inc, Daniel and Joanna S. Rose, the Reba Judith Sandler Foundation, Tiffany & Co., The Timex Corporation, Linda Van Kooy, Murray Weber, and an anonymous donor.

To represent the work of women designers in the twentieth century required the generous support of many lenders. I am grateful to the museums, galleries, design companies, and other concerns for the loans they have made to the exhibition: The African American Museum in Philadelphia; Alternative Design, Jersey City, New Jersey; American Craft Museum, New York; American Indian College Fund, New York; American Museum of Natural History, New York; Andrea Fisher Fine Pottery, Santa Fe; Avery

Architectural and Fine Arts Library, Columbia University of the City of New York; The Black Fashion Museum, Washington, D.C.; Brooklyn Museum of Art; The Cleveland Museum of Art; Colorado Springs Fine Arts Center, Taylor Museum; Condé Nast Publications, New York; Cooper-Hewitt, National Design Museum, Smithsonian Institution, New York; Cornell University Library, Ithaca, New York; The Cranbrook Academy of Art, Bloomfield Hills, Michigan (Archives; Art Museum; and Educational Community); Dallas Museum of Art; Denver Art Museum; Dorothy Draper and Company, New York; Eastman Kodak, Rochester, New York; Ellen McCluskey Associates, New York; Environmental Design Archives, University of California, Berkeley, Beatrix Joseph Farrand Collection; Estate of Loïs Mailou Jones; Everson Museum of Art, Syracuse, New York; Franklin D. Roosevelt Library–Museum, Hyde Park, New York; The Frick Collection, New York; F. Schumacher and Company Archives, New York; Fuller Museum of Art, Brockton, Massachusetts; Gansevoort Gallery, New York; The Gillette Company, Boston; The International Quilt Study Center at the University of Nebraska, Lincoln, The Helen and Robert Cargo Collection; Historical Design, New York; Indianapolis Museum of Art; Institute of American Indian Arts Museum, Santa Fe; Jim Henson Productions, New York; John Fitzgerald Kennedy Library and Museum, Boston; Josef and Anni Albers Foundation, Bethany, Connecticut; Julie: Artisans' Gallery, New York; Knoll Museum, East Greenville, Pennsylvania; Knoll Textiles, New York; Lincoln Center Library for the Performing Arts (Billy Rose Theater Collection), The New York Public Library; McMillen, Inc., New York; Margo Chase Design, Los Angeles; Massachusetts Institute of Technology, Media Lab, Cambridge, Massachusetts; Memorial Hall Museum, Pocumtuck Valley Memorial Association, Deerfield, Massachusetts; Mendocino County Museum, Willits, California; The Metropolitan Museum of Art, New York; Michigan State University Museum, East Lansing; The Minneapolis Institute of Arts; The Mitchell Wolfson Jr. Collection, The Wolfsonian–Florida International University, Miami Beach; The Montreal Museum of Fine Arts/The Montreal Museum of Decorative Arts; The Museum of the City of New York; Museum of Fine Arts, Boston; The Museum of Modern Art, New York; Nancy Goslee Power and Associates, Santa Monica; Nevada Historical Society, Reno; Nevada

State Museum, Carson City; Perkins Design Limited, Mountain View, California; Philadelphia Museum of Art; The Philbrook Museum of Art, Tulsa; Schlesinger Library, Radcliffe Institute for Advanced Study, Harvard University, Cambridge, Massachusetts; School of American Research Indian Arts Research Center, Santa Fe; Martha Schwartz, Inc., Cambridge, Massachusetts; Smithsonian Institution, The Renwick Gallery of the National Museum of American Art, Washington, D.C.; Sussman/Prejza and Company, Culver City, California; Tanner's Indian Art, Gallup, New Mexico; Tiffany and Company, New York; Timex Corporation, Middlebury, Connecticut; United States Patent and Trademark Office, Washington, D.C.; Universal Studios (Archives and Collections), Universal City, California; University of Arizona Special Collections, Tucson; The University of Chicago Library; Unika Vaev, New York; Wallace Library, Rochester Institute of Technology, New York; Washington Design, Brooklyn; and Yale University Art Gallery, New Haven.

Many individuals were also most generous in lending objects from their collections: Sandra S. Adams, Genevieve Allen Aguilar, Diana Balmori, Renée Beggsmith, Rosalie Berberian, Susan Billy, Ayse Birsel, Thomas J. Blumer, Carol Devine Carson, Cara Croninger, Sheila Levrant de Bretteville, Marcia Docter, Michele Oka Doner, R. A. Ellison, Daphne Farago, Natalie and Greg Fitz-Gerald, Sheryl Gorman, Stephen Gray, Toni Wolf Greenbaum, April Greiman, Sandy Grotta, Peggy Gruen, Dorothy Hafner, Sylvia Harris, Marilyn Henrion, Frances Stewart Higgins, Donna Karan, Gere Kavanaugh, Bernarda and Felicisimo Labaco, Kay and Michael Langan, Judith Leiber, Emanuela Frattini Magnusson, Wendy Maruyama, Carolyn L. Mazloomi, Rebeca Méndez, Myra Mimlitsch-Gray, Mrs. Jervey D. Royall, Hiroko Sato-Pijanowski, Wesley Snipes, Lauren Sweder, Vivienne Tam, Cledie Collins Taylor, Lucille Lozada Tenazas, Isabel Toledo, Patricia Underwood, Lella Vignelli, Denise and Samuel Wallace, Rose Piper Wheeler, Barbara D'Arcy White, Fo Wilson, Jean and Jim Young, and an anonymous lender.

The success of the project required a hardworking and committed team. Pat Kirkham has been the guiding force behind its realization. As editor, author, and curator she has brought fine scholarship, insight, and passion to this difficult and challenging task. She has also introduced multimedia and new areas of design (film costume and production design, and landscape design) to our gallery. She benefited from the advice of a small group of consultants including Jacqueline M. Atkins, Joanna Bigfeather, Jeannine Falino, Lynn Felsher, Toni Greenbaum, Wendy Kaplan, the late Richard Martin,

Shauna Stallworth, and Lynne Walker, and she had the support of two exceptional assistants, Ella Howard and Ronald Labaco.

This comprehensive publication was made possible by the contributions of twenty-one scholars. I would like to thank Jacqueline M. Atkins, Whitney Blausen, Eileen Boris, Cheryl Buckley, Leslie Rose Close, Edward S. Cooke Jr., Jeannine Falino, Toni Greenbaum, Judith B. Gura, Ella Howard, Wendy Kaplan, Pat Kirkham, Pamela Kladzyk, Deborah Nadoolman Landis, Ellen Lupton, Mary Schoeser, Eric Setliff, Penny Sparke, Shauna Stallworth, Valerie Steele, and Lynne Walker. Martina D'Alton did a skillful job as line-editor and assisted with the book's production.

We were fortunate to have a talented group of women designers working on this project. I appreciate the fine creative input of Ellen Lupton, design director of the catalogue. Deborah Sussman, Jennifer Stoller, and Ana Llorente-Thurik of Sussman/Prejza and Company created the remarkable context line that affords a sweeping view of developments in different aspects of women's history in the twentieth century. It also places many of the objects in the exhibition within this context. Patrick Seymour, designer of the catalogue, and Vicki Latimer Roan, of Tsang Seymour Design coordinated the complex production of *Women Designers in the USA*. I would also like to thank Sally Salvesen and John Nicoll of Yale University Press in London for their support and assistance. A dedicated and talented crew in the Bard Graduate Center assisted with many aspects of the exhibition preparation and installation. I would like to extend a special note of thanks to Steve Waterman, Steven Berkhart, Janet Hawkins, Alissa Warshaw, and Han Vu for their expertise and professionalism.

The staff of the Bard Graduate Center contributed substantially to the success of this project. In the exhibition department, Nina Stritzler-Levine, exhibitions director, was truly committed to the project, attending to the myriad logistical details of the exhibition and general matters relevant to the catalogue. Dana Bielicki helped coordinate photographic requests and exhibition loans. Susan Wall, assisted by Tara D'Andrea, directed the fundraising effort, and Tim Mulligan, working with Polly Giragosian, coordinated the publicity campaign. Lisa Podos orchestrated the marvelous public programs with the assistance of Jill Gustafson and Lee Talbot. Jason Petty organized the exhibition tours. Lorraine Bacalles assisted by Dianora Watson, oversaw many financial matters. I also appreciate the excellent care and maintenance of the gallery that is provided by the facility and security staff at the Bard Graduate Center.

PREFACE

PAT KIRKHAM

DEDICATION: In memory of my mother—the first feminist in my life—who told me her stories, and introduced me to the decorative arts, Hollywood movies, fashion, politics, pleasure, and much else. And of my father—the first male supporter of "equal rights" in my life—who told me his stories and introduced me to history, architecture, politics, soccer, and much else. Her stories, his stories, and herstory/history continue to sustain and nourish me, as I hope they will my three wonderful daughters, Sarah, Alex, and Kate.

The idea of marking the millennium and the end of a century labeled by some "The American Century" and by others "The Women's Century" with a research, exhibition, and publishing project about women designers in America was the brainchild of Susan Weber Soros, director of the Bard Graduate Center, and Shelby White, a member of the center's executive planning committee. What better exhibition in a center dedicated to the study of design and the decorative arts, it was argued, than one featuring women designers across a century that saw women win the vote and enter many professional design fields for the first time? I am indebted to them both. Susan Weber Soros not only invited me to direct the project but also supported the focus on "diversity and difference" and the placing of women at the center of history, rather than the margins. A champion of design and the decorative arts, she is also a supportive and stimulating academic colleague. I applaud her for the former and thank her for the latter, and for many personal kindnesses.

Since working on this project, I have sometimes been asked "why just women?" While pointing out that no exhibition can hope to be all-inclusive and that no one ever asked "why men?" during any of my projects involving male designers over the last thirty years, I make no apologies for singling out for study a sector of society whose histories are still not told in all their complexities—and certainly not in terms of design. This exhibition and publication stand in the spirit of those feminists who, over a century ago, favored separating women's art and design from that of men at the World's Columbian Exposition held in Chicago in 1893. They did so then not because of an abstract principle but because they believed a separate exhibit at that moment in time would better highlight women's work and achieve-

ments and lead to greater understanding and appreciation of it. I hope that this publication and the exhibition it accompanies, along with the special issue of *Studies in the Decorative Arts* and related public programs, will lead to a deeper understanding of the varied and multiple roles and achievements of women designers during the twentieth century, as well as the constraints within which they worked.

The immediate aims of the exhibition and book are to celebrate the scope as well as the quality of work designed by women in the United States, and to better understand the various ways in which a wide range of women came to be designers and to practice as such. The broader aims are to counter the marginalization of women within design history, to emphasize the gendered nature of design practice, highlight the intersections of gender with other factors such as "race," class, employment, and experience, and to help erode the eurocentrism of much current scholarship in a century where magnificent work came from "minority ethnic" women. All areas of design are treated equally seriously—be it ceramics or cinema; fashion or furniture; graphics or gardens; interiors or industrial design—and no attempt was made to privilege hand-made work over machine-made, or vice versa.

Selection is never easy and in a show that covers a whole century one cannot hope to be inclusive. I took chronological spread as well as types of objects into consideration (and occasionally size since we are a relatively small gallery). The show includes only one item per designer—something I agonized over but which has been declared "the fairest way" by each and every living designer.

ACKNOWLEDGEMENTS

Collaboration has been one of the joys of this large and sometimes overwhelming project. So many people have been helpful that I hardly know where to begin my expressions of gratitude. Any omissions relate to editorial exhaustion and "senior moments" rather than lack of gratitude. Special thanks to the twenty authors whose work is presented here. I enjoyed the dialogues of the editorial process and learned a great deal. It was a pleasure to work with Toni Greenbaum, Deborah Nadoolman Landis, Penny Sparke, Shauna Stallworth and Lynne Walker—with whom I coauthored chapters—and with Jaqueline

Atkins, Whitney Blausen and Mary Schoeser, Eileen Boris, Cheryl Buckley, Leslie Close, Ned Cooke, Jeannine Falino, Judith Gura, Ella Howard and Eric Setliff, Wendy Kaplan, Pamela Kladzyk, Ellen Lupton, and Valerie Steele. Valerie, who originally contracted to write the second half of a chapter split between herself and Richard Martin, kindly took over the entire chapter when Richard became too ill to continue. He was a good friend to this project and we miss him. Special thanks also to Lynne Walker, whose perceptive comments as "reader" of all the chapters, was greatly appreciated and to Michelle Black Smith who, due to unforeseen circumstances, was not able to contribute. Thanks also to Nicole Demerin and Cynthia Lee Henthorn for use of data relative to student designers.

The late Richard Martin was our consultant on fashion. Joanna Bigfeather was consultant on matters related to Native American design and craft traditions and objects, and Shauna Stallworth acted in a similar capacity for African American design and designers. Wendy Kaplan was consultant on items related to the Arts and Crafts movement. Jacqueline M. Atkins, Jeannine Falino, Lynn Felsher, and Toni Greenbaum advised on quilts, metalwork, textiles, and jewelry respectively. Johanna Brenner and Beverley Skeggs (two of the best friends anyone could wish for) advised on feminist theory, history, and gender issues. Denis Gallion, Daniel Morris, and Mark McDonald were helpful throughout. My thanks to them all.

I would like to reiterate Susan Soros's thanks to the lenders whose precious objects tell many important stories and affect us in many ways. I also extend my gratitude to the sponsors without whose generosity this project would have been lesser at every level and to the designers whose work is exhibited. Special thanks to Elise Jaffe and Jeffrey Brown, who funded this publication, and to Barbara and Richard Debs, who funded the research assistantship that got this project under way. I am also grateful to the Wolfsonian–Florida International University, Miami Beach, for awarding me a Fellowship (February 1999) to study women designers. Mitchell Wolfson Jr. and all the staff were unfailingly helpful. A special thank you to funder Sheri Sandler who introduced me to a variety of women engaged in wider "practical feminism." One such was photographer Joan Roth, some of whose images appear in the Context Line (together with one of a hair curler patented by her mother, Clara Altman). I hope that all the lenders, funders, designers, and other supporters of the project will take pleasure in the fact that over the last three years Bard Graduate Center students have been involved with the research, planning, and execution of the exhibition and publications. My

generation of design historians did not enjoy such opportunities, and I am grateful to all those who make them available to young scholars.

My thanks to Ellen Lupton and Patrick Seymour for designing a beautiful book, and to Vicki Latimer Roan of Tsang Seymour Design for her invaluable input. Thanks again to Ellen for the cover design. I feel honored that Deborah Sussman, a member of the team that produced the first Eames Office "timeline" in 1960, agreed to lead the team that designed the one for our exhibition (a redesigned version of which appears in this book). Working with her and with Jennifer Stoller and Ana Llorente-Thurik was extremely rewarding, and I am delighted with the results. My thanks to them, and to Sarah Lichtman, my co-compiler, whose keen intelligence in matters visual and historical, was crucial to the success of the endeavor.

The exhibition would never have taken final form without an enormous amount of "backstage" work and I am extremely grateful to Steven Berkhart, Janet Hawkins, Alissa Warshaw, and Han Vu for all the work they put into its design and preparation. My thanks also to two former exhibition assistants, Nicole Linderman and Dana Bielicki, for their help with securing loans and photographs; to Steve Waterman who advised on design until May 2000.

Nina Strizler-Levine guided me through curating this exhibition. The very best of exhibition directors, she encouraged me to be as ambitious for it as she was herself. I hope she will not be disappointed. Martina D'Alton also proved to be the very best and most patient of editors; her calmness is matched only by her perceptive readings and excellent editorial skills. She, Nina Strizler-Levine, and my research assistants, were the linchpins of this project. I want them all to know just how much I appreciate their efforts and how much I enjoyed working with them.

My immediate support structure came in the shape of two excellent full-time research assistants (who, unfortunately, overlapped for only a short time), student assistants, and a husband who ferried food to my office. My grateful thanks to Ella Howard, a model researcher, whose initiatives, organizational skills, and feminist insights enriched the project, and to Ron Labaco whose passion for and knowledge of objects, together with his incomparable "people skills," smoothed many loan requests and research inquiries. Three student assistants from the current Bard Graduate Center student body, Stephanie Day Iverson, Sarah Lichtman, Margaret Maile, and Scott Perkins, played an important part in the preparation of the exhibition and book. I commend them for their professionalism and the pleasure they take in knowledge as well as their commitment to gender issues. Andy Hoogenboom,

whose enthusiasm for art, design, and life is unbounded, supplied moral support as well as food. Without his readiness to take over all domestic responsibilities, this project would never have been completed.

At the Bard Graduate Center, academic librarians Greta Earnest, Stephanie Sueppel, and Irina Kandarasheva went out of their way to be helpful, as did Lorraine Bacalles, Judith Maiorana, and other staff. Fundraising was expertly handled by Susan Wall and Tara D'Andrea and publicity by Tim Mulligan and Polly Giragosian. Lisa Podos, Jill Gustafson, and Lee Talbot produced an exceptionally varied schedule of public programs. They were all a pleasure to work with. Bard Graduate Center students, past and present, who have helped in a variety of ways include Eric Setliff, Edina Deme, Emily Miller, Lisa Dent, Sarah Maud Lydiatt, Deborah Miller, Jennifer Scanlan, Marlyn Musicant, Christian Carr, Lisa Bingham, Leslie Klinger, Mary Dohne, James Beebe, Jason Petty, Barbara Mayer, Grace Jeffers, and Maria Perers.

I am grateful to my academic colleagues Ken Ames, Amy Ogata, Derek Ostergard, and Kevin Stayton for helpful suggestions about the project. Thanks also to Beth Holman, François Louis, Michele Majer, Andrew Morrall, Elizabeth Simpson, and Stefanie Walker for their support and collegiality, and to Sally Sherrill, editor of *Studies in the Decorative Arts*, for producing the special issue on women designers. I also want to thank Leon Botstein, Bob Martin, and Stuart Levine for welcoming me into the academic community of Bard College.

A large number of archivists, curators, collectors, librarians, scholars, and administrative assistants helped at every stage of this project. My thanks to the following for their efforts and courtesies: The Academy of Motion Picture Arts and Sciences, Los Angeles (Anne Coco, Kristine Krueger); The African American Museum in Philadelphia (Aileen Rosenberg); American Craft Museum, New York (Marsha Beitchman, Larry Giacoletti, Shawn Greene, Ursula Ilse-Neuman, David McFadden); American Museum of Natural History, New York (Kristen Marble, Enid Schildkrout); Arizona Historical Society; The Art Institute of Chicago (Jennifer Downs, Nicole Finzer, Hsiu-Ling Huang); Avery Architectural and Fine Arts Library, Columbia University of the City of New York (Angela Giral, Janet Parks); The Baltimore Museum of Art (James A. Abbott); The Black Fashion Museum, Washington, D.C. (Joyce Bailey, Valerie Chisholm, Dennis McBride); The Boston Public Library; Brooklyn Museum of Art (Deirdre Lawrence, Diana Fane, Ruth Janson, Arnold L. Lehman, Patricia Mears, Kevin Stayton, Robert Thill); California College of Arts and Crafts, San Francisco (Kristin Bach); The Charles Hosmer Morse Museum of American Art, Winter Park, Florida (Jennifer Perry);

Cincinnati Art Museum (Jennifer Howe); Cincinatti Museum Center (Cynthia Keller); Colorado Springs Fine Arts Center, Taylor Museum (Susan Conley, Cathy Wright); Columbia University of the City of New York, Archives and Special Collections; Cooper-Hewitt, National Design Museum, Smithsonian Institution, New York (Jill Bloomer, Gail Davidson, Joanne Kosuda-Warner, Emily Miller, Cordelia Rose, Deborah Sampson Shinn, Marilyn Symmes, Stephen Van Dyk); The Cooper Union for the Advancement of Science and Art, New York (Carol Salomon); Cornell University Library (Lorna Knight, Peter Martinez); Corning Museum of Glass (Jutta-Annette Page); Costume Institute, The Metropolitan Museum of Art, New York (Amy Beil, Stéphane Houy-Towner, Myra Walker, Emily Martin, Dennis Sewell); Coty, Inc. (Rick Kinsel); The Cranbrook Academy of Art, Bloomfield Hills, Michigan (Archives: Mark Coir, Amy James; Art Museum: Ashley Brown, Roberta Gilboe, Gregory Wittkopp; Educational Community: Robert Saarnio); Dallas Museum of Art (Stephen Harrison, Anne Lawrence, Charles Venable); Denver Art Museum (Shannon Corrigan, Emily Kosakowski, R. Craig Miller, Tamara Roghaar, Eric Stephenson); Everson Museum of Art, Syracuse, New York (Michael Flanagan, Tom Piche, Jr., Debora Ryan); F. Schumacher and Company Archives, New York (Richard Slavin, Phyllis Wickham); The Frank Lloyd Wright Archives, Taliesin West, Scottsdale, Arizona, Fine and Decorative Arts Collections (Penny Fowler, Donna Hoover); The Frick Collection, New York (Katherine Gerlough, Edgar Munhall, William Stout); Fuller Museum of Art, Brockton, Massachusetts (Jennifer Atkinson); Grand Canyon National Park Museum Collection (Sara Stubbins); The Heard Museum, Phoenix (Diana Pardue); Hearst Castle—Hearst San Simeon State Historical Monument, California (Hoyt Fields, Deborah Weldon); Indianapolis Museum of Art (Barry Shifman); Institute of American Indian Arts Museum, Santa Fe (Joanna Bigfeather, Paula Rivera); International Quilt Study Center, University of Nebraska, Lincoln (Caroline Ducey); John Fitzgerald Kennedy Library and Museum, Boston (Alan Goodrich, James Hill, Frank Rigg, Megan Sawyer); John M. Flaxman Library, The School of the Art Institute of Chicago (Roland Hansen); The Josef and Anni Albers Foundation, Bethany, Connecticut (Brenda Danilowitz, Phyllis Fitzgerald); The Library of Congress, Washington, D.C.; Los Angeles County Museum of Art (Jo Lauria); Lincoln Center Library for the Performing Arts, New York Public Library, Billy Rose Theater Collection, (Rick Hunter, Robert Taylor); Lucy Scribner Library, Skidmore College, Saratoga Springs, New York (Elizabeth Putnam); Marathon County Public Library, Wausau, Wisconsin; Massachusetts College of Art, Boston (Paul Dobbs); Memorial Hall Museum,

Pocumtuck Valley Memorial Association, Deerfield, Massachusetts (Suzanne Flynt, Christine Granat); Mendocino County Museum (Rebecca Snetselaar); The Metropolitan Museum of Art, New York (Jane Adlin, Alice Cooney Frelinghuysen, Sandra Fritz, Stewart Johnson, Julie Jones, Kendall McWilliam, Amelia Peck, Jennifer Wade, Myra Walker); Michigan State University Museum, East Lansing (Lynne Swanson, Pearl Yee Wong); Minneapolis Institute of Arts (Patricia Martinson, Christopher Monkhouse, Lotus Stack); The Montreal Museum of Fine Arts/The Montreal Museum of Decorative Arts (Diane Charbonneau, Linda-Anne D'Anjou, Guy Cogeval); The Museum at the Fashion Institute of Technology, New York (Joanne Dolan, Ellen Shandley); Museum of Fine Arts, Boston (Jeannine Falino); Museum of Indian Arts and Culture, Laboratory of Anthropology, Santa Fe (Tony Chaverria, David McNeece); The Museum of Modern Art, New York (Pierre Adler, John Alexander, Mary Corliss, Jennifer Culvert, Terry Geesker, Madeleine Hensler, Luisa Lorch, Cora Rosevear, Kirk Varnedoe); Museum of the City of New York (Anne Easterling, Marguerite Lavin, Phyllis Magidson, Eileen Morales, William Wise); National Japanese American Historical Society, San Francisco; Nevada Historical Society, Reno (Andrea Mugnier); Nevada State Museum, Carson City (Gene Hattori, Roz Works); New York Public Library (Photographic Department); The Norwest Collection, Norwest Corporation, Minneapolis (David Ryan); The Palace of the Governors, Museum of New Mexico (Arthur L. Olivias, Richard Rudisill); Parsons School of Design, New York, The Anna-Maria and Stephen Kellen Archives (X. Theodore Barber); Philadelphia Museum of Art (Dilys Blum, Donna Corbin, Kristina Haugland, Kathryn B. Heisenger); The Philbrook Museum of Art, Tulsa (Christy Fasano, Shelby Tisdale, Thomas Young); Schlesinger Library, The Radcliffe Institute for Advanced Study, Harvard University, Cambridge, Massachusetts (Anne Englehardt); The Renwick Gallery of the National Museum of Art, Smithsonian Institution, Washington, D.C. (Elizabeth Broun, Abigail Terrones, Kenneth R. Trapp); Rhode Island School of Design (Madlyn Shaw); The Ryerson and Burnham Libraries, The Art Institute of Chicago (Jason Molina, Mary Woolever); Savannah College of Art and Design, Georgia (Gill Davies, John Micheal Pearson, George Perez); Schomberg Center for Research in Black Culture, The New York Public Library; School of American Research—Indian Arts Research Center, Santa Fe (Christy Sturm); University of Arizona, Tucson, Special Collections Library (Jan Kathy Davis, Roger Myers); Syracuse China Archives, New York (Ruth Pass Hancock); Syracuse Public Library, New York; The Textile Museum, New York (Madeline Shaw); Tulane University Art Collection, Tulane University Library (Wilbur Mener-

ay, Leon Miller); Universal Studios, Archives and Collections (Daryl A. Maxwell), Licensing (Nancy Cushing Jones); University of California, Berkeley (Art Museum: Jacquelynn Bass, Stephanie Cannizzo); Environmental Design Archives (Beatrix Jones Farrand Collection: Waverly Lowell, Kelcy Shepherd, Jody Stack); The Wolfsonian–Florida International University, Miami Beach (David Burnhauser, Pedro Figueredo, Joel Hoffman, Wendy Kaplan, Cathy Leff, Frank Luca, Richard Miltner, Annie Wharton); Yale University Art Gallery, New Haven (Jennifer Bossman, Patricia Kane, Jock Reynolds, Nancy Yates); and the Yosemite Museum, Yosemite National Park, California (Craig Bates, David Forgang).

Many design companies, galleries, and other organizations were supportive of this project. I am most grateful to them all: Alternative Design, Jersey City, New Jersey (Susan Santoro); American Indian College Fund, New York (Wayne Martin); American Institute of Graphic Arts, New York (Alice Twemlow); American Society of Interior Designers, New York (Susan Aiello, Nancy Blocks Barsotti); Annie Leibowitz Studio, New York (Michael Fisher); Association of Women Industrial Designers, New York (Erika Doering, Rachel Switzky, Rebecca Welz); Balmori Associates, New Haven (Mary Rickel); Bison Archives, Hollywood (Marc Wanamaker); Buena Vista Film, Burbank, California (Sales: Sarah Stevenson); Cecil's Designers Unlimited, Coconut Creek, Florida (Mike Orgill); Clodagh Design, New York (Jen Diamond); Columbia Tristar Motion Pictures Group, Culver City, California (Margarita Medina); Condé Nast Publications, New York (Kate Gardner, Deanna Raso, Michael Stier); Contact Press Images, New York (Jeffrey Smith); Copy Door Graphics, New York; Donna Karan Company, New York (Jennifer Cohen, Nadia Sulaiman); Dorothy Draper and Company, New York (Carleton Varney); Dreamworks Skg, Universal City, California (Melissa Hendricks); Eames Office, Los Angeles (Eames Demetrios, Lucia Eames, Shelley Mills); Eastman Kodak (Tom Bonisteel); Ellen McCluskey and Associates, New York (Frank Sierra); *Emmy* Magazine (Rosa Madonna); Estate of Loïs Mailou Jones (James Larry Fraiser); Esto Photographics, Mamaroneck, New York (Meiers Tambeau); Exhibitions International, New York (David Hanks, Osanna Urbay); Facets Multimedia, Chicago; The Fashion Group International, New York (Lenore Benson); Forty Acres and a Mule (Spike Lee); Gansevoort Gallery, New York (Eric Setliff, Scott VanderHamm); Garth Clark Gallery, New York (Gretchen Adkins, Garth Clark); General Motors Design Center, Warren, Michigan (Matt Koesler); Gleason Gallery, New York (Tim Gleason); Higgins Glass Studio, Riverside, Illinois (Louise Wimmer); Historical Design, New York (Denis Gallion, Caroline Hannah, Daan de Kuyper,

Daniel Morris); Knoll, Inc. East Greenville, Pennsylvania (Lauren Cadmus, Hee Sun Choi, Mary O'Grady, Albert Pfeiffer); Krohn Design, Los Angeles; Larsen, Inc., New York (Crystal Cooper, Matko Tomicic); McMillen, Inc., New York (Edward Jenkins, Mora Mathews, Betty Sherrill); Margo Chase Design, Los Angeles (Chris Lowery); Martha Schwartz, Inc., Cambridge, Massachusetts (Evelyn Bergalia, Laine Butterworth); MGM, Santa Monica, California (Ugene Park); The Michigan Guild of Artists and Artisans, Ann Arbor, Michigan (Deborah Miller); Moore College of Art and Design, Philadelphia (Doris Chorney); New Line Cinema, New York (Robin Zlatin); Olive 1:1, New York (Noen Nguyen); Organization of Black Designers, Washington, D. C. (Bill Brown); Paramount Pictures, Hollywood, California (Bill Berrios); Pentagram Design, New York (Kurt Koepfle); reasonsense, Alta Dena, California (Adam Eeuwens); Robert Cargo Folk Art Gallery, Tuscaloosa, Alabama (Robert Cargo); Rose Cumming, Inc., New York (Ronald Grimaldi); St. Clare Entertainment (Sharon Dolin); Source One International, Chicago (Cecelia Mitchell Daspit); Southern Highland Craft Guild, Asheville, North Carolina (Laurey-Faye Long); Spanierman Gallery, New York (Betty Krulick); Spelman College, Atlanta (Taronda Spencer); Sussman/Prejza and Company, Culver City, California (Selene Rawls); Tenazas Design, San Francisco (Jennifer Kaufman); Tiffany and Company, New York (Fernanda Kellogg); Time-Life Syndications, New York (Katherine Hopkins, Jennifer McAlwee); Twentieth Century Fox, Century City, California (Andrew Trosman); UNISYS Corporation, Blue Bell, Pennsylvania; United Airlines, Chicago; Universal Studios, Universal City, California (Thomas Casteneda, Nancy Cushing-Jones); University of Kentucky, Lexington (Allison Carll-White, Anne Whiteside-Dickson); Venturi, Scott Brown and Associates, Philadelphia (Emily Fuller); Vignelli Associates, New York (Arielle Goldberg); and Warner Bros., Burbank, California (Judith Singer).

I am also extremely grateful to the following individuals for help and permissions: Donald Albrecht, Anita Stewart Bach, Bernard Banet, Jim Benjamin, Eugene Bielawski, Lynne Breslin, Talisman Brolin, Ashley Brown, Maite Bursic, Beatriz Colomina, Barbara B. Cooke, Lucia DeRespinis, Mary Donahue, Deidre Donohue, Sara Dubow, Harriete Estel-Berman, Lisa Farrington, Martin Filler, Matt Flynn, Nancy Gruen, Rosemarie Haag-Bletter, Albert Hadley, Karen Hampton, Linda C. Hartley, Dolores Hayden, Valerie Hennigan, J. Michelle Hill-Campbell, Janet Kardon, Gere Kavanaugh, Grace Keating, Juliet Kinchin, Sally Kinsey, Giles Kotcher, Rachel Kueny, John Landis, Spike Lee, Annie Leibovitz, Victor Margolin, Santana Martinez,

Anne Massey, Barbara Mayer, Louise Meire-Dunn, Marilee Boyd Meyer, Lloyd Morgan, Susan Peterson, Wendy Ponca, Richard Quinn, Rosalie Raab, Peter S. Reed, Faith Ringgold, Mary Roehm, Elaine Rosenfeld, Joan Rothschild, Troy Segal, Molly Seiler, Deita and Vincent Simone, David Small, Wesley Snipes, Janis Staggs-Flinchum, Jewel Stern, Stephanie Stokes, Nancy Ellen A. Streeter, John Stuart, Usha Subramaniam, Karen P. Swanson, Judith Tankard, Diane Taylor, Ruben Toledo, Dorothea Towles, Denise J. Vetter, John Michael Vlack, Judith Wilson, Stuart Wurtzel, and Kohle Yohannan.

Last but by no means least, my thanks to all the designers without whose work and cooperation this project would not have been possible. I hope their work gives readers and viewers as much pleasure as it has me.

EDITOR'S NOTE: In the chapters that follow, the checklist numbers at the end of each caption refer to the Checklist of the Exhibition, beginning on page 381. The endnotes for each chapter will be found in the section beginning on page 400. Sources there are given in a shortened form; full references will be found in the bibliography.

PROLOGUE

American Women in the Twentieth Century

CONTEXT LINE

COMPILED BY PAT KIRKHAM AND SARAH A. LICHTMAN

DESIGNED BY SUSSMAN/PREJZA & COMPANY—DEBORAH SUSSMAN,

JENNIFER STOLLER, AND ANA LLORENTE-THURIK

1900

CARRIE NATION, temperance crusader, embarks on saloon attacks, Kansas

CARRIE CHAPMAN CATT succeeds Susan B. Anthony as president of National American Woman Suffrage Association

National Women's Business Association founded

Courtesy of Spelman College Archives, Atlanta, Georgia

JANE ANNA GRANDERSON and CLAUDIA T. WHITE first college graduates, Spelman Seminary (later Spelman College)

Lowthorpe School of Landscape Gardening for Women founded, Groton, Massachusetts

Courtesy of Nancy Perkins

ANNA KEICHLINE, age 14: *Philadelphia Inquirer* reports she "may devote life to Industrial Art"

EDITH WHARTON publishes *Italian Villas and Their Gardens*

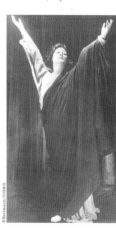
Library of Congress, Prints & Photographs Division. Photograph by Edward Curtis

NAMPEYO demonstrates Hopi polychrome pottery, Hano, First Mesa, Arizona

LENA and LYDA BURTON CONLEY protest against plans to build on Native American Wyandotte burial grounds, Kansas

LUCIA (LUCY) GONZALEZ PARSONS helps found the Industrial Workers of the World (IWW)

ANNA M. JARVIS initiates Mother's Day

HARRIOT STANTON BLATCH sues after New York restaurant prohibits her from dining alone

MARY CHURCH TERRELL and IDA B. WELLS-BARNETT among founders of National Association for the Advancement of Colored People (NAACP)

NANNIE HELEN BURROUGHS heads National Training School for Women and Girls.

| 1900 | 1901 | 1902 | 1903 | 1904 | 1905 | 1906 | 1907 | 1908 | 1909 |

MADELINE YALE WYNNE, ca 1900

AMY SACKER, 1902

ANNA MARIE VALENTIEN, ca 1902

MARION MAHONY, ca 1903

ELLEN GATES STARR, 1905

JANE CARSON BARRON and FRANCES BARNUM SMITH, ca 1905

CLARA BARCK WELLES, ca 1905–14

ZULMA STEELE, ca 1905–10

ADELAIDE ALSOP ROBINEAU, 1908

MARGARET WHITING and ELLEN MILLER, 1905–16

MARIA LONGWORTH STORER and MARY LOUISE McLAUGHLIN win medals for decorative arts at the Exposition Universelle, Paris

"MOTHER" MARY HARRIS JONES, United Mine Workers organizer, helps coordinate strikes in Pittsburgh, Pennsylvania

CANDACE WHEELER publishes *Principles of Home Decoration with Practical Examples*

Women's Trade Union League (WTUL) founded

MAGGIE LENA WALKER, daughter of former slaves: first American woman bank president, St. Luke Penny Savings Bank, Richmond, Virginia

SARA BREEDLOVE (Madame C. J. Walker) develops haircare products for African American women: becomes millionaire

ELSIE DE WOLFE designs interiors for The Colony Club, New York City (1905–07)

LUCIA KLEINHANS MATHEWS and Arthur Mathews establish The Furniture Shop, San Francisco (1906–20)

Sullivan Ordinance bans women from smoking in public places, New York City

ISADORA DUNCAN rebels against rigidity of classical ballet to pioneer modern dance

©Bertmann/CORBIS

New England Telephone Switchboard: more than 35,000 women work as switchboard operators nationwide
Boston Public Library, Print Department. Photograph by E.E. Bond

1910

LUISA CAPETILLO launches *La Mujer*, first Puerto Rican women's rights newspaper

Immigrant shirtwaist workers protest after fire at New York Triangle Shirtwaist Factory kills 146 workers, mostly Jewish and Italian women

ELIZABETH GURLEY FLYNN organizes textile workers, Bread and Roses strike, Lawrence, Massachusetts

ANN LEE WILLETT and William Willett design stained glass Liberal Arts Window, Proctor Hall, Princeton University

DOROTHY NEWELL displays suffrage slogan

MARY PICKFORD, "America's Sweetheart," earns $104,000 per year as movie star

ALICE G. BRYANT and FLORENCE DUCKERING: first two women admitted to American College of Surgeons

Cambridge School of Architecture and Landscape Architecture for Women founded after Harvard School of Landscape Architecture refuses admission to Radcliffe graduate

ZITKALA-SA (Gertrude Simmons Bonin) forms Society of American Indians, fights for recognition of land claims and American citizenship

Women sell Liberty Bonds to help fund war effort

African American women form Circle for Negro War Relief after refused admission to Red Cross

HATTIE CARNEGIE opens clothes salon, New York City

House of Representatives approves 19th Amendment, giving women the vote

Korean Women's Patriotic League founded, California

1910 1911 1912 1913 1914 1915 1916 1917 1918 1919

 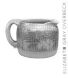

Kansas Attorney General rules women may wear trousers

JULIETTE GORDON LOW founds first U.S. Girl Scouts unit, Savannah, Georgia

EMMA PERRY CARR and DOROTHY HAHN: pioneers in absorption spectroscopy

JEANETTE RANKIN: first woman elected to House of Representatives (Montana)

EMMA GOLDMAN, anarchist and anti-war organizer, imprisoned two years and deported to U.S.S.R. after convicted of conspiracy to violate U.S. conscription law

ADELAIDE ROBINEAU: *Scarab Vase* wins grand prize, Esposizione Internazionale d'Arte Decorativa, Turin

Feminists, radicals, labor organizers, sex reformers, and civil rights workers form Heterodoxy Club, New York City

FLORENCE NIGHTINGALE GRAHAM opens ELIZABETH ARDEN beauty salon on New York's Fifth Avenue

SOPHIE TUCKER, "the last of the red hot mamas," sings "Some of These Days"

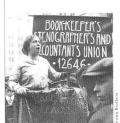

ROSE SCHNEIDERMAN: labor organizer (later national president of Women's Trade Union League) addresses rally, New York City

CHRISTINE FREDERICK, efficiency expert, publishes *The Principles of Household Management*

MARGARET SANGER opens first birth control clinic, Brooklyn, New York

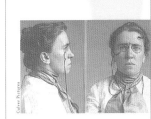

America enters WWI: women work as street car drivers, elevator operators, postal workers, munitions plant workers, and in other jobs from which they had been excluded. Women admitted to Armed Forces as "Yeomanettes" and "Marinettes": duties primarily clerical

JULIA MORGAN designs estate for William Randolph Hearst, San Simeon, California (1919–42)

1920

Senate ratifies the 19th Amendment. League of Women Voters formed. In southern and western states, African American, Mexican American, and Native American women, like men, face literacy tests, property tax requirements, intimidation, and other obstacles barring them from voting

BEATRIX JONES FARRAND begins gardens at Dumbarton Oaks, Washington, DC (1921–38)

EMILY POST'S *Etiquette* sells 660,000 copies, establishing her as the authority on "good manners"

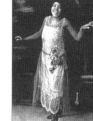

Equal Rights, newspaper of National Woman's Party

BESSIE SMITH sings *Down-Hearted Blues*

ANNA RACHEL RUSSELL JONES graduates from Philadelphia School of Design for Women and joined James G. Speck Studio as textile designer.

RUTH MCCORMICK organizes the World Exposition of Women's Progress, Chicago, to showcase achievements of women in fields such as plumbing, printing, and banking

PEARL WHITE, action heroine, stars in *Plunder*, 1923

MARTHA GRAHAM establishes School of Contemporary Dance, New York City

MARGARET MEAD, anthropologist, publishes *Coming of Age in Samoa*

DOROTHY ARZNER directs Paramount's first talking picture, *The Wild Party*, starring Clara Bow

1920	1921	1922	1923	1924	1925	1926	1927	1928	1929

DAT SO LA LEE (LOUISA KEYSER), 1921

NATACHA RAMBOVA, 1922

JANET PAYNE BOWLES, ca 1925–29

WINI AUSTIN, ca 1925

JULIA MORGAN, 1927

MARISKA KARASZ, ca 1927

LOIS MAILOU JONES, 1928

ILONKA KARASZ, ca 1928

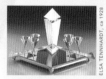
ELSA TENNHARDT, ca 1928

JANE ADDAMS, HELEN KELLER, ELIZABETH GURLEY FLYNN, and CRYSTAL EASTMAN help found American Civil Liberties Union (ACLU)

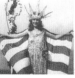
MARGARET GORMAN: First Miss America

BESSIE COLEMAN: first U.S. woman to earn international pilot's license. Refused admission to U.S. aviation schools because African American, Coleman is licensed by Fédération Aéronautique Internationale

ALICE PAUL of the National Woman's Party introduces the Equal Rights Amendment to Congress

EDNA ST. VINCENT MILLAY: first woman to win the Pulitzer Prize for Poetry, *The Ballad of the Harp-Weaver* and *A Few Figs from Thistles*

ELEANOR MCMILLEN BROWN establishes interior design firm, McMillen, Inc., New York City

FLORENCE SABIN, first woman professor at Johns Hopkins Medical School, appointed first woman president of American Association of Anatomists

GERTRUDE EDERLE: first woman to swim English Channel, 14 hours and 31 minutes

ALINE BERNSTEIN designs costumes for *Commedia dell'arte*, at Neighborhood Playhouse, New York City

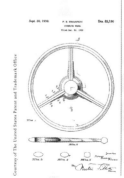

PIPSAN SAARINEN SWANSON: 1929 design for steering wheel (patent Des. 82,190 issued 1930)

MARIA LATIGO HERNANDEZ and Pedro Hernandez found Mexican American civil rights group, Orden Caballeros de America

1930

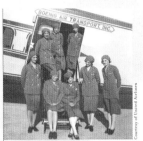

"The Original Eight": first airline stewardesses hired by Boeing to fly from Cheyenne to San Francisco

GERTRUDE VANDERBILT WHITNEY founds Whitney Museum of American Art, New York City

AMELIA EARHART, first woman to fly solo across Atlantic.

HATTIE WYATT CARAWAY first woman elected Senator (Arkansas)

FRANCES PERKINS, Secretary of Labor: first woman Cabinet member

KATHERINE HEPBURN stars in *Little Women*

25,000 quilts submitted to Sears National Quilt Contest, A Century of Progress Exposition, Chicago.

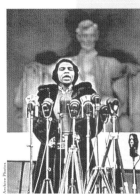

MAE WEST, star of *I'm No Angel* and *She Done Him Wrong*, as Statue of Liberty

MAHALIA JACKSON: her first gospel recording, "Move on Up a Little Higher"

LILLIE MAE JACKSON and other NAACP members start national "Buy Where You Can Work" campaign to encourage businesses to hire African American workers

MAUD BOWERS: first person to receive Bachelor's degree in Industrial Design (Carnegie Institute of Technology)

MARGARET BOURKE-WHITE photographs Fort Peck dam, Montana, for first cover of *Life* magazine

KATHERINE PRATT, metalworker, wins gold medal at Exposition Internationale, Paris

MARIAN ANDERSON denied rental of Constitution Hall by the Daughters of the American Revolution (DAR) because African American; Eleanor Roosevelt intervenes. Anderson sings at the Lincoln Memorial before a crowd of 75,000

| 1930 | 1931 | 1932 | 1933 | 1934 | 1935 | 1936 | 1937 | 1938 | 1939 |

MARY HETTIA, ca 1930

RUTH REEVES, 1930

MAGGIE MAZYCK, ca 1930

RUTH CLEMENT BOND, 1934

MARIA KPP, 1935

VALENTINA, ca 1935

DOROTHY DRAPER, 1935

BELLE KOGAN, 1936

DOROTHY THORPE, ca 1937

LILLIAN M. HELAND, R. ca 1939

CIPE PINELES, 1939

FANNIE SHAW designs "Prosperity Is Just Around the Corner" quilt (1930–32)

FLORENCE SEIBERT isolates a pure form of tuberculin and develops skin test for tuberculosis

JANE ADDAMS, founder of Hull House Settlement: first woman to win Nobel Peace Prize

Unites States Postal Service allows women postmistresses

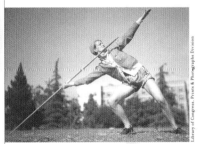

MILDRED DIDRIKSON ZAHARIAS, nicknamed "Babe" after Babe Ruth, wins 2 gold medals— for the 80-meter dash and the javelin throw— at Los Angeles Olympics

MARY MCLEOD BETHUNE, Director of Negro Affairs for National Youth Administration, founds National Council of Negro Women

LAURA INGALLS WILDER publishes *Little House on the Prairie*

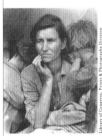

DOROTHEA LANGE, *Migrant Mother, Nipomo, California*. Lange photographs migrant workers and sharecroppers for Farm Security Administration during the Depression

EDITH HEAD assumes charge of Paramount's costume design department

PEARL BUCK: first American woman to win Nobel Prize for Literature

GERTRUD NATZLER and Otto Natzler win prize for ceramic bowl, Ceramic National competition, Syracuse, New York

VIVIEN LEIGH AND HATTIE MCDANIEL: Academy Awards, Best Actress and Best Supporting Actress, *Gone With The Wind*

1940

Red Cross workers
land in France
during WWII

Culver Pictures

U.S. enters WWII.
Women join
auxiliary corps
of Army (WAAC's),
Navy (WAVES),
Coast Guard
(SPARS), and Air
Force (WASPS)

BILLIE HOLLIDAY
records "God Bless
the Child"

Lanham Act
provides day
care for women
working for
government in
war-related
activities

AYN RAND publishes
The Fountainhead

LUTAH MARIA
RIGGS designs
set for film *The
White Cliffs of Dover*

HELEN VALENTINE
founds *Seventeen*
magazine

Courtesy of Joan Roth

CLARA ALTMAN:
design patent for
curling hair (Des.
614,711)

FLORENCE KNOLL
and Hans Knoll found
Knoll Associates;
Florence Knoll heads
Planning Unit

EVA ZEISEL: solo
ceramics exhibition,
Museum of Modern
Art, New York

GERTY RADNITZ
CORI shares Nobel
Prize for Physiology
or Medicine
for synthesizing
glycogen

Courtesy of the Academy of Motion Pictures Arts and Sciences

JUDY GARLAND
stars in *Easter Parade.*
Costume design: Irene
(IRENE LENZ GIBBONS)

ELEANOR RAYMOND,
architect, and MARIA
TELKES, solar-energy
expert, design solar-
heated house for
AMELIA PEABODY

GEORGIA NEESE
CLARK: first
woman appointed
U.S. Treasurer

| 1940 | 1941 | 1942 | 1943 | 1944 | 1945 | 1946 | 1947 | 1948 | 1949 |

MAIJA GROTELL, 1940

DORIS ONDELACEY, ca 1940

ANNI ALBERS and
ALEX REED, 1941–46

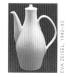
EVA ZEISEL, 1942–43

MARION DORN, 1941–43

LENA FRANK, 1944

CLAIRE McCARDELL, 1944

LILLY DACHE, 1940s

ESTELLE LAVERNE, 1947–48

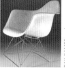
RAY EAMES and
CHARLES EAMES, 1948–50

RAY KAISER and
Charles Eames
marry and form
design partnership
(1941–78)

DOROTHY KUNHARDT
publishes *Pat the Bunny*

ROWENA KOSTELLOW:
design patent for
centerpiece bowl
(des. 121,119 assigned
to United States Glass
Company)

LT. ANNIE G. FOX,
nurse: first woman
awarded Purple
Heart, Pearl Harbor

MITSUYE ENDO
organizes movement
against wartime
internment

Harvard admits
women to Graduate
School of Design
for duration of war

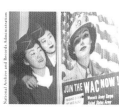
National Archive and Records Administration

20 million U.S.
women in wartime
workforce: 46% of
Boeing employees
are women

EMIKI and ROSE
TANADA join the
Women's Army
Corps (WAC)

RUTH MUSKRAT
BRONSON establishes
Washington, DC
Bureau of National
Congress of American
Indians

EMILY BALCH,
organizer Women's
International
League of Peace
and Freedom
(WILPF), wins
Nobel Peace Prize

CIPE PINELES:
first woman
member of Art
Directors Club
of New York

AUDREY MOORE
HODGES designs
interior of Tucker
Torpedo automobile

ANNI ALBERS: solo
weaving exhibition,
Museum of Modern
Art, New York

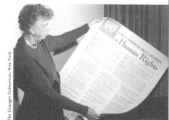
The Granger Collection, New York

ELEANOR ROOSEVELT,
delegate to United
Nations, reviews
Universal Declaration
of Human Rights
after passage by
General Assembly

1950

EMMA LUCY BRAUN
writes *Deciduous
Forests of Eastern
North America* and
elected first woman
president, the
Ecological Society
of America

GRACE BREWSTER
HOPPER develops
first language
compiler, eventually
leading to the
computer language
COBOL

ANN LOWE designs
wedding dress of
Jacqueline Bouvier
for marriage to
Senator John F.
Kennedy

ROSA PARKS,
fingerprinted and
arrested for refusing
to give up her seat
on a segregated bus;
Montgomery, Alabama,
bus boycott begins.

PATSY CLINE
records "Walkin'
After Midnight"

CHIEN-SHIUNG WU
elected to National
Academy of Sciences
for her work on
atomic particles

ETHEL PERCY ANDRUS
founds American
Association of Retired
Persons (AARP)

MARGUERITE
HIGGINS: first
woman to win
Pulitzer Prize
for international
reporting, Korean
War

HELEN ROSE:
Academy Award,
Costume Design,
for *The Bad and
The Beautiful*

KAREN KARNES
and David Weinrib
establish pottery
studio at Stony
Point, New York

ELLEN
MANDERFIELD:
first woman mem-
ber of American
Society of Industrial
Designers (ASID)

ELIZABETH BISHOP:
Pulitzer Prize
for Poetry, *Poems
North and South*

ELLA FITZGERALD
records *Ella Fitzgerald
Sings the Irving Berlin
Songbook*

IDA LUPINO directs
film *Never Fear*

1950 1951 1952 1953 1954 1955 1956 1957 1958 1959

GRETA GROSSMAN:
design patent for
floor lamp (Des.
160,084)

LUCILLE BALL
stars in *I Love Lucy*
(1951–58).
Costume design:
ELOIS JENSSEN

FREDA DIAMOND,
industrial designer,
featured in *Life*
magazine

EUDORAH MOOORE
edits *California
Design*

RUTH HANDLER
develops product
concept, Barbie doll

Harvard Law School
admits women

ANNIE DODGE
WAUNEKA: first
woman elected
to Navajo Tribal
Council

VIRGINIA APGAR
develops Apgar
Score to indicate
if newborn child
requires medical
attention

HENRIETTA
MANVILLE: design
patent for lipstick
container (Des.
176,364 assigned
to Revlon Products
Corporation)

BETTE McMURRAY
NESMITH, secre-
tary, invents Liquid
Paper in kitchen
blender

MARIANNE
STRENGELL designs
upholstery used in
Lincoln Continental
automobile

NANCY McCLELLAND:
first woman
president of
American Institute
of Decorators (AID)

SUZANNE VANDERBILT,
JAN KREBBS, and
RUTH GLENNIE work
in Automotive Interior
Design division
of General Motors

ELIZABETH ECKFORD
and eight other African
American high-school
students, known as
the Little Rock Nine,
face hostility and
violence during inte-
gration of Little Rock
High School, Arkansas

1960

FLORENCE BALLARD, DIANA ROSS, and MARY WILSON form the Supremes

JOAN BAEZ, singer/songwriter, releases *Joan Baez*, first of eight gold albums

RITA MORENO stars in *West Side Story*

HELEN GURLEY BROWN publishes *Sex and the Single Girl*

RACHEL CARSON publishes *Silent Spring*

Equal Pay Act: both sexes to be paid equally for same work; domestic and agricultural workers, administrators, and other professionals excluded

I.D. magazine enquiry into women in design

Title VII of 1964 Civil Rights Act bans discrimination on basis of race, color, religion, sex, and national origin

National Organization for Women (NOW) founded

10,000 women, mostly nurses, serve in Vietnam

Women's Strike for Peace participants storm doors of Pentagon, Washington, DC

BILLIE JEAN KING wins U.S. Open and Wimbledon singles, doubles, and mixed doubles tennis titles

Airlines forbidden to discriminate against married and "over-age" (older than 32) flight attendants

DAGMAR ARNOLD joins IBM and designs computer products

JOAN GANZ COONEY, head of Children's Television Workshop, produces *Sesame Street*

Vassar College goes coed

1960	1961	1962	1963	1964	1965	1966	1967	1968	1969

 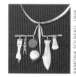

MARY THOBURN: design patent for folding transparency viewer (Des. 188,773 assigned to Eastman Kodak Company)

JANE JACOBS publishes *The Death and Life of Great American Cities*

JACQUELINE KENNEDY greets crowds, Dallas, Texas, November 22

SYLVIA PLATH: posthumous publication, *The Bell Jar*

BETTY FRIEDAN publishes *The Feminine Mystique*

BETSEY JOHNSON, designs for Paraphernalia fashion boutiques, New York City

JULIA WASCH and PHYLLIS PETERSON: first women members of American Stock Exchange

VIRGINIA JOHNSON and William Masters publish *Human Sexual Response*

BETTY MAE JUMPER: first woman to chair Seminole Council

ARETHA FRANKLIN records "I Never Loved a Man"

Antiwar organization Another Mother for Peace founded

TAMMY WYNETTE records "Stand By Your Man"

DOLORES HUERTA, United Farm Workers (UFW) leader, addresses demonstrators, Coachella March, California

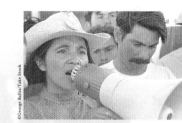

Birth control pill approved by FDA

1970

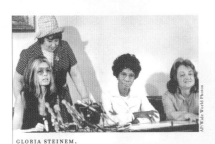

GLORIA STEINEM, BELLA ABZUG, SHIRLEY CHISHOLM, and BETTY FRIEDAN found National Women's Political Caucus

Lesbian activists, responding to "Lavender Menace" label, demand women's movement supports lesbian rights

CAROLE KING records *Tapestry*

Equal Employment Opportunity Act bans discrimination in employment on basis of race, color, religion, sex, national origin, age, and handicap

Battered women's shelters founded: Rainbow Retreat, Tucson, and Woman's Advocates, St Paul

Little League baseball: girls allowed to play

DOROTHY HAMILL: Olympic Gold Medal and World Title, figure skating

ADRIENNE RICH publishes *Of Woman Born: Motherhood as Experience and Institution*

ROSALYN SUSSMAN YALOW shares Nobel Prize for Physiology or Medicine for developing radioim-munoassay (RIA), used to diagnose diabetes and thyroid diseases

MAGGIE KUHN founding member Grey Panthers, senior advocacy group, addresses rally, Washington, DC

MICHELE WALLACE publishes *Black Macho and the Myth of the Superwoman*

| 1970 | 1971 | 1972 | 1973 | 1974 | 1975 | 1976 | 1977 | 1978 | 1979 |

DOROTHY HAYES and JOYCE HOPKINS organize *Black Artists in Graphic Communication* exhibition, New York City

KATE MILLET publishes *Sexual Politics*

LIZA MINELLI stars in *Cabaret*

Title IX of the Education Amendment Act bans sex discrimination in educational institutions and programs

Boston Women's Health Collective publishes *Our Bodies, Ourselves*

Height and weight restrictions eliminated from Civil Service; more women work in police, fire, and park services

Roe v. Wade: Supreme Court rules women's right to abortion protected under the constitution

Equal Credit Opportunity Act prohibits credit discrimination on the basis of sex, race, marital status, religion, national origin, age, or receipt of public assistance

Taylor v. Louisiana: Supreme Court bans automatic exclusion of women from jury duty

SUSAN JACKSON KEIG establishes own graphic design company, Chicago, Illinois

NASA accepts women for astronaut training

LOIS ALEXANDER founds Black Fashion Museum, New York City

SUSAN B. ANTHONY: first woman depicted on a U.S. coin

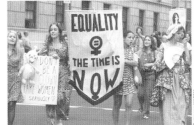

Women's Liberation March, New York City, 1971

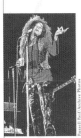

JANIS JOPLIN performs at Festival for Peace, New York City

1980

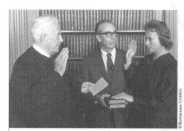

SANDRA DAY O'CONNOR sworn in as first woman Supreme Court Justice

PATRIZIA VON BRADENSTEIN: production design for film *Amadeus*

GERALDINE FERRARO: first woman nominated by major political party as candidate for vice president of the U.S.

JUDITH REICHEL RILEY: chief industrial designer, Timex Corporation

GERTRUDE ELION: Nobel Prize for Physiology or Medicine for work developing drugs to combat leukemia, malaria, and herpes

NICOLE MILLER founds own fashion company, New York City

ALICE WALKER: Pulitzer Prize for fiction, *The Color Purple*

MADONNA: *Like a Virgin* tour

PAULA SCHER: "To Be Good is Not Enough," poster design for the School of Visual Arts, New York City

CANDICE BERGEN stars in television show *Murphy Brown* (1988–98)

WENDY WASSERSTEIN: Pulitzer Prize for drama, *The Heidi Chronicles*

CAROLE BILSON joins Eastman Kodak Company as industrial designer

EFFIE OSCEOLA: patchwork panels in Miccosukee tradition for Westinghouse Electric Corp.

New York Times adopts use of "Ms."

JODIE FOSTER stars in *The Accused*

1980 1981 1982 1983 1984 1985 1986 1987 1988 1989

KATHERINE McCOY with DANIEL LIBESKIND, 1981

WENDY MARUYAMA, 1981

DOROTHY HAFNER, 1981–84

DEBORAH SUSSMAN, 1984

ANNE KRAUS, 1985

LISA KROHN, 1980–85

DIANA BALMORI, 1985

DONNA KARAN, ca 1987

ARLINE FISCH, 1988

KAREN CARPENTER, vocalist, dies of anorexia nervosa

Meritor Savings Bank, FSB v. Vinson: Supreme Court declares sexual harassment an illegal form of employment discrimination

JESSIE TELFAIR: "Freedom" quilt

MAYA LIN designs Vietnam Veterans Memorial, Washington, DC

DONNA KARAN launches own fashion company, New York City

DEBORAH BORDA, Director, Detroit Symphony Orchestra: first woman executive director of major U.S. symphony orchestra

Homeless woman, New York City: over 30,000 homeless women nationwide

Equal Rights Amendment (ERA) falls three states short of the total needed for ratification

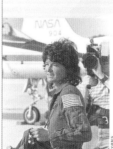

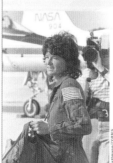

SALLY RIDE: first U.S. woman in space

WILMA MANKILLER: first woman principal chief, Cherokee Nation

BARBARA D'ARCY, MELANIE KAHANE, and "SISTER" DOROTHY PARISH: Interior Design Hall of Fame

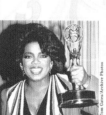

OPRAH WINFREY wins Emmy, Outstanding Talk Show Host

1990

The Museum of Modern Art Stills Archive

SUSAN SARANDON and **GEENA DAVIS** star in *Thelma and Louise*

Robert Trippett/Sipa Press

ANITA HILL testifies that Supreme Court Justice nominee Clarence Thomas sexually harassed her while she worked for him at the Equal Employment Opportunity Commision (EEOC)

COURTNEY SLOANE establishes Alternative Design (AD), Jersey City, New Jersey

JUDY RINGEL CLOSE designs Reebock "Shaq Attack" sports shoe

Women earn 71 cents for every male dollar

TONI MORRISON: Nobel Prize for Literature

JANET RENO: first woman U.S. Attorney General

RUTH BADER GINSBURG appointed to U.S. Supreme Court

Family Medical Leave Act: up to 12 weeks unpaid leave for childbirth or family illness

Landscape Architecture Magazine report: *Women and the Profession: "Glass Ceilings and Bottom Lines"*

Women account for nearly half of all union members

AFL-CIO establishes Working Women's Department

©1997 Time Inc. Reprinted by Permission

ELLEN DeGENERES declares that she is a lesbian, as is her television character Ellen

JODY WILLIAMS: Nobel Peace Prize for campaigning to ban antipersonnel mines

MADELINE ALBRIGHT: first woman Secretary of State

MICHELE WASHINGTON designs cover for *Black Issues Book Review*

CYNTHIA ROWLEY: hospital gown for Hackensack Hospital, New Jersey

1990	1991	1992	1993	1994	1995	1996	1997	1998	1999

 CHERYL RILEY, 1992

 REBECA MENDEZ, 1992

 ELAINE BASS and SAUL BASS, 1993

 JILL SHIRTLEFF, 1993

 Mrs⅜Eaves

 ZUZANA LICKO 1995–96

 VIVIENNE TAM, 1998

 DOROTHY COSONAS-DE FIEBRE, 1999

 NANCY PERKINS, 1995–2000

 APRIL GREIMAN and DALE HERIGSTAD, 1999–00

 ISABEL "OLEDO, 1999

 AYSE BIESEL 1999–2000

SARAH TOMERLIN LEE: Designer of Distinction Award, American Society of Interior Designers (ASID)

MARTHA STEWART: *Martha Stewart Living* magazine

CARRIE MOYER and **SUE SCHAFFNER** design Dyke Action Machine (DAM) posters

Shortchanging Girls, Shortchanging America published by American Association of University Women

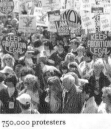

©Laine Griffiths Bettmann/CORBIS

750,000 protesters join NOW's March for Women's Lives, Washington, DC

ROBERTA COOPER RAMO: first woman president, American Bar Association (ABA)

Women's National Basketball Association (WNBA) founded

QUEEN LATIFAH records *U.N.I.T.Y.*

RAE JEAN WALKING EAGLE: "Basketball Star" quilt

NANCY GOSLEE POWER designs Sculpture Garden, Norton Simon Museum, Pasadena, California

SYLVIA HARRIS: commissioned to redesign Census 2000 form

JEANNINE OPPEWALL: production design for film *Pleasantville*

Zeralda Diaz/Archive Photos

U.S. Women's Soccer Team wins World Cup

SOCIAL CHANGE AND CHANGING EXPERIENCE

EILEEN BORIS

AMERICAN WOMEN ENTERED THE TWENTIETH CENTURY as unpaid family laborers constrained in their sexual expression and subject to legal and political disabilities. Nevertheless, through their determination and activism, they demanded and won recognition and rights that transformed the workplace, family, and polity. American women left the century with a vastly expanded public presence, but most still retained responsibility for home and children.

If the struggle for equal rights amid persistent reminders of female difference marks the twentieth century, so too have inequalities among women. Such factors as race and class separated women from each other. African American women, for example, experienced segregation along with disenfranchisement and poverty, while Asians and Latinas found their very right to live in the United States challenged through immigrant restriction. Class allegiance made white working-class women more likely to side with their brothers, sons, and husbands than with activist or philanthropist upper-class women. Indeed, more privileged women benefited from the labor of other women, often from a different racial or ethnic group, who produced the consumer goods and provided the services that enhanced the day-to-day lives of the better-off. In short, uneven and unequal progress has characterized the "American Century," which many have also dubbed the "Women's Century."

WORK AND EDUCATION

Throughout the twentieth century, households depended on mothers to cook, clean, and raise children. From the 1920s through the 1960s, women spent about fifty hours a week on housework. They consulted experts on home and family management, ranging from cookbook author Julia Childs to baby expert Penelope Leach.[1] At century's end, according to economist Juliet B. Schor, wives had "cut back on scrubbing the floor" more than "on child care, laundry or meal preparation," though they continued to perform two to four times as much housework as husbands.[2] A new age of affluence promoted elaborate homemaking and entertaining, with television personality Martha Stewart its impresario. Household services and day nurseries increasingly became available to middle-income families, but working mothers with small children particularly were caught in a time bind.[3]

Meanwhile, women had entered the workplace on a full-time basis, with the "working mother" replacing the "working girl" as the dominant type of woman worker.[4] The arrival of children no longer meant staying home.[5] Most women needed to earn money, though many found pleasure in their labor. In the 1970s, an elderly Japanese American household cleaner recalled, "it's the work itself that I enjoy,"[6] while one college-educated woman confessed, "I like getting dressed and coming to work, and I like thinking."[7] By the year 2000, women had invaded professions, arts, and skilled trades once reserved for men, even though single mothers and their children remained the poorest Americans.[8]

Women's move into white-collar labor anticipated America's economic transformation from a nation of smokestacks to one of word processors. "Woman's place is at the typewriter," *Fortune* proclaimed in 1935, as white women—including the daughters of eastern and southern European immigrants—abandoned the factory and home for "cleaner" clerical and sales work.[9] African American women remained domestic servants until the post–World War II years when, despite continued racial discrimination, many were able to gain office jobs that had eluded their mothers and grandmothers. They also swelled the ranks of the professions, following the footsteps of pioneer lecturer, government worker, and teacher Mary Church Terrell, lawyer Sadie Mossell Alexander, and lawyer, writer, and Episcopalian priest Pauli Murray.[10] In contrast the rising numbers of employed Latinas in the 1980s clustered in jobs set aside for new immigrants and the less educated, laboring as hotel maids, servants, and factory operators in the apparel, electronics, and food-processing industries.[11] In the 1990s, while the wage gap between the sexes narrowed, the earnings gap between white women and women of color actually widened—a crucial measure of growing inequality as American women entered a new century.[12]

Women's greatest occupational advances came during periods of feminist activism—between 1900 and 1920 and after 1960. Wartime advancement was disappointing in contrast, because employers, returning veterans, and union seniority preferences pushed the Rosie the Riveters out of well-paying industrial jobs into "pink collar" service, retail, and clerical work.[13] World War II saw women's first significant presence in the military with the

creation of the Women's Army Corps (WAC) under Colonel Oveta Culp Hobby, but not until the Gulf War in 1991 did the lines separating women from combat duties blur.[14] Though early in the century many women entered the professions, they generally remained within "female" occupations, such as elementary-school teaching, nursing, social work, and librarianship. Their movement into male-dominated areas such as law, medicine, and business management was slow.[15] By the mid-1990s, however, about a quarter of physicians and lawyers were women, although only Carly Fiorina of Hewlett Packard had become the CEO of a "Fortune 100" company at century's end.[16]

In general, as professions "feminized," their prestige and monetary compensation decreased. Moreover, women specialized in less lucrative fields, such as pediatrics and general medicine, and worked for nonprofit organizations and the government rather than private firms.[17] Nonetheless, they made a huge difference in the practice of law and medicine. Nadine Taub, who ran a Women's Rights Litigation Clinic at Rutgers Law School, New Jersey, remembered how in the heady days of the early 1970s, "we were examining our experiences as women as much as the law."[18] Other feminist lawyers, including Catherine A. McKinnon, Wendy Williams, Sylvia Law, and Patricia J. Williams, transformed jurisprudence in areas such as sexual harassment, reproductive freedom, and civil rights.[19]

Native American women presented a different pattern, especially before 1950. Continued disruption of tribal societies, facilitated by government allotment of tribal land to men, brought severe economic hardship. Nearly half of the female population farmed, ranched, or fished. A quarter engaged in handcraft production, while the rest worked as domestics. The boarding-school system that removed them from reservations for acculturation into the dominant society encouraged them to abandon traditional ways. Not until the economic boom following World War II did Native American women gain wider opportunities as clerical, service, and professional workers. Termination of the government's "special relationship" to the tribes after 1953 pushed more Native American women into the labor force. "Although I have long strived to preserve our old Pima ways, the poverty, grueling work, and bloody battles are things I do not miss!" explained one Native American resident of Phoenix in 1974.[20] By 1990 nearly as many Native American women worked as did other groups, but the vast majority could not find full-time jobs. Native American unemployment remained the highest of any racial/ethnic group, and poverty rates continue to soar.[21] In the face of social and economic dislocation, Navajo Ruth Roessel urged women to turn

the husband into "the kingpin around which all other activities . . . revolve."[22] Others followed the advice of Pueblo-Sioux writer Paula Gunn Allen, who urged recovery of the "sacred way of women" as an alternative to the culture of a patriarchal, white society.[23]

Workers struggled against inadequate wages and unsafe workplaces throughout the century. Immigrant shirtwaist makers in 1910 responded to the call of Clara Lemlich for a general strike, and southern textile mill operatives in the late 1920s sang the slain Ella Mae Wiggins's "Mill Mother's Lament" during their walkout.[24] During the Great Depression, Harriet Wilson and Rosina Tucker of the Ladies' Auxiliary to the Brotherhood of Sleeping Car Porters instigated "Don't Buy Where You Can't Work" campaigns in black communities, while in 1937 socialist activist Genora Johnson formed the Women's Emergency Brigade to assist sit-down strikers in Flint, Michigan. This pivotal event for the autoworkers encouraged Woolworth waitresses and other women strikers to occupy their work sites as well.[25] Women were reputed to be the most militant picketers. "We had knitting needles. We had safety pins . . . We had chili peppers," one Mexican American woman said, describing the preparedness of miners' wives during the 1950 walkout against Empire Zinc in New Mexico, the strike depicted in the classic blacklisted film, *Salt of the Earth*.[26] From 1904 until 1950 the Women's Trade Union League under Margaret Dreier Robbins and Rose Schneiderman, and after 1974 the Coalition of Labor Union Women under Olga Madar and Joyce Miller, lobbied for legal protections and organized women into unions.[27]

A new activism blossomed in the 1960s and 1970s among teachers, government employees, secretaries, and hospital workers. Fighting for union recognition, one flight attendant countered the popular image of airline stewardesses as "sex objects in the sky" by proclaiming, "We're in the business of saving tails, not serving them."[28] Despite the overall decline of trade unions during the last third of the century, female-dominated industries actually witnessed modest growth, so that by 1995 women accounted for nearly half of all union members.[29] The AFL-CIO recognized the changing face of the American worker by electing American Federation of State, County, and Municipal Employees official Linda Chavez-Thompson as a vice-president in 1995. A year later clerical organizer Karen Nussbaum left the directorship of the U.S. Women's Bureau to head the AFL-CIO's new Working Women's Department.[30]

As woman's place expanded from the home to include the workplace, professional educators continued their task of socializing women for their

future roles. In late-nineteenth-century America, founders of women's colleges, such as Sophia Smith, sought "to develop as fully as may be the powers of womanhood."[31] Justified by new "scientific" requirements for mothering and domesticity, schools prepared women for the "caring" professions, such as home economics, nursing, social work, and teaching. Other educational institutions—high schools, business academies, and settlement houses—also trained women for "women's work," especially sewing, typing, and housekeeping.[32]

In 1900 elite white women attended female colleges such as Vassar and Mount Holyoke, which had grown from mere finishing schools into bastions of the liberal arts.[33] More affluent African Americans often opted for segregated southern institutions founded by such remarkable black educators as Charlotte Hawkins Brown, Nannie Helen Burroughs, and Mary McLeod Bethune.[34] These schools, such as Bethune-Cookman College, Haines Normal and Industrial Institute, and Palmer Memorial Institute, some of which were co-educational, cultivated Christian virtues and proposed education not for the self but "for your people."[35] Whether higher education subverted domesticity remained a debatable question at midcentury, when women increasingly left school for marriage.[36] As anthropologist Margaret Mead asked: "Have we cut women off from their natural closeness to their children, taught them to look for a job instead of the touch of a child's hand, for status in a competitive world rather than a unique place by a glowing hearth?"[37]

Business needs for "womanpower" and women's needs for economic independence and personal fulfillment, however, encouraged women to return to the classroom. At century's end, in all racial/ethnic communities except the Asian American, more women than men graduated from both high school and college. The most dramatic increase came among African American women who accounted for one in eight of female undergraduates.[38] Women increasingly sought degrees in the previously male-dominated fields of business, engineering, and science, though in the 1990s, they still clustered in education, English, the arts, and health care—professions commanding lower salaries than male-dominated ones.[39] Higher education benefited women, but in the most prestigious fields, it still paid off more for men.[40]

SEXUALITY AND FAMILY

"It is very important to have a job so that I don't have to depend on somebody to take care of me," reported one woman in a 1997 survey of union members.[41] Between 1900 and 2000 women's developing economic independ-

ence generated greater sexual freedom and control over their bodies within as well as outside of marriage. More women chose to leave bad marriages, delay marriage, or remain single.[42] The archetypal family of bread winning father, stay-at-home wife, and two children, where *Father Knows Best*, existed for a brief moment in the 1950s and then only for the more affluent.[43]

The pre–World War I sexual revolution initially challenged the conventions of middle- and upper-class respectability and fostered a new openness toward sex and sexuality.[44] Urban life facilitated heterosexual and homosexual encounters in public spaces such as dance halls, bathhouses, and interracial cabarets. "Sex radicals," such as Margaret Sanger and Emma Goldman, disseminated information about birth control and advocated "free love," joining personal and social revolution in a link only broken in the 1930s when the Communist Party substituted the Proletarian Mother for the Rebel Girl as its icon of womanhood.[45] During the first few years of the Great Depression, when couples could not afford to have children, marriage rates dropped and contraceptives became "big business."[46]

Popular culture, particularly movies and advertising, portrayed the "new woman" as sexually open. During the 1920s advertisements displayed women's bodies. Flocking to the cinema, Los Angeles Chicanas imitated "'Las Pelonas,' the Bobbed-haired Girls." African American singers, such as Billie Holliday and Bessie Smith, claimed their own sexuality through lyrics full of double entendres, while covers of the NAACP's magazine, *Crisis*, featured black bathing beauties. Flapper and writer Flora Belle Jan "long[ed] for unconventionality and freedom" from the constraints of the traditional Chinese family.[47] "Dating" sometimes came to imply sex, and growing numbers, from the middle as well as working classes, "flirt[ed] with freedom" before settling down to marriage.[48]

Increased mobility during wartime further loosened traditional sexual mores. During World War II, "victory girls" entertained servicemen, and lesbians discovered their identities in the armed forces. "For the first time I had a name for myself," a volunteer with the Land Army remembered.[49] Over the next thirty years a vibrant lesbian culture came out of the closet, while explicit heterosexuality pervaded print and visual culture. By 1950 more than half of married women confessed to researchers that they had engaged in premarital sex. A decade later W.H. Masters and Virginia Johnson's *Human Sexual Response* placed a scientific imprimatur on the female sexual satisfaction that one wife celebrated by exclaiming, "everybody else is going to the moon, I might as well go to Heaven!"[50] But not all women benefited from this second and more pervasive sexual revolution; many contin-

ued to experience sexual dissatisfaction within marriage.[51]

By the late 1960s feminists demanded better—not just more—sex. Activists Andrea Dworkin, Susan Brownmiller, Del Martin, Kathy Barry, and others exposed the "crimes against women" of rape, pornography, and domestic violence.[52] Led by the Boston Women's Health Collective and its best-selling book, *Our Bodies, Ourselves*, women reclaimed knowledge of their bodies, including natural childbirth.[53] Greater access to contraception, new birth-control devices, and, after 1973, legal abortion increased reproductive control. Births dropped dramatically, especially for white women (their fertility rate fell below replacement level),[54] reversing the baby boom that had produced seventy-six million children between 1946 and 1966.[55] Some minority women, however, demanded the right to have children. In the 1980s Native Americans, members of the Women of All Red Nations, protested involuntary sterilizations performed in reservation hospitals, while African Americans fought welfare rules that forbade recipients from having additional children.[56] By century's end new reproductive technologies, including in vitro fertilization and artificial insemination, joined surrogate mothering to further separate reproduction from sexuality and made it possible for childless couples to have their own babies.[57]

Illegitimacy per se ceased to be the social scourge it had been earlier in the century, but as birth control became widely accepted, unwed mothers, particularly young and poor ones, were viewed even less sympathetically than in earlier times.[58] Women headed a quarter of African American households in 1950 and half by century's end.[59] Minority women were especially at risk of losing custody of their children because, as one Lakota Sioux explained, "A flush toilet to a white social worker is more important than a good grandmother."[60] Labeled as "welfare queens," unmarried black mothers from the mid-1970s became the scapegoats for backlash "family values" attacks on women who sought greater sexual freedom and independence from men.[61]

LAW AND POLITICS

During the twentieth century women won equal protection under the law. They gained the vote in 1919 and by the 1990s had become a political force responsible for the election of a Democratic president. At the end of the century women held one in five seats in state legislatures and one in nine in congress.[62] The current gender gap, in which women more likely support proponents of social welfare and peace, represents a new manifestation of the maternalist impulse behind government programs for women and children that laid the basis for the New Deal welfare state of the 1930s. But whether

equality comes from being treated the same as or different from men remained as hotly contested at the century's end as it was in the 1920s when the Women's Movement divided between "social feminist" defenders of protective labor laws that applied only to women and National Woman's Party (NWP) supporters of the Equal Rights Amendment (ERA).[63]

Early twentieth-century reformers such as Jane Addams had sought the ballot because "American women need this implement in order to preserve the home."[64] Addams and other social feminists argued that the power of the vote would enable women to rid cities of corruption and pollution and thus better care for their families in an increasingly interdependent society. A younger generation of feminists, such as Katherine Anthony (grandniece of Susan B. Anthony), demanded "the emancipation of woman both as a human-being and as a sex-being."[65] In the 1910s maternalist social reformers and "New Feminists" alike joined with female factory workers, African American clubwomen, society ladies, and socialist housewives to form a massive coalition for women's suffrage. Imaginative strategists such as Harriet Stanton Blatch, daughter of Elizabeth Cady Stanton and organizer of the cross-class Equality League of Self Supporting Women, reinvigorated the suffrage campaign through open-air meetings and flamboyant parades. Militants under Alice Paul of the NWP further dramatized the cause by picketing the White House and courting arrest; in jail their continued resistance to men's power over women elicited brutal forced feedings. Under the leadership of Carrie Chapman Catt, the National American Women's Suffrage Association launched a final assault for a federal amendment during World War I, convincing politicians that rewarding women with suffrage for wartime contributions served the national interest.[66]

Though ratified in 1920, the Nineteenth Amendment failed to enfranchise African American women in the South, Mexican Americans in Texas, or Native Americans in Arizona who, like men, were kept from the polls by primaries restricted to white voters, taxes, literacy tests, and intimidation. Southern black women risked their lives to register to vote because as one Mississippi woman clarified in 1960, "I want to be a citizen. I registered so that my children could get their freedom."[67] Not until the 1965 Voting Rights Act, which penalized states restricting the right to vote on account of race, did African American and other minority women finally gain suffrage on the same basis as their white counterparts.[68] After 1980 women were more likely to vote than men, but by then fewer people overall participated in an electoral system in which large campaign contributors ensured that some votes counted more than did others.[69]

Fear of women voting as a block initially led politicians to enact the Shepard-Towner Maternal and Infant Health Act in 1921, which marked the culmination of the pre–World War I maternalist reform. Before suffrage, states had created mother's pensions for needy women judged worthy of support, and the federal government had established the Children's Bureau and Women's Bureau to address issues of child welfare, maternal health, and women's wage-earning. When no unified women's vote emerged, however, politicians became less receptive to the social welfare agenda promoted by the Women's Joint Congressional Committee, an umbrella organization of groups spearheaded by the League of Women Voters. Redrawing gender divisions, political parties in the 1920s established their own women's committees—the Republicans even formed a separate Colored Women's Department.[70] Led by First Lady Eleanor Roosevelt, a women's network within the Democratic Party in the 1930s crusaded for social security and labor standards. Eleanor Roosevelt carried the banner of civil rights in fighting for a federal antilynching law; her friend Mary McLeod Bethune, a New Deal official and head of the National Council of Negro Women, actively wooed African Americans away from the party of Lincoln to the party of the Roosevelts.[71] Only with Hillary Rodham Clinton sixty years later would a First Lady play such a major role in domestic policy.

On the local level, women successfully invaded party apparatuses, but not until the 1970s did they reach any kind of equal representation in national conventions, and then only among the Democrats. Their political style was less partisan, focused on lobbying, education, and grass roots mobilization.[72] By the end of the century Native American women had gained election to tribal governments; the most prominent were Wilma Mankiller, the first woman chief among the Cherokees in nearly two hundred years, and Verna Williamson, the first Isleta Pueblo woman governor in recorded history.[73]

Not only did women participate in electoral politics, but they also took part in every major social movement of the Right as well as the Left, sometimes in separate women's sections, other times in mixed sex organizations. Women members of the Ku Klux Klan in the 1920s, for example, while no less reprehensible than their male counterparts, resembled earlier women moral reformers—chastising wife-beaters and policing sexual morality even as they joined the men in donning white robes, burning crosses, and campaigning for white supremacist politicians.[74]

After suffrage, the League of Women Voters concentrated on ending women's other civic disabilities. The 1922 Cable Act broke the link between wives' and husbands' citizenship, except for those married to ineligible for-

eigners—which had a strong impact on American-born Japanese and Chinese women, since most Asian nationals were barred from citizenship until after World War II.[75] Holding dual citizenship, Native American women fell under tribal regulations. In 1939, for example, the Santa Clara Pueblo in New Mexico determined that those who married outside the tribe lost membership and their children lost property rights. The Supreme Court upheld this determination in 1972, supporting cultural autonomy over Native American women's rights over sex discrimination.[76]

Jury service proved harder to obtain than independent citizenship. Even states that permitted women to serve made it easy for them to be exempted. In 1961 the Supreme Court upheld Florida's restrictions out of the belief "that the state might have an interest in enforcing women's 'performance of their domestic chores.'" Not until 1994 did the Court determine that gender could not provide a basis for peremptory challenges. It accepted the arguments of Ruth Bader Ginsburg, recently appointed to the Court, that equal protection under the law meant holding men and women to the same standard, except where the state could prove a compelling reason to act otherwise.[77]

Women's legal advances were real, but limited. The 1963 Equal Pay Act stopped short of demanding equal pay for comparable work, a costly goal since men and women still rarely performed the same jobs. ERA supporters added "sex" to Title VII of the 1964 Civil Rights Act that prohibited workplace discrimination by employers and unions—though it took the formation of the National Organization for Women (NOW) in 1966 to push the Equal Employment Opportunities Commission to enforce this provision. Presidential Executive Orders included women in affirmative action, though glass ceilings and muddy floors persisted for women in corporate management, the professions, and skilled crafts, including landscape design and construction. The separation of race from gender in antidiscrimination law meant that black women "fell through the cracks" when an employer hired black men and white women. Other times they served as a double token, counted in compliance statistics as female and as a racial minority. Despite all the hopes of the 1960s and 1970s, by the end of the century, federal courts had severely restricted affirmative action as a remedy for discrimination. Congress sought to weaken Title IX of the 1972 Educational Act, which had brought equal funding to girls' and boys' sports. This funding enabled the growing competitiveness of women's teams, marked by the 1999 victory of the United States in women's World Cup soccer.[78]

Equality generated its own conundrum. Title VII overturned mini-

mum wage and maximum hour requirements, restrictions on night work, and other women's labor legislation that had protected the unorganized in female-dominated industries. Labor feminists, led by Florence Kelley of the National Consumers' League, had fought for these laws in the first decades of the century, even though some women in male-dominated industries—from train conductors in the late 1910s to autoworkers in the 1950s—argued that such laws made them more expensive to hire than men.[79] Domestics and agricultural laborers—mainly women of color—stood outside of such laws. Though a new generation of feminist trade unionists embraced equal rights in the 1970s, a few, like Myra Wolfgang of the Hotel Employees and Restaurant Employees International Union, still argued that "the multiple roles that women fill in society [call] for dealing with their problems in a special way."[80] Pregnancy proved difficult to fit into an equality paradigm. A reason for dismissal from the workplace that left women unqualified for unemployment, pregnancy became classified in a 1978 law as a disability to be treated like any other temporary interference with work. Despite the gender-neutral Parental and Medical Leave Act of 1993, mothers remained the parent usually taking time off from work to care for children.[81]

Betty Friedan uncovered "The Problem That Has No Name" in *The Feminine Mystique* (1963), encouraging white middle-class suburban women to reexamine their lives. In the late sixties, their daughters joined the more radical Women's Liberation Movement, which generated a plethora of groups that addressed every aspect of womanhood in a male-dominated society.[82] Proclaiming that the personal is the political, "Second Wave" feminists argued that women were oppressed by men. They held intimate relations up to public scrutiny while consciousness-raising groups empowered women to seek social and political solutions for inequality rather than blaming themselves. The Women's Liberation Movement directed attention to institutional and structural supports to male dominance and exposed media imagery, which reinforced "traditional" notions of femininity and objectified the female body. The 1968 protest against the Miss America contest saw radical women dumping "'instruments of torture to women'—high-heeled shoes, bras, girdles, and copies of *Playboy*, *Cosmopolitan*, and *The Ladies' Home Journal*—into a Freedom Trash Can."[83]

The 1969 radical feminist "Redstockings Manifesto" presented women as an oppressed class and called upon men "to give up their male privileges."[84] Many women, particularly women of color, rejected the universalism of such declarations. A Chicana striker at the El Paso Farah plant explained in 1972, "I don't believe in burning your bra, but I do believe in having our rights."[85] A poll that same year revealed more black women than

white in favor of "efforts to strengthen or change women's status in society" and in "sympathy with efforts of Women's Liberation groups."[86] Diverse among themselves, black feminists—including Marxist prison reformer Angela Davis, cultural critic bell hooks, and sociologist Patricia Hill Collins—forged a critique of American society that recognized the "interlocking" play of "racial, sexual, heterosexual, and class oppression."[87] Writer Alice Walker labeled black feminism "womanist" to emphasize commitment "to survival and wholeness of entire people, male *and* female."[88]

In the early 1970s Women's Liberation included mothers on welfare and striking miners' wives. It generated academic women's studies programs and popular magazines, most notably *Ms.* under activist celebrity Gloria Steinem.[89] Women's increased employment and feminist challenges to male dominance within the family, however, threatened more traditional women, especially as global economic restructuring generated greater economic insecurity after 1975. "While middle-class women gained MBAs, working-class women won the right not to be called 'honey'—and not a whole lot more than that," journalist Barbara Ehrenreich quipped nearly a quarter century later.[90] In the 1980s feminist activists and trade unionists sought to beat the conservative "family values" lobby by claiming that they were the ones who truly valued families in seeking the child care, parental leave, and other policies that enable women to combine employment and motherhood. They exposed workplace sexual harassment, dramatized by Anita Hill's charges against Supreme Court appointee Clarence Thomas in 1991.[91]

As the century closed, activists of many persuasions—such as NOW President Patricia Ireland, sociologist Frances Fox Piven, political scientist Gwendolyn Mink, and Black Radical Caucus leader Barbara Ransby—sought to combat the growing inequality among women that the 1990s attack on welfare for poor single mothers exacerbated. They offered an alternative vision for ending poverty by valuing all the work of women, their mothering as well as market labor.[92] Though judged a liability in a world organized around the unencumbered individual, caretaking—with its responsibility for others—has generated a vision of social justice and formed the basis for political reform for some women, even as others fought for treatment the same as men. The success of feminism has come not merely from the numbers of women whose lives have drastically changed since the 1970s, but also from the ability of many women to set their own course, redefining the meaning of equality through new life choices and new combinations of motherhood with wage work.

Fig. 1-A. Florence Knoll, designer,
at a meeting with executives of
Connecticut General, Bloomfield,
Connecticut, ca. 1956–57.

I

PAT KIRKHAM AND LYNNE WALKER

CONTEXT AND ISSUES

THERE WERE AS MANY WAYS FOR WOMEN TO BECOME DESIGNERS during the course of the twentieth century in America as there were ways for them to practice design. In considering women's identities as designers, *Women Designers in the USA, 1900–2000: Diversity and Difference* concentrates on professional designers, while recognizing the permeable line between amateur and professional, especially at the beginning of the century.[1] This essay serves to contextualize the chapters that follow and presents an overview of them. The chapters discuss a diversity of design types and media, as well as differences between women in terms of cultural identities, training and education, and practice. They also consider the broad proscriptions on women's design activities alongside new opportunities. Included, where appropriate, are the contributions of women designers to the teaching of design and thereby to the shaping of new generations of designers—men as well as women.

The gendered nature of work is a common thread running through the chapters, as are the shifting conceptions of what was and was not thought appropriate

Women Designers in the USA, 1900–2000:

DIVERSITY AND DIFFERENCE

for women to design. The richly textured history resides in the multifaceted ways in which gender intersected with many other factors, including "race," ethnicity, class, training, employment, experience, and individual talents. Given the paucity of prior research on minority ethnic women designers in the United States—with the exception of Native Americans—and the brief to consider a whole century across a range of media, two discrete studies were selected for closer attention. Native American women designers (mostly designer-makers) were chosen largely because of the wide range of existing

publications, archives, and collections that represent the tangled, often troubled, relationships between Native Americans, private collectors, institutions, and the federal government throughout the century. African American women designers were chosen not only because documentation is lamentably patchy and many African American design traditions were marginalized, if not denigrated, for most of the century, but also because there was a substantial body of "contextual" material on other areas of African American cultural production.[2]

This publication contributes to the ongoing efforts, which began with the Women's Movement in the late 1960s, to recover women previously "hidden from history" and to reevaluate their roles and contributions.[3] It is easy to caricature such studies as little more than adding token women to "male" narratives. However, the best feminist scholarship has always gone beyond that—to the broad social context of political and personal issues—and has been at the center of reshaping and rethinking the telling of history. *Women Designers in the USA* seeks a place in those traditions of feminist scholarship, informed by theory and qualified by women's lived experience. It embraces difference and attempts to explain women's absences from certain activities as well as their participation in others. The intellectual framework within which this publication falls is discussed further in the second part of the essay.

DESIGN EDUCATION

In the twentieth century, a vital enabler of women's access to design in America was systematic design education, available from a broad base of public and private institutions that trained designers for both industrial and hand manufacture. By 1900 design education in America had achieved the basic shape it would hold throughout the century, although it would develop in new, distinctive directions—in the 1930s, for example, through government-funded training programs and "progressive" new art and design institutions; or in the 1970s in feminist art and design programs. In addition to women-only schools of landscape architecture, which flourished earlier in the century, programs in nascent design areas were introduced: industrial design in the 1930s; studio furniture design and making, from the 1960s; and computer graphics in the 1980s and 1990s.[4]

In the nineteenth century, the expense of importing foreign designs and the understanding that well-designed goods were essential to successful competition in international markets had prioritized industry's and government's goals for a well-trained design workforce.[5] Art classes—especially in drawing (a traditional part of a "lady's" education)—were often open to women in such institutions as the National Academy of Design, New York, which accepted women in 1831.[6] Design education for women, which began in 1848, the year of the first women's rights convention at Seneca Falls, New York, was initially perceived as providing access to respectable employment

for single middle-class women, a goal of philanthropists and feminists alike. While the Centennial Exhibition of 1876 in Philadelphia promoted the applied arts to a national audience, it inspired higher standards of artistic production in design, craft, and industry, and stimulated and regalvanized design education for women.[7]

When schools of design were established in America (mainly in the last quarter of the nineteenth century) educators and philanthropists looked to Britain, a leader in international trade, for prototypes.[8] The influential Philadelphia School of Design for Women (founded 1848) and the Massachusetts Normal School of Art (founded 1873) adapted British models of curriculum and teaching materials to American purposes, and key staff were recruited from the Normal School of Design in London.[9] American design schools developed in the climate of struggles for women's rights, which included education, training, and employment, as well as suffrage. Women's involvement with art and design in the late nineteenth century helped them develop organizational skills and confidence that could then be used for suffrage work. However, at least one influential proponent of education for women, Walter Smith, director of the Massachusetts Normal Art School, proposed design education to distract women from political activities:

> We have a fancy that our lack of art schools and other institutions where women can learn to employ themselves usefully and profitably at work which is in itself interesting and beautiful, is one of the causes which drives them to so unsex themselves as to seek to engage in men's affairs. Give our American women the same facilities as their European sisters, and they will flock to the studios and let the ballot-box alone.[10]

In the early 1900s to about 1920, when suffrage activity was heating up, women were again encouraged to become involved with the arts as "safe activities."[11]

Although conceptions of design education for women varied, women's schools of design and philanthropic training programs had at least one thing in common: they were mainly founded by women for women. The first school of design for women, the Philadelphia School of Design for Women, was started by Sarah Worthington Peter in her own drawing room as a philanthropic project—but one that recognized the hard economic facts of single middle-class women's need of training for employment.[12] The New York School of Design for Women was founded by Susan Carter in 1852 and merged in 1859 with the Cooper Institute (now Cooper Union for the Advancement of Science and Art); it became a major design school.[13] The Western Reserve School of Design for Women in Cleveland (founded 1882), which began in the home of Sarah M. Kimball, was established to train designers for industry and flourishes today as an independent coeducational school of art and design (renamed Cleveland School of Art, 1891–1948; now the Cleveland Institute of Art).[14]

Fig. 1-1. Agnes F. Northrop. Design for stained-glass window for Sarah Cochran, Linden Hall, Pittsburgh, Pennsylvania. Designed for Tiffany Studios, New York, ca. 1913. The Metropolitan Museum of Art, New York. Purchase, Walter Hoving and Julia T. Weld Gifts, and Dodge Fund, 1967 (67.654.229). *Checklist no. 20*

Fig. 1-2. Candace Wheeler, 1893.

The Chicago World's Columbian Exposition of 1893, which promoted American interests, included a separate Woman's Building.[15] The catalogue indicates the scope and success of design training for women to that point. Virtually all areas of the applied arts were represented, and most were referred to as "modern" in style: stained glass and glass mosaics, woodcarving, wallpaper, textiles, embroidery, designs for jewelry and metalwork, bookbinding, illustration and cover design, china painting, lace, and applied and decorative painting. The catalogue also revealed women's own ambitions in design: the "main object" of applied arts exhibitions from the contributor's point of view "was to obtain rightful recognition of her work."[16] Women's increasing access to training and their professionalism are evidenced by the many women designers represented in exhibits mounted by individual firms. Tiffany's Glass and Decorating Company, for example, showed thirty-nine pieces by women designers, including twenty sketches for glass windows by Grace deLuze, Lydia F. Emmet, and Agnes Northrop (fig. 1-1). Emmet also designed the seal of the Board of Women Managers of New York, which was used on official stationery and display caption cards.[17]

The Woman's Building itself was designed by a young woman architect, Sophia Hayden. Candace Wheeler, a leader of the Arts and Crafts movement and head of the design and interior decoration firm, Associated Artists (figs. 1-2 and 1-3), received the plum commission of designing the library (fig. 1-4), which was marked as a "feminine" space not only by its type (a Ladies' Reading Room) and the design language of its furnishings and interior decoration, but by its contents—including portrait busts of notable women by women sculptors and a grand allegorical ceiling painted by Wheeler's daughter, Dora Wheeler Keith. The alcovelike side rooms contained statistics relating to women's employment, thus emphasizing the social and economic importance of design work for women.[18]

At the Chicago exposition generally and in the Woman's Building specifically, design exhibits were separated by "race" as well as by gender and viewed from a perspective that remained current well into the twentieth century and combined liberal reform, paternalism, and social Darwinism with assumptions of white supremacy. Native American basket makers Kittie Coates and Emma Reeves were present at the fair's "Iroquois Camp"[19]; in the Woman's Building, an "Afro-American Exhibit" was organized by the sole black woman on New York State's Board of Women Managers, the tireless J. Imogen Howard. While featuring the craft skills of African American women, especially in needlework and other handmade textiles,[20] the exhibits forcefully demonstrated the exclusion of African American women from professional and commercial design and from formal design training. Unlike their more privileged, white middle-class counterparts, they generally lacked academic credentials. There were no firms exhibiting their work or hiring them as name designers (see chapter 4). In contrast, today one in

eight female university graduates is African American—many from art and design programs. Nevertheless, although education and training have been among the best tools for women's advancement, that alone did not guarantee progress or acceptance in the design world for women of color.

By the beginning of the twentieth century, the Arts and Crafts movement, then at its peak, emphasized the importance of everyday "commonplace" objects. It extolled the unity and equality of all arts and challenged the inferior status of design (and designers) in the hierarchy of the arts. Design and the decorative arts were depicted as suitable work for respectable women, and the Arts and Crafts movement both constituted and stimulated educational programs. Specialist schools of design for women, private women's colleges, and philanthropic classes and facilities for working-class women and girls all taught art and design, often along Arts and Crafts lines. In the early twentieth century, the most design-oriented women's liberal arts college was the H. Sophie Newcomb College in New Orleans (founded 1886), which taught undergraduate and graduate courses in design, and operated a commercial pottery—the Newcomb Pottery. Newcomb students exercised their skills in ceramic decoration and sold their pots. In other workshops they aspired to professional standards in bookbinding from 1913, jewelry, and metalwork in the 1920s and 1930s—products that represented the rethinking of women's roles as well as the renewal of southern cultural and regional identity in the protracted post–Civil War period.[21]

Fig 1-3. The "Designing-Room," Associated Artists (1883–1907). From *Harper's Bazaar*, August 1884.

Philanthropic organizations and their training facilities were by nature less highly structured and less comprehensive in their programs than design schools and design courses at colleges. However, they were capable of providing training and opportunities for work and sales in craft-based industries, which offered an economic lifeline to many women. Organizations such as the Saturday Evening Girls Club (1906–42) in Boston provided paid employment and training as well as leisure pursuits for immigrant working-class girls and women. The traditionally "feminine" crafts of embroidery and lace-making became vehicles for social amelioration and assimilation through some of these groups, such as the Sybil Carter Indian Lace Association (founded in 1890, the same year as the infamous massacre of Native Americans by United States troops near Wounded Knee Creek), which, unlike similar organizations for Native Americans, prioritized the production of marketable goods over craft preservation.[22]

Fig. 1-4. Candace Wheeler. Interior design for the Library of the Woman's Building, World's Columbian Exposition, Chicago, ca. 1893.

After 1900, new women-only design schools resulted in response to women's exclusion from professional training in the fiercely contested male-

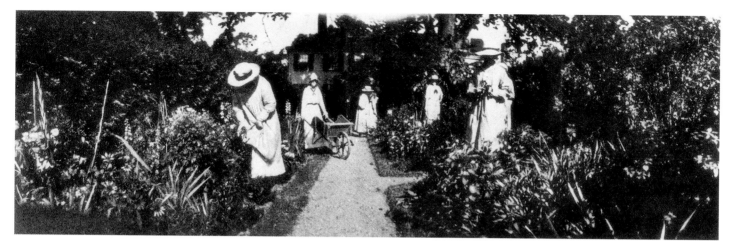

Fig. 1-5. Students of the Lowthorpe School of Landscape Gardening for Women, Groton, Massachusetts, 1916. From *House Beautiful*, March 1916.

dominated areas of architecture and landscape architecture. The Lowthorpe School of Landscape Gardening for Women (founded 1901; fig. 1-5) and the Pennsylvania School of Horticulture for Women (founded 1910) reflected the growing importance of this field for women, as well as their problematic access to professional training. The door to women's admission to education in landscape architecture had been pried open only to be slammed shut at the Massachusetts Institute of Technology, but it was the exclusion of women from Harvard's School of Landscape Architecture that directly led to setting up the Cambridge School of Architecture and Landscape Architecture for Women (1915–42). At the same time, the Philadelphia School of Design for Women, under the direction of Harriet Sartain (fig. 1-6), had strong links to industry and continued to prepare designers for commercial employment. By 1925 its graduates occupied a wide range of jobs thought appropriate to women, from fashion design and illustration to interior decoration.[23] Today, as Moore College of Art and Design, it maintains its high standards, while remaining the only all-female school of art and design to grant degrees in the United States.

Although women-only design schools preceded coeducational ones, the direction of twentieth-century design education soon became strongly coeducational. By 1925, the overwhelming majority of "over sixty art schools and more than a hundred colleges and universities and countless other and less reliable organizations offering courses of all sorts in one or more of the [art and design] subjects" were coeducational.[24] Boston, Providence, New York, and Chicago were (and are) home to a group of remarkably robust coeducational art and design schools: the Massachusetts Normal Art School in Boston (founded 1873; from 1959, the Massachusetts College of Art; fig. 1-7); Rhode Island School of Design in Providence (founded 1877); Pratt Institute, Brooklyn (founded 1887); and Parsons School of Design, New York (founded 1896). Leading museum-linked institutions include the School of the Art Institute of Chicago (founded 1869); Art Academy of Cincinnati (1869–present; a museum school 1887–1998); and the School of

Fig. 1-6. Harriet Sartain, dean of the Philadelphia School of Design for Women, 1920s.

the Museum of Fine Arts in Boston, which offered classes in the decorative arts from 1884. Design schools on the West Coast were mainly a twentieth-century phenomenon. In the 1970s, the California Institute of the Arts (CalArts) was a prime site of feminist art and design education (see pp. 77-78), but in its earlier years as the Chouinard School of Art, founded by Mrs. Nelbert Chouinard in 1921, some of Hollywood's most prominent costume designers studied there, including Edith Head, Elois Jenssen, and Irene Conley (known as Renie).[25]

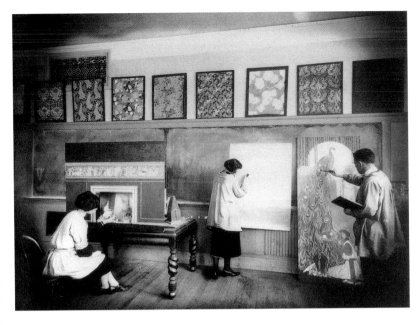

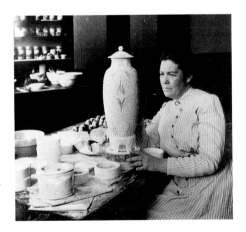

Universities that offered "mechanical" or "industrial arts" in addition to liberal arts in the late nineteenth and early twentieth century set the stage for the major role universities would play in later twentieth century design education, producing a wide range of specialist design students at undergraduate and graduate level. The Land Grant Acts (1862 and 1890) endowed institutions of higher education in order to establish programs in design-related subjects.[26] Julia Morgan (architect-designer), Bertha Stenge (quilter), Dorothy Liebes (textile designer), and Gail Fredell (furniture maker and architect-designer) were among those who studied at the University of California, Berkeley, a leading Land Grant institution. Universities particularly "responded to the need for professionally trained ceramicists."[27] Potters Mary Chase Perry (Stratton), Elizabeth Overbeck, and Adelaide Alsop Robineau (fig. 1-7a) all studied and worked at the New York School for Clay-Working and Ceramics (now New York State College of Ceramics at Alfred University), which also includes Betty Woodman and many other of today's leading ceramists among its graduates.

In education a distinctive feature of the twentieth century was federal government funding for design teaching and training through the Federal Art Project (FAP, begun in 1935) of the Works Progress Administration (WPA), which was part of Franklin D. Roosevelt's New Deal—the wide-ranging response to severe unemployment and social dislocation during the Depression.[28] The textile designer and artist Ruth Reeves, with others, established the Design Laboratory, a federally funded school of industrial design in New York City for (re)training designers for industry. She also conceived, piloted, and briefly headed (as National Coordinator) the WPA Index of Design, which recorded American decorative and applied arts from the colonial period to the late nineteenth century.[29] Although the images were produced mainly by fine artists rather than designers, the rhetoric of the Index's administrators challenged the distinctions between (useful) handicrafts and (creative) arts and promoted early American material culture as an educa-

Fig. 1-7. Coeducational design studies, Applied Design department, the Massachusetts Normal Art School, ca. 1914-29.

Fig. 1-7a. Adelaide Alsop Robineau working on her award-winning "Scarab" vase, ca. 1910.

tional tool and a source for design practice and national unity. However, the categorization (and dismissal from the Index) of Native American design and artifacts as "ethnography"[30] weakened the claims of the Index to represent the design past of all Americans.

Other WPA/FAP programs affected design training, notably in African American institutions such as Howard University, Tuskegee Institute, and the Hampton Institute (now Hampton University),[31] which set up government-funded ceramics programs, along with other imaginative institutional partnerships. WPA Community Arts Centers were established in African American neighborhoods to provide free instruction for students and work for art and design teachers. The prototype was the highly successful Harlem Community Art Center (1937–42), which offered classes in design and craft, as well as fine arts, to 1,500 students. Although the integrated staff included men and women, at its core were women, mostly African American: Augusta Savage (its first director and a leading art and design educator), Gwendolyn Bennett (painter and Savage's successor), Louise E. Jefferson (textiles), Octavia Clark (costume design), Sarah West (metal crafts), and Selma Burke (sculpture).[32]

In spite of the WPA/FAP's unprecedented achievements, full gender equality was not a goal of government policy or programs, and the Federal Art Project did little fundamentally to challenge or alter hierarchies of "race," gender, or the arts. In terms of practice, mural painting, printmaking, and ceramics were developed, but the hierarchy of the arts was left virtually intact. The marginality of women designers in WPA/FAP programs was further compounded by the broader marginalization of women in a period characterized by "a stagnant women's movement, a widespread rejection of feminist claims and a renewed attack on wage-earning women."[33] The undisputed importance of the period, and of the New Deal itself, for positive social change and welfare reform must be set against "the ideology of female dependent and male provider [which] remained strong even as women gained access to paid employment."[34] Government patronage of the arts, which the New Deal programs initiated on a large scale, survives most significantly today in the National Endowment for the Arts, a federal agency established in 1965.

Although throughout the twentieth century Native Americans continued their traditions of passing on craft skills from one generation to another, from 1900 the United States Bureau of Indian Affairs became involved in the preservation of Native American arts and crafts; "for the first time, the government-supported Indian program at the Normal and Agricultural Institute in Hampton, Virginia, included training in beadwork, basketry, and pottery."[35] Basketry became part of the curriculum at government schools, while quilting, although introduced by European Americans later became an expressive cultural form for Native Americans.

Having lost much of their traditional lands through wars and acts of Congress, "most Indians were living in extreme poverty on marginal lands. . . in a worse state psychologically, physically, and economically than they had ever been before."[36] For many the 1920s were the nadir of Native American experience. In the early 1930s, in the harshest days of the Depression, the federal government looked sanguinely to the applied arts for the economic and social regeneration of Native Americans. Under the Treasury Department's Public Works of Art Project, a New Deal program established in 1933, Native American students of arts and crafts participated in the decoration of new schools, hospitals, and community centers for Native Americans. Although the government failed to develop a freestanding program specifically tailored to Native American conditions, Bureau of Indian Affairs policy during the New Deal recognized the cultural value and richness of Native American arts and crafts and redoubled its efforts to teach the crafts, looking somewhat over-optimistically to a craft revival in its schools.[37] Many of today's younger Native American designers, such as Wendy Ponca, acquired their skills by combining cultural experience with formal craft training at a Native American high school and undergraduate and graduate study in American design schools (in Ponca's case, the Institute of American Indian Arts in Santa Fe, Kansas City Art Institute, and Parsons School of Design, respectively).

Émigré designers from Europe, particularly Germany and Scandinavia, had a profound impact on design education and practice in the United States between the wars, not only by fostering modernism, but also by helping build some of the most influential design institutions in America. Anni Albers, the textile designer and weaver, arrived from Germany in 1933 with her husband, artist Josef Albers, taking their Bauhaus ideas to the "progressive" Black Mountain College in North Carolina, founded around social and pedagogic ideals which involved staff and students living and working together in a radical mixture of the arts. In a similar climate, intense explorations of design and design teaching were fostered at the Cranbrook Academy of Art in Michigan around a humane, broad-based Scandinavian approach to design teaching developed under the direction of Eliel Saarinen (from 1932) and other émigré designers: his spouse, the weaver Loja Saarinen; textile designer Marianne Strengell; and potter Maija Grotell.[38]

The open-minded Cranbrook legacy can more recently be seen in postmodern design education. From the 1980s, Katherine McCoy, the graphic designer and co-chair (with her husband Michael McCoy) of the Cranbrook design program, rejected "the Modernist design paradigms of objective rationalism" as "typical of male sensibility, safely disengaged from emotional involvement."[39] Among the first to introduce American design students to French post-structuralist theory, she drew their attention to the interactive relationship of user and object, which was seen as producing

Fig. 1-8. Anna Wagner Keichline, age fourteen, 1903. The [Philadelphia] *Inquirer* announced that she "may devote life to industrial art."

Fig. 1-9. Anna Wagner Keichline. K-Brick for hollow wall construction with predetermined fracture joints for custom fitting at the job. Designed 1926 and patented 1927.

meaning, narrative, and poetic expression, while maintaining an emphasis on the designer as interpreter of technology.[40]

Industrial design programs began in the 1930s; the first course was in 1934 at Carnegie Institute of Technology (now Carnegie-Mellon University).[41] One of the finest, at Pratt Institute, pursued modernist preoccupations with mass production and technology. Women were never excluded from such courses, but across the country students were predominately male. In a similar way, in the last thirty years new courses and programs, which featured computer graphics, explored design thinking, teaching, and practice that was animated by (and participated in) the postmodern culture of electronic technology, global capitalism, and volatile international markets. Particularly important were those at the Cranbrook Academy of Arts, at CalArts (under April Greiman), and at the Massachusetts Institute of Technology in Muriel Cooper's Visible Language Workshop. As chair of graphic design at Yale University since 1990, Sheila Levrant de Bretteville continues the feminist project through a program that encourages an interactive partnership with users and considers the social implications of design practice.

In contrast to formal education, apprenticeships and workshop training became generally less important during the twentieth century. However, individual tuition and training in a workshop, studio, or design office for initial or advanced work remained important for women metalworkers, jewelers, silversmiths, potters, and landscape architects. Other more informal arrangements, including "on-the-job training," were common in interior design, where travel abroad also formed part of the "training" of many women designers, particularly in the first half of the century.[42]

EARLY EXPERIENCE, SUPPORT, AND MENTORING

In addition to formal education, early childhood activities and the experience of "doing" have been identified as central to design students' personal and professional identities, as well as to their area of study and choice of career. A recent survey found that, in terms of personal biography and experience, "doing"— the "direct, hands-on, visceral, pleasurable experience"— was:

> the core identity of the people we interviewed in explaining their attraction to design courses . . . Women mentioned knitting; decorating dollshouses; using plasticine . . . using model kits; and making furniture. For young women coming into design (and particularly into furniture and product design), positive experiences of craft making appears crucial. These experiences from childhood appear to have imbued these women with a pleasurable sense of their own skill.[43]

The internalization of skills learned in childhood, especially those with parental direction or support, play a powerful and insufficiently recog-

nized part in the formation of women designers— both those who work within areas conventionally defined as "feminine," such as fashion and interior design, and those gendered "masculine," such as industrial design. Throughout the century this early "hands-on" experience compensated in part for the effects of specialization and gendering within the United States education system.

Arts and Crafts metalworker and jeweler, Madeline Yale (Wynne), acknowledged the influence of her father Linus Yale Jr., inventor of the Yale lock. In 1906 she recalled that, as a young girl, she "had a training in mechanics and access to shop

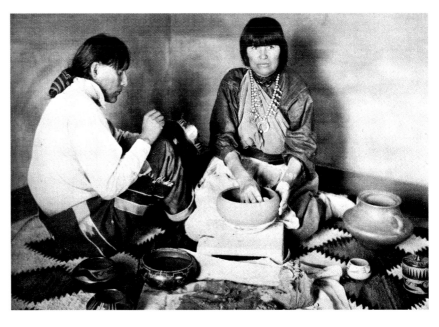

Fig. 1-10. Maria Martinez (*right*) and Julian Martinez, demonstrating various stages in the production of their black-on-black pottery, 1920s.

and machinery . . . became interested in Arts and Crafts [and] developed my own line in metalwork and enamels without instruction."[44] By 1903 fourteen-year-old Anna Keichline, who went on to become an architect and industrial designer (figs. 1-8 and 1-9), was already winning prizes for furniture made in the workshop built for her by supportive parents.[45] Lucia DeRespinis, who worked as an industrial designer in the 1950s, spent a great deal of time in her father's home workshop making small motors and other items, while Gere Kavanaugh, another industrial designer of the same generation, recalled "at a very early age my father taught me how to use a hammer and saw and nails."[46]

Within design gendered "feminine," the practicalities of making and constructing things were also important. The earliest toys of fashion designer Bonnie Cashin were remnants of beautiful textiles by leading major European designers; and like fashion designer Isabel Toledo, she grew up sewing and designing clothes.[47] Fashion designer Ann Lowe, a third-generation dressmaker-designer, learned from her mother and grandmother, who designed and made clothes, particularly evening gowns (Lowe's specialty), for the wealthy women of Alabama.[48] Designers who recall learning by seeing include Maria Martinez (fig 1-10), who, aged about eleven, watched her aunt, grandmother, and father's cousin make pottery in the 1890s. Martinez later remarked that "they didn't teach. Nobody teaches. But in 1932 much later, someone took me to the government Indian school in Santa Fe and told me to teach. I said no, I come and I work, and they can watch."[49] Discussing this "observation-instruction," ceramics historian Susan Peterson commented that Native American daily life "is organized so that it sets up sequences of repetition that become frameworks for a subtle educative process. In this way Maria and Julian [Martinez] continuously showed

Fig. 1-11. Mariska Karasz (*left*) and Ilonka Karasz. ca.1917.

Fig 1-12. Mariska Karasz. Day ensemble, ca. 1927. Silk and silk appliqué. The Metropolitan Museum of Art, New York, Gift of Katherine J. Judson, in memory of Jeanne Wertheimer, 1977 (1977.284.2ab). *Checklist no. 39*

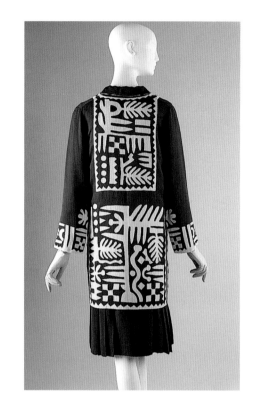

Fig. 1-13. Ilonka Karasz. "Java" armchair, ca. 1930. Teak and woven flax. The Metropolitan Museum of Art, New York. Purchase, Theodore M. Gamble Jr., Gift, in honor of his mother, Mrs. Theodore Robert Gamble, 1983 (1983.228.5). *Checklist no. 49*

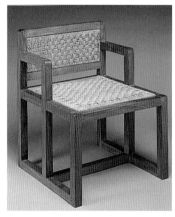

Fig. 1-14. Holly Hampton (*left*) and Karen Hampton, 1962.

Fig. 1-15. Karen Hampton. *Memories*, 1992. Dyed and woven cotton.

Fig. 1-16. Holly Hampton (Sussman/Prejza & Company). Custom handwoven carpet runner, New Jersey Performing Arts Center, 1997.

Fig. 1-17. Eva Lisa (Pipsan) Saarinen and Eliel Saarinen in his studio, Hvitträsk, Finland, ca. 1910.

others in the pueblo their method of making black pottery, so that those others could make it for themselves and involve their own family members."[50]

Siblings can also be teachers, mentors, supporters, critics, collaborators, and sources of inspiration (figs. 1-11 to 1-16).[51] The Overbeck sisters founded a pottery during the early years of the century.[52] Sisters Verma Nequatewa and Sherian Honhongva worked together in the 1980s, designing and making jewelry, but later went their separate ways, linked by the design aesthetic and craft traditions of their training and culture, as well as by personal bonds.[53] Ilonka and Mariska Karasz pursued broadly similar, but by no means identical, careers which each influenced the other, as is the case with Holly and Karen Hampton.[54]

Some designers grew up with both parents actively engaged in design. It is not altogether surprising that Pipsan Saarinen (Swanson) became a designer—patenting a steering wheel and designing textiles, furniture, interiors, glass, and clothing. Her mother was a distinguished handloom weaver; her father a world-renowned architect and designer (fig. 1-17). The Saarinens extended their family through mentoring a fellow Finn, Marianne Strengell (herself the daughter of a designer and an architect) and the orphaned Florence Schust (Knoll), both of whom became internationally known designers. Before being "adopted" by the Saarinens, Schust (Knoll) had been inspired to become an architect by her art teacher, Rachel de Wolfe Raseman, who had a degree in architecture from Cornell University.[55] Deborah Sussman, the graphic and environmental designer, found mentors in Ray and Charles Eames, whose spirit endures in the firm run by Sussman and her designer husband, Paul Prejza (figs. 1-18 and 1-19).[56] Mentoring was

Fig. 1-18. Charles Eames and Deborah Sussman, 1961, working on the layout of the timeline/"History Line" for *Mathematica: A World of Numbers . . . and Beyond*, an exhibition held in 1961.

Fig 1-19. Deborah Sussman, Jennifer Stoller, and Ana Llorente-Thurik, 2000, working on the layout of the timeline/"Context Line" for *Women Designers in the USA, 1900–2000: Diversity and Difference*.

often mentioned by designers interviewed for this publication, but never so consistently as by African American designers, many of whom see this process as crucial to expanding horizons and providing opportunities for young women of color.

DESIGN AS GENDERED WORK

In the twentieth century, design was a site of gendered work (figs. 1-20 to 1-24). Like social relations generally, the different areas categorized as "design" were subject to the organizing principle of the sexual division of labor, whereby tasks were assigned according to gender. The residual strength of the nineteenth-century cult of domesticity and "true womanhood" depicted woman as genteel guardian of the home, taste, and morality. When women worked as designers in the early twentieth century, they did so largely in occupations associated with the "feminine."[57] By 1900 embroidery and the decoration of china were already deemed suitable for women, while jewelry, metalwork, and interior design were beginning to open up to them. Men had varying reactions to women's entry into areas formerly closed to them. Some, such as educator and interior design "authority" Frank Alvah Parsons, vigorously resisted "feminization,"[58] while others, such as the Navajo silversmith Grey Moustache, initially felt their masculinity affronted by women doing similar work, but later revised their opinions.[59] Some male teachers, partners, employers, and mentors welcomed women, offering economic, emotional, and professional support.

Although contemporary conceptions of appropriate occupations for women and men were central to women's access to particular types of design, the conditions and parameters within which women worked were fluid and changed over time. The concepts of "women's work" and "woman designer" were redefined and extended. Women were active participants in the construction of new meanings about themselves—challenging, resisting, and negotiating restrictive ideologies about "suitable" activities. For example, Katherine McCoy decided in high school during the early 1960s that she wanted to be an architect, but a career counselor persuaded her that interior design would be more appropriate for a woman. McCoy thus embarked upon an interior design degree at Michigan State University, only to change to industrial design. After another career shift, she ultimately became one of the most influential graphic designers and design educators of the 1980s and 1990s.[60]

The gendering of design took place not only *between* fields but also *within* them. Even in the infant film industry, women were excluded from art direction and production design and steered toward costume design—a segregation not breached until late in the century. In landscape and interior design, women found it easier to get residential commissions, paralleling practices in architecture, whereby men dominated nonresidential work. In

Fig. 1-20. Students studying textile samples, Cooper Union, New York, 1921.

Fig. 1-21. Interior design students studying wallpaper collection at Cooper Union, New York, ca. 1955–59.

Fig. 1-22. Robert Castle with students of interior architecture and decoration, Parsons School of Design, New York, 1955.

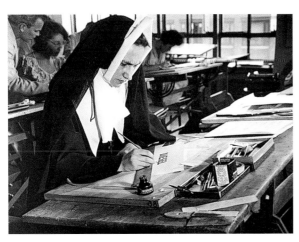

Fig. 1-23. Sister Marie preparing a DIESEL sign at Parsons School of Design, New York, 1949.

Wayne Boyer John Siena Tom Freese Fred Ota David Blumenthal Tom Miller

Morton Goldsholl Millie Goldsholl John Weber Susan Keig James Logan William Langdon

Fig 1-24. Goldsholl Office staff, 1963. The firm was known for its "progressive" hiring policies in the 1960s. Millie Goldsholl mainly worked on film design, leaving Susan Keig the only woman involved in mainstream graphic design.

furniture and metalwork, women tended to be restricted to small-scale domestic products in the early years of the century.[61] Gendered views and assumptions may have limited the ways in which they worked, but an increasing number of women staked claims to these "male" fields. They did so as designers and designer-makers in their own right, rather than as widows or daughters of furniture makers, silversmiths, or others, continuing family businesses after the death of the male owner, as had previously been the case.[62]

By contrast, larger-scale furniture, metalwork, and certain aspects of landscape architecture, as well as industrial design, all of which more closely conformed to markers of masculinity (size, strength, being allowed to dirty one's hands, and working in the public realm), remained male preserves for longer periods of time.[63] When women began to be involved in the design of automobiles in the 1930s, they worked almost exclusively on interiors, whereas men designed all aspects of vehicles ("hard" exteriors as well as "soft" interiors). In the 1940s and 1950s, General Motors hoped its women industrial designers might give automobiles "woman appeal" (fig. 1-25). When

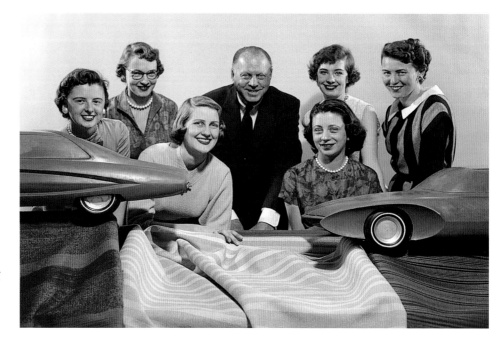

Fig. 1-25. Women industrial designers at General Motors, ca. 1955. "Damsels of Design": (*from left*) Suzanne Vanderbilt, Ruth Glennie, Marjorie Ford Polham, Harley Earl (vice-president of styling at General Motors), Jeanette Linder, Sandra Longyear, and Peggy Sauer.

women were hired "largely for their 'feminine' sensibilities," the work of women designers was "simultaneously encouraged and circumscribed by a contemporary understanding of gender's influence on aesthetics."[64] Gendered divisions that were based on the size of items and/or the relationship of products to the home continued throughout the century. Since the 1970s, however, some women, such as Gail Fredell and Wendy Maruyama, have worked on large pieces of furniture, although noticeably not in the realm of machine mass production.

The impact of feminism on attitudes toward women working and the fluctuations of the economy also affected women's place in design. The greatest occupational advances for women generally came during periods of feminist activism—from 1900 to 1920, and from 1960 to the present. However, important developments also occurred in the years between 1920 and 1960, including women's entry into industrial design (fig. 1-26) and film costume design and their increasingly important role in design education.

Fig. 1-26. Ellen Manderfield at the bureau of design, Montgomery Ward, 1950.

The two world wars, which drew men away from work and education, contributed to changing ideas about "women's work"—even though in most cases women's entry into "male" jobs ceased at war's end. During World War I, when male students were abroad fighting, female applied arts students, particularly metalworkers and jewelers, were able to acquire greater workshop skills. These included "Vice and Benchwork, Forging, and Machine Tool Practice," a wide array of techniques for working cast and wrought iron and welding and tempering steel (fig. 1-27), which were normally missing from the education of girls in the United States.[65]

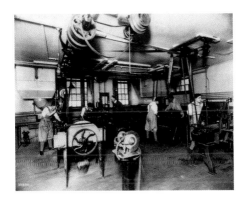

Fig 1-27. Women students working in the machine shop at the Massachusetts Normal Art School, 1918.

World War II led to even greater acceptance of women doing "men's work."[66] Griswald Raetze, Margaret Harris, and Ray Eames were among the few women designers directly involved with military contracts and working on products usually associated with male industrial designers. From 1942 they were part of a team of men and women, headed by Charles Eames and Ray Eames, working on Naval contracts to design and produce molded plywood aircraft parts as well as splints and body litters for wounded soldiers.[67] The armed forces provided some opportunities for women in graphic design (then almost exclusively white and male). When Anna Russell (Jones), whose main design expertise lay in textile design, joined the Women's Army Auxiliary Corps (WAAC) in 1942, she was given work as a graphic designer at a military camp for African American troops (fig. 1-28).[68]

The war also offered opportunities for women to study drafting, engineering drawing, machine design, and engineering illustration skills (fig. 1-29). Special "war training courses" were established at many schools of design for women and men not eligible for military service, in order to free those men who were eligible.[69] However, wartime changes in work practices and the cultural endorsement of women's employment were largely temporary. In postwar America, women's "traditional" social roles were reasserted,

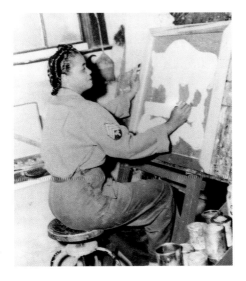

Fig. 1-28. Anna Russell Jones, serving in the Women's Auxiliary Army Corps (WAAC) during World War II.

Fig. 1-29. Class in production illustration for airplane assembly work, Parsons School of Design, 1942.

House & Garden

A Condé Nast Publication

WOMEN AT WORK BUILDING TOMORROW

In this Issue:
TOMORROW'S HOME
How it will look and work

YOUR WARTIME BUDGET
Making it ★★★★★

NEW FALL COLOR SCHEMES

SEPTEMBER 1943
PRICE 35 CENTS

Fig. 1-30. John Rawlings. Front cover for *House & Garden*, September 1943.

if not always reassumed in prewar mode, during the late 1940s and 1950s.

WORKING MOTHERS

Sometimes the different aspects of women designers' lives were mutually supportive; at others they tugged in opposite directions. In 1945 Anita Stewart, who worked at engineering drawing during the war, went to Parsons School of Design to study interior design (spending a year in Paris). She built a successful career in New York before marrying the well-known designer and architect Alfons Bach in 1952 and giving up her career to raise a family.[70] In subordinating her career to that of her husband, she was typical of many women designers at that time.

Figure 1-30 indicates the duality of working wife and mother, but without any hint of the dilemmas featured in pre- and postwar discourses on women's roles. Yet even during World War II, when government and media propaganda encouraged wives and mothers to work, the dilemmas faced by such women, designers included, were acutely felt. Throughout the century, women were the primary child caregivers and housekeepers, and every woman who worked outside the home while raising children invariably juggled work and home (figs. 1-31 and 1-32). Little wonder that, particularly for the first seventy years of the century, in design areas based outside the home, many of the most successful women designers (though by no means all) were unmarried or married but had no children[71]; some came to design late in life after their children were grown; others did not work full-time or were dependent upon a variety of types of childcare other than their own.

Ellen Shipman, who became a well-known landscape designer, only sought paid employment after her husband left the family home and she was only able to build a professional career by passing on increasing responsibility for house and childcare to her teenage daughter (fig. 1-33).[72] Eva Zeisel had a studio in the same building as her apartment (fig. 1-34) and a mother who came to live next door and look after her children. This helped her sustain a career as a ceramic and product designer after she had children in the 1940s.[73] Some women changed to another area of design in order to continue working when they had young children. Maud Bowers Rice, for instance, the first graduate in industrial design in America, and Nina Wolf, a costume designer, both turned to jewelry so that they could work from home and more readily combine design with domestic duties.[74] In a recent interview, product and interior designer Lella Vignelli (fig. 1-35) was candid about how frustrating it had been in the 1960s and 1970s to be a working designer and a wife and mother, commenting on the gap between the idea and the reality of working at home— or rather *not* being able to work because of the children.[75]

Fig. 1-31. Detail of first page of "American Woman's Dilemma," 1947. From *Life*, 16 June 1947.

WORKING GIRL GWENYTH JONES IS SINGLE, PRETTY AND MUST DECIDE ON HER FUTURE

AMERICAN WOMAN'S DILEMMA

She wants a husband and she wants children. Should she go on working? Full time? Part time? Will housework bore her? What will she do when her children are grown?

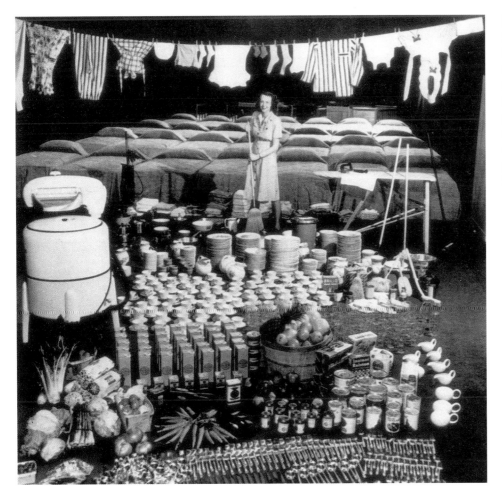

Fig 1-32. "Mrs. Clean," Marjorie McWeeney of Rye, New York, whose husband and three children "keep her busy 100 hours a week," with 35 beds to make, 750 items of glass and china and 400 of silverware to wash, 175 pounds of food to prepare, and 250 pieces of laundry to handle. From *Life*, 16 June 1947.

Fig. 1-33. Ellen Shipman with Ellen, Evan, and Mary at Brook Place, Plainfield, New Hampshire, ca. 1910.

Fig. 1-34. Eva Zeisel and assistants, Riverside Drive studio, New York, ca. 1950.

Fig. 1-35. Lella Vignelli and Massimo Vignelli, 1976, with Heller plastic stacking dinnerware (1964–76) and Heller Glass Bakeware (1975).

Circumstances have changed for many working women, particularly in the last quarter century. A greater acceptance of flexible working hours and patterns, online communications between home and design studios, parental-leave plans, and the greater involvement of some men in childcare, have eased certain aspects of being a working designer-mother. However, childcare and housework remain largely the concern of women. They also consume enormous time and energies, and most women designers with children continue to "juggle" as best they can.

COUPLES, COLLABORATION, AND CREDIT

The wife/husband partnership, which allowed for the combination of home responsibilities with those of work, was one of the ways women designers negotiated the dilemma of work after marriage.[76] Such partnerships were not restricted to couples with children; some of the most successful were between men and women free from childcare responsibilities. It is notoriously difficult to assess the particular nature of and individual contributions to collaborative work, particularly that between people who both live together and work together, not least because the best collaborations involve dialectic, dynamism, and "telepathy."[77] Nevertheless, it is often assumed (incorrectly) that the woman is the less active and less dominant professional partner.[78] As the partnerships featured in the ensuing chapters show, however, the texture of partnerships and the balance of power and responsibilities within them varied considerably.

By the 1940s such partnerships were a distinctive feature of design practice in the United States.[79] More traditional forms of courtship and separate spheres within the married home had begun to give way to "partnership and communication" in domestic and personal relationships.[80] At best these "couple collaborations" were mutually stimulating and extremely supportive; at worst, working relationships suffered the consequences of personal problems (and vice versa) and such working practices often resulted in women being overshadowed in terms of public recognition.[81]

In the 1940s and 1950s, women designers married to designers were often viewed as auxiliaries of their husbands and commonly featured as "pretty girls" and "faithful helpmates."[82] When Ray and Charles Eames appeared on a television show in 1956, she did not share the limelight equally with him. After Charles and their *joint* work had been introduced, the presenter hailed Ray (hidden behind a screen) as the wife behind the successful man, before announcing: "This is Mrs. Eames and she is going to tell us how she helps Charles design these chairs."[83] Now widely accepted as an equal partner in one of the most exciting design firms of twentieth century America (fig. 1-36), Ray Eames did not receive full credit for her contributions at the time (1941–78). When she died in 1988, most obituaries were less than generous; some were insulting, despite the huge body of joint work—

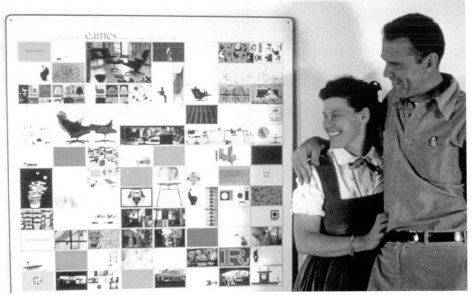

Fig. 1-36. Ray Eames and Charles Eames with panel illustrating the work of the Eames Office, 1957.

Fig. 1-37. Denise Scott Brown and Robert Venturi, 1984.

acknowledged as such by Charles—and despite two decades of feminism and feminist scholarship in the United States.

Despite changing attitudes toward the recognition of women within partnerships, issues of credit and recognition, which go far beyond personal assertiveness, remain endemic.[84] Architect, urban planner, and designer Denise Scott Brown can testify that neither assertions nor statements by both partners about joint credits guarantee recognition in a world that defines genius as "male" and considers women who ask for recognition as neurotic or self-serving.[85] In 1967 Scott Brown began working with her husband, Robert Venturi (fig. 1-37), as a partner in the architectural design firm Venturi and Rauch (from 1980, Venturi, Rauch and Scott Brown and presently Venturi, Scott Brown and Associates). She is widely recognized as opening new discourses about women's marginalization within design and architectural partnerships— and the resulting frustrations.[86] She and Venturi recently revised the credit line for a chair (fig. 1-38) commonly assumed to have been designed solely by him (because the collection of which it is part was named after Venturi by the manufacturer). By 1984, however, that particular issue of credit was but one of many instances of "discrimination...at the rate of about one incident a day."[87] Scott Brown recently stated that "the idea of making a chair like a billboard came from both of us, as did the desire for a floral print that was rich in complexity," adding that "the conception of a piece—the basic idea—is just as important as deciding on pattern details— and I was involved in *both* on this project."[88]

Throughout her life, Pipsan Saarinen Swanson had to negotiate the shadows cast by the fame of her father and brother—Eliel and Eero Saarinen. Ironically, she found herself in a marriage and design partnership in which her architect husband, Robert Swanson, came to feel overshadowed by her

Fig. 1-38. Robert Venturi with Denise Scott Brown; project manager: Maurice Weintraub. "Queen Anne" side chair with "Grandmother" decoration, 1979–84. Manufactured by Knoll International, East Greenville, Pennsylvania (1984–89). For an example of chair with cushion, see *Checklist no. 148*

reputation and success and had to deal with his bitterness.[89] The case of Maria and Julian Martinez, who might well qualify as the first American designer couple of the twentieth century, is somewhat different in that he was given recognition during his lifetime but, today, his talents and contributions to the partnership are generally under recognized. Indeed, Maria Martinez always insisted on full credit for him.[90]

"ANONYMITY," VISIBILITY, AND RECOGNITION

Several chapters make the point that many women designers were, and are, "anonymous," in the sense that they worked within firms and in industries where individual designers were rarely acknowledged by name.[91] The term is a useful shorthand for such situations, but further scholarship, particularly that which uses the archives of design studios and manufacturing industries, will reveal more hitherto unknown histories. Art historian Patricia Mainardi pointed out as early as 1971 that many quilts, whose designers and makers were known, were often labeled as "anonymous" simply because the objects and those involved in their conception and production were not highly valued by those who displayed them or wrote about them.[92]

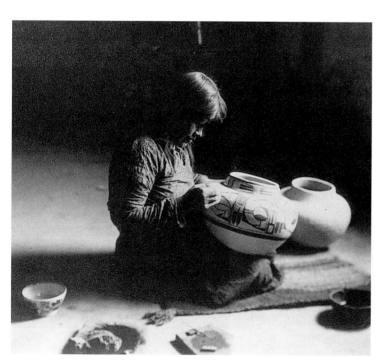

Fig. 1-39. Nampeyo demonstrating Hopi polychrome pottery, Hano, First Mesa, Arizona, ca. 1900–1908.

Neither "anonymous" nor "named" are fixed concepts and they need to be considered within specific cultural contexts. At any given moment, a particular designer could be both known and unknown. For example, before the prodigious talents of Nampeyo were "discovered" by trader Fred Harvey at the beginning of the twentieth century, she was well-known by name within her community (fig. 1-39). The duality of known and not-known continued when she became known by name to Harvey but not to the tourists who made brief train stops to buy "Indian" wares (fig. 1-40). Apart from the quality of her work, Nampeyo became an increasingly familiar name through her demonstrations of pottery making, rather than by signing her pottery. Photographs of her at work (including some by the well-known photographers Edward S. Curtis and A. C. Vroman) appeared in advertising material issued by the Santa Fe Railroad.

There was increasing pressure from "museum people" and collectors from the mid-1920s for signatures; anonymous "authenticity" no longer satisfied collectors or scholars who required guarantees of "authorship."[93] Maria Martinez, who spent her "honeymoon" demonstrating pottery at the 1904 Louisiana Purchase Exposition and went on to become even more famous than Nampeyo, signed work from the mid-1920s.[94]

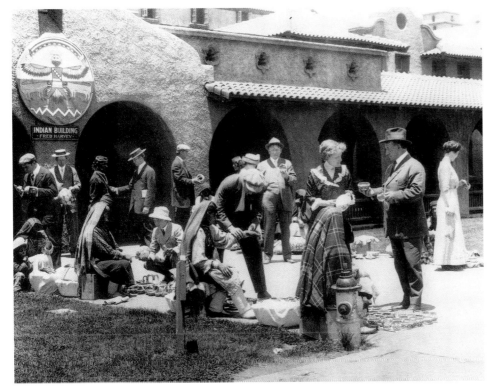

Although there was an increasing trend towards recognition of individual designers throughout the century, circumstances differed greatly between design areas as well as between those who headed their own firms and those who were employees. The textile industry, for example, was noted for the lack of recognition given to designers. In the late 1920s Loïs Mailou Jones realized that since "only the name of the design, printed on the borders of the fabric, was known, never the name of the artist who created it I would have to think seriously about changing my profession if I were to be known by name."[95] In the 1960s and 1970s, Rose Ransier was largely invisible as a designer of knitted textiles in an industry that sought her services but rarely named company designers (figs. 1-41). As the painter Rose Piper, she had received reviews, but as a professional textile designer she became resigned to seeing fabrics made to her designs advertised and sold without mention of who designed them.[96] World War II and the hopes of wresting world fashion leadership from Paris greatly increased the visibility of fashion designers in the United States, as did a buoyant postwar economy. In the film industry heads of costume departments in the larger studios were usually credited onscreen rather than individual designers, but there was still a much greater chance of getting one's name known as a costume designer for films than as a company designer in the textile industry or in industrial design.[97]

Some designers were more bitter than others about customs and practices that worked against them becoming renowned. Ann Lowe, for example, resented that credit for her designs went to the women who

employed her and to their companies. The white strapless evening gown that actress Olivia de Haviland wore to receive her Academy Award in 1946, for example, was a Lowe design even though it bore the "Sonia Rosenberg" label.

General office credits or labels avoided squabbles about who was and was not credited for particular designs, but the custom reinforced the high profiling of the owner of the firm. It was extremely difficult for many young designers to make a name for themselves. Industrial designer Lucia DeRespinis recalled: "It was Catch 22—no matter how good you were there was little chance of getting your name known. It is very odd when I see the clock and tiles, designed by me when I worked for George [Nelson], sold as 'designed by George Nelson' rather than as by George Nelson Associates, let alone by me" (see figs. 11-18 and 15-13).[98] Today, more firms credit individual designers than ever before, but not naming remains endemic in particular areas, such as fashion, textiles, and industrial design.[99]

Credit brought recognition and recognition brought visibility. But visibility had different implications for black designers than for white designers, particularly before the 1960s and 1970s when "color" affected chances of working in the more "visible" areas of design.[100] Visibility remains a central issue today; as the eminent academic Paul Gilroy recently observed, "If you want to make younger black people interested in education and the arts, you need black folks visibly successful outside music and sports."[101] The importance of Courtney Sloane's high visibility—not just as an interior designer but as one with whom young women can empathize—is seen in the large number of inquiries about becoming a designer she receives through her "By Design" column in *Essence* magazine.

Over the century, women designers addressed the issue of recognition in different ways (figs. 1-42 to 1-44): opening their own firms; securing high-profile clients and prestigious commissions; gaining publicity in magazines and journals; participating in exhibitions and competitions; and being featured in advertisements. Fashion houses had "shows" and some interior designers contributed to "show houses." Some designers became better known through teaching and others appeared on television.[102] Like Bonnie Cashin and Courtney Sloane, interior designer Dorothy Draper wrote a design advice column; by 1934 she had appeared on the covers of more magazines than Eleanor Roosevelt. The profiles of others were heightened by writing books about design: Candace Wheeler's *Principles of Home Decoration* (1908) and *The Development of Embroidery in America* (1921); Elsie de Wolfe's *The House in Good Taste* (1913); Elizabeth Hawes's *Fashion is Spinach* (1938); Mariska Karasz's *Adventures in Stitches* (1949); Edith Head's *The Dress Doctor* (with Jane Kesner Ardmore, 1959); Anni Albers's *On Designing* (1959) and *On Weaving* (1965); and Carolyn Mazloomi's *Spirits of the Cloth* (1998). These and other publications placed the designer-author's ideas on the content and practice of design before wider audiences than those of fellow designers and clients/users.

Fig. 1-42. Verma Nequatewa,
Polacca air strip, near First
Mesa, Arizona, with her Piper
Turbo Lance and Jaguar XJ6,
1998.

Fig. 1-43. Suzanne
Vanderbilt, on "Wide Wide
World TV," 1956. Filmed in
Cadillac Studio, General
Motors Technical Center.

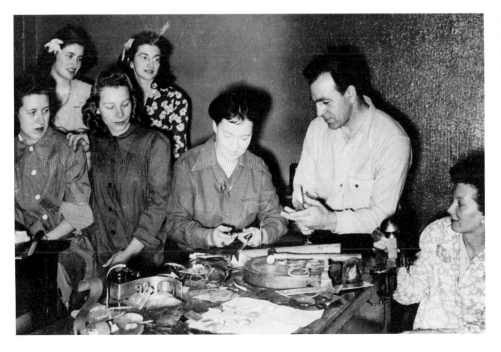

Fig 1-44. Margaret De Patta
and Eugene Bielawski co-
teaching jewelry design and
fabrication at an Oregon
University summer class, 1947

Fig. 1-44a. Cheryl Riley seated in the public lobby of the Bayview Police Station, Bayview, California, an interior she designed (1991–97).

Diversity and difference were the hallmarks of the backgrounds, training, education, and practices of women designers working between 1900 and 2000 in the United States, a nation that supported an enormous range of design-related crafts and industries. Whether they worked in areas marginalized because of associations with the "feminine" or in those that challenged stereotypes of what it was to be a woman designer, and whether the products were produced by hand, machine, or a combination of both, women designed a rich array of objects. Their work touched the lives of many and inspires new generations of women designers making their own contributions to the material culture of the United States.

Today, the gendered nature of certain areas of design is marked. Fields in which women heavily outnumber men (at least 80 percent of the total), such as textiles, interior design, jewelry, and fashion, are those more readily categorized as "feminine."[103] Given that women were barely represented at a professional level in interior design and jewelry in 1900, it would appear that, as in other professions such as education, men gradually looked elsewhere as their occupations "feminized."[104] The two areas of design in which women are most poorly represented (approximately 20 percent of the total) are film production design and industrial design. The latter is most closely identified as a "masculine" occupation, and a speciality within it, transportation design, has the distinction of having fewer women students than any other design area (less than 10 percent).[105] The biggest changes in terms of the gendering of product design have been in furniture, an area with more "domestic" connotations and less technical associations than the design of aircraft or trains. Women now account for approximately half of undergraduate furniture students, an area of design in which women practitioners currently flourish.[106]

Graphic design and landscape design, like furniture design, also fall between the extremes of design occupations associated with the "feminine" (and largely undertaken by women) and those categorized as "masculine" (and dominated by men). All three areas of design have changed radically since the 1970s. At the end of the century, women accounted for approximately half of all landscape designers, and more than half of graphic designers.[107]

Some areas of design continue to show "an appalling lack of ethnic diversity."[108] In textiles, the relative ease of access by women of color throughout the century was related to the prevalence of women in general in that industry, and to the high degree of "anonymity". In industrial design and film production design their low profile coincided with the low profile of women generally. However, women of color remain few and far between in certain areas in which women have been well-established for many years— for example, interior design (fig. 1-44a) and film costume design. By contrast they have fared better within graphic design, an area that did not open up to women on any significant scale until the 1970s when "race" and gender discrimination were simultaneously challenged.

Hindsight reveals the illogicality of arguments against women participating in the design of public parks in the 1910s or designing film sets in the 1930s. And it is also easier today to question earlier assertions that women were "naturally" suited to embroidery and the decoration of china. More recent discrimination is far more difficult to pinpoint. In the last twenty years barriers to women's participation and advancement in design have been less tangible, and prejudices less openly articulated. The term *glass ceiling* has been used to describe the invisible yet pervasive and continuing discrimination against women designers, especially in terms of access to senior and well-salaried positions in fields such as graphics and landscape design where women have more than shown their competency.[109]

There is much in this book to arm those concerned with confronting stereotypes and establishing more complex histories and representations of women. In 1903 Anna Keichline, the young girl in figure 1-8, who declared that she might devote her life to the "industrial arts," shattered conventional understandings of adolescent female ambitions, and today Eva Zeisel shatters stereotypical expectations about ninety-four-year-old grandmothers by her continuing career as a designer. Zeisel, who was born in Hungary in 1906, eventually moving to the United States in 1938, has been honored many times for her contributions to design, as practitioner and as teacher. The year 2000 sees her as dynamic and inventive a designer as ever (fig. 1-45), still as dedicated to "the playful search for beauty."[110] Zeisel's life spans the century upon which this publication focuses; "my century" she calls it.

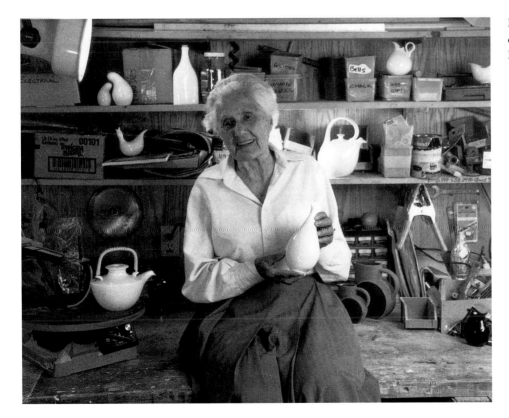

Fig. 1-45. Eva Zeisel in her country studio, New City, New York, 2000.

WOMEN DESIGNERS AND
HISTORIES OF DESIGN

Major revisions to histories of women designers and their work took place against not only a growing body of feminist scholarship but also renewed interest in crafts and the questioning of orthodox modernism from the late 1960s. The subsequent collapse of hegemonic modernism, the revalidation of the decorative, and the emergence of new design theories and practices were central to reenvisionings of the history of women designers. A close intertwining of gender and pro-modernist biases has marked much of the writing about design since the 1930s. Within modernist discourse and practice there was much that marginalized "the feminine" in general and women designers in particular. "Postmodern" discourses and sensibilities—which privilege margins over center(s), favor difference, hybridity and multiculturalism, and embrace the crafts and the decorative—have helped open up new spaces and places for women designers within design history.[111] As noted in chapter 15, feminism's "reassessment of the value system and practices of the arts and crafts occurred alongside" and was reinforced by considerations of "why crafts, particularly those made and consumed at home, had been devalued by historians." Postmodern debates about "cultural meaning, value, and consumption," which examined and revalued the decorative after its long period of suppression by modernism, also contributed to this reassessment.

Until the 1980s one of the topics considered "unworthy" of serious study was African American design. Despite the veritable industry of scholarship relating to African American art since the late 1960s, there are no major, scholarly studies of African American design — although important work has been undertaken on particular areas of design (such as graphics and quilts) and on some individual designers, not least by committed feminist designers interested in their cultural heritage.[112] The Civil Rights Movement of the 1950s and 1960s changed the terrain of political life in the United States and helped catalyze a "renaissance" of cultural production by African Americans that was as broad in scope as it was layered and nuanced.[113]

The reinvigorated exploration of cultural bonds with Africa engaged in a dialectic with a multiculturalism that recognized rather than suppressed difference, hybridity, the decorative, and craftwork. Pride in African origins and the questioning of "authenticity" as an intellectually valid category led to value being placed on the very things for which African American design and craft traditions had been marginalized. Until the last twenty years, most major museums of design and applied arts in the United States had scandalously low holdings of African American items with the possible exception of quilts and items classified as "folk." Given this situation, the Cooper-Hewitt National Museum of Design's African-American Design Archive

(AADA), established in 1991, was particularly important as a symbol of change and as a facilitator of further scholarship.

The study of Native American design was dominated for most of the century by the admiration (often obsession) of collectors and scholars for its supposed "authenticity." The postmodern denial of the "authentic," however, affords new opportunities to reassess and rework histories of Native American design and craft. The increasing focus on cultural diversity and hybridity also brought a greater awareness of the rich cultural heritage of Hispanic Americans, Asian Americans, and other minority ethnic groups. Increased respect for the crafts, and for objects often categorized as "folk" or ethnographic, was evident in many exhibitions and publications since the 1970s. *Revivals! Diverse Traditions 1920–1945*, published in 1995 by the American Craft Museum, promoted a much-needed multicultural approach to craft and design history and helped bring such objects into discourses of the history of design, while addressing the issue of eurocentricity.[114]

For those interested in design and architecture, two of the most influential texts arising out of the questioning of the universality and rationality, which had dominated Western intellectual thought since the Enlightenment, were *Complexity and Contradiction in Architecture* (1966) by Robert Venturi and *Learning from Las Vegas: The Forgotten Symbolism of Architectural Form* (1977) by Venturi, Denise Scott Brown, and Steven Izenour. They argued for the inclusion of popular culture in design thinking and repertoires and also for hybridity, contradiction, and symbolism, rather than "purity" and simplicity, as well as the end of polarities and exclusivity. In 1966 Venturi claimed to prefer "black *and* white, *and* sometimes gray, to black *or* white" (emphasis added), whereas by 1977 the whole riot of color and "messy vitality" was validated.[115]

Interest in crafts did not die after the Arts and Crafts movement but their lack of status in the Machine Age led to attempts to recategorize them as "art" beginning in the 1940s. Thus, as this book demonstrates, by the time of the so-called Crafts Revival of the 1970s, some of the boundaries between art and craft, on the one hand, and between art and design, on the other, had been broken down — at least in the minds of designer-makers of objects, if not fine artists. Although design and making in certain areas, such as ceramics, were considered by some to be "art" by the 1970s, the hostility expressed at the threatened inclusion of more marginalized crafts, such as needlework, is a measure of the strength of the art/craft divide that feminist artists and designers sought to eliminate.[116] Judy Chicago, Miriam Schapiro, and Sheila Levrant de Bretteville were prominent in a movement to radically refocus art and design practice and education by eliminating sexism within the education system and making it more open to the ideas of the Women's Movement. Revaluing and affirming both "women's work" and craft, feminist artists and designers linked and reinvigorated art, design, and craft through hybrid work

and politicized aesthetics as well as through antimodern and pluralist discourses.

The rich matrix of postmodern theory, feminist writing on and about women designers and artists, the re-reading of ("feminine") decoration, and the activism associated with the Women's Movement produced critically informed designers such as April Greiman, Sheila Levrant de Bretteville, Wendy Maruyama, Cheryl Riley, Anne Krauss, and Joyce Scott, to name but a few. Their work, which also fed the impetus for change, ranged from personal, often densely woven narratives of identity, interiority, sexuality, and oppression to equally multilayered commentaries on patriarchy, stereotypes, the social construction of femininities, and the interplay of gender with "race," cultural heritage, and other factors.

What little feminist design history there was in the 1970s was written by art historians, which is not surprising given that design history did not emerge as a specific academic discipline until the mid-1970s and that those who wrote about "decorative arts" generally focused on the stylistic analysis and attribution of high culture objects. The two most influential texts of that decade in terms of design history addressed the art/craft divide. Women artists — and, by inference, women designers — were seen to have suffered in terms of reputation not only because women were regarded as "lesser" in patriarchal society but also because the products of their labors were devalued. Despite the Arts and Crafts movement's call for the unity of the arts, the applied arts, also known as the "lesser arts," had remained inferior to fine art and architecture in the hierarchy of the arts because they were associated with *making* (as well as designing) and with the domestic and the decorative (i.e., the "feminine").

Patricia Mainardi's "Quilts: The Great American Myth" of 1973 argued against the contemporary dismissal of quilts as noncreative, collaborative, repetitive, and anonymous efforts by amateur women in the home, claiming "anonymity" was often little more than sloppy scholarship and a blatant disregard for "women's work" and women's culture. She stated that needlework was so important to women's culture "that a study of the various textile and needlework arts should occupy the same position in Women's Studies that African art occupies in Black Studies—it is our cultural heritage."[117] At one stroke Mainardi placed at the center of design history "women's work" and low status craft and design traditions considered old-fashioned by modernists. Her polemic also introduced the issue of "race" through the strong African American presence in quilting.

In 1975 Rozsika Parker used the art/craft divide to explain that, although embroidery was a "craft" with low status in the nineteenth and twentieth centuries—not least because it was almost exclusively a women's amateur pursuit—men had been actively engaged with it when it was a commercially

viable and high status ecclesiastical and secular art between about 900 and 1500. Insisting that art made with thread is not intrinsically different from art made with paint, Parker emphasized that the real differences lay in terms of *where* products were made (inside or outside the home) and *who made them* (women or men).[118] In 1986 design historian Cheryl Buckley echoed Parker when she argued, in "Made in Patriarchy: Towards a Feminist Analysis of Women in Design," that the work of many women designer-makers and designers was marginalized because it was decorative and domestic; made by the "wrong people" in the "wrong place."[119] Buckley went on to take to task the strong faction within design history that emphasized modernist form and practice, machine mass production, and innovation.[120]

The privileging of industrial design practice within design history reflected modernist discourses that claimed parity for "serious" design with architecture and abandoned the decorative, domestic, fashionable, and "feminine"—together with designers associated with them— in the hope of escaping the epithet "lesser." Nikolaus Pevsner's *Pioneers of Modern Design* (1936) set the tone for histories of male modernist heroes, and for proto-modernist ones too.[121] Women designers were largely ignored or blamed for holding back "great men" from greater things. Thomas Howarth, whose *Charles Rennie Mackintosh and the Modern Movement* (1952) was for long the "definitive" work on the subject, is fairly typical of architectural and design historians blinkered by sexism and modernism. Of the impact of Margaret Macdonald Mackintosh, wife of Charles Rennie Mackintosh (who himself went against conventions of gendering genius as "male," stating that Margaret had "genius" whereas he had mere "talent"),[122] Howarth wrote:

> It is probable that Margaret Macdonald, however unwittingly, was respon-
> sible for limiting her husband's vision, for tying him more securely to the
> aesthetic movement, and encouraging him to dissipate his energies on
> work of comparative unimportance when he might have consolidated his
> position in the architectural field.[123]

Not surprisingly, given the admiration for modernist heroes and value systems based on innovation, several feminist architectural historians focused their attentions on women architect/designers who worked in modernist mode. In the case of Lilly Reich, for example, they argued that she not only deserved more recognition for work that had been attributed to Ludwig Mies van der Rohe, but also outstripped him in her modernism. Some of this research was published in 1981 in a special issue of *Heresies*, the same year in which the highly influential *Old Mistresses: Women, Art and Ideology* by Rozsika Parker and Griselda Pollock argued against the selective celebration of women modernists in art history and in favor of explaining the limitations within which women worked.[124] Parker and Pollock's position, particularly

their examination of the historically specific constraints upon the ways women produced art, together with that of Mainardi in "Quilts," is central to the intellectual underpinning of this text.

The sexual division of labor was first explored in design history by Anthea Callen in *Angel in the Studio: Women in the Arts and Crafts Movement* (1979). Callen, like Mainardi, Parker, and Pollack, drew on the concept of the hierarchy of the arts. Her study of the gendered nature of work within the Arts and Crafts movement remains the point of reference for all subsequent studies of women in the movement.[125] In 1985 and 1989 Cheryl Buckley looked at the sexual division of labor in the British ceramics industry, later publishing a comprehensive study (1990), in which she related contemporary notions of femininity to the types of work undertaken by women.[126]

The 1980s and 1990s were marked by further attempts to rethink women's diverse histories within wider parameters. The existing interdisciplinary nature of design history increased as other disciplines—women's studies, cultural studies, anthropology, sociology, and the history of technology—had an impact on the new discipline, which was from the start influenced by the history of art and architecture and social history. Feminist architectural historians proved particularly influential, especially Dolores Hayden. Her *Grand Domestic Revolution* (1982) offered new accounts of women's lives and cultural work and historical alternatives to contemporary gendered ways of living, while *Power of Place* (1995) suggested new ways of considering "grass roots" public memory and the use of public landscape.[127] Essays in Ellen Perry Berkeley and Matilda McQuaid's *Architecture: A Place for Women* (1989) addressed women's position in the profession, a topic also scrutinized in Abby Bussel's "Women in Architecture: Leveling the Playing Field" (1995), which commented upon "glass ceilings" and low salaries.[128] Although the idea of women as a homogenous whole was never as all-embracing within the Women's Movement as is sometimes now suggested, Lynne Walker's *Drawing on Diversity: Women, Architecture and Practice* (1997) was the first study to focus specifically on diversity in historical as well as contemporary architectural practice, training, and identities.[129]

Historian of technology Ruth Schwartz Cowan's 1976 essay, "The 'Industrial Revolution' in the Home: Household Technology and Social Change in the Twentieth Century,"[130] and two anthologies edited by the historian of technology and the designed environment, Joan Rothschild—*Women, Technology and Innovation* (1982) and *Machina Ex Dea: Feminist Perspectives on Technology* (1983)—rendered problematic the relationships between technology, design, and gender. They worked against a modernist view of "progress" through "good design" and applied technology.[131] Although the 1983 Rothschild anthology touched upon "women as designers of technologies," it was Autumn Stanley's *Mothers and Daughters of Invention* (1995) which brought to the attention of a wider audience the historical and cultural specificity of

women's engagement with "inventing." Little has been written on women product designers or the gendering of that occupation, but the small exhibition and catalogue, *Goddess in the Detail: Product Design by Women* (1994), at the Pratt Institute, Brooklyn, had an influence way beyond its size.[132]

Binary oppositions, such as masculine/feminine, public/private, amateur/professional, formal/intuitive, modernist/traditional, decorative/unadorned, which structured much feminist scholarship in the 1970s and 1980s, were increasingly rethought. "Masculine" and "feminine" and public and private, for instance, were seen as the polarities of broad spectrums of shifting categories constructed through cultural discourse.[133] Design historians increasingly brought to the fore designers who did not fit neatly into the previously favored binaries, "unpicking" categories which contained and circumscribed women. Binaries came to be used as markers of extremes or indicators of generalizations in need of qualification in the light of scholarly investigation and the particularities of women's subjectivities and lived experience.[134]

Lynne Walker's *Women Architects: Their Work* (1984), Whitney Chadwick and Isabelle De Courtivron's *Significant Others: Creativity and Intimate Partnership* (1993), Pat Kirkham's *Charles and Ray Eames: Designers of the Twentieth Century* (1995), and Janice Helland's "Critics and the Arts and Crafts" (1994, on the collaboration of Margaret Macdonald Mackintosh and Charles Rennie Mackintosh) helped reshape analyses of "designer couples," as did Helland's study of the Macdonald sisters.[135] Deliberately eschewing the "great name" approach to design history, *Glasgow Girls: Women in Art and Design 1880-1920* (1990), edited by Jude Burkhauser, located women designers within the context of a particular city. They were set against Glasgow's commercial and economic development, wider cultural, educational, and artistic developments, the sexual division of labor, and the gendered nature of design education and practice.[136]

When anthropologist Jean Hess wrote "Domestic Interiors in Northern New Mexico" (1981), she based her conclusion that the interior design practices of her Los Adobes neighbors should be regarded as "art" on a study in which she was situated as an engaged observer. The agency of women amateur interior designers did not surface in design historical studies until 1989 when Judy Attfield, herself influenced by anthropology, examined the ways in which the female occupants of houses subverted the intentions of the modernist architects in terms of interior design. Picking up on this theme, Penny Sparke chose the misery of a woman whose modernist architect husband policed the contents of their home and banished the "decorative" and the "feminine," to open *As Long as It's Pink: The Sexual Politics of Taste*, her 1995 study of the gendering of "taste" in the nineteenth and twentieth centuries, and the "survival" of "feminine taste" during the hegemony of modernism.

Attfield's essay appeared in *A View From the Interior: Feminism, Women, and Design* (1989), an anthology that represented plural approaches by design his-

torians working within various feminist frameworks—from Marxist to post-modernist. Several sought to establish new places and spaces for women designers within historical analyses—absences included—while others reflected the influence of cultural studies in their focus on consumption and pleasure and the different meanings of objects for designer(s) and user(s).[137] Two more recent anthologies offer a combination of material culture studies and cultural studies filtered through gender theory as a way forward for the writing of design histories. *The Gendered Object* (1996) addressed the gendering of objects of everyday life—from clothes to cartoons and from bicycles to hearing aids—in terms of design, use, advertising, language, absence and presence, power, sexuality, and "beliefs about gendered acts, gendered behaviour, [and] gendered bodies."[138]

The work of many design historians was influenced by the study of material culture, an approach/discipline developed mainly in the United States in the 1970s and 1980s. The sensitivity to gender within material culture studies, displayed by writers such as Cheryl Robertson (the Arts and Crafts movement), Katherine Grier (nineteenth-century interiors), and Beverly Gordon ("women's culture") was most recently evidenced in a collection of papers presented in 1989 but only published in 1997—*The Material Culture of Gender, the Gender of Material Culture*, edited by Katharine Martinez and Kenneth L. Ames.[139] Although not focused on design, the essays emphasize the complex interplays between gender, design, and the material world in which we live. *Winterthur Portfolio* has contributed new perspectives on gender and design. Particularly germane is a special issue edited by Katherine Grier—*Gendered Spaces and Aesthetics* (Winter 1996)—the focus of which parallels that of Juliet Kinchin's essay on gendered interiors in *The Gendered Object*.[140]

Although fashion is a central part of material culture, and one of the most obviously gendered, it has been largely ignored by historians of material culture. Having been regarded by modernists and traditionalists alike as epitomizing the false consciousness of the frivolous, fashion—like crafts, the decorative, and the domestic—came in from the academic margins in the 1980s and 1990s, decades that saw pop stars such as Madonna use clothes and makeup to deconstruct femininity. In *Adorned in Dreams: Fashion and Modernity* (1985), sociologist Elizabeth Wilson challenged then-current feminist critiques of the "fashion system" as duping women and argued for fashion to be considered central to reevaluations of women's culture. Wilson's refusal to dismiss fashion and her theorization of the field of study brought a new type of intellectual rigor to the subject. Fashion was an obvious area of focus for the new scholarly interest in sexuality and sexual orientation, and books such as Valerie Steele's *Fashion and Eroticism: Ideals of Feminine Beauty from the Victorian Era to the Jazz Age* (1985) and Marjorie Garber's *Vested Interests: Cross-dressing and Cultural Anxiety* (1992) resulted.[141] At the same time, architectural and design theorist

and historian Beatriz Colomina focused on sexuality, while Mark Wigley brought fashion to the forefront of reappraisals of modernism.[142]

Elizabeth Wilson's summary of the main developments within feminist fashion history to the early 1990s applied to design history in general. She saw hope in the convergence of feminism and postmodernism, writing "the postmodern breaking down of aesthetic divisions has opened a space for the reappraisal of what was traditionally seen as the feminine, and postmodern culture criticism has provided a forum that has been used by feminist writers to explore subjects once considered unworthy of serious attention, while insisting on the validity and seriousness of a feminine/feminist point of view."[143] *Women Designers in the USA, 1900–2000: Diversity and Difference* continues the reappraisal of subjects formerly regarded as "unworthy" of serious attention—"the lesser arts," "women's work," the decorative, the hybrid, the traditional—without losing sight of the many contributions of women designers who worked in areas deemed "worthy" by those who defined "good design" within more narrow modernist parameters.

Fig. 2-A. Zulma Steele.
Design for "Dragonfly" wall-
paper, 1905–10. Watercolor,
pen, and ink on paper.
Collection of Jean and Jim
Young. *Checklist no. 10*

2

WENDY KAPLAN

Women Designers and the Arts and Crafts Movement

THE QUESTION OF WORK FOR WOMEN in the decorative arts, as both employment and creative expression, was addressed by social reformers, advocates of women's rights, and followers of the Arts and Crafts movement at the end of the nineteenth century and into the twentieth. Drawing on the ideas of John Ruskin, British designer William Morris declared, "Art is the expression of man's pleasure in labour,"[2] referring to the joy of making objects by hand. He and other Arts and Crafts leaders believed that the Industrial Revolution exploited workers, blighted the countryside, and produced poorly made goods. They were convinced that mechanization and the division of labor had caused the degradation of work, reducing craftspeople to anonymous laborers repeating unfulfilling tasks. Beginning in Britain, the most industrialized nation of the nineteenth century, the movement spread to the United States in the century's last years.

This essay explores the roles of women designers in the American Arts and Crafts movement. They participated in and sometimes led the attempts to achieve its goals—the revival of handcrafted work, the elevation of the decorative arts to the status of fine arts, the embracing of vernacular traditions, and the promotion of truth to materials, honesty of construction, and utility as well as beauty. Equally important ideals were that well-designed products should be made available to the broadest possible audience and that leading a "simple life" in uncluttered interiors had moral as well as aesthetic value.[3]

The movement provided new opportunities for women. Its emphasis on crafts as equal in value to painting and sculpture helped promote "traditional" women's skills such as needlework and further their acceptance as professional design activities. In addition, the growth of large manufacturing units, many of which were mechanized, resulted in a pressing need for new schools to teach design related to production. First introduced in the 1840s, design education for women was widespread by the turn of the century. So deeply entrenched was the belief that women's place was in the home that

One of the pressing questions of our time— How shall poor gentlewomen support themselves? . . . many imagine that the career of art, and of decorative art especially, is open to them.
—Magazine of Art (1881) [1]

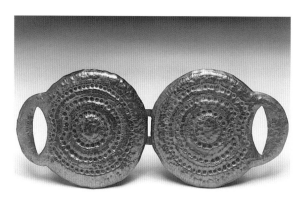

Fig. 2-1. Madeline Yale Wynne. Belt Clasp, ca. 1900. Brass. Memorial Hall Museum, Pocumtuck Valley Memorial Association, Deerfield, Massachusetts, Gift of Mary Marsh (1980.80.15). *Checklist no. 1*

professional opportunities within the Arts and Crafts movement were limited to areas associated with domesticity and with "feminine" qualities such as dexterity, as opposed to "masculine" ones such as strength and originality. Sexual divisions of labor prevailed: women were confined to "woman's work," particularly the textile arts of embroidery and weaving. In ceramics they designed and executed the decoration of pottery (as opposed to shaping form); in metalwork they usually designed and made relatively small objects and jewelry.[4]

Women designers of the Arts and Crafts movement can be divided into three categories.[5] First were the women who succeeded as decorative arts designers. While the most innovative contributions were made in ceramics, important accomplishments were also achieved in the design of textiles, metalwork, stained glass, and bookbinding. The women in this group have received the most attention because, through records and signed objects, their lives and work are much more accessible. Articles were written about them in periodicals such as the *Craftsman*, *Good Housekeeping*, and *Brush and Pencil*. They showed and won prizes at exhibitions and often wrote instructional handbooks or memoirs of their pioneering experiences. They also played leadership roles in other design-related activities—teaching, mounting exhibitions, and establishing organizations to promote the crafts. Bookbinder and stained-glass designer Sarah Wyman Whitman, for example, was a founder of the Boston Society of Arts and Crafts. Metalsmith Madeline Yale Wynne (fig. 2-1) was not only a founder of the Arts and Crafts societies in Chicago and Deerfield, Massachusetts, but also president of the latter organization's later manifestation, Deerfield Industries, whose members made and sold rugs, baskets, wrought iron, jewelry, and furniture. Many of these women trained others, either by teaching at universities and schools of art and design or by offering classes in their own workshops.

Women in the second group tended to be less well off financially than those in the first group. They needed to earn their own living and took advantage of the new educational opportunities to do so. Many in the second group became salaried employees as decorators at art potteries such as Rookwood in Cincinnati or Marblehead in Marblehead, Massachusetts, or at more commercial potteries with an "art" line such as Roseville in Zanesville, Ohio. In many potteries, however, decorators were remunerated only when the item was sold and the cost of materials deducted.

The third group consisted of leaders of organizations that sought to establish alternatives to factory production in the belief that the revival or continuation of handcraft traditions would provide more rewarding work. The focus of their attention was the dire economic plight of urban immigrants and the rural poor. The women who served as the financial patrons of these groups were important participants in the Arts and Crafts movement,

as were the recipients of their charity. Those discussed here also functioned as designers.

The career of textile designer Candace Wheeler, who wrote several "how to" and historical books about handcraft and design, provides a model for the first group: she created opportunities for herself and for other women, while transcending gender restrictions.[6] At age forty-nine, she came late to an independent path, although she had long studied painting and moved in artistic circles. After visiting the 1876 Centennial Exposition in Philadelphia, she was inspired by the display of London's Royal School of Art Needlework, which turned "the common and inalienable heritage of feminine skill in the use of the needle into a means of art-expression and pecuniary profit."[7]

With the Royal School as the model, in 1877 Wheeler spearheaded the establishment in New York of the Society of Decorative Art. The goal of this influential and profitable society was, as Wheeler stated, to help break down the "wall of prejudice and custom which had separated well-bred women from money gaining enterprise."[8] The Society promoted the work of women designers and also offered design training. In 1879 Wheeler defied social convention again by joining Louis Comfort Tiffany, Samuel Colman, and Lockwood de Forest to design interiors as "Associated Artists." When the successful New York firm disbanded four years later, Wheeler adopted the name, and she and her family operated the company for twenty-five years. (Her daughter Dora was one of the chief designers.) The firm specialized in textiles (fig. 2-2). Embroideries were executed at Associated Artists, and its designs for silks and other materials were produced elsewhere, by such leading textile companies as Cheney Brothers in South Manchester, Connecticut, for sale at Associated Artists. While these expensive products were not made in huge quantities, they provide an early example of a woman leading the development of design for commercial manufacture. Wheeler also oversaw all the interior decoration for the Women's Building at the World's Columbian Exposition in 1893 and designed the furnishings for the library in the building (see chap. 1).

While Wheeler's story is largely a nineteenth-century one, an understanding of women's role in the American Arts and Crafts movement must start with her. She not only established the precedent for elevating "women's work" to "real" work by professionalizing home decoration and training women to design for manufacture, but she also championed the psychological need to work. The design and execution of textiles and embroidery were not undertaken solely to "prevent starvation of the body, but to comfort the souls of women who pined for independence."[9] She further recognized the economic necessity of work and in 1878 cofounded the Women's Exchange to help women sell products they made at home.[10] The societies she was instrumental in founding promoted women's economic independence, whether as

Fig. 2-2. Candace Wheeler. Sample for "Fish" textile no. 1, for Associated Artists, ca. 1885–95. Probably made by Cheney Brothers, Hartford. Printed denim. The Mark Twain Memorial, Hartford, Connecticut (72.14.26).

designers or as wage earners (or both), and became models for similar organizations throughout the country.[11]

As the first successful "art industry" in America, and one where women played a critically important role, art pottery provides a model for how women functioned as designers in the Arts and Crafts movement. Those discussed below benefited from new professional educational opportunities available to them through schools of art and design. All started their careers in traditional roles, as china painters. A popular hobby for women beginning in the mid-1870s, china painting (on porcelain blanks purchased from large companies) was considered delicate work that would not tax the "fairer sex" and could be executed at home or in a small studio. While many used this process to generate income, a few also found in china painting a path to careers usually restricted to men.

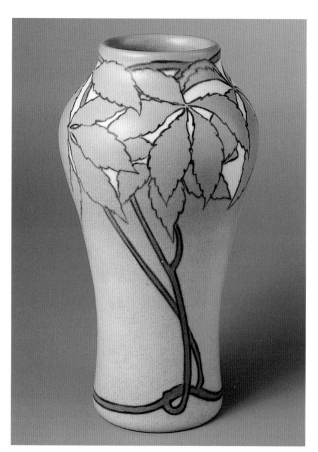

Fig. 2-3. Anna Marie Valentien. Vase, ca. 1902. Made at Rookwood Pottery Company, Cincinnati. Glazed earthenware. Private collection.
Checklist no. 3

Within ceramics the women who designed shapes and threw pots as well as decorated surfaces most fulfilled the Arts and Crafts ideal of one person controlling the creative process from inception to completion. In most cases, however, they could not support themselves solely through the sale of their work. Their incomes were supplemented by design-related activities, such as teaching and writing instructional publications about their handcraft, or by relying on patrons, family, or friends to subsidize their endeavors. This was not a circumstance particular to women—it was a paradox of the Arts and Crafts movement. Craft is labor intensive, and a fair wage for handwork usually precludes large-scale production. Few craftspeople of either gender could earn a living solely through the sale of their work, be it singular or limited production. For women to function successfully as designers during this period, either the ideal of "democratic" art had to be sacrificed, or the work had to be standardized into set patterns and shapes conducive to multiple production, or design needed to function separate from execution.

A few women, such as Maria Longworth Nichols (Storer), were independently wealthy and did not have to rely on others for support. In 1880 Nichols founded Cincinnati's Rookwood Pottery, which became the most renowned and successful art pottery. It was an outgrowth of the new opportunities for women's creative expression: most of the women who worked there received formal training at the School of Design at the University of Cincinnati (which in 1884 was transferred to the city's art museum), or in the early years, had joined the Cincinnati Pottery Club. As Nichols herself pointed out: "It was at first an expensive luxury for which I, luckily, could afford to pay."[12] The pottery was soon put on a businesslike footing. In 1883 Nichols hired William Watts Taylor as a business manager; he decided which

shapes and decoration would be most profitable and forced amateur potters using the kilns for underglaze experiments to leave.

The socialist Oscar Lovell Triggs described Rookwood as "an ideal workshop" in his book *Chapters in the History of the Arts and Crafts Movement,* because "the fullest possible freedom is given to the workmen; they are encouraged to experiment, to express their own individuality, and to increase their culture by study and travel."[13] Perhaps he should have called it an "idealized" workshop, since Rookwood, like all large-scale Arts and Crafts manufactories, based its output on the division of labor. While some designers such as Anna Marie Valentien (fig. 2-3) were responsible for overall surface design and each piece was different from the next, shapes were standardized and production was subdivided.[14] Potters who wanted more creative control left to form their own companies. Valentien and her husband Albert, who had been the first full-time decorator at Rookwood, moved to San Diego and founded the short-lived Valentien Pottery in 1911.[15] There they decorated and sculpted the pottery, which was thrown by Arthur Dovey.

Designer-makers who worked outside the larger companies generally enjoyed the greatest freedom to experiment, but very few were able to support themselves by their efforts. Although Adelaide Alsop Robineau's work is considered among the finest porcelain produced in the twentieth century, her livelihood was gained by disseminating information about china decorating, the field in which she first practiced. Realizing that no periodical existed to serve the needs of china painters, she and her husband founded the influential magazine *Keramic Studio* in 1899 in Syracuse, New York. The journal soon became a success, functioning as an important educational tool for aspiring designers and practitioners as well as a vehicle for women to publish designs for china painting.[16] About 1903 Robineau abandoned her career as a china painter and decided to devote her artistic energies to designing, throwing, decorating, and glazing porcelain, the most difficult ceramic medium. Her skill is demonstrated by a lantern (fig. 2-4), a tour-de-force of carving (incising, piercing, and excising) that required hundreds of hours of labor. Content with nothing less than perfection, Robineau, who limited her output and completed every stage of manufacture herself, achieved worldwide acclaim. Her husband's help was invaluable: in addition to copublishing *Keramic Studio,* he translated treatises on the making of porcelain, gave technical assistance in the firing process, and offered continual encouragement. First shown publicly at the 1904 International Exposition in St. Louis, her work was sold at

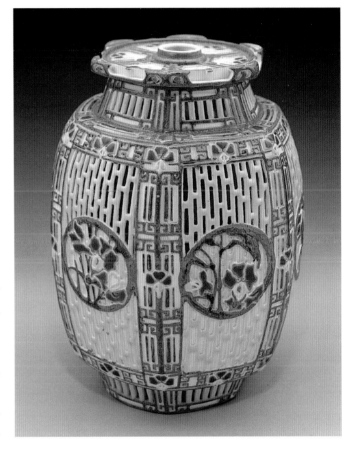

Fig. 2-4. Adelaide Alsop Robineau. Lantern, 1908. Glazed porcelain. Everson Museum of Art, Syracuse, New York (P.C. 16.4.5). *Checklist no. 14*

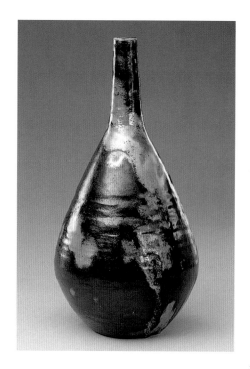

Fig. 2-5. Mary Chase Perry
(Stratton). Vase, ca. 1907–10.
Made at Pewabic Pottery,
Detroit. Glazed earthenware.
Collection of R. A. Ellison.
Checklist no. 13

exhibitions and through mail order: beginning in 1903 her new designs for
"experimental pottery and porcelain" were published in *Keramic Studio*.[17] Her
work became extremely well known (for example, her porcelain was awarded
a grand prize at the 1915 *Panama-Pacific International Exhibition* in San Francisco),
and she exerted further influence on design in her day through publishing
and teaching. She taught at the important school for ceramic art in
University City, Missouri (1909–11), founded by Edward Lewis and the
American Woman's League, and in 1920, she became an instructor of pot-
tery and ceramic design at Syracuse University.

Mary Chase Perry (Stratton) in Detroit was also able to find individ-
ual joy in creativity (fig. 2-5) because her enterprises were subsidized. She,
too, began as a china painter, but several factors contributed to her success-
ful transition to studio potter. With Horace Caulkins, who owned a prosper-
ous dental supply company, she experimented with dental kilns that would
enable potters to fire their work at very high temperatures in their home or
studio. (The development of these smaller, more efficient "Revelation" kilns
created more opportunities to design and shape pottery, for many other
women as well, including Robineau and the Overbeck sisters.) Perry
enhanced her technical skills in 1901 and 1902 by studying with renowned
teacher and potter Charles F. Binns at Alfred University, New York. Last,
and equally significant, she entered a partnership with Caulkins, who
financed and subsidized the pottery they established in 1903, which she
named "Pewabic." More interested in surfaces than in form, Perry developed
glazes characterized by their stunning iridescence, inspired by her study of
Asian ceramics. Although she and Caulkins successfully extended their oper-
ation to the production of architectural tiles, Pewabic remained a small pot-
tery. She was the designer within the partnership, as well as the glaze chemist;
Caulkins was the kiln specialist and business manager. They also hired a pot-
ter (to throw pieces not made in molds) and a few assistants.

Perry's unpublished memoirs are full of Arts and Crafts ideals:
fidelity to materials ("I wanted a glaze to look like a glaze and nothing else"),
joy in labor ("even though we were hoping to make ends meet, we wanted to
work with real pleasure and satisfaction"), and the desire to improve the aes-
thetic life of the consumer. When a visitor to the pottery inquired about the
cost of a vase, Perry responded: "I tried to explain our purpose in not show-
ing prices and that we had hoped for appreciation without it."[18] This longing
for a special connection between the maker and the purchaser, emblematic
of the Arts and Crafts movement, extended to commercial clients as well.
Pewabic sold regularly to Burley and Company, a Chicago dry goods store.
Perry described Mr. Burley as "our first and wisest patron" and noted sadly
that after his death, "the ordering of pottery was in the hands of
professional buyers."[19]

Some small craft studios were able to function as self-sustaining businesses. The Overbeck pottery, in Cambridge City, Indiana, for example, was run by three sisters, Elizabeth, Hannah, and Mary Frances Overbeck. (A fourth sister, Margaret, had died the year the pottery was established.) Elizabeth, the only sister to receive formal training in ceramics (with Binns at Alfred University), was responsible for glazes and clay mixtures and for shaping and throwing the pots. Hannah and Mary Frances contributed the decoration, such as the abstract incised forms drawn from nature by Mary Frances and applied to a pitcher (fig. 2-6). Conventionalized design rendered in subdued colors was the dominant aesthetic at Overbeck, a product of the design training the sisters received. All four had attended schools of art and design and started their careers as china painters; Hannah and Mary Frances frequently contributed decorative designs to *Keramic Studio*, as had Margaret.

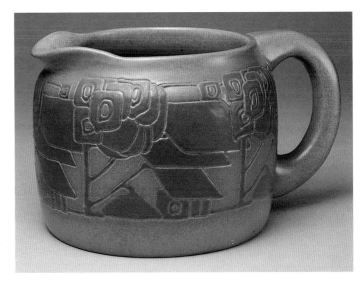

Fig. 2-6. Elizabeth Gray Overbeck (form) and Mary Frances Overbeck (decoration). Pitcher, ca. 1914. Made at Overbeck Pottery, Cambridge City, Indiana. Glazed earthenware. Collection of Stephen Gray. *Checklist no. 22*

It would be impossible to underestimate the importance of the new colleges of art and design as the vehicle by which most women Arts and Crafts designers gained professional credentials. Binns, who had himself played a major role in training other potters, pointed out that before such institutions were established, "Handicraft and design were divorced, technical instruction was unknown."[20] Arthur Wesley Dow was one of the most influential teachers of future designers in America at the turn of the century. Former curator of Japanese art at the Museum of Fine Arts, Boston, an instructor at the Pratt Institute in Boston, and a noted painter, Dow was appointed director of fine arts at Teachers College, Columbia University, in 1904. Japanese art and design had had the greatest influence in his work, and he believed that the oriental aesthetic of "rhythm and harmony, in which modeling and nature-imitation are subordinate,"[21] was the fundamental principle behind all good art and design.

John Ruskin had maintained that stylization would separate the fine arts from the decorative arts by establishing a different set of standards for the latter, but Dow argued that abstraction was most appropriate for both disciplines and that true creativity emerged after mastering the principles of composition, rather than literal representation. Students, including Zulma Steele (fig. 2-7), and teachers from all over the country came to study with Dow. Many spread his design philosophy to their own institutions or workshops, using his oft-reprinted book, *Composition*, as the authoritative text. A great number were women, as teaching was one of the few professions they could enter without social opprobrium. Margaret and Mary Frances Overbeck had been students of Dow at Columbia. Margaret then taught art at DePauw University, whereas Mary Frances was a public-school art teacher

Fig. 2-7. Zulma Steele. Design for "Dragonfly" wallpaper, 1905–10. Detail of Fig. 2-A.

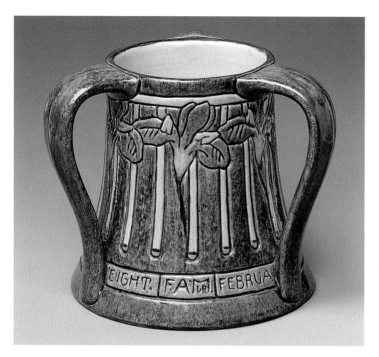

Fig. 2-8. Leona Nicholson. Tyg, 1908. Made at Newcomb Pottery, New Orleans. Glazed earthenware. The Metropolitan Museum of Art, New York, Purchase, Mr. and Mrs. David Lubart Gift, in memory of Katherine J. Lubart, 1944–1975, 1983 (1983.26) *Checklist no. 15*

before turning her attention to the family pottery. In the early years of the century, when design and manual training was being integrated into the national curriculum, women teachers played a key role on every level (see chap. 1).

The Newcomb Pottery exemplifies the new focus on education and training and its impact on opportunities for women in design. H. Sophie Newcomb Memorial College had been founded in 1886 as the woman's college of Tulane University in New Orleans.[22] Its founder, Josephine Louise Newcomb, wanted to provide women with training in "practical and industrial subjects," while also stimulating their creativity. The art pottery was established nine years later, fulfilling "a dual purpose—to create pottery (and soon after other hand-crafts objects) of high artistic quality, and to provide young women who had received education in art at the college an opportunity to earn money. It was to be a 'model' industry."[23]

Newcomb College students or graduates worked as decorators at the pottery. Especially in the early years of operation (until about 1910, when patterns became more standardized), they had freedom to create individual designs, working within the pottery's broad vocabulary. Following the dictates of the Arts and Crafts movement, decoration was inspired by forms found in nature and particular to the region, namely magnolias, live oaks, hanging moss, cypress trees, and other southern vegetation. In one example, a tyg (a three-handled mug; fig. 2-8), was decorated by Leona Nicholson with incised irises, another favored motif, and dated February 27, 1908, to commemorate midyear graduation at the college and Tulane University. Following the dictates of Dow, the decoration was characterized by flat patterns abstracted from nature, with black outlines defining broad bands of color. Dow's influence is hardly surprising. Mary Sheerer, who directed production at the pottery for decades, studied at Dow's famous summer school in Ipswich, Massachusetts, together with several Newcomb students, and Dow's *Composition* was a standard text in Newcomb College art classes.

The pottery also exemplifies the continuing restrictions on women designers. Not until 1914 were women offered training in the actual making of pottery so that they could complete a piece from conception to final production. Even then, Joseph Meyer, hired in 1896, continued to throw nearly all the pottery made until 1927. Despite the critical acclaim Newcomb garnered (it won numerous awards at international exhibitions) and its success in selling work both in showrooms of Arts and Crafts societies and through specialty vendors of artwares throughout the country, most women could not actually support themselves by working at the pottery. They were

paid too little, and the paternalistic nature of this "educational" pottery forbade aggressive commercial marketing.[24]

Small-scale metalworking proved more conducive to women's economic autonomy. Like Candace Wheeler, metalworker Clara Barck Welles was the principal designer of a large company that she herself had founded. Established in Chicago in 1900, the Kalo Shop became the most important silver company in the Midwest for producing handmade work (fig. 2-9). It began with a small staff consisting of "Clara serving as designer, a silversmith, and the Kalo girls [young women assistants], but later expanded to include as many as twenty-five silversmiths. The Kalo Community served as both workshop and school for many artisans, male and female, for Clara was an advocate of women's active participation in the arts."[25]

Kalo came closer than most companies to fulfilling the ideals of the Arts and Crafts movement. The emphasis was equally on superb quality work (an employee recalled, "Mrs. Welles wanted perfection") and on enlightened working conditions.[26] Adhering to the Arts and Crafts dictates of simplicity and functionalism, the silver produced was characterized by minimal ornamentation, utilitarian shapes, and the retention of the hammer marks demonstrating that the piece was handmade. Kalo's success can be attested to by its longevity (it closed in 1970, thirty years after Welles, who always oversaw the design process, retired), the consistent excellence of its silver and jewelry, and the influence of its aesthetic. Many men and women went on to establish their own shops after training at Kalo, continuing the company's tradition of production, which is reflected in its motto, "Beautiful, Useful, and Enduring."

Welles was exceptional in creating a large metalworking company, since most women metalsmiths worked either by themselves or with a few others. The partnership of Jane Carson (Barron) and Frances Barnum (Smith)

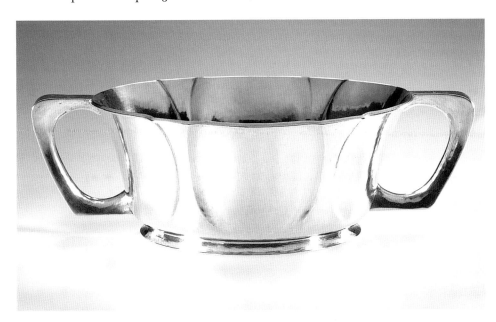

Fig. 2-9. Clara Barck Welles. Bowl, ca. 1905–14. Made at The Kalo Shop, Chicago. Silver. Collection of Dennis Gallion and Daniel Morris, Historical Design, New York
Checklist no. 11

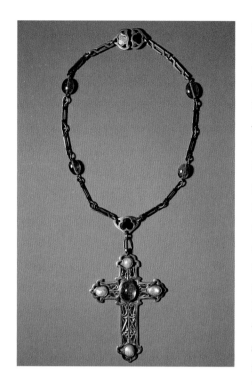

Fig. 2-10. Jane Carson (Barron) and Frances Barnum (Smith). Necklace with cross pendant, ca. 1905. Silver, enamel, amethyst, and pearls. The Cleveland Museum of Art, 1999, John L. Severance Fund (1996.290).
Checklist no. 8

in Cleveland provides a more characteristic example of the way women could forge independent careers in metalwork within the Arts and Crafts movement. Both trained in design and decoration at the School of Art in Cleveland and then at the school of the Museum of Fine Arts in Boston before returning to establish a studio in Cleveland. Within a few years, they won a silver medal for their work at the 1904 international exposition in St. Louis. In an article entitled "The Successful Pursuit of An Art-Industry" (1905),[27] prominent critic and art history professor Irene Sargent analyzed their work in the context of the Arts and Crafts movement, noting how Barron and Smith fulfilled its goals of design unity on all levels. First, a decorative arts discipline (in this case metalwork) was given the same artistic attention bestowed upon painting, sculpture, and architecture. Second, there was unity of design and execution: "[they] can not be included in the reproach sometimes justly addressed to representatives of the Arts and Crafts Movement: that they have neglected the bench for the designing board; on the contrary, they are striving to lessen the distance between these two opposite points of their activity, and to establish them upon the same level of importance." Third, the design itself, typified by a cross (fig. 2-10), allowed "symbol, substance and design . . . to produce a unified whole." The cross encompasses the vocabulary of Arts and Crafts—Gothic in form but with ornamentation derived from plant motifs and not overly worked: "even the amethyst centering the cross being *en cabochon*, or cut without facets, as was characteristic of medieval gems."[28]

That a woman should be a metalsmith at this time was still a phenomenon worth comment. Describing Marie Zimmermann, the headline of an article in the *Evening Sun* proclaimed, "This Being a Feminist Age, the Village Smithy Is a Studio and the Smith a Comely Young Woman." The newspaper article provides a fascinating example of a woman designer and craftsperson overcoming her male interviewer's initial condescension, as when he suggested that she must have had considerable financial backing, doubting that she supported herself. Zimmermann responded, "But I have had no help from the outside. It has paid for itself from the beginning."[29] Zimmermann successfully worked with iron, copper, bronze (fig. 2-11), silver, and gold. She knowledgeably (albeit eclectically) drew from many historical sources—Oriental, Greek, Egyptian—to create her metalwork and jewelry, examples of which were purchased by The Metropolitan Museum of Art, New York (a silver box in 1922), and shown at prominent galleries to critical acclaim.

While these stories of women potters and metalsmiths who independently ran their own studios and manufactories are far from unique, an even more common story tells of the impoverished women who were helped by others more formally trained in design and economically privileged. Much of the renewed activity in textiles falls under this category of art in the service of philanthropy. This phenomenon reaffirmed the traditional role

played by middle- and upper-class women. It also offered new opportunities as women went beyond local and individual dispensation of charity to establishing city, state, and national organizations that required substantial management and design skills. Like their counterparts in Britain, these women formed groups to teach and market women's crafts emanating from indigenous "folk" or "primitive" segments of society. Encouraging the survival, or in some cases revival, of these design traditions not only reinforced Arts and Crafts aesthetic values but also reflected the contemporary nostalgia for an idealized preindustrial past.

Over one hundred settlement schools (usually operated by Protestant missions) were established in the South, mostly by women designers from the northeastern states. In 1908 New York-born Frances Goodrich, who studied at the Yale School of Fine Arts and founded Allanstand Cottage Industries, opened a retail shop in Asheville, North Carolina, for regionally made baskets, rugs, and especially coverlets. Since the 1890s, when she had served as a volunteer for the Presbyterian Church's Women's Board of Home Missions, Goodrich had been supplying local women with designs based on indigenous Appalachian weaving. These were modified either to standardize production or to appeal to particular associations that northerners, who were a primary market, had about the rural South. For decades, other groups followed the Allanstand model. In 1925, for example, the Pi Beta Phi Settlement School in Gatlinburg, Tennessee, founded by a sorority in Pennsylvania, established a weaving division. Inspired by work traditional to the area, Boston-educated Winogene Redding designed and supervised the weaving as well as managed what became the Arrow Craft Shop.[30]

In the case of the Fireside Industries in Berea, Kentucky, the leader was a man, but the template for establishing cottage industries was the same. William Frost, president of Berea College, began marketing Appalachian coverlets in the mid-1890s. While weaving had become idealized as a true expression of native culture, the actual quality of production was thought to have deteriorated. Ironically, the women who made the quilts were retaught by professionally trained designers, mostly women, to modify their designs or create new ones, as well as to improve their techniques of manufacture.

The Boston, New York, and Philadelphia purchasers of these coverlets and other Appalachian products felt morally and aesthetically uplifted.

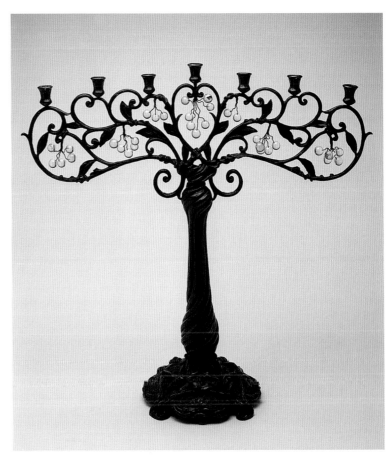

Fig. 2-11. Marie Zimmermann. Candelabrum, ca. 1916. Bronze and crystal. The Mitchell Wolfson Jr. Collection, The Wolfsonian-Florida International University, Miami Beach, Florida (1990.1847)
Checklist no. 24

They believed they were contributing to the preservation of a native American craft, while providing destitute people with a way to earn a living through handwork. Similar activities also took place in the North, one of the best-known being the Abnakee Rug Industry in Pequaket, New Hampshire, established by designer Helen R. Albee in 1897. Although the women who made hooked rugs and other textiles were paid no more than factory wages, the therapeutic value of handcraft was considered an incalculable benefit. In Rhode Island the philanthropic women who employed immigrant Portuguese weavers under the aegis of the Providence Handicraft Club invoked John Ruskin to support their assertion "that the best development of fingers, limbs, and brain is found in hand labor and that there is great moral value in an industry that can be carried on in the home and participated in by every member of the family."[31]

The drive to preserve a "national" past and have it inform the present could be as strong a motivation as philanthropy. Margaret Whiting and Ellen Miller founded the Society of Blue and White in Deerfield, Massachusetts, in 1896, in order to preserve the techniques of eighteenth-century embroidery they had admired in their local historical society. The

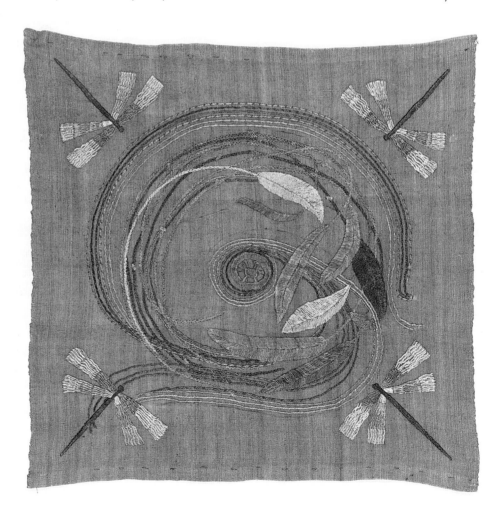

Fig. 2-12. Margaret Whiting and Ellen Miller. "Seaweed and Dragon Flies" embroidery, 1905–16. Made by the Deerfield Society of Blue and White Needlework, Massachusetts. Linen with linen embroidery. Memorial Hall Museum, Pocumtuck Valley Memorial Association, Deerfield, Massachusetts (NBW-99). *Checklist no. 12*

creative adaptation of these designs was later explained by Whiting: "Since it was the spirit of the Colonial work that called for revival, and neither imitation nor strict copying of its style could meet the present needs, the quarry of drawings and specimens of old work was used with discriminating freedom of selection"[32] Within a few years of its founding, Whiting and Miller were successfully marketing the work of the Society throughout the country.

Trained at art schools in New York, Whiting and Miller alone designed all the patterns, which were made by local farmers' wives and their daughters in Deerfield as a way to supplement their incomes. Women summer residents also participated in the execution of the work.[33] As Whiting explained: "Though entirely under the control of the two heads, the number of needle-women engaged in the work varied from a half dozen to thirty, according to circumstances."[34] An embroidery depicting seaweed and dragonflies (fig. 2-12) exemplifies the excellence of the Society's work, the freedom with which the women departed from the colonial model, and their adherence to Arts and Crafts principles of using natural materials and dyes. Their linen cloth was purchased from Berea College or imported from Russia, and only dyes derived from plants, such as indigo, madder, and butternut, were used. Passionate about quality, hand-work, and the preservation of a threatened craft, Whiting and Miller do not belong in the group whose primary concern was the improvement of social conditions. Whiting insisted: "It is not charity but art which founds and maintains a craft."[35]

This mixture of charity and design, however, proved a potent one in most media. In addition to embroidery, rag rugs, weaving, and lacemaking, many designer/philanthropists were involved in pottery, bookbinding, and furniture-making enterprises. For example, the Paul Revere Pottery, which produced and sold breakfast and tea sets, lamps, tiles, and vases, grew out of the Saturday Evening Girls' Club established in 1908 at the North End Branch of the Boston Public Library. Pottery decoration provided the daughters of Italian and Jewish immigrants with an alternative to factory work and an opportunity to earn money while receiving artistic instruction. Professional designer Edith Brown oversaw all the work and produced her own (fig. 2-13); she also designed the homey building that housed the pottery after it moved to the suburb of Brighton in 1915.

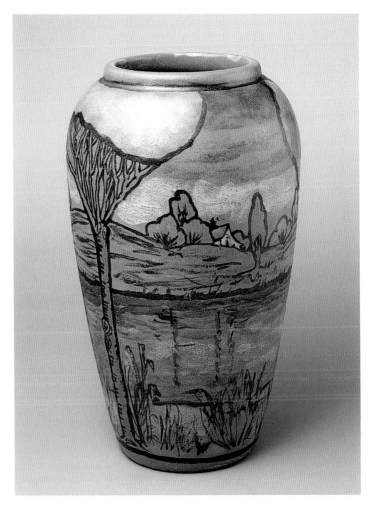

Fig. 2-13. Edith Brown. Vase, 1922. Made at Paul Revere Pottery (Saturday Evening Girls' Club) Boston/Brighton, Massachusetts. Glazed earthenware. Private collection. *Checklist no. 30*

Ellen Gates Starr was the cofounder of Hull House (1888), a settlement house modeled on Toynbee Hall in London, which provided support to the struggling immigrant population of Chicago. A committed socialist, Starr also believed in the redeeming power of "art," broadly defined to include the applied arts. She became the first president of the Chicago Public School Art Society in 1894, in addition to teaching and organizing exhibitions at Hull House. Teaching and proselytizing were not enough for personal satisfaction, however; Starr herself felt the need for expression through the "labor" of art.[36] In 1897 she traveled to England, where she served as an apprentice at the Doves Bindery under T.J. Cobden-Sanderson, the most renowned bookbinder of the Arts and Crafts movement. Upon her return to Chicago, she established what became a successful bindery at Hull House. Her designs (fig. 2-14) followed the Arts and Crafts aesthetic, unifying decoration and content and, as she expressed it, "the love of the thorough, of the patiently wrought out."[37]

Although none of her work is known to have survived, Louise Brigham provides a quintessential example of a life devoted to addressing

Morris's question, "What business have we with art at all, unless all can share it?"[38] In 1909 Brigham published *Box Furniture: How to Make a Hundred Useful Objects for the Home*, illustrating the book with images of furniture she designed using only disassembled wooden packing boxes (fig. 2-15). Sending her "message" to "all who care for simplicity and thrift, utility and beauty," she taught her methods at settlement houses and organizations such as the Home Thrift Association in New York, which she founded. Brigham displayed her furniture at exhibitions from San Francisco to New York, also publishing photographs of her New York apartments, which, entirely furnished with her designs, were each named Box Corner.[39] She attributed the furniture's severe, geometric appearance not only to the dictates of its material, but also to the teachings of "her Austrian master, Professor [Josef] Hoffmann," a leading European architect and designer, with whom she claimed to have studied.[40] Brigham's designs were recognized and applauded on both aesthetic and moral grounds—the ideal Arts and Crafts combination.

While women designers of the Arts and Crafts movement had greater educational and training opportunities than ever before, they remained relegated to sections of design broadly categorized as domestic. Nevertheless, women played an important, and in many cases central, role in the American Arts and Crafts movement. Their contributions were recognized at the time and are perhaps best summarized in an article in Gustav Stickley's *Craftsman* magazine, which discussed the transformation of traditional "fancy work" for ladies into a significant category of paid labor. Through women's efforts, art had become democratized and now included "landscape gardening, weaving, embroidery, pottery, furniture and a hundred other forms" This work had become "an industrial art, a thing not to be done lightly and inconsiderately but to be regarded as part of the decorative scheme of the inside of the home."[41] Seeming continuations of time-honored roles also presented new ways of redefining them, and the new value ascribed to the crafts opened unprecedented areas of independence for women in design.

Fig. 2-15. Louise Brigham. Front cover of *Box Furniture*. Published by The Century Company, New York, 1909 (this edition 1919). The Winterthur Library: Printed Book and Periodical Collection, Winterthur Museum, Garden and Library, Winterthur, Delaware.

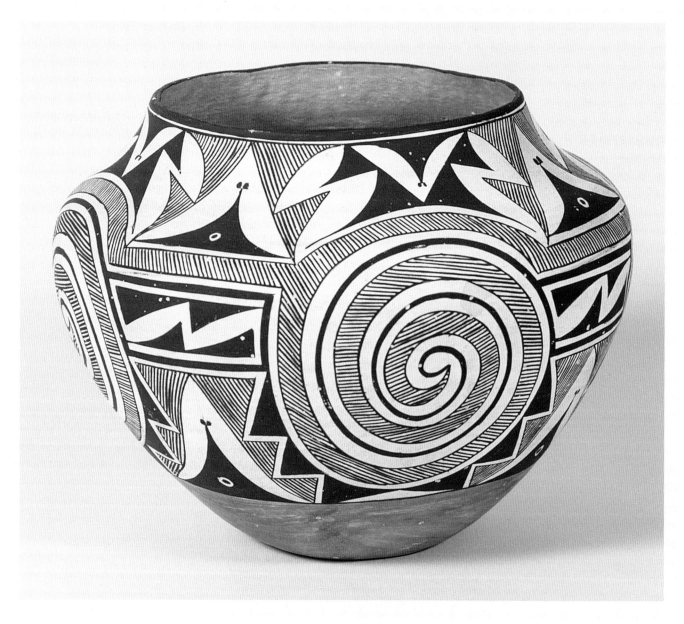

Fig. 3-18. Lucy Lewis.
Jar (Acoma Pueblo), 1940s.
Polychrome earthenware.
School of American Research,
Santa Fe, New Mexico (IAF
2979)
Checklist no. 76

3

PAMELA KLADZYK

The Sacred Hoop

IN THE TRADITION OF OGLALA LAKOTA people, maintaining the "Sacred Hoop" refers to living, understanding, and teaching one's culture and language from generation to generation. Engendering and maintaining the sacred circle of life has motivated the creation of Native American design as diverse as the "Basketball Star" quilts of Rae Jean Walking Eagle (Assiniboine/Sioux), the coiled baskets of Dat so la lee/Louisa Keyser (also known as Dabuda; Washoe), and the encircling jeweled belts of Denise Wallace (Sugpiag). Moving in beauty through life has informed the design traditions of America's First People throughout the twentieth century. The concept of the hoop serves this essay as a structuring device and symbol, joining the end of the century with its beginning.

Some Native American design traditions date back to ancient times, while others are of much more recent origin. Some survived into the twentieth century; others had to be consciously revived, often after long periods of dormancy. Some traditions were newly invented during the course of the twentieth century, as in the case of "Basketball" quilts, and the hybridity of more recent Native American design traditions is apparent. However, older design traditions of Native Americans were far less fixed and unchanging than is often supposed, especially in the light of postmodern questioning of authenticity. Furthermore, both survivals and revivals of older traditions took the form of dynamic aesthetic developments that drew on but differed from (in varying degrees) those that nourished them.

Many, but by no means all, Native American design traditions were perpetuated by women and this continued to be the case in the twentieth century. During the last hundred years women have produced many works of outstanding beauty and utility, with basketry, pottery, and textiles among the most significant. In several regions of the United States during the early years of the century, European American collectors and tourists rushed to purchase supposedly "authentic" Native American objects thought to encapsulate a way of life that removal, genocidal, and philanthropic policies alike had done their best to obliterate.

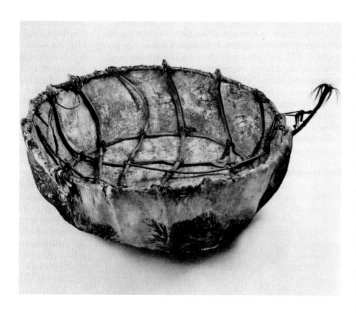

Fig. 3-1. Owl Woman and Many Growths. Bullboat (Mandan), ca. 1916. Cowhide, wood, cotton, and hide strips. The Science Museum of Minnesota, Saint Paul (A76:2:399).

Some traditions associated with women, such as that of bullboat design and making (fig. 3-1), died out completely during the twentieth century.[1] Buffalo Bird Woman (Hidatsa), one of the women who continued working in this tradition in the 1910s on the upper Missouri river, recognized the hoop was broken: "I am an old woman now. The buffaloes and black-tail deer are gone, and our Indian ways are almost gone. . . . I see but shadows and hear only the roar of the river; and tears come into my eyes. Our Indian life, I know, is gone forever."[2] Many design traditions continued to be highly valued throughout the century, some more than others. Among Plains tribes, for example, certain forms of design knowledge are sacred, such as quill embroidery and beadwork.[3] Among the Hidatsa, basketry, pottery, and architecture were sacred skills, but mat weaving was not.[4] Accepted design practices, whether sacred or secular, continue to support a steady stream of innovation and creativity by Native American women.

This is a story of many parts and many players, some of whom are anonymous today, though not in their own time and their own settlements. Within each community those people who were specially talented at design or making were known. Where possible, this chapter names women whose skills continue to delight and inform; it does so not only to celebrate them and their achievements but also to emphasize that they were real women with real lives.

The late nineteenth century saw changes in what girls were taught as well as how they were taught. Girls who formerly would have learned how to design and build permanent or nomadic lodges, or adobe pueblos, now lived on reservations or at American boarding schools such as the Carlisle Institute in Carlisle, Pennsylvania. Those who remained within their communities continued to learn skills associated with domestic matters, such as weaving and pottery, although practices did vary. Into the twentieth century, design and craft skills, and knowledge of particular meanings for particular designs, were passed on from woman to woman, mother to daughter or daughter-in-law, grandmother to granddaughter, and friend to friend.[5] Learning was part and parcel of the living nature of the work, even as what was produced in certain regions was a response to a huge increase in demand from European Americans early in the century.[6] From the beginning of the century Fred Harvey was building one of the earliest tourist-driven design markets in the United States. Through advertising campaigns and collaboration with the Santa Fe Railroad, Harvey's company promoted many designers from the Southwest including the Navajo weaver Elle of Ganado and the Pueblo potters Nampeyo and Maria Martinez.[7]

Both Pomo men and women traditionally gathered parts of plants for basket-making. Men typically wove baskets for fishing, capturing small game, and carrying wood. Women wove for the home and later for collectors.[8] The female basket designers of northern California's Lake, Sonoma, and Mendocino counties brought basket design and making to an extraordinarily high level early in the twentieth century. Articles in popular magazines and newspapers throughout America encouraged the collection of baskets, most of which came to be made specifically for non-Native decorative or museum use.

Matriarchal lineage was a feature of the great Pomo basket weavers. Mary Benson, one of the most talented and versatile designers of the early century, learned her craft, and possibly also her design skills, from her mother, Sarah Knight. Two daughters of Sally Burris, who designed large, dramatic baskets early in the century (fig. 3-2), Rosa Burris Smith and Laura Burris Willum, became basket makers and designers of distinction.[9] Burris's granddaughter, Annie Willum Boone, also wove, employing forms and motifs used by her mother and grandmother. Around 1900, at the age of fifteen, Boone made small baskets that were greatly admired by peers and collectors alike.[10]

The work of Annie Ramon Burke (fig. 3-3), together with that of other Pomo women of her generation, survives today as a result of her decision to break with the tradition of burying baskets with the woman who had made them.[11] It was clear to her by 1940 that few baskets were available for Pomos to learn from since those that had not been sold to collectors had been buried. Burke, her daugher Elsie Allen, and other women basketmakers began collecting Pomo baskets and recording the names of the women who had designed and produced them so that thereafter there was no excuse to simply refer to them as "Pomo" or "Indian." The women displayed the baskets at a Native American community clubhouse in Ukiah, California, beginning in 1940.[12] Burke, Allen, and others continued gathering baskets and data to be used to inspire younger designers. The baskets formed a visual design bank for both Native Americans and non-Native Americans, much like the national applied arts museums of nineteenth-century Europe. Known as the Elsie Allen Collection, it is now on long-term loan to the Mendocino County Museum in Willits, California.

Allen's grandniece, Susan Billy, is a well-known designer working in the Pomo tradition today. She began learning techniques and designs from her great-aunt in the 1970s. During her sixteen-year apprenticeship with Allen, Billy was taught about the twelve shapes and nearly three hundred designs that comprise the basic repertoire of Pomo basketry. It is on this repertoire that she now draws. She also learned from the Grandmothers that: "Everything in the lifestyle was connected to the baskets . . . there was a balance, centering and healing."[13] Traditional Pomo baskets range from large sizes requiring years of work, to smaller, intricately feathered "sky" baskets,

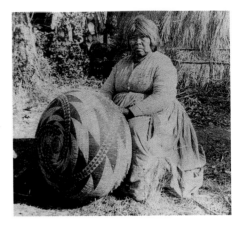

Fig. 3-2. Sally Burris holding the "Great *Shu-set*" bowl (Pomo), a diagonally twined feast bowl. Photographed ca. 1905.

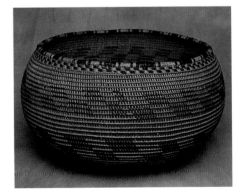

Fig. 3-3. Annie Burke. Basket (Pomo), ca. 1940. Willow shoots, sedge root, and redbud. On loan to the Mendocino County Museum, Willits, California, by Genevieve Allen Aguilar (EA#30). *Checklist no. 73*

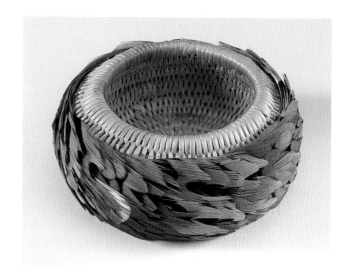

Fig. 3-4. Susan Billy.
Feathered basket (Pomo;
shown near actual size),
ca. 1976. Pheasant feathers,
willow shoots, and sedge root.
Collection of Susan Billy.
Checklist no. 145

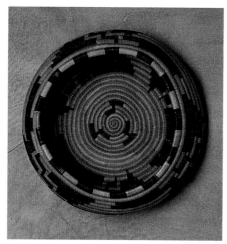

Fig. 3-5. Rhoda Knight.
Basket (Pomo), 1930s. Willow
shoots, sedge root, and bul-
rush. Collection of Genevieve
Allen Aguilar, on loan to the
Mendocino County Museum,
Willits, California (EA#51).
Checklist no. 53

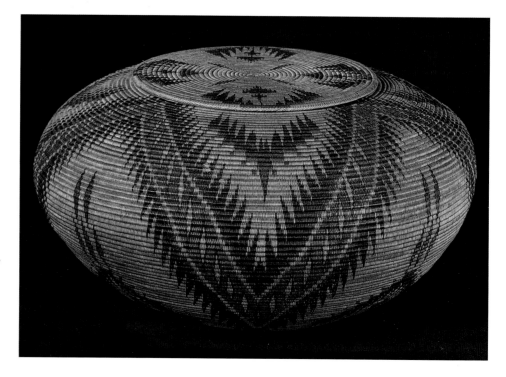

Fig. 3-6. Lucy Parker Telles.
Lidded basket (Miwok Paiute),
1930. Squawgrass and maid-
enhair fern. Colorado
Springs Fine Arts Center,
Taylor Museum, Gift of the
estate of Phillip B. Stewart
(TM 5641). *Checklist no. 45*

to thimble-size miniature gift baskets. Many of Billy's baskets are small or miniature,[14] some incorporating feathers, designed to be given as special gifts (fig. 3-4). Billy's greatest contribution, however, may be furthering the design education of younger Pomo weavers through her demonstrations. The materials, shapes, and motifs she uses express the energy of birds, plants, and sea creatures of the region. Strongly aware of her Pomo heritage, she admires the work of earlier designers, including Rhoda Somersal Knight, whose complexly designed three-rod coiled baskets pushed her considerable craft abilities to the limit (fig. 3-5). Billy

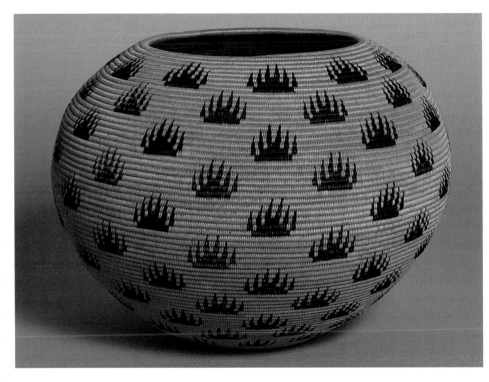

Fig. 3-7. Dat so la lee (Louisa Keyser Dabuda). "Bright Morning Light" basket (Washoe), 1921. Tule and bracken fern root. Nevada Historical Society, Reno (LK80). *Checklist no. 27*

and others continue in the design spirit, if not the letter, of the traditions of their female forebears; they respect them but do not feel restricted to working within the same parameters.[15]

From the early 1900s, and particularly from the 1920s, women basket weavers of Miwok and Paiute descent living in the Yosemite Valley area were encouraged to create and display their work to the growing numbers of tourists visiting the region.[16] Lucy Parker Telles (Miwok-Paiute) was among this group who designed and sold their baskets to tourists visiting Yosemite National Park from the early 1900s into the 1930s (fig. 3-6). The work of Julia Parker (Kashia Pomo), who married Telles's nephew in 1948, refers not only to the design traditions of the Yosemite valley but also to those of the northern California coastal region from which she comes. Her baskets combine forms and techniques from the different traditions, and through her teaching and basketry demonstrations, she passes on elements of Kashia Pomo, Mono Lake Paiute, and Yosemite Miwok designs to future generations.[17]

In the Great Basin, in Nevada's Carson Valley, Dat so la lee (Washoe), who preferred to be known as Louisa Keyser but was also known as Dabuda, achieved fame during the first quarter of the twentieth century. Her baskets commanded prices up to $1,400 each, paid to her patrons, Amy and Abe Cohn.[18] The Cohns had first hired Dat so la lee as a laundress and later sponsored her weaving, with its high production values, in return for ownership of all the baskets she created.[19] The high prices partly related to the Cohns' promotion of the work as "authentic," "timeless" products of a Washoe princess.[20] Patron and consumer were linked in a tangled fabrication: "What

Fig. 3-8. Edith Bondie. Basket (Ojibwa), ca 1992. Black ash. Michigan State University Museum, East Lansing. *Checklist no. 181*

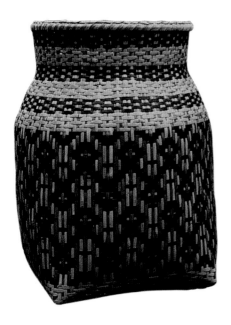

Fig. 3-9. Rowena Bradley. Basket (Cherokee), 1984. River cane. Collection of Qualla Arts and Crafts.

Fig. 3-10. Pauline Paul. Lidded basket (Chitimacha), ca. 1938. Cane. The Philbrook Museum of Art, Tulsa, Oklahoma (48.39.97).

the customer actually purchased was thus equally the creation of the Washoe woman who wove the basket and of Amy Cohn, who invented its context.[21] Dat so la lee/Keyser was a great innovator. Her *degikup* basket was a brilliant adaptation of a shape used in California basketry.[22] The overall design is a highly sophisticated dialectic between shape, pattern, and materials (fig. 3-7). Throughout her work, she created the illusion of patterns that move in their own time; finely stitched designs travel over the smooth, curving surfaces of her baskets with a speed that is transforming.

Not the only one among the Washoe to design and produce innovative and dynamic baskets, Dat so la lee/Keyser was joined by Sarah Jim Mayo and Maggie Mayo James. Additionally, Lena Frank Dick designed finely detailed baskets, notable for geometric patterns that appear to "swim" from the bottom of the basket to the top (*Checklist no. 28*). Like Dat so la lee/Keyser, Mayo, James, and Dick, were patronized by European American collectors, a situation that enabled them to concentrate on design and making. Nevertheless, the Depression years of the 1930s saw the design traditions of Great Basin basketry begin to disappear, and today the Washoe basketry circle is all but broken. By contrast, southwestern traditions of Hopi, Pima, Tohono O'odham, Western Apache, Southern Paiute, Chemehuevi, Yavapai, Hualapai, Havasupai, Pueblo, Seri, and Navajo grow in strength; there are currently more than two hundred master basket weavers in the Southwest, the great majority of whom are women.[23]

In woodlands stretching from Minnesota to Maine, women wove baskets and floor mats of utility and beauty throughout the century, using grasses, reeds, wood, and roots.[24] Ojibwe, Odawa, Mohawk, Micmac, Maliseet, Passamaquoddy, Penobscot, and other northeastern Native American designer-makers have often worked cooperatively with family members to

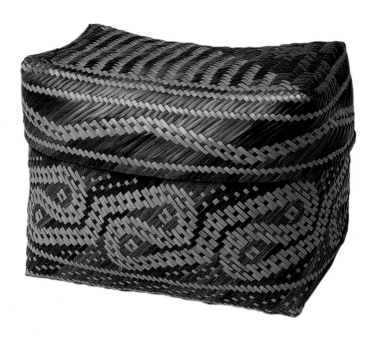

produce splint baskets for hunters' game or sweetgrass baskets for the thimbles of seamstresses.[25] Low sales and limited marketing of baskets during the first half of the century caused production to fall off.[26] The conscious revival of basket making in the 1980s, particularly among Mohawk designers, as well as the marketing of baskets through museums, cultural centers, and private enterprises, led to a flurry of design activity.[27] Baskets continue to be designed and used for traditional ceremonies, household chores, hunting, and less common purposes such as to honor wild strawberries.[28] Black-ash, porcupine-quill, globe baskets made by the Michigan designer-craftworker Edith Bondie (Ojibwe; fig. 3-8) are sure-handed and symmetrically perfect containers that maintain the basketry tradition of America's Northeastern Woodland peoples.

Important basketry traditions of the southeastern United States were sustained in the twentieth century by Cherokee, Catawba, and Chitimacha designers-makers such as Rowena Bradley (Cherokee; fig. 3-9). Using a twill plaiting technique of sharply contrasting red, black, and naturally colored river cane, she made visually bold and functionally strong containers. Stylized diamond-shaped patterns enliven the lower portion of her baskets, and light bands encircle the openings on top. Further to the south, in Chitimacha country, Clara Dardin, active at the beginning of the century, and Pauline Paul, active in the 1930s, became highly skilled producers within an American design tradition that dates back at least to the mid-sixteenth century,[29] whereby double-twilled plaited cane, plain and dyed, was used to create multilayered diagonal, circular, undulating, and geometric patterns (fig. 3-10). Some baskets made by Paul in the late 1930s seem inspired by ancient motifs similar to the stylized sacred rattlesnake head engraved on an ancient Cherokee shell gorget unearthed at McMahon Mound in Tennessee.[30] The wide eyes of Paul's "snakes" look out at the observer, bridging sacral tradition with utility. Large rectangular floor mats, designed and woven by Chitimacha women from cane and other plant materials, also displayed prominent diagonals, usually in the form of dark bands across light backgrounds. Accented with distinctive diamondback rattlesnake patterns, the diagonals divided the ground into large, light squares running from edge to edge (fig. 3-11). In terms of survival, basketry fared far better than mat weaving, mainly because there was less demand for such mats in white society. That circle has been broken, or at least interrupted.

TEXTILES

Woven blankets and rugs from the Southwest are often associated with Navajo females.[31] Spider Woman, a mythical spiritguide, has been their teacher.[32] The earliest Navajo rug, found in a dry cave, has been dated about 1750. By the nineteenth century, women were creating woven blankets to be worn on the body. One of the most striking visual effects in American clothing design

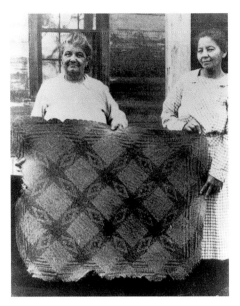

Fig. 3-11. Christine Paul and Pauline Paul holding a Chitimacha cane mat, outside Christine Paul's house, Chitimacha Indian Reservation, Louisiana. Photographed in 1908.

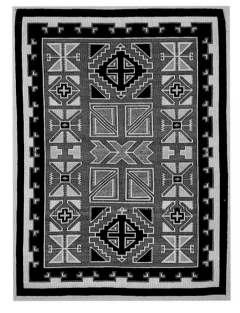

Fig. 3-12. Daisy Tauglechee. "Two Grey Hills" rug (Navajo), 1948. Wool. Denver Art Museum (1948.445).

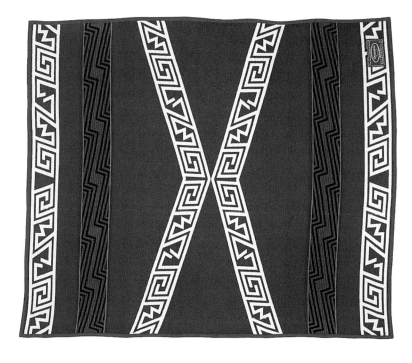

Fig. 3-13. Ramona Sakiestewa. "Chiricahua" blanket (Hopi), 1994–99. Produced by Scalamandré for Sakiestewa Textiles. Silk.

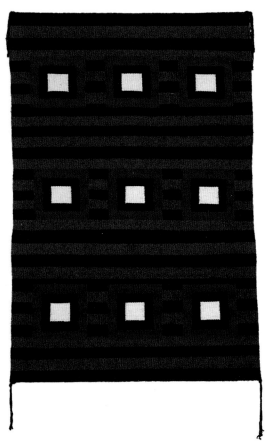

Fig. 3-14 Gloria Begay. Moki stripe rug (Navajo), 1991. Wool. Denver Art Museum, Gloria F. Ross Collection (1991.742). *Checklist no. 174*

was achieved through the meeting of a Navajo blanket's short ends over breast or shoulder. "Eye Dazzler" blankets, of bold and bright geometric patterns that create optical illusions, were developed in the 1880s after aniline-dyed yarns became available in the region.[33] Such blankets immediately became popular with both Native and non-Native consumers.[34] In 1908–9 alone, the Indian Department of the Fred Harvey Company purchased almost four thousand Navajo textiles,[35] and blankets and rugs were featured in books and magazines published by the company.[36] Some Navajo designers were encouraged to return to the use of natural vegetal dyes thought to be more "authentic" by collectors.[37]

The Navajo weaver, Daisy Tauglechee of Two Grey Hills, New Mexico, who was born in 1909, emerged as a "name" in the early 1970s.[38] Her technically intricate Two Grey Hills rug (1948; fig. 3-12) of finely spun wool features a sharply edged symmetrical pattern of stepped platforms, crosses, and arrows, designed in the black, white, brown, and gray palette traditionally used in her village. Her simplified forms are expressed through subtle color relationships and a fine weave of 115 weft threads per inch, rather than the conventional 30 to 40 weft threads per inch.[39]

Ramona Sakiestewa (Hopi), born forty years after Tauglechee, is one of the best-known contemporary Native American textile designers. Self-taught, she works in a self-consciously hybrid style, drawing upon Native American ceramics and textile designs, as well as contemporary fine arts. For a series of blankets manufactured by the Santa Fe Pendleton company in the early 1990s, she adapted motifs from ancient Mimbres black-on-white pottery, such as birds, bugs, fish, plants, and human and composite forms.[40] While her blankets were being manufactured by Pendleton, she established her own company, Sakiestewa Textiles, with art consultant, Karen Hyatt. From 1994 to 1999, the well-known textile manufacturer Scalamandré pro-

duced a series of six blankets (fig. 3-13) designed by Sakiestewa and based on remains of pottery, textiles, and petroglyphs from ancient sites in the Southwest such as those at Canyon de Chelly and Gila Cliff Dwellings National Monument.[41] She is currently a planning consultant for the National Museum of the American Indian, Smithsonian Institution, Washington, D.C., and has worked as a design consultant for the observatory and astronomy center of the University of New Mexico. The sacred hoop of her heritage stretches beyond the traditional Hopi way.

Navajo designer-maker Gloria Begay is the daughter and granddaughter of weavers. Her minimal yet vibrant "Moki Stripe" rug, made in 1991 (fig. 3-14), was inspired by "Moki" blankets of the nineteenth century. A gifted follower of Spider Woman, Gloria weaves new life into traditional forms.[42]

POTTERY

In New Mexico and Arizona, Native American women potters have operated successful "home-industries" throughout much of the twentieth century. One of the most celebrated, Nampeyo (Hopi-Tewa, Hano Village Pueblo), worked in the early part of the century. She and her husband John Lesso revived an ancient pottery style known as Sikyatki. Nampeyo shaped and painted pots and Lesso helped with polishing and painting.[43] They had initially studied pottery shards from an 1895 archaeological dig near their home and developed a style that would become known as Sikyatki Revival.[44] Nampeyo grew up learning to make traditional forms such as seed pots by

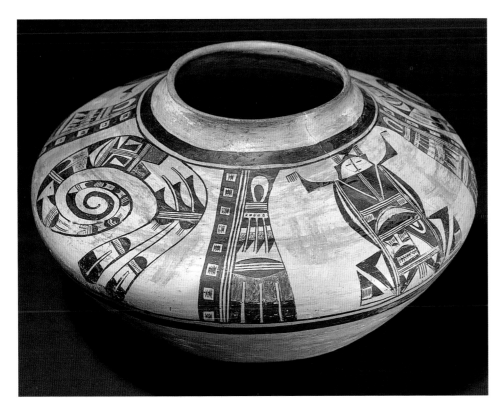

Fig. 3-15. Nampeyo. Jar (Hopi Pueblo), 1910–15. Polichrome earthenware. School of American Research, Santa Fe, New Mexico (IAF 1645). *Checklist no. 18*

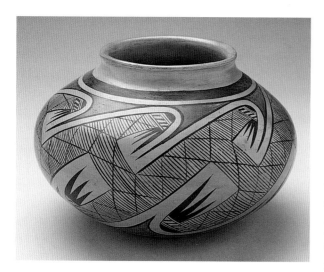

Fig. 3-16. Fannie Nampeyo. Jar (Hopi-Pueblo), ca. 1930. Polychrome earthenware. The Philbrook Museum of Art, Tulsa, Oklahoma, Gift of Clark Field, 1942 (1942.14.2199). *Checklist no. 47*

coiling clay found locally. Like many other women designers in the region, Nampeyo was "discovered" by Fred Harvey,[45] whose company promoted her and her work in its tourist facilities along the Santa Fe Railroad. In response to this broader market Nampeyo flattened the form of her seed pots to provide a broader surface on which to paint (fig. 3-15).[46] With Lesso and her daughter, Fannie Nampeyo (Hopi-Tewa; fig. 3-16), Nampeyo developed an innovative line of pottery notable for technical virtuosity, sophisticated aesthetics, and relatively high profitability.[47] After her loss of vision in 1920, she continued to form pots, which were then painted by Lesso (until his death in 1930) and Fannie.[48] Nampeyo initially followed Puebloan tradition by not signing her pots, but pottery from the mother-daughter collaboration is signed with both women's names.[49]

Stylized forms of birds and bird feathers, and a motif sometimes referred to as a "bear claw," often appear in Nampeyo's work.[50] Similar forms are repeated in the work of other members of the Nampeyo "dynasty," including daughters Nellie and Annie, as well as granddaughters Leah, Elva, Marie, Augusta, Daisy, Rachel, and Beatrice, and great-granddaughters Adelle, Miriam, Melda Dextra, and Priscilla.[51] Nampeyo's relatives pay homage to her

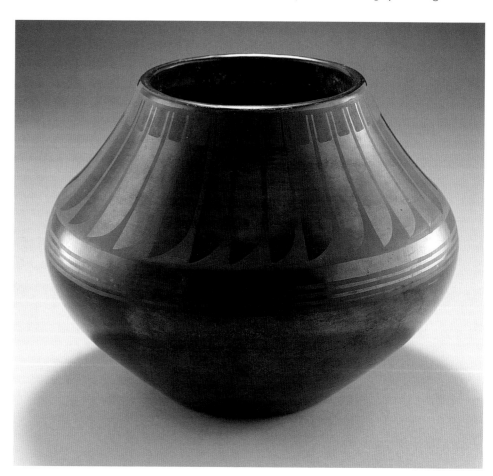

Fig. 3-17. Maria Martinez and Julian Martinez. Jar (San Ildefonso Pueblo), ca. 1935–43. Blackware. Institute of American Indian Arts Museum, Santa Fe, New Mexico (SILD 8). *Checklist no. 61*

by seeking to work within the broad design parameters she set, but do not slavishly reproduce her designs. The women of this dynasty often by-pass dealers in favor of direct sales of their pots, and increased profits.[52] As Fannie Nampeyo commented: "The trader says he'll make you famous and he gets richer and sells them for so much more."[53]

Maria Martinez (San Ildefonso, Pueblo), perhaps the most famous of the Pueblo pantheon of twentieth-century designers, also breathed new life into the ancient forms of San Ildefonso Pueblo pottery. Like Nampeyo and Lesso, Maria and her husband, Julian, took advantage of archaeological work in the vicinity of their village in 1908 to examine remains of pottery made by their ancestors. After intense experimentation Maria succeeded in producing technically complex black-on-black ware for which they are famous. Its ancient references, combinations of matte and shiny surfaces and plays of black on black, elegant new forms and decoration, and stylized motifs that conformed to Western notions of "modern," all contributed to its popularity (fig. 3-17).

As a potter, Maria Martinez was responsible for notable innovations among Southwestern Native American women designers. She broke with the customary practice of Native American women potters in that she was responsible for the design and making of the pot but not its decoration. Maria shaped the forms and explored the technology of ceramics, while Julian applied the decoration (see chap. 15). In addition, beginning in the 1920s, Maria signed her work, the first Pueblo potter to do so.[54] Julian began cosigning their work in 1934, and by his death in 1943, their signed plates and bowls had found buyers throughout the United States.[55] After Julian's death, their son Popovi Da and daughter-in-law Santana decorated Maria's pieces, and until Maria's death in 1980, she continued to develop and produce her highly individual pottery.

Lucy Lewis (Acoma Pueblo), who was born at the end of the nineteenth century and raised nine children, made and sold pottery throughout her life.[56] She was honored at the White House in Washington, D.C., in 1977, and died in Acoma, the "Sky City," in 1992. Observant of form from a young age, she learned pottery making from a great-aunt. The thin walls of her coiled pots, which she began making at the age of seven in about 1902,[57] provide the surface for bold graphic designs painted with brushes made of traditional yucca leaf strands (see fig. 3-A). Lightning bolts, zigzags, bird and feather patterns, and revived Mimbre motifs were all part of her repertoire.

Mary Histia (Acoma Pueblo) is another designer to come from Acoma, one of the longest continually occupied settlements in North America. Her work of the 1930s, like that of Lewis, derives its basic forms from the water jars and seed pots of her farming ancestors. Her delicate designs are painted with fine lines and geometric elements, sometimes based on contemporary themes. In one, for example, she expresses her belief in

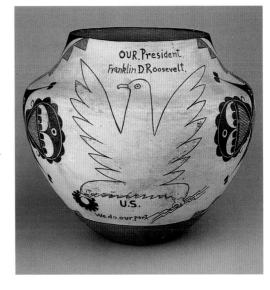

Fig. 3-18. Mary Histia. "National Recovery Act" jar (Acoma Pueblo), ca. 1930. Polychrome earthenware. Franklin D. Roosevelt Library-Museum, Hyde Park, New York (MO 55-107). *Checklist no. 48*

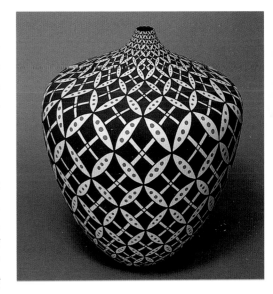

Fig. 3-19. Dorothy Torivio. Vase (Acoma Pueblo), 1995. Polychrome earthenware. Collection of Andrea Fisher Fine Pottery, Santa Fe, New Mexico. *Checklist no. 195*

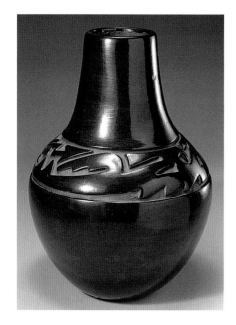

Fig. 3-20. Margaret Tafoya. Vase (Santa Clara Pueblo), ca. 1945–60. Blackware. Institute of American Indian Arts Museum, Santa Fe, New Mexico (SC.37). *Checklist no. 86*

President Franklin D. Roosevelt and demonstrates to non-Native Americans the patriotism of her people (fig. 3-18).

In recent years Dorothy Torivio (Acoma Pueblo) has expanded the parameters of decorative pottery design while drawing on the recognizably Puebloan shapes of other Acoma potters. Her water jars, seed pots, and miniatures feature precise and meticulous patterns of leaves, crosses, and star shapes that link together, lacelike, and join any part of the pot with another. The optical quality of her white-on-black and black-on-white (with color sometimes sparingly introduced) designs of the 1990s activates not only her forms but also the space in which they exist (fig. 3-19). The circle of Acoma designers continues to spin with great energy.

Margaret Tafoya (Santa Clara Pueblo; fig. 3-20) and one of her granddaughters, Nancy Youngblood Lugo (Santa Clara Pueblo), living in nearby Santa Fe, complete another smaller circle. Tafoya learned pottery making from her mother, and during the 1920s she distinguished herself by developing a unique line of blackware pottery featuring highly polished, molded and carved surfaces. Nancy Youngblood Lugo draws strength from the work of her illustrious grandmother, who also serves as a role model, but Lugo has not felt bound to conform to any "Tafoya Tradition." The links with the work of Tafoya reside in pottery with surfaces as smooth as ripe melons and often larger than that made by other potters of the region (fig. 3-21). The measured folds of her precisely shaped pots (miniature and large) create visual surface-rhythms moving over forms reminiscent of both traditional Pueblo water jars and machine-aesthetic modernism.

Fig. 3-21. Nancy Youngblood Lugo. Bowl (Santa Clara Pueblo), ca. 1999. Blackware. Collection of Natalie and Greg Fitz-Gerald. *Checklist no. 218*

Fig. 3-22. Doris Wheelock Blue. "Indian Head" pot (Catawba), ca. 1973. Earthenware. Collection of Thomas J. Blumer. *Checklist no. 138*

Fig. 3-23. Georgia Harris. Water jug (Catawba), 1979. Earthenware. Collection of Thomas J. Blumer. *Checklist no. 146*

Despite receiving less publicity and fanfare than their counterparts in the Southwest, women potters from the Southeast also distinguished themselves in the twentieth century. Throughout the century Catawba potters of South Carolina used clay from deposits probably found before the arrival of Europeans during the sixteenth century, thus linking their work with that of their ancestors.[58] Doris Wheelock Blue and Georgia Harris, both of whom were born in 1905, created unique finishes on their pots as varied as clouds each day (figs. 3-22 and 3-23). They have handed down this tradition of abstraction to the present generation, including Cheryl Harris Sanders and Caroleen Sanders. Their clay is coiled by hand, shaped with shells of river clams, smoothed with corn cobs, and polished with quartzite rubbing stones. Pots are fired outdoors, using certain types of dried bark toward the end of the firing to create subtle areas of gray-and-black on reddish brown backgrounds that distinguish their wares.[59] Catawba potters continue the circle, through pots that have been consistently varied in design, useful, and affordable.

In 1969 Anna Belle Sixkiller Mitchell (Western Cherokee) revived Western Cherokee pottery, which was moribund at the beginning of the century. Her experimentation with forms originating in ancient Southeastern material culture has brought her critical acclaim. Many of her pots feature traditional Southeastern ceremonial figures, based on creatures of the air and water, presented as symbols of natural power and of the relationships between their world and ours (fig. 3-24). Self-taught, she began to research ancient pottery after her husband asked her to make a clay smoking pipe like

Fig. 3-24. Anna Belle Sixkiller Mitchell. Jar (Western Cherokee), 1998. Earthenware. Private collection.

Fig. 3-25. Women dancers in Rocky Boy, Montana, wearing jingle dresses.

Fig. 3-26. Lena Frank. Skirt (Big Cypress Seminole), 1944. Machine-stitched cotton, rayon satin, rickrack, patchwork, and appliqué. American Museum of Natural History, New York (50.2/6371a). *Checklist no. 83*

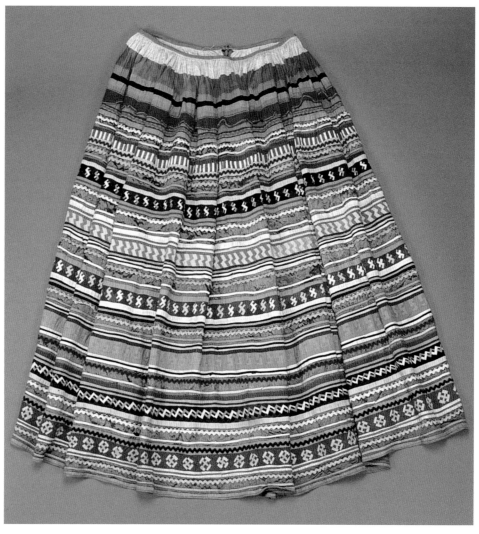

those used by Cherokee in the past.[60] She studied designs in museums, worked with clay found near her home, and embarked on a career that has spanned more than thirty years. Consciously adhering to old ways, she fires outdoors using wood and pulverizes her own sandstone.[61] Mitchell found spiritual sustenance in the examples of women potters from the Catawba, Pueblo, and Eastern Cherokee tribes when attempting to revive and reinvigorate her own "lost" tradition. Women outside her particular culture helped her to mend the Western Cherokee hoop.

REGALIA

Predominantly designed by women, regalia—clothing, jewelry, and other items worn for special feasts, healing purposes, gatherings, dances, and pow wows—is central to Native American culture. Garments are often made for a specific person and purpose, having become increasingly elaborate over the past fifty years, with designers using synthetic fabrics as well as more traditional materials such as porcupine quills, ribbons, and beads. Cone-shaped

"jingles," made by hand from tin cans in the nineteenth century, continue to be produced and used decoratively as much for their sound effects as for their reflective quality. When worn by dancers moving in personal space within a larger community of dancers (fig. 3-25), jingle-covered dresses and fancy shawls create unique effects on both participants and audience.[62]

A design tradition synonymous with southern Florida which survived the century is the intricately stitched patchwork clothing made by Miccosukee and Seminole people.[63] Eye-catching and unique, the dresses, jackets, and skirts are created almost exclusively by women for everyday wear as well as special occasions. The full-length skirts of contrasting bands of primary and secondary colors echo the tropical colors of the Florida Everglades and Great Cypress Swamp and recall the weaving patterns displayed in the architectural forms of chickee compounds.[64] The skirt made in 1944 by Lena Frank (Miccosukee) typifies the vivid use of colors and precision sewing (fig. 3-26).

Miccosukee and Seminole patchwork developed contemporaneously with that of European Americans, African Americans, and other Native Americans in the first half of the twentieth century, but patchwork crosses, with arms aimed at the four cardinal points, like the logs used for sacred fires, relate to ancient southeastern religious beliefs.[65]

In the first decade of the century, hand-cranked sewing machines were used by Miccosukee and Seminole women to sew together very small pieces of colored cotton cloth into bands of various widths. These bands were designed to run around the body horizontally, alternating with contrasting patchwork bands and with larger pieces of cloth. All were sewn into regalia according to the imagination of the designer, who drew on a variety of sources including commercial packaging, such as the red and white checkerboard pattern of Ralston-Purina foods beginning in about 1917–30.[66] As treadle sewing machines became available, running repeat designs became more complex, with some looking like stylized lightning or fire.[67]

Patchwork design continues to be a living tradition among the Miccosukee and Seminole. As the twentieth century came to a close, a new direction was explored. Effie Osceola (Miccosukee) completed large patchwork panels for Westinghouse Electric Corporation (1981; fig. 3-27) and the Florida Power and Light Company (1987).[68] With these commissions produced as "art" for the walls of corporate America, Native American patchwork broke away from the customary categorizations given to this form of Americana.

Woolen trade blankets worn by many Native Americans throughout the nineteenth century illustrate the symbiosis between European American

Fig. 3-27. Effie Osceola. "Lightning" patchwork panel (Miccosukee), 1981. Materials. Collection of Westinghouse Electric Corporation.

manufacturers and Native American consumers. In 1989 the American Indian College Fund, in cooperation with Pendleton Woolen Mills, raised money to further education by the sale of blankets designed by Native Americans.[69] Pendleton produced four limited-edition woolen blankets. Their promotion brought the work of Wendy Ponca (Osage) to a larger audience.[70] Ponca had already won seven first-place awards for her designs at the annual Santa Fe Indian Market from 1982 to 1987. Her "Wah-sha-she" blanket drew on a nineteenth-century Osage tradition of embroidering bands of multicolored ribbons on blanket ends.[71] In her design bands of ribbonlike color frame "picture words" of Osage visual language—golden hands opened on a green background (fig. 3-28).[72] In traditional Osage design, as well as in the textile design of other Prairie peoples, background is extremely significant and the images appearing on it change its meaning.[73] The solid background of Ponca's blanket also seems to share the visual phenomena of color fields created by Native and non-Native contemporary fine-art painters of the 1960s and 1970s. The path from one point of the hoop of weaving traditions to another is not always linear. Ponca reconnected her hoop after opening herself to non-Native design traditions.

As a high-school student in the 1970s Ponca studied at the Institute of American Indian Arts in Santa Fe, New Mexico, and it was at that time that she came closer to her roots. She recently commented: "I didn't really know what Native American traditions were. I had always loved beading as a young girl—really loved it—but it was many years later that I discovered it was part of my cultural heritage—as a Native American and as a Native American woman. It was a powerful discovery."[74] She went on to study fiber arts at the Kansas City Art Institute and eventually focused on blanket design. Ponca also studied weaving in Greece and was a graduate student of fashion illustration at Parsons School of Design, New York. As a designer she has bridged Native and non-Native worlds in reconnecting her own circle.

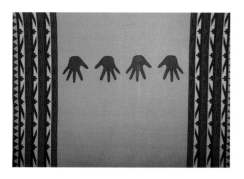

Fig. 3-28. Wendy Ponca. "Wah-sha-she" blanket (Osage), 1995. Manufactured by Pendleton Woolen Mills, Oregon for American Indian College Fund, New York. Collection of American Indian College Fund, New York. *Checklist no. 192*

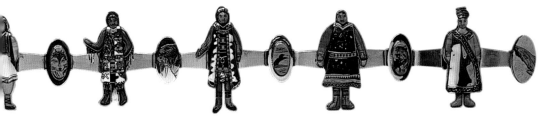

Fig. 3-29. Denise Wallace. "Crossroads of the Continents" belt (Sugpiag), 1990. Silver, gold, semi-precious stones, and fossilized walrus tusk. Collection of Denise and Samuel Wallace. *Checklist no. 171*

Denise Wallace (Sugpiag) ranks among the finest jewelry designers of the twentieth century. Inspired by the people, animals, and the natural environment of the Northwest Coast and Alaska, her pins, pendants, and belts, which often depict people dressed in traditional regalia, can themselves be considered a type of regalia. Ceremonial embroidery is simulated in one example with ivory, lapis lazuli and coral. "My pieces tell a story, and the people who buy them become storytellers,"[75] she says. Wallace grew up in Seattle, Washington, and after high school traveled to Alaska to spend time with her grandmother. It was not until she became a silversmithing student at the Institute of American Indian Arts in Santa Fe, New Mexico, however, that she and Sam Wallace (her partner and husband) began making jewelry. She executes her own designs in silver, gold, fossilized walrus tusk, lapis, coral, spectrolite, chrysoprase, and other stones, making and connecting the bezels for Sam's lapidary work.[76]

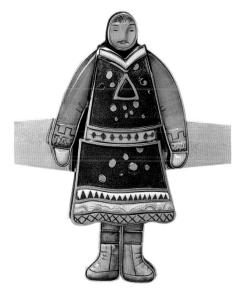

Detail of fig. 3-29.

The "Crossroads of the Continents" belt (fig. 3-29), includes linked concho forms from the Southwest, as well as references to the regalia and lifeways of Native people from the Aleutian Islands and other groups living along the Bering Sea. It was produced after a surge of pride in her Aleut ancestors and their circumpolar connections: "I wanted to create a belt that spoke from my heart about the pride I feel as a Native person from an arctic land. The exhibit "Crossroads of the Continents" spoke to me in a way that sparked that pride I was inspired by the details of the garments. All the painstaking hours and thoughtful use of materials . . . my vision was to create an arc of the different tribes from Siberia across to Southeastern Alaska in their different but similar traditional garments. This piece is an expression of appreciation and pride for these northern peoples, my ancestors."[77] Not all the items the Wallaces make are as elaborate, and in the early 1990s six assistants helped to fabricate a limited production run of cast jewelry. However, it is for her one-of-a-kind pieces that Wallace is best known.[78]

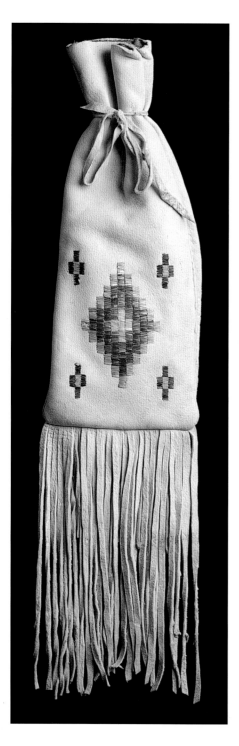

Fig. 3-30. Rosella Wounded
Eye Rider. Quilled pipe bag
(Northern Cheyenne), 1993.
Leather and porcupine quills.
Collection of Chuck Lietzau,
Cosmos, Minnesota.

QUILLWORK

At the beginning of the twentieth century, designs in porcupine quillwork appeared on moccasins, pouches and bags, quivers, shirts, dresses, cradleboards, bark containers, accessories for horses, and lodge decorations. These objects illustrated the technical abilities, aesthetic sensibilities, and spirituality of women quillworkers throughout the Great Plains, Great Lakes, and Northeastern Woodland regions. Women competed with each other in perfecting techniques and modes of expression in this uniquely Native American design tradition.[79] Among Cheyenne today, quilling is more than a gendered design tradition, it is a sacred act.[80] Honoring a brother or husband by quilling life-enhancing designs on his clothing and accessories is a matter of great importance. Despite the introduction of glass beads by European fur traders in the sixteenth century,[81] many womens' quilling societies in the twentieth century continued to use indigenous material for sacred as well as aesthetic reasons. The flattened and dyed quills reflect light when woven into nearly solid surface fields of red, yellow, blue, black, and white. Designers of regalia at the end of the twentieth century are more likely to use beads than quills, but many follow quillworking traditions.

Of all Native American design, beadwork is the most available and affordable.[82] Earrings, belts, and clothing often feature glass beads woven, strung, or sewn in patterns that include stylized sunrises or American flags. Quilled and beaded designs bless wearers with protective energy and endow them with power. Many of the finest quilled and beaded objects are buried with the deceased, an ancient tradition that survived through the twentieth century.[83] Quillworker and teacher, Rosella Wounded Eye Rider (Northern Cheyenne), who died in 1997, when only in her forties, shared elements of these sacred design traditions with Native and non-Native Americans. Two of her smoke-tanned, elk-skin quilled bags (fig. 3-30) are displayed at the Labre Indian School gallery in Ashland, Montana.

NEW MEDIA: BEADWORK

Melanie Printup Hope (Tuscarora) began designing with beads as a child on the Tuscarora Reservation in northwestern New York, and is now a graphic designer and artist, specializing in digital design. She studied graphic design at the Rochester Institute of Technology, received her master of fine arts degree from Rensselaer Polytechnic Institute in 1994, and is an assistant professor of graphic design at The Sage Colleges in Albany. She tried the life of corporate designer in the Albany area but was uncomfortable with it. Now she combines family life with teaching and a design practice that encompasses more conventional forms of graphic design, such as greeting and business cards, with digital design for music CDs and interactive on-line graphics and sculpture. Her nontraditional beadwork, which references the past as well as the present, has joined traditional ways with the digital age.

Many of Hope's designs are inspired by natural forms and forces, as well as by wampum—woven shell-beads produced by Native Americans living along the east coast of New York and New Jersey for use as ceremonial pledges, money, and record keeping.[84] Her beaded designs are made with variously sized glass beads on hard paper board. She scans them into her computer and repeats designs, adding text and colors in layers to create images of depth and beauty. The beading produces a raised surface that, when photographed and scanned, appears in high relief which, in turn, is enhanced by the planar transparencies of colors that look like translucent air or water. In one design, influenced by Northeastern Woodlands tradition, filtered forest-green plays over beaded plant forms. In others, beaded bears and birds communicate in a world created from ancient beliefs and new media (fig. 3-31). Hope has learned from the elders and speaks to young people through her teaching and designs. Embracing the past, present, and future of design in America, she is one of many Native American designers who serve Native and non-Native Americans through a steady and persistent maintenance of the Sacred Hoop.

Fig. 3-31. Melanie Printup Hope. "Heron," digital imagery from "The Prayer of Thanksgiving" (Tuscarora Iroquois), 1997.

NATIVE AMERICAN QUILTING

Quilts have become potent objects of popular material culture among many Native American groups, replacing earlier objects such as buffalo hides and blankets that were often used in significant life-defining ceremonies. Women in Native American communities learned quiltmaking in the latter part of the nineteenth century. Their teachers were most often European American missionaries and educators in schools established by religious groups or government schools on reservations, where quilting was one of the "domestic arts" taught in home economics classes.[85] Although quiltmaking was a new medium for all Native American groups, it was quickly adopted, and by the opening of the twentieth century quilts were being made by women in a wide range of communities, even in groups such as the Hopi, where textile work— weaving and the production of many items of clothing—had traditionally been men's work.[86] Quiltmaking not only fit with a traditional affinity for fine handwork, but also provided a tangible means to give "eloquent voice to dearly held cultural values and beliefs."[87]

Native American women initially used designs that were common in the European American quilt tradition, but they soon brought their own cultural heritage into quilts through imagery and import, creating, in the process, an unambiguous hybridized tradition. A pictorial quilt made in 1915 by Rebecca Blackwater (Sioux; fig. 3-32) represents everyday life of Native peoples and suggests the conflict with European Americans by the inclusion of a tomahawk and peace pipe—symbols for war and peace. The

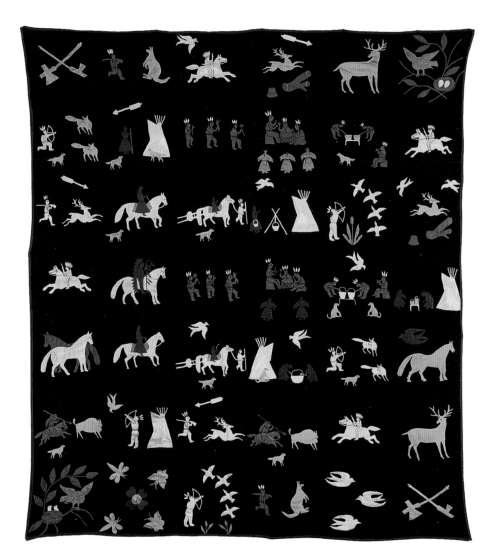

images on the quilt and the story it tells are reminiscent of images and designs painted or quilled on buffalo hides in the preceding century.

The morning star—the brightest object in the sky just before dawn—had long held great symbolic meaning for Plains groups, and representations of it appeared in painted and beaded designs on clothing, bags, hides, and shields.[88] The traditional "Lone Star" (or "Star of Bethlehem") quilt lent itself well to this iconic imagery, and this motif was in use in quilts made by Plains women by the early twentieth century.[89] The "Star" quilt also appealed to Great Lakes groups, who expanded the design by appliquéing floral motifs traditional to their culture between the points of the star. By the mid-twentieth century, "Star" quilts (called "Morning Star" or "Northern Star" by some groups) had become an integral part of a number of renewed Native-based traditions.[90]

Among the Lakota of South Dakota, "Star" quilts are used in traditional "giveaways," where the items given away are highly valued by the giver. A public way to show respect for people in the community, Giveaways also

honor rites of passage such as naming ceremonies, memorial feasts, graduations, weddings, and funerals.[91] Women may spend much of the year preparing quilts for these ceremonies, their contributions reaffirming "the traditional role of the woman as artist and craftsman [which] is still important because all Oglalas [Lakotas] require an abundance of star quilts over their lifetimes."[92] Quilts also continue to be made for the non-Native market as a source of steady income.[93]

One of the most distinctive and culturally powerful uses of "Star" quilts as part of a tradition transformed for contemporary use is seen among the Sioux and Assiniboine of the Fort Peck Reservation in Montana. There, a much older tradition of honoring warriors by bestowing on them objects of special beauty and meaning metamorphosed in the mid-twentieth century into a ceremony tied to high school basketball.[94] Where warriors were once given buffalo robes or beadwork, basketball heroes are now given "Star" quilts that feature variations of the "Star" pattern and, usually, a basketball motif, representing a significant everyday object for the youths to whom the quilts are presented.[95] Entire families may be involved in producing the quilts for such a ceremony, traditionally held after the last game of the season. This hybrid form, which originated in Brockton, Montana, in 1947 when a grandmother honored her grandson with the first "Basketball Star" quilt, reflects new "authenticities" of life at the beginning of a new millennium and reinforces the strength of ties to the past. Some women, including Rae Jean Walking Eagle (fig. 3-33), have become noted for their designs of "basketball" quilts.[96]

Quilts—both of "Star" designs and otherwise—are important among other Native American groups in traditional ceremonies, especially those involving gift-giving.[97] In this context, they represent a blending of past and present and mark the resiliency and dynamism of Native American design traditions in the late twentieth century. Native American women create quilts along a broad design spectrum, from unique narrative quilts that continue telling stories of the elders to those based on traditional European American patterns. Although variations on the "Star" design remain popular, Native American quilters have also used motifs and images created through other media, such as beadwork, basketry, sand painting, and weaving, thus expanding the design tradition and ensuring the survival of some motifs that might otherwise have been lost. The designs and uses of Native American quilts celebrate culture and community. They stand as tribute to a unique assimilation of Native and non-Native American design traditions, unbounded by definitions of authenticity. Experimentation by Native and non-Native quilt designers draws both together in the always present, past, and future of a Sacred Hoop.

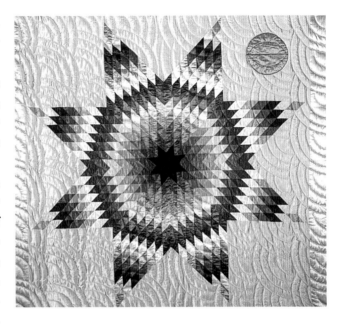

Fig. 3-33. Rae Jean Walking Eagle. "Basketball Star" quilt (Assiniboine/Sioux), designed ca. 1996, made 2000. Machine-pieced and hand-quilted polyester and cotton/polyester blend. Michigan State University Museum, East Lansing. *Checklist no. 207*

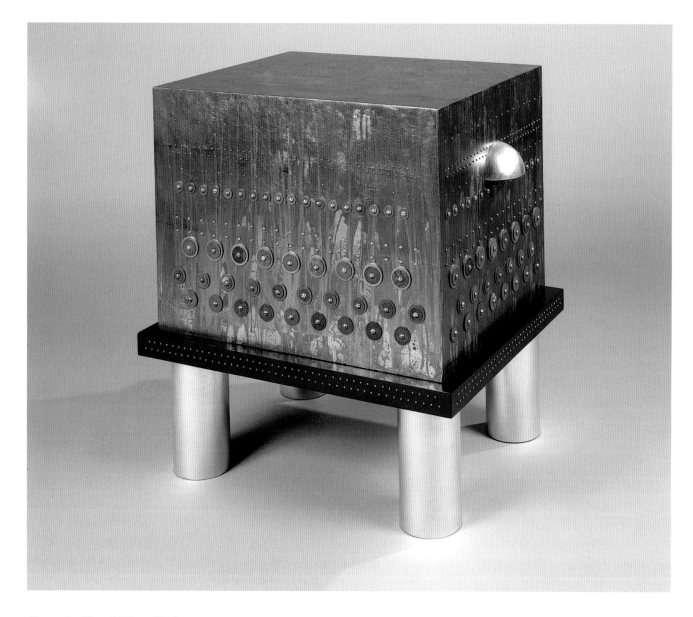

Fig. 4-A. Cheryl Riley. "Tudor
Coin-Encrusted Table," 1992.
Wood, enamel, copper leaf, coins,
brass, and gold leaf. Produced by
Right Angle Interiors, San Francisco
1993. Cooper-Hewitt, National
Design Museum, Smithsonian
Institution, New York, The
Decorative Arts Association
Acquisitions Fund (1993-9-1a, b).
Checklist no. 177

4

PAT KIRKHAM AND SHAUNA STALLWORTH

"Three Strikes Against Me":

AFRICAN AMERICAN

WOMEN DESIGNERS

LOOKING BACK ON THE "DIFFICULT PATH" of her "wonderful life," Anna Russell Jones, the first African American woman to graduate from the Philadelphia School of Design for Women (now Moore College of Art and Design), commented, "I had three strikes against me: I was a woman, black, and a freelancer."[1] Multiple discrimination is central to the study of African American women designers of a century that witnessed major challenges to racist structures and policies. Other factors, such as education, training, mentors, class, and sheer determination and talent, intersected with those noted by Russell Jones, shaping the various ways in which African American women became and worked as designers.

The low status of the "applied arts" within white culture ensured that, for much of the century, they played little part in any African American movements that encouraged artistic expression or "self-improvement." Design fell between two stools: hand, mechanical, and artisanal skills were emphasized as a means to "self improvement," while the "fine arts" were considered the appropriate vehicle for black visual expression and a means of convincing white America that African Americans were "civilized." For a moment in the 1890s the increased status sought for design by followers of the Arts and Crafts movement suggested it was worthy of indicating black capabilities,[2] but in the 1920s and 1930s it was notably absent from the creative arts agenda of the New Negro Movement, better known as the Harlem Renaissance, which sought to allay racism by illustrating the cultural accomplishments of African Americans.[3] In the late 1940s designers were not included (although artists were) in an article entitled "The Social Contributions of the Negro Woman Since 1940," published in the *Negro History Bulletin*.[4] Nevertheless, despite various levels of invisibility, some black

women worked as designers throughout the twentieth century, though only in large numbers toward its end.

As the new millennium begins, dynamic, talented African American women are found in most areas of design—from computer graphics to corporate communications, and from interior design to industrial design. Although opportunities are greater now than ever before, issues of gender and race remain. Black women tend to be best represented (if still underrepresented) in areas more open to women as a whole and less represented in those with fewer women. A single essay cannot be comprehensive. We offer instead a selection of case studies that raise key issues and shed light on how and why women from an historically marginalized sector of American society entered various fields of design and how they fared therein.

BLACK STUDENTS; WHITE SCHOOLS

Of the scores of "anonymous" women trained as textile designers in schools of design in the 1920s, two of those better-known today were African American. Anna Russell Jones was the first black woman to graduate from her particular college. The Philadelphia School of Design for Women had been established for eighty-one years when Russell Jones graduated in 1925.[5] Her admission in 1921 came when middle-class African American women were increasingly gaining access to higher education and when textile manufacturers showed a greater willingness to use American designs (see chap. 5). Born Anna Rachel Russell, she was not from a wealthy family; her father, a Pullman porter on the Pennsylvania Railroad, died before she reached her teens. Her mother had been a schoolteacher in the South before marriage, but nonetheless objected when her daughter decided to go to college. Russell Jones later commented that "The climate was to keep the Negro down" but "it didn't bother me because I was going to do what I was going to do, whether my brothers or mother liked it. That's why I got the scholarship I had an aim in life."[6]

Russell Jones won three senior year awards[7] and joined the James G. Speck Studio as an in-house designer until November 1928, when she established her own studio.[8] She was warned that it would not be easy to go to showrooms and sell her work, but she succeeded, mainly selling designs for carpets and wallpapers (fig. 4-1).[9] The Depression ended her career as a textile designer, and as unemployment among architects and designers soared, freelancers were the first to be let go. Nevertheless, Russell Jones continued to sell designs until 1935—no mean feat in those years.[10] World War II brought new opportunities. In 1942, at the age of forty, she joined the Women's Army Auxiliary Corps (WAAC) and worked as a graphic designer at Fort Huachuca, Arizona.[11] Besides maps, plans, and diagrams, she designed morale-boosting cartoons and promotional posters for visits by celebrities such as Bob Hope. Peacetime and the return of male veterans brought an end to such work, and

Fig. 4-1. Anna Russell Jones. Design for carpet, ca. 1930–35. Gouache on paper. The African American Museum in Philadelphia, Ann Russell Jones Collection (86.040). *Checklist no. 52*

she retrained in medical illustration (at Howard University) and later made a career in nursing.[12]

By contrast, Loïs Mailou Jones came from a lower-middle-class Boston family where both parents encouraged her artistic talents.[13] During summers at her grandmother's house on Martha's Vineyard, Massachusetts, she came into contact with notable African American artists, including Meta Vaux Warrick Fuller, whose sculpture *Ethiopia Awakening* (1923) offered black women a modern image of their past and present.[14] Mailou Jones called Fuller "my inspiration."[15] While at the School of the Museum of Fine Arts, Boston (1923–27), Mailou Jones, the only black student, won a fifty-dollar prize for a dress design in a competition sponsored by Shepherd Stores and the Rayon Institute of America.[16] She also earned a scholarship to attend the prestigious Designers Art School of Boston (1927–28), but it was conditional on her cleaning the studio. She feared that fellow students would not regard her as their equal if they knew she cleaned, so her mother did the work—an act Mailou Jones later described as a "great sacrifice."[17] A white student initially refused to sit next to her, but such were Mailou Jones's personality and talent that the two students became friends.[18] Between 1927 and 1928 Mailou Jones freelanced, selling textile designs to F. A. Foster Company, Boston, and F. Schumacher and Company, New York.[19] Her designs were bold, colorful, and "modern"; her "Totem Poles" textile (1928; fig. 4-2), a tight, dense, and rhythmic pattern, was influenced by Native American and African design traditions and reflects the contemporary interest in "primitive" art and design; the motif also suggests a self-conscious involvement with attempts to establish an "American" design vocabulary.[20] Unlike Russell Jones, Mailou Jones never faced the problem of working as a designer through the Depression; lack of "name" recognition within the textile industry led her to quit the profession, although she continued to teach for nearly fifty years.[21]

Fig. 4-2. Loïs Mailou Jones. Design for "Totem Poles" textile, 1928. Tempera on paper. Estate of Loïs Mailou Jones. *Checklist no. 40*

VISIBILITY AND INVISIBILITY

Ceramist Winifred Owens-Hart has commented on the invisibility of African Americans in American ceramics, particularly women.[22] In the early years of the century, china painting offered employment to many women. Although more black women created Arts and Crafts–type handicrafts than has been acknowledged,[23] only Rubie (Kesiah) Booker Lucas and her friends in Washington, D.C., in the late 1910s and early 1920s are known to have worked in ceramics.[24] Combining social and artistic pleasures, they met in each others' homes to decorate porcelain blanks. It has been suggested that

Lucas may have learned china painting at the YWCA near her home, in a "philanthropic" class (see chap. 2). Whatever the case, Lucas was not able to turn her considerable skills into full-time employment. The history of black women's responses to Arts and Crafts ideals and activities, as amateurs and professionals, has yet to be written. Consequently it is difficult to speculate on the complex interconnections of racism, paternalism, liberalism, gender bias, and Arts and Crafts practice, particularly in the late 1910s and early 1920s when many handicrafts workshops had lost much of their dynamism. As it was, in the late 1920s Lucas sought employment in an area unrelated to her creative talents in order to support her family.[25]

Recognition raised different issues for black designers than for white ones. Publicity often worked against black designers because visibility made them more vulnerable to discrimination and patronizing attitudes, particularly early in the century. No matter how brilliant the designs, in a society riddled with racism there was a world of difference between a manufacturer knowing a designer was black and potential clients or customers handling that knowledge. In the first half of the century, opportunities for African American designers came in areas and in positions where contact between designer and customer was not necessary. The "anonymity" of most textile design explains why it encompassed women who were among the most "invisible" in the United States (see chap. 5).

Mailou Jones "passed" some designs as those of a white designer: the friend who had once refused to sit next to Mailou Jones took them to textile firms along with her own.[26] Patronizing attitudes were not uncommon in the industry, and Mailou Jones later recalled three incidents that remained with her all her life. The first occurred when she applied for an assistant's post after graduation. She commented, "The director stared at me with his steely blue eyes and said, 'We have no openings here but why don't you go South and help your people?'" The second involved responses to learning she was the designer of popular fabrics. When she told someone in the New York branch of the F. A. Foster Company that she had designed the "Ganges" fabric prominently featured in the display room, he replied "'You mean *you* did that!' and called others out to see this little Black girl who designed the cretonne which was all over the place." In the third instance, an interior designer who displayed one of Mailou Jones's fabrics in his shop was "surprised to think that a woman of color could have done that, had done those drapery fabrics from a big company in New York."[27]

FASHION

Issues of visibility were circumvented when designers worked within African American communities. Many who did so were self-employed. In the urban centers to which African Americans migrated, the demand for stylish clothing was great. Many black dressmakers, such as Annie Hauer, who worked in

Brooklyn at the turn of the century,[28] became well-known in their local neighborhoods for creating original designs; unfortunately, little is known about the work of these women until the 1940s and 1950s.

Willi Jones, known professionally as Madame Posey, was a woman of style who, in the 1950s, "settled for a modest career as a Harlem fashion designer in an entirely black world of fashion, made up of black designers, black models and black photographers."[29] She had originally wanted to go on the stage, but "show business was considered a sure road to hell."[30] Nevertheless, the career to which she turned in the early 1950s, when her two children were teenagers, offered some of the glamour of the stage (fig. 4-3). Madame Posey and thousands of clothing designers like her across America—some professional, some amateur—were a key element in a world of style and modernity against which black women shaped their identities, learned self-confidence, and found myriad pleasures.[31] She, Barbara Mayo, Margaret Floyd, and designer/model Lois Bell went into business at a time when the Association of Negro Business and Professional Women's Clubs and the National Association of Fashion and Accessory Designers (NAFAD) brought them into contact with other black fashion designers and business women.[32] Lack of acceptance by the mainstream fashion industry did not deter them from attempting to gain wider recognition. They held their own fashion shows at the Waldorf Astoria, in midtown Manhattan, as well as in Harlem, in the hope of attracting major manufacturers and new clients.

Lois Alexander, an advocate of women's organizations and professionalism who helped found and was president of NAFAD (1955–63), ran a custom clothing shop in Washington, D.C., from 1945 to 1955. In 1964 she opened a boutique in Harlem, which sold clothes she designed. Two years later, together with a group of friends, she launched the Harlem Institute of Fashion, which helped African Americans find work in the highly competitive fashion industry by teaching the design and making of clothes.[33]

Black women fashion designers gained greater recognition in every major American city during the 1940s and 1950s. Dorothy Alexander, Barbara Williams, Fontaine Bradley, Hazel Shumate (fig. 4-4), Mildred

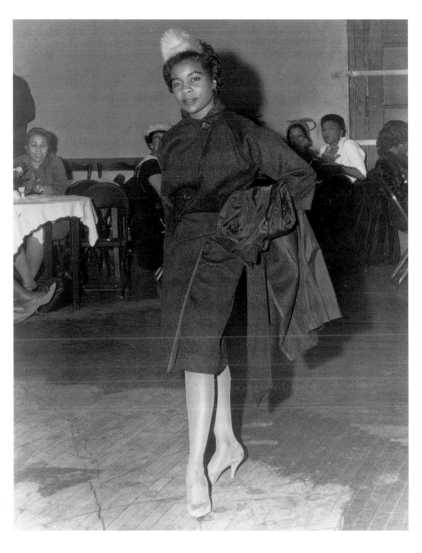

Fig. 4-3. Willi Jones, a.k.a. Madame Posey. Ensemble with wraparound skirt modeled by the designer's daughter Barbara Jones, 1950s.

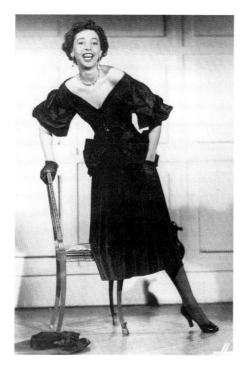

Fig. 4-4. Hazel Shumate. Dress and hat worn by Dorothea Towles, 1949.

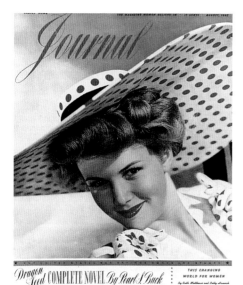

Fig. 4-5. Mildred Blount. Hat shown on the cover of *Ladies Home Journal* (August 1942).

Blount, and Bernice L'Tanya Griffin (whose label read "Fashions by L'Tanya, Hollywood") were among the best known.[34] Blount's hats, which appeared in magazines (fig. 4-5) and movies, were worn off-screen by movie stars Marlene Dietrich, Joan Crawford, and Rosalind Russell.[35] Russell invested $10,000 (a sizable amount in the 1940s) in the business of another black designer—Hazel Washington, her former maid—who designed and made stylish leather handbags and belts.[36] It was against this background that Ann Lowe became the first black designer to be "part of the fashion establishment" when she opened a salon in New York in 1950.[37]

The story of Lowe—great-granddaughter of a slave and a plantation owner, who first married in 1912 at the age of fourteen—is a mix of invisibility and recognition, of successes and failures, of snobbery and seeming rejection of "race" and class, and of determination, perfectionism, and pride-in-work. An Alabama-born daughter and granddaughter of designer-makers of ballgowns for Southern belles, Lowe grew up amid quality fabrics and magnificent gowns and determined she would create only the finest dresses for the very "best" people.[38] When she enrolled in design school in New York in 1917, the director laughed at the idea of a black girl at "a high-class fashion school" and "didn't believe I could learn the things they had been teaching there."[39] Unable to find regular work in New York after graduation, she established a salon in Tampa, Florida, which became the leading one in the city, and, in 1928, with $20,000 in savings, she returned to New York.[40]

Lowe worked on commission for major stores and salons such as Chez Sonia, but it annoyed her that her name was not included on the labels. When Olivia de Haviland wore an Ann Lowe gown to accept her 1946 Academy Award for *To Each His Own*, the label read "Sonia Rosenberg"; Lowe later commented: "For twenty years I worked for others. I rode one person after another to glory on my back."[41] Some degree of recognition came with her own salon. Her reputation for couture quality at prices below those of the leading Paris and New York houses brought clients from the Rockefeller, Vanderbilt, Du Pont, and Roosevelt families. Nevertheless, when she designed an ivory silk gown with "signature" appliqué flowers for one of the most visible social events of 1953—the wedding of debutante Jacqueline Bouvier to Senator John F. Kennedy (fig. 4-6)—she was virtually ignored in the press.[42]

Although Lowe achieved considerable commercial success for awhile, her emphasis on perfection rather than profit eventually forced the business to close. She came to an arrangement with Saks Fifth Avenue, New York, whereby she headed a custom salon and kept her private clients. Her name became known to an even wider clientele, albeit still an upper-crust one, when, in 1960, she was featured in Saks advertisements. A year later glaucoma forced her to leave but, after the removal of an eye, she returned to work in the mid-1960s, designing for Madeleine Couture,[43] driven by her own determination to succeed as well as by financial problems. In the late 1960s,

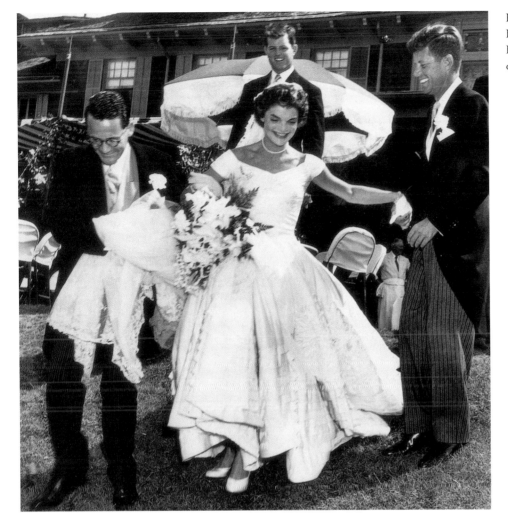

Fig. 4-6. Jacqueline and John F. Kennedy, Newport, Rhode Island, 1953. Wedding dress designed by Ann Lowe.

when she was nearly seventy, for a short time she again ran her own salon, Ann Lowe Originals, on Madison Avenue.[44]

TEXTILES

It took "hugely different attitudes towards black people" before Jacqueline (Jackie) Peters gained visibility as a textile designer in the 1960s. Her story is one of finding conducive work in the absence of other opportunities. After studying fashion and fine art at the School of the Art Institute of Chicago and spending a year at the Chambre Syndicale d'Ecole Couture Parisienne, she expected to "take New York by storm as a fashion designer." She recalls, "I had a great portfolio but only got offered modeling jobs I was too shy to take." Realizing "there weren't many, or any, black fashion designers," she tried to enter fashion illustration, only to be directed to textile design.[45]

Entering the textile business did not prove easy, and Peters worked at a variety of jobs, including selling fabrics at Bloomingdale's, until she got a toe-hold in the industry. In the early 1960s she learned "at the board," working in the studios of Cohen-Hall-Marx, Renoir, Crown Fabrics, and

Fig. 4-7. Jackie Peters presenting fabric designs to William Kolbe, president of H. M. Kolbe, and Carey Klippsten, merchandise manager for a Kolbe client, 1968.

Fig. 4-8. Rose Ransier. Design for polyester textile, 1970.

Rosewood Fabrics (where she was in charge of the design studio and assistant to the top designer). A move to "high fashion" fabrics during "the style and political 'revolutions' of the mid-1960s" brought her extensive press coverage. In 1965 Peters went to work for William Kolbe, "a wild white man who thought it was cool to employ a stylish black designer—there was a lot of Civil Rights stuff going on. He liked to promote himself but his public relations person [a woman] found it easier to promote me. 'A Black woman is news,' she told him 'You are not.'"[46] Headlines of a nationally syndicated article ranged from "Paris-trained Designer Negro to Head Fabrics Studio" and "Negro Breaks Color line In Textile Design Field" to "Negro Named Chief Designer Of Textile Firm."[47] In 1968 *Ebony* presented her as "one of the few Negro women to make it big on the creative end of the fashion world" and as a capable working woman with a responsible and rewarding job (fig. 4-7).[48]

In 1979 Peters opened the first black textile design studio in New York. "Had I known black people could make so much money, I'd have done it years before—but years before I wouldn't have succeeded," she quipped. Best-known for bold abstract, floral, and "ethnic" prints, and for hand-painted silks (she was one of the first American designers to paint directly onto silk fabric for apparel), she attributes her success to luck, changing times, talent, enthusiasm, and "not having married until I was fifty-four years old!" Now "retired," she and her artist husband, Bernard Cully, continue this line of work on a smaller scale.[49]

Although Peters thought she was the only black textile designer, Rose Ransier (a.k.a Rose Piper) was a highly respected knitwear designer in the 1960s. She had won critical acclaim as a painter in the late 1940s, for work that evoked the black creative experience, turning to design in 1952 to support her two children, husband, and parents. Ransier went from the visibility of exhibitions and reviews of her paintings in the *New York Times*, *Art Digest*, and *Art News* to the anonymity of textile design, in which she worked for the next twenty-eight years. Juggling home and work was not easy: "My first job was designing silks for Fred Levi Studios. I was able to accept it because my younger child was in nursery school. Before that I took her with me to my own one-woman greeting-card business."[50]

Ransier became the most sought-after designer of knit fabrics; she recalls, "I was in the right place at the right time. When knit fabrics became high fashion in the early 1960s, I was the only designer who could design directly for the machines; others handed over sketches and seemed surprised when they were altered for production." She had majored in fine art and minored in geometry at Hunter College (1936–40) and had a complete understanding of knitwear machines. Her aptitude for mathematics as well as pattern making meant she was able to produce detailed drawings on graph paper that corresponded with each machine stitch (fig. 4-8).

Her most popular designs sold over two million yards each in the 1960s and early 1970s and were featured in fashion advertisements in women's and "lifestyle" magazines. This gave her power. "Being in demand gave me enormous control. You cannot imagine what it was like for a black woman then to have such control at work. I moved jobs eleven times in twenty-eight years, each time for better wages and conditions. I was never frightened of losing my job. If anything, my bosses were a bit frightened of me because I always said what I thought, including the time I found out my white male assistant earned more than I did! I threatened to leave and they upped my salary. At Texti they gave me eight assistants; I didn't need them but they did things in a big splashy way."[51] Outside the circle of knitwear fabric manufacturers, however, Ransier was not known by name as a designer.

Among the handful of African American women to work as textile designers in the 1960s and 1970s were Cheryl Nero, who designed home-furnishing fabrics—from pillowcases to slipcovers—and Beverly Nusom, who produced some exotic prints for the Design Works of Bedford Stuyvesant in Brooklyn. Nusom's "Wild Banana" (fig. 4-9), a 1972 screen-printed cotton sailcloth design, which featured large white bananas outlined in brown against an orange ground, was based on botanical drawings of African flora.[52] In 2000 J. Michelle Hill, who has run her own design studio since 1984 and recently retrained in computer-aided design (CAD), commented, "there are still relatively few women of color in the industry compared with the large numbers of women working therein, but knowing about past designers gives us hope for the future."[53]

QUILTS

Quiltmaking has long been a part of the African American experience, reaching back to the earliest years of African presence in America. Although it is a medium in which African American women have excelled, examples of their quilts have been conspicuously absent from most American quilt histories.[54] That quiltmaking has been a pervasive presence in the lives of African American women is evident in much contemporary writing and art, including that of Alice Walker, bell hooks, Romare Bearden, and Faith Ringgold.

The narrative quilt, common to many quilt traditions, has been used to great effect by African Americans—from the well-known Harriet Powers "Bible" quilts of the late nineteenth century to those that carry more personal tales. Not all narrative quilts are pictorial; Jessie Telfair's "Freedom" quilt (1980; fig. 4-10), for example, is a compelling and forceful statement about the Civil Rights struggle.[55] Quilts designed and made by African American women cover a broad spectrum of design, technique, and style. Some, such as those by Lucile Young (ca. 1935; fig. 4-11) and Anna Williams (1992, see fig. 6-13), constitute a design tradition that encompasses textile traits common to many West and Central African cultures: for example, the

Fig. 4-9. Beverly Nusom. "Wild Banana" textile (*detail*), 1971. Hand-screen-printed by The Design Works of Bedford Stuyvesant, Brooklyn. Cotton. The Metropolitan Museum of Art, New York, Gift of The Design Works of Bedford Stuyvesant, Brooklyn, C. Mark Bethel, president, 1972 (1972.115.2). *Checklist no. 129*

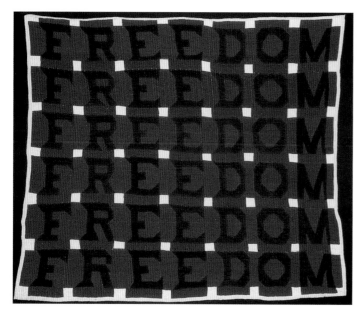

Fig. 4-10. Jessie Telfair. "Freedom" quilt, 1980. Cotton and synthetics. Collection of Shelly Zegart.

use of strong colors, asymmetry, multiple patterning, large-scale motifs, strip-piecing, and improvisation.[56] It is important, however, not to ignore quilts designed by African American women that also contributed to and continue to draw on other design traditions, including the so-called European American tradition, not least because these too indicate the rich veins of African American women's creativity.[57] Within quilt traditions that did not offer the same scope for working with strip-piecing, large-scale motifs, or multiple-patterning, African American women brought new approaches and redrafted the "norm" in their own visions.[58] Wini Austin, for example, strikingly reinterpreted the popular "Log Cabin" design (fig. 4-12).

Despite the splendid designs of the first half of the century, by the 1940s and 1950s most young African Americans regarded quilt design and making as old-fashioned. By the end of the century, however, it was accepted as a medium for modern expression (see chap. 6). Many black women used quilts to explore a wide range of personal and political concerns, including their identities as women and as African Americans. Particularly powerful has been the influence of the "African Revival." African themes, images, motifs, and textiles influence

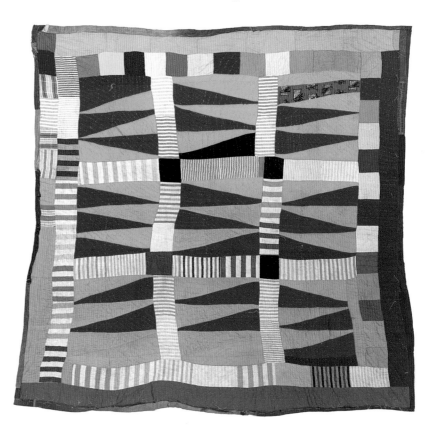

Fig. 4-11. Lucile Young. Quilt, ca. 1935. Cotton and wool. The Helen and Robert Cargo Collection of the International Quilt Study Center at the University of Nebraska, Lincoln.
Checklist no. 59

many quilt designers. Some, such as Carol Harris of Detroit, who majored in art at Wayne State University, have gained a national reputation for their innovative designs. Harris, who has been producing quilts since the 1960s, creates dramatically spare works, many of which draw on African sources. Carolyn Mazloomi's narrative quilts tell complex stories in space, pattern, and time, while exploring heritage within the context of contemporary African American life experiences (fig. 4-13). In 1986 she founded the Women of Color Quilter's Network to help preserve, sustain, and expand the quiltmaking tradition of African Americans.[59]

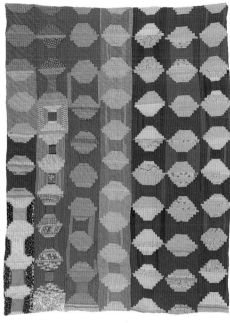

Fig. 4-12. Wini Austin. "Log Cabin" quilt, ca. 1925. Quilted by Roberta Jemison, 1997. Cotton. H. and R. Cargo Collection, University of Nebraska, Lincoln. *Checklist no. 34*

"HARLEM," AFRICA, MODERNITY, AND "TRADITION"

Consciousness of African heritage was evident throughout the century—sometimes more so than others—as African Americans drew on cultural bonds with Africa. Modernist interest in "primitivism" fused with older African American discourses of Africa as evidence of a cultured past.[60] European modernity embraced, if not fetishized, design, but it was paid little attention by the Harlem Renaissance, a broad-ranging movement of the 1920s and 1930s that aimed to "establish a new, spiritual, political and self-conscious nation" and an "unapologetically hybrid subversive modernity."[61] While design was marginalized, fine art was eulogized.[62] Nevertheless, the centrality of design to everyday life and the reverberations of the Harlem Renaissance ensured that the movement's ideas and imagery had an impact on some African American designers. For example, it was through involvement with the design and making of modernist masks for the dance company established by Ruth St. Denis and Ted Shawn in 1915 that Mailou Jones was "introduced to Africa"; nineteen years later she designed masks and coordinated the costumes for another dance troupe, this one in Harlem and led by Asadata Dafora.[63]

The pervasiveness of Harlem Renaissance–style imagery and ideas was seen in Ruth Clement Bond's 1934 designs for quilts. Her only foray into design occurred when her husband became an administrator in the Tennessee Valley Authority (TVA), four years after she completed a master's degree in English.[64] Bond produced the designs for execution by the wives of the black workers building a dam in northern Alabama.[65] Although the Bonds lived in the same housing project as the workers and a remarkable spirit of camaraderie prevailed, she not only designed the quilts but also suggested the colors and fabrics used.[66] Compelling as her modernist, Harlem Renaissance–style versions of black creative expression are, they marginalized the existing quilt design traditions of the women who made them, traditions which today nourish many African American

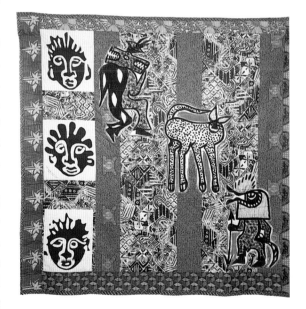

Fig. 4-13. Carolyn L. Mazloomi. "The Ancestors Speak to Me" quilt, 1996. Reverse appliquéd and quilted cotton and mudcloth. Collection of Carolyn L. Mazloomi. *Checklist no. 194*

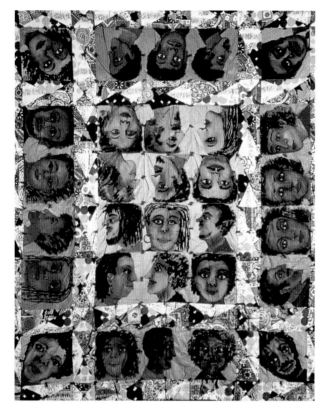

Fig. 4-14. Faith Ringgold with Willi Posey. "Echoes of Harlem" quilt, 1980. Acrylic on canvas and dyed fabric. Collection of Philip Morris Companies.

Fig. 4-15. Ruth Clement Bond. Tennessee Valley Authority "Lazy Man" quilt, 1934. Made by Grace Reynolds Tyler. Cotton. Private collection.

Fig. 4-16. Aaron Douglas. Cover of *Opportunity: Journal of Negro Life* (February 1926).

designers. The ignoring of the "old" in favor of the "new" brings to mind Faith Ringgold's wonderfully frank discussion of her rejection of her mother Willi Posey's design concepts for a quilt border on their collaborative project, "Echoes of Harlem" quilt (1980; fig. 4-14). Ringgold thought them old-fashioned and feared they would be regarded as unprofessional and inappropriate to "modern" cutting-edge artistic expression.[67]

Whatever Bond's thoughts about the design capabilities or preferences of the other women, she had very clear ideas about her openly ideological quilts; indeed, it is largely because they used iconic images that they retain such impact today. Just as aesthetically they ignored the "old" in favor of the "new," the politics of the "new" were privileged over "old ways." Her designs indicate a desire to forge new beginnings and illustrate the centrality of the black male and of labor to representations of the black (modern) future.[68] In the TVA "Lazy Man" quilt (fig. 4-15), which recalls paintings and graphics by Aaron Douglas (fig. 4-16), a leading figure of the Harlem Renaissance,[69] Bond wanted to illustrate the black man doing the "right thing"—choosing the path of the TVA—as opposed to the "old ways" represented by sexual desire.[70] As she explained, "The man with his banjo is full of frivolity. He is between the hand of the government and the hand of a woman. He must choose between the government job and the life he has known."[71]

In her TVA "Black Power" quilt, the "right" choice has been made. Her original design (now lost)—a male silhouette holding a lightning bolt—evoked Soviet imagery of the period in its heroicization of (male) labor and

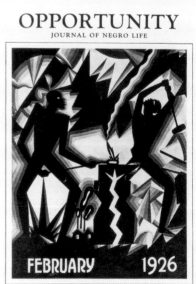

OPPORTUNITY
JOURNAL OF NEGRO LIFE

FEBRUARY 1926

INDUSTRIAL ISSUE

the transforming nature of electrification, aiming to symbolize the power of electricity. However, the tribute to electricity was read as one to Black Power by TVA interns.[72] Bond's TVA "Man with Crane" design (1934; see fig. 6-10) further eulogized male workers' power, the dignity of labor, and economic transformation through modernization. Bond's Harlem Renaissance quilts placed an African American craft tradition within "progressive" black artistic and political expression while ignoring the design aspects of that tradition. It was not until the 1970s and 1980s that the more hybrid and apparently ad hoc nature of that particular African American design tradition would be appreciated by "progressive" modernists.

"Harlem" also manifested itself in Greenwich Village, the mecca of modernist artists, designers, and intellectuals. The Village scene offered new routes to visibility and recognition. The 1940s movement to reclassify crafts as modern art allowed jeweler Winifred Mason to locate herself within a circle of well-known black intellectuals and artists when she moved to the Village from Brooklyn.[73] Mason, the first African American professional jewelry designer now known to us by name, was also one of the first to make modern "art" jewelry (see chap. 8). What little is known of Mason comes from comments by Art Smith (now dead), to whom she was a mentor, and two photographs. Possibly self-taught, she started designing and making at home, producing hand-made copper jewelry that she mostly sold to friends. The studio she opened in 1942 employed several people. Smith remembered it as filled with enthusiasm: "a kind of . . . little Bauhaus . . . in the midst of compatible neighbors and friends . . . like Talley Beatty, Ralph Ellison, Gordon Parks."[74] Her work brought her a degree of fame in her day, which makes her current marginalization all the more frustrating.

In the late 1960s Evangeline Montgomery, a former student of weaving and metalsmithing, worked in California in metal and enamels. Her highly textured jewelry, which drew on natural forms, combined fusions of metals with uncut stones or rock crystals. At about that time, she began exploring her African heritage and in 1971 produced a lost-wax cast box, "Ancestor Box I: Justice for Angela," featuring the Ashanti symbol for justice, which she intended to function as a link between current concerns of African Americans (in this case, the trial of political activist Angela Davis) and their African past.[75] She pioneered black "political" jewelry and objects (fig. 4-17) and paved the way for other "issue"-oriented black designers, including Phyllis Bowdwin, Renée Beggsmith (see chap. 8), and Joyce Scott, a tireless promoter of African American creativity in the last quarter century.

Fig. 4-17. Evangeline Juliet Montgomery. "Garvey Ancestral Box" also known as "Red, Black, and Green Ancestral Box," 1973. Cast silver and enamel. Collection of Cledie Collins Taylor. *Checklist no. 136*

MAKING AN IMPACT: GRAPHICS, INTERIORS, AND FURNITURE

Black women designers made inroads into graphic design from the 1970s, some twenty years after the entry of African American men into this field.[76]

Fig. 4-18. Sylvia Harris with Two Twelve Associates, New York. Prototype for *U.S. Census 2000*, 1996. Offset lithograph. Collection of Sylvia Harris. *Checklist no. 204*

Fig. 4-19. Fo Wilson. Brochure for African American Design Archive, Cooper-Hewitt, National Design Museum, Smithsonian Institution, New York, 1996. Offset lithograph. Collection of Fo Wilson. *Checklist no. 205*

As in other areas, those who broke down barriers were often single-minded. Dorothy Hayes, born in Mobile, Alabama, in 1935, decided on graphic design while in high school. Full of confidence—"I've never been afraid of anything or anybody in my life"[77]—she moved to New York in 1958. Graduating in graphic design from Cooper Union (1967), she determined to be ultra-professional and win respect as both a woman and a designer.[78] In 1971 she told a journalist, "You can't get round being a woman. They're going to see it the moment you walk in the door, and they're going to have to go through their man thing with you, the idea that you're theirs, that you'll do whatever they say, like an office wife. It's beautiful though: if you present yourself as a professional they really respect you for it. They know you've paid your dues just like they had to."[79] When she first arrived in New York she "couldn't find any brothers or sisters to whom I could relate professionally," an experience that later prompted her to promote and advise other black designers.[80] With Joyce Hopkins, a designer with Harper and Row book publishers, Hayes organized *Black Artists in Graphic Communication* (1970), an exhibition that profiled forty-nine young black graphic designers—men and women, including Dorothy Akubuiro, Josephine Jones, and Diane Dillon.[81] Still going strong, Hayes runs Dorothy's Door, a commercial art and design studio that services major corporate clients such as CBS Radio and AT&T.

There is not space to include all African American women working in graphics today, but the profiles of a few indicate the variety of their contributions. Sylvia Harris, who in the early 1970s was one of only two black students in the design department at Virginia Commonwealth University, has helped younger black designers by speaking and writing about her experiences, focusing on African American design, and chronicling searches for a "black aesthetic."[82] Today she is a consultant specializing in planning "user-friendly" communications, which help institutions find new ways to present cultural resources, information, and instructions to diverse communities. From 1980 (the year in which she received her MFA in graphic design from Yale University) to 1993, she was co-founder and principal of Two Twelve Associates, New York, which developed information programs and signage for clients such as the New York State Council on the Arts, the New York Zoological Society, Citicorp, and Mastercard International. She was a member of the 1992 Presidential Round Table on Design Initiatives Towards a Competitive and Inclusive America, co-authoring the report, "America by Design."[83] More recently, she headed an all-woman team commissioned to revamp the 2000 census form (fig. 4-18).

Fo Wilson is another well-known designer, with over twenty years of experience in publishing (including *PC Computing*, *Psychology Today*, *New York Times Magazine*, *Glamour*, *Essence*, and *Condé Nast Traveler*) and in corporate communications, including annual reports, broadcast programs, and catalogues (for AT&T, Black Entertainment Television, Spiegel, Pottery Barn, and Warner

Brothers Records). Before becoming vice president and director of design and development at Tendo Communications, San Francisco, she ran her own design firm in New York (1991–98) and obtained an MBA from New York University's Stern School of Business (1997). She came to design by accident. Theater classes taken to counter shyness led to poster design for a theater company and the realization that she wanted to be a designer. "Self-taught," she took continuing education design classes at Parsons School of Design and learned on-the-job about making mechanicals. She acknowledges that the new digital age reduces the possibility of such an accidental mode of entry: "I am acutely aware that if I was armed only with what I knew at seventeen, I couldn't get into the business today."[84]

Fig. 4-20. Michele Y. Washington. Inside spread for *Black Issues Book Review*, Published by CMA Publishing, March–April 1999. Collection of Michele Y. Washington, Washington Design, Brooklyn.

Wilson speaks eloquently of hybridity and the ways in which black people in the United States have to traverse two cultures. Her work for *Essence* (1981–83) took into account the African American cultural background of the magazine's readers, as did her 1996 brochure design for the Cooper-Hewitt National Design Museum's African American Design Archive (fig. 4-19), which plays off bold, energizing colors against restrained typography and line. Both have been seen as examples of an African American aesthetic. Wilson views herself "as a hybrid, a zebra. I've been cross-culturally fertilized and the brochure is representative of my design approach: a marriage of my (somewhat unconscious) African past and (very conscious in-my-face) American present."[85]

Michele Washington, who received her master's degree in visual communications from Pratt Institute, Brooklyn, is a graphic designer, archivist, author, and educator. With more than twenty years' experience as a designer and art director, she has developed a distinctive design style that attracts a wide range of clients (fig. 4-20). Prior to launching Washington Design in 1992, she worked as senior designer or art director for magazines such as *Essence*, *Self*, and *Black Enterprise*. She has also provided design services for the *Chicago Tribune*, *New York Times*, *YSB*, *Business Month*, *CBS Publications*, and the New York Botanical Garden.[86] With Fo Wilson, she co-curated an exhibition of posters by African American designers—*Visual Perceptions: Twenty-one African American Designers Challenge Modern Stereotypes* which was held at Parsons School of Design in 1991.[87]

Holly Hampton, who has a degree in visual communication design from California State University, Long Beach, and is a principal at Sussman/Prejza and Company, Los Angeles, recently drew on African design traditions when working on the lobby of the New Jersey Performing Arts Center, Newark (1997; fig. 4-21), one of the first major cultural institutions in the United States to use African motifs in a central public space.[88] As lead designer of a team including Deborah Sussman and Scott Cuyler, she was

Fig. 4-21. Lobby of the New Jersey Performing Arts Center, Newark, with carpet runner designed by Holly Hampton, 1995–96.

Fig. 4-22. Holly Hampton, designer, and Deborah Sussman, art director. Sample of carpet runner for New Jersey Performing Arts Center, Newark, 1995–96. Manufactured by Decorative Carpets, Inc., 1997. Wool. Collection of Office of Sussman/Prejza and Company, Culver City, California.
Checklist no. 198

responsible for the custom-designed handwoven carpet runner (fig. 4-22), etched copper doors, and custom glass mosaics that reference West African textiles, ceramics, sculpture, and architecture. Underpinning the project was an interchange between Sussman and Hampton, one woman rooted in an Eamesian joy in color, decoration, and "ethnic" design, the other informed by a love of textiles and African Revivalism.

Hampton's final carpet design (a nonrepetitive asymmetrical pattern) aimed to capture the spirit of African design traditions while avoiding pastiche. It is a contemporary, everchanging, but neverending story, blending the fabric of African life with that of African America. Hampton's recently completed projects include graphics and interpretative exhibits (Hancock Park, which houses both the Los Angeles County Museum of Art and the Page Museum of La Brea Discoveries); wayfinding and pageantry (the Queensway Bay development, Rainbow Harbor, Long Beach, Long Island); and environmental graphics.[89]

Other important figures include Robin Lynch, a graduate of Howard University and Yale, who has strong professional connections with the music industry, and Auriea Harvey, who focuses on interactive design and says she "fell into the Web." Loretta Staples, who for the past decade has headed U dot I, specializes in the design of graphic user interfaces (GUI), while Tracey J. Hill has been fulfilling corporate and brand identity assignments since the 1980s. Cynthia R. Jones is president and chief executive officer of Jones Worley Design, an Atlanta-based environmental, graphic, and corporate design firm.[90]

It is only recently that African American women have become more visible in interior design, a field dominated by white male and female professionals. The two best-known today are Courtney Sloane and Cecil N. Hayes, both of whom head their own firms. Each offers, among other things, interiors linked to both African and African American culture that signal heritage and personalize space.

Cecil Hayes, who studied interior design and fine art, is principal and creative director of Cecil's Designers Unlimited, Coconut Creek, Florida. One of the most prestigious and oldest African American–owned residential interior design firms in the United States, it recently celebrated its twenty-fifth anniversary. *Architectural Digest* included Hayes among the "top one hundred" international interior designers and architects of the twentieth century—the only African American in a curious and extraordinarily Eurocentric selection.[91] The determination to get *exactly* the right furniture and fittings for the interiors she conceives led Hayes to establish a manufacturing plant within her business—a rare occurrence even at the exclusive end of the market.[92] Hayes has a high-profile clientele,

including entertainment and sports celebrities—Wesley Snipes (fig. 4-23), Samuel L. Jackson, Anfernee "Penny" Hardaway, and Derek Brown—as well as corporate executives Jacoby Dickens and Harold Toppel.

Sloane also has a star-studded roster of clients—Sean "Puffy" Combs, Fila, Black Entertainment Television, Sony Music Entertainment, the Rock and Roll Hall of Fame, Queen Latifah, and Sha-Kim Compere, among others—for whom she has designed showrooms, executive offices (fig. 4-24), restaurants, entertainment venues, and retail businesses as well as domestic interiors. Since establishing Alternative Design (AD), in 1991, and expanding into design development,

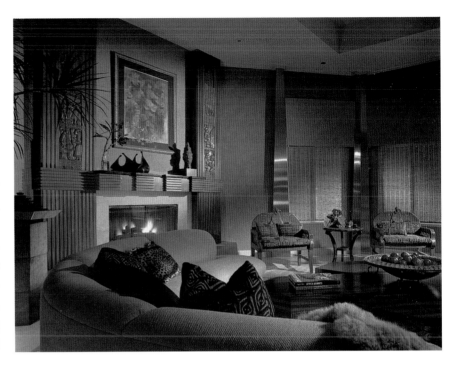

Fig. 4-23. Cecil N. Hayes, Living room in the Wesley Snipes residence, Florida, 1996. *Checklist no. 206*

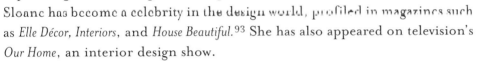

Sloane has become a celebrity in the design world, profiled in magazines such as *Elle Décor*, *Interiors*, and *House Beautiful*.[93] She has also appeared on television's *Our Home*, an interior design show.

Sloane always wanted to be a designer, but parental expectations led to marketing: "I had no role model to look to, no mentor."[94] She worked for Formica for six years, during which time the company sponsored her through design school (Pratt Institute). She cites her abilities as a fabricator when explaining why she likes to design complete interiors—including furniture, lampshades, and desk accessories.[95] "To enter a space is to become part of its conversation. Design is not merely a problem-solving exercise, but a way to push through boundaries and expectations," states Sloane, who believes in synergistic collaborations between designer and client.[96] She has identified three main obstacles in her career—"youth, color, and gender,"and recalled, "I've had my share of terrifying experiences . . . being snuffed by contractors, dealing with men with big, big issues."[97] Her "By Design" column in *Essence* brings her into contact with young women wishing to become designers. She makes time to reply to their letters because: "The landscape of the industry has changed, even in the last five years, and I want to keep that momentum going for the next generation of women."[98]

While Courtney Sloane, Cecil Hayes, and others design custom furniture for their interiors, Cheryl Riley, who founded Right Angle Designs in 1986, is the only African American designer to have established a national reputation on the basis of her furniture designs.[99] She graduated with a double major in fine art and fashion but worked in advertising and as a fashion executive before turning her talents to design. Her custom pieces are in the

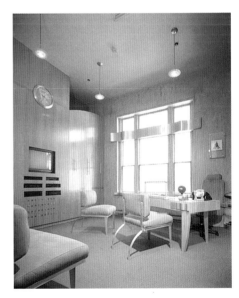

Fig. 4-24. Courtney Sloane. Office of Sha-Kim Compere, CEO, Flavor Unit Entertainment, Jersey City, New Jersey, 1996. *Checklist no. 202*

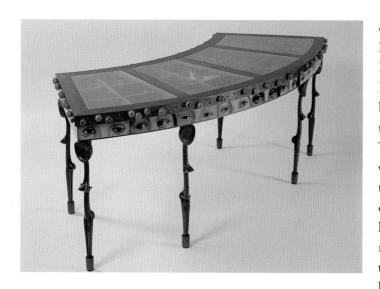

Fig. 4-25. Cheryl Riley. "Zulu Renaissance Writing Table for a Lady," 1995–96. Kiaat, copper, goldleaf, oil paint, and personal and found objects. San Francisco Museum of Modern Art.

collections of four major museums as well as those of a host of celebrities including Danny Glover, Terry McMillan, Denzel Washington, and Morgan Freeman.[100] Her involvement with women's issues and black heritage issues is evident in her work, sometimes together, as in the case of "Zulu Renaissance Writing Table for a Lady" (1995–96; fig. 4-25). Her impressive work, rich with postmodern references, venerates quality workmanship. Unlike many of the women discussed in chapter 12, however, Riley does not execute the pieces herself, which allows her the freedom to design for a range of specialist skills, such as painting on furniture in the mode of Renaissance "masters" or silverleafing leather.[101] Her one-person show at the Cooper-Hewitt National Design Museum, New York in 1993, featured two coin-encrusted tables, one of which is shown in figure 4-A.

Among the first to respond to the demand for Africentric interiors and home furnishings were Cheryle Dent and Kim Bressant-Kibwe who established African Home in Brooklyn in 1989. Each left "secure" jobs: Dent, a talented amateur interior designer, worked on Wall Street, and Bressant-Kibwe, who had traveled extensively in Africa, was a corporate lawyer.[102] The mainstay of the firm was imported African fabrics, but in 1993

Fig. 4-26. Cheryle Williams Dent and Kim Bressant-Kibwe. "Benin" wallpaper, 1991. Screen-printed by African Home, Brooklyn. Paper. Cooper-Hewitt, National Design Museum, Smithsonian Institution, New York, Gift of African Home, Brooklyn (1993-142-1). *Checklist no. 172*

they launched an award-winning line of seven hand-printed wallpapers in various colorways. African references were strong; "Benin" (1991; fig. 4-26) was inspired by West African textile designs while "Amandla" (1993), named after the South African freedom chant, used the *Adinkra* (a diamond-shaped symbol for freedom).

Current preoccupations with "lifestyle," including Africentric design, encouraged Sheila Bridges, known for her understated "classic" style, to expand her horizons. Bridges's work has been featured in many publications, including *Martha Stewart Living*. Stewart's ethos and success inspired Sheila Bridges Home, which opened in 1999 in Hudson, New York, and retails lifestyle products, some to Bridges's own designs.[103] Four years earlier Bridges had started her own business, after working on commerical and residential projects for Renny B. Saltzman Interiors, and for the architectural and interior design firm of Shelton, Mindel and Associates. Leslie Williams, who recently founded Hawkeye Designs with the goal of giving young and creative designers "a place to grow," also worked within a larger enterprise that combined architecture and interior design—Vernon Williams Architects, Chicago, formally the Amistad Group founded in 1980.

"NO BLACK CAMARADERIE": BUILDING NETWORKS

This case study focuses upon two women who, as late-twentieth-century "pioneers," find themselves in worlds where very few other black women work. Carole Bilson is a product designer working for Eastman Kodak, and Ruth Carter is one of a handful of costume designers of color within the "so unbelievably white and male" American film industry.[104] It stands also as a shorthand way of conveying that "race" and gender issues remain within design today; they do so to greater and lesser degrees in different areas of design but nonetheless persist as the twenty-first century gets under way.

The history of black women's involvement in industrial design remains to be written. There is evidence of it in patents and inventions from the late nineteenth century,[105] but little is known about African American women in this predominantly male profession, which was established in the 1930s (see chap. 11). Carole Bilson, who began working for Eastman Kodak in 1980 and became worldwide product/marketing manager for its Consumer Imaging–Digital Products Business, has designed a wide range of cameras, printers, x-ray processors, and copiers (see fig. 11-23). In the mid-1990s she was responsible for developing the "Picture Maker" system (fig. 4-27), including the world's smallest do-it-youself photo-processing unit, which allows anyone to make reprints and enlargements from original photographs in three minutes and also to mount and frame them. Used in pharmacies and convenience stores, the system contributed $80 million in revenue to the company in its first year.

Fig. 4-27. Carole Bilson. Kodak "Picture Maker," 1995–97. Manufactured by Eastman Kodak, Rochester, New York. Collection of Eastman Kodak, Rochester, New York.

Bilson remembers designing items as a child and taking them to a local carpenter to be made.[106] A high school trip to General Electric influenced her choice of career. She studied at the University of Michigan, and when she walked straight into a job at Eastman Kodak, she was probably the only African American woman working as an industrial designer. She commented recently that "in industrial design there are still hardly any minorities, particularly women. Even at the Organization of Black Designers (OBD), I don't think I met any women [industrial designers] only men." Asked how being an African American woman affected her career, she commented: "Initially, I had to prove myself with my peers. They weren't used to working with women, let alone an African American woman. . . . Sometimes people have low expectations of you, or no expectations. Sometimes I felt invisible. But I have persevered and never given up."[106]

Conscious of being a role model, she had taken seriously the task of "paving the way for others who follow." For the first seven years she worked exclusively with men at every level. Eastman Kodak then had no mentoring policy, and Bilson was prominent in the establishment of employee networks at the nonunion company. First came one for African Americans, then one for women. Bilson has also been active in the Rochester Women's Network, the largest organization of professional women in the United States, because she feels she has a commitment not only to share her experiences but also to answer questions raised by younger people. All three organizations have, she feels, helped build her self-esteem.

Ruth Carter has similar views on the importance of support. Something of a "pioneer" since her student days as a theater arts major at Hampton Institute in Virginia, where she decided she wanted to specialize in design and had to shape her own curriculum, Carter was interested in art from an early age. "My eldest brother, now a graphic designer, had tons of art books," she recalled, "and my other brother and I were always drawing."[107] She apprenticed with a theater costume designer in her hometown of Springfield, Massachusetts, and interned at the Santa Fe Opera in New Mexico.

She was fortunate in that her career in film coincided with "a surge of up-and-coming black directors." Carter is the first to admit her good luck: "I was in Los Angeles working in theater in the 1980s and desperately wanted to get into films. But it was extremely difficult. A friend introduced me to Spike Lee, who had only just made *She's Gotta Have It* (1986), and I hadn't heard of him. Some people imagine he saw my work and the rest was history! He offered me strategies of 'dipping my toe into the business' by going to courses at USC and UCLA and later asked me to work on *School Daze* (1988). Before I went on payroll, I had illustrated every character. It took six months and I temporarily relocated to New Hampshire where my designer brother helped me work through ideas—that is how important it was to me."

Carter's skill and career advanced while working with Lee, a director with a strong visual sense of his own: "I call him a 'master teacher' because he let me go my own way while keeping a watchful eye and giving advice at just the right moments. He gave me space to make mistakes then helped me out of them." She collaborated with him on *Do The Right Thing* (1989), *Mo' Better Blues* (1990), *Jungle Fever* (1991), *Crooklyn* (1994), and *Malcolm X* (1992), for which she received an Academy Award nomination—the first for an African American costume designer. She was also nominated for *Amistad* (1997, dir. Steven Spielberg; fig. 4-28). When asked if her Oscar nomination made any difference in getting work outside the African American network, she commented: "I have become better known but much as we might like to wish people into a more multiculutural way of thinking, Hollywood producers don't seem willing to 'match' famous white actresses with a black designer. The exclusivity is very strong and the mindset very narrow. I still rely on black directors to fuel my career."

Fig. 4-28. Ruth Carter Costume design for *Amistad*, (1997, Dir. Steven Spielberg).

She speaks with pleasure and regret about being one of the few black women in film costume design—indeed in the industry as a whole—commenting: "I used to always look for black women in the film industry but they were hard to find. The door was not open. There was not a black camaraderie; my camaraderie came from white women costume designers—they gave me support, just as black directors gave me support. There were simply no other black women to share things with." Bent on building "camaraderie," she has mentored several aspiring African American women costume designers, including Sandra Hernandez, Dana Burwick, Rita McGee, and Danielle Hollowell, who now work in film, theater, and television.

The history of African American women designers over the last century is as rich as it is varied. The careers and work of the individuals discussed in this essay indicate the wide range of areas in which they worked as well as their many achievements, often against considerable odds. Across the century, they all had at least two strikes against them—gender and "race." Taken together, their efforts significantly challenged entrenched divisions of race and gender within American design and, by extension, in the wider society. At the beginning of a new century, there is an optimism among them that the future is theirs. They are confident that the strengths necessary to win greater access to areas such as film costume, production design, and industrial design, are there and that the landscape of design is being reconfigured in ways more conducive to the participation and creative fulfillment of women, African Americans, and particularly African American women.

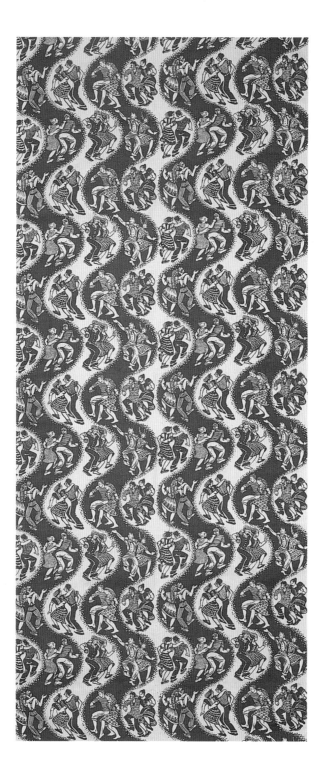

Fig. 5-A. Virginia Lee Demetrious. "Finnish Hop" textile, 1943. Manufactured by F. Schumacher and Company, New York, beginning 1946. Aralac. Dallas Museum of Art, 20th Century Fund (1997.74). *Checklist no. 87*

5

MARY SCHOESER

WHITNEY BLAUSEN

"Wellpaying Self Support"

WOMEN TEXTILE DESIGNERS

AS THE TWENTIETH CENTURY OPENED, the American textile industry was unrivaled in its volume of cotton growing, calico printing, and carpet weaving; in silk weaving it was second only to the French. Yet American manufacturers, even when they overtook the French during the early 1920s, still relied on France for ideas.[1] Nevertheless, as early as 1905, Charles Cheney, a leading silk manufacturer, had employed American designer Grace Simonson, who taught at the New York School of Applied Design for Women.[2] At another important center for training women, the Philadelphia School of Design for Women (now Moore College of Art and Design), the dean, Harriet Sartain, made certain that "no girl was allowed to produce a textile design that could not be produced by a modern textile plant."[3] The competency of graduates is demonstrated by Alice Dorothy Few, a 1926 recipient of the school's P. A. B. Widner Fellowship for Studies in London with Lindsay P. Butterfield, who sold two of her cretonne designs to Liberty and Company.[4] Among Few's Philadelphia instructors was Mary Braid Hartman, who in 1922 came to her teaching position with fifteen years of industrial experience, although it is not known where she had worked. Clearly there were opportunities for some women designers in this most productive and profitable of industries.

American manufacturers' ability to compete on the world mass-market as well as with up-market imports was called into question in the early years of the century. The status of American-designed patterns, generally, considered too similar to those available elsewhere, was low. These concerns were confronted first by producers of machine-printed silks for the ready-to-wear and home dressmaking industries and, after about 1925, by other sectors of textile manufacturing. This chapter examines these sectors in turn, highlighting the way market needs placed women designers in roles that, at different times, shaped stylistic trends, design and production techniques, and corporate strategies.

Just prior to World War I, the American ready-to-wear clothing industry was estimated to be a $2.5 billion business, second only to the steel industry in the value of its products. The aggregate income of the United States silk mills, the main suppliers of stylish apparel cloth, was $500 million.[5] Both the silk and clothing industries depended on seasonal changes to stimulate sales. European designs and prototypes (cloths and garments) were the lifeblood of most American manufacturers; with the onset of war in Europe in 1914, many feared a disruption in their supply.[6] The problem was less pressing for the manufacturers of furnishing fabrics; yet even they would have to be ready with a flurry of fresh designs to satisfy the anticipated post-war boom in consumer demand. It was a unique opportunity to develop an aesthetic that would be distinctly American, a project that was to engage the talents of many women unschooled in industrial design practices.

In 1916 museum curators and industry analysts joined forces to campaign for a national style, one that would convince American women to "buy American." The chief strategists were the New York curators Stewart Culin and Herbert J. Spinden, and the ebullient Morris de Camp Crawford, the driving force and chief propagandist behind the campaign.[7] Together, they developed classes in museum-based object research, assembled study collections for designers and manufacturers, organized textile design contests based on museum research, and ultimately mounted exhibitions of contemporary clothing and textiles based on that research. This was an innovative and important change in the use of museum resources.[8] The main industrial participants were leaders in their fields and were primarily silk and clothing manufacturers.[9]

The trade paper *Women's Wear* (later to become *Women's Wear Daily*) sponsored a series of national contests with cash prizes for the winners. Only a few won cash awards, but every design suitable for production was exhibited to industry buyers. From 1916 to 1922 there were five consecutive *Women's Wear* contests for designs ready for production and six parallel contests for hand-decorated fabrics, chiefly batiks or block prints, requiring adaptation. Design contests were not new,[10] but the *Women's Wear* contests were the first ones related to textiles to be nationally based and open to all comers—amateurs, students, and established designers. The 1920 competition attracted one thousand submissions from thirty-four states.[11] To encourage originality and, especially, to avoid duplication of European patterns, another innovation was that design sources were specified to be what Crawford called "primitive" (the arts of Native Americans, the Maya or the Ainu, for example).

Of the forty-six designers noted as consistently successful competitors, 75 percent were women.[12] Only a few, however, became and remained well-known: Marion Dorn, Ilonka Karasz, Ruth Reeves, Hazel Burnham Slaughter, and Marguerite Zorach.[13] None are known to have trained specifi-

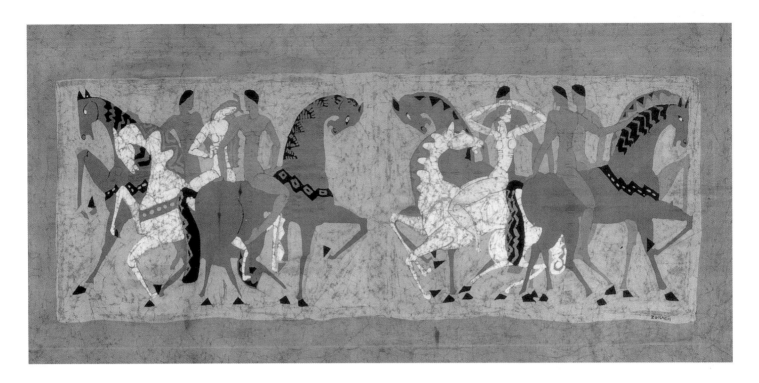

Fig. 5-1. Marguerite Zorach. Scarf, 1918. Silk batik. Museum of Fine Arts, Boston, Gift of Mrs. Alice B. Hornby (68.592).

cally in designing for industry, but they had in common a practical application of their drawing skills and firsthand experience of European art and design.

Initially, the textile medium of artistic expression for all these women was batik (fig. 5-1). It had the economic advantages of requiring only a home studio with little special equipment and, during the late 1910s and early 1920s in particular, limited editions and one-off creations found a ready market among New York's specialty shops. It was also through one-off batiks submitted to the contests that Karasz and Slaughter had designs produced by H. R. Mallinson and Company. All five women retained freelance status and, typically, generated much of their own publicity. They considered themselves artists as much as designers, competing effectively over the long term with numerous other artists, and occasionally celebrities, who made forays into textile design.[14]

Martha Ryther, who won more prizes than any other competitor, disappeared from public view, although she had been once actively engaged in designing for the Mallinson company and another silk-printing firm, Belding Brothers. This occurred despite the fact that she, with Reeves, Karasz, and fashion designer Jessie Franklin Turner, had gained notice for batiks shown in a 1919 exhibition held at the American Museum of Natural History in New York as part of the campaign.[15] Her later anonymity was typical of those working within the industry; other prize winners of 1922 included a number of students at the New York School of Fine and Applied Arts (now Parsons School of Design), some of whom presumably found employment but left little record of their work.[16]

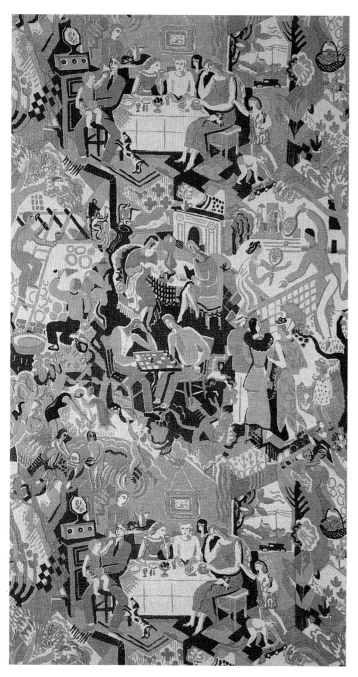

Fig. 5-2. Ruth Reeves.
"American Scene" textile,
1930. Block-printed cotton.
Yale University Art Gallery,
New Haven, Connecticut,
The John P. Axelrod, B.A.
1968, Collection of
American Art (1995.49.7).
Checklist no. 46

AMERICAN FABRICS FOR MODERN INTERIORS

By the end of the 1920s, batik had ceased to be considered experimental; popular women's magazines gave instructions for batik projects that were "no longer a thing set apart for talented artists alone to work at."[17] Dorn, Karasz, and Reeves were among those who moved on to explore the relatively untried possibilities of hand screenprinting, producing both custom wall hangings for private clients and furnishing fabrics, which were sometimes transferred to commercial manufacture, but still in limited runs. Even so, textiles were the first medium through which the potential of artistic screen-process printing was explored extensively[18]; indeed, Reeves often based hand screen-printed furnishing fabrics on her paintings.[19] Individually and as a group, these women received significant coverage in various art journals and in popular women's magazines, where their work was referred to as "modern," "experimental," and representative of the American spirit[20] (even though it was often informed by a wide variety of European modern art and design sources).

Evoking such then-new phrases as "the American way of life" and "the American dream"[21] is "American Scene" (fig. 5-2) by Ruth Reeves, which was first exhibited in 1930. Unlike the industry's norm for furnishing fabrics—florals or formal brocades and damasks—"American Scene" celebrates everyday life: productive work, sports and sportsmanship, the happy family. Abstract prints such as Henriette Reiss's "Rhythm" series (fig. 5-3) or Vally Wieselthier's stylized "Children at Play" (fig. 5-4) touched a similar chord and evoked the freedom suggested by music or play. In different ways, each presented an idealized view of American life.[22]

The Depression rendered such designs more poignant, and the government's response to the economic turmoil of the 1930s aided the emergence of an American design style.[23] These "American" textile patterns drew upon and familiarized a wider buying public with the imagery of the so-called American Scene art movement—a form of realism that swept the country in the wake of the stock market crash of 1929. From 1930 until about 1947, social and political factors gradually reduced both the *cachet* and the practicality of European sourcing of textile designs and prototypes, while increasing the number of émigré designers actually at work in America itself. The search for and development of an American style in the

Fig. 5-3. Henriette Reiss. "Rhythm" series, 1928. Printed silk. Brooklyn Museum of Art, H. Randolph Lever Fund (1996.125.1).

end embraced many who were foreign born, Reiss and Wieselthier among them. Reiss, an Englishwoman married to the Austrian artist, Winold Reiss, lived in New City, New York, the artists' colony where Reeves, Ryther, and Dorn also lived. Reiss had studied textile design in England, Germany, and Switzerland. In America she was noted as having "developed a number of promising pupils" by 1928.[24] In the same year Wieselthier, well-known for textiles, wallpapers, and ceramics designed or hand-decorated for the Weiner Werkstätte, left Vienna for New York.[25] Pola Hoffmann, the daughter-in-law of the famous architect and designer Josef Hoffmann, was also connected with progressive Viennese design. She arrived in America in 1934 at the age of thirty-two, initially designing interiors, rugs, and metalwork with her first husband, Wolfgang Hoffmann.[26] By 1939 she was a weaver-designer of some repute, working as Pola Stout, after her marriage to mystery writer Rex Stout.

Until the early 1930s fashionable textiles emphasized surface rather than structure, encouraging designers whose work was based on artistic skills such as graphics, fine art, and pattern-making, rather than on one particular technique.[27] This had allowed women trained in fine or graphic arts to design mass produced textiles and, as Reeves commented later, satisfied the need to earn a living at whatever artwork could be found.[28] Their strength was in printed textiles, as evidenced by fabrics illustrated in the 1931 *Annual* of the American Union of Decorative Artists and Craftsmen (AUDAC).[29] The alternative for women with artistic skills was to handproduce, or design for limited edition, products such as rugs, tapestries, and embroideries, which were increasingly important vehicles for designer-makers such as Zorach (fig. 5-5) during the 1930s and 1940s, when specialist handweavers rose to prominence.

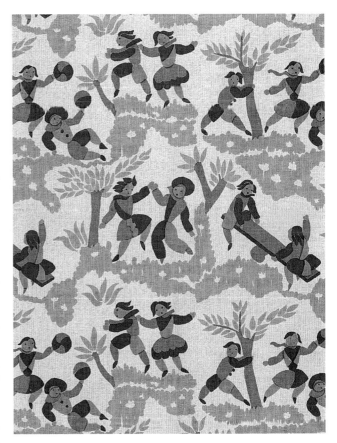

Fig. 5-4. Valerie (Vally) Wieselthier. "Children at Play" textile, ca. 1929. Printed by F. Schumacher and Company, New York. Linen. F. Schumacher and Company Archives, New York. *Checklist no. 44*

Many of the European émigré designers had specialized training in weaving. Since much of European manufacturing remained handpowered until mid-century, even an education in an Arts and Crafts school promoted knowledge of "industry" and manufacture, albeit of a handcrafted nature. Such training bore fruit in America from the 1940s through the 1960s, particularly in the development of handwoven prototypes for powerloom production.

Of the émigré women considered here, Maria Kipp (fig. 5-6) was the first to move to the United States, arriving in 1924. She had studied privately in drawing and painting, attended the Munich Kunstgewerbeschule for two years, and then was the first female student at the State Academy for the Textile Industries, in Muenchberg, Bavaria, graduating in 1923. There she studied all aspects of hand- and powerwoven textile production including spinning, cloth analysis, loom construction, and marketing. Once settled in Los Angeles, Kipp opened a studio specializing in handwoven furnishing fabrics for architects and interior designers, including Richard Neutra and Rudolph Schindler. Among her celebrity clients were Walt Disney and

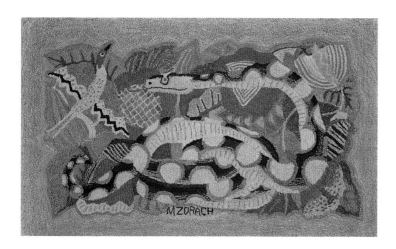

Fig. 5-5. Marguerite Zorach. "The Jungle" rug, 1936. Hand-hooked wool and jute. The Museum of Modern Art, New York, Gift of A. Conger Goodyear, 137. *Checklist no. 63*

Fig. 5-6. Maria Kipp. Drapery fabric, 1935. Hand-woven cotton and wool. Dallas Museum of Art, The Jane R. Van Hooser Collection, Gift of Edd M. Van Hooser, the Stephen W. Van Hooser family, and the Diana Jane Shelby family (1998.19). *Checklist no. 58*

Claudette Colbert. Her commissions were diverse: from the Mormon Temple in Salt Lake City to *Air Force One*. Although less-well-known today than her contemporaries Anni Albers and Dorothy Liebes, Kipp won the first award for woven fabrics, given by the American Institute of Decorators in 1948, and until 1977 maintained a profitable handloom business, supporting some eighteen to twenty employees.[30]

Pola Stout, like Kipp, trained in a European Kunstgewerbeschule, but had a far more varied career. She designed hand- and powerwoven fabrics for Dunhill, Clare Potter, Elizabeth Hawes, Molyneux, Muriel King, Valentina, and, during World War II, Botany Mills. After the war she had her own mill (1945–54), with clients that included Hollywood film costume designers Adrian[31] and Irene. Throughout her career, she taught weaving and fashion design at various institutions, devoting herself to this in the 1960s, when she was employed by the Fashion Institute of Technology (FIT), New York.[32]

Kipp and her husband came to the United States independent of sponsorship. Other European émigrés, some escaping the growing threat of Nazism, were sponsored by individuals or institutions guaranteeing employment at the handful of schools trying to improve craft training in America. Architect Philip Johnson, for example, secured teaching positions for Bauhauslers Anni and Josef Albers at Black Mountain College, North Carolina, in 1933 (fig. 5-7). Their departure from Black Mountain in 1949 coincided with an exhibition of Anni's woven textiles at the Museum of Modern Art, New York, the first devoted to a single textile artist. Although she abandoned weaving for printmaking in the mid-1960s, Albers's publications and the MoMA show, which traveled to twenty-six North American museums between 1949 and 1953, ensured her continued influence in the 1960s and 1970s.[33]

Like Albers, Marianne Strengell came to the United States as a sponsored weaver. Arriving at the Cranbrook Academy of Art, in Bloomfield, Michigan, in 1937 under the auspices of Loja and Eliel Saarinen, Strengell taught weaving and joined a group of Swedish professional designers and weavers who staffed Studio Loja Saarinen. Strengell became head of the textile department upon Loja's retirement in 1942. An influential teacher—her students included Win Anderson, Jack Lenor Larsen, and Ed Rossbach—Strengell's presence at Cranbrook until the early 1960s was seminal for American woven fabrics.[34] She also formed strong ties with industry. In 1945 Strengell, with the help of former student Robert Sailors, installed one of the first powerlooms to be found in an American art college (as

Fig. 5-7. Anni Albers. Display fabric sample, 1944. Handwoven cellophane and jute. The Museum of Modern Art, New York, Gift of the designer (454.51).

Fig. 5-8. Marianne Strengell. "Taj Mahal" automobile upholstery fabric for 1959 Lincoln Continental, ca. 1958. Woven by Chatham Manufacturing Company, Elkin, North Carolina. Cotton, rayon, and metallic strands. Cranbrook Art Museum, Bloomfield Hills, Michigan, Museum purchase with funds from the Cranbrook Foundation (CAM 1981.5). *Checklist no. 111*

opposed to a technical college), demonstrating her commitment to design for mass production. Her clients included General Motors, the Ford Motor Company, and Knoll Associates; industrial designers Raymond Loewy and Russell Wright; and the architectural firms of Skidmore, Owings and Merrill, and Eero Saarinen and Associates. "Taj Mahal" (fig. 5-8) typifies the many automotive fabrics Strengell designed; woven by the Chatham Manufacturing Company, it was used by Ford in the 1959 Lincoln Continental, their top-of-the-line luxury car.

While Kipp remained faithful to hand power until later in her career and Albers moved toward textile art and then art without the textiles, an American-born handweaver—Dorothy Wright Liebes—was making a substantial contribution to the development of powerwoven cloths. Like many of her colleagues, she hoped to be a painter but found her metier in textiles, which she studied under Anne Swainson at the University of California, Berkeley, where she completed a second bachelor's degree, in applied arts. In 1930, after a year in France studying with the renowned handweaver Paul Rodier, Liebes opened a San Francisco studio, specializing, like Kipp, in customwork for architects and interior designers. When Liebes became consulting designer and stylist for Goodall Fabrics in 1940, her role was to handweave prototypes for power-loom production, a practice she continued almost until her death in 1973.

Although a concept associated with the Bauhaus (and thus, in America, with Albers and fellow Bauhausler Marli Ehrman, who taught weaving at the Chicago Institute of Design from 1939 to 1947[35]), the use of craft as a means of designing for industrial production had been widely advocated by Crawford during the 1910s and had been the guiding principle behind the early contests based on hand-decorated fabrics. Craft-scale production also had the advantage—as demonstrated by those who worked in batik during its heyday—of being semi-industrial (that is, capable of producing repeat lengths), yet "hands on" and creatively satisfying. In the middle decades of the twentieth century it was the rug and cloth weavers who were most closely associated with this type of production, particularly after the start of World War II, when textile design and manufacture declined as government restricted the use of dyestuffs and raw materials. New designs for roller-prints could not be considered because the copper used for the engraved printing cylinders was needed for shell casings and other war-related products. Significant numbers of new designs were not available to the public from roller-printers until 1947, and the alternative, mechanized screen-printing, was not

widely available until the 1960s. Meanwhile, hand or craft-scale production (including *hand* screen-printing) filled the gap, particularly when it used unrestricted materials such as mohair, one of the fibers explored by Liebes for Goodall Fabrics.

The vitality of craft-scale textile production, and women's role in it from the late 1930s to the 1960s, was apparent at the 1939 Golden Gate International Exposition, in San Francisco. Liebes, as director of the decorative arts division, was responsible for the selection of modern rugs and textiles representing some 150 designers from some dozen countries, mainly the United States, France, England, and Scandinavia. Women far outnumbered men among the designer-makers. Those working in the United States included Albers, Reeves, Saarinen, Strengell, Stout, and Zorach.[36] Theresa Kilham and Marguerita Mergentime, textile printers who had been included in the AUDAC 1931 *Annual*, were also selected, as were handweavers Anne Franke (of the Willich-Franke Studios, New York) and Helen and Boris Kroll (whose New York studio was then only a year old but would become a thriving international business that included hand screen prints).[37] California was particularly well-represented by female weavers.[38]

The 1939 exposition illustrated that woven cloth and rug making were the main expression of modernity within textiles. As Liebes herself urged: "Consider the shining cellophanes, dull acetates, lacquered plastics, treated leathers, artificial horsehair, nontarnishable metals and glass threads!"[39] Liebes used the term *artist-designer* not only for those who solely designed (mainly for mass production by machine) but also for those who were designer-makers (usually by hand). Nevertheless, there was an apparent division between the men and women: the former seldom made, while the latter almost invariably did.[40] In 1948, when the SS *United States* was refitted, the handwoven fabrics and prototypes for powerwoven cloths for this prestigious project were all supplied by women: Kipp, Liebes, Grete Franke, Abbie Blum (in 1952 requiring no description beyond "this well-known New York weaver" but today virtually forgotten), and the Aileen Deleine studio, New York.[41] In contrast, the 1956 exhibition, *Textiles USA*, at the Museum of Modern Art, New York, indicated the degree to which men had begun to dominate in sectors of the industry. Of the designers of apparel fabrics, thirty were men as opposed to thirteen women, and all ten designers of industrial-use fabrics were men. Only in home furnishings did women outnumber men (twenty-two as opposed to eighteen), and largely by virtue of the inclusion of a large number of handwoven textiles. By 1960, when *Design Quarterly* devoted a double issue to American handweaving, of the fifty-seven designers selected, fifty were women with independent home- or college-based studios, where, in several cases, prototypes for industry were made.[42] None were employed full-time by a single manufacturer.

Public recognition of designers became increasingly important with the onset of World War II, when a shortage of salesmen induced wholesale fabric companies to advertise directly to consumers as a matter of policy, rather than on an occasional basis, as before. The scarcity of mass-produced consumer goods meant that corporate advertisements (featuring, for example, designers rather than products) became more common. Propelled into the public arena were several freelance women designers, some of whom controlled their own destinies by dint of their reputation in other fields, such as fine arts, and others by virtue of their direct involvement with company design policy, whether as owners or design directors. In either case, the most successful designers in the postwar years were those whose names were linked with important manufacturers, architects, and furniture and interior designers, or with institutions, whether galleries, museums, or colleges.

Even Marion Dorn, in the 1930s one of Britain's leading freelance textile designers, faced difficulties when she returned to the United States in 1940. Her companion, graphic designer Edward McKnight Kauffer, remembered that she "peddled Seventh Avenue and made scarves" (fig. 5-9), surviving through "infinite scraping and working like hell on small jobs, anything that came along."[43] Although she resumed her career in the 1950s, it was as consultant designer for the custom carpet company, Edward Fields. She obtained fewer commissions for printed textiles and never reestablished her own design company. Reeves, too, tried to do at the end of the war what she had done throughout her, thus far, successful career: she sought sponsorship for an exhibition of the drawings and paintings executed while a Guggenheim Fellow in Latin America for eighteen months in 1940–41, to be shown with the textiles derived from them. For the first time in her life, she failed. Neither MoMA (where she hoped to show her work) nor IBM (whose financial backing she sought) were interested.[44] Perhaps she had aimed too high. Perhaps, as Dorn found, freelancing was no longer the route to success it had been. Or perhaps it was that women, having done so much to establish freelance printed textile design as a profitable profession, were now competing with the "stars" of the design and architectural professions, as well as "known" modern artists, who were sought after for their greater "promotional appeal."[45]

New marketing strategies (and increasing confidence in American artists and designers) coincided with a flurry of collaborations between galleries and textile manufacturers.[46] Among these were the *American Artist Print*

Fig. 5-9. Marion Dorn. Headscarf, 1941–43. Hand-screen-printed silk. Philadelphia Museum of Art, Given by Mrs. John Platt (1971-042-001). *Checklist no. 80*

Series of 1947, for which the Onondaga Silk Company joined forces with New York's Midtown Gallery, which showed the work of living American artists, and the design division of the Associated American Artists, New York,[47] which was "dedicated to applying art to industry at budget prices" through a program that included textiles, wallpapers, ceramics, and graphic design.[48] Through the "Signature Fabrics" collection of dress and menswear cloths, first marketed by M. Lowenstein and Sons in 1952, and three collections of furnishing textiles, produced in conjunction with Riverdale Fabrics in 1952–53, members of the Associated American Artists, among them Ilonka Karasz, Doris Lee, Laura Jean Allen, and other women, designed textiles that were exhibited at the American Artists' Gallery and widely marketed as practical and affordable designs of museum caliber.[49] For interiors, by 1953 there was "a complete line of home furnishings in the same prints, including ready-made draperies, . . . studio couch covers, pillows, and lampshades, all of which coordinated with Stonelain ceramics—bowls, pitchers, plates, and ashtrays—also designed by Associated American Artists."[50] A feature of this joint effort was that each textile bore the signature of the designer on the selvage, a practice that was unusual within the industry, although not unknown.

The numerous "art"-into-textile collections in the ten or so years after the war promoted some women, but they were far outnumbered by men. Manufacturers actively promoted these designers as "stars" in their advertisements, hoping to distinguish their products and boost sales. Among the already-established female designers, Liebes was one of the few to achieve star status. She became known for her boldly textured woven fabrics incorporating disparate materials such as bamboo and Lurex (made by the Dobeckman Company, to which she was a consultant from 1946 to 1962; fig. 5-10). Her work for Goodall Fabrics was widely promoted in the 1940s and 1950s, both contributing to her fame and capitalizing on her reputation as a designer and consultant.[51]

NEW FIRMS, NEW OPPORTUNITIES

A more certain but financially riskier route to public recognition and/or control over seeing designs into production was to create one's own firm. This avenue served a number of women well, and the most successful among them from the mid 1940s into the 1970s formed partnerships with their husbands.[52] Helen Kroll has already been mentioned. Ray Eames, a painter and sculptor, formed a partnership with her husband, Charles Eames, in 1941. Although she concentrated on product design, she was the sole female contributor to Schiffer Prints' "Stimulus Fabrics" range of "star"-designer screen-printed textiles in the early 1950s (fig. 5-11). By contrast Estelle Laverne, Ruth Adler, Eleanor McMaster, Vera Neumann, Doris (d.d.) Tillet, and Marcelle Tolkoff were more closely associated with textiles. On the whole, their enterprises were independent family-owned businesses, capitalizing on

Fig. 5-10. Dorothy Liebes. "Mexican Plaid" drapery panel, 1938–40. Wool, cotton, silk, rayon, metal laminate. The Metropolitan Museum of Art, New York, Gift of Dorothy Liebes Design, 1973 (1973.129.2). *Checklist no. 66*

Fig. 5-11. Ray Eames. "Crosspatch" textile, designed ca. 1945. Screenprinted by Schiffer Prints, Division of Mil-Art Company, New York, ca. 1947–49. Cotton. Lucia Eames dba Eames Office.

the postwar up-market growth industries of well-designed furniture and interior fittings, and/or fashionable sportswear.

Estelle and Erwine Laverne met at the Art Students League, New York,[53] and established Laverne Originals (later Laverne International) in 1934, originally producing wallpapers but soon printing the same designs on cloth—often of two or more different types. By the 1940s the Lavernes were well-known for textile designs by Estelle (fig. 5-12) and by others, including artists such as Alexander Calder. By the time the firm closed in the mid-1960s it had received many accolades including four Good Design Awards from MoMA and five awards from the American Institute of Decorators. Between 1947 and 1958 another recipient of awards from the same two institutions was Ruth Adler. Born to a Bauhausler mother in Frankfurt, Germany, she came to the United States at the age of sixteen, studying design, fashion illustration, and architecture at Harvard University, the Rhode Island School of Design, and the Cranbrook Academy of Art. From 1947 to 1951 she ran her own studio, where textiles were designed and custom-screened (fig. 5-13). From 1949 to 1977, with her architect-trained husband, Edward Schnee, she was co-owner and creative director of the inte-

rior design firm, Adler Schnee, Detroit, which continued for some time to issue printed textiles.[54]

A span of thirty-odd years also characterizes other husband and wife operations—Elenhank, Printex, and the Tillet partnership, all founded in 1946–47. The first was initiated by Chicago Art Institute–trained Eleanor (El) McMaster as a home industry, using linoleum blocks she designed and cut. The printing was carried out with the help of her husband, Henry (Hank) Kluck II. Only in 1958 were their Chicago studio and home separated. By that date fabrics and wallpaper were hand screen-printed for their own range in a five-thousand-square-foot workspace; tufted-woven fabrics had been introduced; and custom designing begun, the latter extending, in 1961, to consultancies with rug, wallpaneling, and cloth-making companies. Printex, on the other hand, was founded by Vera and George Neumann in Ossining, New York, as a textile printing company, "one of the most up-to-date and efficient units of its kind in the world."[55] Vera Neumann designed, and her husband, who came from a Hungarian textile-printing family, supervised the production and coloring until his death in 1962. The Tillets, from England, had a similar partnership in that Doris (d.d.) was a designer

Fig. 5.12. Estelle Laverne. "Fun to Run" textile, 1947–48. Silkscreen printed by Laverne Originals, New York. Rayon and gold foil twill weave. The Montreal Museum of Fine Arts/Montreal Museum of Decorative Arts, Gift of Alan Moss (D85.145.1). *Checklist no. 92*

Fig. 5.13. Ruth Adler Schnee. "Seedy Weeds" textile, 1953–54. Hand-screen-printed by Adler-Schnee Associates, Detroit, Michigan. Cotton. The Montreal Museum of Fine Arts/Montreal Museum of Decorative Arts, The Liliane and David M. Stewart Collection (D85.148.1). *Checklist no. 101*

while Leslie, who came from a mill-owning family, was a textile engineer. Unlike the Neumanns at Printex, however, the Tillets shared credit for their printed fashion fabric designs, supplied at first from a shop in New York. Ultimately the firm encompassed the shop, their own printing plant, design consultancy, and a beachwear fabric firm, Belle Fabrics Division.

Elenhank, Adler Schnee, and Laverne won awards and established a credible international market with relatively exclusive products, sold to decorators and architects; Printex aimed directly at the mass market and by the late 1970s, the firm's tableware, bed linen, scarves, and sportswear, most bearing the signature "Vera" with a ladybug logo, were in twelve hundred stores nationwide with annual sales of over a million dollars.[56] Although the buying public knew her signed work, Vera also designed scarves under license for Perry Ellis (a former employee) and Anne Klein, bedding for Burlington Industries, and furnishing fabrics for the Scalamandré and Schumacher firms (fig. 5-14).

Fig. 5-14. Vera Neumann. "Papaya" textile, 1952. Printed by F. Schumacher and Company, New York. Cotton. F. Schumacher and Company Archives, New York. *Checklist no. 99*

Screen-printing—by hand and, in the case of Printex, by machine—provided the basis by which these enterprises expanded. These women designers worked with relatively new and inexpensive technology, transforming textile patterns into flat, highly stylized designs of the type best-suited to a stencillike process. They gained notice from the novelty and prestige of screen-printed fabrics as well as the images they offered of husband and wife, sleeves rolled up, working together. Additional attention came from their associations with famous people: the artists commissioned for Laverne's "Contempora" series; Adler's childhood painting lessons with Paul Klee and architectural studies with Walter Gropius; or the design of Printex's New York showrooms by Marcel Breuer. The Tillets, too, took a stand for good design.[57] It all made good copy. In a profile of 1964, Vera outlined the foremost advantage for all these "designing wives," commenting that the designer (meaning herself) ruled at Printex: there was no sales manager to please and no president (except herself) whose taste controlled design.[58]

Elenhank and the Tillets also took advantage of other new processes; a serviceable acrylic coating and practical application of paper backing took Elenhank from wallpaper into fabric wallcoverings in 1967, while the Tillets became known for printed wools and blends, probably using the new reactive dyes (directly applied and many not requiring heat) that first emerged for acrylic fibers and fabrics in 1956. Advances in chemistry and in the use of

plastics made it possible for the same bright, even psychedelic, print to be used on a dress (which might be made of paper) and on a vinyl raincoat or on coordinating bath towels and bath accessories. Marcelle and Daniel Tolkoff and their companies Tiger Fabrics (established 1959) and Tiger Things (1965) championed this minor revolution (fig. 5-15). Having met at Fuller Fabrics, they initially set up their own sportswear cotton business because, although they could find buyers for the more adventurous concepts, manufacturers were not forthcoming. Daniel Tolkoff is credited with having developed the first vinyl coating for fabric that neither "crazed" nor dulled the original colors. Using this process, the Tolkoffs produced vinyl prints for a wide range of objects.[59]

Fig. 5-15. Marcelle Tolkoff. Furnishing fabric, ca. 1964. Printed by Tiger Fabrics. Cotton. The Museum at the Fashion Institute of Technology, New York.

In the last quarter of the twentieth century, with another generation of designers interested in handweaving, computer-aided design (CAD) provided new opportunities for women to take a leading role once again in the evolution of a new design process. This is illustrated by the contrasting experiences of Patrice George and Jhane Barnes. George, with a degree in art history, sold her weaving at craft fairs until 1975, when she took up a four-year position as a designer/stylist for the textile manufacturer Cohama. Then freelance, in 1982 she tested the first computer-driven loom for AVL (Ahrens and Violette Looms) and, under the auspices of New York's School of Visual Arts, taught this then-revolutionary technique to industry specialists and teachers.[60] Among her specialities today are cubicle cloths for hospitals—fabrics taken for granted, much like those designed by Strengell for the automotive industry. In contrast to George, Barnes has a higher profile, having launched her own company in 1976 while still a student at FIT. One of a handful of women to design menswear under her own name, she was an eager and early convert to the use of the computer. Finding that the purchased program, while dispensing with the labor-intensive task of making handwoven samples, was less than perfect, Barnes's love of mathematics led her and a team of specialists to develop her own software, using algorithms to produce patterns.[61] She also designed furnishing fabrics under license to Knoll Associates from 1983 to 1998 (fig. 5-16), at which date she founded Jhane Barnes Textiles, which supplies textile designs to the contract furniture industry.

Fig. 5-16. Jhane Barnes. "Nuance" textile, 1989. Manufactured by Knoll Textiles, New York. Cotton, rayon, silk, and polyester. Courtesy of Knoll Textiles, New York. *Checklist no. 170*

Also based in New York is the weaver-designer Gretchen Bellinger, owner of her own firm since 1976. A coup for her firm was the contract from British Airways to refit their ten-year-old Concorde fleet in 1986. Bellinger selected the color schemes and fabrics, choosing her own company's robust worsted corded fabrics for seating, and the more fluid "Arcadia" for the interior divider curtains (fig. 5-17). She employs a number of studio designers, who, like those who worked for H. R. Mallinson and Company, Dorothy Liebes, or, more recently, Martha Stewart, rarely expect their contributions to be publicly acknowledged because it is still not customary to do so.

PLAYING THE GAME: CORPORATE STRATEGIES

The 1970s saw a revived interest in traditional handcraft techniques including beading and embroidery (often applied to blue jeans), tie-dye, and macramé, which accompanied a "back-to-basics" philosophy. The parallel emergence of the fiber art movement gave ample opportunity for women to find individual expression and recognition. The manufacturing sector, including firms such as Greeff Fabrics and Brunschwig and Fils, responded by focusing on natural fibers in solid colors or in retro prints. At Greeff the design director from 1953 to 1979 was Virginia Nepodal,[62] winner of two MoMA design awards in the 1940s. Even higher up the corporate ladder are the Brunschwig co-owner, and senior vice president since 1982, Murray Douglas, and the vice president for development since 1978, Ross Francis. Corporate strategy, however, combined with an emphasis on the historical basis of their ranges, does not prioritize publicizing the talents of such women.

Fig. 5-17. Gretchen Bellinger. "Arcadia" textile, 1976. Produced by Gretchen Bellinger, New York. Wool and silk. The Montreal Museum of Fine Arts/ Montreal Museum of Decorative Arts, Gift of Gretchen Bellinger (D85.204.1). *Checklist no. 144*

The changes in textile production and marketing over the second half of the twentieth century allowed room for women studio designers to develop their careers within the multinational textile industry. Those who worked for Liebes, Kipp, Bellinger, and others remained relatively anonymous, not least because the increasingly competitive market required brand recognition above all. Some studio designers, however, became known in their own right. Tammis Keefe, for example, worked in Liebes's San Francisco and New York studios for a number of years and, through Liebes, supplied printed textile designs to Goodall Fabrics. By 1949 Keefe was also working freelance for other companies.[63] Her "Lemons" fabric (fig. 5-18) was shown in the MoMA *Good Design* exhibition of 1950[64]; this and the employment of a publicist, Rea Lubar, boosted her career, cut short by her early death in 1960.[65]

For in-house designers, the knack for garnering publicity was an increasingly critical aspect of their contribution to a company's success. Hungarian-émigré textile designer Eszter Haraszty achieved "name" recognition in the United States during her tenure (1949–55) as director of Knoll Textiles, a division of Knoll Associates, and won five Association of Interior Designers' awards. A publicist's dream, she had trained in art history, was acknowledged as a brilliant colorist, and known for her own vibrant personality.[66] She came from a privileged background in terms of modernist design, which included her parents' friendship with Marcel Breuer and his wife.

Fig. 5-19. Eszter Haraszty.
"Fibra" textile, 1953. Block-
printed by Knoll Textiles,
New York. Linen. Dallas
Museum of Art, 20th
Century Design Fund
(1996.235). *Checklist no. 100*

Haraszty worked with the designer-photographer Herbert Matter on Knoll's
distinctive graphics and advertising, including that which promoted her own
work[67] The success of some of her humorous designs—such as the in-joke
"Fibra" (a print produced from 1953 to 1965 and showing a blowup of the
heddles of a handloom; fig. 5-19)—meant she was identified with Knoll long
after her departure, when she became a color and interior design consul-
tant.[68] The Tiger companies also benefited from well-planned publicity.
Marcelle Tolkoff had trained in journalism and initially pursued a career in
public relations. In 1961 she took on this role, very successfully, for Tiger; it
was not until 1967 that she was noted as in charge of their designs, rather than
the company's publicist.[69]

Fig. 5-20. Win Anderson and Jack Lenor Larsen. "Magnum" textile, 1970-73. Produced by Aristocrat Embroidery, Guttenberg, New Jersy, for Jack Lenor Larsen, New York. Mylar, cotton, vinyl, nylon, and polyester. The Minneapolis Institute of Arts, Gift of Charles M. Senseman (85.26). *Checklist no. 126*

In the second half of the century, the most sustained international recognition was granted to the companies owned by Jack Lenor Larsen (JLL). Few knew of the significant contribution made by Win Anderson to JLL's reputation, although Larson's recent memoir, peppered with references to "Win and I," redresses this.[70] As weaving students at the University of Washington, Seattle, and the Cranbrook Academy of Art, Anderson and Larsen had already collaborated when she became manager of his design studio in 1952. By the mid-1960s she was president of the company's separate JLL design corporation, and until 1976 she was active in creating some of JLL's most noted fabrics, such as the varied-warp weave of 1954, "Remulade," and the embroidered mirror Mylar curtains made first for the Phoenix Opera House as curtains and in 1970 released as the upholstery and wallcovering fabric called "Magnum" (fig. 5-20). With a production manager Anderson worked on both weaves and prints, the latter mainly supplied by freelance designers. She said of her role that the "talent is in making the

Fig. 5-21. Lori Weitzner. "Jacob's Ladder: Simply Grand" textile, 1993. Machine woven by Jack Lenor Larson, Inc., New York. Cotton and rayon. Collection of Larson, Inc., New York.

designs *work*, using the equipment that's available depending on the producer—in thirty-seven countries; there's nothing like the thrill of the fifty-yard prototype roll that fits the production facility."[71]

Far different is the position of Lori Weitzner, a more recent designer for JLL (fig. 5-21). She completed a BFA in textile design at Syracuse University in 1983 and, after a year at the textile firm of Fieldcrest, launched her own studio in Italy, selling to Missoni, Fede Cheti, and others. As she became increasingly well known, "she determined to license her name and produce her own collections,"[72] building a diverse portfolio including designing packaging, dishes, scarves, stationery, murals, and textiles. In 1993 Larsen, "setting a company precedent . . . hired an outside designer [Weitzner] to create the company's fall textile collection,"[73] an ongoing role for which she continues to gain notice.

Like many of the women discussed in this chapter, Dorothy Cosonas-de Fiebre has a fine-art as well as design background. She joined Unika Vaev in 1984, in the last year of her degrees in both fine arts and textiles at FIT, where one of her parttime instructors was Sina Pearson, the company's design director.[74] Quickly becoming Pearson's assistant, Cosonas-de Fiebre moved steadily up the ladder (including a four-year stint as a sales representative); in 1999 she joined the board as vice president of design. Her woven fabric collections—three per year of three to four patterns and sourced from mills around the world—are carefully themed and coordinated. Patterned fabrics—such as "Futura" (from the 1998 "Reflections" collection, inspired by Venetian glass) and "Wink" (from the "2000" collection; fig. 5-22), come in eight to twelve colors, and solids in twelve to sixteen. They exemplify the designer's role in today's corporate "boutique" market; it is "a whole process: aside from finalizing the design, contemporary coloring is vital and the press like a name and a face behind the product."[75] Although she was made design director in 1994, she had to wait four years before her name

Fig. 5-22. Dorothy Cosonas-deFiebre. "Wink" textile, 1999. Manufactured by Unika Vaev, a division of the ICF Group, New York. Nylon, wool, polyester, rayon, and cotton. Collection of Unika Vaev, New York. *Checklist no. 217*

appeared on the firm's fabric tags. Although she can name eight to ten women who head up similar design divisions supplying textiles directly to interior designers or architects, such credit, she observes, is "always asked for—never offered." Asked what it's like to be a woman in this industry, she said simply, "It's tough."[76]

Women are still rare at board level, despite their track record.[77] For most of the century textile design and home-production were recommended to women students, designers in other fields, and artists as a means of "well-paying self support."[78] For many it has been that and much more. Whether working as freelancers, as studio designers, or as heads of firms or partners within them, women designers played a major role in the manufacture of textiles in the United States in the twentieth century, often taking creative risks with new production and promotional techniques, and shaping the design styles associated with them.

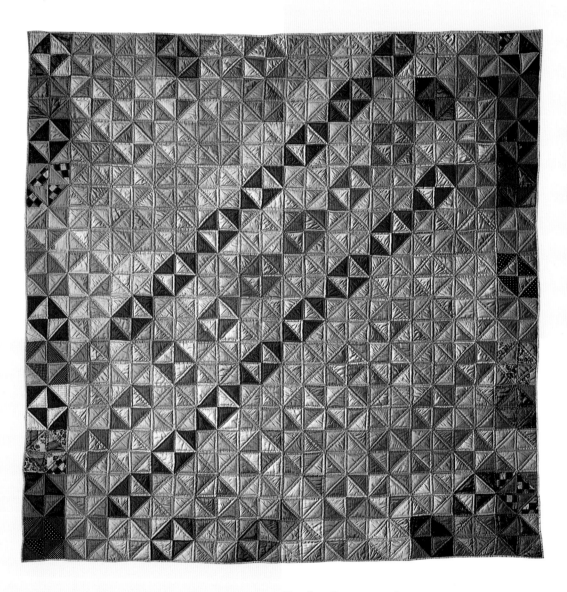

Fig. 6-1. Designer unknown.
"Broken Dishes" quilt, ca.
1920. Pieced and quilted silk
and cotton. The Metropolitan
Museum of Art, Sansbury-Mills
Fund, 1973 (1973.205).

6

JACQUELINE M. ATKINS

Tradition
and
Transformation

WOMEN

QUILT DESIGNERS

OF ALL THE TEXTILES rooted in a utilitarian past, few have inspired such a wide-ranging creative exploration in design as quilts. Quilts came to America from Europe, but their full flowering took place in the United States, propelled almost exclusively by women. This is a dynamic design tradition. Even so-called traditional designs—created in the eighteenth and nineteenth centuries, versions of which were handed down from mother to daughter, neighbor to neighbor, friend to friend—were anything but static; they were constantly revitalized and renewed by women who, with little or no formal design or art training, commanded "a knowledge of the power of form and the value of color (fig. 6-1)."[1]

Quilts have been called "The Great American Art."[2] Countless numbers of women, regardless of race, class, education, or economic level, have participated in and contributed to quiltmaking, creating over the course of the years a richly textured design tradition that indisputably belongs to a diversity of women. Though the quilt tradition has developed in different ways among different groups, including European Americans, African Americans, Amish, and Hawaiians, it is a part of *all* women's tradition and has come to symbolize "women's culture." It is, however, a design tradition too often marginalized or considered trivial because of its association with "craft" and "women's work." British design historian Cheryl Buckley notes that "To exclude craft from design history is, in effect, to exclude from design history much of what women designed," an observation especially pertinent to quiltmaking.[3] Furthermore, Patricia Mainardi, one of the first American women to consider quilts as central to women's cultural heritage, points out that "women's work" is generally undervalued; she notes that "Quilts have been underrated precisely for the same reason that jazz, the great American music, was so long underrated—because the 'wrong' people were making it, and because these people, for sexist and racist reasons, have not been allowed to represent or define American culture."[4] All this notwithstanding, neither marginalization nor trivialization has dimmed the dynamism and exuberance intrinsic to this medium, and quilts have continued to serve as the creative canvases that many women—and a few men—have chosen to express their design ideas.[5]

Fig. 6-2. "The New Flower Patchwork Quilts: Designs by Marie D. Webster." From *Ladies Home Journal* (January 1912).

The twentieth century saw dramatic changes in the way quilts were designed and perceived, as well as in how designs were disseminated. This chapter examines these changes as well as the increasing professionalization of the field. Some of the many women whose work reshaped quiltmaking both aesthetically and conceptually will be considered against a background of broader social and art movements, as well as particular events that had an impact on the popularity of quiltmaking, including the reconceptualization of the quilt as "art."

SURVIVAL AND REVIVAL

By the late nineteenth century, the needle was no longer a woman's constant companion. Factory-produced goods were cheap and accessible to all, and the trend was to the ready-made, especially in bed coverings. This led to a general decline of interest in quiltmaking, except in many rural areas.[6] The pieced and appliquéd cotton quilts that had typified bed coverings through most of the nineteenth century were viewed as unstylish, unsanitary, and suitable only as utilitarian bedding for rural middle and lower classes and the poor. Quilts in the fashionable homes of the time took the form of "Crazy" quilts and throws, often made in silks, satins, and velvets and heavily ornamented with embroidery (and sometimes beads and paint)—objects clearly meant for show rather than use.

The Arts and Crafts movement in America did not single out quilting as it did embroidery for developing new standards in design, but it did focus some attention on quilts. A 1904 *House Beautiful* article noted that "the Arts and Crafts movement has given dignity to even the humbler handicrafts. . . . the old quilts that are reappearing . . . are, many of them, quite worthy of their recall to consequence."[7] In 1908 the *Ladies Home Journal* published an article entitled "When Patchwork Becomes Art," and in 1912 that magazine described quilts as being "as exquisite and artistic as any embroidery."[8]

The Arts and Crafts movement laid the groundwork for a new appreciation of quilts, but it was the Colonial Revival movement that truly reinvigorated interest in quiltmaking. Although the Colonial Revival did not reach its peak until the 1920s and 1930s, its influence was felt as early as 1894, when Sybil Lanigen wrote in *Ladies Home Journal* that "the decree has gone forth that a revival of patchwork quilts is at hand, and dainty fingers whose owners have known only . . . patchworks from family description are busy placing the blocks together in new and artistic patterns, as well as in the real old-time order."[9] In 1905 *Harper's Bazar* acknowledged colonial handicrafts—such as quilts—as having "sufficient artistic value" for "an honored place in modern homes."[10] Quilts were "equally valued because of the excellence of some of the designs and because of [their] association with the four-poster bed of olden times" and became a necessity for the well-decorated "colonial" home.[11] The popularity of quiltmaking was such that in 1935 one author

noted that "the whole country is 'quilt conscious'"[12] The fact that it was most popular with middle- and upper-class women can be seen from additional comments by the same author: "The making of quilts in the home has become astonishingly popular, even to the extent of interfering with bridge schedules and attendance at the matinee."[13]

Although Lanigen had noted "new and artistic patterns" being made, as yet there was little in quilt design that reflected the new aestheticism of the period.[14] *Ladies Home Journal* recognized the need for and the importance of new quilt designs when, in 1905, it commissioned five well-known professional artists—including Maxfield Parrish and Jessie Willcox Smith—to create original quilt designs. A good idea, but one that failed because the designs, presented without patterns or instructions, were too daunting for most quilters to attempt.[15] A 1911 effort, also by *Ladies Home Journal,* was much more successful in setting new directions. It introduced four quilt designs by Marie Daugherty Webster, a banker's wife from Indiana who is regarded as the first of the twentieth-century designers to delineate a new look in quilts (fig. 6-2). Webster's work marked a definitive break with the past in color, fabric, composition, and construction. She played a major role in "quietly revivifying" quiltmaking, while augmenting its design parameters.[16] Webster had no formal art or design training but was well-educated and widely traveled; her appliqué designs paid homage, in line, color, and content, to both Arts and Crafts and Art Nouveau (fig. 6-3). She found inspiration in her flower garden, incorporating graceful, natural images of local flora along with fine workmanship into her quilts, and her use of light, clear colors, and modulated pastels (made possible by technological advances in textile dyes) reflected changing contemporary ideas about interior decoration.[17]

In 1915 Webster wrote *Quilts, Their Story and How to Make Them,* the first book to be devoted to the history and practice of quiltmaking and a seminal (if somewhat romanticized) publication in the area.[18] The book, together with the publication of more of her designs (some thirty-three in all), made Webster the first quilt designer to gain a national reputation. By 1920 the demand for patterns for her popular quilt designs was so great that she started a home-based industry, the Practical Patchwork Company, to supply them. In addition to paper patterns, Webster also sold stamped tops (fabric stamped with cutting lines and instructions), precut and basted quilts, and completely finished quilts, all to her designs.

QUILTING THE "MODERN"

Webster was in the vanguard for placing her design skills on a commercial footing, and over the next two decades a succession of women—Ruby Short McKim, Anne Orr, Rose Kretsinger, and Carrie Hall, among others[19]— would build on the foundation she had established, creating designs that seemed refreshingly different and adding to the growing literature in this

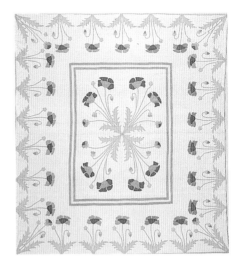

Fig. 6-3. Marie Daugherty Webster. "Poppy" quilt, 1909. Appliquéd linen and cotton. On loan to the Indianapolis Museum of Art by Rosalind Webster Perry. *Checklist no. 16*

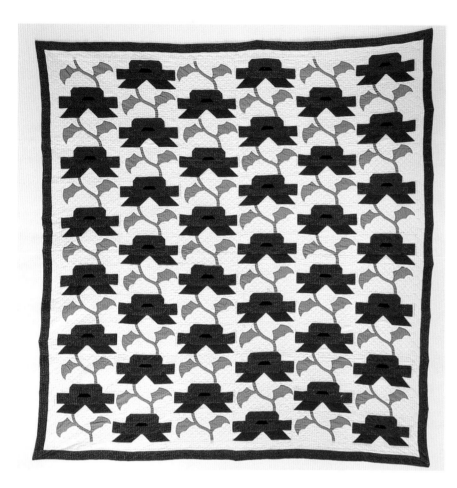

Fig. 6-4. Ruby Short McKim, designer; maker unknown. "Oriental Poppy" quilt, ca. 1930. Pieced and quilted cotton. Private collection.

area. These women also encouraged the dissemination of new and old designs through their own entrepreneurial efforts. Webster's Practical Patchwork Company was only one of a number of cottage industries established by women to trade on their design and quilting skills.

Ruby Short McKim studied at the New York School of Fine and Applied Arts (later Parsons School of Design) under Frank Alvah Parsons, an advocate of introducing art into everyday life. She became supervisor of drawing for the school system in Independence, Missouri, and in 1916 she created her first quilt designs—a series of embroidered blocks (she called them "quilties") based on characters in a children's story by Thornton Burgess—for the *Kansas City Star*.[20] By 1928 she was art needlework editor for *Better Homes and Gardens* and had a nationally syndicated quilt column.[21] Many of McKim's patterns had the angular, stylized aesthetic associated with the Art Deco designs popular after the *Exposition des Arts Décoratifs et Industriels Modernes* held in Paris in 1925, although her use of this style began somewhat earlier.[22] Her "quilties" and stylized blocks were familiar to thousands of women throughout the country (fig. 6-4).[23] Her syndicated column and pattern books (such as *One Hundred and One Patchwork Patterns*, a 1931 compilation still available today) resulted in a widespread demand for her patterns, which were supplied by McKim Studios, a mail-order firm operated by McKim and her husband.

Anne Champe Orr was educated at the prestigious Price's School for Young Ladies in Nashville, Tennessee, where she learned needlework and the principles of design.[24] She became art editor of *Southern Woman's Magazine* in 1913 and soon established a reputation as a designer of embroidery and crochet. In 1919 she began a twenty-year association with *Good Housekeeping* as needlework editor. Orr, a supporter of the then-popular Colonial Revival, designed some eighty appliqué and pieced quilts, the best known of which resemble colonial cross-stitched samplers. She used the fashionable graduated pastels of the day in her designs, which appealed to "we moderns," as she referred to herself and her audience.[25] Her designs were expensive to reproduce, requiring fabric specifically bought for the purpose, but their influence spread beyond her immediate audience of relatively well-off women.

Webster was not the only woman of her time to write about the history of quilts. While Ruth Ebright Finley, a journalist, collected quilts for her "Colonial" home in Hempstead, New York, she also collected stories of the women who designed and produced them, and these formed the basis for her book *Old Patchwork Quilts* (1929).[26] An early feminist, Finley was the first to propose that the study of women's folk art can illuminate the history of women, an idea not taken up again until the Women's Movement of the late 1960s.[27] In a 1929 interview Finley noted that "the patchwork quilt has staged a comeback, not only as a counterpane but as a decoration and wall hanging."[28] This is one of the few indications that quilts were used then as anything other than bed covers.

Rose Good Kretsinger studied applied design at the School of the Art Institute of Chicago; after graduating in 1908, she worked as a jewelry designer and taught at the institute until she married and returned to Kansas in 1916.[29] There, she began to design and make quilts worked in appliqué, because this technique offered "greater freedom for the expression of the designer's artistic capabilities."[30] Influenced by the Colonial Revival, Kretsinger based her quilt designs on traditional ones but "modernized" them by simplifying the designs and introducing new color schemes (fig. 6-5). She felt the enormous popularization of quilting had brought about a decline in design, and she urged her followers to show "invention and individuality in design."[31] Her influence became national with the 1935 publication of *The Romance of the Patchwork Quilt in America,* co-authored with Carrie A. Hall, a professional dressmaker and quilt historian.[32]

Many of these designers and their contemporaries were also highly effective entrepreneurs; they ran mail-order businesses to sell patterns of their designs, many of which had been featured in popular magazines and syndicated newspaper columns. Most also sold stamped or prebasted tops and finished quilts in addition to printed patterns, and offered the services of skilled needlewomen who could complete quilts started but abandoned by others. These designer-entrepreneurs employed hundreds of women during the 1920s and 1930s, many of them impoverished rural women who helped support their families through their quilting skills.[33]

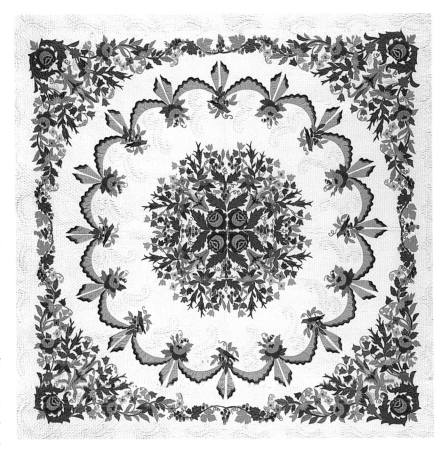

Fig. 6-5. Rose Good Kretsinger. "Paradise Garden" quilt, ca. 1946. Hand-appliquéd, stuffed, and quilted cotton. Collection of Spencer Museum of Art, The University of Kansas (71.104). Gift of Mary Kretsinger.

Fig. 6-6. Advertisement for the "Century of Progress" quilt contest sponsored by Sears, Roebuck, Chicago. From *Sears Roebuck Catalogue* (January 1933).

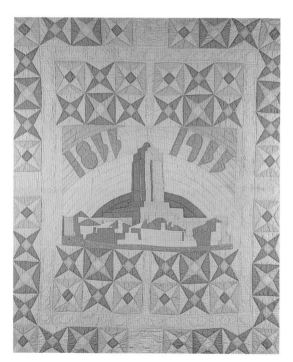

Fig. 6-7. Aurora See Dyer. "Century of Progress/World Without End" quilt, 1933. Pieced and appliquéd cotton. Collection of the Dyer Family Trust.

Print media was extremely important to the quilt revival—and to the success of these businesses. A 1934 survey showed that four hundred metropolitan newspapers published quilt material regularly, and a Gallup survey in six cities showed the quilt columns to be the most popular Sunday feature, one read by 32 percent of the women readers.[34] Add to this the many magazines that also ran quilt columns, and the informal circulation of patterns among quiltmakers, and the potential audience was vast.

From the early years of the nineteenth century, competitions and exhibitions at local, county, and state fairs had encouraged quiltmakers to show off their design and craft prowess and compete for prizes. Similar events continued in the twentieth century, by then also on a national level, and both professional and amateur quiltmakers entered. The Sears National Quilt Contest, part of the Chicago "Century of Progress" Exposition in 1933, stimulated quilters around the country to compete for $7,500 in prize money, including a $1,000 first prize and a $200 bonus if the winning quilt design reflected the exposition's theme—a substantial amount in those Depression years (fig. 6-6). Nearly 25,000 quilts were submitted, and although many were theme-related (fig. 6-7), all the winning quilts were remarkable examples of "traditional" designs in needlework, a reflection of the still-influential Colonial Revival movement.[35] The judges were Anne Orr; Mary McElwain, a radio lecturer on quilts and owner of a nationally known quilt and gift shop in Wisconsin; Sue Roberts, Sears, Roebuck home advisor and contest organizer; Beth Burnett, assistant to Robert B. Harshe, director of the Art Institute of Chicago; and Mrs. Charles Sewell, an employee of the American Farm Bureau Federation (absent at the judging).[36] Eleanor Roosevelt, herself a popularizer of the Colonial Revival, was presented with the grand-prize-winning quilt at the close of the exposition (fig. 6-8).[37]

Contests, competitions, and exhibitions have remained popular events. Many center on themes and emphasize creative design as often as technique. They range from small local events to major international competitions that draw thousands of submissions (though none has yet matched the 25,000 submissions of the Sears contest) and include, among others, Quilt National, held biennially in Athens, Ohio; the annual American Quilter's Society (AQS) Show in Paducah, Kentucky; and the International Quilt Festival, held annually in Houston, Texas, and sponsored by the International Quilt Association. The prizes awarded often total $50,000 or more.

Some of the most individually striking quilts made in the interwar years were personal statements related to the failing economy of the late 1920s and 1930s and the political promises of the period. Many of these

quilts are narratives, abstract or direct, that offer insight into the lives of the women who made them. Fannie B. Shaw, for example, produced her "Prosperity Is Just Around the Corner" quilt (1930–32; fig. 6-9) during some of the most difficult days of the Great Depression. It is a witty poke at President Herbert Hoover; Shaw noted that "Every time you picked up the paper or heard the radio [Hoover] would talk about the good times just around the corner. He would make it sound so good. I wondered if I could make a picture of what he was saying and what he meant . . . I couldn't get it off my mind."[38] In her design, a cross-section of characters peer hopefully around that corner, while the farmer (her husband) keeps on working to produce food for the nation.

A group of especially eloquent designs grew out of a northern Alabama Tennessee Valley Authority (TVA) project, one of the New Deal programs. Ruth Clement Bond, a college-educated African American woman and wife of the highest-ranking black official on that project, suggested to the wives of the black TVA workers that they make quilts to represent the power that TVA electricity would bring into their lives. She drew several powerful, hard-edged designs with large, dynamic images, very much in contrast to the popular light, flowery designs of the time. Several women made quilts according to her designs; some had never quilted before. Each design held a different symbolism, but all reflected new opportunities

Fig. 6-8. Eleanor Roosevelt accepting the prize-winning "Century of Progress" quilt from E. J. Condon of Sears, Roebuck, 1933. The whereabouts of this quilt is unknown today.

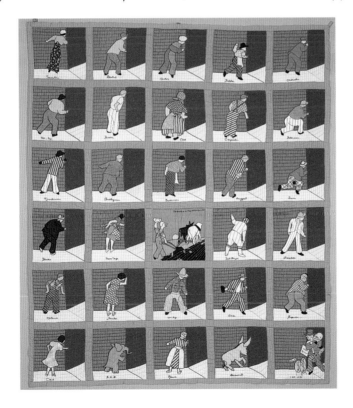

Fig. 6-9. Fannie B. Shaw. "Prosperity Is Just Around the Corner" quilt, 1930–32. Pieced, appliquéd, and embroidered cotton. Dallas Museum of Art (1998.209). *Checklist no. 51*

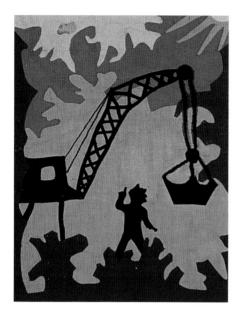

Fig. 6-10. Ruth Clement Bond, designer; Rose Marie Thomas, maker. TVA "Man with Crane" wallhanging, 1934. Pieced and sewn cotton. Collection of the American Craft Museum, New York, gift of Mrs. Rosa Phillips Thomas (1994.17.2). *Checklist no. 55*

for black (male) workers and represented hope for the future (fig. 6-10).[39] Some images that Bond incorporated are reminiscent of the work of Aaron Douglas, a painter of the Harlem Renaissance known for his murals and book illustrations, although Bond does not recall using his work specifically as reference.[40] The stark silhouettes call to mind African American narrative quilts (see chap. 4); they also project hope for social change and a growing sense of Black Power.

RETREAT AND REDIRECTION

After World War II, modernism increasingly dominated art and design discourse. Quilts came to epitomize all that was not "modern"—that is, the past rather than the present. Thousands of women continued to design and make quilts, but no longer as part of the stylish mainstream. The vigor that had characterized quilt design in the first half of the century weakened as Webster and others retired or moved into other areas such as fashion (Hall) or doll design (McKim).[41] Nevertheless, there were many talented quilters in the 1940s and 1950s. Bertha Stenge of Illinois, a former student of Eugen Neuhaus, head of the art department at the University of California, won many local and national contests between 1939 and 1949 with her lively quilt designs, which ranged from variations on traditional designs to creative pictorials.[42] Her quilts were featured in *Woman's Day* and *Ladies Home Journal*, and although she did not enjoy anything like the popularity of a Webster, McKim, or Orr, she was one of the few quilters at the time to have her work recognized by a museum. In 1943 she had a one-woman exhibition at the Art Institute of Chicago, which *Newsweek* reviewed, describing her quilts as "the finest modern quilts in the United States today."[43] This was perhaps the first time that a mainstream non–home-decorating/woman's publication had recognized quilts as art, something that would not occur again until the early 1970s. Working against that recognition was the fact that Stenge's quilt designs, though very creative, were definitely not "modern." Quilts remained identified with the Colonial Revival movement and were generally considered "quaint" and "old-fashioned."

There were few other quilt designers singled out for national recognition at that time. At the commercial level, quilt design became the province of the companies that supplied the batting for quilts (patterns were printed on the batting wrappers or offered for sale). Some companies, such as Mountain Mist, had staff designers or freelancers produce new designs, but these were marketed under the company name or a pen name rather than the designers' names.[44]

A few lone hands, however, were being raised in support of a new point of reference for quilt design. A crafts revival based on emphasizing "modern" expression and defining craft as art was under way. In textiles, interest first centered on handweaving and embroidery, but Anni Albers,

Lenore Tawney, and Mariska Karasz helped to further the idea of fiber, fabric, and stitching as a legitimate area of creative "modern" expression.[45] Katherine Westphal (trained as a painter) and Alma Lesch (known for her assemblages) incorporated quilting into their artwork in the 1960s and contributed to "the acceptance of traditionally female processes as a viable medium for expression in contemporary art."[46] Labeling the design and crafting of quilts as "art" greatly enhanced quilting's status.

Jean Ray Laury, who received an MFA in design from Stanford University, was one of the first fine artists to move to quilting as a medium of choice in the late 1950s. Her quilts followed neither traditional method nor pattern; they were bold, modern, colorful collages, often laced with humor and satire. Nothing like them had been seen before in quilting, but they were in tune with the artistic explorations of the postwar years that emphasized free and personal expression (fig. 6-11).[47] In the 1960s Laury's work, as well as her articles and books on quiltmaking and quilt design, established quilts as a medium of modern artistic expression and broadened the spectrum of women entering quilting. More women with art training—such as Joan Lintault and Therese May, both originally painters—turned to fabric, making quilts in new ways and using new techniques, including collaged work and embellishment. As they and others pushed the medium beyond normally accepted boundaries, the idea of the art quilt was born.[48]

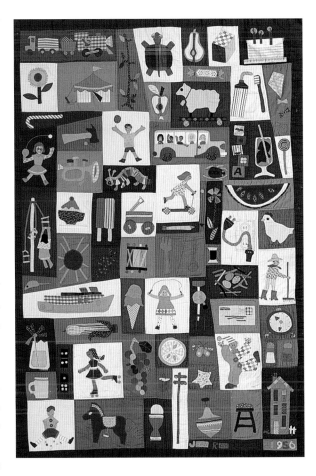

Fig. 6-11. Jean Ray Laury. "Tom's Quilt," 1956. Hand-appliquéd, hand-quilted cotton. Collection of Tom Laury.

The Women's Movement also had an impact on quilting, as women began to celebrate quiltmaking as an expression of the indomitable creative female spirit. Issues of women's heritage were central to the movement and redefined attitudes toward quilting, which moved rapidly from the margins to center stage, and components of the culture of quilting such as quilting bees were viewed as early feminist expressions of communal women's work.[49] Prominent feminist Lucy Lippard later noted, "The quilt [had] become the prime visual metaphor for women's lives, for women's culture."[50]

Some women turned to quilting as an acknowledgment of their connection to past and future generations of women and as a way to ground their work in the historical experience of women: "The artist-makers of our past have become mentors for women who are now unafraid to see domestic life as a locus for the art-making process."[51] As the tenets of High Modernism came to be questioned, other women in the fine arts turned to the "decorative" imagery of quilts as a source for powerful feminist paintings. Miriam Shapiro, for example, combined fabric collage and paint in large-scale works she called "femmages," defining the term as "a word invented . . . to include . . . collage, assemblage, découpage, photomontage as they were practiced by women using

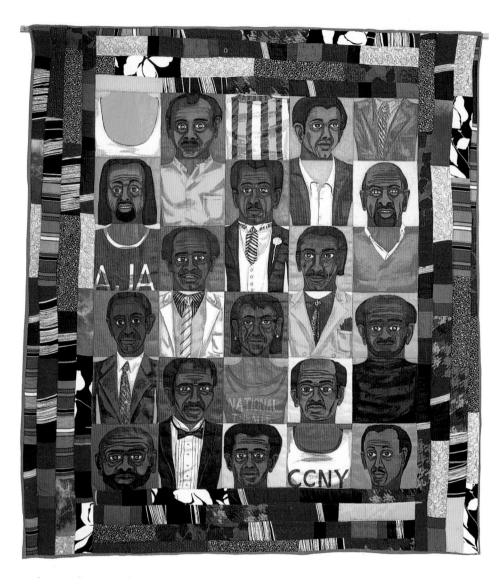

Fig. 6-12. Faith Ringgold. "The Men: Mask Face Quilt No. 2," ©1986 Ringgold. Cotton, acrylic on canvas, sequins. Private collection.

traditional women's techniques to achieve their art—sewing, piecing, hooking, cutting, appliquéing, cooking, and the like—activities engaged in by men but assigned in history to women."[52]

For Faith Ringgold, the issue of heritage comprises both gender and ethnicity, and her art articulates the realities of both. There is a long tradition in her family of working with fabric, and Ringgold suggests she might have turned to cloth work earlier had she not been so influenced by mainstream modernist aesthetics; it took her involvement in the Women's Movement and changing aesthetic consciousness to recognize that heritage.[53] Ringgold combines fabric and paint, text and imagery to create striking and powerful narratives that relate to the African American experience. Sometimes more painting than quilt, other times more quilt than painting, her dramatic story quilts speak to and from the heart of African American experience (fig. 6-12).

Some scholars claim that African American quilts incorporate design traits common to many West and Central African cultures and thus are an expression of African art traditions passed down through generations of African Americans.[54] Others contend that African American quilts represent a diverse body of work influenced by the myriad factors that make up the black experience in America, including the Women's Movement and the Civil Rights movement, which bolstered pride of origin in African Americans and promoted a desire to celebrate it by consciously incorporating African themes in their designs.[55] The two points of view are not mutually exclusive and highlight the hybridity that is so much a part of African American quilt design and of contemporary American quilt design in general. As quilt historian Cuesta Benberry notes, African American quiltmaking was "always there."[56]

The relatively few African American quilts that have been positively identified from the early twentieth century indicate that many African American quiltmakers were no more immune to changing design trends than European American women or than African American designers working in other areas. However, a few distinct design traditions existed. Some quilts designed and made by African Americans show an abundance of pattern; their designs are bold, rhythmic, and often asymmetrical, with continuous variation and elaboration. Colors are bright and offer vibrant contrasts; multiple patterning—in the fabrics, in the design, or both—may be present in any one quilt, with often-unpredictable visual results. Although there are examples of quilts made in this tradition known from the first quarter of the century, most are of more recent origin. The quilts of Anna Williams, a domestic worker in Baton Rouge, Louisiana, are very much of this genre (fig. 6-13). An imaginative, improvisational designer with a passion for color, pattern, texture, and irregularity of line, Williams learned to sew and began to understand design by watching her mother and grandmother quilt. Pictorial narratives form another important tradition within African American quilt design, one that has informed the work of artists such as Faith Ringgold, Carolyn Mazloomi (see chap. 4), Michael Cummings (one of a small number of African American men in quilting), and others. Quilts such as these have influenced a new generation of quilters, within and outside the African American community.

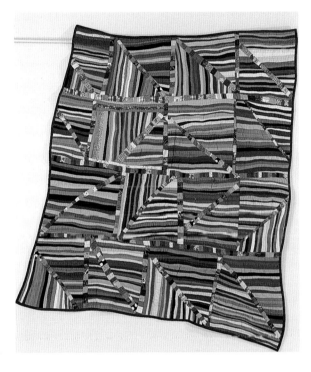

Fig. 6-13. Anna Williams. "Strings and Diagonal Crossbars—Solid Colors" quilt, 1992. Quilted by Marie Whitten and Callie Brian, Baton Rouge, Louisiana. String variation, cotton. Collection of Katharine Watts.

REVIVAL AND REDEFINITION

The crafts revival, the Women's Movement, and the "back-to-the-land" movement of the 1960s effectively set the stage for the major quilt revival of the 1970s. The "back-to-the-land" movement expressed a reaction to corporate capitalism, to a society dominated by technology that no longer

Fig. 6-14. Unknown Amish designer. "Diamond in a Square" quilt, 1925. Pieced and quilted wools. Collection of Kenny and Shelly Zegart.

seemed geared to benefit humankind. Belief in individual creativity and the superiority of the handmade was consistent with the search for a simpler life. Nonconformity and experimentation were the norm, and Laury, then regarded as the leading voice in quilting, wrote in 1966: "There are no rules in stitchery—no single 'right' way of working."[57] This also seemed to apply on a broader societal scale, as rules broke down in many areas in the turbulent late 1960s and early 1970s. A number of quilts made in this period reflect the societal turbulence and are as much (or more) political statement as quilt. Others were more influenced by the new "Colonial Revival" that accompanied the Bicentennial celebration of 1976; interior designers rediscovered traditional pieced and appliquéd quilts, only now the buzz word to describe the appropriate look was "country" rather than "colonial."

The Bicentennial, as much a recognition and celebration of multiculturalism and pluralism in America as it was a commemoration of nationhood, prompted a fresh look at the traditions of the diverse groups that constitute the United States. In quiltmaking, this led to heightened interest in the design tradition not only of African Americans, but also of other groups with strong religious, ethnic, or cultural characteristics—such as the Amish and Hawaiians—who have brought their distinctive influences to bear on quilt design, often with far-reaching effect.[58]

The Amish quiltmaking "tradition" dates back only to the mid- to late-nineteenth century when the skill was learned from "english" (non-Amish) neighbors.[59] It was not an "old" practice brought with them to America. The visually austere geometric designs, with their startling and dramatic juxtapositions of solid colors and the superb workmanship now associated with Amish quilts, appeared only at the end of the nineteenth century and continued through the twentieth (fig. 6-14). As Amish quilts became known, collected (starting about the middle of the twentieth century), and exhibited outside their own communities, they struck a resonating chord in the broader quilt community and encouraged a great deal of experimentation that has broadened the horizons of many non-Amish quiltmakers. The quilts are reflective of the spiritual and social values of the group that makes them: they reject elaborate iconography and naturalistic images and embrace an ascetic simplicity intended to reflect their antimaterialistic lifestyle. Amish

quilts, especially those made before 1950, are often family or communal projects with input from more than one person. Also, in keeping with religious ideals that set no one person above another, the identity of the maker(s) is less important than the fact of the making. Amish women today occasionally sign names or initials to their quilts, more so when it is work to be sold outside the community, but this still remains an uncommon practice.[60]

Amish quiltmaking, although "traditional" in terms of design, is not frozen or static. There is a greater variety of design in Midwest Amish quilts than in those made by Pennsylvania Amish, perhaps because

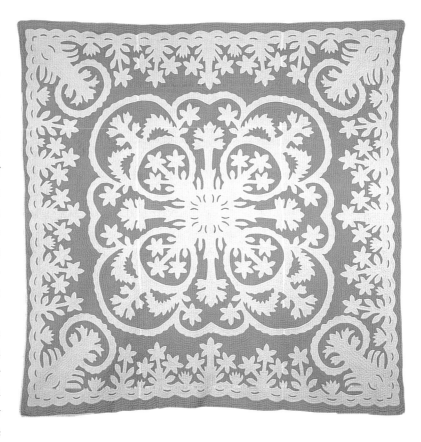

the Midwest communities have been less isolated from neighboring non-Amish communities. Since the 1950s, fabrics other than wool, a color palette more familiar to the non-Amish eye, and printed fabrics have often been used, and less intricate quilting patterns chosen. In some cases these changes are the result of increased market demand as Amish women have found quilt-making an admirable way to supplement their incomes.[61]

Hawaii did not become a state until 1959, but quiltmaking was already well established there by the opening of the twentieth century. The wives of American missionaries introduced cotton cloth and quilting in the nineteenth century, but Hawaiians quickly developed their own design traditions.[62] Most representative are the large, curvilinear appliqué designs that dominate Hawaiian quilting (fig. 6-15). Designs are very personal and ownership is important; a quilt design is never copied without permission, although mainland quilters often try to emulate them. The designs are always named and frequently reflect a relationship with nature; design and names may have symbolic meaning to the maker, but they are not always apparent to others. The islands have produced a number of outstanding "master" quilters. Some are of native Hawaiian ancestry, such as Hannah Ku'umililani Cummings Baker, Meali'i Kalama, and Junedale Lauwaeomakana Quinories; others are mainlanders who now make Hawaii their home, such as Elizabeth A. Akana, founder of the Hawaiian Quilt Research Project. These women have been influential in passing on the quilt tradition as well as in expanding its scope.[63] As elsewhere, quilting in Hawaii is primarily a woman's art, but some men have entered the field and gained recognition,

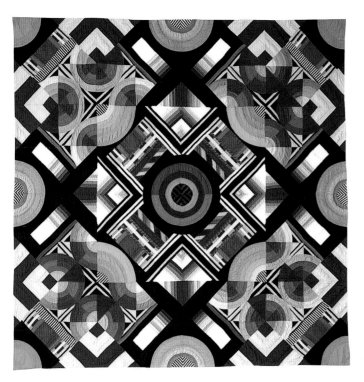

Fig. 6-16. Nancy Crow, designer. "March Study" quilt, 1979. Pieced by Nancy Crow; quilted by Mrs. Levi Mast. Cotton. Collection of Nancy Crow.

among them, Robin Keli'i Jensen and Stan Yates.

As quilts were being freshly appreciated by the public—as craft objects and as symbols of the colonial past, of ethnic and cultural traditions, and of women's creativity—and as artists adopted them as vehicles for creative exploration, an event took place that forced further consideration of quilts as aesthetic art objects. In 1971 the Whitney Museum of American Art in New York mounted the exhibition *Abstract Design in American Quilts*, curated by Jonathan Holstein and Gail van der Hoof. It was the first time a major museum had presented quilts as "icons" of American art and design and, as such, a landmark in the contemporary approach to quilts. Quilts, Holstein noted, "exhibit some particularly American design traits: a traditional, reductive approach to visual problems . . . ; vigorous, innovative form; the bold use of color."[64] Holstein's acknowledgment of the creative process as design was important, even if the involvement of the Whitney Museum meant that "art" remained central to the critical discourse surrounding quilting. *Quilter's Newsletter Magazine* reported that "It seems to be official now—quiltmaking is indeed an art."[65] What was not highlighted was that only pieced antique quilts of abstract (or "modern") design were given the status of art in the show; contemporary fine-art quilters were only beginning their battle for recognition and for the status of "artist" to be extended to them.

The number of fine-art quilters has continued to grow, and several women stand out as influential in this area. Nancy Crow is an academically trained artist who moved into quiltmaking in the mid-1970s; she attributes her affinity for fabric to her father, who was once a tailor's apprentice and taught his children to love quality fabrics and good workmanship. She notes, "I prefer fabric to paint . . . It seems natural to me to make quilts."[66] Crow is known for her wide-ranging color palette and her complex and intricate geometric design structures (fig. 6-16).[67] Her work has encouraged others to experiment and improvise with color, style, and structure. She has been a leader in advancing the idea of the quilt as art; Crow helped create Quilt National, the annual juried exhibition whose mission is to "promote the contemporary quilt as an art form."[68]

Jan Myers-Newbury's contribution came about when she was a graduate design student experimenting with hand-dyeing fabrics for her contemporary quilt designs. Her carefully planned gradations of color and use of a grid format (fig. 6-17) have influenced the work of many quiltmakers, awakening them to the potential power of "fabric, dye, and the simple geometry of patchwork."[69]

In contrast, Yvonne Porcella studied science in college. A self-taught quilter, she worked as an operating room nurse before turning to quilting professionally. Most of her work has focused on color and form; her vibrant and colorful designs seem to flow spontaneously (fig. 6-18). Her audacious use of primary colors has been a hallmark of her work, as have her narrative and often humorous titles.

More men also began to discover the design possibilities of quiltmaking, and, although their number remains minuscule, some, such as Michael James, have had a major influence, both in terms of design and in bringing wider public recognition to the art quilt. James, a formally trained painter and printmaker who received an MFA from the Rochester Institute of Technology, began to work with quilts in 1973. He has written several books on quiltmaking and also provided a range of painterly design ideas that have inspired many other quiltmakers.[70]

Quilt design continues to be influenced and informed by factors other than the people who practice the art. Fabrics for quiltmaking, for example, provide a two-way channel of influence; textile companies are influenced by quilt designers, while available fabrics influence quilt design. For many years, quilters had to follow the textile industry in terms of what fabrics were available for them to use. Starting in the late 1970s, however, the industry recognized the benefits of developing a wide variety of patterns, colors, and textures geared to quilters as the combined economic impact of the estimated 15 million quilters in the United States multiplied by the amount of fabric they are likely to purchase over the course of a year is substantial.[71] Since then, several textile companies have developed special lines based on the needs and recommendations of well-known quilters.[72] Jinny Beyer, for example, one of America's most popular quilt teachers, lecturers, and designers, has worked with RJR Fashion Fabrics since the mid-1970s to produce the fabric line that carries her name. Today, a number of leading quilters lend their expertise in this area, among them Paula Nadelstern, a charismatic designer and teacher now working with Benartex on a fabric collection inspired by her kaleidoscope quilt designs (fig. 6-19).

Fig. 6-17. Jan Myers-Newbury. "Depth of Field III: Plane View," 1985. Machine pieced and quilted with the assistance of Joanne Olson. Hand-dyed cotton muslin. Collection of the International Quilt Study Center, Robert and Ardis James Collection, University of Nebraska–Lincoln.

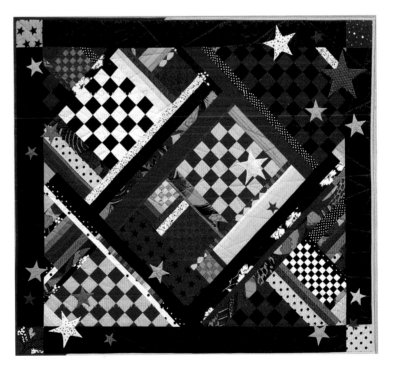

Fig. 6-18. Yvonne Porcella. "On the W. E. Brownie Brown" quilt, 1987. Pieced and appliquéd fabrics. Collection of Yvonne Porcella.

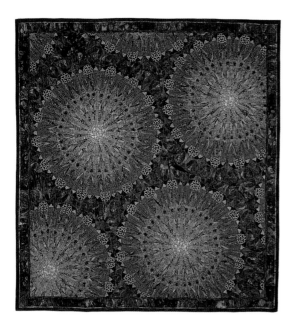

Fig. 6-19. Paula Nadelstern. "Kaleidoscopic XVII: Caribbean Blues," 1997. Pieced and quilted cottons, cotton blends, silk. Private Collection.

Although quiltmaking is within a design tradition that, even in its most "modern" manifestations, symbolizes respite from machine technology to many, approximately 9 percent of quiltmakers use computer software, some in the design process, others to follow complex patterns.[73] The Internet has also changed the way quilters work and may one day replace print media as a means of transmitting designs; scores of quilt-related sites offer old and new patterns for perusal, purchase, or downloading, and many quilters show their most recent work on websites. Additionally, they use the Web to create communal quilts, trade advice and information, and introduce novices to this well-established design and craft tradition.

Major life- and society-defining events elicit powerful public responses, and women have often used such events as inspiration for design. Wars have long provided opportunities for women to use their quilts as silent yet provocative canvases on which to depict their patriotism and beliefs. A proliferation of Red Cross quilts during World War I served as fundraisers and as markers of patriotism. The "Hatfield-McCoy Victory Quilt" of World War II functioned not only as a morale booster but also symbolized the settlement (mediated by women) of a long-standing feud between two Southern families (fig. 6-20). The "AIDS Memorial Quilt," sponsored by the NAMES Project, is an ongoing silent memorial to the tens of thousands who have died of AIDS, a disease that shows no respect for gender, race, age, or creed. Each of the nearly 45,000 panels in the quilt has been created by friends, lovers, and families—women, men, and children. Highly diverse in its separate parts, the quilt is representative of the collective conscience of the country, a commemorative effort that serves as a personal and a social statement, as well as a communal endeavor (fig. 6-21).

Fig. 6-20. America Hatfield McCoy, Rhoda McCoy, and other family members. "Hatfield-McCoy Victory Quilt," 1943. Pieced and appliquéd cotton. Collection of Ohio Historical Society, Columbus, Ohio.

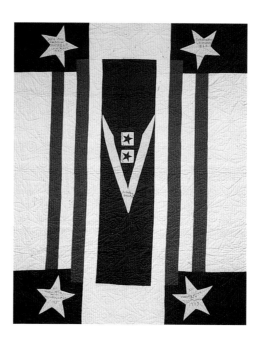

Today, quilt design is many-faceted, active, and flourishing. Women design quilts less to be copied than to inspire and influence. Some quilters produce variations within established design traditions, but always with a personal twist, be it in color, stitching, or use of pattern. Others, such as Marilyn Henrion, who has won international recognition for her work, move in different directions, sometimes drawing on the past for inspiration but always exploring new pathways in both style and technique. Henrion, who studied art and design at Cooper Union in New York and taught at the Fashion Institute of Technology for twenty years, turned to quiltmaking in 1975, when she was in her early forties. Since then she has added considerably to the design lexicon of quilting. Her work transforms the geometric elements associated with pieced quilts into resonating metaphorical images (fig. 6-22).

The quiltmakers of today demand that their work be looked at in new ways, and not only in relation to the past; an increasing amount is designed to be seen on a wall rather than a bed. The boundaries between craft, art, and design have blurred as quilts are now valued as much for their aesthetic possibilities as for their function—indeed the "traditional" forms of rectangle and square are no longer considered "sacred." The move into quiltmaking of trained artists and others who want to test and stretch the medium has broadened it significantly, just as their work has been broadened by looking to the long history of a hitherto marginalized area of craft and design. In quilt design, the "old" and the "new," the past and the present, can and do coexist, and today's quiltmakers have shown their ability to use both creatively in envisioning the future.

Fig. 6-21. "AIDS Memorial Quilt" displayed on the Mall in Washington, D. C., 1996. The "quilt" covers some 13 acres when laid out.

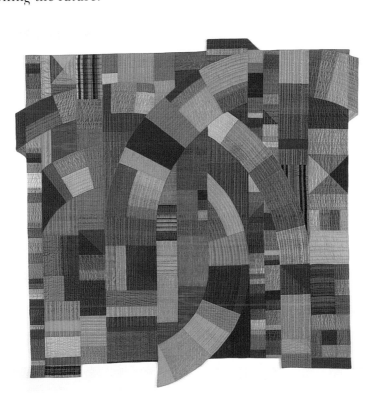

Fig. 6-22. Marilyn Henrion. "Byzantium II" quilt, 1998. Machine-pieced and hand-quilted silk. Collection of Marilyn Henrion. *Checklist no. 213*

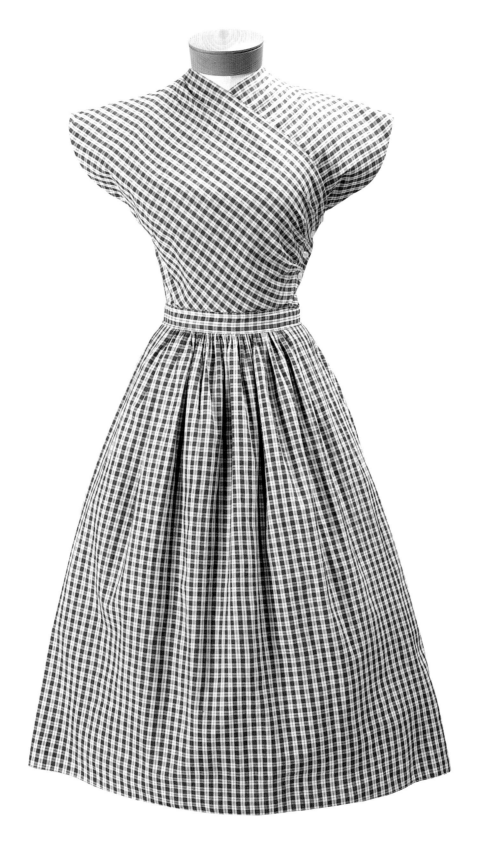

Fig. 7-A. Claire McCardell. Dress, 1943. Cotton. The Metropolitan Museum of Art, New York, Gift of Claire McCardell, 1949 (CI.49.37.41).

7

VALERIE STEELE

Women Fashioning American Fashion

THE EARLY HISTORY OF WOMEN FASHION DESIGNERS in the United States is
poorly documented, because for many years most American "designers" were
dressmakers who left little trace in the historical record. In the late nine-
teenth century, the vast majority of dressmakers were women, but the stereo-
type of the male fashion "dictator" was already in existence, patterned after
the first internationally famous male *couturier*, Charles Frederick Worth. An
Englishman who in 1857 established a couture house in Paris, the world cap-
ital of women's fashion since the seventeenth century, Worth became famous
in part because of his gender: The "man milliner" was a curiosity. However,
Worth also significantly changed the structure of couture, moving it away
from its origins as a small-scale craft (dominated by women) toward its
future as big business and high art.[1] Below the *couturier* (or the female *cou-
turière*), and excluding the emerging business managers, the staff of a couture
house—seamstresses, *premières* (forewomen), *vendeuses* (saleswomen), appren-
tices, and so on—were almost all women.[2]

Concurrent with the modernization of couture was the moderniza-
tion of the ready-to-wear industry, and the "retail revolution" epitomized by
the rise of the department store.[3] In the United States clothing manufactur-
ers and department store owners were almost invariably men. They often
hired in-house designers to create new fashions or modify French models.
These designers were probably often women, although it is difficult to know,
because their names have seldom come down to us. By the early twentieth
century some *couturières* in Paris had become world famous, among them
Jeanne Paquin and the Callot sisters,[4] to be followed in the 1920s and 1930s
by even bigger names, such as Gabrielle "Coco" Chanel, Elsa Schiaparelli,
and Madeleine Vionnet.[5] By contrast, most American custom dressmakers
had only local reputations: who today has heard of Mrs. Osborn or Mrs.
Dunstan of New York?[6] They were known only by their customers and read-
ers of the local society pages, who learned, for example, that Elsie de Wolfe
wore a walking dress by Mrs. Osborn.[7] In 1913, when the *New York Times*
reported on an American fashion design contest, the second prize for an
afternoon dress was won by Irma Campbell, one of Lord & Taylor's other-
wise anonymous in-house designers.[8]

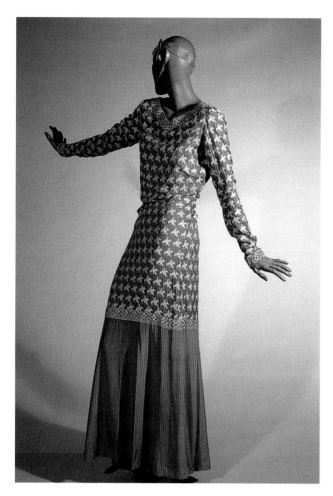

Fig. 7-1. Jessie Franklin Turner. Afternoon dress, ca. 1918–22. Silk crepe with silk floss embroidery. Brooklyn Museum of Art, Gift of estate of Mary Boocock Leavitt (74.185.6).
Checklist no. 25

Most American dressmakers copied or adapted French styles, but the issue at hand is not simply one of center versus periphery. The structure of the American fashion industry and the culture of fashion in America militated against the recognition of individual American fashion designers.[9] America's Puritan heritage and the nation's ideology of egalitarianism resulted in a pervasive cultural suspicion of fashion as something vain, mendacious, erotic, aristocratic, and European. At the same time, many American women were attracted by precisely these characteristics. As a result, both custom dressmakers and the manufacturers of ready-to-wear clothes frequently imported French dresses and/or sewed false Paris labels into American-made dresses.[10] Lacking the prestige that accrued to successful Parisian designers (and the money that promoted American department stores), most American designers labored in obscurity.

The first American woman to achieve a national reputation for fashion innovation was Ellen Curtis Demorest. Known professionally as Madame Demorest, she was "as important to American nineteenth-century fashion as Worth would be to the development of the Paris couture. More than anyone else, she foresaw the structure of American fashion as the combination of invention, production, education, marketing, [and] distribution."[11] Madame Demorest owned and operated her own store in New York City, and eventually published her own fashion magazine.[12] Most importantly, she took the idea of paper patterns (already included in some European fashion magazines) and not only distributed them in American periodicals, but also made them available by mail order and in retail shops. Her patterns were used by professional dressmakers, many of whom adapted them to produce their own designs, as well as by women who sewed at home for themselves and their families.[13]

Few women matched Madame Demorest's entrepreneurial energy, but by the 1920s and 1930s there were thousands of fashion businesses in New York, many of them run by women. Indeed, as fashion historian Caroline Milbank has pointed out, "America's first real crop of designers was predominantly female."[14] Jessie Franklin Turner, for example, was a talented custom fashion designer, who opened her own salon on Park Avenue in 1923, after having worked anonymously for Bonwit Teller (fig. 7-1).[15] Although her business was never large, it was her own and her name achieved a certain recognition among contemporary New York women of fashion. Other respected women designers included Elizabeth Hawes, Valentina, Jo Copeland, Nettie Rosenstein, Louise Barnes Gallagher, and Muriel King.

In a category of her own was Hattie Carnegie. A tough, ambitious

immigrant with great personal style but only the average woman's dressmaking talent, Carnegie possessed exceptional entrepreneurial skills and an excellent sense of what would sell.[16] In 1925 she had her own shop on East 49th Street in New York, where she sold imported French fashions and her own in-house designs. In 1929 she also began producing ready-to-wear clothing. By the 1940s Carnegie was the head of a multimillion dollar ready-to-wear and custom clothing business with her own factories, wholesale operation, and retail stores, employing more than a thousand people. Over the years Carnegie hired many talented American designers, male and female, among them Norman Norell and Claire McCardell. In contrast to the usual pattern, where the female designer tended to work in association with a male business partner (sometimes a husband), in this case the woman was in charge of the *business* of fashion.

Throughout the first half of the twentieth century, fashion design was primarily a woman's career, especially in the United States, where it was regarded as an appropriately "feminine" pursuit.[17] Indeed, in the late 1930s Emmett Joyce, one of Carnegie's stable of designers, was mentioned in an article in the *World Telegram* entitled "Men Are Designing, Too"—as though this was an unusual occurrence.[18] Women faced no formal or informal barriers to access to fashion education and training. Basic training in sewing and dressmaking was quite commonly given to American girls, both at home and in school. They learned to sew with and without sewing machines; to knit and embroider; to use and alter patterns; to choose and cut material; to do seams, hems, and facings; to cut and apply collars, cuffs, and pockets; to make buttonholes, tucks, and ruffles; and to press, clean, and repair the finished garment. Many women outside the ranks of professional dressmakers made their own and their children's clothes, either creating their own designs or working from commercial patterns.[19]

By the 1920s, however, as women's lives and work patterns changed, so too did the image of the dressmaker. No longer looked down on as a humble "trade," fashion design was becoming a popular career choice for young middle-class women. Jo Copeland is a good example. She went into fashion not because her father was in the clothing business (indeed, she looked down on his career as a jobber of inexpensive clothes), but because she wanted a job with artistic and creative associations. The family was sufficiently prosperous to enable her mother to employ custom dressmakers, and this familiarized Copeland with the basics of dressmaking. Her ambitions, however, went far beyond conventional dressmaking. After studying art, she began designing for a company called Pattullo Modes (fig. 7-2).[20] After her marriage she established her own business, designing clothes for her sort of

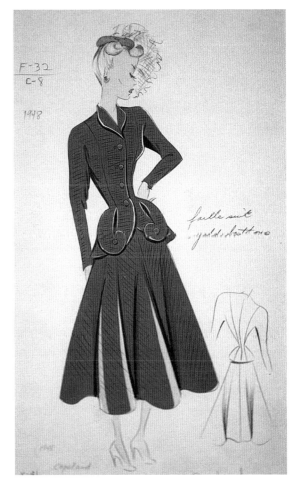

Fig. 7-2. Jo Copeland. Sketch for suit (for Patullo Modes), New York, 1948. Watercolor on printed paper. Special Collections, The Fashion Institute of Technology, New York.

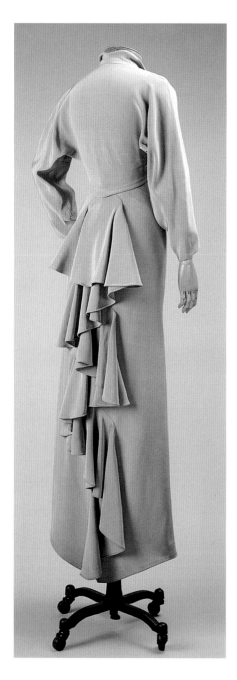

Fig. 7-3. Valentina
(Valentina von Schlee).
Evening ensemble, ca. 1935.
Silk ottoman. The
Metropolitan Museum of
Art, New York, Gift of Igor
Kamlukin, 1995
(1995.245.5a, b).
Checklist no. 60

woman—the young urban matron, "whose social activities justify a concern with style."[21] Copeland made a success of her career, but at great personal expense by alienating her daughter.[22]

It helped if a woman designer could be her own best fashion model, as was Copeland. If dress designers were no longer artisans, then, it seemed, they should be celebrities or at least fashion leaders. The French *couturière* Chanel was the prototype for the designer as woman of style, neatly combining what had previously been the separate female roles of skilled dressmaker and elegant client. The American fashion press frequently commented on the appearance of female designers. In 1933, for example, Muriel King was described in *Vogue* as "a glorious-looking young woman . . . a sort of tawny goddess."[23]

Russian-born Valentina was known as "America's most glamorous dressmaker."[24] She looked like Greta Garbo, with whom she shared her husband, George Schlee. In 1928, with her husband's financial support, she opened a dress shop in New York. For the next three decades, she designed made-to-order dresses for a select clientele, including many theatrical personalities (fig. 7-3). Appropriately, since both her clothing and her personality were highly theatrical, she was also known for her stage costumes.[25] Elegant and authoritative, Valentina bullied her customers, giving them little choice about color or design. "What women want is nearly always wrong," she insisted.[26] One hapless customer who expressed a preference for yellow was told that yellow was for flowers.[27] Valentina was equally dictatorial with fashion editors and usually insisted not only on choosing and styling the dress to be used for an illustration, but on modeling it as well. "*Vogue* needs Valentina drama," she told editor Bettina Ballard.[28]

Elizabeth Hawes was a more unusual candidate for fashion design, because she approached dressmaking from the perspective of a leftist intellectual. As a student at Vassar she recalled "wailing about whether or not it was really the proper thing to devote my life to the matter of clothes."[29] Nevertheless, after studying economics, she went to Paris and worked there as a design spy for an American company that copied couture fashions. Then she became an apprentice at the couture house of Nicole Groult (Paul Poiret's younger sister) and a freelance fashion reporter for the *New Yorker*. In 1928 she returned to the United States and opened a small custom dressmaking establishment in New York City.[30]

Hawes's openings were attended by a mixed group of fashion people, socialites, artists, and intellectuals. Her dresses were given irreverent names, such as "The Revolt of the Masses" (a lace evening dress) and the "Misadventure" cape (fig. 7-4). At her 1933 spring fashion show she ran a fifteen-minute silent film, *The Panther Woman of the Needle Trades*, which playfully suggested that all of world history had led up to her birth. Hawes appeared in the film dressed as a baby and immediately seized a pair of scissors and began cutting patterns. Although she later criticized the "rich bitches" who bought

custom-made clothes, her goal at first was simply to create original and beautiful garments.[31]

Hawes would probably be forgotten today had she not written *Fashion is Spinach* (1938).[32] The title is taken from a Carl Rose cartoon that shows a boy glaring at his dinner plate. "Eat your broccoli, dear," pleads his mother, to which the child replies, "I say it's spinach. And I say, the hell with it." Hawes's attitude toward the fashion industry was similarly disenchanted. Hawes believed that American designers had to learn from the artistry of French couture, while also creating "democratic" and mass-produced clothes that met the needs of ordinary women. She enthusiastically accepted offers from manufacturers to design for the mass market, because she believed that everyone deserved to have beautiful clothes. She became disillusioned with the commercialism of the American ready-to-wear business, however, and eventually abandoned her fashion design work in favor of political activism.[33]

In 1932 Dorothy Shaver, then vice-president of Lord & Taylor, began a campaign to promote American designers. Yet Hawes, who was one of those promoted, complained that the designers' names were never mentioned: "'Our own American designs' . . . by

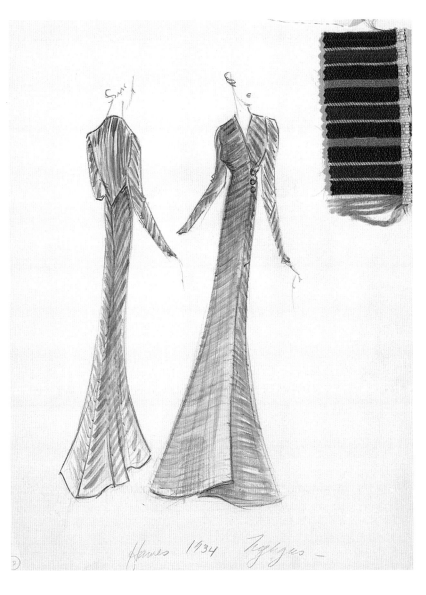

Fig. 7-4. Elizabeth Hawes. Design for at-home negligée, 1934. Watercolor and pencil on paper with fabric swatch. Brooklyn Museum of Art, Library Collections, Fashion Sketch Collection. *Checklist no. 56*

whom? Why, by Americans. Who are they? What are their names? Never mind that, these are 'Clothes designed in America' whoopee—by perfectly nameless people, robots maybe."[34] It is true that if customers recognized an American name, it tended to be that of a department store or manufacturer, rather than a designer. Nevertheless, some designers did manage to get their own names on the label, often together with that of the manufacturer. Claire McCardell was especially insistent on being credited for her designs.[35]

McCardell is probably the most important American ready-to-wear designer of the twentieth century. It is her name, in particular, that is associated with "The American Look" of casual wear and active sportswear that developed during the 1940s.[36] With the Nazi occupation of Paris during World War II, American designers were cast onto their own resources. McCardell flourished. Born in 1905 in Maryland, the daughter of a banker and a southern belle, McCardell studied fashion at Parsons School of Design

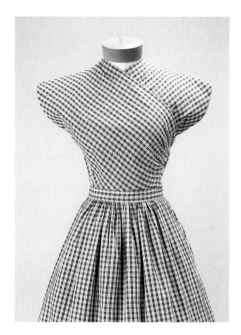

Fig. 7-5. Claire McCardell. Dress, 1943. *Detail of Fig. 7-A.*

in New York and spent her sophomore year, 1926, in Paris.[37] Like Hawes, she was especially impressed by the couture designs of Vionnet. But whereas Hawes only gradually abandoned custom design for ready-to-wear, McCardell knew from the beginning that she had to simplify Vionnet's cut, because she wanted to create ready-to-wear clothes. McCardell always worked strictly within the limits of mass-production, and pioneered the use of unpretentious materials, such as denim, cotton calico, and industrial fastenings for fashion clothes (fig. 7-5).

McCardell made clothes that were "right, ready and revolutionary for every girl in America," declared *Harper's Bazaar* in 1944. There was "something of the pioneer woman in the frugal but beautiful cut of the suit, . . . something of our workmen in the stout welt-seaming, . . . something of Flash Gordon in the adventurous hood."[38] For most of her career McCardell worked for Townley Frocks, where she designed under her own name. Her clothes were young in spirit and moderately priced. Labeled "Claire McCardell for Townley," her innovative designs ranged from play clothes (fig. 7-6) to evening dresses. As one of her customers put it, her clothes were "smart, . . . but casual."[39] Her unstructured jersey bathing suits look particularly modern, since they lack the heavy structural underpinnings that were typical of the period.

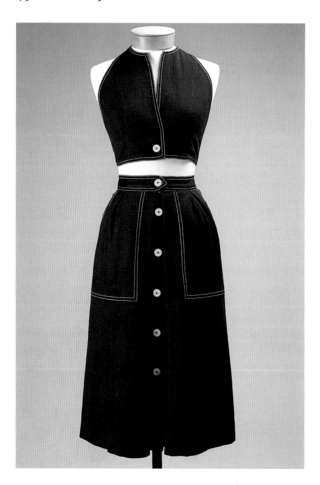

Fig. 7-6. Claire McCardell. Sports ensemble, 1944. Linen. The Metropolitan Museum of Art, New York, Gift of Claire McCardell, 1949 (CI.49.37.30a, b). *Checklist no. 82*

It is important to recognize, however, that McCardell was not alone. There were many accomplished women designers in the United States during the 1940s and 1950s, and an increasing number focused on ready-to-wear and sportswear. "Women Designers Set New Fashions," declared *Life* in 1946. Cited as "outstanding . . . designers of U.S. warm-weather wear" were Claire McCardell, Tina Leser (fig. 7-7), Frances Sider, and Carolyn Schnurer. "The ideal of all four is the long-legged tennis-playing, swimming girl."[40] Not only were their clothes similar, often so were the designers' personal histories. Leser, for example, was the daughter of a stockbroker and came from the same kind of privileged background as McCardell. Less driven to succeed than McCardell, Schnurer quit fashion design after being divorced from her husband and business partner.[41] Mildred Orrick, a friend and fellow classmate of McCardell's at Parsons, was another talented designer. She usually worked anonymously,[42] and her designs are sometimes mistaken for McCardell's.

Bonnie Cashin, another of the great American sportswear designers of the twentieth century, remains surprisingly little known.[43] Although her mother was a custom dressmaker, her own route to a career in fashion design was somewhat unorthodox. "I grew up sewing," she recalled. Passionately interested in dance,

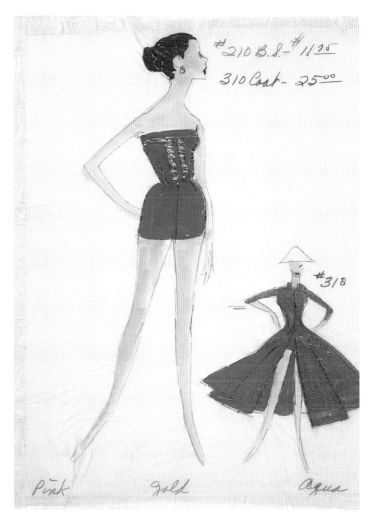

Fig. 7-7. Tina Leser. Design for bathing suit and coat, ca. 1950. Watercolor, pencil, and ink on paper. Special Collections, The Fashion Institute of Technology, New York.

art, theater, and stage costume design, she eventually moved from her native California to New York in 1934 to be a designer for the famous Roxyettes of the Roxy Theater. When she designed street clothes in 1937 to wear in a fashion-show number, they caught the eye of sportswear manufacturer Louis Adler, who offered her a job. "I didn't really know whether I wanted it or not," said Cashin. "The profit-conscious, businesslike atmosphere of Seventh Avenue seemed very different to me from the atmosphere around the theater. I felt more at home with dancers, actors, artists, musicians, writers—people like that—than I did with most of the businessmen I'd met in the clothing industry."[44] Eventually, she took the plunge and began designing for the wholesale apparel industry.

Although successful on Seventh Avenue, after several years Cashin began to feel "boxed-in," and in 1943 she went to Hollywood as a designer for Twentieth Century Fox. She designed fashionable modern clothes for the film *Laura*, as well as historical clothes for *A Tree Grows in Brooklyn* and "ethnic" period costumes for *Anna and the King of Siam*. She especially loved researching and designing the costumes for *Anna*, which, in turn, influenced her own

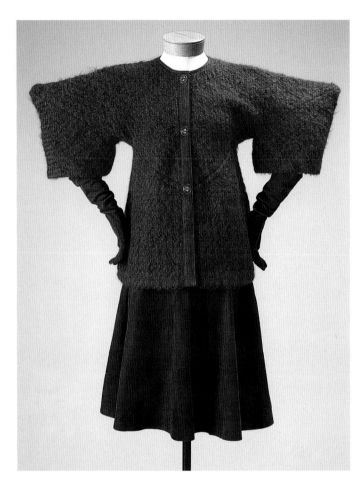

Fig. 7-8. Bonnie Cashin.
Suit, 1964. Wool, mohair,
and suede. The Metropolitan
Museum of Art, New York,
Gift of Helen and Philip
Sills, Collection of Bonnie
Cashin Clothes, 1979
(1979.431.51a–c).
Checklist no. 115

fashion designs. "I've always been strongly influenced by
the Orient It seems to me that Oriental clothes have
a kind of simplicity and elegance and beauty that is applic-
able to our life in this hemisphere today."[45]

Cashin eventually tired of designing costumes at
break-neck speed for films that were not always interesting
to her. Somewhat reluctantly she returned to the trade,
but rather than accept a job with one manufacturer or
another, she decided "to try to work out my own plan. . . .
I realize that no one manufacturer can produce the diver-
sified clothes I feel are needed for today's complex activi-
ties. So—if I can't change the industry, I can try to change
my own working methods." By designing clothes of vari
ous kinds (and price ranges) to be made up by various
manufacturers who specialized in a particular category,
such as coats or handbags, Cashin hoped "to combine the
abilities of the artist with efficient production."[46]

Cashin's approach gave her greater artistic free-
dom, but at the expense, perhaps, of greater recognition
and wealth. She was more like a freelance industrial
designer than a typical fashion designer. Nevertheless, she
won the first of five Coty Awards in 1950, and in 1962 she
was the subject of a retrospective at the Brooklyn Museum.
Cashin was ahead of her time in her advocacy of the pure
lines of "ethnic" clothing, and she was among the first to exploit the artistic
possibilities of leather and suede (figs. 7-8 and 7-9). As the 1960s advanced,
fashion slowly began to catch up with Cashin, who remained critical of the

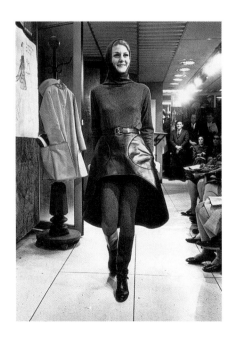

Fig. 7-9. Bonnie Cashin.
"Parabola" leather skirt with
cashmere funnel-neck
sweater and tights, 1968.

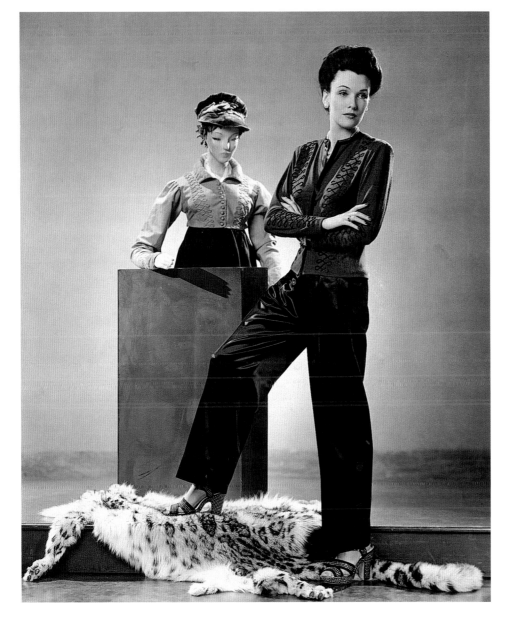

Fig. 7-10. Clare Potter.
Ensemble (*right*) inspired by
an Empire woman's riding
habit. Manufactured by
Charles W. Nudelman, Inc.
Photographed ca. 1940.

commercialism, lack of creativity, and sheer abrasiveness and ugliness of
Seventh Avenue.[47]

McCardell and Cashin were exceptional figures by any standards, but
many other women designers had also been successful in the years before
World War II. In fact, women had dominated the world of fashion in the 1920s
and 1930s, in both Paris and New York. After the war, the situation became
more complex. At the top levels of fashion, women designers on both sides of
the Atlantic were cast into shadow by the rise of famous male *couturiers* based in
Paris, among them Christian Dior, Cristóbal Balenciaga, and Jacques Fath.

The culture of the 1950s was marked by rigid gender stereotypes, and
the resurgent male fashion leaders displayed a certain animosity toward

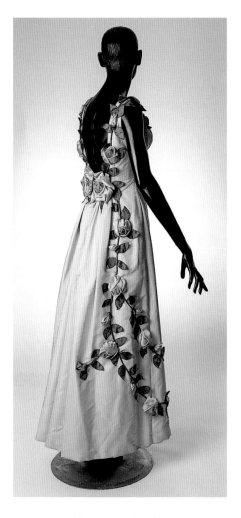

Fig. 7-11. Ann Lowe.
Debutante gown, ca.
1958–60. Silk satin. The
Black Fashion Museum,
Washington, D.C.
Checklist no. 109

women designers. A 1954 newspaper article asked, "Are Men Best Fashion Designers?" and several designers expressed their opinions.[48] Fath proclaimed "Women are bad fashion designers. The only role a woman should have in fashion is wearing clothes." Women designers naturally protested: "Men are the great designers? No! The great designers are women," declared Sophie of Saks Fifth Avenue, citing Vionnet and Chanel as examples. Fath further argued that women could only see fashion in personal terms. "I never design for myself," said Leser. "I'm a big girl. All my designs are for little people." According to Fath, "Fashion is an art and men are the artists." Schnurer, however, argued that "Creative people are creative people, irrespective of sex." Rather than challenge Fath's stereotypes, McCardell simply reversed them: "Someday all designers will be women," she said. "Men, I hope, will be busy with masculine things."

Despite the hostility of Fath and others like him, and the enthronement of male designers at the pinnacle of Paris couture, the 1950s was a period of relatively great professional success for many American women designers. Custom designers, such as Sophie of Saks and Valentina, continued to flourish, as did sportswear designers such as Clare Potter (fig. 7-10), Orrick, Leser, Cashin, and Schnurer. Top-of-the-line ready-to-wear designers, such as Nettie Rosenstein, Ceil Chapman, Jane Derby, Madame Eta, and Copeland (for Pattullo) also continued to be successful. During the 1950s and 1960s, African American designer Ann Lowe created dresses for many socialites (fig. 7-11).[49] By the 1970s and 1980s, though, the most successful black fashion designers tended to be men, particularly gay men.

The ideology challenged in Betty Friedan's *Feminine Mystique* sometimes ran up against women's career ambitions. Anne Fogarty, for example, published a book called *Wife-Dressing* (1959) that offered advice such as not wearing hair curlers in front of one's husband. She herself had a successful career, beginning in the late 1940s, when she designed "teenage" versions of Dior's New Look for a company called Youth Guild.[50] Switching to another company that produced junior sizes, she continued designing feminine, youthful styles that won her a Coty Award in 1951.

Ready-to-wear designers increasingly launched their own businesses, which raised their public profile. In 1942 Pauline Trigère, who had worked for Hattie Carnegie, began designing on her own (fig. 7-12), and in 1947 Vera Maxwell, who had designed for women doing war work during World War II (fig. 7-13), opened Vera Maxwell Originals after having worked as a fashion model and illustrator and then a designer for Adler & Adler. In 1966 Maxwell commented, "So here I stand today, running my own manufacturing business. It is substantial and . . . 'fiscally attractive', serving many customers through hundreds of fine shops and large stores across the U.S.A."[51]

Anne Klein (fig. 7-14), who began sketching fashions at the age of fifteen, designed in the 1950s for Junior Sophisticates. In 1963 she founded her own fashion house and also worked as a consultant for other companies. In the 1960s the Fashion Group, an organization of women in the fashion industries, asked Klein to advise young people hoping to become fashion designers. Klein warned that the "dress business" was not an easy life and tried to dispel popular stereotypes about designers:

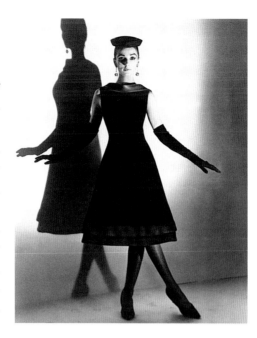

Fig. 7-12. Pauline Trigère. "Rajah" cocktail dress. Wool crepe and peau de soie, 1961. Special Collections, The Fashion Institute of Technology, New York.

"If the image created for you is—that female designers (in ubiquitous hat or horn-rimmed glasses), and male designers (in cravats and tails), function and create in sumptuous, crystal-chandeliered salons . . . [and] lunch daily on champagne and caviar—you are laboring under a delusion!"[52]

As more women entered the workplace at higher levels, they increasingly sought out practical, affordable office attire. Anne Klein's tailored separates, designed for the eponymous firm she headed, were especially popular.[53] When she died in 1974, her twenty-five-year-old assistant, Donna Karan, took over design responsibilities at Anne Klein.[54] Two years later Liz Claiborne and her husband launched their company, which specialized in working women's clothing.[55] Socialite-turned-fashion-designer Diane von Fürstenberg also built a highly successful business in the 1970s based on her simple wrap dress and a genius for marketing. "Dressing for success" became an international phenomenon, and women designers based in the U.S.A. seemed especially successful at the formula. Others of note during this period were Betsey Johnson, Mary McFadden, Carol Horn, Holly Harp, and Cathy Hardwick.

In the mid-1970s fashion critic Clara Pierre wrote that "the current preeminence of female designers is due partly to the fact that they originate ideas for their own use The other reason is that in these days of female emancipation, the ladies have shown that they can make it in business."[56] This picture is too simple. Women such as Betsey Johnson may have become important in the 1960s (fig. 7-15), but so did men like Rudi Gernreich. Mary Quant led the pack in "Swinging London" with her mini-skirts, but she was soon overtaken by André Courrèges, Pierre Cardin, and Yves Saint Laurent in Paris. Like many American women designers, Bill Blass worked semi-anonymously for several companies before starting his own business.

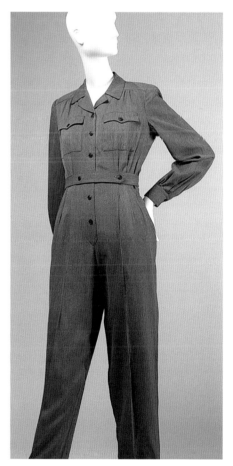

Fig. 7-13. Vera Maxwell. "Uniform for War Work" coverall, 1942. Cotton twill. The Metropolitan Museum of Art, New York, Gift of Vera Maxwell, 1947 (CI.47.60.1). *Checklist no. 78*

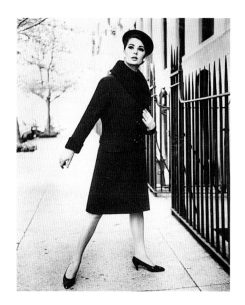

Fig. 7-14. Anne Klein. "Officer's" overcoat, 1964. Made by Junior Sophisticates, New York. Melton wool trimmed with Persian lambskin. Special Collections, The Fashion Institute of Technology, New York.

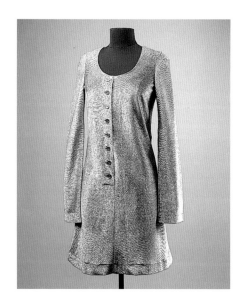

Fig. 7-15. Betsey Johnson. Dress, ca. 1965. Designed for Paraphernalia, New York. Lurex. Collection of Lauren Sweder. *Checklist no. 118*

The 1970s brought "functionalism" into fashion, and many women designers came to the fore, but so did such male designers as Halston, Calvin Klein, and Giorgio Armani. Indeed, male designers were becoming more important, rather than less, in the 1960s and 1970s.

In 1985 Karan left Anne Klein and launched her own company (fig. 7-16). She was hailed as the "Queen of Seventh Avenue," in the same league as men like Calvin Klein and Ralph Lauren.[57] Internationally, also, there seemed to be a new generation of women designers. As one French magazine put it in 1987, "Never before have women designers been so powerful. From Japan's Rei Kawakubo to Donna Karan in the United States and England's saucy Vivienne Westwood—it's women who are offering the challenge, provocation, and innovation to push fashion forward."[58] Had women designers finally achieved parity with men?

"Increasingly, talented female designers are coming into their own—both in creative and marketing terms," declared veteran fashion writer June Weir in a 1985 article, "Closing the Gender Gap." She went on to note that whereas "a decade ago there were only a handful [of women designers], now their ranks seem to be multiplying daily," and that "women designers are becoming successful and influential forces in the American fashion market."[59] In many respects this was true. Gender was less of an issue than ever before. However, this meant not only that women could run businesses, but also that men could explore their creativity without having their masculinity questioned. Gay liberation advanced along with women's liberation.

Ethnic diversity only began to have an impact on fashion in the 1980s and 1990s, when Asian-American designers of note included Anna Sui, Vivienne Tam, Josie Natori, Han Feng, and Vera Wang. Tam, in particular, has chosen to incorporate Chinese motifs in her work (fig. 7-17). Yeohlee Teng, known professionally by her first name, was born in Malaysia and studied in New York at the Parsons School of Design before becoming known for her "architectural" clothes (fig. 7-18), which are popular with artists and intellectuals.[60] The Cuban-born Isabel Toledo, who was sewing with a machine from the age of eight and imaginatively redesigning paper patterns in her teens, is greatly admired among the fashion cognoscenti. One of the most original designers working today, she sees herself in the long tradition of women as dress designers and dressmakers, and her beautifully conceived, cut, and made clothes refer back to that tradition (fig. 7-19).[61]

It is still too early, however, to say that women have attained parity with men—either in the fashion world or in the world at large. In 1990 the *New York Times* reported that investors were increasingly interested in women designers. Unfortunately, this was not because they recognized that women can also be creative, but because they feared that male designers might "drop dead" from AIDS.[62] This anxiety has subsequently become less acute, as new

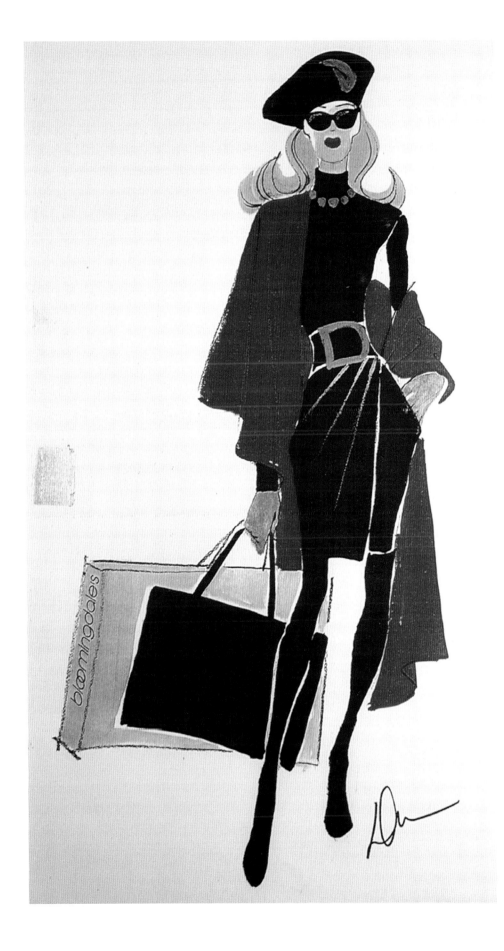

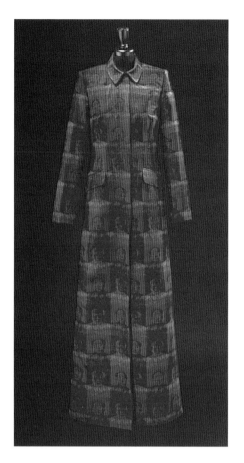

Fig. 7-17. Vivienne Tam.
"Mao" coat, 1998. Polyester.
Collection of Vivienne Tam,
New York. *Checklist no. 211*

Fig. 7-18. Yoehlee Teng.
Cape, 1982. Black melton
piped in white merino wool.
The Metropolitan Museum
of Art, New York.

Fig. 7-19. (facing page)
Isabel Toledo. Wedding
dress, 2000. Cotton lisle.
Collection of Isabel Toledo.
Checklist no. 221

medical treatments have helped contain the ravages of AIDS—at least within the industrialized world.

Nevertheless, men and women in the fashion industry continue to be perceived differently with respect to creativity. As fashion scholar Richard Martin observed, "pernicious and unexamined assumptions of male creativity and female reception [give] an ascribed heroism to the male designer that evades the female designer."[63] So long as fashion commentators tend to praise women designers for their "practicality" and men for their "creative genius," it will be premature to talk about the gender gap having been closed.

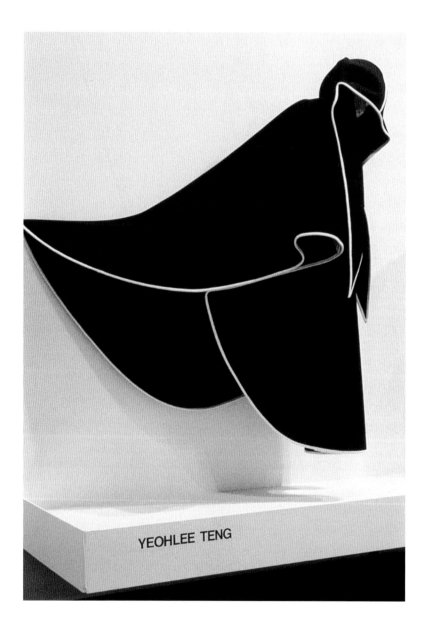

YEOHLEE TENG

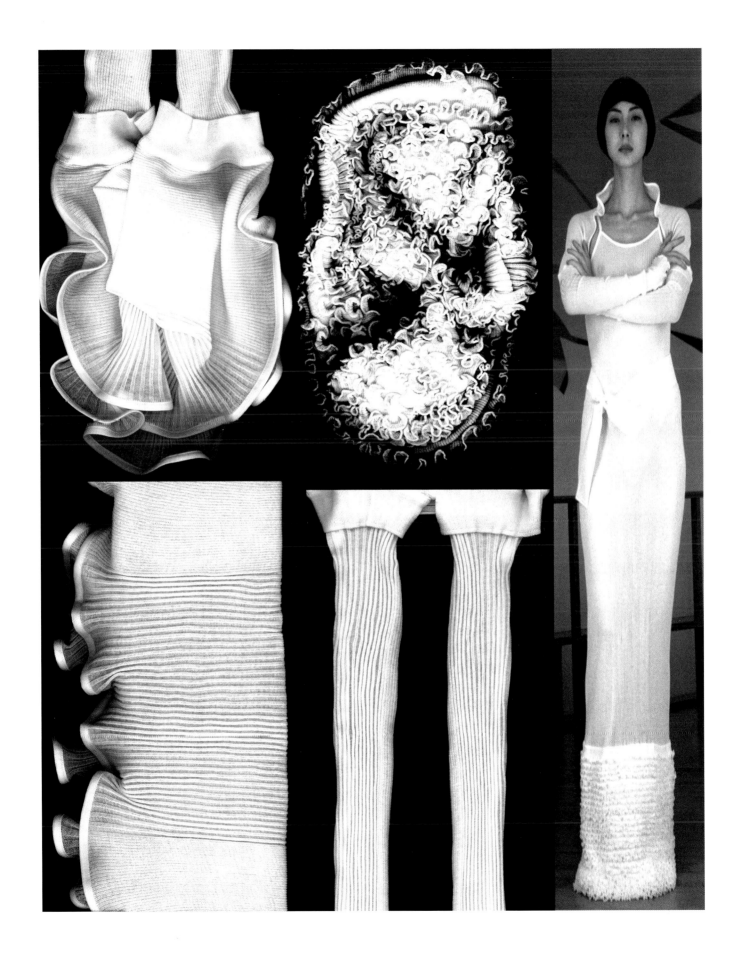

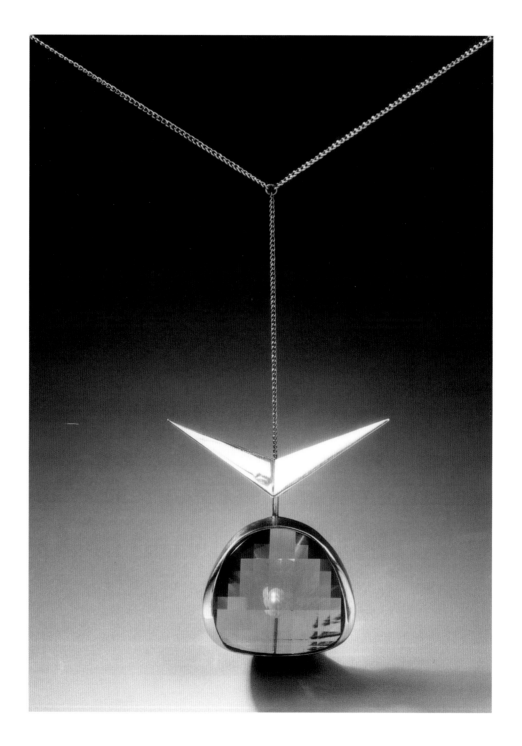

Fig. 8-A. Margaret de
Patta, with Eugene
Bielawski. Pendant, 1952.
Gold and double-faceted
rhomboid crystal.
Collection of Eugene
Bielawski

8

TONI GREENBAUM

PAT KIRKHAM

Women Jewelry Designers

DESPITE THE CLOSE LINKS BETWEEN JEWELRY and the shaping of "the feminine," jewelry design and making in the United States were male-dominated activities until the turn of the twentieth century. In the years between 1900 and 2000, increasing numbers of women, including European Americans, Native Americans, and African Americans, breached the gender barrier, entering a field where they could not only make a living but also express their creativity. Education and training varied greatly, as did practice. Some (the majority) designed and made all their pieces; others designed but only executed some of the objects, leaving the rest to assistants, still others (the minority) only designed. Their workplaces ranged from spaces within or near the home to specialist workshops that varied in size and facilities. Some women worked alone or with other women; others collaborated with husbands or male partners. Some specialized in jewelry, while others engaged in a variety of design and craft areas.

ENTERING MALE DOMAINS

The routes that took Native American and European American women to jewelry design and making were different but equally fascinating. Native American women, whose design traditions are so often depicted as "ancient," disrupted recently gendered practices, whereas European American women faced trade practices rooted in European craft guild and apprenticeship systems dating back to the Middle Ages.

At the time Native American women began to participate in metal jewelry making, the occupation had only been practiced for fifty to sixty years, and during that time it had always been a male occupation. In about 1850–70 Navajo men in the American Southwest learned silver jewelry making from nearby Mexican silversmiths, and Zuni men learned from the Navajo shortly thereafter.[1] At first women's involvement was restricted to assisting spouses, especially with delicate aspects of production such as soldering silver "raindrops," twisting wires, and grinding, polishing and setting turquoise.[2] Some women became highly skilled, but it took an unprecedented demand for Native American artifacts within white communities in the 1910s and 1920s to significantly alter the gender-specific division of labor.[3]

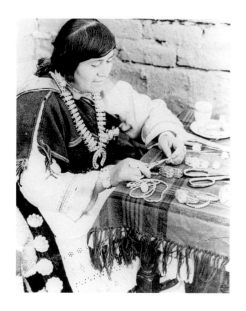

Fig. 8-1. Della Casa Appa (also called Della Casi), Zuni Pueblo, ca. 1935.

By 1900 the Fred Harvey Company, which played a major role in promoting tourism in New Mexico and Arizona, was already supplying the Navajo with silver and turquoise to make lightweight jewelry suitable for purchase by those who traveled by railroad to the southwest.[4] New roads and hotels encouraged unprecedented numbers of visitors, and the sale of "Indian" goods became big business. So dramatic was the transformation of the Navajo economy that Grey Moustache, one of the first Navajo silversmiths, recalled that in the 1910s "money was falling down like rain."[5] It was to catch that money that women became more involved in the actual design and production of metal jewelry, not just as assistants in the process. They learned to form metal. Most worked collaboratively within the family, but a few worked independently. Mary Burnsides, for example, a Navajo woman from the Gallup, New Mexico, area, learned by watching her husband, and in the 1920s she began to produce her own jewelry from silver, turquoise, and shell beads. She worked mainly at night because during the day she continued to weave and take care of the animals. Unfortunately, failing eyesight forced her to abandon jewelry making, in the early 1930s.[6]

The enormously talented Della Casa Appa (also called Della Casi; fig. 8-1), was the first Zuni woman to make a name for herself as a designer-maker of jewelry—both within and outside her own culture. She is also credited with being the first Zuni woman to work independently as a jeweler. In the late 1920s she reputedly hid her work in her apron on her initial visits to the local trading post and only approached the trader, C. G. Wallace, when she was likely to go unnoticed by the community. According to Wallace, who bought her work, she "was afraid other women would resent her efforts."[7] Despite the economic incentives for women to earn cash in a culture whose economic base had been obliterated by government-sanctioned genocidal and "removal" policies, both women and men were concerned about the impact of women's entry into an occupation that in living memory was gendered as male. In 1938 Grey Moustache recalled:

> When I first heard about some women over near Gallup [New Mexico] making silver, I felt sort of silly. I thought that I was better than a woman because I could make silver jewelry and they couldn't. But when I heard this, I had to admit that women were just as good as I was. I think that it is all right if women make silver. They can earn good money that way.[8]

His reaction to women sharing the occupation by which he marked his masculinity indicates the delicate social and psychological terrain to be negotiated by women who wanted to design and make jewelry. Attitudes changed, however, as the economic rewards became more apparent and the talents of women such as Casa Appa were recognized: she even became a member of a Zuni "fraternity," a rare honor for a silversmith and almost unheard of for a woman.[9]

Of the women who followed in Casa Appa's footsteps, included were Annie Quam, Winnie Jackson, and Mary Kalestewa. Some of these early makers are known today by first name only; others were known by their husbands' names, such as Doris Ondelacey, who until recently was referred to solely as Mrs. Warren Ondelacey. An "Olla Maiden" squash-blossom necklace (ca. 1940; fig. 8-2), made by Ondelacy, of silver and Lone Mountain Mine turquoise, is one of the most striking examples of Zuni cluster work ever produced.[10] Nine Zuni women jewelers are known to have had independent accounts at trading posts in 1938, and at least as many again probably worked with their husbands.[11] Although Zuni women began to design and make beaded jewelry, which proved more lucrative than silver and was very popular with tourists, the numbers of women designers remained relatively small. By 1940 approximately 10 percent of Zuni (total number about 140) and Navajo (total number about 600) jewelers were women.[12] Native American women have continued to enter this field, and those who worked as jewelry designers and makers later in the century helped redefine the design traditions within which they work (discussed below).

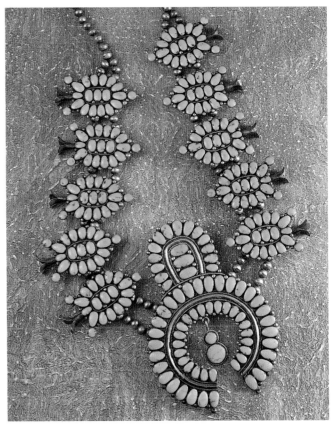

Fig. 8-2. Doris Ondelacey. "Olla Maiden" necklace, ca. 1940. Lone Mountain turquoise and silver. Collection of Tanner's Indian Art, Gallup, New Mexico.

In European American culture, jewelry and metalworking were also male-dominated activities.[13] Although jewelry, like clothing, was integrally related to the construction of female identity and to "women's culture," its design and production were largely excluded from the female domain. The breakthrough for European American women came with the Arts and Crafts movement in the late nineteenth century. When women began to press for careers, jewelry was considered an occupation "to which a woman's light and dainty manipulation is peculiarly adapted."[14] An attraction for women was that production did not require much space and could be carried out in the home. This offered a buffer against the (male) public sphere of work—as did the quasi-domestic small-scale workshops typical of the Arts and Crafts movement.

Arts and Crafts jewelry designers provided adornment for artistically inclined "progressive" middle-class women. Conspicuous consumption, particularly the use of expensive gemstones such as diamonds and emeralds, was shunned but display remained central—as the emphasis on iridescence, large semiprecious stones, and brightly colored enamels testifies. Oxidized silver was the preferred metal, but Madeline Yale Wynne, whose jewelry exalted the handmade and the "primitive," and other "pioneer jewelry practitioners" preferred the even cheaper metals of copper and brass (see fig. 2-1).[15] Gold continued to be used, but surfaces were left "rough" and hammer

Fig. 8-3. Josephine Hartwell Shaw. Necklace, 1910. Silver, gold, and pearls. Private Collection. *Checklist no. 17*

marks revealed. Semiprecious opal, agate, turquoise, and amethyst were favored, together with pearls, shells, and glass. Such materials reflected the movement's preoccupation with the commonplace, even though much of the jewelry was far from "ordinary." A necklace designed and made in 1910 by Josephine Hartwell Shaw (fig. 8-3) recalls the Arts and Crafts movement's fascination with the irregular in nature and in hand production, whereas the 1904 cross by Jane Carson Barron and Frances Barnum Smith (see fig. 2-10) is evidence of its romance with the Middle Ages.

Training and education proved key enablers, but before 1900 there were few places where one could learn jewelry design and making in the United States outside the trade.[16] After 1900 opportunities for women expanded as educational institutions, to which they were gaining access, began instruction in jewelry and art metalwork, often in conjunction with commercial manufacturers whose (male) staff were engaged as teachers.[17] Many of the women jewelers who rose to prominence in the movement attended colleges of art and design, but to attain the skills needed to work professionally some also sought out private teachers. Many of these were men, particularly in the early years, but by 1904 Wynne was passing on her skills to others. A few years later Grace Hazen gave lessons in jewelry from her studio at the National Arts Club, New York, and at the Detroit Society of Arts and Crafts.[18] By 1914, when Shaw was taking apprentices and Barron and Smith ran their all-woman firm, women "comprised the majority of the new breed of studio jewelers and enamelists."[19]

Support networks were crucial for women breaking into new areas. Smith and Barron, who met at college, encouraged each other as well as the women who worked for them.[20] Shaw, whose husband worked in the same field, also enjoyed the type of support given by a fellow designer-maker.[21] Although most of the women were from middle-class backgrounds, coming from a bourgeois home did not necessarily ensure financial assistance from their families. Janet Payne Bowles (see chap. 9), for example, had to support herself and her children after she separated from her husband.[22] Despite the fact that Marie Zimmermann (see chaps. 2 and 9) came from a prominent Brooklyn family, she had "no help from the outside" when setting up her metalwork and jewelry studio/workshop, which "paid for itself from the beginning."[23] Such histories dispel the notion that white middle-class women pursued jewelry design mainly as a hobby.

MACHINE-AESTHETIC MODERNISM

Women played an important role in the development within jewelry of "machine-aesthetic" modernism, sometimes called International Style modernism, which drew more closely on the aims and ideals of the Bauhaus than other versions of modern design. Several women were prominent among those jewelry designer-makers who negotiated ways of working within a "progressive" design ideology, which placed considerable emphasis on machine-made mass-produced goods. Modernist design became increasingly prevalent in the United States in the 1930s, particularly after 1933 when many European designers and architects, some of whom had been at the Bauhaus, emigrated in response to rising Nazism in Germany.[24] Because of its predilection for rationality, functionalism, standardization, mechanized production, "cold" geometric forms, and "hard" finishes and materials, International Style modernism has been categorized as "male," offering little space to women.[25] Given that neither jewelry nor handwork were central to the agenda of Bauhaus-style modernism, the rich and varied products of women jewelers' negotiations of this apparently ideologically unsympathetic terrain suggest that this view may need qualification.

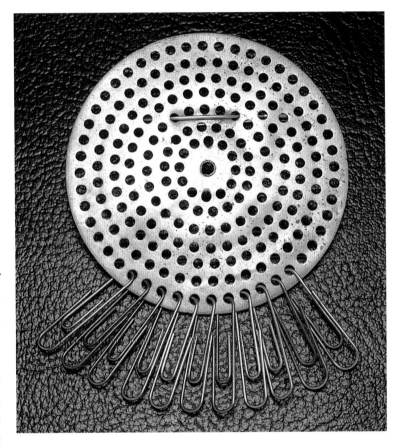

Fig. 8-4. Anni Albers and Alex Reed. Brooch, 1941–46. Aluminum sink drain, paperclips, safety pin. Collection of Daphne Farago.

Two of the most strongly "industrial" designs shown in the Museum of Modern Art's *Modern Jewelry Design* exhibition of 1946 came from women. Izabel Coles, formerly of Tiffany and Company, New York, "confected a sleekly seductive necklace and bracelet out of nothing but brightly enamelled safety pins," while former Bauhaus student Anni Albers and Alex Reed, her student at Black Mountain College, North Carolina, showed several necklaces made from hardware, including a pendant (similar to the brooch shown in fig. 8-4), which is assembled from a metal sieve and paper clips.[26] Other women designers in the exhibition included Fannie Hillsmith, Joan Hurst and Jill Kingsbury, Adda Husted-Anderson, Gertrude Karlan, Hilda Krauss, Madeleine Turner, and Carolyn Wagner—all from New York City—and Madeleine Burrage from Maine, May G. Gay from Oregon, and Margaret de Patta from California.[27]

Margaret de Patta began her career as a painter but shifted to jewelry design in the mid-1930s as a more viable way of making a living.[28] Her earliest work was heavily influenced by "primitive" and Asian art and jewelry, and she "ascribed superior esthetic qualities to handmade things."[29] In

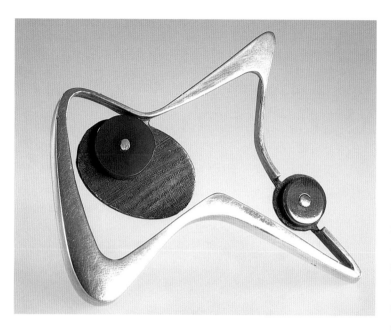

Fig. 8-5. Margaret de Patta. Brooch, 1946–58. Silver, chrysoprase, jasper. Collection of Denis Gallion and Daniel Morris, Historical Design, New York. *Checklist no. 89*

1940–41 she studied with László Moholy-Nagy, a former Bauhaus teacher who had emigrated to Chicago where he helped found the School of Design in Chicago, nicknamed the "New Bauhaus." Her husband, Eugene Bielawski, taught "basic workshop" at the school, and both became dedicated to the ideas of the Bauhaus, later (in 1951) attempting to start their own Bauhaus-style school.

De Patta's work changed radically under Moholy-Nagy's influence. She strove for structural integrity, the avoidance of any extraneous elements, and textural and optical effects through surface treatment.[30] Her jewelry played with space, featured overlapping planes and real and implied movement of elements, contrasted solids and voids, as well as light and shadow, and incorporated pierced metal and transparent stones cut in new ways, such as faceted beneath rather than above, thereby creating a prismatic effect. De Patta agonized over the dichotomy between her handmade work and the modernist call-to-arms over affordable machine-made goods. Frustrated by the cost of her handmade jewelry (approximately $125 per piece), she addressed the "contradictions between my social viewpoints and my method of work."[31] In 1946 she established Designs Contemporary, together with Bielawski, who advised on technical and design matters, and she tried to compete with quality costume jewelry by "altering production methods."[32] The aim was to reduce prices to $50 or less. However, because it took the same amount of labor to produce a design and a model for a production piece as it did for a one-off piece, short of switching to machine production, the only way to cut costs was to handcraft more than one version from the model.

The gap between the language and ideology of modernism, and the practices of modernist jewelry designer-makers, was considerable. De Patta may have failed to incorporate mechanization into her production, but she found consolation in the "political correctness" of her shift to multiple copies. She was delighted when those who, like her pre-Bauhaus self, continued to extoll handwork for its own sake could not tell the difference between her one-off and her serially produced pieces.[33] The difference was largely semantic, however, and "value" hinged on concepts of the "original" versus the "copy." In the 1946 MOMA show, a de Patta "reproduction" ring was exhibited and both the "original" and other "reproductions" were offered for sale.[34] Her 1948 brooch is a rigorous structuring of space by means of light, line, and color (fig. 8-5). The illusion of freely floating forms was achieved by mounting two stones in "invisible" support devices. Without the knowledge that a virtually identical piece is in another collection, however, it

would be difficult to ascertain whether or not it was an "original" or a "reproduction."

By the mid-1950s Designs Contemporary was producing up to sixty-five handmade duplicates of a given design, and de Patta was finding the strain of "repetitious production" and of running a business too much.[35] She felt that designers should be free to concentrate on design, but Bielawski, a more hard-line modernist, believed that "to maintain social contact" designers needed to involve themselves with tasks such as promotion and marketing. Fear of losing sight of her creative vision led de Patta to refocus on design and experimentation, and she turned increasingly to one-off items.

A less self-conscious modernist was Betty Cooke who also designed for limited production runs. Except for occasional die stamping, her jewelry was and still is entirely handmade. In the early 1940s, she apprenticed with a local jeweler of "the old school" while studying fine art at Johns Hopkins University and the Maryland Institute, College of Art. Trusting in her own views, rather than "theory," she was not afraid to claim that the true "function" of jewelry was to "[attract] attention and admiration."[36] Early in her career she turned down the opportunity to design for a large manufacturer because of the pressures generated by working in such an environment, and throughout her career she worked on a small scale. Later she was happy to see her jewelry repeated, usually by assistants whom she allowed to introduce subtle variations.[37] In 1946 she opened a shop in her home, which was located in a Baltimore neighborhood favored by young artists and designers. Immediately after World War II the modernist idea of design offering a new and better world appealed to those attempting to forge a lifestyle "alternative" to that offered by corporate America.[38]

When interviewed in *Arts & Architecture* in 1949, Cooke argued that modern design need be "neither cold nor impersonal" and her own work is among the most "human" and least "serious" of modernist jewelry, particularly her whimsical animal pins.[39] Mainly in silver, sometimes with wood, plexiglass, pebbles, stones, or enameling, her designs were noted for simplicity and minimalism. In one necklace (ca. 1950; fig. 8-6), for example, she achieves a gentle grace by rounding the corners of the otherwise hard-edged rectangles that comprise it and by stringing them on a soft leather thong rather than a rigid metal torque.

Another woman jewelry designer to open shop in a bohemian neighborhood was Winifred Mason, who worked from a studio in Brooklyn, New

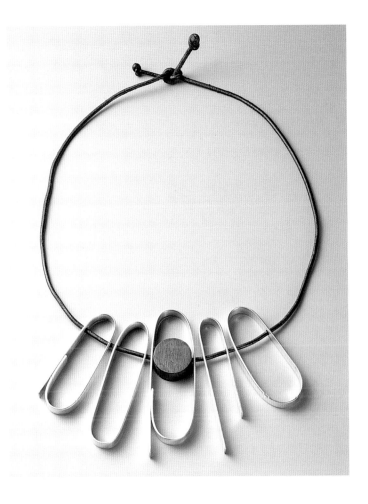

Fig. 8-6. Betty Cooke. Necklace, 1950. Silver and leather. Collection of Gansevoort Gallery, New York. *Checklist no. 96*

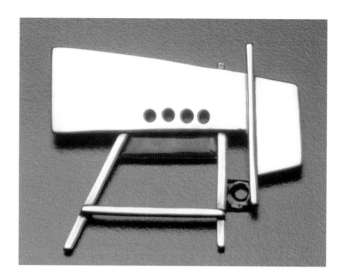

York, making "handmade fake copper jewelry" for friends, before opening a shop in Greenwich Village in about 1942.[40] Although a "famed jewelry maker" of her time,[41] she is little known today, and not a single piece by her has been documented. Featured in *Ebony* in July 1946 as a leading African American designer, she is shown holding a necklace of large silver beads against model Barbara Gonzalez. Another photograph in the same issue features Sally Parks, wife of photographer Gordon Parks, wearing a similar necklace also designed by Mason.[42] She passed on her many skills to Art Smith who apprenticed with her four years before opening his own shop in 1946. He recalled that when she opened her shop, she "needed somebody to carry some of the work, and I fell into it eagerly It was a kind of marvelous place. It was a little Bauhaus in a way We had a whole big establishment, a tremendous enthusiasm, and an exciting group of people contributing to it. It was in the midst of compatible neighbors and friends . . . like . . . Talley Beatty, Ralph Ellison, Gordon Parks They all knew Winnie and we got to know each other."[43]

Modernist jewelers Merry Renk and Irena Brynner both looked to de Patta as mentor. After being widowed during World War II, Renk went to the "New Bauhaus" (then called Institute of Design) to study industrial design, but finding that her handmade jewelry sold well, she embarked upon a new career.[44] Her beautiful small-scale explorations of form and structure ranged from earrings and brooches (fig. 8-7), some of which were produced in multiples, to metal crowns for weddings and other special occasions.

Brynner also changed the direction of her career. In the late 1940s she turned from fine art (especially sculpture) to jewelry, after seeing jewelry by sculptor Claire Falkenstein, which was reminiscent of Falkenstein's monumental work in the use of dense wire formations enclosing space. They also revealed the sculptor's liking for open volume, light and transparency (fig. 8-8).[45] Brynner's own work of the 1950s drew on modern sculpture,

particularly that of Naum Gabo and Vladimir Tatlin.[46] The involvement of "serious" fine artists such as Falkenstein in jewelry design raised the prestige of jewelry and paved the way for expanded visions of jewelry in the last quarter of the century.

COSTUME JEWELRY

An irony confronting modernist jewelry designers was that costume jewelry—serially made, mass-produced, and often referred to as "junk jewelry"—which used nonprecious materials, was affordable to all. It did not, however, conform to modernist notions of "good design." A further irony is that when de Patta designed several pieces of costume jewelry to be produced in the one-to-two-dollar price range, the retail trade did not think much of them and "turned thumbs down."[47] Fashion, rather than narrowly proscribed "good design," was the driving force behind costume jewelry, and in the 1920s and 1930s several costume jewelry firms were established by women associated with the fashion industry. By the end of World War II costume jewelry was considered vital to the American fashion industry and *Fortune* estimated its annual retail gross at $150–200 million.[48]

Fig. 8-8. Claire Falkenstein. Brooch, ca. 1955. Brass. Collection of Sheryl Gorman.
Checklist no. 103

Fashion designers and entrepreneurs, who produced jewelry as part of a fashion-accessorizing service, included Hattie Carnegie, Nettie Rosenstein, Adele Simpson, and Pauline Trigère. Carnegie, who opened first a hat shop in 1909, then a custom-made clothes salon in 1918, and finally expanded into ready-to-wear fashion in 1929, first offered costume jewelry to clients in 1919. It was not until 1938, however, nine years after she entered ready-to-wear, that her jewelry trademark was registered.[49] Although Carnegie is noted mainly for "refining the designs of others"[50] rather than as a designer in her own right, this stylish "tastemaker" with strong opinions almost certainly oversaw design decisions. Little is known about the jewelry designers she employed; some were men, including Norman Norell, but others were women, including sculptor Nadine Effront who had studied with Georges Braques.[51]

Unlike Carnegie and the others, Miriam Haskell, the best-known name in collectible costume jewelry today, was not associated with the fashion business, although her East European parents ran a clothing shop in Indiana.[52] She moved to New York in 1924, opened a gift shop in the McAlpin Hotel and soon headed one of the leading costume jewelry firms in the United States until her retirement in 1950.[53] She may have played a role in the actual design of the jewelry, particularly in the beginning, but most of the work was designed by Frank Hess and later Robert Clark.[54]

One of the few independent costume jewelers about whom anything is known is the multitalented Nina Wolf, "a freelance fashion and handicraft designer and manufacturer."[55] Trained as a costume designer in the late 1910s, she interrupted her career to marry and raise a family, and when her

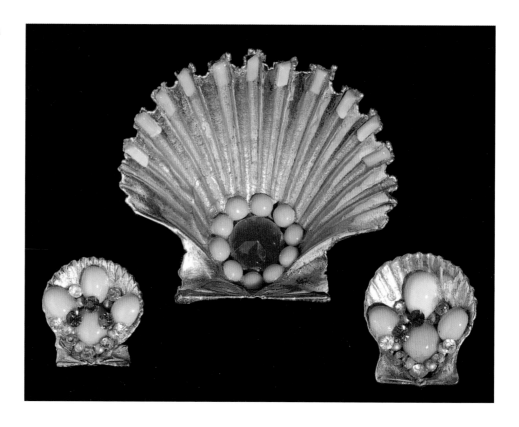

children were grown, she turned her talents to costume jewelry. In the early
1940s her shell-encrusted items with "unreal turquoise," fake pearls, and
amethyst-colored plastics (fig. 8-9) sold at Bonwit Teller from $3.95 to $12,
while Bergdorf Goodman "marketed like precious gemstones" a matching
triple-strand necklace and bracelet of twisted pink and blue glass beads which
sold en suite for twenty-five dollars.[56] In 1945 she designed costume jewelry
to coincide with the release of *Caesar and Cleopatra* (1945), a film directed by
Gabriel Pascal. Her "signature" starburst pin was featured as a *Vogue*
Christmas choice,[57] and the same year she was honored by the fashion indus-
try with a coveted Coty Award.

Somewhat unusually for a woman, especially one who designed "junk
jewelry," Wolf was considered an "idea expert" and industrial designer. This
was mainly because she contributed to developing a technique for gilding
plastic, specifically the Celanese Corporation's Lumarith (cellulose acetate).
She used mass-produced extruded lengths of Lumarith in her designs for
jewelry and cosmetics cases.[58] By the late 1940s women across the country
wore her jewelry or carried her cosmetic cases, yet until recently, her contri-
butions to American culture had been all but forgotten.[59]

REVIVALS AND REDEFINITIONS

Some of the most creative jewelry of the later years of the century related to
redefining the nature of jewelry and to reviving and reworking earlier design
traditions, particularly those of "preindustrial" societies. The barrier between

fine art and craft had been challenged since the 1940s. It was further eroded by postmodern and feminist approaches to design from the 1970s. Some women designers elevated costume jewelry; others used jewelry design to explore personal and political issues. Some told stories through their work, stories in which the personal and the political intertwined, as did those of gender and ethnicity. Taken together, the women designers discussed below, and others not included in this short essay, helped radically change the understanding as well as the appearance of jewelry.

Fig. 8-10. Mary Ann Scherr. "Body-Monitors" jewelery, 1969–74. Stainless steel, liquid crystal devices, and plastic. Private collection.

One redefinition centered on a move away from small-scale "feminine" jewelry. In the late 1960s and 1970s, Arline Fisch, Alma Eikerman, Mary Ann Scherr, Marjorie Schick, and others, produced "body sculpture," which reflected the undulating shapes and forms of women's bodies and the "energy-charged" relationship of solids and voids in space.[60] (fig. 8-10) It belonged to the movement to claim jewelry as "art" and was born out of a new awareness of and pride in the human body. In the 1970s Scherr stretched the boundaries of jewelry by collaborating with (male) scientists to create "body-monitors"—jewelrylike devices that read heart rate, pulse, air pollution, ultra-violet radiation, and other factors.[61] Some of her later "mainstream" work, by contrast (fig. 8-11), was produced in more conventional modes.

In 1972 Eikerman designed a silver and gold bracelet (fig. 8-12), which is organic in form, but the inner surface remains flat in classic bracelet tradition. By contrast, Elsa Peretti's "Bone Cuff" bracelet (1969–70; fig. 8-13) was designed to fit over the wristbone. It reflects an appreciation of organic form and an awareness of the human body beneath the metal, while suggesting both boldness and bondage. Peretti bridged the gap between costume jewelry and "serious" jewelry and redefined jewelry as "fun" in the process.

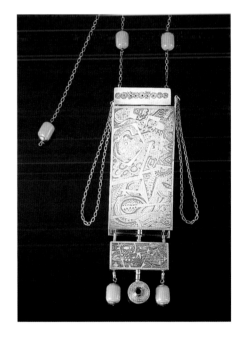

Fig. 8-11. Mary Ann Scherr. "Electronic Oxygen Belt Pendant," 1974. Silver, electronics, amber, and oxygen mask. American Craft Museum, New York, Gift of Mary Lee Hu, 1979, Donated to the American Craft Museum by the American Craft Council, 1990 (1979.2). *Checklist no. 139*

Trained as an interior designer in Italy, Peretti worked as a fashion model in the United States in 1969 and had more in common with clothing designers than with art-school-trained jewelry designers. Her designs fitted the mood of "swinging" New York and were chosen that same year by fashion designer Halston to show with his clothing collections.[62] As a result of contacts established by Halston, Peretti signed a contract with Tiffany and Company in 1974 to design their silver jewelry. The firm had not promoted silver jewelry for many years, and the Peretti mass-produced pieces, which retailed for as little as $18 in the 1970s, attracted a new and younger clientele.[63] By 1979, Peretti was the firm's leading designer and remained so at the end of the century.

The new stature of costume jewelry encouraged designers to explore ways of producing "fun" jewelry for younger buyers. In the early 1970s art-school-trained Cara Croninger turned to jewelry after making leather clothing during the 1960s. She took up plastics because of its potential for casting multiples. However, despite the economic pressures of single parenthood in New York, she chose finally not to design for mass production because it did

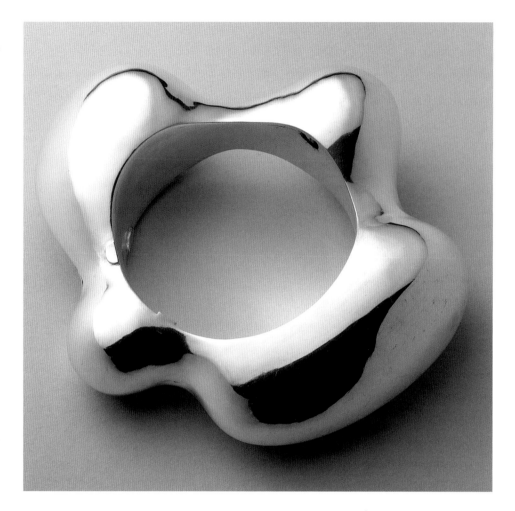

Fig. 8-12. Alma Eikerman. Bracelet, ca. 1972. Silver and gold. Collection of Daphne Farago. *Checklist no. 132*

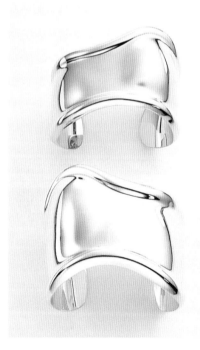

Fig. 8-13. Elsa Peretti. "Bone cuff" bracelet, 1974. Silver and gold. Manufactured by Tiffany & Co., New York. Collection of Tiffany & Co., New York. *Checklist no. 141*

not offer sufficient room for creative experimentation.[64] Her work subverted the notion of the standardized mass-produced piece by emphasizing individuality and handwork within an "industrial" process. Although she cast pieces such as the bracelet from 1975 (fig. 8-14), she varied the colors used in each pouring of the polyester resin and then carved and finished each piece by hand to obtain results reminiscent of paintings by Helen Frankenthaler and Morris Lewis.

Ramona Solberg was one of the first American jewelry designers to adopt a "postmodern" aesthetic, appropriating styles and motifs from other cultures. The postwar admiration for handcrafts was partly expressed through a renewed passion for the "primitive" and the "other," particularly work from Mexico, Asia, and the Near East. Solberg, an inveterate traveler, studied silversmithing and enameling in Norway and textiles in Mexico before graduating with an MFA in jewelry and metal design from the University of Washington, Seattle, in 1957.[65] Her "Shaman's Necklace" (fig. 8-15) illustrates her self-consciously hybrid jewelry. Her work alludes to the forms, proportion, and balance of Western modern art, particularly mobiles by Alexander Calder, while incorporating "ethnic," "folk art," or "found"

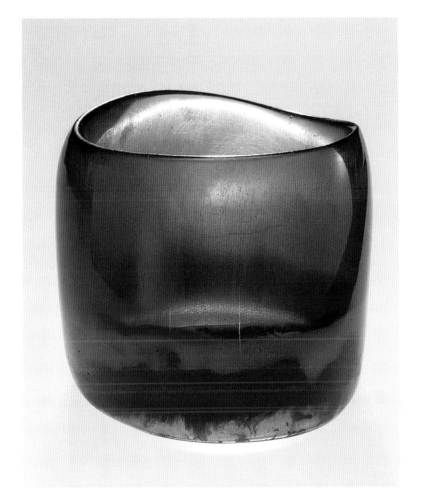

Fig. 8-14. Cara Croninger. Bracelet, 1975. Polyester resin. Courtesy of Julie: Artisans' Gallery, New York. *Checklist no. 142*

objects—old ivory fetishes, votive figures, and an "Indian" head penny—mounted with her own cast and hand-forged elements. In most cases, these were intended to make a spiritual connection with the Native Americans of the Northwest Coast where Solberg resided.

Fisch, another world traveler known for blending contemporary form with a variety of craft techniques, epitomizes the Craft Revival's rethinking of craft as "art" and the integration of feminist perspectives. She developed an interest in ancient weaving and, on a visit to South America in 1963, became fascinated by pre-Columbian artifacts which combined metal and textiles.[66] Her use of techniques identified with women's culture—such as weaving, crocheting, and knitting—combined with materials foreign to those practices, have resulted in beautiful and thought-provoking pieces. Her knitted metal collars (fig. 8-16), for example, refer not only to women's design and craft traditions, but also their subversion.

Like Fisch, Mary Lee Hu, who trained at the Cranbrook Academy of Art and Southern Illinois University, Carbondale, used textile techniques to work metal. Her "Zen" approach to the process of making remains central to her reasons for working in this field and her dazzling, skillfully made jewel-

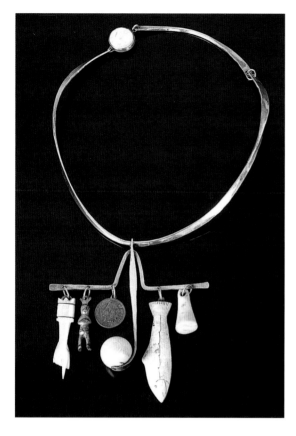

Fig. 8-15. Ramona Solberg. "Shaman's Necklace," 1968. Silver, Alaskan ivory, and found objects. American Craft Museum, New York, Gift of the Johnson Wax Company, from OBJECTS: USA, 1977, Donated to the American Craft Museum by the American Craft Council, 1990 (1978.3.8). *Checklist no. 124*

ry calls attention to the processes of its making.[67] Her most poignantly symbolic work is her "phoenix" necklace of 1973 (fig. 8-17), which represents her own reawakening after the unexpected death of her husband. The piece was partly inspired by the weaving techniques she observed while visiting her in-laws in Taiwan. A different type of spirituality informs Eva Eisler's handcrafted jewelry (fig. 8-18) which in its machinelike precision recalls the "sacred geometry" of Plato in its search for perfection of form.[68]

Given the impact of the socio-political movements of the 1960s and 1970s, which stressed pride in origins and ancestry, as well as gender, it is not surprising that Native American and African American women jewelry designers drew on the design traditions of their own cultures with renewed vigor. Some "traditions" were of relatively recent origin, but they were nonetheless important. Verma Nequatewa and her sister Sherian Honhongva, for example, self-consciously work within the relatively recent "tradition" of their uncle, Charles Loloma, the Hopi jeweler famous for his fusion of mid-century modernism with older Native American design elements. After apprenticing with Loloma (Nequatewa from 1966, Honhongva from 1976), the sisters worked with him until his retirement in the late 1980s. Their "touches" can be discerned in his later work, just as his influence can be seen in theirs. Their sense of continuity with and difference

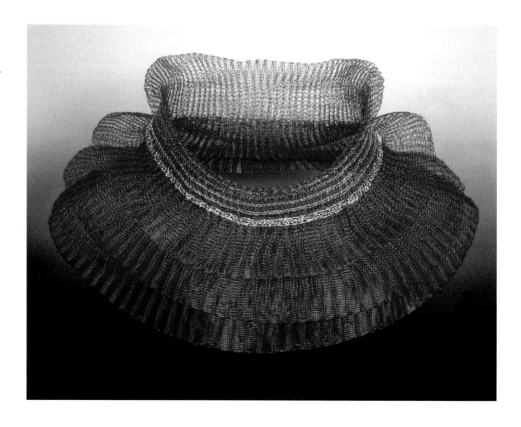

Fig. 8-16. Arline M. Fisch. Collar, 1988. Copper and silver. Collection of Hiroko Sato-Pijanowski. *Checklist no. 167*

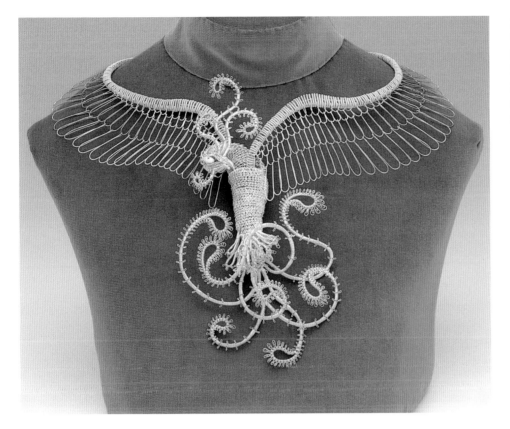

Fig. 8-17. Mary Lee Hu.
"Neck Piece No. 9," 1973.
Silver, gold wire, and pearls.
Museum of Fine Arts,
Boston, H. E. Bolles Fund
and Anonymous Gift,
1996.1. *Checklist no. 137*

from him was reflected in the name they chose to share when they began to exhibit together in 1989: *Sonwai* is the feminine form of the Hopi word for "beauty" (the masculine being "loloma").[69] Around 1993 the sisters began to work independently. Nequatewa still uses the name Sonwai, while Honhongva uses her own name.

Nequatewa is aware that her work breaks considerably with older "traditions" in its embrace of modern Western forms. She has spoken of how she draws strength from the fact that it is greatly admired within her own community and strives to keep her designs "respectful" of her cultural heritage as a Native American.[70] Despite the huge market for her work, she rejects the idea of machine production. Handwork, including hand-selecting stones for inlaid designs reminiscent of the landscape in which she lives (fig. 8-19), together with her connection to that land, are part of her strategy for keeping her work respectful. That heritage also informs her desire to make jewelry that looks "like it belongs on a Hopi spirit."[71] Sometimes, like Loloma, she adds to the underside of bracelets symbols ("inner gems") expressing the wearer's inner beauty and desires. Like the Hopi belief system, her designs stand for the harmonic, balanced relationship of all facets of life. She also finds connections in the process of making jewelry to being a woman. "Each one of my pieces," she says, "begins with a flat sheet of gold and turns into something that comes alive, like *creating children*" (emphasis added).[72]

Fig. 8-18. Eva Eisler.
Brooch, ca. 1985. Silver and
ebony. Collection of Toni
Wolf Greenbaum.
Checklist no. 162

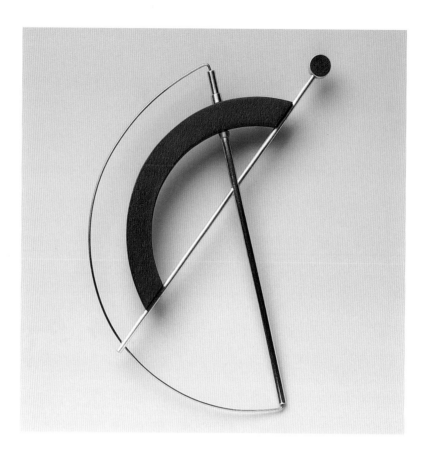

Fig. 8-19. Verma Nequatewa
(Sonwai). Bracelet (Hopi
Pueblo), 1997. Gold, coral,
lapis lazuli, turquoise, and
opal. Collection of Marcia
Docter. *Checklist no. 208*

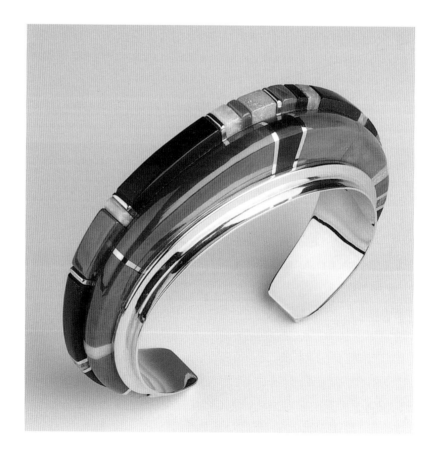

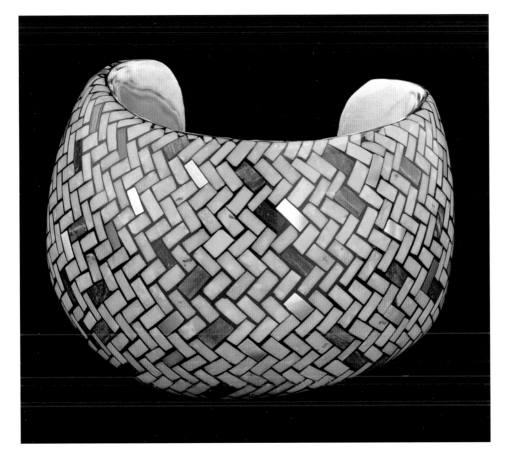

Fig. 8-20. Angelita Reano Owen. "Mosaic Cuff" bracelet (Santo Domingo Pueblo), 1995. Tiger cowrie shell, turquoise, shell, jet with black epoxy. Museum of Fine Arts, Boston, museum purchase with funds donated by Lois and Stephen Kunian, and The Seminarians, 1998.57). *Checklist no. 191*

Other Native American women are more directly involved in studying their cultural heritage to better understand the beliefs and design traditions of their ancestors. Their concern is less to determine a particular version of "authenticity" than to enrich the present through connections to the past. The designs of Angelita Reano Owen (Santo Domingo Pueblo, New Mexico; fig. 8-20), for example, reinterpret the shell-mosaic style of her Anasazi and Hohokam ancestors.[73] Owen comes from a family of jewelers: as a child she helped her parents, Clara Lovato Reano and Joe Reano, produce the innovative work for which they became well-known. Her parents and her then husband, Don Owen (a trader and later director of the Southwestern Association on Indian Affairs), supported her research in 1969 into ancient examples in museum collections and her efforts to revive and rework those techniques. In 1978 she produced her first bracelet in the manner of her Hohokam ancestors, using *Glycymeris* shells.

Ancient motifs, particularly petroglyphs and the stylized human and animal figures on ancient Mimbres pottery, also influenced Gail Bird (Santo Domingo/Laguna pueblos, New Mexico), who in 1988 received a presidential appointment to the board of the Institute of the American Indian and Alaska Native Arts and Cultural Development.[74] Her jewelry (fabricated by her Navajo partner Yazzie Johnson) also connects with that of her ancestors by drawing on the southwestern landscape, and, like that of Loloma and

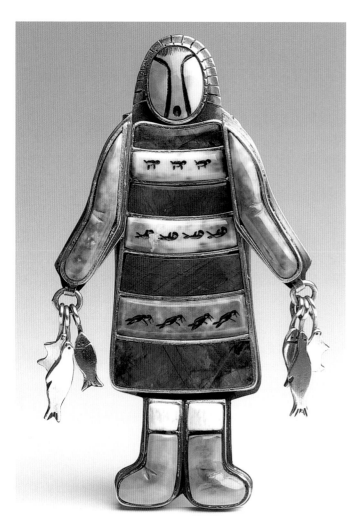

Fig. 8-21. Denise Wallace. "Iman shva" ("Otter Woman") brooch, 1988. Silver, fossil ivory; spectralite. Sandy Grotta Collection.

Nequatewa, it often has "hidden" parts, created by stamping or overlaying an image on the underside of the piece.[75]

Time-honored materials, such as fossilized walrus tusks, and techniques, such as scrimshaw, are used by Denise Wallace, who is of Chugach-Eskimo and Aleut ancestry. However, her work is much more than the sum of her multiple cultural heritage. Her brooches, pendants, and belt medallions involve complex doll-like figures that signal her interest in women-related issues. Articulated parts, which move or open to reveal images, relate to masks and are suggestive of women's interiority.[76] Her concern with what goes on within women extends to the personal. "Otter Woman" brooch (fig. 8-21), which depicts the transformation of woman to sea otter, is testament to Wallace's girlhood memories of being encouraged to emulate the female sea otter's maternal behavior. But her concerns go beyond gender and species. Wallace primarily addresses the concept of "transformation," which underlies the Aleut belief system, whereby humans, animals, and even inanimate objects undergo metamorphoses symbolic of the interconnectedness of all things.[77]

Given jewelry's associations with female adornment, it is not surprising that certain conventional notions of jewelry were "subverted" as feminism began to influence art and design practice. Several women explored the medium of jewelry as propaganda. Its intimate association with the person/wearer renders jewelry ideal for broadcasting personal as well as political messages that signal the agency of designer and wearer. In recent years jewelry designers have drawn attention to gender stereotyping, domestic violence, rape, incest, and "race." A necklace by Myra Mimlitsch-Gray (fig. 8-22), for example, addresses the notion of woman as chattel in a surreal and original manner. The pendant is a large-scale version of an empty mounting of what would have been a ring of the type usually set with a precious stone and given by men to women. In a clever postmodern play on expectations, the usually peripheral setting assumes center stage, and the structuring absence of the stone tells its own story. Visually, Gray forces the viewer to focus on the pregnant void; diamonds are no longer forever.

Certain African American designers used jewelry to explore issues relevant to black experience and to women's experience. Phyllis Marie Bowdwin's brooch, entitled "The Middle Passage—African Holocaust, *Maafa*" (terrible thing, Swahili; fig. 8-23), commemorates the suffering of African slaves and indicates the designer's concern with her own cultural heritage.[78] The brooch is produced in two limited editions, in brass or silver; one

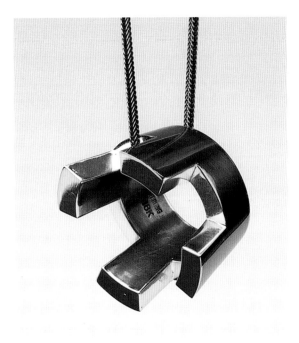

Fig. 8-22. Myra Mimlitsch-Gray. Pendant, 1996. Silver. Collection of Myra Minlitsch-Gray. *Checklist no. 203*

Fig. 8-23. Phyllis Marie Bowdwin. "The Middle Passage, African Holocaust, *Maafa*" brooch, 1993–96. Brass and cowrie shells. Produced by Who Deserves it More Than You?, New York. Cooper-Hewitt, National Design Museum, Smithsonian Institution, New York. Museum Purchase from Monet Jewelry Fund (1997-3-1). *Checklist no. 187*

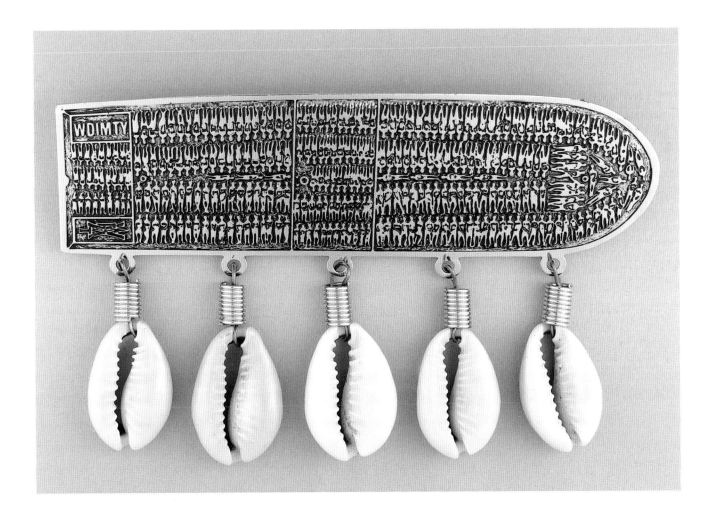

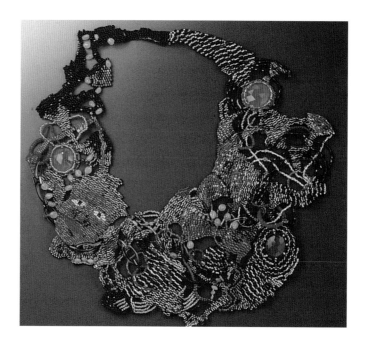

Fig. 8-24. Joyce Scott. "Voices" necklace. 1993. Beads, thread, chain, and synthetic faceted disks. American Craft Museum, New York, Gift of the Horace W. Goldsmith Foundation, 1994 (1994.48). *Checklist no. 183*

depicts the hull of a ship from which hang cowry shells, which make reference to African life and culture and also the profits of the slave trade; the other features noose-encircled human heads. Bowdwin plans a third, even more harrowing, version depicting the destruction of the African family unit, as each member, including children, was sold into slavery.[79]

Joyce Scott grapples with issues of racism and sexism in theater as well as design. She is particularly concerned about stereotypes of women; "As a woman, a cesspool-of-stereotypes woman, I've consistently vented on the society in which we live." [80] Although Scott comes from a family steeped in African American craft traditions, the designs of Mexico, where she studied for an MFA in crafts, also enrich her colorful palette and underpin her fascination with "pre-industrial" craft processes. The beadwork for which she has become most famous as a jeweler is a hybrid of Native American and Yoruba beadwork (fig. 8-24); the former is a tradition to which she relates as a marginalized American, the latter relates to her African heritage.[81] Her use of sewing and beading techniques connects her to women's culture the world over.

The expression of ideas and emotions are central concerns for Renée Beggsmith, a college-educated young designer who taught herself jewelry making. She draws on influences as diverse as medieval and Renaissance metalwork, black and feminist fine art, and East Village "outsider" culture—sometimes more consciously than at others—to produce exuberant, "spontaneous" pieces. They engage the viewer/wearer in emotive narratives and dialogues that are not all intentional. "Another Girl" necklace (fig. 8-25) depicts a caged plastic doll hanging from a heavily oxidized silver torque wrapped in a vinelike wire. Beggsmith emphasizes that the figure happens to

be black and would like her images to be read in "race"-free ways, commenting that "all women face discrimination merely by virtue of their gender—this actuality transcends race."[82] Beggsmith also rails against contemporary standards of female beauty, which exclude so many of us who do not conform to prescribed norms. She demands that all women be freed from the "cage" society places around us—even if the cage is gilded. She insists, "for me the black doll is merely 'another girl'—that is why I named the piece as I did."[83] Beggsmith's gutsy work is refreshingly free from the canons of the academy, and her approach to making seems almost irreverent to the generations brought up to venerate craft for its own sake.

Beggsmith, "a self-taught" woman of the 1990s, brings the narrative full circle, back to the "self-taught" women of the Arts and Crafts movement, and the Native American women who learned from their jeweler-husbands. That there was, and is, no single avenue for women to follow in becoming or practicing as a designer or designer/maker of jewelry—be it in 1900, 1950 or 2000—is evident. Women jewelry designers entered a new field at the beginning of a century that subsequently saw them contribute enormously to it in many different ways.

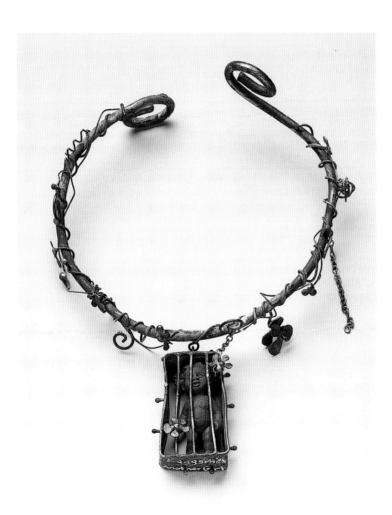

Fig. 8-25. Renée Beggsmith. "Another Girl" necklace, ca. 1995. Oxidized silver, plastic doll. Collection of Renée Beggsmith. *Checklist no. 196*

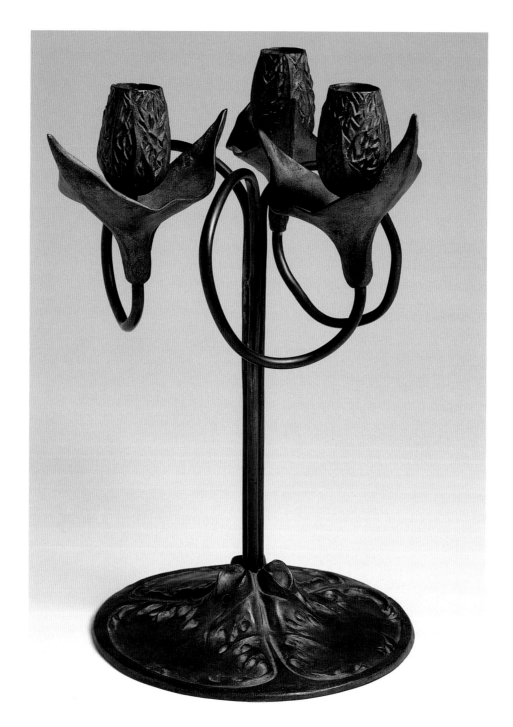

Fig. 9-A. Jessie M. Preston.
Candelabrum, ca. 1905.
Bronze. Collection of
Rosalie Berberian.
Checklist no. 9

9

Women Metalsmiths

BY 1900 A FEW WOMEN in the United States had already begun to practice metalworking.[1] Historically, this was a male-dominated trade, but when women took it up in the 1890s, they did so as a handcraft that was part of the Arts and Crafts movement, mainly designing and making small items of domestic metalware. By 1927 there were roughly equal numbers of women and men metalworkers. Of the 625 metalworkers, enamelers, and jewelers belonging to the Society of Arts and Crafts, Boston (the largest organization of its kind in the country) between 1897 and 1925, about half were women.[2] Women quickly went from being students to teachers and from followers to leaders. Today they form a visible and vocal body of designer-craftworkers and teachers who account for more than half of the entire field of craft metalwork.[3]

There were few barriers to women becoming metalworkers, particularly when they combined it with jewelry, which was more readily identified with feminine spheres of interest. The physical demands of raising domestic forms were not great and well within women's capabilities. In economic terms, it was easy to set up as a metalworker. For a beginner unwilling to make a large investment, a workshop, easily tucked into a back room or basement, could be established with a small workbench, a modicum of tools, and a few sheets of copper or silver. For women who sought new outlets for creative expression and also wanted to identify themselves as modern and as "new women," metalsmithing had the advantage of being distinctly different from needle arts, such as embroidery or quilting, which were well-established in the feminine domain.[4]

The media, often seeking newsworthy material to fill women's sections of newspapers and magazines, found excellent copy in stories about women who had entered this previously male arena, yet they vascillated between praise and patronizing attitudes. One of the most positive statements came in 1913 when the Boston silversmith Sybil Foster was interviewed about her ambitions to work in metal. Two illustrated articles showed a serious, sweet-faced young woman in a smock, working at the bench and before the annealing tray. She was quoted directly and in a way that emphasized women's equality. On the subject of working in the Boston shop of well-known metalworker George Christian Gebelein, she stated, "Yes I am most interested in my work here. I think it opens a new field for women. In the past, the making of hand-wrought silver has been done

Fig. 9-1. Madeline Yale Wynne. Bowl, ca. 1900. Copper with tin. Pocumtuck Valley Memorial Association, Memorial Hall Museum, Deerfield, Massachusetts, Museum Purchase, 1996 (96.33.02).

almost exclusively by men, but I see no reason why women should not do it with equal success."[5] A more patronizing tone was adopted in an article about Marie Zimmermann in 1916, the headline of which read, "This Being a Feminist Age, the Village Smithy is a Studio and the Smith a Comely Young Woman."[6] There were passing references to her blue gingham apron, and she was also described as "a modern witch at the caldron," yet so "slight, so girl-ish, so modish when she is in street garb." The article also referred to her "enormous achievements" over fifteen years and commented that her story was "an encouraging one for the girl who wants to strike out on new lines."

The fascination with the duality of "woman" and "metalsmith" resur-faced in the 1940s, when newpapers and magazines were full of articles about "ordinary" women taking over male roles during wartime. The diminutive Maria Regnier, whose metalsmithing skills were used in wartime service with the Air Force, was the subject of many articles that discussed her "womanly" attributes as much as or more than her silver. She was variously referred to by patronizing, if salutory, titles like "A Rare Smith—A Woman Metalsmith." A particularly long headline read "Air Force Teacher, Artist, Cook; Liquid Cooled Engines or Handwrought Silverware—It's all in the Day's Work for Maria Regnier, Who Also Teaches Deaf Children her Beautiful Art." That and others, such as "Mrs. Kaufmann, Modern Jill of Many Trades, Proves Herself Mistress of them All," proved irksome to this creative and self-made woman.[7] Regnier's work was also discussed in gendered language. Edgar Kaufmann Jr., high priest of modernism and consultant to the Museum of Modern Art, New York, commented upon its "masculine virility" in the 1950s, only to be countered by St. Louis journalist Howard Derrickson, who suggested that "feminine grace [was] another important component of her style."[8] At least Regnier never had to see herself referred to as a "girl" when in her forties, as did Margret Craver. When the latter was made an honorary member of the Master Gold and Silversmith's Guild of Sweden, the first time a woman or a foreigner had been chosen for such recognition, she was referred to in a U.S. newspaper as a "Kansas-Born Girl Silversmith."[9]

It is difficult to know whether by striking out into "new lines" the first wave of women designer-metalworkers had to make difficult career choices between work, marriage, and children. Many, however, including Elizabeth Copeland, Katharine Pratt, Marie Zimmermann, and Charlotte Bone, never married, or like Margret Craver and Maria Regnier, married as mature, established silversmiths. Few of those who practiced after marriage had chil-dren, exceptions being Madeline Yale Wynne and Janet Payne Bowles, but each separated from her husband before her career was fully formed; Clara Barck Welles divorced her husband after a childless marriage. In marked con-trast to these women, June Schwarcz took up her craft while raising two chil-dren and credits her husband Leroy Schwarcz with providing technical expertise. She struggled to balance work and home during the 1950s and

1960s, saying "I often felt very divided when the children were growing up. There wasn't enough time in the day to do all that I wanted to do."[10]

The "pioneer" women metalworkers mostly assembled the necessary skills for professional practice in an ad hoc manner. Many took part in small classes offered by individuals or in privately run programs that sprang up in the early decades of the century, often in small Arts and Crafts workshops. Another route was enrollment in colleges and museum schools, but many students supplemented what they learned there. The most unconventional start in metalsmithing was probably that of Indianapolis-born Janet Payne Bowles. While living in Boston with her husband, Joseph Bowles, publisher of *Modern Art*, Payne Bowles wrote book reviews, painted Celtic-style book illuminations, and attended classes on the "new psychology" given by Harvard professor William James.[11] These activities were largely set aside when the sound of a hammer initiated her lifelong career as a silversmith. She recalled:

> One day I was walking along and heard an orchestral tone which was the most beautiful thing I had ever heard. I traced it to a basement room and found a young Russian metalworker. I asked him a lot of questions and he said, "If you are so curious get me a pail of water, help me." Though scalded by the steam, I stayed and helped and watched. We made a bargain—I was to teach him psychology and he would teach me metalsmithing.[12]

There were few other opportunities for further instruction, but she "kept at it, working in every sort of shop that would give me a wider training."[13]

The degree to which women metalsmiths supported themselves by their skills also varied. Yale Wynne gave private lessons in metalsmithing,[14] but teaching was never a major source of income for this talented woman who worked in a variety of media (fig. 9-1) and energized numerous Arts and Crafts groups. Men generally dominated the teaching positions, but some women taught in manual education programs at the high school level.[15] Payne Bowles, for example, after an early career making powerful, idiosyncratic hollowware, flatware (fig. 9-2), and jewelry among the Arts and Crafts communities of Boston and New York, taught metalsmithing at Shortridge High School in her hometown of Indianapolis from 1912 to 1942.[16] In the 1930s, Greta Pack was an energetic teacher of metal crafts at Cass Technical High School in Detroit. Pack wrote books on lost-wax casting and jewelry making, as well as a standard reference on Mexican jewelry, and encouraged students to participate in the few competitions then available. Harry Bertoia, later professor of metalsmithing at the Cranbrook Academy of Art, was one of her most successful students.[17]

Mildred Watkins is the best known of the women who taught silversmithing at college level between the wars. A graduate of the Cleveland School of Art (now the Cleveland Institute of Art), Watkins furthered her

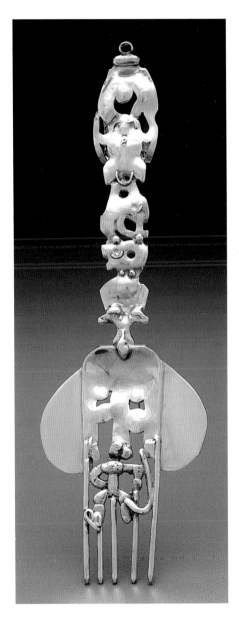

Fig. 9-2. Janet Payne Bowles. Fork, 1925–29. Silver. Indianapolis Museum of Art, Gift of Jan and Mira Bowles in memory of their mother, Janet Payne Bowles (68.21.98). *Checklist no. 35*

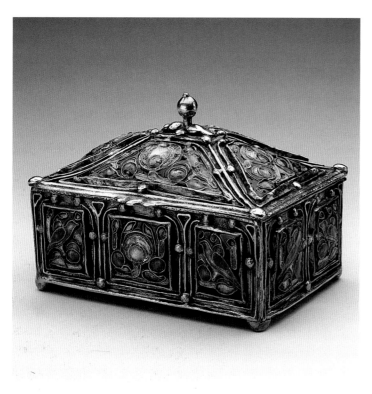

Fig. 9-3. Elizabeth Ethel Copeland. Box, 1922. Silver, parcel gilt, painted enamels, and cloisonné . Cranbrook Educational Community, Bloomfield Hills, Michigan, Gift of Henry G. Booth (TH 1990.46). *Checklist no. 31*

studies in Boston with Laurin Hovey Martin and with George Gebelein at the Handicraft Shop. Between 1918 and 1953 she taught at her alma mater while continuing to exhibit widely.[18]

In the years following World War II, as returning veterans swelled the ranks and budgets of universities, a new emphasis on crafts, and the establishment of metalsmithing programs, energized fine arts departments. Of the few women who ran these early programs, most had received their formative instruction in making hollowware from instructors at the Handy and Harman conferences.[19] Conducted each summer between 1947 and 1951 at the Rhode Island School of Design in Providence, Rhode Island, and later at the School for American Craftsmen in Rochester, New York, they were sponsored by the metal-refining firm of that name. However, their visionary organizer was Margret Craver, who engaged a jury of artists, critics, and curators from the fine and decorative arts to choose art teachers, selected from a national pool of applicants, as conferees.

Discrete, short-term programs in metalworking, such as the Handy and Harman conferences, served as a rite of passage for women wanting to work professionally. Workshops at the Arrowmont School of the Arts and Crafts in Gatlinburg, Tennessee (1945–present), and Penland School of Crafts in Asheville, North Carolina (1980–present), annual conferences of the Society of North American Goldsmiths (SNAG; 1970–present), and summer programs at the Haystack Mountain School of Crafts, Deer Isle, Maine (1980–present), have offered additional platforms where mature artists could share their expertise and serve as mentors for eager students.[20] They provided special opportunities for women, including mothers who could not manage full-time study, to gather, study, and offer mutual support, and together with full-time educational programs, they helped level the playing field. Today, virtually every college program in the United States has at least one female professor of metalwork, a measure of women's progress in the craft by the end of the twentieth century.

The best forum for public exposure and sale of metalwork, however, has remained the exhibition. The early Arts and Crafts shows held by the Art Institute of Chicago, the Society of Arts and Crafts, Boston, and countless other organizations across the United States provided a showplace where work by both men and women could be seen and bought. The Craft Revival, which began in the late 1940s has, since the late 1960s and early 1970s, offered greater opportunities for designers and makers of craft objects, including metalwork, than at any time since the 1910s.[21] The last thirty years

have seen a host of museum-sponsored exhibitions, craft shows, and most recently, dealer-organized exhibitions. The market for one-off, handmade items is such that today women and men find it possible to pursue careers as full-time professional designer-makers in metal.

WHETHER AS PRACTITIONERS OR TEACHERS, working independently or within larger workshops, women metalsmiths of the twentieth century often challenged the establishment by their presence in a formerly male-dominated field. Their individual experiences, touched on below, represent the ongoing struggle faced by many women designers and the gradual changes in status quo that occurred during the century.

A wealthy founding member of the Society of Arts and Crafts, Boston, Sarah Choate Sears attended the Cowles Art School, Boston, about 1885,[22] and probably later attended the School of Miss Amy Sacker in Boston, where the decorative design course included metalwork.[23] Her skill as a metalsmith and jeweler is suggested by items exhibited at the Louisiana Purchase Exposition (1904), including a "round box of silver and enamel," a "square box of silver, set with turquoise and chrysoprase," a "silver bowl set with pearls," and a "necklace of gold, with enamel and stones."[24]

Sears gave a helping hand to at least one fellow Cowles student. Metalsmith and enamelist Elizabeth Copeland's career reflects some of the conflicts faced by women students who juggled schoolwork with domestic responsibilities. In 1900 Copeland commuted to the Cowles Art School in Boston from her home in the suburbs three times a week. She later recalled her study method of pinning design problems above the ironing board in the kitchen so as to contemplate them while doing chores. "No doubt the garments suffered," was her wry comment about her busy student days.[25] For a time, Sears shared her studio space with Copeland, a gesture that enabled the aspiring designer to work unencumbered by financial constraints. Copeland exhibited her works at various exhibitions in Boston, Chicago, St. Louis, and elsewhere, beginning in 1901. She was undoubtedly influenced by a 1908 trip to the museums and schools of Europe, which was financed by her patron.[26] Copeland, whose work was consistent in its predilection for simple box shapes that required a minimum of raising skills, excelled at surface decoration, using silver wire and/or repoussé to contrast with the oxidized ground, and shaped reserves filled with brilliant enamels. In jewelry, she preferred semiprecious stones for their imperfections and range of color, and large, baroque pearls for their dramatic possibilities. In 1924 a majestic box by Copeland (fig. 9-3) was purchased by Henry Scripps Booth, the son of George C. Booth, the philanthropist and founder of the Cranbrook Academy of Art, who owned other pieces by Copeland. With its peaked roof, fashioned in the manner of a medieval reliquary, the richly colored, ceremonial box was used to carry the wedding ring at the younger Booth's marriage to Carolyn E. Farr.[27]

Fig. 9-4. Sybil Foster with samples of her work. From *Boston Post* (27 March 1915): 7.

Copeland's highly praised tactile work with its resolutely handcrafted appearance began to be seen as old-fashioned in the late 1920s, when a taste for modern design increased in popularity. In 1937, at age seventy-one, she resigned from the Society of Arts and Crafts, Boston, and relinquished the Boylston Street studio where she had worked since 1905.[28]

Copeland was among a number of women students of Laurin Hovey Martin, who taught metalwork and enameling at the Cowles School in Boston. She was professor at the nearby Massachusetts College of Art from 1901 to 1939. The college, founded to fulfill the 1870 state mandate to teach art in public schools, drew aspiring art educators from around the country. In addition to local students Copeland and Gertrude Twichell, Martin also taught Mildred Watkins and Jane Carson (Barron), the latter having also studied drawing at the School of the Museum of Fine Arts, Boston.[29]

The enrollment of women metalsmithing students at the School of the Museum of Fine Arts, Boston, began shortly after Liverpool-born George Hunt was hired in about 1905. Among his students were Sybil Foster and Katharine Pratt, who graduated in 1913 and 1914, respectively. Further study was facilitated by one-year scholarships from the Women's Educational and Industrial Union of Boston, which enabled the women to apprentice with George Christian Gebelein. They learned to work in the Colonial Revival style favored by Gebelein, to which they largely adhered after leaving his workshop. Foster's sophisticated Colonial Revival hollowware and flatware were featured in a solo exhibition of her work of 1915 at her sponsoring institution, the Women's Educational and Industrial Union (fig. 9-4). After a few years at the Gebelein shop (1916–18), she moved to a bench at the Handicraft Shop, an arm of the Society of Arts and Crafts, Boston. The Handicraft Shop was originally intended to provide workspace for leather-, wood-, and metalworkers, but by 1906, the cooperative focused exclusively on silver. She then set out on her own, but little more is known about her, and in 1927 she was recorded as "inactive."[30]

Unlike Foster, Pratt achieved considerable long-term success in the male-dominated world of hollowware production. Following her apprenticeship with Gebelein, Pratt progressed in her standing at the Society of Arts and Crafts, Boston, serving in several distinguished positions. She received the society's medal, its highest honor, in 1931, and in 1937 was awarded the *diplome de médaille d'or* by the Paris Exposition des Arts et Techniques. Evaluators at the Society of Arts and Crafts, Boston, considered Pratt somewhat slow, but good at duplicating her own work,[31] and the sale of repeat items no doubt contributed to her success. She produced a variety of forms largely in the Colonial Revival style, consigning silver for sale to the Society until 1946. During these years, she maintained a workroom in her home and used bench space in the Handicraft Shop. By combining studio production and teaching, Pratt worked for over thirty years. She taught bookbinding, silver-

smithing, jewelry, and leatherworking at the Boston
School of Occupational Therapy, and silversmithing at
the Beaver Country Day School for Girls in nearby
Newton, as well as giving private lessons in her Dedham,
Massachusetts, home.[32]

Pratt and Foster were not the only women who
maintained benches at the Handicraft Shop. A series of
fortuitous circumstances brought Mary Catherine
Knight to Boston as the shop manager. A graduate of
the Drexel Institute in Philadelphia, Knight had studied
with Mary Ware (Dennett), founder of Drexel's pro-
gram in decorative design and a teacher of gilded
leatherworking, who later moved to Boston to practice
her craft. When the Society of Arts and Crafts took over
Ware's former workspace for its Handicraft Shop, Ware
suggested Knight, who also had experience as a design-
er of metalwork for the Gorham Manufacturing
Company in Providence, Rhode Island, as a likely man-
ager.[33] Knight used leatherworking punches to stamp
and enamel lacy designs for silver vessels and flatware that she and her col-
leagues made in the Handicraft Shop (fig. 9-5). This collaborative approach
followed the lead of Charles Robert Ashbee, whose utopian crafts communi-
ty in Chipping Camden, England, was based upon socialist ideals. In the
United States, Sheffield-born Arthur Stone operated his shop in a related
manner, allowing the lead silversmith to add his surname initial mark to that
of the master, and, like Ashbee, sharing profits with his staff.[34] Although the
full extent of Knight's silversmithing skills is unclear, she was carefully cred-
ited in contemporary exhibition catalogues for her work as designer, collab-
orator, and/or maker of silver along with her fellow craftsmen Seth Ek, Frans
Gyllenberg, and Karl Leinonen.[35]

Like Knight, Clara Barck Welles managed a full-fledged workshop. A
graduate of the decorative design department at the School of the Art
Institute in Chicago, in 1900 she established the Kalo Shop, its name taken
from the Greek word for "good and beautiful." In 1905 she married amateur
metalworker George Welles, and thereafter the focus of production was on
jewelry and metalwork. Welles engaged many young women, dubbed "Kalo
girls," in her workshop and eventually employed as many as fifty craftspeople,
both men and women. Until closing in 1970, the Kalo Shop produced hand-
crafted hollowware and jewelry in an Arts and Crafts style (see fig. 2-9).[36]

In San Francisco, Lillian Palmer operated an art-metal enterprise
later called the Palmer Shop from 1910 to 1918. Born in Connecticut,
Palmer may have become interested in metalsmithing through her father,
who encountered blacksmiths in his work in the mining industry; she does

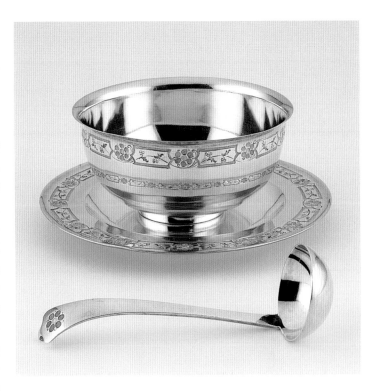

Fig. 9-5. Mary Catherine
Knight. Sauce set, 1902–8.
Silver and enamel. The Art
Institute of Chicago,
Americana Fund
(1982.205a–c).

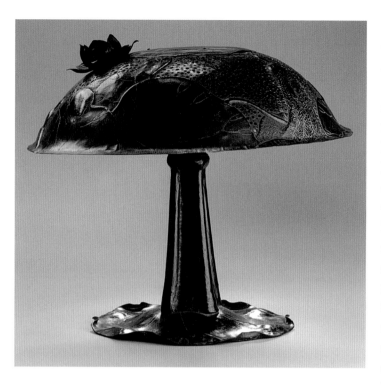

Fig. 9-6. Elizabeth Eaton Burton. Electrical lamp, ca. 1910. Copper with black paint. Collection of Tazio N. Lombardo.

not appear to have undertaken any formal instruction in the craft other than what she might possibly have obtained through her private school education.

Palmer was living in San Jose, California in 1907, when she established a coppersmithing studio in her home. Palmer's assistant that year was Elizabeth D'Arcy Gaw, a 1901 graduate of the School of the Art Institute of Chicago, who took additional courses in design and metalwork at the school in 1903 and 1904. Gaw had been a founding member of the Crafters Design Group in Chicago and had exhibited lighting fixtures there in 1903. She may have influenced Palmer to take up electrical engineering studies in Chicago in 1908–9. By 1910, when Palmer established her shop in San Francisco, Gaw had entered into a brief collaboration as both partner and designer with Palmer's local competitor, coppersmith Dirk Van Erp, introducing electrified lamps into Erp's repertory of forms. At the Palmer Shop, men and women were paid equal salaries in a profit-sharing arrangement that lasted until the outbreak of World War I, when a national effort to conserve metal forced its closure in 1918.[37]

After the war, Palmer and Gaw continued to be active in their communities. Palmer founded the Business and Professional Women's Club in San Francisco in 1917, serving as president and honorary president until her death in 1961. She continued as a metalworker in the 1920s while teaching a course in household repair for women. Nearly forgotten today, Palmer did much to promote equal working opportunities for women. Gaw was a member of the San Francisco Guild of Arts and Crafts beginning in 1910, when she served as its president. Although it appears that she did not continue working in metal, Gaw was afterward engaged as an interior designer in Chicago, New York, and San Jose and Carmel, California, from 1910 to 1934.[38]

The daughter of Arts and Crafts practitioner Charles Frederick Eaton of Montecito, California, Elizabeth Eaton Burton shared her father's aesthetic taste for the medieval, but also incorporated Japanese and natural forms into her work. She included a wide variety of shells, for example, in her electrified, patinated copper lamps, which sometimes had repoussé designs of marine animals, lily pads, and similar motifs (fig. 9-6).[39]

Outside the Boston area, the Arthur Stone workshop in Gardner, Massachusetts, was an important metalworking center and a training ground for a few women metalworkers. The studio was managed by Stone's wife and financial supporter, Elizabeth Bent Eaton.[40] Margaret Craver spent a summer there in 1937, and Charlotte Bone developed close links with the studio beginning in the summer of 1926, when she first worked there as a designer,

returning for a year in 1928. For a while, even after she left to study at Pratt Institute in Brooklyn, Bone supplied the Stone workshop with drawings,[41] and in the 1930s she continued to have them fabricate her own designs. Bone taught at the Childs-Walker School in Boston for a time in the 1930s and in 1937 served as director of Boston's Craft Center School. The simple, elegant shape of the vessel that she designed in 1936 (fig. 9-7) is in keeping with Stone's aesthetic, as are the curling grape tendrils that rise from the low base, but the spiky, applied leaves and lapis-encrusted decoration are part of Bone's personal repertoire that was distinct from the lyrical, but controlled representations of nature preferred by Stone.[42]

One of the most successful women metalworkers of the early twentieth century was Marie Zimmermann who was based in New York City. She attended the Art Students League (1897–1901) and Pratt Institute (1901–3) before establishing a studio at the National Arts Club, adjacent to Gramercy Park, by 1916.[43] Zimmermann often combined dissimilar materials, such as jade and copper, or coral and silver, in hollowware and constantly experimented with materials and patinas. She practiced a synthetic style of design and fabrication that emulated vegetal forms and recalled historical types,

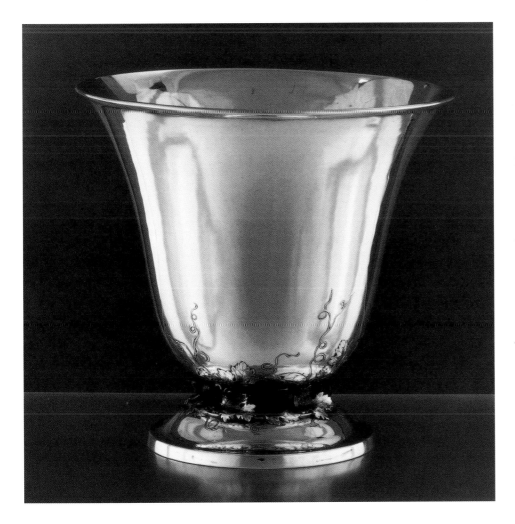

Fig. 9-7. Charlotte David Bone. Vase, 1936. Made by Herman W. Glendenning and chased by Edward Billings for the Arthur Stone workshop. Silver and lapis lazuli. Yale University Art Gallery, Purchased with the Stephen Carlton Clark, B.A. 1903, Fund, with a gift from Mr. and Mrs. Edward Kilroy, Jr., B.A. 1949, and by exchange with bequests from Olive Louise Dann, Edward H. Dunlap, B.A. 1934, Louis Havemeyer, Ph.D. 1910, and gifts from Mrs. Edward F. Dwight, Mrs. Florence Goldsborough, Harold G. Pond, Mrs. Harvey K. Smith, and Miss Mary B. Smith (1993.16.1.1).

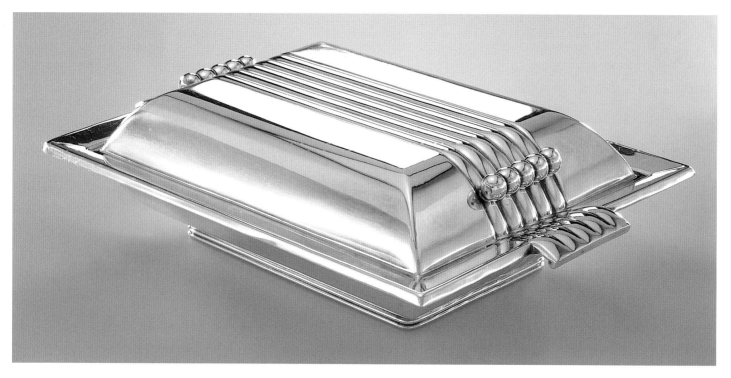

Fig. 9-8. Belle Kogan. Covered vegetable dish, 1936. Manufactured by Reed and Barton firm 1936, Taunton, Massachusetts. Silver plate. This example is dated 1938. Collection of Denis Gallion and Daniel Morris, Historical Design, New York. *Checklist no. 64*

even as she recast them in a fresh, modern idiom. Zimmermann worked for such wealthy clients as the Montgomey Ward and Levi Strauss families, among others, in New York, Detroit, and elsewhere, until the 1930s when she quit out of frustration with a national policy that required individual reports on the sales of precious metals.[44]

During the Depression many educational programs that had begun under the influence of the Arts and Crafts movement lost momentum. By the 1930s, as teachers of the first generation retired, and larger workshops, such as Stone Associates, began to shrink in size, there were fewer places at which to learn silversmithing. At the same time, the new profession of industrial design was rapidly becoming established.

Belle Kogan was not only one of the few women who worked in this new field, but also one of a handful who created fine designs for metal. She studied mechanical drawing at Bethlehem High School in Pennsylvania at the suggestion of her art teacher and was the first woman in the all-male class. When teachers were in short supply at the end of World War I, she was invited to teach the class—the first of many opportunities she took to advance herself. Kogan later studied at the Art Students League in New York with Winold Reiss, attended summer design classes at New York University, and traveled in 1930 to the international jewelry center of Pforzheim, Germany, for a program at the Kunstgewerbeschule in jewelry and silverware design. Meanwhile, she was trained on the job at the Quaker Silver Company from about 1929 to 1930, and greatly benefited from the encouragement and opportunities given to her.[45]

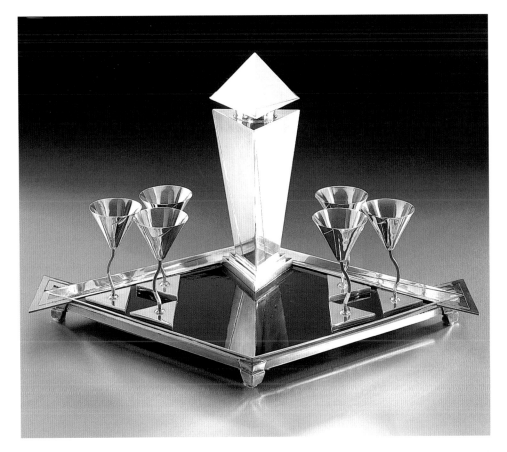

Between 1930 and 1970, Kogan ran a New York firm that produced houseware designs in silver, aluminum, ceramics (see chap. 14), glass, plastic, wood, and cloth. For her metalsmithing clients, such as Reed and Barton and the Towle Manufacturing Company, she designed serving dishes in a modern neoclassical idiom. Her double vegetable dish—so-called because the lid reversed to make a second serving vessel (fig. 9-8)—first produced in 1936 by Reed and Barton, was a stylish essay in streamlined modernism. When her designs were released in sterling silver and in silver plate, Reed and Barton gave credit to Kogan for her ability to meet the "growing demand for Modern design in silverware" and for the broad, fluted decoration that provided both strength and beauty.[46] When the dish was shown in the 1937 contemporary silver exhibition held at the Brooklyn Museum, however, Kogan did not receive formal credit.[47]

Less is known about Elsa Tennhardt of New York City, who openly embraced the cubism of New York skyscraper design and avant-garde paintings. In 1928 she patented a triangular form intended for "a dish or article of analogous nature" and adapted the design for a silver-plated cocktail set (fig. 9-9) made by the E. and J. Bass Company, also of New York.[48]

Similarly, there is scant information on Lillian V. M. Helander, who worked as a flatware designer for Oneida Community Limited, and for the International Silver Company. Her 1930 designs for Oneida included bell-

flower motifs and modified trifid ends suggestive of the Colonial Revival. Some of her later designs produced by International Silver between 1935 and 1945 are also in this idiom, and it is likely that her "Modern Colonial" service by International Silver, seen at the 1939 Golden Gate International Exposition, followed suit. Helander also designed stepped handles for flatware such as those for the large, silver-plated flatware service produced at the time of the 1939 New York World's Fair (fig. 9-10). The trylon and perisphere, ubiquitous symbols of the exhibition, were stamped on the handles; variants appeared as souvenir spoons.[49]

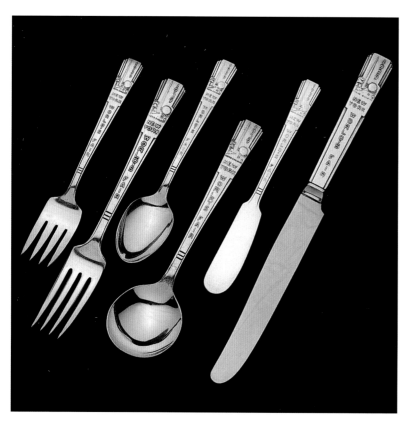

Fig. 9-10. Lillian V. M. Helander. Flatware, ca. 1939. Manufactured by Wm. A. Rogers, Meriden, Connecticut. Silver plate. The Mitchell Wolfson Jr. Collection, The Wolfsonian–Florida International University, Miami Beach, Florida (1991.476.3, 4, 6, 7, 9, 10.1). *Checklist no. 71*

Strong grounding in handicraft and "modern" design traditions enabled Hungarian-born Ilonka Karasz to achieve success in her adopted country soon after her arrival in New York in 1913. Karasz taught at the Modern Art School in Greenwich Village, a vangard institute for art education in the 1910s, and designed for textiles, ceramics, silver, books, and furniture.[50] Along with her mostly male colleagues, Karasz was featured in the 1928 *International Exposition of Art in Industry*, sponsored by Macy's department store. Museum recognition of her metalwork came in 1929 with *Modern American Design in Metal*, held at the Newark Museum, New Jersey, where a silver tea service and candlesticks of her creation were displayed.[51] The generously sized, plated tea and coffee service that she designed in 1929 for Paye and Baker (fig. 9-11) made economical use of a simple cylinder, cut to different lengths to define the various components of the set. Karasz also designed the handles, lids, and Bakelite grips to be largely interchangeable and easily assembled, which further helped to make the service relatively inexpensive.

Despite the increasing links made between design and industry during the 1930s, fine handcraftsmanship continued to flourish under such practitioners as Margret Craver. Craver's early contact with metalsmithing took place at the University of Kansas in Lawrence. When she outgrew the school's offerings, she pursued her training during the 1930s with individual metalworkers, such as Tiffany and Company jeweler Wilson Weir and Leonard Heinrich, a German-trained armor conservator at The Metropolitan Museum of Art, New York, who taught her toolmaking. She fashioned a Colonial Revival-style creamer while at Stone Associates in Gardner, Massachusetts, and traveled to Europe, where she trained in the studio of Baron Erik Fleming, silversmith to the king of Sweden.

Craver achieved stunning success with her first mature piece of hollowware, a teapot that she began in 1936 under the tutelage of Arthur Neville Kirk, a British silversmith who established the metalsmithing program at the Cranbrook Academy of Art.[52] The teapot (fig. 9-12) exhibits the smooth planes and volumetric shape characteristic of what came to be called an Art Deco style, but it does not share the somewhat blocky appearance of many pieces of the era. Its animated, almost weightless form, with its upward tilting spout and birdlike finial, was an original expression. It also heralded the return of the independent studio practitioner that took place in the 1950s.

Maria Regnier, who first learned her craft at Washington University in St. Louis, continued her training at the Rhode Island School of Design

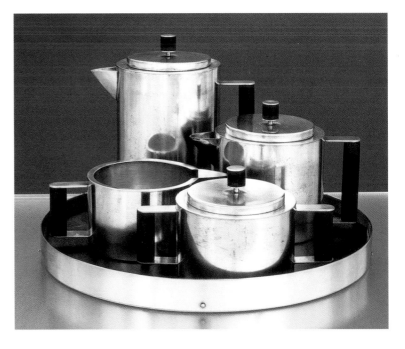

Fig. 9-11. Ilonka Karasz. Tea and coffee set, ca. 1928. Manufactured by Paye and Baker, North Attleboro, Massachusetts. Electroplated nickel silver and Bakelite. Yale University Art Gallery, M. Josephine Dial in memory of Gregory T. Dial, B.S. 1930, Fund (1985.9.1.1–5).

under Sidney Rollins, at the Dixon School in New York, and with Swedish designer Alex Hammer, before setting out on her own. Her preference for simple forms using flat planes and simple monograms suited the streamline aesthetic that prevailed well into the 1950s and proved popular with such high-end stores as Neiman Marcus, Gump's, and Georg Jensen. While shar-

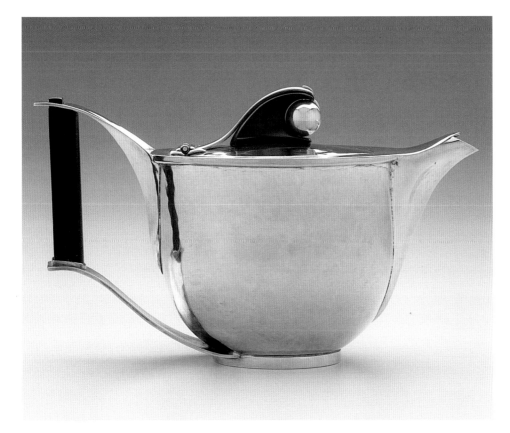

Fig. 9-12. Margaret Craver. Teapot, 1936. Silver and Gabon ebony. Museum of Fine Arts, Boston, Gift in Memory of Joyce Goldberg with funds provided by Mr. John P. Axelrod, Mr. and Mrs. Sidney Stoneman, Mr. Charles Devens, Mr. and Mrs. Peter S. Lynch, The Seminarians, Mr. James G. Hinkle, Jr., The MFA Council, and Friends (1988.533). *Checklist no. 62*

Fig. 9-13. Maria Regnier. Tea service, 1939. Silver and ivory. Museum of Fine Arts, Boston, Gift of John E. Goodman (1989.60–62). *Checklist no. 67*

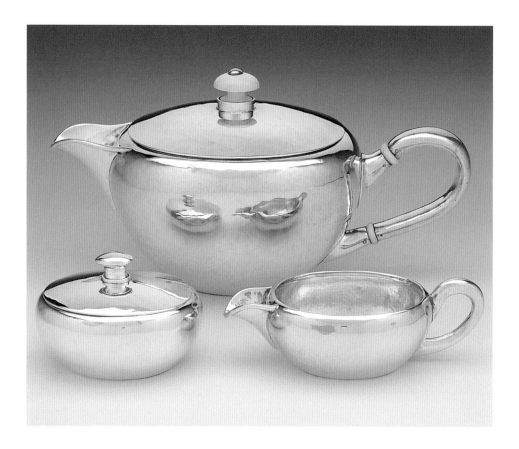

Fig. 9-14. Adda Husted-Anderson. Salt and pepper set, 1953. Silver and enamel. The Newark Museum, New Jersey (53.38).

ing a taste for modern form, Regnier never wavered in her fidelity to the hand and hammer. Her unadorned, elliptical tea service (fig. 9-13), proves her point that "the beauty and glowing warmth of silver, whether in flat ware or hollow ware, is most evident when it is hand crafted."[53]

In the years before and after World War II, few other women besides Craver and Regnier worked as metalsmiths. Copenhagen-born Adda Husted-Anderson trained in Denmark and in Pforzheim, Germany, before moving to the United States in 1930. From her First Avenue shop in Manhattan she sold silver, all the while teaching at the Craft Students League, located at the YWCA at 53rd Street and Lexington Avenue (from 1933 until she retired to Denmark in the 1970s). An enameled salt and pepper set by the artist was shown at the Newark Museum's 1948 exhibition entitled *The Decorative Arts Today* (see fig. 9-14 for a version of the design made in 1953). During her forty-odd years in the United States, Husted-Anderson was a well-respected, independent member of the American metalsmithing community.[54]

The Handy and Harman conferences helped another wave of women silversmiths to become established as teachers at the college level during the 1950s. Most had degrees in design or art education, but few had much, if any, experience in raising hollowware. Among the prominent graduates were Virginia Wireman Cute (later Curtin) of the Philadelphia Museum School; Ruth Penington of the University of Washington, Seattle; Alma Eikerman of Indiana University; and Thetis Lemmon of the Texas State College for Women in Denton. They served long tenures and taught many generations of aspiring students.[55]

Of this group, Eikerman, who attended the 1948 conference, was especially influential. A proponent of Scandinavian modern design, Eikerman gave her students an appreciation for the prevailing methodologies and aesthetics in painting and sculpture. She also listed the Bauhaus approach, as it was adopted at the Chicago Institute of Design, and the teaching of abstract expressionist Hans Hofmann, as particularly potent: "These liberating ideas about teaching, and the freedom from representation implicit in the development of twentieth-century art, were part of my own learning experience and were incorporated in my teaching. By asking my students to do lots of drawing, to design, to cut paper, to rearrange metal scraps, I tried to foster the free association of images and choices that was at the heart of the new approach to teaching design."[56]

Eikerman taught for thirty years and saw many of her MFA graduates make their mark as designers and teachers of metalsmithing. These include Helen Shirk (1969) at San Diego State University; Susan Ewing (1980) at Miami University in Oxford, Ohio; Marilyn da Silva (1977) at the California College of Arts and Crafts; Marjorie Schick (1966) at the Pittsburg State University, Kansas; Lin Stanionis (1981) at the University of Kansas,

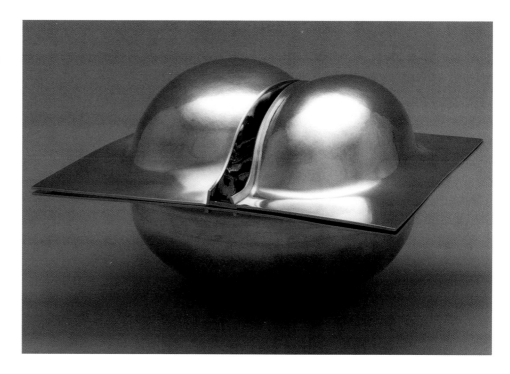

Fig. 9-15. Alma Eikerman. Double-bulged bowl, 1975. Silver. Indiana University Art Museum, Bloomington (81.40a, b).

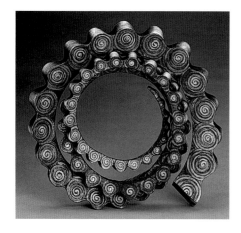

Fig. 9-16. Marjorie Schick. "Tribute to Professor Alma Eikerman" necklace, 1995. Cardboard, papier-mâché, and acrylics. Collection of Marjorie Schick.

Lawrence; and Cindy Eid (1980) at the DeCordova Museum School in Lincoln, Massachusetts.[57]

Eikerman's emphasis on design and techniques, through studies of Western art and in critiques of student work, was a cornerstone of her program in jewelry design and metalsmithing at Indiana University. She encouraged experimentation in two- and three-dimensional forms and combined it with a rigorous technical program that provided her students with the skills to make their designs a reality. Several of her graduates, particularly Shirk, Ewing, and Schick, initially followed her own predilection for powerful sculptural shapes, although each achieved these effects with dramatically different results. Others, like Stanionis and Eid, emulated Eikerman's organically derived forms (fig. 9-15). Marjorie Schick's colorful sculptural necklace, "Tribute to Alma Eikerman" (fig. 9-16), is a loving memorial to the demanding teacher who held her students to her own high professional standards.[58]

Virginia Cute (Curtin) had studied jewelry under Douglas Gilchrist at the Pennsylvania Museum School of Industrial Art (1931–35; now the University of the Arts) and at the Philadelphia School of Design for Women (BFA 1942; now the Moore College of Art and Design). Appointed director of the silversmithing and jewelry department at the Philadelphia Museum School of Art from 1941 to 1953, she continued her education by attending classes in New York taught by Adda Husted-Anderson. She also participated in the first Handy and Harman conference of 1947 and trained at the Sheffield College of Arts and Crafts in Sheffield, England, in 1949 with William Bennett, the same craftsman who taught the 1947 conference. During her British sojourn Cute produced two works in silver with touch-

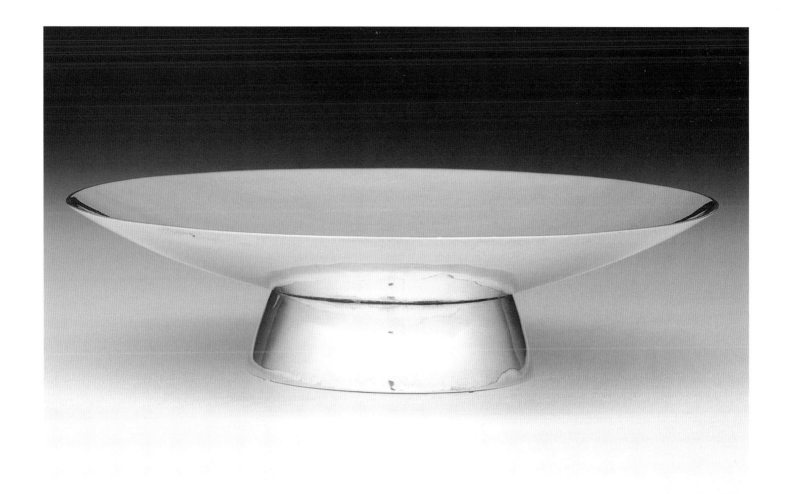

marks that she registered with the Worshipful Company of Goldsmiths, apparently the first such occasion for an American woman.[59]

Like many silversmiths of the era, Cute practiced a Scandinavian modern style of silversmithing. Her simple, elegant bowl (fig. 9-17), produced at the Handy and Harman conference in 1947, is expressed in a similar manner. However, the intertwined script monogram was added sometime afterward, perhaps in a personal reference to her celebrated colonial ancestors, the Richardson silversmithing family of Philadelphia.

Among the many metals departments that expanded during the postwar period, that at the Cranbrook Academy of Art was perhaps the most fertile. Founded in 1927, the program did not become fully active until the 1950s and 1960s. Among their many renowned graduates, a succession of highly original women metalworkers have emerged, among them Chunghi Choo (MFA 1965), Mary Lee Hu (BFA 1965), Myra Mimlitsch Gray (MFA 1986), and Lisa Norton (MFA 1987), all of whom now teach and have experimented with or worked in hollowware, each with a distinctive method and vision.[60]

The 1950s saw the emergence of a few independent studio metalsmiths. The enameler June Schwarcz studied industrial design between 1939

Fig. 9-17. Virginia Cute Curtin. Bowl, 1947. Silver. Museum of Fine Arts, Boston, Gift of David and Chelsey Remington (1999.736). *Checklist No. 90*

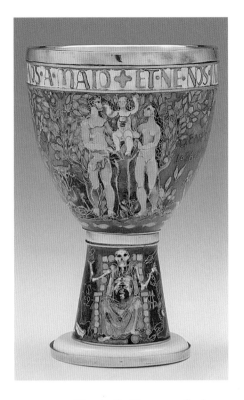

Fig. 9-18. Margarete Seeler. "The Cup of '88," 1988. Silver, gold-plated silver, ivory, polychrome enamel, and gold wire. Museum of Fine Arts, Boston, Gift in honor of Margarete Seeler (1999.135). *Checklist no. 166*

and 1941 at Pratt Institute of Design and for a few years afterward designed toys, printed textiles, and packaging for cosmetics. While her children were young, she picked up enameling, first using spun copper vessels available in craft stores, and over time, experimenting with her own forms until eventually she began to work with delicate copper sheets that she could stitch, fold, and manipulate like paper or cloth. She also attempted to electroform these unorthodox shapes in order to strengthen the metal in an electroplating process that deposits heavy accretions of metal. Heralded for her unique approach to both enamel and metal, Schwarcz has followed her own path, and garnered admiration throughout her long career.

More traditionally oriented was Frances Felten of Winstead, Connecticut, who supported herself with studio sales and commissions of pewter vessels.[61] Some of her work was enameled by Margarete Seeler of Westport, Connecticut, and a covered canister by the two women appeared in the landmark 1969 exhibition *Objects: USA* held at the Smithsonian Institution.[62]

Seeler, a German native, had been educated at the Berlin Academy of Art (Vereinigte Staatsschulen für freie und angewandte Kunst). She first arrived in the United States in 1958 and soon established a reputation as a

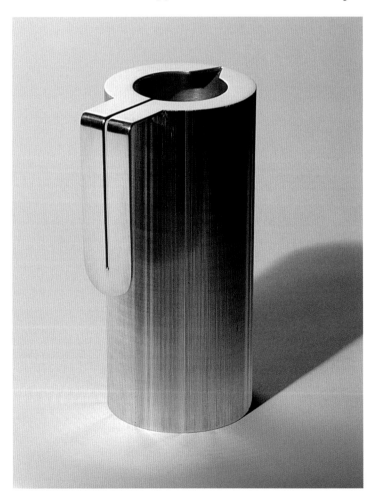

Fig. 9-19. Lella Vignelli. Pitcher, 1971. Manufactured by San Lorenzo s.r.l., Italy. Silver. Collection of Lella Vignelli. *Checklist no. 128*

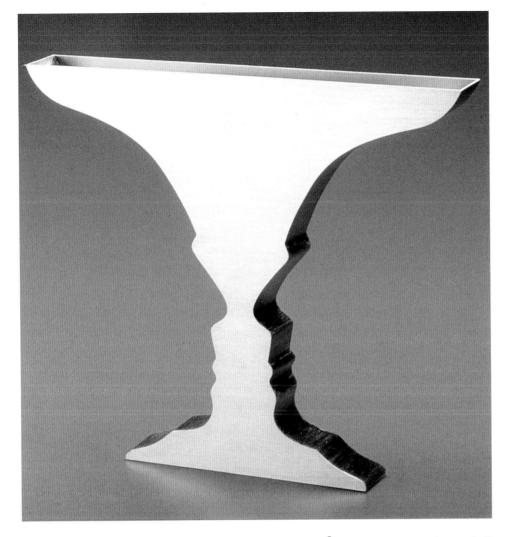

Fig. 9-20. Susan H. Hamlet.
"Silhouette No. 1," 1987.
Stainless steel. Collection of
Susan Hamlet.

metalsmith and enameler of considerable talent.[63] Seeler's astonishing skill
with cloisonné wires and the rich colors she achieved were superseded only by
the potent figurative content of her compositions which were reminiscent of
medieval art. Her "Cup of '88 " (fig. 9-18) reveals her extraordinary artistic
and narrative powers.[64] On one side of the vessel, a nude Adam-and-Eve-like
couple raise their child aloft. The happiness of this Edenic scene is undercut
by a grinning, seated skeleton who grasps the symbol for atomic energy.
Having survived World War II in Berlin, Seeler worked tirelessly in a didactic
manner as a reminder of the awesome human potential for good and for evil.

Unlike Seeler, who maintained a lifelong bond with the traditions of
her craft, many silversmiths today, along with their colleagues in allied fields
such as jewelry and woodworking, have abandoned some of the earlier rever-
ence for the purity of their media in a shift toward greater experimentation
with techniques and new materials.[65] Sociocultural changes have not only
altered attitudes toward conventional silver, but also the types of work pro-
duced in the last twenty-five years. Polishing silver, once a routine chore, is
no longer feasible in most households. Concern with theft, augmented by a

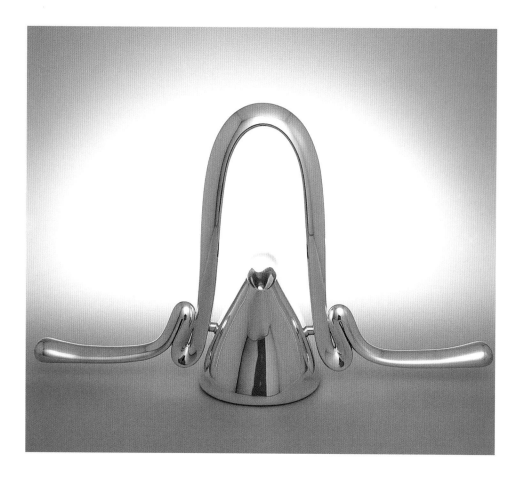

Fig. 9-21. Chunghi Choo. Centerpiece, 1979. Silver-plated copper and acrylic. The Metropolitan Museum of Art, New York, Gift of Jack Lenor Larson, 1980 (1980.580a, b). *Checklist no. 147*

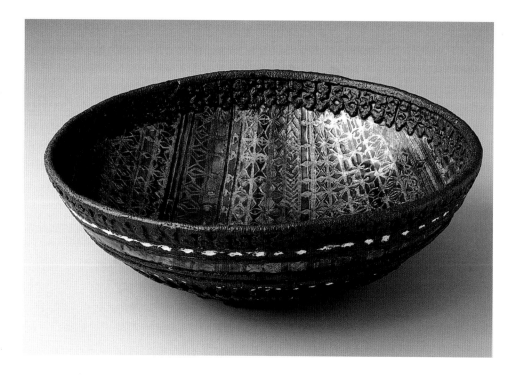

Fig. 9-22. June Schwarcz. Patterned bowl, 1968. Copper. On loan to the San Francisco Craft and Folk Art Museum of Fine Arts by Mrs. Earl Benditt.

rise in silver costs in the 1980s, made consumers timid about purchases. Furthermore, the market for commemorative silver used in trophies and to mark births, weddings, and anniversaries, has dwindled.

With the demand for hollowware in metal at a low ebb, most metalsmiths who make it also make jewelry, but those who focus on hollowware draw their primary income from teaching rather than the sale of their work. For Lella Vignelli, cofounder of Vignelli Designs in New York City, hollowware is only part of her repertory of interior furnishings, all of which bear a rich sense of material even as the design is reduced to an elegantly minimalist statement.[66] Her pitcher (fig. 9-19) possesses both neoclassical elements, in its fluting, and a Bauhaus-style modernism, while her most recent silver chocolate pot (1999–2000) is a beautiful study in refined geometric modernism. Elsa Peretti's silverware designs are now produced by Tiffany and Company but only after she had built an extensive following as the firm's most popular designer of jewelry.

As is true for the entire field of contemporary craft, designer-makers work in a myriad of styles and techniques. No one method or approach to hollowware production can be identified among women metalsmiths working in the 1990s. Susan Hamlet, Chunghi Choo, June Schwarcz, and Myra Mimlitsch-Gray, for example, continue to respect the materials they work in, but each has solved the dilemma of fabrication in a different fashion. Hamlet, who teaches at the University of Massachusetts and Dartmouth, has used sheet metal and simple, but evocative templates to create shallow silver forms (fig. 9-20). Both Choo (fig. 9-21), who teaches at Iowa University, and Schwarcz (fig. 9-22) of Sausalito, California, create unique forms using an electroforming bath, a method that is liberating from the slow and deliberate process of raising, but demanding from a technical viewpoint, and has received wide experimentation in the field. Chunghi Choo's subtly sculpted shapes, for example, are the result of meticulous planning. She first creates a wax form that is electroplated in copper, and then silverplated, before it is further refined to a silken perfection. Mary Lee Hu, better known for her wirework jewelry, has also produced fantastic, undulating wire forms and in recent years has fashioned articulated marine creatures that both startle and fascinate.

Simultaneously conceptual and traditional approaches to the craft of metalsmithing characterize the work of Mimlitsch-Gray at the State University of New York, New Paltz. The surfaces of her recent large copper trays appear to be a sea of jagged, oversized hammer marks; on closer inspection, they are composed of cupped sections that have been soldered together.[67] By accentuating the traditional labor involved in raising a vessel, she pays homage to "traditional" craft values of the colonial era revived during the Arts and Crafts period. At the same time, by leaving the seams in plain

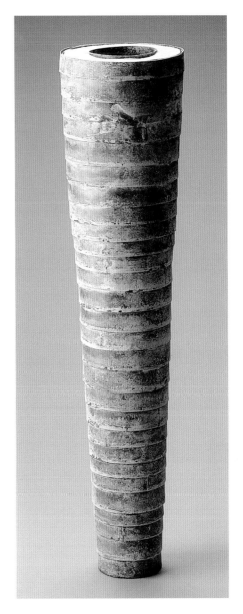

Fig. 9-23. Claire Sanford. "Growth," 1985. Patinated copper. Museum of Fine Arts, Boston, This project was supported in part by a grant from the National Endowment for the Arts, a federal agency, and The Seminarians (1990.186).

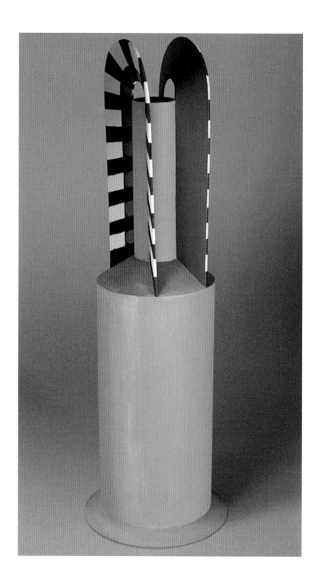

Fig. 9-24. Randy Long. "Lorenzetti Lily" vase, 1990. Copper and acrylic paint. Collection of the Randy Long.

sight Mimlitsch-Gray subverts their message through exaggeration.

Patina and applied color have marked some of the most interesting developments in contemporary metalwork. The wrapped and overlaid copper forms made by Claire Sanford (fig. 9-23) depend upon patina to provide color and texture. Eikerman student Randy Long, professor at Indiana University, applies acrylic paint to vessels that emulate Italian roadside shrines (fig. 9-24). Helen Shirk (fig. 9-25), who also studied with Eikerman, employs an assistant known as a spinner, who shapes the copper forms on the lathe to Eikerman's exact specifications, deliberately breaking the designer-maker pattern that has dominated craft metalworking throughout the twentieth century. She then creates a dense jungle of vegetal forms in repoussé and applies Prismacolor pencil to achieve a brilliant, sculptural result.

This group of metalworkers consider themselves "fine artists," reshaping and redefining a field that appeared set in its ways by the last quarter of the twentieth century. Male dominance of the field, which prevailed in

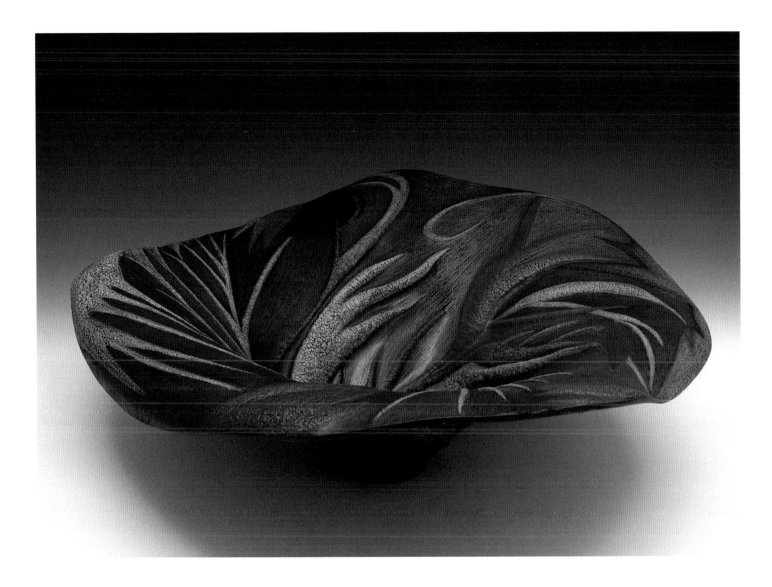

the early 1910s and 1920s, has given way to an easy collegiality and mutual respect between men and women. The ratio of women to men has changed little since the 1930s, when there were roughly equal numbers of men and women, but their impact has probably never been greater than today. Women have assumed a leadership role as professors and as members of the foremost professional organization, the Society of North American Goldsmiths. Women have spearheaded or contributed to some of the most innovative developments and stylistic shifts, from the unprecedented and influential Handy and Harman conferences to more discrete innovations such as the electroforming of hollowware or experimentation with new methods and materials. With such a strong history behind them, and the promise of a new century before them, there has never been a better time to be a woman met-alsmith in the United States.

Fig. 9-25. Helen Shirk. "Sustaining Spirit XIII," 1995. Copper-plated brass with patina and Prismacolor. Private collection.

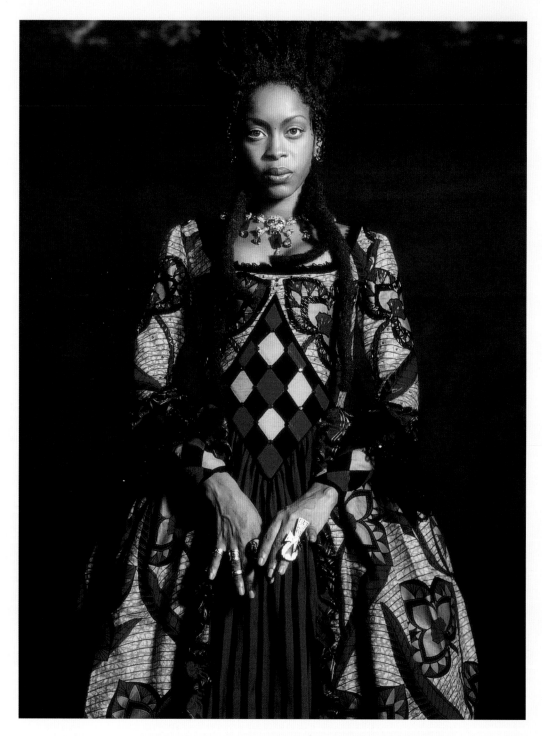

Fig. 10-A. Deborah Nadoolman.
Gown, wig, and jewelry for Queen
Mousette (Erykah Badu) in *Blues
Brothers 2000* (1998, Dir. John
Landis, Universal Studios).
Collection of Universal Studios,
Archives and Collections, Universal
City, California. *Checklist no. 210*

10

DEBORAH NADOOLMAN LANDIS

PAT KIRKHAM

Designing Hollywood:

WOMEN COSTUME

AND PRODUCTION

DESIGNERS

THE AMERICAN FILM INDUSTRY WAS BASED IN HOLLYWOOD by the late 1910s. For the rest of the century Hollywood both shaped and reflected how Americans thought about themselves and their country, as well as how the rest of the world viewed America and its culture. "Moving pictures" were not introduced until the 1890s, and the ad hoc nature of the fledgling industry offered opportunities to those willing to learn new skills and adapt existing ones.[1] Although men dominated the growing business (with the exception of acting), gender divisions were fewer during the first quarter of the century than for the next fifty years.

At first women were involved in every aspect of the business, from clerical work to screenwriting and studio management.[2] During the 1920s, however, with the establishment of the "studio system"—business moguls; permanent buildings; lots and sound stages; highly paid stars; publicity; wardrobe and property departments; and specialist designers—women other than actresses and costume designers virtually disappeared from the industry.[3] They were excluded from art direction and production design until the last quarter of the century.[4]

COSTUME DESIGN

Before the 1920s there were few specialist costume designers (men or women) because of highly restricted budgets, speed of production, and the impermanent nature of film companies. Practices varied. Few companies, if any, could afford extensive wardrobe stock, and "players" generally supplied their own costumes, especially for contemporary roles.[5] "Atmosphere" extras could earn more money by renting their period and fashion costumes than by working; anyone with " 'clothes' had a wonderful open sesame" to acting in the movies.[6] Films featuring fashionable dress drew women to the cinema, and in the 1910s several leading actresses wore couture clothes from French and American fashion houses.

Costuming movies became more formalized as movie going became more popular and respectable, and as longer, more expensive films with larger casts became the norm.[7] Directors and producers realized the importance of costume and glamour to the visual impact and profitability of high-investment ventures in an industry seeking to broaden audiences. Impresario Cecil B. DeMille is quoted as saying, "I want clothes that will make people gasp when they see them."[8] At the other end of the scale, the Western Costume Company supplied stock Western (cowboy), military, and other out-

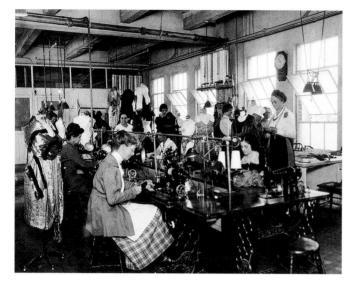

Fig. 10-1. Women making costumes at Paramount wardrobe department, 1920.

fits. But rental stock was limited. Specialized studio costume departments (fig. 10-1), staffed by skilled designers and craftspeople (nearly all women), brought improved quality and saved money on rentals.

The transition to permanent studio costume designers was gradual. Despite the inclusion of costume design in *Photoplay*'s job description of film actresses in 1915,[9] some actresses were more involved with what they wore on screen than others. Lillian Gish, who understood the difference between cinematic and "ordinary" dress, the need to suggest color by tone and contrast in black-and-white films, and the importance of underscoring character by costume, was so closely involved that, at times, she functioned as a costume designer.[10] For *The Birth of a Nation* (1915, dir. D. W. Griffith), she "pored over photographs of the Civil War and *Godey's Ladies' Book*" to ensure that her costumes were "authentic."[11] For the prologue of *Way Down East* (1920, dir. D. W. Griffith), Gish refused to wear couture clothes by Lucile, Ltd., selecting instead items that she felt were more appropriate to the character.[12] In 1922 she refused designs Griffith commissioned for *Orphans of the Storm* because "for my taste they were too much in the fashion of the time."[13] She worked with Herman Tappé to design costumes for herself, her sister, and two women cousins who also appeared in the film.[14]

Despite her early hopes that the celebrated French designer Erté would know just how the character of Mimi should look in *La Bohême* (1926, dir. King Vidor), Gish refused to wear costumes that looked like "brand new dresses" for a scene in which a poverty-stricken Mimi is evicted from her attic.[15] Neither the "hype" surrounding Erté's arrival in Hollywood nor his anger at her refusal daunted her; she had worked in films for fourteen years and knew as much as anyone about what did and did not work on screen. Rejecting all of Erté's costumes except one (a ballgown), she designed her own with the assistance of Lucia Coulter, head of MGM's wardrobe department (fig. 10-2),

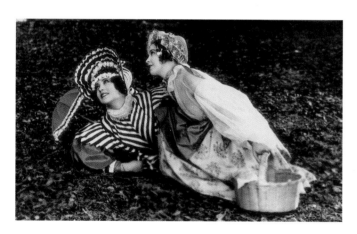

Fig. 10-2. Lillian Gish and Lucia Coulter. Costume for Mimi (Lillian Gish, *right*) in *La Bohême* (1926, Dir. King Vidor, MGM). The costume for Musetta (Renée Adorée, *left*) was designed by by Erté. Film excerpt. *Checklist no. 36*

basing them on her studies of paintings contemporary to the period. Actress Renée Adorée ignored Gish's advice about Erté, and Gish, who grasped Erté's indifference to the female body (and the script) long before Roland Barthes, commented that Adorée's outfits were "so gross they hid and killed all movement of her appealing little French body."[16]

In 1921 *Woman's Home Companion* commented on the relatively new phenomenon of studio designers, while noting that major stars such as Norma and Constance Talmadge, Alice Brady, Pearl White, and Alla Nazimova continued to "dress their own roles."[17] A decade later, however, with few excep-

tions, costume design was within the hands of studio designers.[18] The new profession was to offer space for women's creative expression for the remainder of the century. The first permanent full-time specialist costume designer to be employed by a Hollywood studio was probably Claire West. A talented fashion sketch artist while still in high school, she had studied couture clothing in Paris after graduating from college in 1910. Immediately after her stunning costumes for *Intolerance* (1916, dir. D. W. Griffith; fig. 10-3), she was hired by DeMille to work at Paramount.[19] (Shortly afterward, in 1918, the Triangle Film Corporation contracted Peggy Hamilton as studio designer.[20]) At Paramount, West designed and supervised costumes for the female characters in three films a year, including a 1923 collaboration with Howard Greer on *The Ten Commandments* (dir. Cecil B. DeMille). A year later she left to work as personal costume designer for the Talmadge sisters.[21]

One of the most flamboyant costume designers of the 1920s was Natacha Rambova (born Winifred Shaughnessy), who achieved a degree of fame for her designs and even more when she married heartthrob Rudolph Valentino in 1922.[22] The stepdaughter of cosmetic tycoon Richard Hudnut, Rambova was educated in England and studied in Paris. Her entry into film came through Alla Nazimova, a former actress with the Russian Art Theatre. Rambova is best known for costumes and art direction for *Salomé* (1923, dir. Charles Bryant; fig. 10-4), which Nazimova wrote, produced, and starred

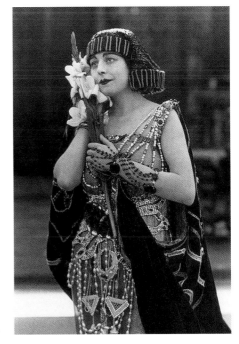

Fig. 10-3. Claire West. Costume for Attarea, the Princess Beloved, (Seena Owen) in *Intolerance* (1916, Dir. D. W. Griffith, Triangle Productions and Wark Production Corporation). Film excerpt. *Checklist no. 23*

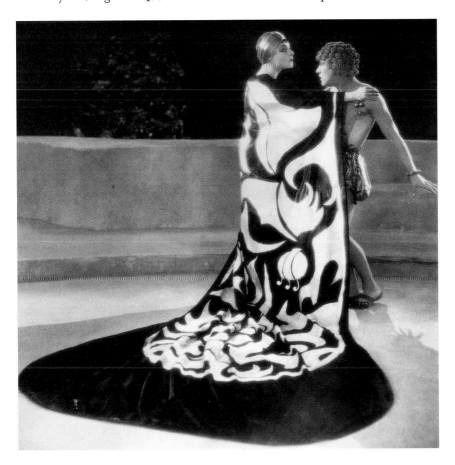

Fig. 10-4. Natacha Rambova. Costume for Salomé (Alla Nazimova) and the Page of Herodian (Arthur Jasmine) in *Salomé* (1923, Dir. Charles Bryant, Nazimova Productions).

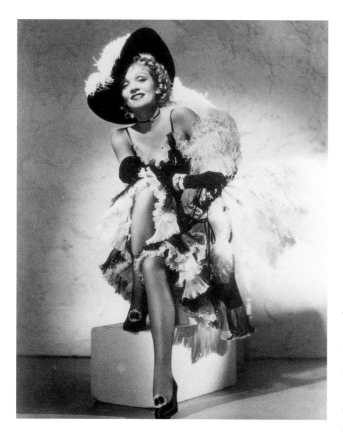

Fig. 10-5. Vera West. Costume for Frenchy (Marlene Dietrich) in *Destry Rides Again* (1939, Dir. George Marshall, Universal Studios). Film excerpt. *Checklist no. 69*

in.[23] Rambova's exotic, sensuous designs drew on Aubrey Beardsley's illustrations for Oscar Wilde's eponymous play,[24] and melded Art Nouveau with what would later be called Art Déco. She also designed the sensational costumes and sets for *Camille* (1921, dir. Ray C. Smallwood), which starred Nazimova and Valentino, but her temperamental behavior and contempt for budget restraints on *Monsieur Beaucaire* (1924, dir. Sidney Olcott) cut short a promising career.[25]

Men were also attracted to the new field of film costume design. Mitchell Leisen, who worked on *Male and Female* (1919, dir. Cecil B. DeMille) with Claire West and French designer Paul Iribe, and who later became a director, was one of the better-known male designers of the 1920s.[26] Howard Greer, Travis Banton, Orry Kelly, Walter Plunkett, and Adrian all entered the industry between 1923 and 1925. With the exception of Plunkett, a former actor, they came with established reputations in fashion and/or theater costume design.[27] All of them, along with Charles Le Maire and Jean Louis, became heads of costume design at a movie studio, and there is no doubt that they made a remarkable contribution during Hollywood's "Golden Age." Given that women overwhelmingly outnumbered men in costume design, however, men occupied a disproportionate percentage of top jobs.[28]

This notwithstanding, some women costume designers also rose to the top. Edith Head, Gwen Wakeling, Irene, and Helen Rose all became chief costume designers at film studios—albeit mainly at a later date. Head is often mistakenly depicted as a lone woman "pioneer," but West and Hamilton had paved the way. Wakeling, who worked for De Mille at Pathé and Paramount from 1927, directed the wardrobe department at Fox from 1933 to 1942—five years before Head took over at Paramount.[29] Furthermore, within a few years of Head's promotion, Irene Lentz Gibbons, professionally known as Irene, became executive director in charge of costume at MGM (1942–50).[30] As studio department heads, these women were responsible for the costuming of every film and were credited with the designs for every movie from their particular studio, even though they had teams of designers working under them. Their actual output was not quite as great as their film credits suggest.

There were, and are, many routes to becoming a film costume designer. Some women had studied art or design or were experienced in theater or fashion design. Dolly Tree, for example, designed costumes for Mae West's Broadway production of *Diamond Lil* in 1927 before Fox lured her to Hollywood in 1930. Two years later she moved to MGM where she worked for the next decade creating such costumes as the lamé gowns for Jean Harlow in *Saratoga* (1937, dir. Bernard Hyman) and Myrna Loy's outfits in *The Thin Man* (1934,

dir. Hunt Stromberg).[31] By contrast, Vera West, a former student at the Philadelphia School of Design for Women, moved to costume design from the wardrobe department. She began at Universal in 1926 and remained there for twenty-five years, designing for stars such as Irene Dunne in *Showboat* (1936, dir. James Whale) and Marlene Dietrich in *Destry Rides Again* (1939, dir. George Marshall; fig. 10-5).[32] She even redesigned her original costumes for *Back Street* (1932, dir. John M. Stahl) for a remake a decade later (1941, dir. Robert Stevenson).[33] Muriel King, who shared credit with West for the 1941 version, used her skills as a former fashion designer when working as "second" designer on many movies (designing for cast members other than stars).[34]

Edith Head entered Paramount as a sketch artist in 1924 when Howard Greer was in charge of costume. She worked as assistant to his successor, Travis Banton, from 1927 to 1938, and took over when Banton left in 1938.[35] Her earliest credits include *Wings* (1927, dir. William Wellman), starring Clara Bow, and *She Done Him Wrong* (1933, dir. Lowell Sherman), starring Mae West. Ambitious and confident in her ability to learn, she freely admitted using designs by fellow students at the Chouinard School of Art to impress Greer sufficiently to obtain a job. Her responsibilities as chief costume designer at Paramount included designing and supervising an average of thirty-five movies a year. Among the many memorable outfits Head created were Dorothy Lamour's "Polynesian" sarong (1936)—copied by bathing suit manufacturers worldwide— Bette Davis's black, off-the-shoulder gown in *All About Eve* (1950, dir. Joseph L. Mankiewicz), Gloria Swanson's ensembles in *Sunset Boulevard* (1950, dir. Billy Wilder), and Grace Kelly's outfits for *To Catch A Thief* (1955, dir. Alfred Hitchcock; fig. 10-6) and for *Rear Window* (1954, dir. Alfred Hitchcock). Her fame as a style guru brought attention to her, to the industry, to Paramount, and to the profession of costume design itself.[36]

Irene studied at the Wolf School of Design in the late 1920s and became a leading West Coast designer of couture clothes.[37] Her film costume career began when one of her celebrity clients, Dolores del Rio, insisted that RKO hire her for *Flying Down To Rio* (1933, dir. Thornton Freeland).[38] Rising to chief designer at MGM, Irene produced designs for *Gaslight* (1943, dir. George Cukor), only to have those for Ingrid Bergman rejected by Cukor.[39] The problem was solved by Irene bringing in Barbara Karinska, an expert in period clothes, who also designed Marlene Dietrich's exotic outfits in *Kismet* (1944, dir. Vincente Minnelli). In each case Irene, like Head, was credited with the designs for the movies.[40]

Fig. 10-6. Edith Head. Costumes for Frances Stevens (Grace Kelly) and John Robie (Cary Grant), in *To Catch a Thief* (1955, Dir. Alfred Hitchcock, Paramount Pictures). Film excerpt. *Checklist no. 102*

Fig. 10-7. Irene (Lentz). Costume for Hannah Brown (Judy Garland) in *Easter Parade* (1948, Dir. Charles Walters, MGM). The costume for Don Hewes (Fred Astaire) was designed by Valles. Film excerpt. *Checklist no. 93*

Fig. 10-8. Helen Rose. Costume for Maggie "The Cat" Pollitt (Elizabeth Taylor) in *Cat on a Hot Tin Roof* (1958, Dir. Richard Brooks, MGM/Avon Productions). Film excerpt. *Checklist no. 108*

Irene preferred designing for stylish, "modern" films, such as *The Palm Beach Story* (1942, dir. Preston Sturges), *The Postman Always Rings Twice* (1946, dir. Tony Garnett), and *Easter Parade* (1948, dir. Charles Walters; fig. 10-7). This left plenty of musicals and period films for Helen Rose, one of the many designers who worked under her. Rose, who studied at the Chicago Academy of Fine Arts, began as a sketch artist at Fox in the early 1930s, moving to MGM in 1942 and taking over from Irene in 1950.[41] She created beautiful outfits for MGM's "stable" of stunning women stars; her signature creations include Lana Turner's provocative dresses in *The Bad and The Beautiful* (1952, dir. Vincente Minnelli), for which she won an Academy Award; Grace Kelly's gowns in *The Swan* (1956, dir. Charles Vidor) and *High Society* (1956, dir. Charles Walters), and the white chiffon gown with plunging décolletage worn by Elizabeth Taylor in *Cat on a Hot Tin Roof* (1958, dir. Richard Brooks; fig. 10-8). The popularity of this white dress led Rose to a new, successful career in the wholesale garment business.[42] She also designed "real life" wedding gowns: for Elizabeth Taylor, when she married Nicky Hilton; and for Grace Kelly, who married Prince Rainier of Monaco. Both dresses were paid for by the publicity department of MGM.[43]

Renie (Irene Conley), who trained at UCLA and the Chouinard School of Art, enjoyed a forty-year career in films (at RKO, 1936–49, and

at Fox, 1951–78). She began by designing revue costumes for the famous Fanchon and Marco troupe (as did Bonnie Cashin and Helen Rose).[44] Extremely versatile, Renie was lured from RKO by Charles Le Maire, chief costume designer at Fox, because she could "do any kind of picture well."[45] Fashion designer Bonnie Cashin was "headhunted" for Fox by producer William Perlberg and worked there from 1943 to 1949. Her designs for Gene Tierney in *Laura* (1944, dir. Otto Preminger; fig. 10-9) brought attention to both star and designer, but her favorite project was *Anna and the King of Siam* (1946, dir. John Cromwell) because she was able to indulge her passion for oriental costume.[46] Yvonne Wood, another Chouinard graduate and Le Maire selection, began with musicals, such as *Something for the Boys* (1944, dir. Lewis Seiler), in the early 1940s and worked in feature films and television through the 1970s. While best remembered for Carmen Miranda's turbans, she also designed many men's costumes, particularly for Westerns.[47]

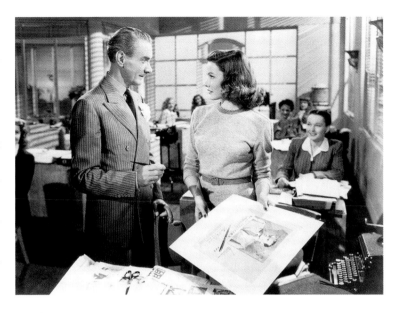

Fig. 10-9. Bonnie Cashin. Costume for Laura Hunt (Gene Tierney) and Waldo Lydecker (Clifton Webb) in *Laura* (1944, Dir. Otto Preminger, 20th Century–Fox).

By midcentury there were many talented women costume designers working in the studios. Adele Palmer, like Head, began as a sketch artist (at Universal Studios) before designing costumes, first at Republic (1938–57), then at Fox (1957–59), working on B-pictures.[48] Elois Jenssen studied at the Parsons Paris School of Design and the Chouinard School of Art.[49] She found work as a sketch artist and assistant to costume designer Natalie Visart at Hunt Stromberg's production company and was promoted to wardrobe head when Visart left to get married in 1947. Jenssen's first screen credit was for *Dishonored Lady* (1947, dir. Robert Stevenson), starring Hedy Lamarr.[50] Two years later she shared the Academy Award for *Samson and Delilah* (1949, dir. Cecil B. De Mille) with Edith Head, Dorothy Jeakins, Gwen Wakeling, and Gile Steele.[51]

Leah Rhodes was Orry Kelly's assistant at Warner Brothers when, halfway through the designing of the costumes for *Old Aquaintance* (1942, dir. Vincent Sherman), Kelly was drafted into the military. Rhodes and Milo Anderson carried on his work, although Rhodes commented: "I never wanted to be a designer on my own because I couldn't argue like Orry did."[52] In 1949 she shared the Academy Award for costume design for a color film, *The Adventures of Don Juan* (1949, dir. Vincent Sherman), with co-designers William Travilla and Marjorie Best. Famous for economizing, Rhodes boasted that the gold beads on a costume worn by Viveca Lindfors "were really just chains off of electric lights."[53] Like Edith Head and Yvonne Wood, Rhodes ended her professional career at Universal, the last Hollywood studio to retain costume designers on staff.

Trained at the New York School of Fine and Applied Arts and the Grande Chaumière in Paris, Irene Sharaff gained invaluable experience on Broadway as assistant to the distinguished set and costume designer Aline Bernstein.[54] Ten years of plays and musicals on Broadway such as *Lady in the Dark* (1941) with Gertrude Lawrence led to a distinguished Hollywood career at MGM, which included the exuberant designs of *Meet Me in St. Louis* (1944, dir. Vincente Minnelli).[55] By 1977 she had been nominated for fifteen Academy Awards and won five: for *An American In Paris* (with Orry Kelly and Plunkett; 1951, dir. Vincente Minnelli), *The King And I* (1956, dir. Walter Lang; fig. 10-10), *West Side Story* (1961, dir. Robert Wise),[56] *Cleopatra* (1963, dir. Joseph L. Mankiewicz), and *Who's Afraid of Virginia Woolf* (1966, dir. Mike Nichols),[57] the last Oscar given for costume design for a black-and-white movie.

The versatile Dorothy Jeakins came to film costume from fashion illustration, via her work as a sketch artist at Fox in the 1930s. A former Otis Art Institute student, she shared an Oscar (with Karinska)

Fig. 10-10. Irene Sharaff. Costume for King Mongkut of Siam (Yul Brynner) and Anna Leonowens (Deborah Kerr) in *The King and I* (1956, Dir. Walter Lang, 20th Century-Fox). Film excerpt. *Checklist no. 106*

Fig. 10-11. Dorothy Jeakins. Costume for Maria (Julie Andrews) in *The Sound of Music* (1965, Dir. Robert Wise, 20th Century–Fox and Argyle Enterprises). Film excerpt. *Checklist no. 117*

for *Joan of Arc* (1948, dir. Robert Stevenson), her first film project. A rare combination of costume historian and brilliant artist, she was admired by Head for her "eye" for color and by Audrey Hepburn for her "genius" in handling textiles and color.[58] After a distinguished career of almost forty years in Hollywood, where she won three Oscars and thirteen nominations, she became curator of the department of costume and textiles at the Los Angeles County Museum of Art. Her many film credits include *South Pacific* (1957, dir. Joshua Logan), *The Sound of Music* (1965, dir. Robert Wise; fig. 10-11), *The Music Man* (1962, dir. Morton Da Costa), *Hawaii* (1966, dir. George Roy Hill), and *The Dead* (1987, dir. John Huston).

Despite the remarkable achievements of those working in costume design, in terms of artistic recognition and salaries, the profession was low in the Hollywood hierachy. Although the Academy Awards were introduced in 1928, costume design was overlooked until 1948, suggesting a gap in status between costume and the male-dominated profession of art direction, which was included among the award categories from the beginning.[59] Soon after Oscar recognition, the Costume Designers Guild in California was established, becoming the Costume Designers Guild IATSE (International Alliance of Theatrical and State Employees), Local 892, in 1953.[60] Six of the nine founders were women: Yvonne Wood, Renie Conley, Marjorie Best, Leah Rhodes, Elois Jenssen, and Sheila O'Brian, who served as its first executive director and business agent from 1952 to 1973. Once the studio system started to be dismantled in the 1960s, the Golden Age of Hollywood was over. Changing viewing patterns and tastes—with musicals and epics losing money at the box office—competition from television, and changing modes of production led to a radical restructuring of the industry.[61] Studios were "downsized" and so too were wardrobe departments. As crippling overheads forced film production out of the studios and onto "locations" around the world, there was less need for large wardrobe departments based in Hollywood. Eventually Hollywood's vast collections of wardrobe stock and props were discarded as studios "sold or threw out their own history"[62]; MGM sold its costume stock in 1970, and Twentieth Century–Fox followed in 1971. The tenured in-house costume designer increasingly became a thing of the past.

Even at the height of the studio system there had been a small number of freelancers. By the late 1960s freelancing was the norm. Veteran designers, such as Edith Head, and a few younger designers trained in the "old system" soldiered on. Despite the changes at the studios, some remarkable work was done in the late 1960s and 1970s, particularly by Theadora van Runkle, Theoni V. Aldredge, Anthea Sylbert, Ruth Morley, and Ann Roth. Van Runkle's first film costumes — Depression-era retro designs for the

Fig. 10-12. Theadora van Runkle. Costumes for Bonnie Parker (Faye Dunaway) and Clyde Barrow (Warren Beatty) in *Bonnie and Clyde* (1967, Dir. Arthur Penn, Tatira-Hiller). Film excerpt. *Checklist no. 123*

Fig. 10-13. Ruth Morley.
Costume for Michael
Dorsey/Dorothy Michaels
(Dustin Hoffman) in *Tootsie*
(1982, Dir. Sydney Pollack,
Columbia Pictures). Film
excerpt. *Checklist no. 154*

Fig. 10-14. Ann Roth.
Costume for Bree Daniel
(Jane Fonda) in *Klute* (1971,
Dir. Alan J. Pakula, Warner
Brothers). Film excerpt.
Checklist no. 131

glamorous bank-robbing renegades in *Bonnie and Clyde* (1967, dir. Arthur
Penn; fig. 10-12) — won her an Oscar nomination, sent young people run-
ning to thrift shops, and were widely copied in the fashion trade,[63] as were
Aldredge's Oscar-winning costumes in *The Great Gatsby* (1974, dir. Jack
Clayton).[64] Van Runkle was also nominated for *The Godfather, Part Two* (1974,
dir. Francis Ford Coppola). The same year, Sylbert, who had established
herself designing for *Rosemary's Baby* (1968, dir. Roman Polanski), was nomi-
nated for Polanski's *Chinatown* (1974) and a few years later for *Julia* (1977, dir.
Fred Zinneman). Shortly afterward, however, Sylbert left her successful
career as a costume designer because she felt she could exercise more creative
power as a screenwriter and producer.

Aldredge was born in Greece but learned her craft at the famous
Goodman Memorial Theater in Chicago before spending twenty years
designing costumes for the stage. In addition to her Oscar for *The Great Gatsby*,
she won nominations for the films *Phaedra* (1962, dir. Jules Dassin) and *Never
on Sunday* (1960, dir. Jules Dassin). German-born Ruth Morley began working
as a stage costume designer in 1951, and her first film credit came in 1958.[65]
In 1963 she was nominated for an Academy Award for *The Miracle Worker* (1962,
dir. Arthur Penn) and in 1977 for *Annie Hall* (dir. Woody Allen). Her diverse
credits include *Taxi Driver* (1976, dir. Martin Scorsese), *Tootsie* (1982, dir.
Sidney Pollack; fig. 10-13), and *Prince of Tides* (1991, dir. Barbra Streisand).

The most prolific contemporary costume designer, Ann Roth, who
has eighty-three credits to her name, also began in the late 1960s.[66] Trusted
by directors and actors alike, she is an acknowledged "master" of "contem-
porary" costume with credits including: *Midnight Cowboy* (1969, dir. John
Schlesinger); *Klute* (1971, dir. Alan Pakula; fig. 10-14); *Silkwood* (1983, dir.
Mike Nichols) and nine other films for Nichols; and *Places in the Heart* (1984,
dir. Robert Benton).[67]

Opportunities opened up for women to design costumes in "inde-
pendent" and nonunion movies during the late 1960s and early 1970s. Some
women designers came out of graduate costume design programs; others had
experience outside the old studio system. Low budgets and fast schedules dic-
tated tight parameters that were more often a challenge than a restriction—the
opportunity to work on a movie being all-important. Although most of these
movies relied on "shopping" (for contemporary films) or rentals (for period
ones), some designers achieved wonders with low budgets. Some managed to
design principal wardrobe for their stars that could be made to order ("mo'd"
in costume slang) more cheaply than it could be bought or rented.[68]

The costuming of movies as an overwhelmingly female occupation was
further consolidated by the increased emphasis on "shopping." Shopping for
existing retail fashion altered the practice of costume design as established in
the 1930s and 1940s. By the mid-1970s, film costuming bore more relation
to the practices of early cinema than to those of the Golden Age. Embattled

unit production managers on shoestring budgets hired set costumers who had hitherto worked for costume designers, supervising alterations, renting uniforms and "atmosphere" outfits, dressing actors, and formulating budgets. The regulations of the Costumers' Union (Local 705) stipulated that they could not design new costumes but were allowed to purchase and copy clothing.[69] By the 1970s demarcations blurred as the studio system collapsed and specialist costume designers feared their own occupation would disappear.

A more recent threat to customary practices of costume design has been the product placement of "designer label" fashion. Ellen Mirojnick, whose credits include *Fatal Attraction* (1987, dir. Adrian Lyne) and *Basic Instinct* (1992, dir. Paul Verhoeven), bemoans the blurring of boundaries between runway fashion and custom-designed costumes. She refused to use certain brands of clothing to dress stars Gwyneth Paltrow and Michael Douglas in *A Perfect Murder* (1998, dir. Andrew Davis), believing that characters should be costumed rather than just stars dressed. In the manner of Hollywood's Golden Age, Mirojnick insists that if the script warrants it, she will even alter a common T-shirt to better convey character or emotion.[70]

Judiana Makovsky was asked to use specific baseball uniforms and sports equipment in *For the Love of the Game* (1999, dir. Sam Raimi). Since she felt it was appropriate for a "baseball movie," she accepted the help of a sports uniform manufacturer in the design and production of those worn in the movie. She rejected "designer clothes," however, for the stars of the movie, only to find that journalists nonetheless cited a well-known fashion designer rather than credit her for Kevin Costner's outfits.[71]

Access to the field of costume design remains relatively open. Specialist college training is increasingly the norm at the graduate level, but the movie industry still offers opportunities to talented individuals without formal training in costume design. Mirojnick, for example, came to film from fashion design. By contrast, Aude Bronson-Howard—*Mississippi Burning* (1988, dir. Alan Parker) and *Carlito's Way* (1993, dir. Brian De Palma)—"tried many back doors" to get into films before Parker "took a great risk" hiring a woman whose experience in film consisted of six years as a stylist on television commercials.[72] Eiko Ishioka, whose background was in graphics, came to design the Oscar-winning costumes for *Bram Stoker's* Dracula (1992, dir. Francis Ford Coppola; fig. 10-15) after working on production design for Paul Schrader's *Mishima: A Life in Four Chapters* (1985). She had no previous experience in any area of film design, but Schrader had sufficient confidence in her skills as a graphic designer to offer her the opportunity to change the course of her career.[73]

Ruth Carter was experienced in theatrical costume before she began working in films. One of the few well-known women of color currently working as costume designers in Hollywood (Francine Janison-Tanchuk and Michelle Cole are among the others), she has found that, despite Academy

Fig. 10-15. Eiko Ishioka. Costume for Mina Murray/Elisabeta (Winona Ryder) in *Bram Stoker's "Dracula"* (1992, Dir. Francis Ford Coppola, American Zoetrope, Columbia Pictures, and Osiris Films). Film excerpt. *Checklist no. 179*

Fig. 10-16. Ruth Carter. Costume for Shorty (Spike Lee) and Malcolm X (Denzel Washington) in *Malcolm X* (1992, Dir. Spike Lee, 40 Acres and a Mule, JVC Entertainment, and Largo International). Film excerpt. *Checklist no. 178*

Fig. 10-17. Julie Weiss. Costume for James Cole (Bruce Willis) in *Twelve Monkeys* (1995, Dir. Terry Gilliam, Atlas Entertainment, Classico, and Universal Studios).

Award nominations for *Malcolm X* (1992, dir. Spike Lee; fig. 10-16), and *Amistad* (1997, dir. Steven Spielberg), her success has mostly depended on commissions from black (male) directors.[74]

Colleen Atwood, Deborah Scott, Betsey Heiman, Gloria Gresham, Rita Ryack, Susan Lyall, Marilyn Mathews, Mona May, Ha Nguyen, Beatrix Pasztor, Aggie Guerard Rodgers, Mary Zophres, Jane Greenwood, Marilyn Vance, and Julie Weiss (*Twelve Monkeys*, 1995, dir. Terry Gilliam; fig. 10-17) are among the many other talented women costume designers who today shape the look of American movies. At the end of cinema's first century, costume design remains the only creative area of the industry dominated by women. In the Costume Designers Guild, women members outnumber men by almost six to one, and the ratio within the industry as a whole is higher. The status of the costume designer is higher and the job description more secure than it has been since the late 1960s; it remains, however, the "poor relation" in the collaborative efforts involved in "designing" a movie.

PRODUCTION DESIGN

The term *production design* was not used until 1939 when something beyond *set designer* or *art director* seemed necessary to describe the scope of William Cameron Menzies's contribution to *Gone With The Wind* (1939, dir. Victor Fleming, George Cukor, and Sam Wood).[75] Before then an art director was responsible for the overall design of a movie, and set designers were responsible to them. Today the production designer is the person charged with creating the visual design of a film. He or she (usually he) is in charge of selecting locations, designing sets, overseeing the building and dressing of sets, and coordinating the various departments involved.[76] In popular usage and in film histories, all three terms have been used interchangeably, particularly art direction and production design, but regardless of the terminology the women discussed here have been involved with the overall design of movies unless stated otherwise.

In early cinema, the design of sets was associated with scenery painting and building, as in the theater. Its close affiliation with the "male" worlds of construction and architecture, particularly after three dimensional sets replaced theatrical flats from the late 1910s, ensured that it became a man's preserve.[77] The act of designing took no particular strength, but arguments posited within architecture and landscape architecture—relating to the physical nature of construction and the inappropriateness of women being "on site" supervising male construction workers — also served to marginalize women within film. Although women architects and landscape architects made some headway against the odds in their professions, women in the film industry made almost none in terms of set design, art direction, or production design until the 1970s.

Before studio procedures were regularized in the 1920s, Lillian Gish, as director of *Remodelling Her Husband* (1920), simply "picked the furniture, told 'Huck' Wortman how to do the sets . . . and was given fifty thousand dollars" to make the movie.[78] Despite Griffith's remark that men worked better for a woman than for a man,[79] the massive sets built by Wortman to designs by Walter Hall for *Intolerance* (1916, dir. D. W. Griffith) ensured the exclusion of women. It was unthinkable at that date for a woman to be in charge of the veritable army of workmen (many foreign) necessary to build such huge sets. Thereafter, there were few opportunities for women to affect the overall design of films.

For a short time in the 1920s, Natacha Rambova was the exception. Her sets were as spectacular as her costume designs and, as art director, she controlled the look of movies such as *Camille* (1921) and *Salomé* (1923), creating some of the most visually unified films in Hollywood history. The transparent structures of the "gold-fish bowl design of Camille's bedroom" suggest voyeurism and modernity as well as transparency of character, while satin cushions and fur rugs spell sensuality (fig. 10-18).[80]

The box-office appeal of sumptuous interiors brought interior designers into the movie industry in the late 1920s and 1930s. Despite the large number of women interior designers at that date, however, only men were recruited. In the late 1930s the president of the Society of Motion Picture Interior Decorators emphasized that the job was not for women, "men being best suited to the mental strain and physical demands exacted by the work."[81]

Landscape designers Florence Yoch and Lucile Council, whose Pasadena-based firm designed gardens for many Hollywood notables including Dorothy Arzner, Jack Warner, David Selznick, and George Cukor, contributed to the design of several movies. They gained a temporary entrée to the "men's club" because they offered a design expertise not available within the industry. Their film work included *The Garden of Allah* (1936, dir. Richard Boleslawski), for which they traveled to North Africa to research the Saharan landscape. They also designed an Italian garden for *Romeo and Juliet* (1936, dir. George Cukor), a rice terrace for *The Good Earth* (1937, dir. Sidney Franklin; see fig. 14-3), and a Welsh valley blooming with ten thousand daffodils for *How Green Was My Valley* (1941, dir. John Ford).[82] For *Gone With The Wind* (fig. 10-19) they studied southern gardens and supervised the shape and scale of every exterior "natural" element, including the tying of dogwood blossoms to the plaster trees of Tara.[83] Selznick relied upon Yoch and Council for the exterior visual look of each plantation, yet their contribution to one of the most popular movies ever has been marginalized, although the Souvenir Theater program credits included "Tara Landscaped by Florence Yoch." [84]

Broadway proved slightly more conducive to women set designers. United Scenic Artists Local 829, founded in 1897, first admitted a woman scenic painter, Mabel Buell, in 1918, and in the 1920s a handful of other women joined, including Millia Davenport and Aline Bernstein.[85] The union (the stamp of which appeared on all theatrical set designs) was open on merit to costume and set designers—male and female. The overwhelmingly

Fig. 10-20. Lutah Maria Riggs. Production design for *The White Cliffs of Dover* (1944, Dir. Clarence Brown, MGM). Film excerpt. *Checklist no. 85*

"male" atmosphere in the 1930s can be glimpsed in Irene Sharaff's descriptions of a rowdy meeting during which she was abruptly cut off by the comment "Shut up Brother Sharaff!"[86] Although best known as a costume designer, Sharaff, who worked as Bernstein's assistant, also worked on set design. When producer Arthur Freed invited Sharaff to design the costumes for the ballet sequences in *An American in Paris* (1951), she was also "allowed to help design some of the settings."[87]

So deep-rooted was the bias against women art directors in the 1940s, that even during World War II, when studios were depleted of men, there was resistance to hiring women. MGM blocked a proposal to allow women architects and draftsmen to work as art directors; the memorandum simply noted that it was "unsuitable" for women to be working in the art department.[88] Nevertheless, William Hornung, Cedric Gibbons's assistant at MGM, asked his friend Lutah Maria Riggs, a well-known California architect who had designed a house for Greta Garbo (1939),[89] to help out. Her contributions to wartime entertainment included *The White Cliffs of Dover* (1944, dir. Clarence Brown; fig. 10-20) and creating fashionable Regency Revival sets for *The Picture of Dorian Gray* (1945, dir. Albert Lewin).[90] After the war she returned briefly—to assist Hornung with the gardens and some interiors for *Quo Vadis* (1951, dir. Mervyn LeRoy). Like Yoch and Council, her work has not been acknowledged within film or design histories.

It proved easier for women to work as art directors in television, which in the 1950s and 1960s resembled the early film industry in its openness and flexibility, although considered "second tier" to film pioneers. Beulah Frankel, who in 1957 became the first woman member of the Art Directors Guild, helped raise the status of production design in television and open new spaces for women. Jan Scott, the first woman president of the Art Directors Guild Local 876, also came to Hollywood design through television. Scott, who as a teenager wanted to become a production designer,

Fig. 10-21. Polly Platt.
Production design and cos-
tume design for *What's Up Doc?*
(1972, Dir. Peter
Bogdanovich, Saticoy
Productions). Interior of a
San Francisco townhouse.
Film excerpt. *Checklist no 133*

studied architecture at her father's insistence, in the hope that it might help her gain entry to the Art Directors Guild. After graduating in the late 1960s, however, she decided to join the New York Scenic Artists Local 829, which was open to both women and men by examination. She passed the grueling eighteen-hour test and worked in production design in New York in both television and film. In the 1970s she relocated to Los Angeles, where her work for television included the spectacular national television "event" *Roots* (1977, dirs. Marvin J. Chomsky, John Erman, David Greene, and Gilbert Moses) and the miniseries *Eleanor and Franklin* (1976, dir. Daniel Petrie).[91]

Polly Platt came to film design via low-budget independent movies. She studied theater costume and set design at Carnegie Mellon University, Pittsburgh, and although she initially disregarded set design as a career because she believed there were no openings for women, she designed some sets for Off-Broadway plays in the 1960s.[92] She then collaborated as a writer with her husband, director Peter Bogdanovich, eventually teaming with low-budget film mogul Roger Corman. In 1971 hers was the first woman's name to appear on the film roster of the Art Directors Guild Local 876.

Platt's memorable production design includes the plexiglass and black-and-white interior that served as an inspired distillation of the character

of Austin, "a pretentious, transparent rich guy," in *What's Up, Doc?* (1972, dir. Peter Bogdanovich; fig. 10-21) for which she also designed the costumes,[93] dustbowl locations for *Paper Moon* (1973, dir. Peter Bogdanovich), and the depiction of small-town America for *The Last Picture Show* (1971, dir. Peter Bogdanovich). She received an Oscar nomination for *Terms of Endearment* (1983, dir. James L. Brooks) but acknowledges that luck played a part in her success. She used to joke: "I slept my way to the top! Of course, he was my husband!"[94] She has also commented that when first seeking work independent of Bogdanovich, she felt she was not getting certain jobs because she was a woman, despite her success and proven track record.[95]

Accumulating production design credits was not easy for other women in the 1970s and 1980s, including Patrizia von Brandenstein and Jeannine Oppewall, both of whom were stonewalled in their attempts to join the Los Angeles Local 876. Von Brandenstein's fascination with production design dates back to childhood shows; an only child, she "invented things to help me have some other presences."[96] She apprenticed at the French National Theater, studied at the Forum of Stage Design, and worked for five years in San Francisco at the American Conservatory Theater as staff costume designer. But in the late 1960s and early 1970s art direction and production

design remained unattainable for most women designers; she recalls, "there really were no women *at all* who did this. . . . It just wasn't something that was open."[97] Production designer Gene Callahan, who gave her a job as set decorator on *The Candidate* (1972, dir. Michael Ritchie), backed her efforts to become a production designer, but she had no luck with the Los Angeles union. Von Brandenstein finally moved to New York where union membership was more accessible. It was after fame as the designer of John Travolta's iconic white polyester suit for *Saturday Night Fever* (1977, dir. John Badham) that her break came in production design with *Breaking Away* (1979, dir. Peter Yates). She went on to re-create a plutonium fuel plant for *Silkwood* (1983, dir. Mike Nichols; fig. 10-22), Mozart's eighteenth-century world for *Amadeus* (1984, dir. Milos Forman), and the gangster glamour of *The Untouchables* (1987, dir. Brian De Palma).

Unspoken prejudice against women in the Los Angeles union also forced Jeannine Oppewall to New York. A graduate of Bryn Mawr with a degree in liberal arts and an MA in English, she joined the Eames Office in 1970. Although she primarily had responsibility for the visual library and film distribution, she also researched and scripted exhibitions. Like everyone in that hothouse of ideas, she flourished in an atmosphere that "encouraged the use of qualities and skills one never knew one had."[98] Her move into film came in 1977 when a college friend was directing his first movie and the art director needed extra help. After assisting production designer Paul Sylbert on three concurrent films, she won critical acclaim as production designer for *Tender Mercies* (1983, dir. Bruce Beresford). Despite this and Sylbert's support, her applications for union membership continued to be rejected. She finally went to New York and took the test for Scenic Artists Local 829, as von Brandenstein had done. Oppewall went on to design many memorable

Fig. 10-24. Kristi Zea.
Production design for *The
Silence of the Lambs* (1991, Dir.
Jonathan Demme, Orion).
Prison passageway and the cell
of Hannibal Lechter
(Anthony Hopkins); Clarice
Starling (Jodie Foster). Film
excerpt. *Checklist no. 175*

movies, including *Ironweed* (1987, dir. Hector Babenco) and *Music Box* (1990, dir. Costa Gavras), and to receive Oscar nominations for both *L.A. Confidential* (1997, dir. Curtis Hanson) and *Pleasantville* (1998, dir. Gary Ross; fig. 10-23). She recalls her early struggles philosophically: "I guess people assumed women didn't know the difference between a one-by-six and a two-by-four."[99] Recently she could even smile when the longtime president of the union local that had excluded her and other women proclaimed, "I don't know why there weren't any women [production] designers; . . . they seem to know what they're doing."[100]

Like von Brandenstein, Kristi Zea came to art direction and production design from costume design. Director Alan Parker gave her the chance to work as art director of *Angel Heart* in 1987, and her production design for *Silence of the Lambs* (1991, dir. Jonathan Demme; fig. 10-24) brought her critical acclaim. Patricia Norris also began production design in the 1980s, making her mark with *Blue Velvet* (1986, dir. David Lynch). More recently she was the production designer of *Hi Lo Country* (1998, dir. Stephen Frears).

The women who followed these "pioneers" continue to have varied backgrounds. More women production designers worked in Hollywood in the late 1980s and 1990s than ever before but, for the most part, they continued to enter via circuitous roots. Chinese-born Mayling Cheng—*Virus* (1999, dir. John Bruno) and *Turbulence* (1997, dir. Robert Butler)—for example, majored in architecture at the Otis/Parsons School of Design, Los

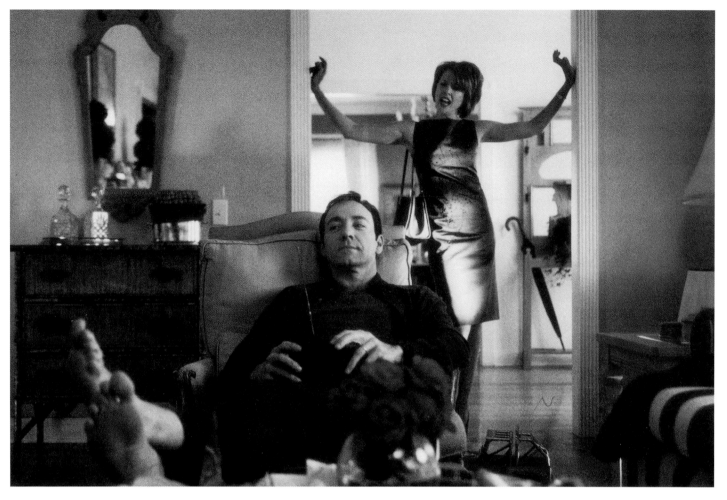

Fig. 10-25. Naomi Shohan. Production design for *American Beauty* (1999, Dir. Sam Mendes, DreamWorks and Jinks/Cohen Company). Interior of the suburban house of Lester Burnham (Kevin Spacey) and Carolyn Burnham (Annette Bening).

Angeles, but found these qualifications did not ensure being taken seriously when she entered the male world of production design in the mid-1980s. She did find, however, that attitudes changed as she won the respect of the men who worked for her.[101]

Jane Musky—*Raising Arizona* (1987, dir. Joel Coen) and *Ghost* (1990, dir. Jerry Zucker)—who graduated from the theater department of Boston University, spent two years painting scenery at the English National Opera and Pinewood Studios before working Off-Broadway, as set designer, art director, and finally production designer, and she also worked in television.[102] By contrast, Ina Mayhew—*Get on the Bus* (1996, dir. Spike Lee) and *200 Cigarettes* (1999, dir. Risa Bramon Garcia)—who studied theater design and visual arts at the State University of New York, Purchase, designed sets for commercials and music videos before moving into feature films.

Lily Kilvert—*I Love You to Death* (1990, dir. Lawrence Kasdan) and *The Story of Us* (1999, dir. Rob Reiner)—began as a photographer and became interested in set design after designing and building sets for magazine layouts. She describes her training for production design as "disjointed": "I learned each craft as I needed it. When I had to learn drafting, I took a drafting course. When I had to build sets, I learned set building."[103] Barbara Ling—*Batman Forever* (1995, dir. Joel Schumacher) and *Random Hearts* (1999, dir. Sydney Pollack)—on the other hand, has a degree in political science and

designed sets and lighting for concert tours, including David Byrne's 1990 world tour, before turning to film.

Catherine Hardwicke, Ruth Ammon, Jane Ann Stewart, and Carol Winstead Wood are also making inroads into production design. In the year prior to the Academy Awards of 2000, approximately 20 percent of Hollywood releases had women production designers, including Naomi Shohan for the Oscar-winning picture *American Beauty* (1999, dir. Sam Mendes; fig. 10- 25) and Therez De Prez for both *Arlington Road* (1999, dir. Mark Pellington) and *The Summer of Sam* (1999, dir. Spike Lee). It has taken the best part of a century but women are finally a permanent part of Hollywood production design.

Gifted and capable women have made a significant contribution to cinema in both costume and film design. At the end of the first century of this modern art form, costume design remains undervalued, too often dismissed as "women's work," and costume designers continue to fight for greater respect and recognition. For production designers, acceptance within a still heavily male-dominated field remains a central issue. Women costume designers and production designers juggle unrelenting work schedules and sometimes distant film locations with personal lives. Endeavoring to work to the best of their capabilities while nurturing children and family is a constant strain in a tough unforgiving industry not noted for its sensitivity to the needs of women. As with women in other professions, the women designers of Hollywood make commitments and sacrifices every day as they work to shape the look of one of the most popular media of the twentieth century.

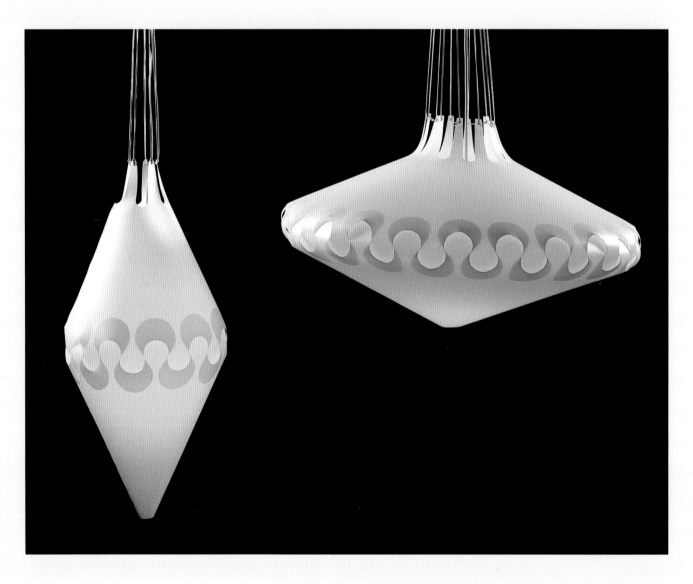

Fig. 11-A. Elsie Crawford. "Zipper"
light prototype, ca. 1965. Acrylic.
Collection of Peggy Gruen.
Checklist no. 119

ELLA HOWARD AND ERIC SETLIFF

"In a Man's World":

WOMEN

INDUSTRIAL

DESIGNERS

WOMEN ARE MENTIONED ONLY INFRE-QUENTLY in histories of twentieth-century industrial design.[1] They have played an important role in that history, however, whether as principals of their own firms, members of collaborative teams, or staff designers at major corporations. This essay traces the history of women's participation in furniture, glass, and product design throughout the century, with emphasis on the education, train

ing, and entry of women to the field. While their backgrounds and education vary widely, they are united by their status as a distinct minority in a field overwhelmingly dominated by men.

Early in the century, women such as Lucia Kleinhans Mathews and Madeline Yale Wynne came to the design and making of furniture through their involvement in the Arts and Crafts movement (see chaps. 2 and 12). Anna Wagner Keichline, however, was an architect who also designed products. As a child in Bellafonte, Pennsylvania , Keichline developed an interest in carpentry, winning a prize at the state fair in 1903 for her furniture design and construction at the age of fourteen (fig. 11-1). She studied architecture at Cornell University, graduating in 1911, and was the first woman listed as an architect in Pennsylvania. During a career in which she designed a number of public and private buildings and a new type of clay brick for hollow wall construction, Keichline also patented solutions to design problems in the home. Her innovative "Bed for Apartments" design (1929) proposed beds that folded up into a wall cabinet to save space during the day, and Keichline's "Kitchen Construction" patent (1924; fig. 11-2) aimed "to provide a kitchen, the parts of which are so designed as to involve the minimum amount of labor on the part of the housekeeper and to reduce the operative cost."[2] Keichline proposed glass-doored cabinets, easily accessible shelving, ample surfaces for food preparation, and the side-by-side arrangement of four stove burners (either gas or electric) for greater ease of use.

Design patents remain a largely untapped resource of information on women's design activities. Over the course of the century, such patents granted to women increased from 3.2 to 13.1 percent.[3] Those issued early in the century included designs for a meat or vegetable chopper, kitchen bin, linoleum, oil cloth or floor covering, and telephone, and an intriguing patent for an ornamental

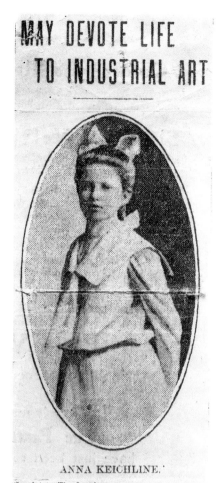

ANNA KEICHLINE.

Special to The Inquirer.

BELLFONTE, Pa., Oct. 18.—Such a liking has she taken to industrial art that Miss Anna Keichline, the fourteen-year-old daughter of John Keichline, a prominent attorney of this place, expects to make it her life study. She has just taken the first prize at the Centre county fair for a card table made of oak, and a walnut chest which she made with her own hands. They, in quality and finish, compare favorably with the work of a skilled mechanic. At her home here she has a workshop complete in every detail, and is in possession of the best outfit of carpenter implements to be found in the town. She goes to school, but every spare moment is put in her shop.

Fig. 11-1. Anna Wagner Keichline at age fourteen. From "May Devote Life to Industrial Art," [Philadelphia] *Inquirer*, 1903.

pedestal, which was granted to Charlotte Kohler, wife of plumbing manufacturer Walter J. Kohler in 1904 and was assigned to his firm.[4] Educated at the University of Wisconsin, the Milwaukee Art Institute, and Pratt Institute in Brooklyn, the newlywed Charlotte Kohler had brought her interest in design to her husband's family business.[5]

Ilonka Karasz was one of the most important figures to answer the call for modern American design in the 1920s. Born in Budapest, where she attended the Royal School of Arts and Crafts, Karasz immigrated to the United States in 1913, settling in New York and quickly establishing a reputation as a designer, painter, and teacher.[6] By the late 1920s, she was designing furniture, ceramics, and silver, often in a cubist, geometric style (fig. 11-3) and was a key member of several organizations of influential artists and designers who sought to foster the development of modern decorative arts. The American Designers Gallery, formed to promote works exclusively by modern American designers, had its premier exhibition in 1928, consisting of ten furnished rooms, two of which were by Karasz.[7] She was also a key member of the American Union of Decorative Artists and Craftsmen (AUDAC), which featured Karasz's work in each of its two exhibitions (1930 and 1931).

By 1930 Karasz's reputation was such that when art critic C. Adolf Glassgold listed the nine American modern furniture designers he believed most worthy of recognition, Karasz was the only woman included.[8] Even by the increasingly adventurous standards of the late 1920s, her work appeared innovative: her furniture for a show of "art in industry" at Macy's, New York, in 1928 was described as "easily the most extreme" and "the most iconoclastic of any in the exhibition."[9] Some of Karasz's inventive designs were for the nursery. Using primary colors and geometric shapes—in keeping with both Bauhaus-style modernism and current educational theory—she devised small-scale convertible furniture, including a tubular metal bassinet that converted to a perambulator, for Saks Fifth Avenue in 1935.[10] That same year she expressed her philosophy of design: "not every problem in furniture design . . . is merely a practical one of employing the shortest and simplest means to a given end, as many modern designers seem to think. Functional design can satisfy one's intellect and meet all the practical requirements, but it has no appeal for the emotions. . . . I believe that form and color should be so related in a useful object that besides serving its purpose it also arouses some feeling which results in a definite pleasure."[11]

The late 1920s saw the emergence of industrial design as a distinct profession in the United States. The intense competition between companies created by the Depression led to an increased emphasis on visual form as an instrument to increase sales, and, as a result, the consulting or in-house industrial designer came to be regarded as playing an essential role in industrial production.[12] In the early years of the profession, while men such as Raymond Loewy, Walter Dorwin Teague, and Norman Bel Geddes became

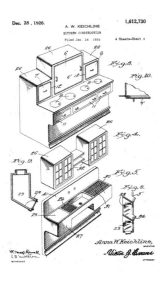

famous by heading their own firms, working across media, and exploiting publicity, the pioneering Belle Kogan was the only woman to employ similar methods and achieve significant results. Kogan emigrated with her parents from Russia at the age of four. From an early age, she demonstrated an interest in art, and in her last year of high school in 1920, "An unexplained inspiration on the part of my high school art teacher induced her to have me study Mechanical Drawing."[13] Kogan was the only girl in the class. She credits this early training as "one of the factors of my ability to provide my clients with exact working drawings."[14] After graduation, Kogan taught the first-year mechanical drawing class at the school, while saving money to enter Pratt Institute in Brooklyn. Forced to leave Pratt after her first semester to manage her father's jewelry store and look after her seven siblings, for the next eight years she designed jewelry settings while attending the Art Students League in Manhattan, gaining experience in both business and design.[15]

Kogan's independent design career began with a fortuitous chance meeting with the head of the Quaker Silver Company of Attleboro, Massachusetts, who hired her on a freelance basis to design pewter and silver

Fig. 11-2. Anna Wagner Keichline."Kitchen Construction" patent drawing, filed January 14, 1924; issued December 28, 1926. United States Patent and Trademark Office, No. 1,612,730. *Checklist no. 33*

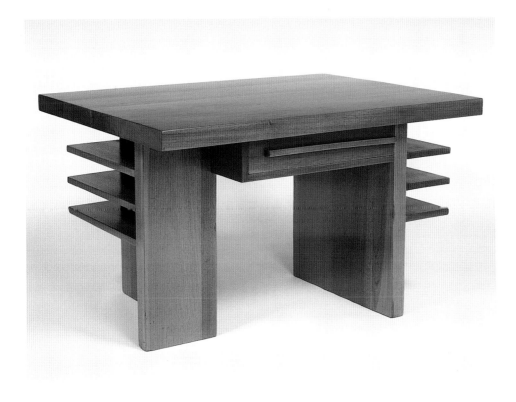

Fig. 11-3. Ilonka Karasz. Desk, ca. 1928. Lauan mahogany. The Minneapolis Institute of Arts, Gift of Norwest Bank, Minnesota (L98.283.11).

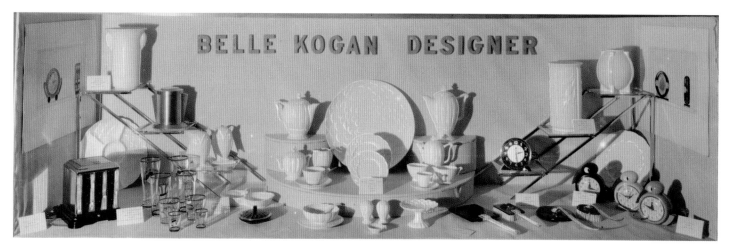

Fig. 11-4. Belle Kogan's works displayed at the *Exposition of Arts and Industries*, held at Radio City Forum, New York, April 15–May 15, 1935.

items. Quaker paid for her to take a course at New York University in the summer of 1929 that "opened my eyes to the fact that design didn't just happen. It had to be developed. I felt that it was wonderful, like a puzzle, all the parts fitted in: the business training, painting, color study, and my interest in mechanics, machinery and production problems." Kogan's father was eager for her to marry, but she had a different plan: "I said to my father, 'Well, I'm going to have a career, goodbye I am never going to get married, and I'm never going to have children. I had a family all my life I helped raise. I helped you in business. I want a life of my own.'"[16] In 1931 Kogan opened her first studio in New York City. She was one of the first industrial designers in America to experiment with plastics, and her early designs included celluloid toilet sets and clocks, a chrome-plated toaster with a plastic base, and Bakelite jewelry (fig. 11-4).[17]

Kogan faced strong opposition from a field unaccustomed to women designers. In a 1939 interview she admitted that "manufacturers were quite antagonistic when a woman came around proposing new ideas—they didn't think a woman knew enough about the mechanical aspects of the situation. I had to prove I have a practical mind."[18] In one memorable episode, "[a] large company that manufactured large electrical appliances, such as washing machines, etc., wrote in answer to a letter of mine that I should come out to see them on my next trip to Ohio. They ignored the fact that my name was 'Belle' and addressed their letter to Mr. Bell Kogan. When I arrived, the shock was unbelievable; the engineers decided they couldn't work with a woman. So I collected my fee of $200 plus expenses and left!"[19]

Kogan also had to deal with male clients who did not respect her personal boundaries: "I found the combination of living and working in the same place was very hard when you had a male client. I had to make a law for myself: no dinners with clients, and do not see them after six o'clock. I had a battle every time I went out with somebody."[20]

Kogan's firm, after several "cruelly discouraging years" in the early 1930s, grew steadily; by 1939 she had a staff of three women designers.[21] "I

believe that good design should keep the consumer happy and the manufacturer in the black," proclaimed her promotional materials, and her designs, which ranged from historicizing to modern in their aesthetic, often proved exceedingly popular with both.[22] By the time she closed her office in 1970, Kogan had designed for a wide range of clients, including Reed and Barton, Red Wing Pottery, Bausch and Lomb, Boonton Molding (for whom she designed popular lines of plastic dinnerware in the 1950s), Libbey Glass, and Dow Chemical. Throughout her career, Kogan made excellent use of publicity, speaking on television and radio, giving lectures and interviews, exhibiting her work frequently, and writing for both trade and consumer magazines on market trends, design, and the role of the industrial designer. Kogan was also an active participant in emerging professional organizations. She was a founding member of the New York chapter of the American Designers Institute (ADI) in the late 1930s, the first industrial design organization in the country, which evolved into the Industrial Designers Institute (IDI) in 1951. In 1994 the Industrial Designers Society of America (IDSA) awarded her its Personal Recognition Award.[23]

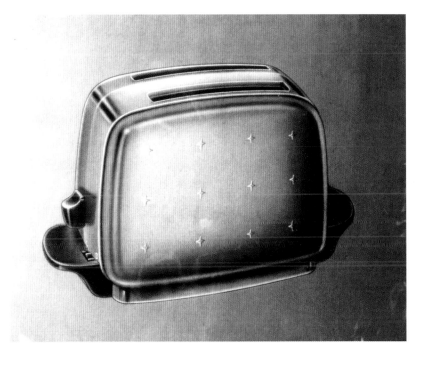

Fig. 11-5. Ellen Manderfield. Drawing for a Montgomery Ward toaster, 1942. The Chicago Athanaeum Design Archives, Gift of Ellen Manderfield (1994.PA.656).

In the first half of the century, women influenced industrial design not only as consultant designers, but also as staff designers with major manufacturers and retailers. When industrial giant Montgomery Ward decided to redesign and modernize their products they hired Anne Swainson.[24] Born in Sweden, she had studied fine and applied arts at Columbia University, New York, and taught textile design and applied arts at the University of California at Berkeley in the early 1920s (where her pupils included textile designer Dorothy Liebes). Swainson then worked as director of design for Chase Brass and Copper, where her department included a number of women designers.[25] She relocated to Chicago in 1931 to establish the bureau of design at Montgomery Ward, initially supervising a staff of fifteen to twenty designers, which increased to thirty-two by 1935 (eighteen product designers and fourteen packaging designers). Swainson's staff redesigned products ranging from tires, arc welders, and radios, to toasters, flatware, and other housewares. In addition to these duties, they also overhauled the company's mail-order catalogue, simplifying its layout, typography, and logos. Few designs can be traced to Swainson's own hand, but Sheldon and Martha Cheney acknowledged the importance of her work to the field in their influential 1936 book, *Art and the Machine*.[26]

Fig. 11-6. Ellen Manderfield (seated, second from left), Charter Meeting of the Industrial Designers Institute, Syracuse Chapter, 1953.

Ellen Manderfield was one of the designers employed by Swainson at Montgomery Ward. A Chicago native, Manderfield joined her father in woodworking projects as a child, but when she announced her interest in designing furniture, "My father advised me that that was not a profession for a woman."[27] Directed toward commercial art instead, Manderfield earned a BFA at Mundelein College of Loyola University, then received a scholarship to a commercial art school. Completing her studies in 1939, she worked for the next six years as a graphic and packaging designer. Determined to move into industrial design work, she obtained a job at the Colonial Radio Corporation (later Sylvania), where she supervised a staff of seven and designed televisions, record players, and radios, including early experimental prototypes for pocket and portable radios. From 1947 to 1951 she worked under Swainson on sewing machines, accordions, bathroom fixtures, lawn mowers, and various appliances (fig. 11-5). Five years in the industrial design department at General Electric in Syracuse followed, designing cabinets for electronic equipment and televisions, and commuting to Chicago to visit her husband. Her work from these years ran the full range of postwar American taste, from "early American" to Scandinavian Modern. In 1956 she was offered a position with the prestigious Donald Deskey firm in New York City, but instead chose to work at Oneida Silversmiths, where, until her retirement in 1986, she designed silver and stainless steel flatware, hollowware, and plastic dishware; ultimately more than two hundred of her flatware patterns were put into production. Her "Omni" design for simple contemporary stainless steel flatware was placed in the collection of the Museum of Modern Art, New York, in 1979.[28] Like Kogan, Manderfield was active in the new professional organizations. An early member of IDI, she founded the Syracuse chapter in 1953 (fig. 11-6) and was the first woman member accepted to the newly formed American Society of Industrial Designers (ASID) in 1957.[29] Almost forty years later, she was also the first woman to receive the IDSA Personal Recognition Award (in 1992).[30]

In the early years of the industrial design field, women (like their male colleagues) tended to obtain art and design training from a wide variety of sources, some more directly related to the developing field than others. By the 1930s, however, educational institutions began to address the need for more formal programs, and access to such programs facilitated some women's entry into the field. In 1936, the first graduating class of five students at the Carnegie Institute of Technology, the first school in the United States to

Fig. 11-7. Eva Lisa (Pipsan) Saarinen Swanson. Glasses (*from left*): wine, sherbet, water, and, champagne, designed 1947. Manufactured by U.S. Glass Company, Tiffin, Ohio. Glass. Cranbrook Art Museum, Bloomfield Hills, Michigan, Gift of Robert Saarinen Swanson and Ronald Saarinen Swanson (CAM 1981.70a–d). *Checklist no. 91*

offer a bachelor's degree in industrial design, included three women: Marylou Henkison, Jane Thompson, and Maud Bowers (Rice).[31] Students took courses in industrial design, production methods, industrial processes, model making, and drawing, and female students excelled within the program. Bowers, for example, won prizes in design competitions for a cigarette holder for Kensingtonware, an Alcoa subsidiary, and a water heater for the Pittsburgh Water Heater Company.[32] Some female graduates went on to design careers, like Irene Pasinski, who began a consulting office, and Marion Costa, who designed for J.C. Penney. Many, however, like Bowers, took on familial responsibilities, and did not practice as professional designers.

The Cranbrook Academy of Art, founded in 1932 in Bloomfield Hills, Michigan, did not at first attract many design students. But in the years just before World War II—in what would come to be known as Cranbrook's "golden moment"—it attracted a circle of students and faculty that would have a major impact on American product design. Several of these influential figures were women. Eva Lisa (Pipsan) Saarinen was the daughter of Eliel Saarinen (Cranbrook's director) and Loja Saarinen (director of the weaving and textile design department). Pipsan had studied design at the University of Helsinki before the family's move to Michigan in 1923. Her first important projects were interiors for her father's architectural commissions,[33] and she taught Cranbrook's first formal class on contemporary furniture design. In 1926 she married J. Robert F. Swanson, an architect, and opened a contemporary interior design department in her husband's firm. After years of producing custom furniture for their clients, she and her husband convinced the Johnson Furniture Company to introduce their F.H.A. (Flexible Home Arrangement) line of functional and flexible furniture in 1939. After the

Fig. II-8. Florence Knoll.
Settee, ca. 1955.
Manufactured by Knoll
Associates, East Greenville,
Pennsylvania. Chrome,
upholstered foam rubber,
and aluminum. Knoll
Museum, East Greenville,
Pennsylvania. *Checklist no. 104*

Fig. II-9. Florence Knoll.
Sideboard, table, and chair,
ca. 1955.

war, they developed coordinated products to complement their furniture, enlisting sixteen manufacturers to produce the new designs. Pipsan Swanson supervised the color and design coordination of the project. She also designed printed textiles, lamps for Mutual Sunset Lamp Company, metalware for Cray of Boston, and glassware for the U.S. Glass Company of Ohio. The latter firm, in 1948, commissioned her to prepare all their major designs (fig. 11-7).[34] In the mid-1940s the Swansons formed the firm of Swanson Associates, and in 1957, Pipsan was awarded the Louise Bolender Woman of the Year award for "outstanding contribution to the Home Furnishings Industry."[35]

Another "Cranbrook woman" was Florence Schust (Knoll), who was orphaned at an early age and sent to the Kingswood School for girls, which was part of the Cranbrook educational community (and featured interiors by Pipsan Swanson).[36] Schust enrolled at Cranbrook Academy of Art in 1934 and attended intermittently until the end of the decade, leaving for periods of study at the Columbia University School of Architecture and the Architectural Association in London. During these years, she was informally adopted by Eliel and Loja Saarinen. In 1940 she worked at the architectural firm of Walter Gropius and Marcel Breuer in Cambridge, Massachusetts, before studying architecture under Mies van der Rohe at the Armour Institute (later the Illinois Institute of Technology). In 1941 she relocated to New York, where she met Hans Knoll, a German immigrant who had recently founded a furniture company. Schust began to moonlight for the struggling firm, and in 1946, Hans and Florence were married and Knoll Associates was founded, with Hans as president and Florence as vice president of what would rapidly become one of the most important modern design companies in the United States.[37]

Florence Knoll created and directed Knoll's design program, becoming best known for her work as an interior designer, but also developing a wide range of furniture. However, she consistently downplayed the latter aspect of her career: "People ask me if I am a furniture designer. I am not. I never really sat down and designed furniture, I designed the fill-in pieces no one else was doing. I designed sofas because no one was designing sofas."[38] She created, she insisted, merely "the background pieces that make a room quiet and peaceful." Nevertheless, by the early 1960s, her furniture accounted for more than half of the pieces in the Knoll catalogue,[39] and today those "background pieces" are highly sought-after products of mid-century modernism.

Knoll's designs from the 1940s included wooden stacking tables and stools intended for domestic interiors[40]; by the early 1950s the company's involvement in corporate interiors focused her attention on the design of desks, conference tables, and storage cabinets, all of which were consistent favorites at the Good Design exhibitions at the Museum of Modern Art, New

Fig. 11-10. Ray Eames and Charles Eames. "LAR" armchair, 1948–50. Manufactured by Zenith Plastics, Gardena, California for Herman Miller Furniture Company, Zeeland, Michigan. Polyester fiberglass composite, zinc-plated steel, and rubber. Collection of Gansevoort Gallery, New York. *Checklist no. 94*

Fig. 11-11. Ray Eames and Charles Eames with their work, ca. 1958.

York.[41] In 1955 Knoll introduced her Parallel Bar System, which included a lounge chair, sofa, settee, and occasional tables, supported by frames of intersecting metal supports (figs. 11-8 and 11-9).[42] Like all of her work, the line was distinguished by Bauhaus-influenced functionalism and rigid geometry, rigorous attention to detail, and careful articulation of component parts. Although Florence Knoll sold the company in 1959 and resigned as president soon afterwards, she remained a consultant and continued to contribute furniture designs until her retirement in 1965.[43]

Ray and Charles Eames have been called "the most influential American furniture designers of this century."[44] Ray Kaiser was born in Sacramento and moved to New York in 1931, where she studied with Hans Hofmann (from 1933 to 1939) and became a founding member of American Abstract Artists, a progressive group of artists with whom she exhibited her paintings and sculptures.[45] In 1940 she began classes at Cranbrook, where she met Charles Eames, an architect and designer who had come to the school in 1938 on a fellowship and been made an instructor of industrial design.[46] Ray's collaboration with Charles began almost immediately and only ended with his death in 1978; in their first project together she assisted Charles and Eero Saarinen with the submission of their entry for a MoMA-sponsored competition in 1940 for low-cost furniture (their bent plywood designs eventually won first prize in two categories).[47]

The Eameses married in 1941 and moved to Los Angeles, where they continued to work with molded compound-curved plywood, producing leg splints for the U.S. Navy, and prototypes for furniture and sculptures. A commercial breakthrough came in 1946, when MoMA featured their chairs, tables, screens, and storage units in an exhibition; that same year, the Herman Miller Furniture Company, initiating an enduring association with the Eameses, began to mass-produce several of the designs. Their molded plywood lounge chair, the "LCW," with its graceful curves and sense of floating planes, quickly became an icon of twentieth-century modernism as did other plywood items produced at this time.[48] Ensuing designs were equally innovative, from both an aesthetic and technological perspective. A series of chairs begun in 1948–50 pioneered the use of molded fiberglass and were ultimately produced in vast numbers and widely imitated (fig. 11-10). Other notable designs of the 1950s included wire-mesh chairs, a plywood-shell lounge and ottoman, and aluminum furniture. The Eameses' mass-pro-

Fig. II-12. Freda Diamond. "Classic Crystal" glasses, 1949. Manufactured by Libbey Glass Company, Toledo, Ohio. Soda lime glass. Philadelphia Museum of Art, Gift of Libbey Glass, Toledo (1982-151-001-005). *Checklist no. 95*

duced designs became ubiquitous in domestic settings as well as institutional and public spaces.

Although the central roles played by both of the Eameses in the development of their designs is now generally accepted, during their years together Charles was the "public face of the partnership," and the one who overwhelmingly received credit for the designs of the firm.[49] Design commentators frequently denied Ray the credit she was due (even when Charles himself emphasized that Ray was "equally responsible with me for everything"), partly because of contemporary gender bias around creativity and aesthetics (fig. II-II).[50]

While Florence Knoll and Ray Eames were more innovative as designers, Freda Diamond had a greater impact on the postwar American home. In 1954 *Life* stated that Diamond had "probably done more to get simple, well-styled furnishings into every room of the average U.S. home than any other designer," while the *New York Times* claimed that she "exerts more influence on the taste of the average home furnishings consumer than any other individual in the United States."[51] The daughter of a New York City costume designer, Diamond studied decorative design at the Women's Art School at Cooper Union and then worked for William Baumgarten, a top furniture store in New York, where her first assignment was to design a house for Barbara Hutton's dog.[52] Finding the atmosphere "'*too* rarified,'" and hoping "to do something *real*," she moved to the furnishings department of Stern Brothers department store, and six years later, in the late 1930s, she set up her own design consultancy.[53] Diamond described her entry to the profession as a struggle: "It was an uphill battle all the way The business was predominantly male at that time."[54]

In the late 1930s Diamond designed furniture in primarily traditional styles for Herman Miller.[55] Her most important professional affiliation, however, was with Libbey Glass. In 1942 she and Virginia Hamill were

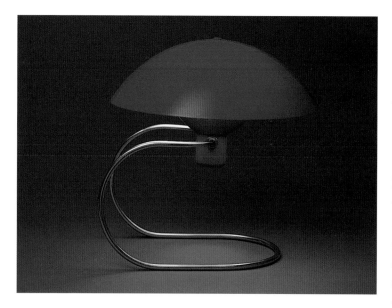

Fig. 11-13. Greta von Nessen. "Anywhere" lamp, 1951. Manufactured by Nessen Lamps, New York. Aluminum and enameled metal. Philadelphia Museum of Art, Gift of Nessen Lamps, Inc., New York. (1974-057-001).
Checklist no. 98

hired as consultants, and in an approach that was extremely innovative at the time, Diamond undertook a year-long nationwide survey to determine consumer preference in glassware. Conducting interviews in twenty-five cities, she determined the price level, style, and packaging methods that would appeal to the largest market.[56] Her first glass designs went into production after World War II, and before long her low-priced glasses, which ranged from cut crystal wineglasses to plain tumblers decorated with whimsical circus scenes, were selling in the millions.[57] She remained a consultant to Libbey until 1987. The success of her Libbey designs, and the use of her name and image in publicity and advertisements relating to them, rapidly established her as an internationally known arbiter of American taste. In 1945 she visited Italy under the auspices of Handicraft Development, a nonprofit organization set up by Italian Americans to help rehabilitate postwar Italy by supplying tools, equipment, and direction to Italian designers and craftsmen.[58] In 1957 she visited Japan as a technical advisor to the Japanese government, which hoped to adapt Japanese designs for the American market.[59]

Diamond never abandoned her faith in the ability of market research to determine consumer preference; as a result, her designs remained relatively conservative. She concluded early on that "period decoration has ingratiated itself into the mind of the public too deeply to be discarded lightly by designers," and so sought to combine "the best features . . . of the traditional and modern" in "liveable pieces" that she felt suited any home.[60] Although a few of her designs were sufficiently minimal to receive the stamp of approval of the pro-modernist Museum of Modern Art (such as her "Classic" shape of 1949, which was featured in the *Good Design* exhibition of 1950; fig. 11-12), most of her pieces were more decorative. Diamond consistently positioned herself, however, as a "crusader for good taste in low-priced accessories and furniture," creating designs that were an alternative to both gaudy inexpensive items and high-style designer goods.[61]

While other designers, such as Diamond, might include lamps among their various design projects, Swedish-born Greta von Nessen specialized in lighting alone.[62] A graduate of the School for Industrial Arts in Stockholm, she came to America with her designer husband, Walter, in 1925 and established Nessen Studio in New York in 1927 for the design and manufacture of modern lamps and lighting fixtures.[63] With Walter's death in 1943, von Nessen closed the studio until 1945, when she began to introduce lamps of her own design, including several that were featured in *Good Design* exhibitions at MoMA. Her most ingenious and versatile creation, the "Anywhere" lamp

(1952), could be hung, mounted on the wall, or used as a table lamp (fig. 11-13).[64]

Von Nessen's counterpart on the West Coast was Greta Magnusson Grossman, another Swedish immigrant, who had moved to California with her husband in 1941.[65] Grossman had studied industrial design in Stockholm, specializing in furniture, textiles, and metalwork, and had apprenticed for a year to a cabinetmaker before opening her own firm in Stockholm in 1933. From the beginning, she viewed her training in craft as central to her work as a designer; in 1951 she defended her technical skills: "The old idea that women are not good at mechanical work is stuff and nonsense. The only advantage a man has in furniture designing is his greater physical strength."[66]

After settling in Los Angeles, Grossman was hired as an interior design consultant by Barker Brothers' department store, a "wonderfully alive and progressive organization," which provided her with an opportunity to create her own custom-designed furniture and, by the late 1940s, mounted exhibitions of her furniture, textiles, and lighting.[67] Such exposure provided her with a national reputation, and contributed to the success of her own firm, which was headquartered in her Beverly Hills studio/home. By the early 1950s she was designing for mass production by various California manufacturers, creating lines of light, functional furniture, made of wood, metal, and plastic laminate. Her lamps, which relied on the reflection of light and often incorporated shallow domelike shades on flexible arms, were among her most successful designs.[68]

Fig. 11-14. Helen Dryden in front of a 1937 Studebaker, for which she designed the interior.

Despite the postwar prominence of a small number of women designers, there were still few women, in the industrial design field at mid-century. In the early 1950s, the Society of Industrial Designers (whose membership included such prominent designers as Donald Deskey, Henry Dreyfuss, and Russel Wright), had only one female member, Peggy Ann Rohde, who had continued the firm of her husband, Gilbert Rohde, after his death.[69] In 1964 the dearth of women prompted *I.D.*, the chief journal of the industrial design field, to inquire into the state of women in the profession: "What happens to girls who graduate from industrial design courses? They marry designers and withdraw from the profession says one designer; and although many of them do . . . many do not."[70] The article singled out Belle Kogan, Freda Diamond, and Florence Knoll as proof that women could make "outstanding designers," but speculated that, while men and women might have the same innate ability to design, "girls may not be encouraged to develop the technical skills and tenacity necessary to a successful design

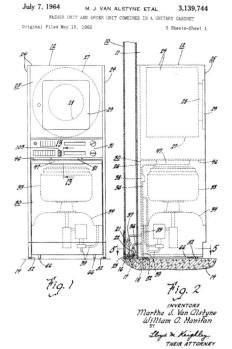

Fig. 11-15. Jayne Van Alstyne. "Washer Unit and Dryer Unit" patent drawing, filed May 15, 1962, issued July 7, 1964. United States Patent and Trademark Office, No. 3,139,744. *Checklist no. 114*

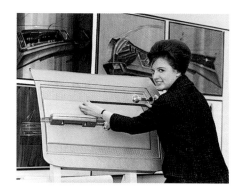

Fig. 11-16. Suzanne Vanderbilt with the door she designed for the 1963 Panther by General Motors.

career."[71] The article went on to note that women designers suffered the same discrimination as women in other fields, citing the report of the Commission on the Status of Women, which identified employers' fears that female employees would move in and out of the workplace more often than their male counterparts and create problems for male employees unaccustomed to a female supervisor. Despite such impediments, however, *I.D.* concluded that "more women are finding their way into design than ever before, and many believe firmly that this trend is right and good."

The same article cited Goertz Industrial Design, a firm employing no women designers, but who hoped that a woman designer's "distinctly feminine approach" would "bring a fresh look to the consumer products Goertz designs." Another design professional expressed disappointment that the work of women designers emerging from design schools was not noticeably "feminine" but rather had acquired a "masculine stamp." The persistent notion that women would bring a unique perspective to design was expressed by several midcentury women designers as well. Ellen Manderfield felt that women industrial designers benefited the "feminine consumer."[72] And both Freda Diamond and Belle Kogan obtained contracts by, in Kogan's words, "persuading manufacturers that a woman designer . . . knew what women wanted."[73] When companies did hire women designers largely for their "feminine" sensibilities, their work was simultaneously encouraged and circumscribed by a contemporary understanding of gender's influence on aesthetics.

During the 1940s and 1950s General Motors' vice-president of styling, Harley Earl, actively recruited women designers, although women had been involved in auto design earlier in the century. Helen Dryden, a graphic, set, and packaging designer, for example, designed the interior of the 1937 Studebaker (fig. 11-14).[74] Thanks to Earl's hiring initiatives, significant numbers of women designers entered the industry, and at GM they became known as the "Damsels of Design," often participating in company promotions, such as television appearances, photo opportunities, and public lectures. Earl described the women as "tuned specifically to the woman driver's problems . . . strong advocates of the six-way seat for greater comfort and visibility . . . always on the lookout for anything in cars that might snag their nylons."[75] Suzanne Vanderbilt, one of the "Damsels," later recalled her frustration: "We had terrific exposure—I'm sure for GM it was good exposure too . . . [but] what distressed most of us was that we could never be identified as just designers. We were always 'les femmes' or we were 'the female designers' . . . [even though] as designers we designed the same as the men did."[76]

A student of interior design at Pratt Institute during Alexander and Rowena Kostellow's tenure there, Vanderbilt was encouraged by Rowena Kostellow to work for GM, rather than pursue a traditional apprenticeship: "[she] did talk to about four of us, four women, and she really convinced us. She said why get caught up in a little town in Massachusetts, polishing some-

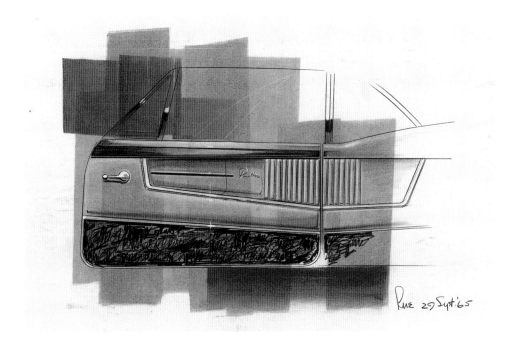

Fig. 11-17. Suzanne Vanderbilt. Sketch for interior door panel of the Panther show car, General Motors, 1965. Charcoal and crayon on paper. Cranbrook Archives, Bloomfield Hills, Michigan (1998-02). *Checklist no. 116*

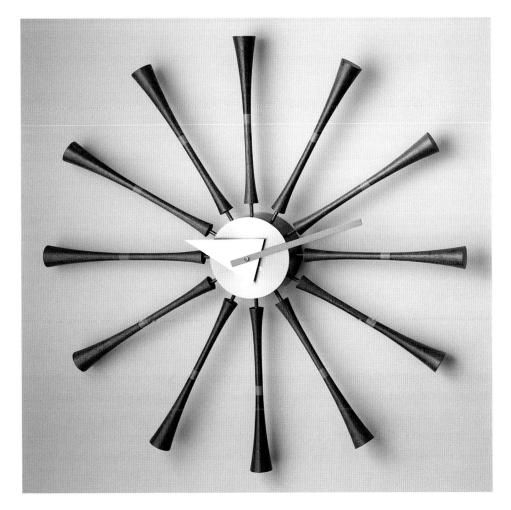

Fig. 11-18. Lucia DeRespinis. Wall clock, model no. 2239, 1957–58. Designed for George Nelson and Company, New York. Manufactured by Howard Miller Clock Company, Zeeland, Michigan. Wood, brass, and painted metal. Collection of Gansevoort Gallery, New York. *Checklist no. 107*

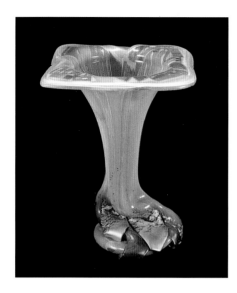

Fig. II-19. Frances Higgins. "Dropout" vase, 1967. Glass. Collection of Frances Stewart Higgins. *Checklist no. 121*

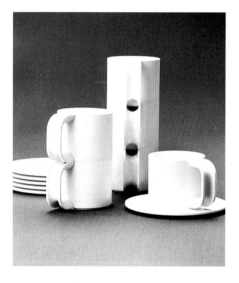

Fig. II-20. Lella Vignelli and Massimo Vignelli. Stacking mugs and dinnerware, 1964–76. Plastic.

one else's silverware and their design for many years until you are able to get onto the design end of something."[77] In 1955 Vanderbilt relocated to Michigan to work in the automotive interior design area of the GM Tech Center with fellow graduates Jan Krebbs and Ruth Glennie. The same year Jayne Van Alstyne, a 1945 Pratt graduate, also joined GM, where she worked on automotive, appliance, and kitchen design (fig. II-15).[78] Another Pratt graduate, Dagmar Arnold, joined them shortly after, also working on appliance and kitchen design.[79] Arnold later worked for IBM, from 1968 until her retirement in 1993, designing computer products such as keyboards and scanners.

Vanderbilt spent twenty-three years at GM, working in several automotive divisions, including Chevrolet, Cadillac, and the advance automotive studio (figs. II-16 and II-17). She also pursued an MFA in metalsmithing at Cranbrook in 1963–65, with the hope of working on automotive exteriors, but persistent gender bias kept her out of this area. Despite such setbacks, she rose through the company's ranks, ultimately being appointed chief designer of Chevrolet Interior II, supervising interior design of the smaller car lines, including Nova and Camaro. In the early 1970s, Vanderbilt also coordinated interiors for commercial vehicles, including semis and tractors. She recalled, "there were some resentments You just were again in a man's world. Now, here we are—we were bad enough in cars, now we're in trucks!"[80] Throughout her career, Vanderbilt tried to expand the range of automotive interior fabrics, frequently drawing inspiration from developments in other, more "feminine" industries.[81]

I.D., in their 1964 look at women designers, cited Lucia DeRespinis as an example of the new generation of women designers who countered stereotypes by remaining active in the field after marriage. Trained at Pratt (1950–52), where she had Eva Zeisel and Rowena Kostellow as instructors and was one of only three women students in the industrial design program (as opposed to sixty-five men), she first worked designing appliances, such as televisions, radios, and air conditioners. Like Belle Kogan earlier, DeRespinis encountered reactions of surprise to her sex: "I would always have to go to the factory . . . and because I was . . . probably the only woman that they'd practically ever seen that came in at this level—someone looked at me and said, 'I thought your name was Lucio or Lucien.' But I really got to understand how to work with groups of men."[82] From 1956 to 1963, she was a designer for George Nelson Associates, the only woman industrial designer in the office. There she worked on a wide variety of projects, from glassware and metalware to interiors, including the American display at the American National Exhibition in Moscow in 1959. DeRespinis's contributions to Nelson's line of modern clocks for the Howard Miller Clock Company were distinguished by their inventiveness and elegance (fig. II-18). From the 1960s through the 1980s, she worked on a freelance basis for a

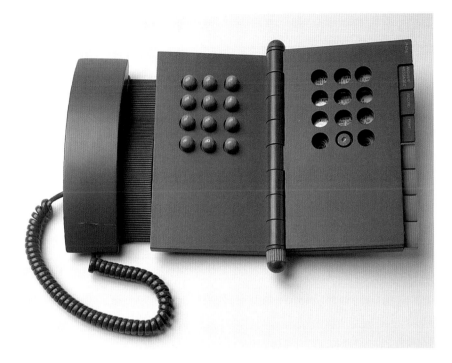

number of companies, designing china, interiors for fast food restaurants, trade shows, and packaging.

Elsie Crawford was born in New York City, where she attended the New York School of Fine and Applied Art (later Parsons School of Design) in the 1920s before moving into a career as an exhibit and window display designer.[83] In the late 1930s she and her future husband, architect Victor Gruenbaum, founded a firm in New York that focused on the design of store fronts and interiors; in 1941 they relocated to California where a burgeoning market was developing. Crawford moved into freelance product design in the 1950s and in 1962 attracted attention with a line of massive but movable sculptural planters for the beautification of urban areas such as malls and parking lots, which were followed by a series of award-winning combined seating units/planters in fiberglass.[84] Her large hanging "Zipper" lamps of 1965 combined a playful modern aesthetic with structural innovation, qualities typical of her work (see fig. 11-1A).[85] Crawford's "Zoo Collection" of wooden children's furniture/play equipment from the late 1960s and her line of knock-down furniture from the mid-1970s used small numbers of basic components to create a variety of combinations. "I think seeking out the most from the least has always been my biggest challenge and my most satisfying experience," she explained.[86]

Frances and Michael Higgins, a husband-wife team, were pioneers of both American studio glass and mass-production pieces. Frances attended the Georgia State College for Women and then taught art until she was awarded a Rockefeller Foundation Fellowship to the Chicago Institute of

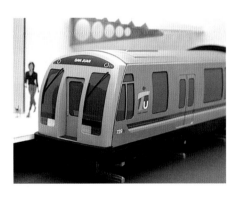

Fig. 11-23. Carole Bilson. "Ektascan" image link ultrasound imager, ca. 1992. Manufactured by Eastman Kodak, Rochester, New York. Collection of Eastman Kodak, Rochester, New York. *Checklist no. 180*

Design, where she met Michael Higgins who was head of visual design. Married in 1948, they left the Institute and began to experiment with glass techniques first developed by Frances in 1942.[87] As Higgins Handcrafted Glass, they produced a line of more than one hundred different trays, plates, bowls, and accessories in their Illinois studio, and by 1950 their creations were selling through major department stores (fig. 11-19). From 1957 to 1965, Dearborn Glass Company produced several of the Higgins' lines. For most of their joint career, they signed their work simply "higgins." "Frances and I work as a joint design-personality," explained Michael. "Our ideas have so blended that we can't always tell which pieces are hers and which are mine."[88]

Lella Valle (Vignelli) exhibited an early interest in design, encouraged by her architect father, with whom she attended an urban planning convention in 1951, where she met her future husband, Massimo Vignelli. She and Massimo studied architecture at the University of Venice, married, and opened their first design studio in Milan in 1960. They moved to the United States in 1965 and established Vignelli Associates in 1971, a consulting firm that has designed corporate identities, furniture, glassware, and showrooms for clients ranging from Bloomingdale's to American Airlines to the New York City Transit Authority, which runs the subway system. Their dramatic plastic tableware, best known as "Hellerware" (and previously marketed as "Compact" and "Max I"), was designed in white and a rainbow of colors and stacked cleverly for storage and presentation (fig. 11-20). Their partnership has evolved over forty years. The interchange of ideas has always been intense, but in the early years there was more of a competitive edge between them than there is now. As Lella explained, "It came late—it has been in the last ten to fif-

Fig. 11-24. Jill Shurtleff. "Sensor for Women" razor, 1993. Manufactured by the Gillette Company, Boston. Plastic, stainless steel, and aluminum. Collection of the Gillette Company, Boston. *Checklist no. 184*

teen years that we have really established a way of working easily with each other, in which we require each other's best qualities. We are complementary and we are lucky because we push in the same direction."[89] She also noted, "I have always been more involved with three-dimensional design . . . furniture, tableware, objects, and jewelry— product design without getting into mechanical things."

Lisa Krohn, who explored narrative design as part of Cranbrook Academy's graduate program in three-dimensional design in the 1980s, won wide acclaim with her first project, a

telephone with answering machine (fig. 11-21). Krohn describes the telephone as "in some ways one of the most conservative things I've ever done—it was trafficking in the tradition of product design as it had developed through the rationalism of the 1970s, with metaphorical reference to a book."[90] Krohn's approach to design involves two dominant concepts: "prosthesis" and "icon," both of which address form and function.

During the 1970s, women continued to shape

Fig. 11-25. Judith Reichel Riley, designer, with Kristi Karpawich, project leader, and Susie Watson. "Timex Rush VO²" watch, 1998. Manufactured by Timex Corporation, Middlebury, Connecticut. Painted injection-molded polycarbonate case, polyurethane strap, and internal timing mechanism). Collection of Timex Corporation, Middlebury, Connecticut. *Checklist no. 209*

the design field from within evolving corporate design structures. An industrial design consultant at Sears Roebuck from 1977 to 1988, Nancy Perkins appreciated the benefits of working in a large-scale retail environment: "You see the entire process, from the manufacture to the selling floor. Often we would observe focus groups from behind the glass to hear feedback on our designs. I developed a deeper understanding of consumer preferences and behavior."[91] While at Sears, Perkins designed a wide variety of products, from lawn sprinklers to automotive batteries. Her work cut across traditional gender divides: "At the same time that I was designing automotive testing equipment, I was designing vacuum cleaners. The whole question of gender came into play—timing lights weren't something I was familiar with, but a vacuum cleaner was something many people would assume I was used to."[92] Now a principal in a California design firm, Perkins and Gard, Perkins maintains diversity in the projects she takes on, which range from housewares to air-conditioning and heating equipment to transportation design (fig. 11-22).

The field of industrial design demonstrates an appalling lack of ethnic diversity. In 1963, in response to the racist bombing of a Baptist church in Birmingham, Alabama, *I.D.* magazine posed the question, "Is Industrial Design Color Blind?"[93] Only one African American woman was discussed, Brooklyn-born Madeline Ward, then a student at Parsons School of Design, New York. Ironically, the authors concluded there were too few African American designers in the field to evaluate whether or not employers maintained discriminatory practices.

Carole Bilson, an African American designer for the Eastman Kodak Company with twenty years of experience in the industry, remembered meeting only a handful of minority women designers.[94] A University of Michigan

Fig. 11-26. Ayse Birsel. Resolve Delta Work Station prototype, photographed in the Herman Miller booth at NeoCon, Chicago, 1999.

graduate with majors in industrial and graphic design, Bilson demonstrated an interest in design from a young age. As a child she knew a local carpenter and "used to love to draw and design things and take them to him and ask him to make them for me." Since joining Eastman Kodak in 1980 she has designed a wide range of products, including copier products, consumer products, medical products, and health-imaging devices (fig. 11-23). As a program manager of eight camera lines with revenues of $120 million and as holder of several patents, Bilson is committed to fostering opportunities for junior staff: "I mentor women, men, groups of diverse people. Because I remember when I was young, first out of college, I had a lot of questions and I didn't have anyone I could ask." Bilson's participation in the founding of two of the first employee networks at Kodak—Network North Star for African American employees and the Women's Forum of Eastman Kodak employees—reflects her multifaceted identity as an African American woman designer. "I think that whenever you are the first or the only one, you're noticeable," she stated. "You can't help but stand out. That can be an opportunity or a detriment. It's an opportunity in that it's a chance to get noticed, if you do a good job, but the flipside is that there's a lot of pressure on you to always be at your best. Lurking in the back of my mind I realize that like it or not, I'm a role model. I'm paving the road for others who follow."[95]

In the 1980s and 1990s, even though more women designers moved into corporate America, many still faced a male-dominated arena. Jill Shurtleff, a designer with Gillette since 1984, recalled: "When I first came to Gillette, never mind being the only woman designer, I was the only female professional on my floor for years—and that included designers, engineers, and business people."[96] A specialist in personal care products, Shurtleff has redesigned several razor lines for Gillette, including Trac II, Agility, and most importantly, the "Sensor for Women," which debuted in 1992 (fig. 11-24). Seeking a razor form that addressed women's shaving needs, Shurtleff developed a flat, wide handle for the Sensor model that allowed one's fingers to change positions during use. The striking design, which has accounted for an estimated $1.5 billion in sales for Gillette, has also attracted many women who previously purchased disposable razors, making it environmentally friendly as well.[97] The Sensor for Women recently won a prestigious Gold Design of the Decade Award, and at the awards ceremony, Shurtleff was "struck by how few women stood on stage to accept awards. Out of the thirty-six awards, maybe three went to women; and I was the only woman who spoke."[98]

Although the women's sports gear market has been thriving since the fitness-conscious 1980s, the Timex Rush line of sports watches by industrial

designer Judy Reichel Riley was the first to be designed both inside and out with the female consumer in mind (fig. 11-25).[99] In order to address the specific needs of women sports enthusiasts and athletes, Timex formed a unique project development team that included Riley and two members of the marketing staff, Kirsti Karpawich (the project leader) and Susie Watson (a former triathlete). Drawing on the input of focus groups comprised of potential female consumers, the team avoided scaling down the typical men's sports watch, with its myriad functions, and focused on those that most women actually used. Ultimately, two watches were produced, the streamlined Timex Rush geared to the fitness enthusiast, and the more complex Timex Rush VO2 for the competitive athlete or team sport participant.

Ayse Birsel's most recent project, the Resolve system for Herman Miller, has captured the attention of the industry and the media (fig. 11-26).[100] Herman Miller wanted an elegant, contemporary office system that would cost less than Bob Propst's iconic Action Office II cubicle system, which debuted in 1968. Seeking to improve the flow of air, light, and data communication through the workplace, Birsel developed a pole and panel system designed for optimum flexibility. Birsel counters stereotypical visions of women's roles in her native Turkey, suggesting that it is women in the American business world who have a long road ahead: "I have found many more female CEOs running industrial companies in Turkey than I have encountered elsewhere."[101]

Throughout the twentieth century, women remained a small minority of industrial designers in the United States. Despite their number, however, they had a considerable impact on design, creating many of the products of everyday American life as well as designs that have become international classics. In the twenty-first century, their achievements are certain to increase as the percentage of women industrial designers climbs. Trends in recent decades indicate that the historical gender imbalance in the field is finally beginning to shift. While women represented only about one percent in 1974, this increased to seven percent in 1986, and jumped again to nineteen percent by 1999.[102] In addition the 1990s saw the formation of the Association of Women Industrial Designers (AWID), which was established with the goal of "facilitating access to design talent, networking and social interaction" for its members, as well as "enriching the growing public awareness of women industrial designers—past, present and on the horizon."[103] "There is much to be said for the industrial design profession," wrote Ellen Manderfield, looking back on her long career in 1978, "and there is room for the feminine touch— with a sincere approach and the right attitude, one can go far."[104] The women who today follow in the footsteps of Manderfield and her colleagues inherit a remarkable legacy from these trailblazing predecessors.

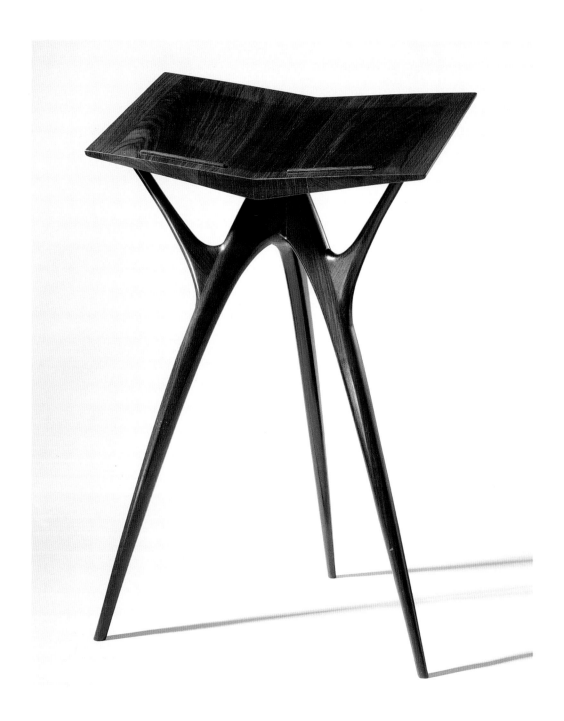

Fig. 12-A. Joyce Anderson and Edgar
Anderson. Dictionary stand,
1960–61. Rosewood. Collection of
Dr. and Mrs. Michael Langan.
Checklist no. 112

12

EDWARD S. COOKE JR.

Women Furniture Makers

FROM DECORATIVE

DESIGNERS

TO STUDIO MAKERS

WHILE A NUMBER OF DIFFERENT TYPES OF CREATIVE PRODUCTION are closely associated with women or considered women's domain—such as embroidery, textiles, or decoration of pottery—furniture making is not one of them. From the apprenticeship system of the eighteenth century through the recent flourishing of studio and hobbyist designer-makers, furniture has retained a male identity. Current popular images such as Norm Abrams on the popular public television series *The New Yankee Workshop* reinforce the wood shop as a male domain. Yet is this identity deserved? Have there been women who have designed and made furniture? What have been their contributions? This essay identifies and recovers the careers of several women furniture-makers of the twentieth century and employs those case studies to address the social, economic, and ideological factors that affected women furniture-makers. Identification of the designers and makers is only a first step; it is also essential to probe why opportunities were denied, circumscribed, or provided.[1]

During the late nineteenth and early twentieth centuries, proponents and practitioners of the Arts and Crafts movement strove to break down the barriers between fine and decorative arts and abolish the hierarchies of media, making ceramics equal to painting or furniture equal to sculpture. Such reformers believed that artistic expression should be an integral part of everyday life and focused their attention on domestic objects. During this period of artistic and design reform, some women found opportunities in the production of art objects. Professional women (especially teachers and

artists) and women of means became active in Arts and Crafts organizations and exhibitions; while working and middle-class girls enrolled in the manual training schools and design colleges that had been established in the last quarter of the nineteenth century. The period thus seemed to promise great opportunity for women to enter furniture making and design, a field formerly dominated by men.[2]

While many American studies have extolled the new opportunities for women during this period and praised their contributions as worthy, most of these studies have focused on social reformers and women philanthropists rather than designers and makers. Drawing on period advertisements and literature and on surviving objects (which tend to highlight male contributions), scholars have identified many more male producers and have often simply plugged the women's story into a male-centered paradigm that assumes equal opportunity for both genders and focuses on a formal stylistic assessment of the work. British scholars such as Anthea Callen, however, have demonstrated how some women's roles appeared more open but, in fact, remained quite restricted. Callen, Lynne Walker, and others have detailed the unevenness of opportunities for women across class and media and have documented the continuing restrictions on women in a society where gender was a major determinant in social stratification.[3]

Essential to understanding the context of women's work within the American Arts and Crafts movement are developments in design education and the period concept of design. In the late nineteenth century, many museum schools and normal art schools, which train high-school graduates to be art teachers, began to offer courses in decorative design. In Boston, the Museum of Fine Arts's School of Drawing and Painting established such a program in 1885; its mission

> was to give the student careful grounding in the principles and methods that lie at the bottom of all good design; a sense of decorative fitness, and the good qualities of design in every form; a broad, general acquaintance with the best that has been done in various styles, and especially, a feeling for harmony and purity in design—qualities to which the decoration of to-day pays too little heed. This was to be done in a way that should lay a fit foundation for any special decorative work to which the student might afterwards turn, and make his power independent of the decorative fashions of the day.[4]

Such language makes it clear that design and decoration were inextricably linked and that a well-designed object featured appropriate decoration. Although usually taught by male architects, such as C. Howard Walker in Boston and Louis Millet at the School of the Art Institute of Chicago, courses in decorative design had a predominantly feminine identity: most of the students in these programs were well-to-do women who sought artistic fulfill-

ment or middle-class women who intended to work as professional designers before they married.[5]

The link between design and decoration continued even in the realm of manual training and industrial arts. In 1916 William Varnum, a graduate of the Massachusetts Normal Art School (the foremost program in manual arts) and professor of manual arts at the University of Wisconsin, wrote one of the clearest volumes on the practice of design—*Industrial Arts Design, A Textbook of Practical Methods for Students, Teachers, and Craftsmen*. In it he distinguished between three different types of design: structural design, contour enrichment, and surface enrichment. Women of the period tended to participate in the third realm. While some high-school girls in manual arts classes studied cabinetmaking techniques to produce *Craftsman*-style furniture according to provided plans (fig. 12-1), the extent of most women's participation in furniture making at this time was restricted to painting and carving, primarily because the educational opportunities for women emphasized the supposedly female predilection for floral ornament and because of the interest in surface enrichment as a means of adding explicit artistic meaning to objects. Central to the economies of such production was the fact that women's lower wages or amateur status made decorative-intensive work more affordable. Given the number of women who enrolled in woodworking at school or who participated in the Arts and Crafts societies as "decorators and designers," however, it is surprising how few are presently known and how little of their work has been documented.[6]

Gendered social conventions circumscribed the promise of Arts and Crafts rhetoric and rendered many of the women involved in furniture design invisible. Many with informal or formal education in painting focused on painted decoration for furniture. Annie Nowell, a single woman who lived with her mother and sister in the Boston suburb of Winchester and maintained a studio at the Grundmann Studios in Boston's Copley Hall, exhibited her oil portraits and still lifes in several area exhibitions

in the 1880s and 1890s, provided decorative motifs for *Modern Art*, worked for Louis Prang Chromolithographers, and belonged to the Society of Arts and Crafts. She was listed as a "designer and decorator of wood," but her main skill was as a decorative painter of floral motifs for desk accessories (fig. 12-2), tables, and cabinet doors. Because she did not marry, Nowell had a certain freedom to pursue several artistic ventures and establish a long career, but her furniture design was limited to the painting of floral imagery on furniture or architectural "blanks."[7]

Fig. 12-1. Furniture made by girls in manual training at Inglewood Union High School in California. From *Industrial-Arts Magazine* 1, no. 4 (April 1914): 159.

Fig. 12-2. Annie Nowell. Letter box and picture frame, 1895–1905. Mahogany, painted decoration. JMW Gallery, Boston.

Fig. 12-3. Lucia Mathews and
the Furniture Shop. Folding
screen, 1910–15. Framed ply-
wood panels with painted dec-
oration. Oakland Museum of
California.

In San Francisco, Lucia Kleinhans studied painting at the Mark
Hopkins Institute of Art, where Arthur Mathews was the director and a fac-
ulty member. Kleinhans married Mathews, and together they founded the
Furniture Shop in 1906. The division of tasks followed conventionally gen-
dered lines: Arthur undertook most of the structural and contour design, to
borrow Varnum's terms, while Lucia specialized in choosing colors, painting
floral or landscape imagery on the furniture (fig. 12-3), and supervising
carving. For Lucia Mathews, education and marriage allowed her to maintain
an identity as a designer who supplied decoration for objects designed by her
husband and made by male craftsmen working in their shop.[8] The restriction
of women's craft activity to surface decoration and the narrow range of motifs
reveal the gendered biases of the period.

For other women marriage meant the end of the public dimension of
their design work. Molly Coolidge, who had studied sculpture and decorative
design at the School of the Museum of Fine Arts, Boston, exhibited her

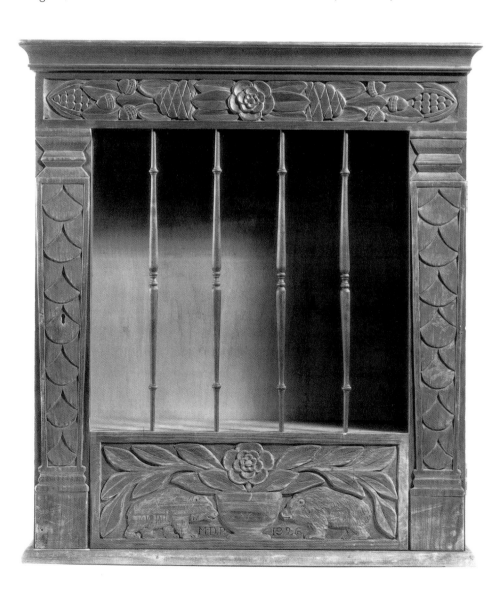

Fig. 12-4. Molly Coolidge
Perkins. Hanging "Bear" cab-
inet, 1926. White pine.
Private collection.

carved and polychromed wooden objects in the first two
exhibitions of the Society of Arts and Crafts (1897 and
1899) and was recognized as a master craftsman.
However, after her marriage to John Perkins in 1905,
she focused on carving objects for their house in Milton
and for members of her own family (fig. 12-4). She thus
eschewed the public stage of production for the private
familial one. Throughout both stages of her career, how-
ever, she contracted with local carpenters and wood-
workers to construct the objects which she then embell-
ished.[9] Margery Wheelock, a student at the California
College of Arts and Crafts whose carved work was shown
in the 1915 Panama-Pacific International Exposition
(fig. 12-5), also specialized in carving carcasses designed
and made by male craftsmen. After graduation from col-
lege, her furniture career came to a halt with marriage.
Wheelock became the bookkeeper for her husband, the
metalworker Harry St. John Dixon.[10]

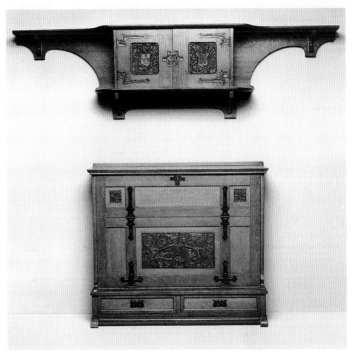

Fig. 12-5. Margery Wheelock.
Print chest and wall cabinet,
1915. Oak, carved and rubbed
with pigment, copper.
Oakland Museum of
California.

The link between women and decorative design
came under attack in the 1910s as modernists questioned the moral value of
decorative embellishment. Male architects such as the Austrian Adolf Loos
and critics such as the German Karl Scheffler argued that ornament was a
crime, indirectly indicting the female contribution as a primitive, debased,
and merely commercial activity.[11] Male writers of this period extolled the
virtues of masculine abstract design as heroic, serious, rational, and pur-
poseful, while dismissing the feminine decorative impulse as mawkish, frivo-
lous, and corrupt. Such an attitude empowered the new male professional
architect-engineer and undercut the traditional female temporary or avoca-
tional decorator. During the 1920s and 1930s the rise of the new profession
of industrial design—characterized by a firm in which a principal studied
social and economic needs, developed programmatical concepts, and coor-
dinated a team of specialists to stylize, make, and market those products—sig-
naled a new conception of design as a scientific planning exercise. Most
architects and industrial designers who developed concepts for furniture
were men who simply provided drawings for producers and therefore
involved themselves very little with the actual furniture making process.[12]

A few women such as Ilonka Karasz, Bertha Schaefer, Virginia
Connor, Florence Knoll, and Ray Eames designed furniture in the interwar
years, but they tended to work within the dominant male power structure.
Karasz designed many textiles and graphics, but relatively few pieces of fur-
niture such as convertible nursery furniture. Schaefer and Connor began as
interior designers, an acceptable women's pursuit because it implied taste
and decoration more than serious planning, and then developed lines of

Fig. 12-6. Molly Gregory. Modular stools or tables, 1941–46. Photographed at Black Mountain College, North Carolina, 1940s.

furniture that were made by large manufacturers. Florence Knoll, who trained as an architect, conducted her furniture design activities under the auspices of the Knoll Planning Unit. Like the male architects and industrial designers, these four focused on drawing, having little personal interest in making and finishing their designs.[13]

Ray Eames was an exception to the gendered rule. Trained as a sculptor and painter, she was very hands-on in the development and prototyping of furniture, which was then produced by large-scale manufacturers. Ray and her husband, Charles, who was trained as an architect, sought to design affordable furniture made of new modern materials with industrial techniques. While Ray was interested in process and participated in making, her goals differed from the designer-craftsman who did everything from design to sales. In addition, her opportunities were circumscribed by her husband's reputation. Charles garnered the majority of the credit for the Eames design work during the 1940s and 1950s, and Ray's reputation remained subsumed within his "genius."[14]

Economic concerns about the costs of ornament also influenced arts education in the public schools in the 1930s, as the emphasis on personal taste and development gave way to the new interest in practical vocational education. Courses in the decorative design of domestic objects became anachronistic. New industrial curriculums focused on job training and became more gendered: courses in mechanical drawing, graphic design and printing, automobile repair, electrical engineering, and sheet metalworking were offered for men; home economics, for women. Educational leaders worked closely with industrial leaders to ensure a ready supply of mechanics with specific skills in the growing modern industries. This pedagogical reform, and the critical reaction against ornament, shifted the focus of design away from decoration and toward scientific planning and coordination, a switch that privileged male contributions and largely excluded women.[15]

In the post-World War II era, new social circumstances provided opportunities for some women to take up furniture making. Women as well as men responded skeptically to the materialistic culture associated with corporate capitalism and the growth of a white collar managerial class, and they sought more direct ways of earning a living. Encouraged by the release of pentup consumption and the promise of a buoyant economy, emboldened by women's work experience during the war, and enabled by the growth of hobbyist woodworking tools originally intended for the man's workshop, several women became designer-makers of furniture in the 1940s. As critics of the new corporate economy, they were determined to design and make their own furniture and sell these custom works directly to clients. They were gentle revolutionaries who sought a pastoral lifestyle and proudly used the term

"designer-craftsman" to describe their niche. The latter term signifies the importance attached to the concept that a single person should have a hand in all stages of the process, from designing the object to selling it.[16]

Among these pioneers were Molly Gregory and Joyce Anderson. After graduating in the first class from Bennington College in 1936, Gregory began to teach sculpture at the Cambridge School in Weston, Massachusetts. She had gained a basic understanding of woodworking while using tools and repairing things on her family's farm and had refined this knowledge by working with Alfred Hulst, the shop teacher at the school. In the fall of 1941 she took a position as an apprentice woodworking teacher, with Josef Albers at Black Mountain College in North Carolina, where she also ran the wood shop. From 1942 through the spring of 1947, she was a full-time faculty member there and developed furniture that was "constructivist and utilitarian"[17] but still based on good craftsmanship and traditional joinery (fig. 12-6).

After Black Mountain College, Gregory moved to Woodstock, Vermont, where David Bailey, a former Black Mountain student and headmaster of Woodstock Country School, hired her to run Woodstock Enterprises. Gregory oversaw a woodworking shop that produced custom furniture in a vaguely Scandinavian modern style, built limited runs of furniture for Hans Knoll and for Josef Albers, and milled out architectural woodwork. By 1953 Gregory was overseeing four different male housebuilding crews, but she grew tired of being a manager. She left Woodstock in 1954 and moved first to Lexington and then to Lincoln, Massachusetts, where she set up a small shop to make furniture for a local, personal clientele. She continued to take on male employees such as Bob Lloyd and Ted Dodd, making

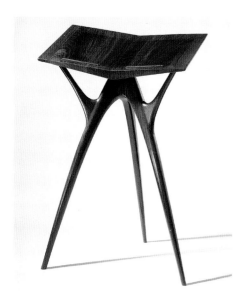

Fig. 12-8. Joyce Anderson
and Edgar Anderson.
Dictionary stand, 1960–61.
Rosewood. Collection of Dr.
and Mrs. Michael Langan.
Checklist no. 112

custom furniture in an original blend of Japanese, Shaker, and Scandinavian joinery, as well as architectural details and cabinetry (fig. 12-7). Throughout her life, Gregory pursued her dream as an independent maker, free from the influence of a "middleman": "I wanted to do every job myself, all of it, savoring the appropriateness or uniqueness of each assignment Each job had its own place, each a different rhythm and its own right way to be done that was quiet, considered, and somehow serene."[18]

Joyce Anderson turned away from an office job to make furniture with her husband Edgar. Drawn to custom furniture making since it "was a process for which we alone could be totally responsible" from idea to execution,[19] they set up a woodworking shop in 1948, using wood from their heavily forested fifteen-acre property in Morristown, New Jersey, and teaching themselves cabinetmaking skills as they went. At first Joyce focused on turning, but she eventually participated in all aspects of the work, from design, through construction, to finish. Much of their work was truly collaborative, but some designs, such as a dictionary stand, reveal the strong influence of Joyce's aesthetic, such as her interest in arching lines and modeled edges (fig. 12-8).[20]

The emergence of a craft culture as an alternative to modernist industrial production and impersonal corporate identity in the 1950s provided a new context for the activity of women as furniture-makers. As a single woman, Gregory forged ahead, taking advantage of the new open climate that permitted craft activity, while Anderson took a slightly more traditional route, teaming with her husband, but as an equal partner, to practice furniture making and build a small business. The crafts thus became a place where women could make a mark.

The individual commitment of a few women in the 1940s and 1950s resulted in a rather decentralized small group of women designer-makers of furniture. Nevertheless, developments in the broader world of small-shop custom furniture in the third quarter of the twentieth century, particularly the professionalization of the field of studio furniture making in the 1970s, exerted considerable impact on women's opportunities. Of particular importance was the proliferation of art and design schools offering programs in furniture making and design. In the 1950s only the Rochester Institute of Technology's School for American Craftsmen (RIT) offered a furniture program and its emphasis was originally oriented toward the training of foremen designers for industry. Beginning in the 1960s other schools such as the Rhode Island School of Design (RISD) and the Philadelphia College of Art began furniture programs that focused on the training of studio makers and the integration of conceptual ideas and technical skills in the production of one-of-a-kind furniture. The expansion of the number and orientation of furniture programs increased the gross number of academic furniture makers and validated more personal and varied expression in furniture forms. The number of self-taught makers also grew, due to newly published books

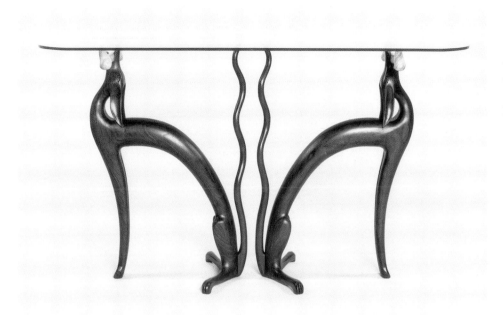

Fig. 12-9. Judy McKie. "Glass-top Table with Dogs No. 2," 1984. Walnut, ash, and glass. Fuller Museum of Art, Brockton, Massachusetts, Commissioned with funds provided by the Massachusetts Council on the Arts and Humanities New Works Program. *Checklist no. 157*

and periodicals that provided a greater range of technical information and images of current work. The debut of *Fine Woodworking*, a journal devoted to high-quality tools and materials, in 1975 documented a new design sense in the 1970s, one based on a fetishism of technique and exotic woods. This world of refined workmanship was largely male.[21]

The new availability of academic credentials also attracted a number of women who recognized the educational system as a way to break into the male field. Several programs, such as that at California State University at Northridge in the 1970s, became particularly well-known for encouraging women. As the field of studio furniture grew and matured in the 1980s, women found new opportunities for artistic expression and several emerged as leaders who have influenced the entire field. Judy McKie, who studied painting at RISD in the 1960s, joined a cooperative furniture shop called New Hamburger Cabinetworks, where Ted Dodd, a former employee of Gregory, owned the bulk of the machinery, taught cabinetmaking to the other members, and served as resident technician. Initially designing and making straightforward, spare furniture while she learned woodworking, she began in 1978 to explore forms and techniques outside the usual furniture repertory. Instead of decorating or embellishing a familiar table form with legs, McKie built sculptural supports for a table top and substituted a glass top for a wooden table surface in order to permit easy viewing of the supports (fig. 12-9). McKie has continued to explore the use of fanciful creatures and figural elements in her furniture, even making models that were then cast in bronze (fig. 12-10). Her carved work has inspired many other makers to use carved figural elements, explore the possibilities of cast versions, incorporate color, and use various materials to realize their ideas. Rather than showcasing applied decoration as an end unto itself, her work springs more from an

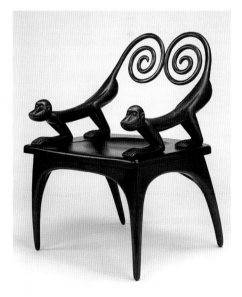

Fig. 12-10. Judy McKie. "Monkey" chair, 1994. Walnut, cast bronze. Private collection.

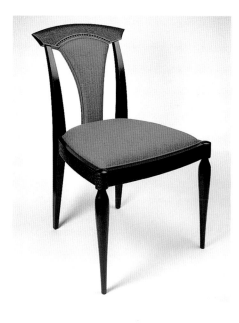

Fig. 12-11. Kristina Madsen. Dining Chair, 1993. Blackened imbuya, silk, and metal. Smithsonian Institution, Washington, D.C. The Renwick Gallery of the National Museum of American Art. Gift of James Renwick Alliance (1998.82). *Checklist no. 182*

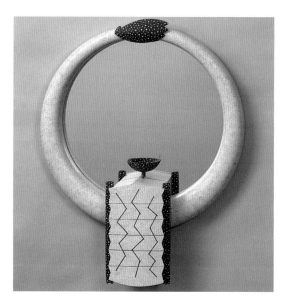

Fig. 12-12. Rosanne Somerson. "Earring" cabinet, 1989. Yellow poplar, maple, padauk, birch plywood, paint, and handmade paper. Yale University Art Gallery (1989.661.1). *Checklist no. 169*

artistic process in which she conceives the idea, figures out how to solve the technical issues, builds the actual object (oftentimes adjusting her ideas as she proceeds), and integrates the decoration as she builds.[22]

Another woman who learned woodworking in a nonacademic manner is Kristina Madsen. In 1975 Madsen began to study woodworking through private lessons with David Powell, a British cabinetmaker, who had apprenticed with Edward Barnsley and emphasized hand tools and traditional techniques. In 1977, when Powell opened up the Leeds Design Workshop in Easthampton, Massachusetts, an alternative to academic training programs at colleges and universities, she enrolled. After two years there, she taught part-time in the program while working in a cooperative shop. Her woodworking education was thus a combination of private lessons, workshop education, and informal sharing with colleagues.

Beginning in 1984 Madsen began an exploration of surface decoration and carving inspired by the geometric patterns of Maori and Fijian artifacts. Her cultural immersion in those design traditions, made possible through two Fulbright grants and close study of the traditional carver's free workmanship, has enabled her to recompose these principles on furniture forms for a modern Western audience (fig. 12-11). Not content merely to replicate South Pacific carving, she has used routed panels to update the free workmanship of the regional style, incorporated dark veneers over lighter cores to provide color contrasts, and developed her own series of patterns that combine geometry and natural imagery. The high standards of her craftsmanship and her strong sense of composition, in which form and carving patterns are carefully integrated, have inspired a number of craftsmen to explore the graphic possibilities of furniture surfaces in the 1990s.[23]

While McKie and Madsen developed their woodworking skills in nonacademic settings, other contemporary designer-makers have entered the field through academic channels and continue to shape the field through their teaching as well as their work. Rosanne Somerson attended RISD in the 1970s with the intention of majoring in photography but switched to industrial design, the undergraduate program that offered furniture making. She was drawn to the combination of problem solving and aesthetics offered in furniture. After graduation in 1976, Somerson taught woodworking to various age groups, from school children to adults, wrote for and edited *Fine Woodworking,* and continued to draw ideas for furniture before turning to full-time furniture making in 1979. Initially making big and technically impressive pieces to prove she could make significant objects comparable to those made by men, she turned in the mid-1980s to explore smaller and lighter forms, combining natural with painted wood and incorporating more playful and expressive detailing. As she explained, "I hope to draw the viewer in

first with a pleasing overall form and a hint of mystery which will then attract the viewer to a closer relationship with the piece. I try to succeed in holding interest by layering the work with levels of detail."[24]

Her "Earring" cabinet illustrates this new direction (fig. 12-12). Shaped like an earring, it has a self-evident, gendered function, but incorporates certain surprises and mysteries, such as the way the half-cup above the drawers appears as a full cup in the mirrored reflection and the use of handmade paper lining the interiors of the drawers. Somerson's ability to design, make, and decorate a delicate "feminine" object that evokes an intimate response and suggests the rituals associated with jewelry and domestic culture underscores the importance of woman's contributions to studio furniture. Somerson has also brought her broad understanding of the personal and evocative power of furniture to her teaching position at RISD, where she has headed the graduate program in furniture design since 1984 and established an undergraduate department of furniture design in 1996. Under Somerson's leadership, RISD's furniture programs stress the relationships between art, design, and craftsmanship.[25]

Wendy Maruyama and Gail Fredell were the first women to earn master's degrees in woodworking and furniture design at RIT. Maruyama, who had begun studying furniture making with Larry Hunter at San Diego State University, was attracted to the expressiveness of wood but found she lacked the technical skills to realize her ideas. In order to gain a solid foundation in technique and the sculptural possibilities of well-built furniture, she studied at Virginia Commonwealth University and in Boston University's Program in Artisanry. Knowing that she wanted to teach and make things, she then enrolled in the master's program at RIT. The curriculum in the late 1970s stressed cabinetmaking skills as an end rather than a means to a variety of ends and emphasized technique-based design. Maruyama found herself frustrated by this conservative tone, which galvanized her developing ideas about expressive furniture. Since her graduation in 1980 she has continually challenged past perceptions of furniture in a variety of ways. Initially she experimented with paint and color. Then she blended elements of popular culture and historical design, often incorporating social commentary or humor, seen clearly in her "Mickey Mackintosh" chair that playfully pays homage not only to Mickey Mouse but also to the Scottish designers Charles Rennie Mackintosh and Margaret Mcdonald Mackintosh. She updated their signature tall-back chair form into a pop icon by capping it with mouse ears (fig. 12-13). In the late 1980s she relied on more organic shapes and textured painted surfaces to bring the natural world into the domestic realm.[26]

Maruyama's recent work has focused increasingly on personal narratives, endowing her cabinets with layers of access, from stolid exterior shapes with darker colors to small intricate interior spaces detailed with rich, passionate colors. In exploring her own femininity and the nature of personal

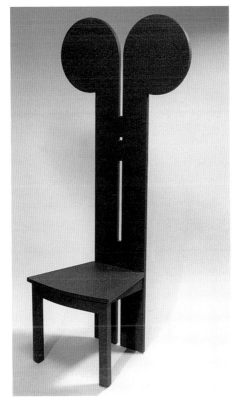

Fig. 12-13. Wendy Maruyama. Mickey Mackintosh chair, 1981. Painted maple. Collection of Wendy Maruyama. *Checklist no. 152*

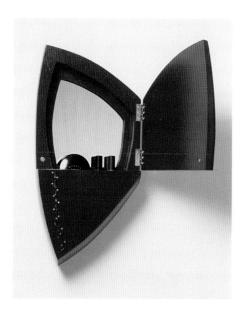

Fig. 12-14. Wendy Maruyama. "Shut Up and Kiss Me" cabinet, 1999. Polychromed jelutong, mixed media. Collection of Saul and Hilla Rosen.

relationships, Maruyama uses sculptural shapes, bright color, and texture to evoke feelings of love, lust, and jealousy. A recent cabinet reveals her feminist angle: shaped like the tip of a lipstick cylinder to announce its intended function, the door opens to reveal a mirror as well as shelf and drawers that are detailed in brighter color. Such an object celebrates women as makers and users (fig. 12-14). Throughout her work she has retained a balanced emphasis on form, color, and function, often embedding the latter in a colorful form that seems to hide function. Maruyama has exerted an influence not only through her work but also as a teacher, first at the California College of Arts and Crafts (CCAC) and then at San Diego State University.

Gail Fredell, Maruyama's classmate at RIT and co-chair of the woodworking and furniture design program at CCAC with Maruyama from 1985 to 1989, developed a different approach to furniture design and construction. Fredell majored in architecture as an undergraduate at the University of California, Berkeley, and worked in architectural construction and remodeling for a number of years before focusing upon furniture. To furniture she brought an architectural approach that emphasized simple structural compositions and contrasts between materials and surfaces. She was a pioneer in combining different media with wood, using them with a refinement consistent with her joinery skills. In the late 1980s she incorporated landscape narratives into her architectural forms, seen clearly in her "110 in the Shade" bench (fig. 12-15). Intended as an outdoor garden seat for one person, the bench features a granite base with roughly textured surfaces, spare ebonized mahogany tie beams with precise mitre joints, and a subtly patinated brass seat. Metaphorically the seat represents a cool lake nestled into a granite mountain setting suggested by the rough-faced granite. Fredell has thus blended consummate craftsmanship with mixed media to explore landscape through architectural sensibilities. This is her unique contribution to the new developing sense of a furniture-maker who combines rigorous design development, personal involvement in making, and high standards of workmanship to realize the power of the design. Like Somerson and Maruyama, Fredell has balanced her making with teaching. Since 1988 she has taught at Anderson Ranch Arts Center, a nonprofit arts organization in Aspen, Colorado, that houses artists-in-residence and offers summer programs. In 1994 she became the head of the woodworking program there, bringing in guest instructors for the two- to three-week courses in the summer and coordinating the residencies of makers during the remainder of the year.[27]

Developments of the second half of the twentieth century reveal that women have not only infiltrated the male domain of furniture making, but have also risen to become leaders in the field, producing some of the most influential objects and heading some of the most prominent training programs. There is not a single "women's" aesthetic at work in the field of furniture making, but there seems to be a common commitment to overturn the

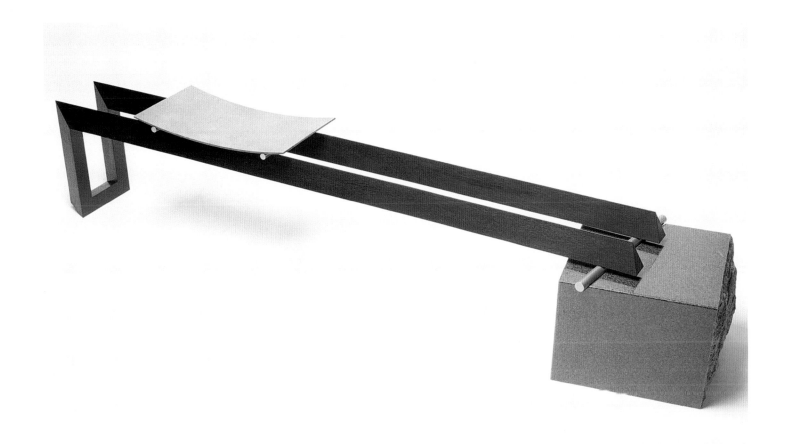

Fig. 12-15. Gail Fredell, "110 in the Shade" bench, 1987. Black granite, ebonized mahogany, lacquered metal, and brass. San Francisco Museum of Modern Art.

cold, impersonal design of high modernism and to restore the decorative as a form of personal expression. To accomplish this agenda, contemporary women studio makers combine design, workmanship, and personal expression. As teachers they demonstrate little interest in producing clones of themselves, but rather see their roles as facilitators who help each student recognize his or her own voice, learn the appropriate technical means to realize those ideas, and achieve fulfillment and success.

Although earlier in the twentieth century women were left on the margins of the dominant design culture, unable to share fully in contour design, executive design, and technical design, the women designer-makers of the 1980s and 1990s managed to radicalize the furniture field by parlaying their own marginalization into strength. Rather than take on the machismo of technical fetishism and showy woods common in the 1970s, the women turned their liability into a productive critique. They embraced the potential of paint, decoration, and personal narrative and have assumed leadership positions in the field.

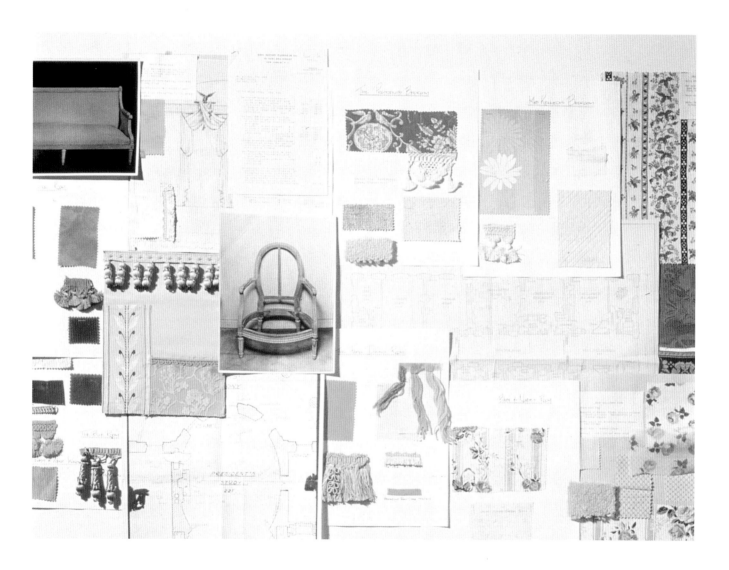

Fig. 13-A. Sister Parish. Scheme boards for the family living quarters in the White House, Washington, D.C., ca. 1961. Cooper-Hewitt, National Design Museum, Smithsonian Institution, New York, Parish-Hadley Collection.

13

"A Woman's Place. . ." ?

PAT KIRKHAM AND PENNY SPARKE

WOMEN INTERIOR

DESIGNERS

DURING THE TWENTIETH CENTURY a large number of women worked professionally as interior designers. There were also many thousands of "amateurs" (the mothers of the present authors included), who designed the interior spaces in which they and their families lived, but this essay focuses on women who worked professionally. The notion that "anyone" could design a living space, however, played its part in the marginalization of an area of design already often characterized as trivial—not least because of its association with the domestic. The term *interior decorator*, which itself replaced earlier terms such as *upholsterer* and *upholsterer-decorator*, was most often used in the early years of the century to describe what later came to be known as interior design.[1] The occupation remained the same, but the term *decorator* was later denigrated.[2]

Contrary to popular opinion, professional interior design was not dominated by women in the early twentieth century. At the turn of the century, decorating domestic and public interiors was a male domain, and the names Frank W. Richardson, H. F. Huber, Emile Baumgarten, and George Leland Hunter filled the advertising pages of interior design magazines.[3] Nevertheless, because women were considered to have a "natural bent for interior decoration,"[4] it was thought suitable for respectable women seeking occupation outside the home. In 1895 Candace Wheeler, who provided a role model for genteel women wanting to work creatively, published two articles entitled "Interior Decoration as a Profession for Women."[5] Although she had agreed that women had a predisposition to work intuitively in this area, she also advocated a formal education. Dubbed the "mother" of women decorators, she had many followers.[6] One, a Mrs. Davidge, "studied for more than ten years before she attempted to decorate a single house" and recommended "long preparation and the study of the history of furniture, architecture and design."[7] Mary Bookwalter Ackerman, an interior decorator who attended classes established by disciples of Wheeler and other "pioneers" and apprenticed to a restorer of antique furniture, argued for a six-year training.[8] She favored certification to ensure high standards but only after students spent their final year apprenticed with a reputable firm. In a series of articles on interior design in the *Craftsman*—the mouthpiece of the Arts and Crafts movement in the United States—she called for interior design to be set on a professional footing.[9]

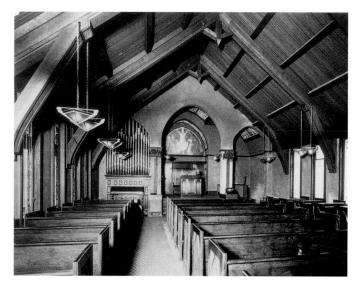

Fig. 13-1. Marion Mahony. Interior of the Church of All Souls, Evanston, Illinois, 1903.

Other women interior designers who were associated with the Arts and Crafts movement included Wheeler's daughter-in-law, Alice G. Dunham Wheeler, who enjoyed a successful career designing the interiors of houses designed by her architect husband.[10] Darcy Gaw and Mary Mower also worked in partnership with a male architect, in this case Lawrence Buck. Between 1901 and 1903 they designed interiors, electrical fixtures, and furnishings; the motto of their Chicago firm was "Houses made beautiful in an inexpensive way."[11]

After graduating with a degree in architecture from the Massachusetts Institute of Technology in 1894 (only the second woman to do so), Marion Mahony found work first with a male cousin, then with Frank Lloyd Wright in his Oak Park studio.[12] Until recently, many of her designs, including those for stained glass, were thought to be by Wright himself. For the Church of All Souls, Evanston, Illinois (1903; fig. 13-1), Mahony designed not only the building, but also the interior and fittings, including the ceiling lights (fig. 13-2) and mural on the chancel wall.[13]

Another recently "rediscovered" woman interior design "pioneer" is Mary Jane Colter. Trained in the 1890s at the California School of Design in San Francisco and an active member of the Artworkers Guild of St. Paul, Minnesota at the turn of the century, she epitomized the "new woman" of independent mind and adventurous spirit.[14] She was supporting her widowed mother and sister by teaching design when, in 1902, she gained her first commission—to decorate an "Indian" gift shop at the Alvarado Hotel in Albuquerque, one of the hotels opened by the Fred Harvey Company along the route of the Santa Fe Railway.[15] Colter eventually became "house architect" for

Fig. 13-2. Marion Mahony. Hanging lamp for the Church of All Souls, Evanston, Illinois, ca. 1903. Leaded stained glass. The Mitchell Wolfson Jr. Collection, The Wolfsonian–Florida International University, Miami Beach, Florida (84.13.13.1). *Checklist no. 5*

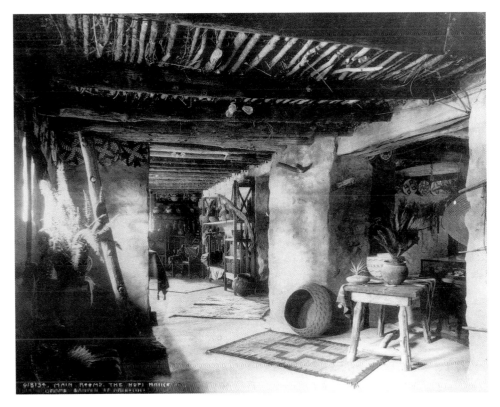

the company, designing hotels such as Hopi House at the Grand Canyon
(1905; fig. 13-3) and El Navajo in Gallup, New Mexico (1923), as well as inte-
riors and furnishings. In 1936 she designed the interiors of the Fred Harvey
Company dining cars for the Santa Fe Railroad's new Super Chief train. Her
designs covered every aspect of the interior, including silverware, flatware, and
crockery (fig. 13-4). The latter was based on ancient Mimbres pottery, some of
which had been recently excavated.[16] Her work, which reflected her passion for
Native American design traditions, shaped the experiences of generations of
tourists and gave material form to the Arts and Crafts' love affair with Native
American "primitive." Some rank Colter with her better-known contempo-
rary, Julia Morgan, the architect of William Randolph Hearst's San Simeon in
California (begun in 1919 and completed in 1937). Morgan's designs for that
project included not only magnificent interiors and garden terraces but also
individual tiles (figs. 13-5 and 13-6).[17]

 The other important development in the history of interior design to
affect the gender configuration of the profession centered on what were to be
termed "lady decorators"—women without formal training who mainly
designed historicist interiors for the homes of the social elite. Elsie de Wolfe
was the first of this new type of woman professional with no qualifications
beyond "flair" and "style." Inspired by Edith Wharton's influential book, *The
Decoration of Houses* (1897), de Wolfe abandoned acting for interior design. In
1905, at a time when the profession was dominated by men, this fashion-
conscious feminist was hired as interior designer for the Colony Club, New

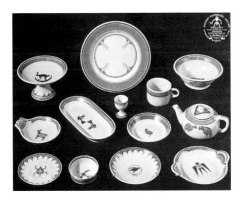

Fig. 13-4. Mary Jane Colter
with Guy Cowan. Tableware
for the Fred Harvey
Company's dining cars on the
Santa Fe Railroad's *Super Chief.*
Designed 1936; manufactured
by the Syracuse China
Company, 1936–70.

Fig. 13-5. Julia Morgan. The Roman Pool in La Casa Grande, William Randolph Hearst Estate, San Simeon, California, ca. 1927–32. Photographed in 1993.

York's first all-woman's club, designed by architect Stanford White (fig. 13-7).[18]

Her credentials for selection resided in her reputation as a "woman of taste," in the interiors of her own home, and her beliefs in "women's rights." It also helped that she was friends with the architect and with members of the managing committee of the club. The latter included Elizabeth Marbury, a literary and theatrical agent, with whom de Wolfe lived, and Anne Morgan, daughter of financier J. Pierpont Morgan.[19] The light and relatively uncluttered Colony Club interiors were widely and favorably reviewed, and articles outlining de Wolfe's approach to decorating appeared in key women's publications, including the *Delineator* and *Good Housekeeping*.[20] Many of de Wolfe's highly lucrative commissions in the next few years came from wealthy, fashion-conscious women, who stayed at the Colony Club when visiting New York.[21]

De Wolfe's fame and affluence reached new levels in 1913 when she was commissioned to design and furnish the private rooms of the new Frick mansion on Fifth Avenue in New York (fig. 13-8). She was paid a commission on everything she bought for the rooms, including antiques. De Wolfe's example encouraged other women to take up interior design.[22] Ruby Ross Wood was one of the few "working girls" to follow de Wolfe. A journalist, Wood was a ghostwriter for de Wolfe's *House in Good Taste* (1913). A year later, she published her own "how-to" book, *The Honest House*, and by 1918 headed "Au Quatrième,"

Fig. 13-6. Julia Morgan. Study for tiling to top of stair tower, William Randolph Hearst Estate, San Simeon, California, 1927. Graphite and colored pencil on tissue paper. The Mitchell Wolfson Jr. Collection, The Wolfsonian–Florida International University, Miami Beach, Florida, TD1997.17.1. *Checklist no. 38*

the interior design section of Wanamakers' New York store, which had been established by Nancy McClelland in 1913.[23] The interiors Wood created there and for her own firm increasingly favored American and English eighteenth-century furnishing styles and helped popularize the Colonial Revival in the United States.

Frances Elkins became the most famous woman decorator on the West Coast. The Milwaukee-born daughter of a wholesale men's garment manufacturer, Elkins may have had no formal training, but she was well versed in design and architecture before she opened shop in Monterey, California, in 1918. She learned a great deal from her brother, Chicago-based architect David Adler. She accompanied him to Paris when he was a student at the École des Beaux-Arts in the 1910s and later collaborated with him on several interior design commissions. Elkins, who became a friend of Coco Chanel and Syrie Maugham, became noted for domestic interiors that mixed "traditional" and "modern"—the finest European antiques with modern sculpture and "folk" ornaments. Dubbed the "first great California Decorator," she introduced lamps and sculptures by Diego and Alberto Giacometti and furniture by Jean-Michel Frank, to her more adventurous clients. Besides residences

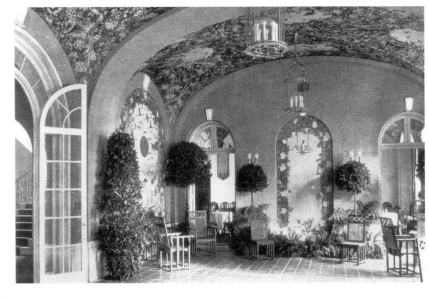

Fig. 13-7. Elsie de Wolfe. Loggia, the Colony Club, New York, ca. 1905–7.

Fig. 13-8. Elsie de Wolfe. Boudoir of Adelaide Howard Childs Frick, Frick Mansion, New York, 1913. Photographed in 1965. *Checklist no. 19*

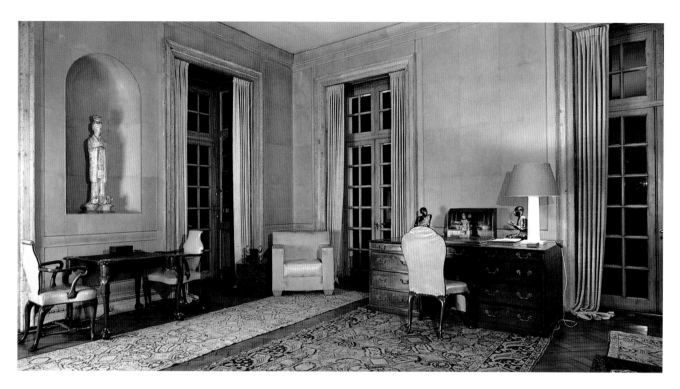

Fig. 13-9. Frances Elkins. Library in the Kersey Coates Reed residence, Lake Forest, Illinois, ca. 1931.

for wealthy clients such as Edward G. Robinson, the Marshall Fields, and others (fig. 13-9), she designed an "Italian Gallery," shown at the Golden Gate International Exposition, San Francisco, in 1939, and interiors for social clubs in the Monterey area.[24]

The extent to which interior design was seen as an occupation open to women with "flair" but no formal qualifications is indicated by Frank Crowninshield, editor of *Vanity Fair*, suggesting it to Rose Cumming when she arrived in New York from Australia in 1917.[25] Her training came "on the job"; she worked for Mary Buehl before opening her own shop in 1921. Cumming's flamboyant, colorful, eclectic, and sometimes exotic interiors (fig. 13-10)—"potpourris of many styles and periods"—were filled with objects invoking personal histories. Although adamantly opposed to modernism, Cumming designed interiors that were perceived as modern[26] and found favor with Hollywood stars, including Marlene Dietrich and Norma Shearer.[27]

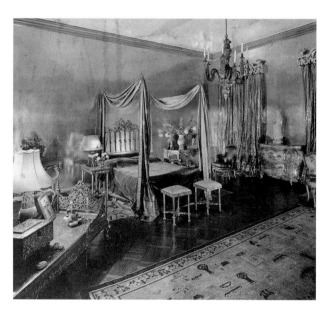

Fig. 13-10. Rose Cumming. Bedroom in her own residence, New York, 1946. Rose Cumming, Inc., New York.

Cumming believed that no amount of schooling could produce a designer—"Either you have a flair or you haven't."[28] Another designer who believed that design talents came "naturally" was former debutante Dorothy "Sister" Parish.[29] She began to work professionally when the family's high standard of living was threatened during the Depression and became one of the best-known interior designers in the country (fig. 13-11). In the 1960s her preeminence in the profession was acknowledged when she was invited to be part of the team that revamped the White House interiors during Jacqueline Kennedy's tenure (fig. 13-12).[30] Guided by "intuition" and a belief that the expression of "personal feelings and memories" was "the

essence of decorating,"[31] Parish became noted for an Americanized version of the "undecorated" chintz-filled English country-house interior, complete with patchwork quilts, painted floors, and rag rugs. This design approach remains influential today.[32]

Albert Hadley, Parish's partner from 1964, compared the informal organization of the Parish firm to the super professionalism of that run by college-trained Eleanor McMillen Brown, for whom he also worked.[33] Although McMillen Brown mainly designed "traditional" European-style interiors for wealthy clients, (figs. 13-13 and 13-14), she always insisted she "wasn't one of the 'ladies'."[34] She trained at the New York School of Fine and Applied Arts and, after graduation, sought to emphasize her professionalism by naming her firm (established in 1924) "McMillen, Inc." rather than "Eleanor McMillen." One of the few to offer an interior architecture service, the firm attracted public commissions in the 1930s for the interiors of the Cosmopolitan Club in New York (1933; fig. 13-15) and the redesign of the Steuben Glass showroom (1934).[35] In 1939 McMillen Brown was one of two women interior designers out of a total of thirteen working in the United States to be included in the decorative arts section of the Golden Gate Exposition, San Francisco.[36] In the following year the firm opened a Houston branch and by mid-century was acknowledged as one of the leading exponents of "traditional" interior design.

Fig. 13-11. Aaron Shickler. *Portrait of Sister Parish*, 1968. Oil on canvas. Cooper Hewitt, National Design Museum, Smithsonian Institution, New York, Parish-Hadley Collection.

Grace Fakes was the most senior of the many women employed. McMillen Brown's college tutor and an expert on historic woodwork and architectural and interior plans, Fakes headed the interior architecture section. Most of the other women employed were New York School of Fine and Applied Arts graduates. Ethel Clarke Smith, who joined the firm immediately after graduating in 1929, later testified to her employer's sympathetic attitudes toward her situation as a working widow with children in the late 1930s and 1940s.[37] Betty Sherrill, who joined immediately after graduating in 1951, heads the firm today.

Like other graduates of the interior design department of the New York School of Fine and Applied Arts, McMillen Brown was imbued with the professional ethos expounded there. The curriculum was based on the ideas of Frank Alvah Parsons, after whom the school was renamed in 1941. His *Interior Decoration: Its Principles and Practice* (1915), which claimed the house as "externalized man; himself expressed in colour, form, line and texture," posed itself against de Wolfe's *House in Good Taste* (1913), which viewed the house as a feminine space.[38]

Despite Parsons's "masculinization" of the occupation, women formed the first professional organization of interior designers. The Women Decorators' Club of New York, founded in 1914 with a policy of exhibiting members' work, restricted entry to those who had produced "something worthwhile."[39] Male decorators in the same city later formed the Society of

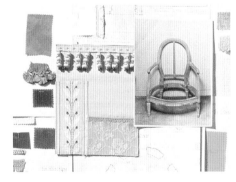

Fig. 13-12. Sister Parish. Scheme boards for the family living quarters in the White House, Washington, D.C., ca. 1961. Detail of Fig. 10-A.

Fig. 13-13. Maquette of drawing room design for The Honorable and Mrs. Sheldon Whitehouse, Newport, Rhode Island, 1933. Design by Eleanor McMillen; maquette by Grace Fakes.

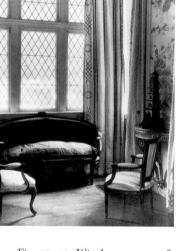

Fig. 13-14. Window corner of the drawing room, designed by Eleanor McMillen, for The Honorable and Mrs. Sheldon Whitehouse, Newport, Rhode Island, 1933.

Interior Decorators, but members of each society joined a new national organization, the American Institute of Decorators (AID), when it was founded in 1931.[40] In the wake of falling commissions after the Wall Street crash of 1929, AID sought to raise the status of the profession and contain competition. Its emphasis on qualifications worked to marginalize those women without them. The most active members were men from well-established firms, but women such as Florence Ely Hunn and Marian Gheen, members of the Women Interior Decorators Association of Chicago as well as AID, also championed putting their occupation on a professional footing. As Mary Ackerman, "dean of decorators," put it in the early 1930s: "The person who shapes your home through her work subtly influences your very conceptions of living and feeling. You have a right to demand the same training you require of your lawyer and architect."[41]

Nancy McClelland, who favored "period" styles and designed wallpapers as well as interiors (figs. 13-16 and 13-17), helped raise the status of the profession through radio broadcasts.[42] She and Florence Hunn sat on the first AID Advisory Board—with four men. Just under half of the non-board members who attended early meetings of the association were women[43]; that all but one were married indicates that interior design was considered an acceptable occupation for upper-middle-class women after as well as before marriage. Marion McClure was elected president of AID's Louisiana chapter in 1934, and Florence Weisskopf was elected to the same high position in the Wisconsin chapter the following year.[44] By 1941, however, a decade after inauguration, only three of AID's fourteen chapters had as often elected women presidents as men. It was not until 1951 that McClelland became the first woman national president of AID.

The denigration of the term *interior decorator* led to calls to substitute the more up-to-date *interior designer*.[45] It was claimed that associations with

decorating led to confusion with the work of painters and paper-hangers, but the main motivation was to halt the "inroads by unqualified persons, modistes, hat-makers etc." into the field.[46] The villainous "amateurs" were portrayed as the feminine "other"—as representatives of the transient and frivolous world of fashion. The "feminine" and domestic qualities that had led Wheeler and others to argue women's particular suitability to interior design at the beginning of the century were now ignored, as was women's experience as homemakers.

A 1935 editorial in *Interior Design and Decoration*, then a mouthpiece for AID, further attempted to associate women with the highly ideologically charged stamp of the "amateur." It specified three groups within the profession: one with academic and practical training, one with practical training only, and one with no training at all.[47] Decorators in general were referred to as both male and female, and those with practical training as male. Only novices without any training were referred to as female. Like was not compared with like. In a clever sleight-of-hand, the unqualified woman was compared to the experienced man, despite the fact that men without academic qualifications were inexperienced as well as unqualified when they first entered the occupation.

Fig. 13-15. Eleanor McMillen. Dining Room, the Cosmopolitan Club, New York, 1933.

The crime of hiring unqualified women described as "dilettante" and "daughters of wealthy men" escalated from encouraging "illegitimate and unethical competition" to "contributing to the general decline in the national standard of taste."[48] The gendered double standard drew attention away from the fact that many male AID members, including Founder-President William Moore, had no formal training. Few worried about it or about Billy Baldwin's lack of training. Ruby Ross Wood's famous protegé had dropped out of college and was untrained in design. His only "experience" was as an insurance salesman and a crime reporter.[49] Baldwin and other male decorators may have been considered effeminate by association with the feminized world of "lady decorators (fig. 13-19)," but they were never denigrated as were de Wolfe and Dorothy Draper.[50]

The most vilified female interior designers were those who most successfully competed in the "male" arena of public commissions and resisted modernist form—particularly Elsie de Wolfe and Dorothy Draper. A 1937 editorial in *Interior Design and Decoration* referred to de Wolfe as a symbol of all that was worst about decorators who worked for the rich in a period of "vacuous" and "stagnant" design.[51] Three years later, however, there was sufficient support within AID to honor her. As the emigré Lady Mendl, de Wolfe was feted as "the pioneer of the interior designing profession" to whom "everyone here owes a debt of gratitude for the inspiration she has given us."[52] A canny operator to the end, de Wolfe used the occasion to take a swipe at unqualified decorators.

Fig. 13-16. The work of
Nancy McClelland fea-
tured in *Life,* 3 October
1949, pp. 56–57.

Fig. 13-17. Nancy McClelland.
Wallpaper, ca. 1940–50.
Block-printed by Mauny,
Paris; distributed by Nancy
McClelland, New York. Paper.
Cooper-Hewitt, National
Design Museum, Smithsonian
Institution, New York, Gift of
the Museum at the Fashion
Institute of Technology
(1998-75-65). *Checklist no. 77*

Adopting the caricaturing tone of the many unwarranted attacks upon her for her lack of formal training, she noted "In my day . . . all one had to do to be a designer was purchase two or three yards of stuff, a chair or two, and then put out a sign that read, "'Mary Tomtom—Decorator'."[53]

Draper may have been a debutante without any certified education in interior design, who started her business with money from her parents, but even before her divorce in 1930, her many interior design skills were apparent. A media celebrity in the interwar years (by 1934 she had appeared on more American magazine covers than Eleanor Roosevelt), she became a champion of professional women.[54] Many of her major commissions allude to the Baroque and to Surrealism in their exhibitionism and exaggeration of scale: the Mark Hopkins Hotel, San Francisco (1935; fig. 13-18); the Coty showroom, New York (1941); the Fairmont Hotel, San Francisco (1945); The Greenbrier, Virginia (1946–48); and the cafeteria at The Metropolitan Museum of Art, New York (1954). She was at the peak of her career when, in 1952, Frank Lloyd Wright lambasted her in public in her presence at an AID event. Crude and cruel—even by his standards—he attacked "inferior dese-crators" in general and singled her out by name.[55] Lesser mortals might have been intimidated, but Draper's upbringing and her status in the trade gave her the confidence to stand up to him—literally rising to end his diatribe—on behalf of herself and, by extension, all women interior designers.

Although the notion of women as embodiers of domesticity brought new opportunities in design in the early years of the century, it also func-tioned to restrict them to domestic interiors. There were notable exceptions, however, besides de Wolfe and Draper. In the early 1900s Mrs. Davidge designed interiors for a number of men's clubs and for the Martha Washington Hotel, New York; Lewis and Much more designed interiors for

Fig. 13-19. Dorothy Draper. Lobby, the Mark Hopkins Hotel, San Francisco, 1935. *Checklist no. 57*

churches and the much-admired Connecticut Building at the Louisiana Purchase Exposition of 1904, and a Mrs. Brown-Sarre designed a business office for Frank Seaman.[56]

In 1929 Pipsan Swanson, designer-daughter of Loja and Eliel Saarinen, established an interior design department within the architectural office of her husband, Robert Swanson, and undertook office interiors as well as domestic ones.[57] The 1930s and 1940s were marked by increasing numbers of women working on public interiors. Mabel Schamberg, for example, designed interiors for the 1933 "Century of Progress" exposition and the Ladies Cocktail Room at the Drake Hotel, both in Chicago.[58] There were also Mary Ryan's showrooms at the Chicago Merchandise Mart (1935); Florence Hunn's interior for the Brach candy factory salesroom (1941); Jane Higbie's hospital bedrooms (1941); Anne Urquardt, Miriam Smyth, and Dorothy Marckwald's interiors for the luxury liner S.S. *America* (1941); and Colter's restaurant and cocktail lounge for the Fred Harvey Company at Union Station, Los Angeles (1945).[59]

During the same period, many women interior designers also designed furniture. Ethel Pilson Warren designed aluminum stools for the interior of the Washington National Airport; Draper designed furniture, wallpapers, and fabrics for some of her hotel commissions; and Virginia Connor and Bertha Schaefer were both well-known as designers of furniture as well as interiors.[60]

More and more women came to design interiors in a "modern" manner. Architect-trained Florence Schust Knoll, who grew up with the expansive view of design expounded by the Saarinens, her unofficial "step-parents," turned to interiors and furniture after working for and marrying Hans Knoll who ran a furniture firm.[61] In 1943 she became vice-president of Knoll Associates and director of the Knoll Planning Unit, the company's interior design division. A woman in the male world of office planning and design, she helped establish the interior style of the late 1940s that expressed the confidence and forward-looking approach of corporate America during the next quarter century.[62] Although the Knoll "story" belongs mainly to the second half of the century, Florence Knoll stands as a mid-century marker of women's extensive achievements within a profession in which they barely had a toehold in 1900.

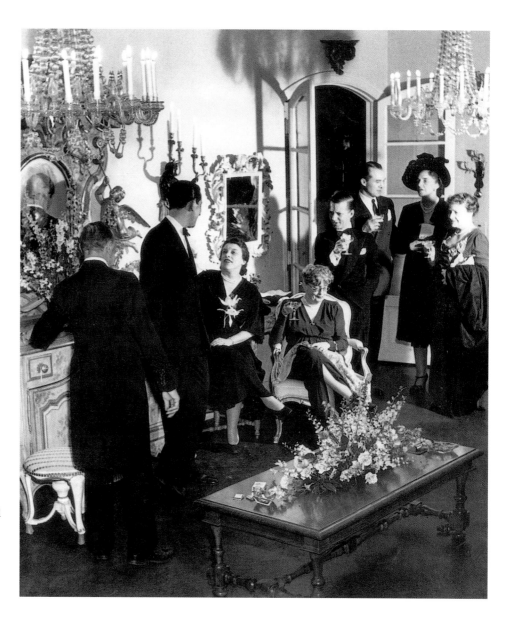

Fig. 13-18. Designer cocktails in the home of James Amster, early to mid-1940s: *from left,* a servant, James Amster, Muriel Draper, Ruby Ross Wood, Billy Baldwin, William Pahlmann, Dorothy Draper, and Eleanor McMillen Brown.

JUDITH B. GURA

THE DEATHS OF ELSIE DE WOLFE AND RUBY ROSS WOOD in 1950 marked the passing of an era. In the expanding American economy after World War II, interior design continued its transformation into a serious profession and became the center of what is now a 30 billion dollar industry.[63] The key features of postwar interior design were greater specialization, broader marketing of the profession, and the ongoing development of professional standards. Although new opportunities emerged for women engaging in interior design, these changes affected the context and nature of their practice. The growing acceptance of interior design as a professional pursuit and the prosperity-linked expansion of the field brought greater rewards to both women and the increasing number of men entering the field: "After World War II, a lot of smart people began to see a lot of money to be made in interior design," observed Ellen L. McCluskey, one of the leading women designers at the time.[64]

In the immediate postwar years, encouraged by the growing prestige of professional interior design and the potential for profit, and not repelled by its designation as an effeminate practice, more men enrolled as students of interior design or came into the field from other careers. In at least two major colleges they outnumbered women for a time,[65] but by 1960 the majority of interior design students, and practioners, were women—a situation that persists today.[66] Billy Baldwin and William Pahlmann continued to enjoy high profiles, paving the way for later male "stars," such as Mark Hampton and Mario Buatta, but during the 1950s and 1960s, women such as Dorothy Draper and others held their own in terms of celebrity status. Women also began to make more headway within the male-dominated AID; Nancy McClelland was elected to the post of national president in 1951, Dede Draper (no relation to Dorothy) in 1962, Mary Dunn in 1963, and Rita St. Clair in 1979 (after the organization became ASID).[67] This still represents just four women in the entire history of an organization founded in 1931.

As the design field expanded, offering a broader base of potential clients, practitioners increasingly specialized—the major areas being residential, hospitality (hotels, clubs, and restaurants), and corporate and commercial interiors. In the first two categories, women and men competed on a relatively level playing field. The third category placed greater emphasis on academic credentials. Like the

Fig. 13-20. Sister Parish. Bedroom in her own apartment, 960 Fifth Avenue, New York, as featured in *House & Garden,* September 1972. Cooper Hewitt, National Design Museum, Smithsonian Institution, New York, Parish-Hadley Collection.

clients it served, it was a male-dominated culture, which afforded men greater respect than women.[68]

Most women gravitated toward residential design which, despite the marginalizing effect of its link to domesticity, provided them with a large degree of freedom for creative expression. Since individual practitioners and small firms predominated in this specialty, it was possible to start a residential design career with little capital—though many women developed substantial businesses. In the twenty years or so after the war, the most prominent women in this area included Melanie Kahane, Dorothy "Sister" Parish (who pioneered the "undecorated" look; fig. 13-20), and Eleanor McMillen Brown (best known for her French-style "traditional" interiors). They, and others such as Eleanor Pepper, Elisabeth Draper (second wife of the celebrated Dorothy's husband), and Dorothy Paul, worked primarily for a select and affluent clientele.

Betty Sherrill, a Southern belle who married soon after college, cut short her Parsons training to begin a family. Recommended to Eleanor McMillen Brown, who had decorated her in-law's home, Sherrill joined McMillen, Inc., in 1951 and moved up in the ranks through skill and social connections—"I didn't have to go knock on any doors," she explains—and developed an elite clientele for whom she designed antiques-filled residences (fig. 13-21) and executive offices. Assuming the presidency on McMillen Brown's retirement in 1975, she purchased the firm in 1986 with two associates. "I think Mrs. Brown really wanted a man to succeed her," Sherrill comments, "but she couldn't find one."[69] McMillen, Inc. is probably the oldest woman-owned professional design firm in the country, and one of the most prestigious. Though conscious of her position as a role model for women, Sherrill astutely employs a balanced staff (all professionally trained) of men and women. The best known of these, after herself, is Ethel Smith, a lively ninety-four-year-old who joined McMillen in 1929 and, save for a brief maternity leave, has worked there for more than sixty years. Of herself, Smith says, "I'm probably the oldest decorator I don't know anyone else my age who's still around."[70] The current generation of women designers known primarily for residential interiors includes Mica Ertegun (MACII, founded with Chessy Rayner), Victoria Hagan, Mariette Himes Gomez, and Bunny Williams.

A "feminine touch" was welcomed not only in residential design but also in the hospitality industry, and several women designers found consider-

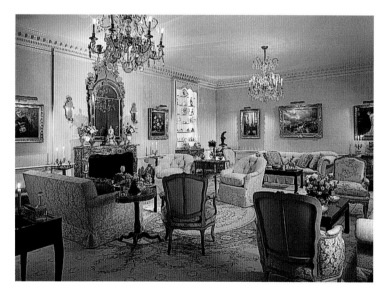

Fig. 13-21. Betty Sherrill for McMillen, Inc. Living room, Mrs. Anne McDonnell Ford Johnson's residence, New York, ca. 1985.

able success and recognition in this area, particularly during the explosive growth of hotel and resort development in the 1970s and 1980s. The most prominent was the colorful Dorothy Draper, whose career was already established before World War II. Her major postwar projects included The Greenbrier in White Sulphur Springs, West Virginia (1946–48), and the cafeteria at The Metropolitan Museum of Art, New York (1954), most of which employed the dark-walled, bold color schemes that she made fashionable. Her syndicated column, "Ask Dorothy Draper," and her weekly radio program helped her become internationally famous.[71] When she sold her company in 1960, the new owners, Carleton Varney and Leon Hegwood, wisely retained her name, and in 1964 the Dorothy Draper Dream House was featured at the New York World's Fair, reinforcing her considerable reputation even in retirement.[72]

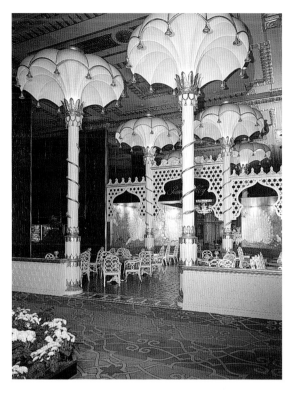

Fig. 13-22. Ellen Lehman McCluskey. "Peacock Alley" lounge, Waldorf-Astoria Hotel, New York, 1970. *Checklist no. 127*

Ellen Lehmann McCluskey, whose wealthy family background suggested the stereotypic designer-socialite, was nothing of the kind. A skilled pilot who had trained men to fly during World War II, she studied at the New York School of Interior Design and opened her own business in 1946.[73] From celebrity residences she moved quickly into corporate work and important projects in the hospitality arena, including designs for such prestigious New York City hotels as the Regency (1960) and the Waldorf Astoria (1970; fig. 13-22). She introduced the concept of the "lobby lounge," and her sumptuous traditional interiors helped her become one of the most successful women of her generation: in 1977, Ellen L. McCluskey Associates claimed annual revenues of over $1 million.[74]

After Draper the name most associated with hotel design has been Sarah Tomerlin Lee, an advertising copywriter and magazine editor whose design career did not begin until she was almost sixty. Despite a lack of formal training, when her husband died in an automobile accident in 1971, she took over the jobs under contract to his design firm, Tom Lee, Ltd.—notably the Four Seasons in Toronto—and went on to complete dozens of major projects including the Helmsley Palace, New York (1980), and the Willard Intercontinental Hotel, Washington, D.C. (1986; fig. 13-23). Lee retired in 1998 after almost thirty years in design, during which time she garnered major awards and international recognition. Even so, she still considers herself more a writer than a designer. Other women in hospitality design include Dallas-based Jill Cole (Adolphus Hotel, Dallas, 1982) and Tricia Wilson (Palace of the Lost City Resort, South Africa, 1993), and Miami-based Lynn Wilson (Al Bustan, Dubai, 1996).

Fig. 13-23. Sarah Tomerlin Lee. Lobby of the Willard Intercontinental Hotel, Washington, D.C., 1986.

The path to success in corporate design was more difficult for women to negotiate. With the postwar boom in glass-walled modern office buildings, the Knoll Planning Group, formed in 1943 under Florence Knoll, was the first of a new genre of design firms specializing exclusively in business interi-

Fig. 13-24. Florence Knoll. CBS executive offices, New York, ca. 1965.

ors. Knoll's New York showroom of 1951, considered to be the paradigm International Style corporate space, was one of many projects, mostly for blue-chip corporate clients such as Cowles Communications (1961) and CBS (fig. 13-24; from 1964). At George Nelson Associates from 1955 to 1968, Dolores Engle headed an interiors department, doing most of its work (residences as well as offices) for clients who had used Nelson for other design projects.[75] With only a few exceptions, however, the contract design business was populated by men. Emily Malino, who, along with Maria Bergson, Jill Cole (Cole Martinez Curtis), and Eleanor Le Maire, specialized in the field in the 1960s, recalls that "I would do an interview with myself and perhaps one associate, and in would come three 'suits.' But often," she adds, "I got the job."[76] In 1973 author Beverly Russell was able to document the careers of thirty-three women who had achieved substantial success in the male-dominated world of corporate interior design.[77] During the 1970s a number of women established their own firms in this area, including Karen Daroff in Philadelphia (Harrah's Smoky Mountain Casino, Cherokee, North Carolina, 1997; fig. 13-25) and

Fig. 13-25. Karen Daroff. Slot machine arcade in Harrah's Smoky Mountain Casino, Cherokee, North Carolina, 1997.

Fig. 13-26. Eva Maddox. Lobby area, the Rehabilitation Institute of Chicago, 1988.

Fig. 13-27. Sally Sirkin Lewis. Living room in the Lopez apartment, Los Angeles, ca. 1995.

Eva Maddox in Chicago (Rehabilitation Institute, 1988; fig. 13-26). Others built successful firms with a mix of residential and corporate clients—including Rita St. Clair in Baltimore (Baltimore City Hall, 1976), Sally Sirkin Lewis in Los Angeles (Lopez apartment, ca. 1995; fig. 13-27), and, later, Naomi Leff, who designed retail environments for Ralph Lauren (fig. 13-28), Giorgio Armani, and other firms.

As the contract design field expanded in the final quarter of the century, this practice was increasingly concentrated in the interior design divisions of large architectural firms. Many women found work in these offices, though the top posts were generally held by men. There were a few exceptions, including Jane Graham, Carol Groh, and Diane Legge Kemp (Skidmore, Owings and Merrill), Sally Walsh (Gensler), and Patricia Conway (Kohn, Pedersen, Fox & Conway). Most significantly, Margo Grant Walsh opened new vistas for women designing corporate interiors by breaking the "glass ceiling" that had kept them from the highest levels of the business. In 1996 she was named managing principal at Gensler, the country's largest commercial design firm. The sole woman in her University of Oregon interior architecture program, she began her career at Skidmore, Owings and Merrill in the early 1960s when, as she recalls, "It was definitely a boy's club."[78] In 1973 Gensler lured her away, and she moved up rapidly—"I got respect because I could draw really well"—taking on projects around the country and overseas, for such corporate clients as Pennzoil and Bank of America (fig. 13-29).[79] At Gensler half of the staff are now women, with about one-third of them holding titles, including six of nineteen partnerships. Other women in contract design, such as Deborah Lehman-Smith and Lauren Rottet, left larger firms to head their own. At this writing, however, Margo Grant Walsh is still the only woman at her level in a company of comparable size, and, of the one

hundred largest-grossing interior design firms in the country in 1999, only thirteen were headed by women.[80]

A number of women have worked in partnership with men, most frequently their husbands. Although many of these have maintained independent design identities, they are more often mentioned in the context of a "team." There is little question, especially among the older practitioners, that male-female partnerships helped overcome potential bias against female practitioners. Many of these partnerships focus on corporate clients, the category most likely to resist hiring women, rather than residential ones. Italian-born Lella Vignelli, who studied architecture and interior design in Italy and designed interiors at Skidmore, Owings and Merrill in Chicago, has worked with her husband, Massimo, for thirty-five years.[81] Vignelli Associates, probably best known for their product and graphic design, has created distinctively purist modern interiors (St. Peter's Lutheran Church, New York, 1977; fig. 13-30). Other partnerships include Denise Scott Brown and Robert Venturi—known for innovative postmodern architecture and environments—and Laurinda Spear and Bernardo Fort-Brescia, who, as Arquitectonica, created a trademark aesthetic of color-block forms. Margaret McCurry works on independent projects within her partnership with Stanley Tigerman (Harris residence, Sawyer, Michigan; fig. 13-31). Other architectural partnerships that cover interior design include Billie Tsien (with Tod Williams), Hsing-Ming Fung (with Craig Hodgetts), Elizabeth Diller (with Ricardo Scofidio), and Laurie Hawkinson (with Henry Smith-Miller). There are few husband-wife partnerships in which both are interior designers, Jo Heinz and Andre Staffleback being a notable exception.

The most significant changes in terms of women in interior design came from a renewed movement to establish it as a serious and respectable

Art 13-27. Fig. 13-30. Lella Vignelli and Massimo Vignelli. St. Peter's Lutheran Church, New York, 1977.

profession, on a par with architecture, engineering, and law, and better positioned to compete with architects, with whom its relationship was competitive, and sometimes adversarial.[82] These efforts culminated in the establishment of stringent educational and qualification standards in the last quarter of the century. The professional groups representing interior designers increased their efforts to encourage the perception of their members as knowledgeable professionals. By its twentieth annual conference in 1951, AID, with 1,200 members, had begun promoting itself to the public.[83] By 1960 membership had more than doubled, and by 1980 it reached 20,000. Internal conflicts within the institute in 1958 resulted in the creation of a second organization, the National Society of Interior Designers (NSID),[84] which pursued its own efforts to raise professional standards until the two organizations again combined forces in 1975 to form the American Society of Interior Designers (ASID).

ASID embarked upon a three-pronged program of professionalization. The first part came under the auspices of the Foundation for Interior Design Education and Research (FIDER), an international organization founded in 1970 by ASID, NSID, and the Interior Design Educators Council (IDEC). FIDER accredits interior design education programs around the country through on-site visits by volunteer teams of unpaid professional interior designers and educators.[85] Another part of the program, the National Council for Interior Design Qualification (NCIDQ), operating since 1972 and incorporated in 1974, designed a qualifying examination and guidelines for design licensing.[86] Finally, there was a decade-long campaign, spearheaded by Ruth Lynford, a New York designer trained in architecture, to gain legal recognition of interior design professionals via certification or licensing.[87] The effort had its first success with legislation passed in 1982 in Alabama and, as of January 2000, in a total of twenty-one states.[88] The professional design organizations require their members to meet these qualifications.

Professionalization has benefited women by helping to remove the taint of housewifely dilettantism. Conversely, it has made the field even more attractive to men. Despite the intense concentration on qualifications, however, interior designers can still practice without specific training: examples of the "designer by instinct" plus "hands-on" experience include Barbara Barry in Los Angeles and Clodagh in New York, both of whom have engaged in product design as well as interiors. It is, however, a fallacy to view interior design as solely "intuitive." For most designers today—raw talent notwithstanding—technical skills and knowledge are important requisites of practice.

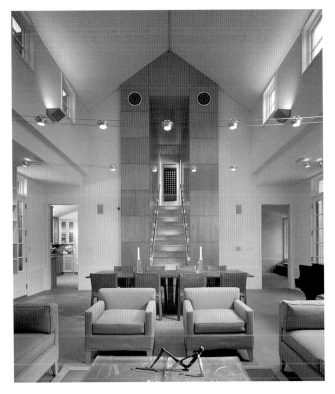

Such nonesoteric topics as computer-aided drafting (CAD) techniques, accessibility requirements, and fire code regulations are now part of the interior design vocabulary. As Paige Rense observes, "Some of the most talented designers couldn't pass the NCIDQ test"[89]—probably not even Elsie de Wolfe.

More immediately apparent to consumers were new ways of showcasing interior design, which considerably enhanced the image of the profession and, in the process, attracted new constituencies of clients. From 1970, under editor Paige Rense, *Architectural Digest* became the first industry magazine aimed at potential clients to focus exclusively on the work of professional designers.[90] Another development was the concept of the "designer showhouse," whereby designers (generally selected by a charity committee) decorate rooms of an empty residence which is then opened to the public as a fund-raising venture. The most prominent of these, the annual Kips Bay Decorator Showhouse, New York, began in 1973 and attracts several thousand visitors and potential clients (fig. 13-32). It has inspired similar projects in major cities around the country. Perhaps the most influential marketing vehicle, however, was the revival of the department-store "model room," presenting the art and artifice of the interior designer (at no charge) to a wide audience. Begun in the 1920s and 1930s, this mode of presentation reached its peak with first Henriette Granville and then Barbara D'Arcy at Bloomingdale's, New York (fig. 13-33). D'Arcy's extravagant, attention-getting interiors, beginning in the 1950s and continuing for over two decades,

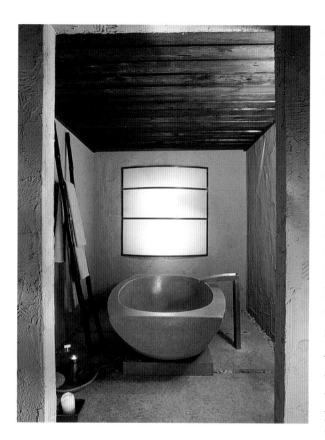

Fig. 13-32. Clodagh for Clodagh Designs. Bathroom for the Kips Bay Decorator Showhouse, New York, 1988.

were launched with great fanfare and media attention, establishing the store's credentials as a trendsetter in home-furnishings style, and in the process selling professional interior design.[91]

Despite the leveling effect of such exposure of women designers, many perquisites still accrued to men. A tally of honorifics and awards since 1980 shows a continuing imbalance in terms of recognition. The "Hall of Fame," created by *Interior Design* in 1985, inducted only three women (Barbara D'Arcy, Melanie Kahane, and Sister Parish) in an initial roster of fifteen, and two out of eleven (Sarah Tomerlin Lee and Sally Walsh) the following year. Honorees to date number 35 women out of a total 125.[92] *Interiors'* Designer of the Year award, begun in 1980, has been given to only seven women, and none in the first six years.[93] Even in ASID itself, less than half of its 181 Fellows are women, and only six women are among its twenty-one Designers of Distinction, despite the fact that an estimated 85 percent of the 1999 membership is female.[94] In January 2000 *Architectural Digest* lauded "Design Legends of the Twentieth Century," naming twenty-five designers of which only seven were women (all deceased). In the same issue, out of an international list of "Top 100" residential designers and architects, one-third of the featured United States–based interior designers were female; two-thirds, male.

"Professional judgments by others, [however], both male and female, have not always been based on talent, skill or achievement, but often on gender," as Beatrice Rivas Sanchez, president of the Kansas City Art Institute, commented in 1993.[95] She criticized the continuing gender imbalance in art and design fields, citing a "complex and sometimes hostile male-dominated arena." Women practicing interior design, particularly those who have been in it for some time, tell the same gender-bias stories as those in other careers. In recalling the design partnership formed in the 1960s, Lella Vignelli says, "I was the woman, so I was expected to do the typing."[96] Janet Schirn, a fifty-year veteran in interior design practice, remembers, "When I got my resale certificate in 1950, my mother reminded me to be careful never to make more money than my husband. And for years I worked hard to do just that."[97] Margo Grant Walsh, who married late in her career, credits part of her success to remaining single: "Perhaps one reason I got where I did was because I wasn't married or tied down, I could travel for projects, in other cities or abroad."[98]

Cultural bias notwithstanding, this survey of the period 1950 to 2000 has indicated the significant contributions of women to interior design in the United States. Women continue to dominate the field in sheer

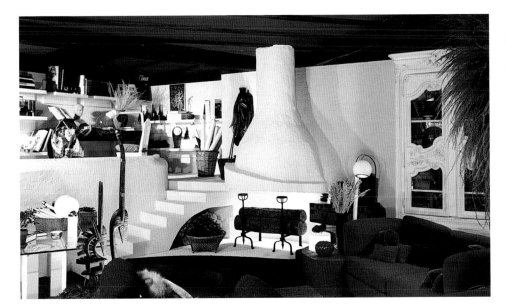

Fig. 13-33. Barbara D'Arcy. Model room, Bloomingdale's department store, New York, 1970. *Checklist no. 125*

numbers. A 1995 study for *Interior Design* estimated that there were 75,000 practicing interior designers in the country, 73 percent of whom were women.[99] More women who trained as architects are now taking up interior design,[100] and more women of color are competing at the upper levels of a profession that remained whiter than white for most of the century. In the late 1970s and early 1980s, Cecil N. Hayes and Rita Falkener broke ground for African Americans, and more recently, high-profile designers such as Courtney Sloane have further opened doors for others to enter.[101] Beatrice Rivas Sanchez, a Latina, and increasing numbers of Asian American women, including Carolyn Woo (Skidmore, Owings and Merrill), are now making names for themselves in commercial design offices.

Defining the place of women in interior design is a ticklish task: their roles are more complex, more elusive, and sometimes more transient than they appear. Women can, and many have chosen to, move in and out of full-time practice, delaying, discarding, or balancing careers with children and family life. Though allowing women a flexibility rarely found in other professional careers, this practice has contributed to the underrecognition of women's importance within the profession. It may also help to explain the scarcity of "famous" woman designers in this generation. After seventy years of professionalization, the only woman in the field whose name is known to most Americans is Martha Stewart. A tastemaker rather than a designer, she views interior design as the purview of every woman (or man) and not solely that of the professional designer.

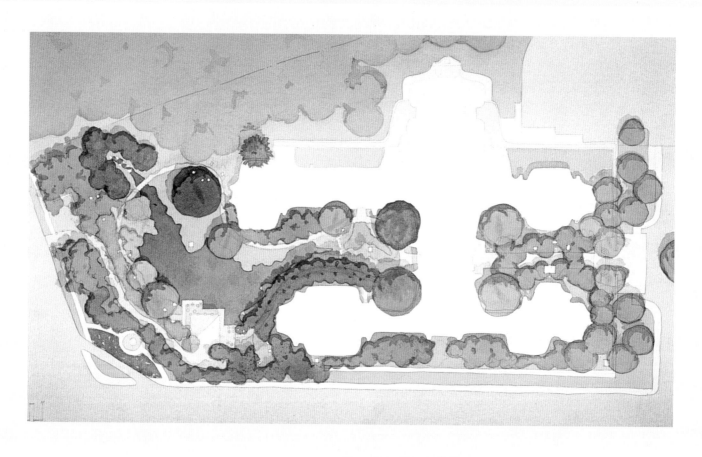

Fig. 14-A. Nancy Goslee
Power. Plan for Norton
Simon Museum Gardens,
Pasadena, California, 1995,
Rendered by Doug Jameson.
Watercolor on paper.
Collection of Nancy Goslee
Power and Associates, Santa
Monica, California.
Checklist no. 199

14

Women Landscape Designers

AT THE THRESHOLD of the twentieth century, overdrawn gender roles cast American middle- and upper-class women as providers of beauty and creators of a morally uplifting home, embracing the notion that women are by nature suited to gardening. While such stereotyping marginalized women in the workplace, paradoxically, it facilitated their entry into the profession of landscape design, which was easily viewed as an extension of women's sphere and harmonious with their traditional domestic identity. Harriet Beecher Stowe, who designed her own Connecticut house in 1863, proposed that "architecture and landscape gardening are arts every way suited to the genius of woman, and there are enough that have the requisite skill . . . for the elevation of domestic concerns to a profession for women."[1]

Domestic beautification, in which the garden became emblematic, was so dominant a theme in the education of wealthy women at the turn of the century that garden articles appeared in the society pages of early twentieth-century newspapers. An influential, widely read, "how-to" literature, written by and for women, included many popular works on gardening.[2] Garden connoisseurship, cultivated on well-guided travels abroad, further defined the creation of elaborate gardens as a pursuit of privileged women. The gender lines are drawn in the preface to Louise Shelton's popular *Beautiful Gardens in America* (1916): "*he* is by custom acknowledged master of the house; it is oftener *she* who reigns supreme among the flowers."[3]

Many women working as landscape designers were essentially self-taught or mentored in their training. Beatrix Jones Farrand (figs. 14-1 and 14-2) studied privately with Charles Sargent, the first director of the Arnold Arboretum, but was not college-trained, nor was Ellen Shipman, whose mentor and first employer was landscape architect Charles Platt.[4] As landscape design emerged as a credentialed

profession, however, and women obtained degrees, the demographics shifted and middle-class women entered the field in increasing numbers.[5]

Women had been educated in private women's colleges since the 1830s, but it was not until the 1860s that they were granted admission to state universities. These land-grant state schools were required by law to admit both men and women, although there were no courses in landscape design until late in the nineteenth century. Few women were admitted to or graduated from such courses before 1900, despite the fact that, by then, women accounted for a third of all college students.[6] While MIT was one of the earliest schools of landscape architecture to admit women, which it did by the 1890s as nondegree students, Marian Coffin was the only woman in the 1904 class to complete that program. Twenty-five years later, Elizabeth Lawrence was the only female graduate in the first landscape architecture class at North Carolina State College.[7] Among the increasing numbers of women to enter university programs of landscape architecture, Florence Yoch and Annette Hoyt Flanders graduated from the University of Illinois in 1915 and 1918 respectively, and Genevieve Gillette from Michigan Agricultural College in 1920.[8]

Women's educational opportunities in general expanded through the 1920s, and landscape design continued to be considered a viable career for women. *Profitable Vocations for Girls* (1924) included public park commissions, engineering details, and the supervision of gardeners in the scope of the job description. A popular book, *What Girls Can Do* (1926), stated that a woman with an artistic sensibility and a "love of things that will grow" could become a landscape gardener, providing that "she first attend a good school of horticulture in which she would be trained to design beautiful gardens for beautiful

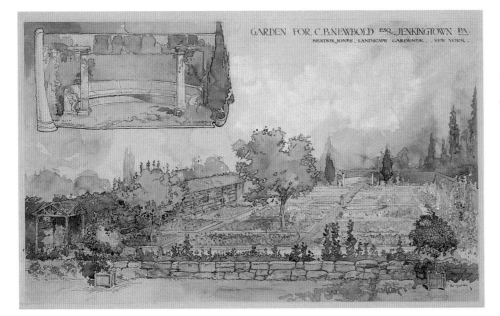

Fig. 14-2. Beatrix Jones Farrand. Garden design for C. B. Newbold, Jenkingtown, Pennsylvania, ca. 1903. Watercolor on paper. Beatrix Jones Farrand Collection, Environmental Design Archives, University of California, Berkeley (1955–2). *Checklist no. 4*

homes." By 1924, there were twenty schools with departments of landscape architecture open to women, in addition to several "alternative" schools.[9]

Two schools founded in the early years of the century played a pivotal role for women in the profession: the Lowthorpe School of Landscape Gardening for Women, founded in 1901, and the Cambridge School of Architecture and Landscape Architecture for Women, founded in 1915. These schools educated many of the outstanding designers of the period and had a lasting impact on the evolution of the entire profession.[10]

Responding to the difficulty women faced in gaining admission to the few existing university programs, the Lowthorpe School was established in Groton, Massachusetts, by Judith Motley Low, who believed that "women were naturally adapted to this profession."[11] All officers, the board of trustees, and members of the corporation were women. It became the Lowthorpe School of Landscape Architecture in 1917, offering a two-year nondegree program.[12] Low had been trained in England, and Lowthorpe leaned heavily toward the English tradition of landscape design; Gertrude Jekyll, the famous English garden designer and author, was revered by many of the students. The Jekyll influence can be seen in the work of several prominent graduates, including Elizabeth Pattee, Louise Payson, Isabella Pendelton, Frances V. McLeod, Henrietta Marquis Pope, Constance Peters, Mary P. Cunningham, and Agnes Selkirk Clark.

Lowthorpe's faculty was drawn from the vibrant academic and design community around Boston, which included the highly respected Olmsted office.[13] At various times in its brief history, full-time and adjunct faculty included Norman Newton, Martha Brookes Hutcheson, Josef Albers, Fletcher Steele, Paul Frost, and Louise Beebe Wilder. While advocating the

advancement of female landscape architects, the school promoted a "special" role for women as horticultural assistants in nurseries, estates, and landscape offices, as teachers of gardening, and as consultants.[14] The scope of the school's mission articulated a persistent bias inhibiting the progress of women working professionally in the public arena. Nevertheless, Lowthorpe produced nearly three hundred accomplished landscape architects in the years between 1901 and 1945.

The Cambridge School of Architecture and Landscape Architecture for Women focused on competitive professional training for women landscape designers. It initiated an unconventional interdisciplinary approach to the education of architects and landscape designers, viewing them as collaborators rather than competitors and requiring all to follow nearly identical programs. This approach produced a remarkably versatile and competent generation of landscape architects possessing an unprecedented range of skills. Of the twenty-eight women elected Fellows of the American Society of Landscape Architects (ASLA) by 1978, ten were Cambridge School graduates.[15]

The school began with two Harvard instructors, architect Henry Atherton Frost and landscape architect Bremer Pond, conducting a private tutorial for a Radcliffe graduate refused admission to Harvard's School of Landscape Architecture. Operating out of Frost and Pond's shared Cambridge office, the school began in 1915 and functioned as a graduate program, with twelve women seeking training.[16] Its success and later influence came from a standard of education measured against Harvard, the best graduate program in architecture and landscape architecture available to men. Women students were expected to be dedicated and determined. As Frost stated in a 1930 Cambridge School *Alumni Bulletin*, "The professions of architecture and landscape architecture have been, until very recent times, entirely in the hands of men. At present, women are not welcomed in many offices [even] as draughtsmen, and not a few practitioners are sincere in advising women not to attempt either profession. Therefore, a student must realize that success in a field where men are receiving their training in long-established schools requires for her a training as good [as theirs] . . . and that, with this training, because she is of necessity a pioneer, must go a high enthusiasm and an unusual tenacity of purpose."[17]

In 1920, at the height of the boom in estate design, Frost, in the interest of promoting his graduates, added the word "domestic" to the name of the school. Unfortunately, his calculated addition encouraged the popular view that women were qualified exclusively for residential work, and, in 1932, the word was removed from the name of the school.[18] By 1927 European study trips, cosponsored with Lowthorpe, were added to the curriculum. Contacts initiated on these travels would later prove to be crucial for several of the students: Elizabeth Lord and Edith Schryver, for example, partners in a successful Pacific Northwest landscape firm for more than forty

years, met on one of these trips in 1927.[19] Faculty often overlapped as well, and several instructors taught at both schools.

In 1928 the Cambridge School affiliated with Smith College, becoming the Smith College School of Architecture and Landscape Architecture, granting undergraduate and graduate degrees in both disciplines. Organizing a conference in the same year, Frost sought to explore women's long-term goals in the profession, recognizing the conflict between women's personal lives and careers. The document created by that meeting suggested married partnerships of female landscape architects to male architects—a relatively common phenomenon in the first half of the century—as one viable "solution" to several pervasive problems.[20] The husband, as "head" of the firm, could finesse a client's reluctance to conduct business with a woman, and the resistance of male crews to women in supervisory positions could be circumvented, because the husband/partner could "front" for the wife/partner in that role. Some of the better-known married partnerships of male architect and female landscape architect included Ruth Dean and Aymar Embury; Janet Darling and Richard Webel; Agnes Selkirk Clark and Cameron Clark; and Helen Morganthau Fox and Mortimer Fox.[21] Until closing in 1942, the school remained in Cambridge, and for its entire history, the faculty of the Cambridge School was virtually identical to Harvard's departments of architecture and landscape architecture. The school also offered important teaching opportunities to women, including its own graduate landscape architects Mary P. Cunningham, Mary Nearing, and Frances Jackson.[22]

As part of the curriculum, Cambridge students routinely visited the Brookline offices of the influential landscape architect Frederick Law Olmsted, whose firm was, with Harvard, a big presence in Boston. This influence was evident in the quality of the work of the faculty and students of the Cambridge School, in sensitivity to topography, sophisticated handling of plants, and an underlying grounding in architectural design. James Pray, chair of landscape architecture at Harvard, and one of the Cambridge School founders, was also president of the ASLA from 1915 to 1918. His prominence in the profession gave him a strategic position from which to promote the Cambridge students.

By 1936 more than one hundred women had graduated from Cambridge. After the 1929 market crash and the Depression, the profession went through profound changes, for which Frost worked to prepare his students. Responding to the virtual end of private-sector building, and the increasing trend toward public work, in 1941 Frost proposed that the school offer a wider curriculum in planning and public design. This would be for the students whose horizons had "broadened steadily" and were interested "in housing rather than houses; in community centers for the masses rather than neighborhood clubs for the elite; in regional planning

more than estate planning and social aspects of the profession more than private commissions."[23]

Persistent financial problems forced the Cambridge School to close in 1942. When Harvard's enrollment declined during World War II, it allowed women to enter the Graduate School of Design as degree candidates in architecture, landscape architecture, and regional design. Cambridge School students could apply to Harvard, and, if accepted, complete their education there.[24] Walter Gropius, at Harvard, objected, proposing that women be admitted only as "special students" limited to the duration of the war. Although he did not prevail and women were allowed to obtain degrees, at war's end women were, again, refused admission.[25]

Despite the excellent available training and the remarkable talent demonstrated by many, the strong bias against women in the profession proved an obstacle to the success of women in landscape architecture. Even Beatrix Jones Farrand, who in 1899 had been a founding member of the ASLA, was dismissed by Frederick Law Olmsted, a forward-thinking, progressive humanist, as "inclined to dabble in landscape architecture."[26] More than twenty years later, after women had established a strong presence in the profession, such bias was reiterated when the Third National Conference on Instruction in Landscape Architecture resolved that female landscape architecture students be required to take stenography to enhance their opportunities for work in landscape architecture offices.

The most pervasive bias against women landscape architects related to public work. In 1938 the *New York Times* applauded women's rise to the top of the profession, commenting that it was "astonishing" to realize that the "huge undertakings" of landscape work at Princeton and Yale "were directed by a woman, Mrs. Beatrix Cadwallader Jones Farrand," who also undertook residential projects.[27] Both Cambridge and Lowthorpe attempted to redress the stereotyping of women as qualified only for small-scale residential work and deficient in landscape construction and engineering skills. Both schools were found to exceed the ASLA standards for education in these areas, including courses in construction and engineering in the curriculum.[28]

It was consistently difficult for women graduates to secure entry-level or apprenticeship positions in professional practice. The traditional career path for (male) landscape architects was a postgraduate internship with an established firm, but such opportunities were simply not available to female graduates. The prevailing prejudices that engendered this exclusion were two-fold. It was widely believed that the mere presence of women "upset morale" in an (all-male) office environment and that women had neither the personal authority nor the managerial skills required to supervise construction.[29] Marian Coffin, one of the most accomplished landscape architects of her generation, was forced to open her own office soon after her graduation from M.I.T. because she was unable to find a job in an established firm.[30]

Fig. 14-3. Florence Yoch and Lucile Council. "Rice terrace" landscape for *The Good Earth* (1937, Dir. Sidney Franklin).

Later, as women entered the profession in greater numbers, women employed women as a matter of course, affording them the apprenticeship supervision to launch their careers. Those women, in turn, opened firms, hired female graduates, and a professional network emerged. Ellen Shipman, for example, employed women, predominantly Lowthorpe gradu-ates.[31] Dorothy May Anderson, Frances McCormic, Edith Schryver, Dona Caldwell, and Mary P. Cunningham all worked for her, as did Louise Payson, Eleanor Roche, Agnes Selkirk Clark, and Martha Brookes Hutcheson (author of the popular book *The Spirit of the Garden*). Anne Baker, a Cambridge graduate, served as director of Lowthorpe from 1932 to 1934 and was also executive head of Beatrix Farrand's office in New York, where all of the employees were women.[32] Florence Yoch hired a Cambridge student, Lucile Council, and they became partners in a long and productive Pasadena-based firm (fig. 14-3), from 1921 until Council's death in 1964.[33] In some instances young graduates formed partnerships,[34] and faculty members of both the Cambridge and Lowthorpe schools were extremely supportive of their students, giving many of them their first jobs. Mentoring thus became a crucial component of women's success in this and many other realms, a phenomenon that had been cited in recent studies of the career paths of con-temporary professional women.[35]

The early decades of the twentieth century, the "Country Place Era,"[36] witnessed the influx of women into landscape architecture and their extraordinary success in the profession. This was a unique golden (or "gold-plated") moment for a relatively young profession that was, essentially, just coming of age, its status elevated when in 1915 the American Academy in Rome established the first fellowships in landscape architecture. Unprecedented numbers of large-scale designs for lavish estates constructed on virtually limitless budgets gave work to the women landscape architects also coming into their own during the first thirty years of the century.

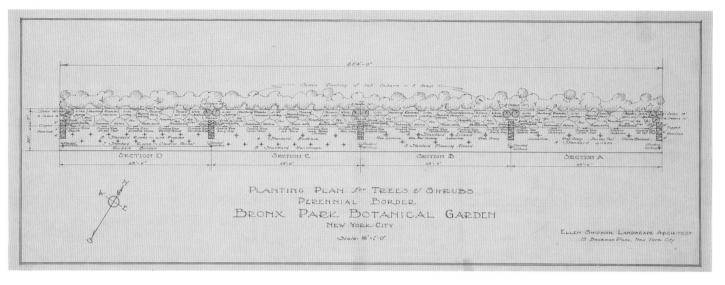

Fig. 14-4. Ellen Biddle Shipman. Planting plan for trees and shrubs of the "Women's Advisory Council" border, New York Botanical Garden, Bronx, ca. 1928. Ink on tracing paper. Cornell University Library.

The extravagant historicist architecture of the early mansions encouraged historicist gardens. French, Italian, and Spanish garden features often appeared on the same grounds, including stonework, topiary, parterre, ironwork, statuary, fountains, and pools. A less formal English style, with its romantic rose and perennial gardens, was adopted for the shingled "cottages" of seaside resorts. Lavish plantings and detail were most celebrated in these country house properties, dovetailing with those aspects of design most associated with women in the field. Ellen Shipman, Annette Hoyt Flanders, Marian Coffin, Ruth Dean, and Isabella Pendelton were among the women best known for estate gardens.[37]

Estate-scale residential landscape architecture came to a virtual halt with the crash of 1929, and since women had specialized in this area, as a group, they were especially hard hit. Fewer and smaller homes were built after 1929, and few featured elaborate grounds, often forgoing the services of a landscape architect. Small projects that did include landscaping were less profitable than in earlier years, and with greatly reduced project loads, many landscape architects closed their offices or drastically cut their staffs. So lean a time was this for landscape architecture that in the 1934 exhibition of the Architectural League, only previous years' projects were shown, because there was simply no new work.[38]

Firms that survived the Depression moved toward public work, which had been growing steadily since the establishment of the National Park Service in 1916.[39] Planning was increasingly the concern of landscape architects, and Harvard opened the School of City Planning in 1920.[40] Changes in the tax laws and the scarcity of private sector building made government the biggest employer of landscape architects.[41] The profession, once known for serving the wealthy elite, attempted to redefine itself by embracing a more public mission. Even the annual competitions of the Garden Club of America reflected this shift. The first competition, in 1917, was for a flower border design, but by 1933, the challenge was to design a small suburban development.[42]

Park design, preservation, and planning became the primary sources of work for landscape architects (figs. 14-4 and 14-5). The New Deal put many

Fig. 14-5. Ellen Biddle Shipman. "Women's Advisory Council" border, New York Botanical Garden, Bronx, 1928.

more men than women to work in public arena programs such as the Civilian Conservation Corps, and women were at a distinct disadvantage in the competition for government projects.[43] Cambridge-trained landscape architects Mary Duguid and Wenonah Sibley worked for the Tennessee Valley Authority; Eliza Birnie worked for both the National Capital Parks and Planning Commission in Washington, D.C., and the National Forest Service, which hired very few women.[44] The National Park Service hired more landscape architects during the 1930s than any other institution but few were women.

Under Roosevelt's Resettlement Administration, landscape architects were put to work developing designs for new suburban communities that began emerging at this time.[45] Marjorie Sewell Cautley, one of the first women landscape architects to successfully navigate through the changes in the profession, was known especially for her work in community planning and municipal landscape architecture. A 1917 graduate of Cornell, with a master's degree in planning from the University of Pennsylvania, she was the author of a textbook, *Garden Design: Principles of Abstract Design as Applied to Landscape Composition* (1935). With architects Henry Wright and Clarence Stein, Cautley was the landscape architect for Sunnyside Gardens, in Queens, New York (1924–28), an early experiment in low-cost urban housing. Cautley designed the landscape for the planned community of Radburn, New Jersey (1928; figs. 14-6 and 14-7), and for the Phipps Garden Apartments in Long Island City (1931). Under the Public Works Administration, she was landscape consultant for the State of New Hampshire, in 1935 and 1936, supervising Civilian Conservation Corps work in the state's parks.[46]

In an effort to find work for thousands of the unemployed, Commissioner Robert Moses hired forty landscape architects to develop a rehabilitation program for New York City's parks, among them Helen Bullard, Alma Alison, Eleanor Jones, Helen Swift Jones, Maud Sargent, Cynthia Wiley, and Rosalind Spring LaFontaine. Bullard, a Cornell graduate, began her career in the offices of Warren Manning and Annette Hoyt Flanders before working for the Long Island State Park Commission, designing bathhouse landscapes for Jones Beach and landscape plans for the

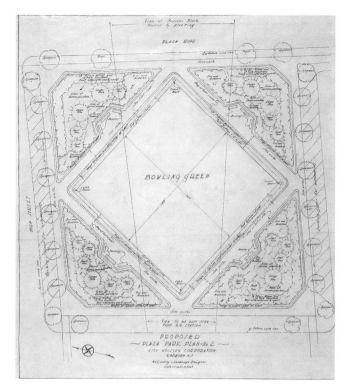

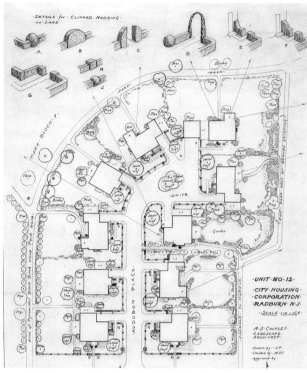

Fig. 14-6. Marjorie Sewell Cautley. Proposed plaza park plan no. 2 for City Housing Corporation, Radburn, New Jersey, 1928. Ink on linen. Avery Architectural and Fine Arts Library, Columbia University in the City of New York. *Checklist no. 42*

Fig. 14-7. Marjorie Sewell Cautley. Plan for Unit 12, City Housing Corporation, Radburn, New Jersey, 1928. Ink on linen. Avery Architectural and Fine Arts Library, Columbia University in the City of New York.

Southern State Parkway, Grand Central Parkway, and Montauk Highway in the 1930s.[47] Active in many important public projects throughout her career, Bullard was the only woman among nine landscape architects chosen to design the 1939 World's Fair in New York, for which she received considerable press attention.[48]

In Louise Shelton's *Beautiful Gardens in America* (1915), while many of the grandest estate gardens of the period are illustrated and described in great detail, not a single landscape architect is named. And in a manifestation of "client vanity," owners were credited with the good taste to have created such extraordinary estates, while the participation of professional designers was not even acknowledged. The fact that so many of these uncredited landscape architects were women more than suggests a bias that contributed to this common "oversight." By the 1930s, however, women had achieved a visible success in landscape architecture, and increasingly the names of designers as well as their clients were given in the popular shelter magazines and professional journals that proliferated at the time.

Photography did much to publicize the very photogenic gardens of Ruth Dean, Isabella Pendelton, Ellen Shipman, Annette Hoyt Flanders, and other women. Books and articles written by accomplished "amateurs," such as Louisa Yeoman (Mrs. Francis) King[49] and Louise Beebe Wilder, as well as by professional landscape architects Coffin, Dean, and Marjorie Sewell Cautley, promoted the visibility of women in the profession. As the authors, landscape architects, and, in many cases, the photographers of the gardens were women, the network expanded, promoting women's careers in what was still, predominantly, a man's profession.[50]

Women began to garner awards for their work. Between 1929 and 1936, three women won the Architectural League of New York's highest awards for landscape architecture. Ruth Dean won the Medal of Honor in 1929 for gardens in Grosse Pointe, Michigan; Marian Coffin's designs for Mrs. T. Morgan Wing and Mr. and Mrs. Edgar Bassick won in 1930; and in 1932, Annette Hoyt Flanders won for the "French Gardens" of the McCann Estate in Oyster Bay, New York.[51]

Even as women designers were celebrated at the top of the profession, however, a 1936 Gallup Poll reported that 82 percent of Americans felt that wives should not work if their husbands were able.[52] Employers in many fields continued to refuse to hire married women, and a New York University abstract of 1944 pointed to substantial, persistent prejudice against women in landscape architecture.[53] Antagonism toward women working had strengthened during the Depression, when it was felt that women took jobs away from men (fig. 14-8).[54]

It was during the 1930s that the Cambridge School's Henry Frost, approached the editor of *American Architect* with an article he had written promoting the hiring of women landscape architects. Commenting on the response, he noted: "The explosion was immediate. My editor friend told me forcefully that he would not be guilty of lifting his hand to help the cause of women in any fields that belonged by rights to men. He harangued on the way women were forcing themselves into business and professional circles everywhere He said that (sic) the subways of New York are filled with ticket-takers and track walkers who hold degrees from our leading law schools, and are forced to do such menial labor by the influx of women into their profession."[55]

World War II altered that climate. Rosie the Riveter was offered as the model for women entering a wartime workforce in which their labor was now to be viewed positively. College admissions were increasingly open, and some women experienced an occupational mobility uncompromised by marital status. Nonetheless, during the war, only 6 percent of government-employed landscape architects were women.[56] Despite the early success of a few women, the Depression, the end of the boom in estate design, the postwar concern to reemploy returning veterans, and a backlash aimed at driving women back into the home slammed shut the windows of opportunity through which women had entered landscape architecture. By 1946 more than 2 million working women were replaced in their jobs by returning veterans, and the G.I. Bill further fueled the bias that contributed to women's exclusion from university programs.[57] Without the sup-

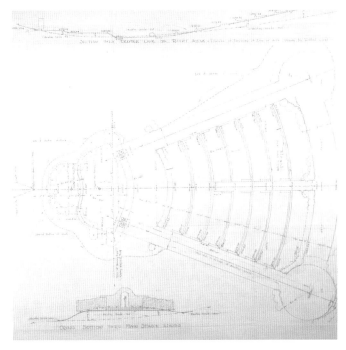

Fig. 14-8. Rose Greely. Staking and grading plan for an outdoor theater, The Madeira School, Greenway, Virginia, 1933. University of Virginia, Charlottesville.

14-9. Agnes Denes, "Wheatfield—A Confrontation," 2 acres of wheat planted and harvested by the artist, Battery Park Landfill, New York City, 1982.

port and mentoring of the women's schools, which had closed, women found it increasingly difficult to enter, be trained, or succeed in the profession.

The bias against women working as landscape architects persisted for decades. The pervasive conservative, historicist leanings of the profession continued through the 1950s, when vanguard landscape architects Dan Kiley, James Rose, Garrett Eckbo, Thomas Church, and A. E. Bye brought to landscape architecture the formal modernist issues at the center of developments in American art and architecture. Women were relatively absent from the profession during the modernism of midcentury and beyond, further widening the divide necessary for women to cross on reentry.

An ASLA study of the profession, conducted by Albert Fein in 1969–71, found that landscape architecture was a relatively obscure profession, little known outside its own insular community, and that literature about it was available in only a handful of academic libraries. Further, its demographic profile was white, middle and upper-middle class, and male.[58]

While the ASLA reported less than 5 percent enrollment for women in landscape architecture programs before 1970, by 1982, female enrollment was up to 50 percent of students of landscape architecture. It was not until the 1970s, when a dynamic social and political climate broadened the opportunities open to American women in general, that significant numbers of women began to reenter the profession. Landscape architect and historian Eleanor McPeck cites the publication of Rachel Carson's *Silent Spring* (1962) and Jane Jacobs's *Death and Life of Great American Cities* (1961) as catalytic contributions to women's increased participation in a profession that came to be associated with a strong commitment to the social good.[59]

Women had also lagged behind in terms of their inclusion in academic landscape architecture programs. A 1972 study conducted by Darwina Neal for the ASLA pointed to the underrepresentation of women in university departments of landscape architecture, a reality corroborated by Miriam Rutz in 1975, when she noted that only 9 of the 350 women teaching landscape architecture in the United States were full-time faculty at the graduate level.[60] At that time, there was not a single female faculty member on the Harvard Landscape Architecture faculty, although 30 percent of the students were women; by the 1980s, however, there were three women on the full-time faculty.[61] By 1990 women still held fewer than one quarter of all landscape architecture faculty positions.[62] The increasing concern with broader social

and cultural issues manifested during the last thirty years of the century was not exclusive to women, but female faculty and female practitioners played an important role in leading the profession in a new direction. Sometimes, as in "Ecological Feminism and Landscape Education," a workshop at the University of Virginia in 1992, issues related to women and landscape architecture, both in education and the profession, were brought together for analysis.

Feminism was one of several developments of the 1960s and 1970s that contributed to major changes in the profession. Blurred boundaries between landscape architecture, architecture, and art animated the fertile aesthetic climate of the 1960s.[63] Conceptual art, earthworks, and the ecology movement played pivotal roles in derailing—or at least confusing—prevailing trends in landscape architecture. Expanding the view of the landscape through radically varied lenses, many of the artists who focused on the landscape, were women.[64] While some artists created works in remote sites, others addressed urban and conceptual landscapes, injecting provocative questions of gender, class, and ethnicity into an arena from which they had been glaringly absent. Feminist writers and critics considered a new social and contextual vocabulary of sources, including ritual and mythology, from which to explore landscape.[65]

Mierle Laderman Ukeles made visible the invisible process of waste management, creating performance pieces around rituals of cleaning and maintenance.[66] Meg Webster constructed minimal sculptural forms, infused with the iconography of birth and growth, represented by plant and earth materials, as did her "Conical Depression," for Virginia and Bagley Wright, in Seattle.[67] Ana Mendieta used female forms—often her own body—to imprint, carve, burn, and stain the ground.[68] Creating visual narratives to illuminate ecological systems of land/water environments, Helen Mayer Harrison worked with Newton Harrison for many years.[69] And, in collaboration with local scientists, Patricia Johanson revived a dying Texas lagoon, building a matrix of paths over the restored landscape.[70]

Fluent in the language of both disciplines, a number of artists, among them Elyn Zimmerman and Mary Miss, have made site-specific works that straddled the boundaries between sculpture and landscape architecture. Others have made works that emphasize the ironic dissonance of contemplating our relationship to landscape in an urban context. In a romantic, elegant gesture, Agnes Denes planted her "Wheatfield—A Confrontation" (fig. 14-9) on a lower Manhattan landfill in the summer of 1982, yielding a half-ton of wheat from the derelict site.[71]

In the last three decades, landscape architecture has incorporated into professional practice much of the enriched aesthetic vocabulary that emerged in the 1960s and 1970s. Some landscape architects on the expressive, theoretical edge of the profession have made landscapes that are aligned as much with art as landscape architecture. "The Bagel Garden" (Boston, 1979; figs. 14-10 and 14-11), designed by Martha Schwartz, pushed the envelope on the bound-

Figs. 14-10 and 14-11. Martha Schwartz. "The Bagel Garden," Boston, Massachusetts, 1979 (plan and view). Plan: pencil on vellum. Collection of Martha Schwartz, Cambridge, Massachusetts.
Checklist no. 149

Figs. 14-12 and 14-13. Diana
Balmori. Wintergarden,
World Financial Center, New
York, 1985 (plan and view).
Plan: colored pencil on trace
paper over printed paper.
Collection of Balmori
Associates. *Checklist no. 161*

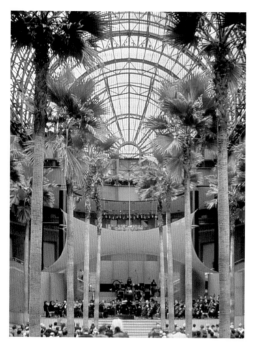

ary between landscape and art, engendering anxiety, even anger, from the
more conservative center of the profession.[72] In her design for "The Citadel"
(City of Commerce, California, 1990), Schwartz tweaked a highly formal plan
with a pop vocabulary.[73]

Diana Balmori has long been committed to working in the public
realm, her designs addressing the tension at the border between architecture,
art, and landscape (figs. 14-12 and 14-13). Her interest in drawing and
sculpture imbues the work with an expressiveness; her long experience in
teaching and writing have honed her sensitivity to historical context and to
the pressing ecological problems at the center of the profession today.[74]

Also working within the public realm, architect Maya Lin produced a
powerful design for the Vietnam Veterans Memorial (Washington, D.C.,
1982), enriching what had become the narrow vocabulary of memorial
design. Her expressive sculptural and architectural landscape work reinvigo-
rated this historically static, if not retrograde, genre.[75]

Since social and political issues were first raised by the Women's
Movement, several generations of women have entered the profession of
landscape architecture. By 1982, most women landscape architects were in
private practice, and almost half were self-employed.[76] Represented at every
level, many head their own small firms, while others navigate the somewhat
less flexible world of corporate landscape offices. The large, multioffice cor-
porate firms that have dominated the profession since the 1970s have not
been entirely hospitable in accommodating the conflicts between women
working and family responsibilities. At the end of the century women cited
the "big firm blues," reporting that male-owned large corporate firms
demonstrate less willingness to accommodate conflicting demands of person-

al and workplace responsibilities than do government offices, where women find fewer limitations to their success.[77] In recent years, telecommuting and team-work cooperation have been offered as flexible solutions to women's complex lives, for landscape architects and other professionals.

The difficulties of corporate culture notwithstanding, female associates and employees made important, while less visible, contributions to many well-known projects within large corporate firms (male-owned and run). Landscape architect Angela Danadjieva was the principal designer for two of the most celebrated Halprin Associates' works, Lovejoy Plaza (1961–68) in Portland and Freeway Park (1970–76) in Seattle.[78] Janis Hall, an environmental artist, worked with renowned landscape architect A. E. Bye. Her landscape, Mnemonic River (1985–86; fig. 14-14) in southeastern Massachusetts, and her sculpture, "Murmuring Flow" (1992–93), in southwestern Connecticut, reflect her skill in working with the most intangible aspects of landscape—light and shadow, air and water.

Fig. 14-14. Janis Hall. Mnemonic River landscape, private residence, southeastern Massachusetts, 1985–86.

The projects of one of the largest female-owned firms, Carol R. Johnson Associates, have included park design, reclamation projects, campus planning, and recreational and waterfront site design. The firm's recent projects include Lechmere Canal and Park (1983–91; fig. 14-15) in Cambridge, Massachusetts, and site analysis and feasibility studies for Ocean Spray Cranberries Headquarters (1988), also in Massachusetts.[79]

Patricia O'Donnell's smaller firm, LANDSCAPES, specializes in cultural landscape preservation, including planning, estate and historic

Fig. 14-15. Carol R. Johnson. Lechmere Canal and Park, Cambridge, Massachusetts, 1933.

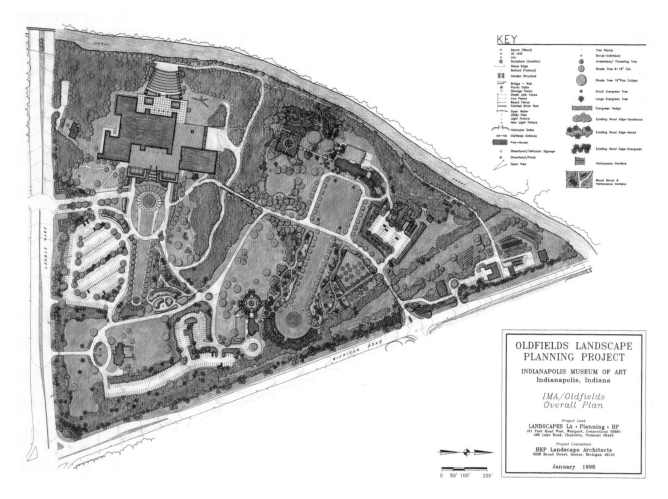

Fig. 14-16. Patricia O' Donnell. Restoration and preservation planning for Oldfields, Indianapolis. 2000. The original landscape was designed by Percival Gallagher, Olmstead Brothers, Landscape Architects, Brookline, Massachusetts, 1920s. LANDSCAPES Landscape Architecture · Planning · Historic Preservation. Indianapolis Museum of Art.

landscape preservation, and public landscapes by the Olmsted firm. Among recent projects are an Olmsted restoration, Oldfields (Indianapolis, 2000; fig. 14-16); a Martha Brooks Hutcheson landscape, Bamboo Brook (Morristown, New Jersey, 1999–2000); and a master plan for Thomas Jefferson's Poplar Forest (Bedford County, Virginia, 1999–2000).

At the end of the century, half of all landscape-architecture students were women, and opportunities seemed better than ever before. Women have a highly visible presence in the profession today. Susan Child, Nancy Goslee Power (figs. 14-17 and 14-18), Pamela Burton, Christine Ten Eyck, Achva Benzinberg Stein, and Kathryn Gustafson are but a few whose work has contributed to the success of women in the profession. Nevertheless, many women continue to acknowledge evidence of persistent bias.[80] As of 1992, only 4 percent of ASLA members were female, and of respondents to an ASLA questionnaire the same year, an overwhelming majority felt that discrimination against women remained an important issue in the profession. More than half cited a "glass ceiling" limiting women's access to top positions in professional practice.[81] As in the earlier part of the twentieth century, women are more likely to mentor women and support young practitioners entering the profession. Only with the continuity of a multigenerational network of women in landscape architecture, holding upper-level academic positions, as heads of firms, and as policy makers, will the continued success of women be assured.

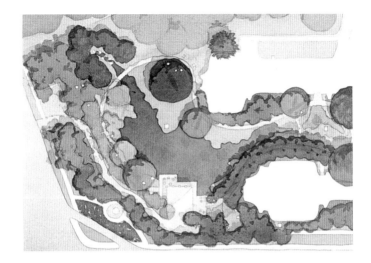

Fig. 14-17. Nancy Goslee
Power. Plan for Norton
Simon Museum Gardens,
Pasadena, California, 1995.
Detail of Fig. 14-A.

Fig. 14-18. Nancy Goslee
Power. Sculpture garden
at the Norton Simon
Museum, Pasadena,
California, 1997.

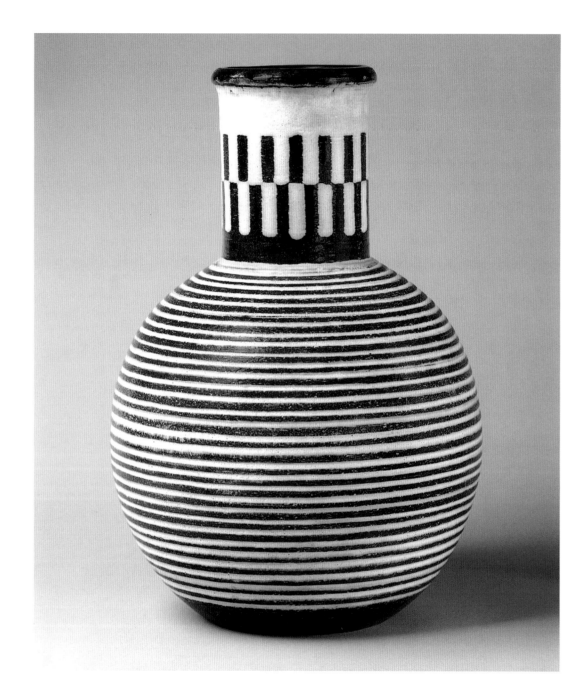

Fig. 15-A. Maija Grotell. Vase,
1940. Glazed stoneware. The
Metropolitan Museum of Art,
New York, Purchase, Edward C.
Moore, Jr. Gift, 1940
(40.153.1). *Checklist no. 72*

I5

CHERYL BUCKLEY

"Quietly Fine" | *Quietly Subversive*

WOMEN CERAMIC DESIGNERS

IN FEBRUARY 1900 the *Crockery and Glass Journal* reported on a meeting of the United States Potters' Association at which its president claimed that "American pottery has at last found favor among the American people."[1] Despite such certainty, establishing a market for the products of the American ceramics industry and developing an American aesthetic or style continued to preoccupy manufacturers, industrial ceramic designers, and craft potters alike throughout the twentieth century. In their different ways, they searched for an aesthetic that not only distinguished American ceramics from European antecedents, but also responded to the diversity of America in the twentieth century. Women played a multifaceted role in this process. They were major consumers, articulating and guiding taste; writers and critics interpreting the meaning and significance of ceramics; educators training generations of students; and designers producing a wide range of different types of pottery, including art pottery, studio pottery, and industrial ceramics.

Threading through the narrative of women's contribution to ceramic design are several themes. One of these is women's experience of modernity. Another is the recurrent dialogue between fine art and craft, in which the boundaries between art, architecture, industrial design, and craft became blurred. There was also an ongoing debate over the relationship between formal concerns such as style, form, and decoration, on one hand, and the nature of clay, the technologies of glazes and firing, and the status of the object, on the other. And there were inevitable reverberations from other ceramics traditions, especially Bauhaus-style and Scandinavian modernism and British studio pottery, and from wider social and political developments.

Despite the complexity of the relationship between women and ceramics in the United States in the twentieth century, there has been little attempt to address the issue of gender critically.[2] Assumptions regarding women's design skills, which were informed by a reductivist reading of gender difference, are evident in John Ramsay's influential text, *American Potters and Pottery* (1939). The vocabulary used to

Fig. 15-1. Maria Longworth
Nichols, ca. 1880

describe the work of Maria Longworth Nichols, who founded Rookwood Pottery in Cincinnati in 1880 (fig. 15-1), is highly revealing.[3] Damning with faint praise, Ramsay calls it "lady-like," "conservative," and "quietly fine," making no reference to its late-nineteenth-century context.[4] At that time decorating and designing ceramics were considered appropriate occupations for a middle-class woman to make a respectable living and participate in artistic production, albeit in the so-called minor or lesser arts.[5] Ramsay could just as easily have described Nichols as one of a group of commercially minded American women potters who set up their own companies, acquired an appropriate ceramics education, and articulated and contributed to the ongoing discussion about ceramics. "Quietly fine" does not do justice to the "pioneers" of the Arts and Crafts movement in America nor to those who followed in the twentieth century.

ARTS AND CRAFTS LEGACIES

The American Arts and Crafts movement established a precedent for women to pursue ceramics as a serious activity—as art, design, craft, science, and business.[6] They learned how to design, throw, decorate, glaze, and fire pottery, and to research, manufacture, and market it.[7] Most of their production came under the label of art pottery, which describes a type of ceramics that emerged in the context of the Arts and Crafts movement in the last quarter of the nineteenth century. While it began in Britain, it rapidly spread to the United States. Independent art potteries such as Rookwood were established by practicing designer-makers, and studios were formed by large established manufacturers to produce art pottery, probably the most famous of which was in England—the Doulton Art Pottery established by Henry Doulton at his Lambeth Pottery in London about 1870. Art potteries were generally small-scale and, although some art potters did throw their own ceramic shapes, sometimes, as was the case with Doulton, industrial methods of production were used. The decoration, which was done by hand, either by the designer or by a decorator, was highly "artistic" and usually unique.

Mary Chase Perry Stratton exemplifies the ceramics designers who came out of this tradition. She learned china-painting as a young girl in the 1880s, studying at the Cincinnati Art Academy between 1888 and 1890. She also wrote magazine articles about pottery and designed and made her own.[8] Needing full-time employment, she helped promote Horace J. Caulkins's "Revelation kiln," traveling around the country, visiting industrial potteries and small artistic ones, and meeting educators and practitioners.[9] In 1903 she and Caulkins established the Pewabic Pottery in Detroit, the outcome of their extensive knowledge of pottery manufacture, design, and promotion.[10] The pottery was dependent upon the energy, tenacity, and ability of this thirty-six-year-old college-educated, but impoverished middle-class woman who was a lifelong "student." She drew on her contacts in the industry and in

education to extend and refine her expertise, training with the renowned Charles F. Binns at the New York State School of Clay-working and Ceramics at Alfred University in Alfred, New York, and investigating the manufacture of tiles with a large-scale producer in Zanesville, Ohio.[11]

Stratton pioneered exquisite iridescent glaze effects and simple forms, making her an important transitional figure between art potters and studio potters later in the twentieth century.[12] Pewabic increasingly specialized in the manufacture of Stratton's designs for architectural tiles, especially those for churches such as Most Holy Redeemer in Detroit (1920; fig. 15-2) and the National Shrine of the Immaculate Conception in Washington, D.C. (1923–31). These tiles, finished with Stratton's richly colored irides-cent glazes, used subtle, mainly abstract and simplified, decorative designs.[13]

The legacy of the Arts and Crafts movement can be traced not only in the emerging studio pottery movement, in which women such as Mary Scheier and Marguerite Wildenhain agreed that designer and maker should be one, but also in some of the more socially aware developments, including those related to the Federal Art Project (FAP), a branch of the Works Progress Administration (WPA), part of the New Deal in the 1930s. Government aid helped establish the Savage Studio of Arts and Crafts in New York in 1932 and the Harlem Community Art Center (1937–42).[14] Founded by African American ceramics sculptor Augusta Savage, the studio offered ceramics training as part of its communi-ty arts program. Savage was also the first director of the Harlem Community Art Center, which was described as a model WPA art center.[15]

Another WPA/FAP program that included ceramics was established as a collaborative venture by the Cleveland School of Art, the Cleveland Museum of Art, and the Cowan Pottery Studio in Rocky River, Ohio, in 1932. Participating in this was Edris Eckhardt, who was in the last year of her ceram-ic studies at the Cleveland School of Art. Initially working at Cowan Pottery[16] and as an independent glaze chemist in her own studio, Eckhardt went on to receive "wide recognition for her work in establishing a successful program with the Works Progress Administration Federal Art Project in the 1930s."[17] Her own design practice was primarily concerned with small, figurative sculp-tures influenced by Vally Wieselthier, and she produced small detailed sculp-tures for children's libraries based on themes from American folklore such as Johnny Appleseed and Huckleberry Finn.[18] The project was part of a five-month WPA/FAP pilot program in 1933–34. As director of the newly found-ed WPA/FAP at the Cleveland School of Art from 1935 to 1941, Eckhardt

Fig. 15-2. Mary Chase Perry Stratton. Tilework in the Church of the Most Holy Redeemer, Detroit, Michigan, 1920. Pewabic Pottery. Photographed in the 1980s.

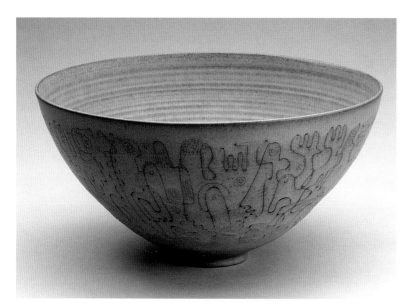

Fig. 15-3. Mary Scheier and Edwin Scheier. Bowl, 1951. Glazed earthenware. Cranbrook Art Museum, Bloomfield Hills, Michigan, Museum, Purchase with funds from the Cranbrook Foundation (CAM 1951.9). *Checklist no. 97*

established a workshop on all aspects of ceramics including moldmaking, glazing, and decorating.[19] The program developed decorative architectural murals and garden ornaments that depicted aspects of American life and literature for public housing projects, arguably extending "the medium of ceramic art into new areas of monumentality and social impact."[20]

Mary Goldsmith Scheier's involvement with FAP, as director of the two FAP art centers at Big Stone Gap and Abingdon, Virginia, from 1935, led directly to her becoming a potter. She used local clays to make sculpture, puppets, and simple bowls and jars.[21] After marrying Edwin Scheier, a WPA field supervisor in 1937,[22] they gave up their jobs and traveled through the South performing puppet shows, before eventually settling in Tennessee in 1938, when he became director of the Tennessee Valley Authority Art Center at Norris.[23] Free access to the center's industrial ceramics laboratory at night allowed them to experiment with throwing and glazing ceramics.[24] In 1939 they left Tennessee and set up their first pottery, Hillcrock Pottery, in Glade Spring, Virginia, where they were inspired by the forms and decoration of Appalachian folk pottery.[25] They used three local clays: red, blue swamp, and white, and as they said, "It was all empirical. We learned from North Carolina potters about Albany slip, and we would use that on the inside to make vessels waterproof, and just the clay on the outside, without glazing. We didn't keep formulas or notebooks on glazes."[26] The Sheiers also developed new, almost transparent glazes in green, purple, and pink, which highlighted the delicacy of both the form and decoration of their designs.

In the early 1940s they moved to New Hampshire to teach at the University of New Hampshire and the League of New Hampshire Arts. Defying the conventional gender roles in ceramics, by which women were the decorators of pottery, the Sheiers' collaboration consisted of Mary making the forms and Edwin decorating them. Mary threw a range of functional wares, including vases, bowls, and large plates, and Edwin finished them with sgraffito and sprigged decoration (fig. 15-3).[27] The combination of simplicity of form and naivete of decoration chimed with the contemporary modernist enthusiasm for "preindustrial" forms, and their work was selected for The Metroplitan Museum of Art's juried exhibition, *Contemporary Industrial Arts*, in 1941.[28] With their use of local clays, their formal interest in indigenous decorative traditions, including sgraffito and sprigging, and their experimentation with natural colored slips over a red earthenware body, the Sheiers work marks the emergence in America of what came to be known as studio pottery. In contrast

to art pottery, studio pottery describes a type of ceramics that developed in Britain in the late 1910s/early 1920s (although its influence was still evident in the 1960s and 1970s); in the United States it emerged in the 1930s, but gained enormously in popularity after World War II. It self-consciously revived craft methods of throwing and decorating and was based in small workshops often headed by an individual who might also teach a number of apprentices. Studio potters sought out traditional glazes, forms, and methods of decoration, often celebrating vernacular, regional traditions of pottery making. However, this interest in regional and national traditions was, arguably, reinvigorated by an interest and enthusiasm for the pottery traditions of different cultures. Unlike art pottery, studio pottery eschewed all industrial processes.

Like the Sheiers, other husband-and-wife partners contributed to the reassessment and revival of local, regional, and native traditions of American pottery-making. From 1915 Juliana and Jacques Busbee were instrumental in encouraging, photographing, training, and ultimately selling "Jugtown" pottery, at first in the Village Store, their Greenwich Village tearoom (run mainly by Juliana), but by 1919 at Jugtown, North Carolina.[29] Traditional Jugtown pottery was dying out at that time, but Jacques Busbee established a small pottery employing local potter Ben Owen to throw forms that Busbee designed. Juliana, whose commitment to Arts and Crafts ideals extended to wearing clothes made from handwoven fabrics, was involved with the promotion of the pottery throughout the Depression, until 1958.[30]

In New Mexico, at the San Ildefonso Pueblo, Maria and Julian Martinez revived traditional Native American pottery of the Southwest with their renowned black-on-black vessels (fig. 15-4).[31] Producing traditional polychrome wares in the early years of the century, they progressed in the 1920s to creating shiny jet black pottery with matte black painted decorations, which also suggested modernist and art deco motifs (see also fig. 3-17). Later, adopting the modern studio practice of signing her work at the request

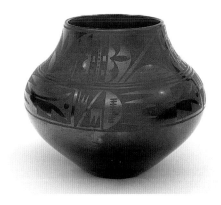

Fig. 15-4. Maria Martinez and Julian Martinez. Jar, ca. 1939. Earthenware. The National Museum of Women in the Arts, Washington, DC, Gift of Wallace and Wilhelmina Holladay.

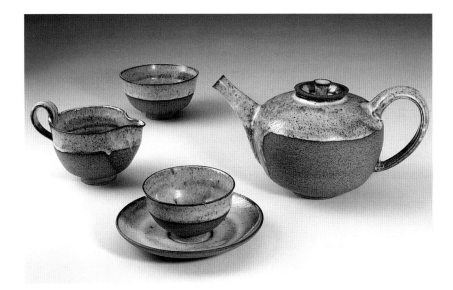

Fig. 15-5. Marguerite Wildenhain. Tea service, ca. 1946. Glazed stoneware. Everson Museum of Art, Syracuse, New York (P.C. 47.515.1–13).
Checklist no. 88

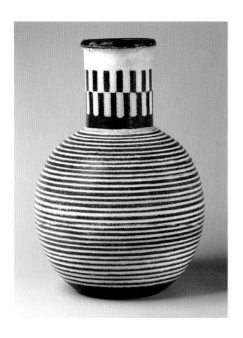

Fig. 15-6. Maija Grotell. Vase, 1940. Glazed stoneware. The Metropolitan Museum of Art, New York, Purchase, Edward C. Moore, Jr. Gift, 1940 (40.153.1). *Checklist no. 72*

of traders, Maria Martinez became one of the best-known and best-loved of all American women potters. She was part of what Susan Peterson describes as a matriarchal tradition of pottery-making, which included Lucy Lewis and Margaret Tafoya.[32]

DESIGN FOR MODERN NEEDS

A number of "modernisms" helped shape ceramic design in the United States in the twentieth century. Bauhaus-style modernism became prevalent after the arrival of former Bauhaus staff and students from Germany in the 1930s. Its most direct influence on ceramics came via Marguerite Wildenhain, who had trained with Max Krehan and Gerhard Marcks at the Bauhaus before emigrating to the United States and settling in California where she worked as a designer, maker, and teacher of ceramics (fig. 15-5).[33] The synthesis of studio pottery and modernism was a central concern for American potters in the 1940s and 1950s, and Wildenhain was one of the foremost thinkers and writers on the subject. In 1950 she corresponded with preeminent British studio potter Bernard Leach who had established his renowned workshop in St. Ives, England, in 1920, aided by the Japanese potter Shoji Hamada. She took issue with Leach's later criticism of American craft pottery which he claimed had "no tap-roots."[34] Strongly rebutting Leach's claim, she persuasively argued:

> America has roots too, but they are many and come from all over the world, from all races. In this lies its uniqueness, its grandeur—this cementing together of a thousand parts. A country like America cannot have just one expression, one way of doing things. It must perforce have as many forms of expression as the sources of its life as a whole. That is America's beauty and greatness, and nobody would want to see just one single form, one single way of thinking grow on this continent. For our tradition is just the opposite: it stands for the free choice of each individual.[35]

She recognized the importance of tradition, but stressed that "the forms that were valid in the horse and buggy times are not ours any more And if we are honest in our work and it expresses what we stand for and what we are, I feel we cannot look to the Orient or neither to the tradition of Europe to find our forms."[36] Wildenhain's major theoretical text, *American Pottery: Form and Expression* (1959), articulated an aesthetic reconciling the contradictions inherent in modernist and craft approaches to ceramics,[37] and in both her writing and her own practice she sought a modern American aesthetic for craft pottery that moved beyond "cheap streamlining" and foreign traditions.[38]

Scandinavian modernism began to have an impact in the United States in the 1920s and 1930s. Finnish designer Maija Grotell, who taught at the Cranbrook Academy of Art in Michigan, contributed to the development of an aesthetic that combined subtle and dramatic combinations of glazes and

incised modern decoration on high-fired stoneware (fig. 15-6). Although initially her work included stylized decorative motifs that had an abstract feel to them, increasingly at Cranbrook her pottery became more focused on surfaces, which were built up with various glazes or slips, the latter in the manner of *pâte sur pâte*.[39] Fired in large kilns at Cranbrook, her stoneware pieces were often large and imposing, and the high-fire, strongly colored glazes covered the dramatically incised and pitted surfaces to create ceramics that effectively synthesized modernism and studio pottery.[40]

The relative status of craft, fine art, and industrial design was important in defining the relationship between women designers and ceramics. In a century that celebrated the functional object, professional designer, and mass consumption of design, women's continued engagement with decorative aspects of design and the hand-made, and their interest in the domestic context of the production and consumption, to some extent mitigated against their wider recognition.[41] Although some women did design for industrial ceramics production and others worked on a large, if not monumental scale, many continued to work in ways that were small-scale, independent, and domestic, allowing them to combine work and home. This was true of Mary Scheier, Marguerite Wildenhain, and Gertrud Natzler. Undoubtedly they operated across the boundaries between art, design, and craft, producing one-off signed wares which, although simple in form, were often highly decorative, with stunning glazes and surface effects. These pieces functioned primarily as art objects, although combined with their utilitarian wares, the work demonstrated the maker's concern for broader social and design issues. However, in their relatively remote studios, they remained isolated from the mainstream ceramics industry.

A number of women, including Wildenhain and Natzler, were highly influential as educators. Following the studio pottery tradition, Wildenhain took on apprentices and Gertrud Natzler taught throwing on the wheel to Beatrice Wood and Laura Andreson, among others.[42] Andreson, who taught at the University of California, Los Angeles, from the mid-1930s to 1970, developed a pioneering ceramics course, handbuilding pottery and using low-fire techniques before other, similar programs were established.[43] She was interested in researching glazes for her own work (fig. 15-7), which was influenced by aspects of modernism (Scandinavian and Bauhaus) and Asian pottery forms.[44] Marion Fosdick Lawrence was an influential teacher of industrial ceramics, who was appointed to the staff in the New York State School of Clay-working and Ceramics at Alfred University in 1915. A former postgraduate student at the Kunstgewerbe Museumschule in Berlin between 1911 and 1913, she taught pottery, glaze experiments, and ceramic technology until her retirement in 1953.[45]

The economic status of the American pottery industry, which was largely in decline throughout the century under pressure from Asian and

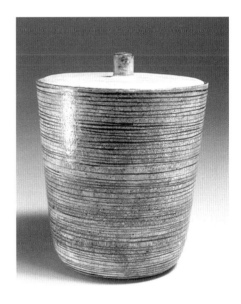

Fig. 15-7. Laura Andreson. Cookie jar, 1946. Earthenware. Everson Museum of Art, Syracuse, New York (47.507).

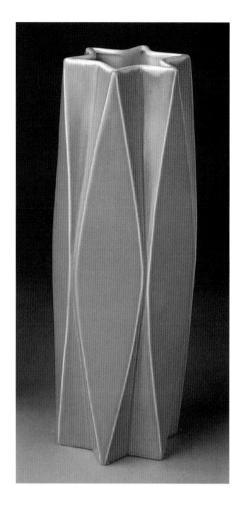

Fig. 15-8. Belle Kogan. "Prismatique" vase, early 1960s. Manufactured by Red Wing Potteries, Red Wing, Minnesota. Glazed earthenware.

European ceramics producers, governed the opportunities open to women designers of industrial ceramics.[46] Industrial ceramic manufacture, which had begun to develop in the mid-eighteenth century in England, was based on complex labor divisions and new technologies. New kiln designs, semiautomated ways of forming pottery (including casting and molding, and the use of jigger and jolley machines), new types of ceramic bodies, improved glazes, and new decorative processes, such as decals, enabled manufacturers to produce a vast array of cheaper, standardized wares for the mass-market. By the early twentieth century, the concept of "design" adding "value" to the product gained ground, particularly during the Depression. Many companies began to hire designers, and many of these were women.[47] Belle Kogan, for example, a freelance designer in metal, wood, and plastics, as well as ceramics, was employed by Red Wing Pottery in Minnesota in 1938.[48] Kogan had studied at the Rhode Island School of Design, establishing her own industrial design studio in New York City in 1931. Ever conscious of the "pressures and conditions of our present way of life," she sought to present modern forms that would meet the needs of the modern consumer.[49] At Red Wing she designed 150 new shapes, including the "Terra-Craft," "Magnolia," and "Green" ranges, which were slip-cast with relief molding and incised decoration in new colors typical of the 1930s (fig. 15-8). Having traveled to Germany, Czechoslovakia, and France in 1930, she brought to her work modern European aesthetics, especially French Art Deco and Art Moderne with their streamlined, angular forms.[50]

Eva Zeisel and Edith Heath were also highly conscious of designing for contemporary needs. Hungarian-born Zeisel was one of a number of émigré women designers who played a significant role in developing modernist ceramic designs in America between 1930 and 1960.[51] With an art and design education, an apprenticeship, and experience acquired in ceramics factories

Fig. 15-9. Eva Zeisel. "Museum" Teapot, coffeepot, and creamer ca. 1942–43. Manufactured by Castleton China, Shenango Pottery, New Castle, Pennsylvania. Glazed porcelain. Collection of Bernarda and Felicisimo Labaco. *Checklist no. 79*

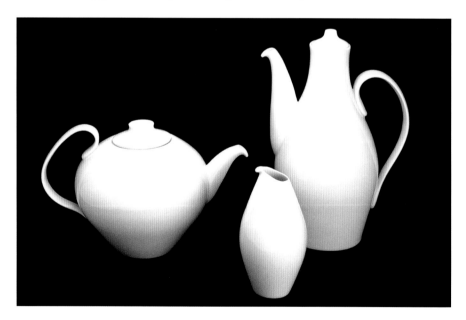

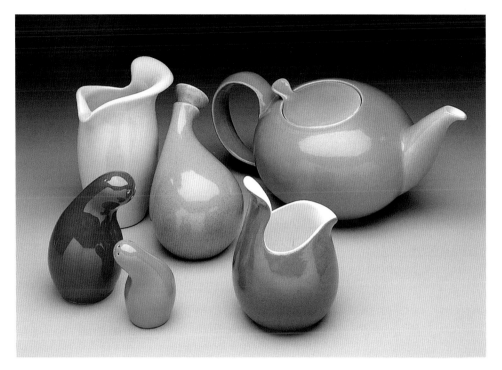

Fig. 15-10. Eva Zeisel. "Town and Country" dinnerware, ca. 1950. Manufactured by Red Wing Potteries, Red Wing, Minnesota. Glazed earthenware. Dallas Museum of Art, 20th-Century Design Fund (1995.119.1a, b–6a, b).

and workshops in Hungary, Germany, and the Soviet Union, Zeisel worked as a freelance designer for Castleton China Company, Red Wing Pottery, and Hall China Company, among others. During a distinguished career that is not yet over, she developed a number of organic designs, including "Museum" (1942–45 for Castleton; fig. 15-9), "Town and Country" (ca. 1946 for Red Wing; fig. 15-10), and "Tomorrow's Classic" (ca. 1952 for Hall China). These designs came to epitomize postwar, mass-produced ceramics. For the most part Zeisel preferred her designs undecorated, but Castleton and Hall, for example, employed others for decal designs. Ching-Chih Yee designed "Mandalay" (fig. 15-11) for the "Museum" line, while Irene Haas, one of Zeisel's assistants, and Charles Seliger and Erik Blegvad produced decals such as "Frost Flower," "Arizona," and "Buckingham," respectively, for "Tomorrow's Classic".[52] In what Zeisel called a "playful search for beauty," she developed a modernist aesthetic that challenged the functionalist straitjacket of Bauhaus modernism by drawing on a plethora of sources, including the work of Swedish ceramics designer Wilhem Kåge for Gustavsberg and the Finnish architect and designer Alvar Aalto.[53] Recognition by the modern design "establishment" came early, and in 1946 her "Museum" service was given a special exhibition at the Museum of Modern Art, New York.[54] Zeisel brought enormous energy, honesty, and determination to her design practice. She also inspired subsequent generations through her teaching at Pratt Institute in the Department of Industrial Design, which focused the attention of students on how to look at things around them for new perspectives. Her witty and stylish designs were intended to bring joy to their users and were eminently suitable for postwar American lifestyles.

Fig. 15-11. Eva Zeisel. Cup, saucer, and plate from "Museum" service, ca. 1942-43. "Mandelay" design by Ching-Chih Yee; form by Eva Zeisel. Porcelain. Private Collection.

Fig. 15-12. Edith Heath.
"Coupe" casseroles, 1952.
glazed stoneware.
Philadelphia Museum of Art,
Gift of the Designer (1983-
49-1,2,3).

Edith Heath attempted to combine the simplicity of form and glaze embodied in the work of craft potters with industrially produced ceramics manufactured by her own company, Heath Ceramics, in Sausalito, near San Francisco, founded in 1941 with her husband, Brian, then head of the Red Cross on the West Coast.[55] Trained initially as a sculptor and painter at the Institute of Design in Chicago under former Bauhaus teacher László Moholy-Nagy, she studied ceramics at the California School of Fine Art in San Francisco in 1942 and ceramic chemistry at the University of California.[56] Heath Ceramics mass-produced her designs for stoneware dinner sets, casseroles, covered jars, bowls, and other domestic items.[57] Her work encapsulated "California" style with its informality and ease of use. Intended for indoor and outdoor eating, the "Coupe" stoneware service (fig. 15-12), designed in 1947, was an oven-to-table range. In its "rustic" modernism, it fused the modern and the vernacular and represented what Heath described as "the roughness of America."[58]

Zeisel and Heath designed industrial ceramics that reflected the experience of modern life in postwar America. Although highly responsive to modernism, they moved beyond it, to produce design solutions that recognized the importance of the female consumer, and the need for reasonably priced, mass-produced tableware, which was adaptable to the changing function of domestic ceramics. Neither woman subscribed to the formal orthodoxy of modernism and its strict functionalist agenda; instead they developed designs that were challenging and adventurous in form and decoration.

In addition to following more casual lifestyles, which included outdoor eating, casual dining, and buffet-style entertaining, postwar Americans created new sectors of the ceramics market, which required distinctive wares for airline use, corporate in-house restaurants, and fast-food chains.[59] It was in such a context that Lucia DeRespinis, an industrial designer trained at Pratt Institute with Rowena and Alexander Kostellow and Eva Zeisel, among others, worked in the office of George Nelson Associates, designing china, glassware, and furniture for Restaurant Associates in the 1950s and 1960s.[60] She also worked freelance for Walker China in Ohio designing the "Table-Lite" line, as well as producing designs for decals, and in the 1960s she designed tiles for the Pomona Tile Company (fig. 15-13) and ceramics for

Fig. 15-13. Lucia DeRespinis.
Clockwise from top left:
"Impressions," "Reflections,"
"Dimensions," and "Prisms"
tiles, ca. 1957. Produced by
Pomona Tile Manufacturers,
California. Collections of
Lucia DeRespinis and Pat
Kirkham.

first-class service for several airlines, including American and Northwest.

The designs of Gertrud Natzler, who worked collaboratively with her husband, Otto (she designed and threw the pots while he developed glazes and fired the work), represent a different response to designing for the modern world.[61] Another European émigré, she arrived in the United States in 1938 and drew on British and European craft traditions. Her pots have a delicacy of form reminiscent of Lucie Rie, a fellow Viennese designer, who also emigrated in 1938, but to England. Natzler's exquisitely thrown, classically proportioned vessels (fig. 15-14), which "touched perfection" according to Beatrice Wood,[62] gained rapid recognition through the annual Ceramic National Competitions in Syracuse, New York, especially when in 1940 the Natzlers won a prize for a turquoise and gray oval bowl.[63] Together with Wildenhain, and Grotell, Gertrud Natzler mediated European and American ceramic craft traditions through the emerging languages of modernism—Bauhaus and Scandinavian in particular—but with a passing glance at British studio pottery. The synthesis arrived at contributed to the emergence of an aesthetic in clay that was distinctly "American."

John Kenneth Galbraith's *Affluent Society* (1958) provides the context for the burgeoning market for art, craft, and design in postwar America.[64] The 1960s and 1970s saw the establishment of numerous private galleries, specialized journals, and increasingly well-endowed museums, which, together with college ceramics departments, functioned to locate ceramics as part of the "art world" and the art market. Studio ceramics became increasingly influenced by fine art and associated with the art market.

West Coast potters, notably Peter Voulkos, who developed an aesthetic informed by avant-garde fine art practice, especially Abstract Expressionism, flamed the debates about the nature of and rationale for craft/studio ceramics, which had begun in the 1950s.[65] The work of these primarily male potters celebrated the large-scale, abstract, expressive qualities of ceramics at the expense of small-scale, functional domestic pottery, a category in which women predominated. Significantly, Bernard Leach's highly publicized visits to the United States, first in 1949–50, then in 1953, when Leach and Shoji Hamada attended an important international symposium held at Black Mountain College, influenced a younger generation of potters, including Voulkos and a number of women such as Karen Karnes. It was Leach the scholar, however, who influenced Voulkos rather than Leach the potter, whereas Voulkos was fascinated by Hamada's intuitive response to clay.[66]

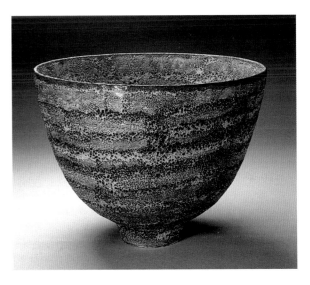

Fig. 15-14. Gertrud Natzler and Otto Natzler . Large bowl (H331), 1956. Glazed earthenware. American Craft Museum, New York, Gift of the Johnson Wax Company, from OBJECTS: USA, 1977, Donated to the American Craft Museum by the American Craft Council, 1990 (1977.2.66). *Checklist no. 105*

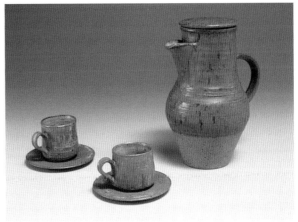

Fig. 15-15. Karen Karnes. Demitasse service, 1957. Glazed stoneware. The Everson Museum of Art, Syracuse, New York (60.16.1–7).

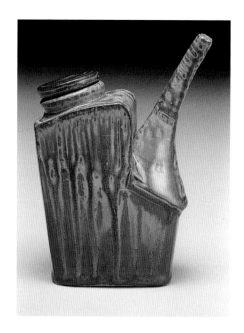

Fig. 15-16. Ellen Shankin. Soy bottle, 1999. Glazed stoneware. Collection of Gallery 1021: Lill Street, Chicago.

Karnes, potter-in-residence at Black Mountain College between 1952 and 1954, and her husband, David Weinraub, organized the 1953 symposium. She was also influenced by Hamada, and in 1954 she and Weinraub established their own studio at Stony Point, New York, where her work focused on simple functional forms (fig. 15-15) with striking surfaces created by salt-glaze firing. Like Leach and his follower Michael Cardew, Karnes appreciated "the universal past" of ceramics.[67] Since 1979 she has developed a new range of wares based on the possibilities of wood-firing from her new studio in Morgan, Vermont.[68] A younger group of women including Clary Illian, who trained at the Leach pottery in England, Ellen Shankin (fig. 15-16), Anne Hirondelle, Linda Arbuckle, and Linda Sikora have drawn on ceramic traditions associated with Leach and Hamada, but reinvigorated by women such as Karnes.[69] Discussing the work of Shankin and Sikora in *American Craft* in 1998, Polly Ullrich argued that their functional pots embodied, "the integration of art and the everyday, the emphasis on intimacy between maker and user and the celebration of a sense of touch as an equal partner with vision in understanding the ceramic object."[70]

FEMINISM, DECORATION, AND POSTMODERNISM

A number of women ceramics designers worked in ways that directly challenged the high modernism of mid-century American ceramics. Frequently working at the boundaries of art and craft practice, Beatrice Wood arrived at ceramics almost by accident, although her interest in Dada and her friendship with Marcel Duchamp indicate her close links to the visual arts.[71] She established a studio in 1948 in southern California after studying with the Natzlers and Glen Lukens between 1938 and 1940. As Garth Clark, who has promoted American ceramics through his galleries and publications, noted, Wood was "never seduced by perfectionism" and her work showed an "indifference to the formal tenets of craftsmanship."[72] In this she was typical of many who helped develop and become part of the craft revival movement in ceramics. Yet her particular use of in-glaze lusters was pioneering, enabling her to create rich, stunning colors and complex textural qualities, which took her work beyond any obvious functionality it might also suggest (fig. 15-17).

Starting in the 1960s, drawing on postmodern theories in general and feminist fine art practice in particular, women ceramic designers began to revalue and reassert those qualities denigrated by modernists and some studio potters alike. The decorative possibilities of ceramics evident in Wood's work is a dominant concern of a number of women designers working since the late 1960s. Women potters, along with other women artists and designers, began to interrogate the value systems and assumptions that underpinned their own particular field within the context of feminist theory. High priority was given to examining aspects of crafts that had been devalued due to their association with women, particularly textiles and ceramics.

Feminist artists began to question assumptions about women's artistic practice. Most famously, Judy Chicago's *Dinner Party* (1979) drew on the "gendered" meanings associated with ceramics to question the values of art and crafts generally. At the same time feminist art and design historians began to question why crafts, and particularly those made and used within the home, had been devalued by historians.[73] Reinforcing this, but coming from a different starting point, postmodern discourses around cultural meaning, value, and consumption began to reassess the decorative after its banishment and denial from design and the visual arts during the period of high modernism. Writing in 1986 in *The New Ceramics: Trends and Traditions*, Peter Dormer argued, "Decoration and symbolism in ornament has to emerge from common ideas and practice."[74]

By drawing on a decorative vocabulary, women such as Dorothy Hafner, Betty Woodman, Joyce Kozloff, Jo Buffalo, Paula Winokur, and Anne Krauss have, in different ways, attempted to reassert "a common practice," one integral to ceramic traditions previously associated with women, but subsequently denigrated within the context of modernism. Buffalo, Woodman, Kozloff, and Krauss have taken a more intuitive, expressive approach with their one-off studio ceramics, which are concerned with volume, malleability, surface, and personal exploration. Discussing Winokur's work, Dormer observes that it is, "quiet, observant, reflective and feminine," yet he adds, "This is emphatically not to use feminine as a simile for weak or retiring, but to indicate again the sense of control and care which quite frequently marks out art made by women."[75] Clearly influenced by feminism and postmodernism, Dormer's writing reveals the paradigm shift which has taken place in recent years.

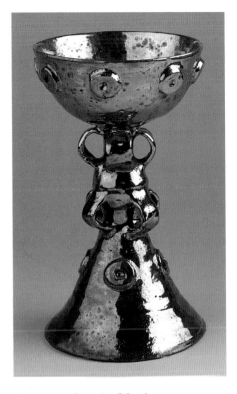

Fig. 15-17. Beatrice Wood. Chalice, ca. 1975–83. Glazed earthenware. Collection of Denis Gallion and Daniel Morris, Historical Design, New York *Checklist no. 143*

Fig. 15-18. Joyce Kozloff. Tiles in the vestibule of the Amtrak Station, Wilmington, Delaware, 1984.

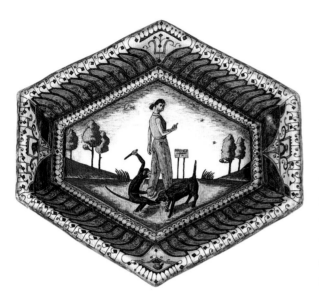

Fig. 15-19. Anne Kraus. "Peaceable Kingdom" bowl, 1985. Glazed porcelain. Everson Museum of Art, Syracuse, New York, Gift of Garth Clark (P.C. 85.74). *Checklist no. 158*

Kozloff's ceramic designs have "incorporated feminist and social issues, critiquing the biases implicit in the Western concept of high art."[76] Co-founder of the Pattern and Decoration group in 1975, Kozloff distanced herself from her fine art training, becoming more interested in the crafts, particularly jewelry, textiles, and ceramics.[77] As decoration and pattern functioned as form for Kozloff, she became interested in using decoration as a source for feminist practice. This led her to investigate the social and cultural meanings of different types of decoration and, ultimately, to realize that "although her intention was to break down the barriers between the high and low arts, from the Western point of view she was simply transforming craft sources into high art."[78] In an attempt to overcome this she involved herself in large-scale public art and craft projects, designing, for example, decorative tiles for the subway station at Harvard Square, Cambridge, Massachusetts (1979–85), and the suburban train station in Wilmington, Deleware (1985; fig. 15-18). Richly patterned and frequently figurative, these decorative schemes attempt to highlight regional and cultural differences, as well as to reassert the validity of the crafts and the ornamental.

Working with Kozloff under the auspices of the Pattern and Decoration group was Betty Woodman. They had worked together in 1981 at the Tibor de Nagy Gallery in New York, when Woodman made pots that Kozloff painted.[79] However, Woodman, a graduate of Alfred University, was already well established as a potter by the 1950s. Initially producing utilitarian ceramics, she became increasingly eclectic, appropriating features from a variety of cultures and periods. According to Dormer, she "kept the torch of decoration alight during the matt-grey days of modernism, minimalism and conceptualism."[80] In her increasingly "fine art" pieces, Woodman retains an interest in the functional qualities of pottery, but working on a large scale, she plays with the meaning of "function" by exploring the innate characteristics of the clay.[81]

Highlighting another aspect of women's experience of ceramics, the designs of Anne Krauss are small-scale and domestic, combining items of everyday use, such as teapots, cups and saucers, and bowls, with autobiographical fragments that point to a personal narrative (fig. 15-19)[82] and texts that refer to "women's culture." Although adopting craft methods, materials, and processes, Krauss, who was trained in fine art, also explores the boundaries of art and craft in her work. Like Kozloff, she is both contributor to and the beneficiary of the feminist interventions in art, design, and craft of the last thirty years, which have legitimized the reassertion of the domestic, decorative, small-scale, and personal.

Dorothy Hafner designed simultaneously for industrial and one-off ceramic production.[83] Throughout the 1980s she worked for firms such as Rosenthal AG, for whom she designed shapes and patterns including "Mars Landing" and "Flash" (fig. 15-20), while also producing one-of-a-kind pieces such as "Cha-Cha." She acknowledges that these two aspects of work constantly "nourish" each other.[84] Although trained as a fine artist, Hafner commented, "I do not consider myself a painter. I consider myself a decorator because of my iconography and context. It interests me to develop decoration that is of my time."[85] She also enjoys and is highly

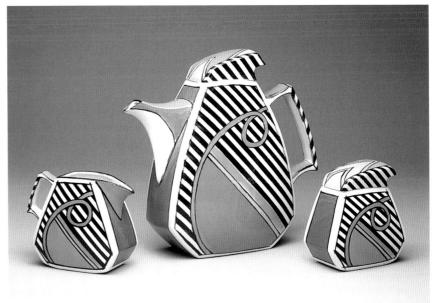

skilled at designing form, much of which is directly influenced by postmodernism. Hafner's designs emerged in response to the "complexity and con tradiction" that are at the heart of effective design. Informed by the increasingly political agenda of second-wave feminism, which argued for the reevaluation of "women's work" and decoration, and suggesting the complexities and contradictions of women's culture, Hafner's quietly subversive work is not overtly political. By designing both shape and decoration, however, she defied conventional gender roles within industrial ceramics, which continued to separate male designers of form from female designers of decoration.

Fig. 15-20. Dorothy Hafner. "Fred Flintstone, Flash Gordon, and Marie Antoinette" coffee service prototype with "Blue Loop with Headdress" decoration, 1981-84. Glazed porcelain. Collection of Dorothy Hafner. *Checklist no. 153*

The history of women ceramics designers in twentieth-century America is a complex and varied one. It encompasses the "roots," which Marguerite Wildenhain identified in her spirited riposte to Bernard Leach, and it has been enriched by the "thousand parts" which she claimed as a characteristic of America. Wildenhain and other women of her generation, such as Mary Scheier, Gertrud Natzler, and Maija Grotell, established a number of powerful precedents for how women could engage with the art, design, and craft of ceramics. They, along with numerous other women, including those working in industrial ceramics, such as Eva Zeisel, Belle Kogan, and Edith Heath, worked to challenge the gender divisions that had existed in American ceramics by integrating form and decoration in the different contexts of the Arts and Crafts movement, studio pottery, and modernism. Subsequent generations, including Karen Karnes (fig. 15-21), Betty Woodman, Dorothy Hafner, and Ellen Shankin, have benefited from their example, and they in turn have questioned the nature of the clay, the function of the pot, and the meaning of decoration. At the start of the twenty-first century, women can be justly proud of their contribution to American ceramics over the preceding hundred years.

Fig. 15-21. Karen Karnes, in her studio, Morgan, Vermont, 1992.

Fig. 16-1. Zuzana Licko. Brochure with "Mrs Eaves" typeface, 1995–96. Brochure designed by Rudy VanderLans and printed by Peter Koch, 1996, published by Emigré Fonts. Letterpress. Private collection. *Checklist no. 197*

16

ELLEN LUPTON

Colophon: WOMEN GRAPHIC DESIGNERS

GRAPHIC DESIGN IS THE ART OF COMBINING WORDS AND IMAGES for public dissemination. Graphic designers create the visual and physical framework for published information, from books and magazines to packaging, environmental signage, and digital media. Designers regulate the tempo and texture of information on page, screen, and street.

A colophon is a note appearing at the end of a book that describes the volume's design and production. From the Greek *kolophon,* meaning summit or finishing touch, such commentary falls outside a publication's main body of content, belonging to the technical apparatus of end matter, along with the index and other credits. A summit is also a peak, a climax, and it is fitting that in a book about the field of design in its broadest sense, the final chapter should confront the medium of publishing itself.

The preceding chapters present remarkable evidence of women's creativity in the applied arts, across a wide range of practices and over a century. The pages themselves and the cover that encloses them are also evidence of design, reflecting the efforts of a team of collaborators. The letters that have been gathered together to form printed words also are objects of design, exemplars of the art of typography.

This book is set in Mrs Eaves, a typeface designed by Zuzana Licko in 1996 (fig. 16-1). Mrs Eaves is a revival of the eighteenth-century types of John Baskerville, an English typographer. Whereas most modern revivals of historic typefaces impose ideals of regularity and compactness onto past forms, Mrs Eaves is organic and lyrical, favoring the extension of vertical lines over the bottom-heavy but space-saving proportions typical of twentieth-century letterforms. Licko named her font Mrs Eaves, after Baskerville's intimate friend and housekeeper. Together with Rudy VanderLans, Licko founded the company Emigre in 1984, which produces digital typefaces and the magazine *Emigre.* She pioneered the design of typefaces for use within the nascent culture of "desktop publishing."

Licko's early fonts were simple and geometric, emphatically embracing the limitations of early laser and dot matrix printers. Her more recent work exploits the capacity of digital media to approximate the complex curves of past typographic technologies.[1]

Within the field of graphic design, Licko's work is by no means marginal. She belongs indisputably among the most gifted and influential typeface designers of her generation, regardless of sex. The pages that follow describe the work and careers of many women who were among the best designers of their century. While graphic design is concerned, fundamentally, with margins—with setting the frame for content—many of the women described here helped construct their profession from its core.

The book, a physical artifact and a medium of communication, offers an appropriate opening for a survey of women graphic designers. Today, women are among the most influential designers of American books, having forged key paradigms in the exterior packaging and internal architecture of jacket and page. Across the twentieth century, women found opportunities to work in the publishing world—as editors and authors as well as designers.

The printing trades had provided employment for women during the nineteenth century, especially as typesetters, although they were subject, as in other trades, to lower pay for equal work. [2] During this industrial era, the appearance of books, magazines, and advertising was largely determined by printing technicians. In the second half of the nineteenth century, the field (then better known as "commercial art") of graphic design began to emerge as an artistic discipline.

The transformation of book design owed much to the Arts and Crafts movement, which revered the book as an object both functional and aesthetic, a part of everyday life yet worthy of care and adornment. William Morris had turned to typography in the 1890s, late in his career. Reacting against the harsh, sparkling pages of spiky type made possible by nineteenth-century printing and paper technologies, Morris reclaimed the weighty, dull-edged letters of early Renaissance typography. [3]

The Arts and Crafts movement that spread from Britain to the United States at the end of the nineteenth century nurtured a new attentiveness to the book arts promoted by the operators of small private presses as well as by designers working for commercial publishers. Margaret Armstrong's design for *Wanted: A Matchmaker* exemplifies the Arts and Crafts ideal of approaching the book as a total object, from outside to inside (figs. 16-2 and 16-3). With its use of slender, attenuated letterforms and light colors, *Wanted: A Matchmaker* rejects the ponderous density of William Morris's printed pages in favor of a more conventional and pragmatic attitude, appropriate to the book's commercial distribution and light-hearted romantic content.

Fig. 16-2. Margaret Armstrong. Dust jacket and cover for *Wanted: A Matchmaker*, 1900. Published by Dodd, Mead & Company, New York. Die-stamped cloth binding. Private collection.

Promoting moral uplift through meaningful labor, the Arts and Crafts movement was relatively open to women, who belonged to many of the Arts and Crafts societies founded around the turn of the century. As historian Ellen Mazur Thomson has argued, membership in clubs aided designers' professional advancement, and apart from the Arts and Crafts organizations, most denied access to women until much later in the century.[4]

In Boston, a strong publishing industry provided fertile ground for experiments with typography, calligraphy, illumination, illustration, and bookbinding. The Society of Arts and Crafts, Boston, founded in 1897, celebrated the book arts in its exhibitions and included numerous women among its active members, such as Sarah Wyman Whitman, Julia DeWolf Addison, Mary Crease Sears, and Amy Sacker. Several of these designers ran small schools and workshops and taught bookbinding, illustration, and other skills in fields that might provide suitable employment for young women.[5]

While the workshop of Mary Crease Sears produced hand-tooled bindings using luxurious materials, other Boston designers worked in the commercial arena. The prominent society woman Sarah Wyman Whitman designed numerous machine-stamped bindings for Houghton Mifflin, as well as interiors and stained glass windows and screens for private clients.[6] Amy Sacker's 1902 design for the commercial binding of *The Kindred of the Wild* achieves a sense of depth and drama with a minimal number of colors and simple, linear illustrations (fig. 16-4).

Fig. 16-3. Margaret Armstrong. Page design for *Wanted: A Matchmaker*, 1900.

Fig. 16-4. Amy Sacker. Book cover for *The Kindred of the Wild*, 1902. Published by L. C. Page and Company, Boston. Die-stamped cloth binding. Collection of Sandra S. Adams. *Checklist no. 2*

While the Arts and Crafts movement provided philosophical fuel for progressive graphic design in the early twentieth century, by the 1940s the formal and technological experiments of the Bauhaus and such European avant-garde movements as Futurism, Constructivism, and Surrealism had reached a small community of American designers.[7] Fewer women gained entrance to this new American vanguard than to the fine press movement. Among them was Elaine Lustig Cohen, who married the graphic designer Alvin Lustig in 1948. Elaine Lustig managed her husband's studio in Los Angeles and later New York, serving as an all-purpose secretary, production assistant, and draftsperson—the "office slave," as she recalls.[8] Alvin Lustig suffered from diabetes, a condition that led to blindness, and as he lost his eyesight, he increasingly relied on his wife to implement his ideas.

After Alvin Lustig's early death in 1955 at age forty, Elaine married Arthur Cohen, publisher of Meridian Books, and established her own design practice. In her innovative covers for Meridian Books, designed from 1955 through 1961, she used geometric symbols, evocative photographs, and expressive typography. For her cover for *The Noble Savage 4*, she affixed a typo-graphic mustache to a marble statue, adorning a literary journal with a Dada flourish (fig. 16-5).

Fig. 16-5. Elaine Lustig Cohen. Cover for *The Noble Savage 4*, 1959. Offset lithograph. Cooper-Hewitt, National Design Museum, Smithsonian Institution, New York, Gift of Tamar Cohen and Dave Slatoff (1993-31-37). *Checklist no. 110*

Several women were leaders in the postmodern return to historical styles that reshaped the top level of commercial book cover and jacket design in the 1980s. Working in New York, designer Louise Fili literally changed the surface of mainstream publishing, rejecting the shiny finishes and garish foil-stamping that served as standard packaging for mass-market books. Fili's designs for Pantheon used matte, laminated coatings to create mysteriously soft yet durable, highly plasticized surfaces. Her cover for Marguerite Duras's *The Lover* (1983) was a lasting icon, later serving as the basis for the motion picture promotion (1992). Along with her contemporary Carin Goldberg, Fili explored historic alphabets and decorative vocabularies, assembling these elements with a modern sense of color and composition.[9]

The neo-historical designs of Fili and Goldberg readied the publishing industry for a more flexible approach to cover and jacket design, a medium made rigid by conservative editors and marketing managers. Carol Devine Carson became art director of Alfred A. Knopf, a division of Random House, in 1987. According to Carson, the book business traditionally has made a place for women: "We have always done a lot of the real work in this industry. The difference in the past fifteen years is that it's more common for women to be rewarded for the work they do."[10] Carson and her core staff of gifted younger designers—Chip Kidd, Barbara de Wilde, and Archie Ferguson—transformed bookstore shelves across the country.

Knopf's covers often impart new meanings to familiar images by changing their scale or shifting their context. Carson's designs for books such as *Damage*, *Degree of Guilt*, and *Midnight in the Garden of Good and Evil* became icons of popular culture in the 1990s. Her cover for Anne Carson's *Autobiography of Red* takes a distant view, its modesty undercut by the implied eroticism of an erupting volcano, heaving like a breast from the supine earth (fig. 16-6).

Fig. 16-6. Carol Devine Carson. Dust jacket for *Autobiography of Red*, 1998. Published by Alfred A. Knopf, New York. Offset lithograph. Collection of Carol Devine Carson. *Checklist no. 212*

The interior architecture of books, and not just their facades, has also been subject to renovation. In the publishing industry, the design of covers typically is divorced from the design of a book's content, especially in text-dominated works of literature and nonfiction. In an organization like Random House, the interior pages often follow a formulaic design, in contrast with the glamour and novelty afforded the book's cover. Illustrated volumes about art and architecture are a different matter, however, involving a greater level of skill to successfully combine elements.

As design director at MIT Press, Muriel Cooper focused on the book as an intelligent device for storing information. In 1974 she became one of the first designers to set her own type on a computer, using an IBM system to design Herbert Muschamp's collection of essays, *File Under Architecture*. The only font available was Courier, but this limitation was offset by the freedom discovered in "mise-en-page" typography. Cooper's other groundbreaking books for MIT included the first edition of *Learning from Las Vegas* (1972), a large-format interpretation of the now-famous pop document, and Hans Wingler's *Bauhaus* (1969), a vast archive of visual and verbal documents compiled within a massive yet eminently manageable volume over 650 pages long.

Lorraine Wild's 1985 design for *Mask of Medusa*, a book of images and texts by architect John Hejduk, was published by Rizzoli at a moment when architects were producing an astonishing number of monographs, each an assertion of personal greatness and professional viability during a period of rapid stardom in the field of architecture. The acknowledged master of the architectural monograph was Massimo Vignelli. Often using a single typeface, he orchestrated his books around a consistent grid, creating a cinematic sequence of images—large views underscored with drawings and plans, fullpage images confronted with generously framed details. Vignelli's books are big, simple, and direct.

Fig. 16-7. Lorraine Wild.
Book design for *Mask of Medusa*,
1985. Published by Rizzoli,
New York. Offset lithograph.
Private collection.
Checklist no. 160

Then along came *Mask of Medusa*, a tribute to poetics, which asserts the architect's pleasure with ideas rather than the construction of monuments (fig. 16-7). Wild used varied column widths and a range of typefaces to interpret a rich diversity of texts—poems, commentaries, interviews. Working before the Macintosh computer put the tools of typesetting into the hands of the graphic designer, Wild carefully customized her approach to each section of Hejduk's work, creating a book of enormous subtlety.

The sea change signaled by *Mask of Medusa* expanded beyond the architectural monograph; Wild's exhibition catalogues, designed for the Whitney Museum of American Art and other institutions, helped revise standard expectations of the museum publication as a neutral portfolio of essays and reproductions. The book, like the installation of works in a gallery, became recognized as an interpretive context. Other women designers working in the 1990s who helped rethink the art book included Bethany Johns, Laurie Haycock Makela, Rebeca Méndez, Susan Silton, and Susan Sellars.

Fig. 16-8. Cipe Pineles. Proposed cover for *Vogue*, December 1, 1939. Paper collage. Wallace Library, Rochester Institute of Technology, Cipe Pineles Collection, Archives and Special Collections. *Checklist no. 68*

Magazine publishing is another field where women have found opportunities to thrive. While names such as Grace Mirabella (*Mirabella*), Tina Brown (*Vanity Fair* and *The New Yorker*), and Anna Wintour (*Vogue*) have figured high on the mastheads of great magazines, women's roles as art directors and designers have been far less prominent. An exception is Cipe Pineles, whose brilliant achievements beginning in the late 1930s recently were documented in a critical biography by Martha Scotford Lange.[11] Pineles, a Polish immigrant who came of age in Brooklyn, began working in 1932 as assistant to M F Agha, art director of *Vogue* and *Vanity Fair*. Agha, testing ideas from European modernism within the heady world of New York publishing, was forging new attitudes toward photography and layout. He conducted many of his experiments with Pineles at his side but gave her considerable independence, and she designed numerous significant projects on her own. For a *Vogue* cover proposed in 1939, Pineles drew the magazine's name with jewelry and pushed the model off the edge of the page (fig. 16-8).

Fig. 16-9. Bridget de Socio. Magazine cover for *Paper*, 1995. Offset lithograph. Published by Paper Magazine Publishing, New York.

In 1942 Pineles became art director of *Glamour*, a Condé Nast publication directed at younger women. The looser and more popular style Pineles crafted there was linked to modernist principles of structure and abstraction while making playful use of images and type. Her open-hearted brand of modernism continued to evolve in her work as art director of *Seventeen* (1947-50), *Charm* (1950-59), and *Mademoiselle* (1959-61). She paid close attention to the physical setting of fashion shoots and their two-dimensional impact, using typography to echo and emphasize images. Approaching the magazine as an environment with its own scale, as well as a window onto other worlds, Pineles often staged three-dimensional objects on the page, allowing samples of reality to converse with printed texts.

Although few women achieved the status of magazine art director in the 1940s and 1950s, some filled other executive positions. Estelle Ellis, a colleague and collaborator of Pineles, became promotion director of *Charm*, the "magazine for women who work," in 1944. She had also worked with Pineles on the marketing of *Seventeen*. In 1951 Ellis commissioned one of the first market surveys of working women, charting women's spending on shoes, stockings, cosmetics, and other high-status items worn in the office. Ellis worked with women designers on some of her advertising campaigns, including Helen Federico, who used modernist collages and photograms to depict the material world of the working woman.[12]

In more recent decades, several women have served as chief designers for major magazines. Bea Feitler was art director of *Harper's Bazaar*, *Ms.*, and *Rolling Stone* during the 1960s and 1970s.[13] Rhonda Rubinstein has worked since the late 1980s as art director of *Esquire, Mother Jones*, and other publications. New York's downtown-style magazine *Paper* was given its signature identity—irreverent photography and pop-retro typography—by art director Bridget de Socio during the 1990s (fig. 16-9).

Perhaps the most influential magazine of the 1990s, conceived and executed by women, has been *Martha Stewart Living*, which has had a considerable impact not only on publishing but on electronic media, the mail-order catalogue business, and mass-market merchandising.[14] Launched in 1991, *Martha Stewart Living* revolutionized the genre of the home style magazine. Any subsequent publication dealing with cooking, gardening, or decorating, as well as any upscale catalogue devoted to home furnishings, has been forced to confront the *Martha Stewart Living* ethos, with its use of soft, organic colors, crisp, overlapping typography, and atmospheric photographs that seek to capture the effects of natural light, often by combining soft and sharp focus within a single shot.

The magazine's distinctive look was created by Gael Towey, who now, as creative director of Martha Stewart Living Omnimedia, oversees the design of all the company's products, publications, and programs. With a circulation of over 2.1 million, *Martha Stewart Living* presents a mix of articles—at once

Fig. 16-10. Gael Towey, creative director. Eric A. Pike, art director. Agnethe Glatved, designer. Christopher Baker, photographer. "Farmstead Cheese" magazine layout, *Martha Stewart Living*, 1995. Offset lithograph. Martha Stewart Living Omnimedia.

educational and sensual—that combine detailed, original research with a romantic sensibility that provokes pleasure and longing. An article about cheese juxtaposes a photograph of a lamb against a tower of handmade cheeses, staggering in its variety and scope (fig. 16-10).

The magazine's editorial content fuels the company's product development. The Martha Stewart brands of paint, for example, originated in an article about decorating with color, inspired by the eggs from Stewart's own flock of Auracana chickens. An exclusive line of paints was put into production, and later, a less expensive grade was developed for sale nationwide in Kmart stores. Thus a magazine, created by one of America's most famous women, working with a largely female staff, transformed the everyday domestic environment and the way we use and imagine it.

POLITICAL AND PUBLIC REALMS

A book or magazine is an inward volume of pages reflecting out on the world of events and ideas. Designers use words and images to directly engage the physical environment as well. There is a long tradition in the United States of posters promoting social and political causes or cultural events. Graphic design also marks the landscape with wayfinding systems, commercial signs, and institutional identities, annotating public space with logos, icons, and directional cues.

Suffrage was the central issue for feminism in the early twentieth century. As art historian Paula Harper has pointed out, the suffrage posters of the 1910s (as opposed to cartoons and other graphic work) tended to be conservative in their rhetoric and visual style. While such works dated among the earliest uses of the political picture poster in this century—anticipating the medium's widespread deployment during World War I—the strategies chosen by the posters' publishers and designers aimed to reassure as well as to agitate. While many nineteenth-century feminists had taken a revolutionary stance against society's norms and institutions, many of the suffragists of the

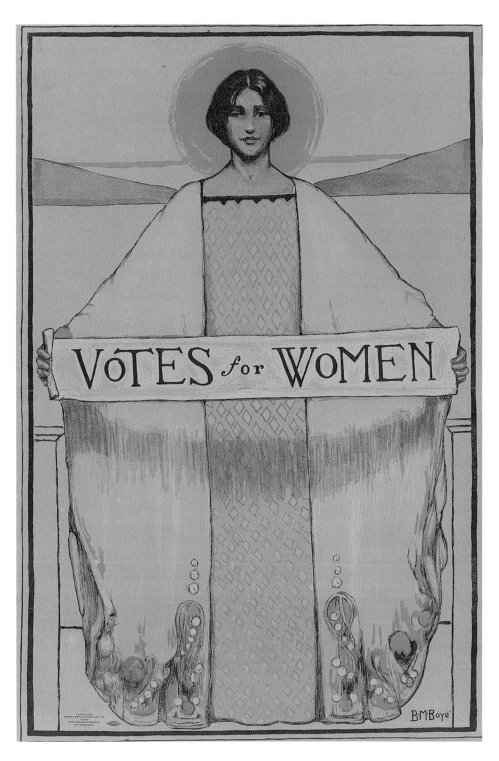

Fig. 16-11. Bertha M. Boyé. "Votes for Women" poster, ca. 1913. Printed by Sierra Art and Engraving Company, San Francisco. Lithograph. Schlesinger Library, Radcliffe Institute for Advanced Study, Harvard University, Cambridge, Massachusetts (GR-1-45). *Checklist no. 21*

1910s did so by suggesting that women's vote would strengthen rather than destroy the existing culture.[15]

Bertha M. Boyé's 1913 poster "Votes for Women" is symmetrical in design, reinforcing the sense of serene stability emanating from the statue-like figure at its center; the orb rising behind her head is both sun and halo, suggesting unambiguous warmth and virtue. The poster's slogan appears not as an argument or battle cry, but as an unassailable truth, an "inalienable right" whose time had come (fig. 16-11).

In contrast to the 1910s, the women's movement of the 1960s and 1970s viewed itself as a counterculture phenomenon, appearing within the context of the battle for Civil Rights, the protest against the war in Vietnam, the international student upheavals of 1968, and the sexual revolution. Feminism's "second wave" unfolded within—and sometimes against—the anti-Establishment freedoms promoted by these movements. Posters, buttons, and bumper stickers, carrying such slogans as "Women's Liberation IS the Revolution" and "Women Are Not Chicks," suggest that feminism was its own battle within the broader counterculture.[16]

The Woman's Building in Los Angeles, conceived as a studio and exhibition space for women's art and design, was founded in 1973 by Sheila Levrant de Bretteville, Judy Chicago, and Arlene Raven. Printing equipment—from offset lithography to letterpress—was made available as a resource for personal and political expression. De Bretteville's 1974 poster "Women in Design: The Next Decade" promoted one of the many public events organized there. Marching across a gridded landscape are eye screws fitted with bolts—translations into hardware of the female symbol that had become the movement's icon (fig. 16-12).

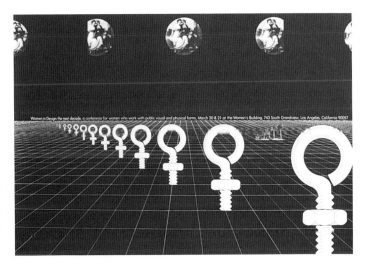

Fig. 16-12. Sheila de Bretteville. Poster for "Women in Design: The Next Decade" conference at the Woman's Building, Los Angeles, 1974. Blueprint. Collection of Sheila Levrant de Bretteville. *Checklist no. 140*

De Bretteville, who worked as a successful commercial designer in the 1980s (redesigning, for example, the *Los Angeles Times*), as well as an educator and public artist through the 1990s, continued to assert her identity as a feminist. Few women designers have willingly used the "f-word," fearful, perhaps, of alienating their colleagues or of casting doubt on the legitimacy of their own success. De Bretteville articulated a set of design strategies in the early 1980s that reflected feminist principles, such as the attempt to represent a subject from multiple perspectives, to allow words and images to contradict each other, or to allow viewers to complete the meaning of a communication.[17] Such strategies coincided with the increasing circulation of postmodern ideas and theories of experimental typography.

Marlene McCarty is part of a younger generation that has used graphic design as a tool of social agitation. She was part of the AIDS activist collective

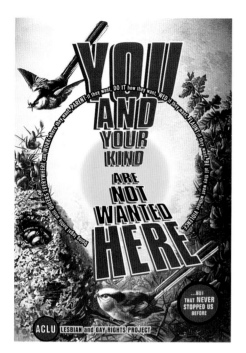

Fig. 16-13. Marlene McCarty and Donald Moffett. "You and Your Kind are Not Wanted Here" poster, 1994. Offset lithograph. ACLU Lesbian and Gay Rights Project, New York.

Gran Fury in the late 1980s and early 1990s, where she helped keep women's issues on the AIDS agenda. McCarty also was an active member of WAC, the Women's Action Coalition, founded in 1992. Together with designer Bethany Johns, she created posters and media-savvy demonstrations on current issues.[18] McCarty founded the New York design studio Bureau with Gran Fury colleague Donald Moffett in 1989. During the 1990s, the firm pursued commercial work for clients such as Clinique and Elektra Records, as well as creating graphics for various political organizations. Their large-scale poster "You and Your Kind Are Not Wanted Here," promoting gay civil rights, was sniped in the streets of New York in 1994. It features birds chirping around an strangely cheerful sunburst, surrounded by an explosion of pop letterforms recalling mainstream consumer packaging (fig. 16-13).

In addition to punctuating the landscape through guerilla postings and political announcements, designers create signage that explains and identifies public spaces. Over the past several decades, information systems increasingly have pervaded the built landscape. A leader in this evolution has been Deborah Sussman, who founded the firm Sussman/Prejza with Paul Prejza in 1980. The firm has created urban signage programs for numerous cities in California, as well as environmentally based identities for corporations such as Hasbro and Apple Computer.

One of Sussman/Prejza's most famous projects was the environmental design program for the 1984 Summer Olympics in Los Angeles: the signs and related kiosks and pavilions needed to guide an enormous international audience through a complex space, while visually celebrating the games and the surrounding city. Sussman's system of bright colors, striped columns, and large-scale graphics was both functional and popularly accessible (fig 16-14).

Fig. 16-14. Deborah Sussman, art director, and Debra Valencia, designer, for Sussman/Prejza & Company. Preview of environmental design for the XXIII Olympiad, Los Angeles, 1984. Collection of Sussman/Prejza & Company.

Fig. 16-15. Deborah Sussman and Paul Prejza. Highway sign for EPCOT Resorts and Disney Village, 1990. Produced by Walt Disney World, Orlando. Sussman/Prejza & Company.

Sussman/Prejza also created signage for Disney World in Orlando, Florida, where the languages of public information and commercial iconography joyfully mingle, as Mickey Mouse peers over the top of a standard-issue highway sign (fig. 16-15).[19]

Paula Scher also creates institutional identities that merge with the built environment. In 1991 Scher became the sole woman among over a dozen partners in the international design firm Pentagram, making her what she has called "the only girl on the football team." That doesn't make her a cheerleader or a trophy date, but an equal player in a pack of heavyweights. Pentagram brought Scher a level of visibility and cultural clout virtually unattainable to a woman working on her own, while in turn, her fresh, energetic approach earned new recognition for Pentagram, a venerable company whose reputation had begun to level off.

Scher's work for clients ranging from museums to global corporations has grown increasingly environmental, encompassing banners, building signs, and urban advertising campaigns. In 1994 she conceived a total design program for the New York Public Theater that ranges from billboards, street signs, and lobby interiors to logos, tickets, and stationery. Scher used a rhythmic mix of sans serif letterforms, drawn from the American printer's vernacular, to construct a visual vocabulary that is both diverse and coherent—like the theater's programming.[20] Many of her posters combine evocative images with dramatic typography to reflect the spirit of the production, rather than showcasing individual stars (fig. 16-16). Although print is Scher's native medium, the impact of her work, like that of Deborah Sussman, Sheila de Bretteville, and Marlene McCarty, is felt most powerfully on the street.

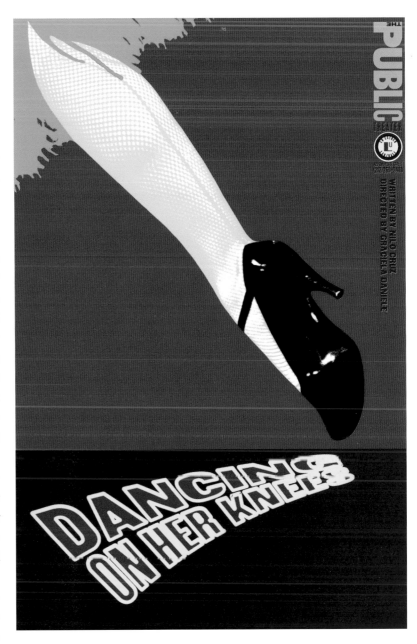

Fig. 16-16. Paula Scher. Poster for *Dancing on Her Knees,* The Public Theater, New York, 1996. Silkscreen. Private collection.
Checklist no. 201

During the last quarter of the twentieth century, women played a central role in building the discourse of graphic design. During this period the profession came of age both as a recognized business and as a field of study in university art and design programs, including at the graduate level. Women were no minority among the educators, critics, editors, and curators who defined the theoretical issues of the time. Schools and museums provided accessible platforms from which women could influence the direction of graphic design.

Many of the women already discussed in this essay as key practitioners also were influential educators, including Cipe Pineles, who taught during the 1960s at Parsons School of Design; Lorraine Wild, a professor at California Institute of the Arts in Valencia, California; and Sheila Levrant de Bretteville, who in 1990 became director of the graphic design program at Yale University School of Art.

De Bretteville's appointment at Yale signaled changes and rifts within the design world. Since the late 1950s, the Yale program had been entrenched in high modernist theory, associated in particular with the work and philosophy of Paul Rand, a legendary corporate designer and stalwart defender of modernist ideals of direct communication and simple form. De Bretteville arrived at Yale advocating a more socially oriented, critical approach to design that would address the needs of multiple audiences. Rand resigned after de Bretteville's appointment and convinced other key faculty to do so as well. In an angry manifesto published in the *AIGA Journal of Graphic Design*, Rand railed against the violation of modernism by screaming hordes of historicists, deconstructivists, and activists.[21] Behind each of these challenges to modernism stood a powerful woman: behind historicism was Paula Scher, behind deconstructivism was Katherine McCoy, and behind activism was Sheila Levrant de Bretteville.

Katherine McCoy, co-director of the design program at the Cranbrook Academy of Art in Bloomfield Hills, Michigan, from 1971 to 1995, promoted ideas of postmodernism and critical theory in relation to typographic practice. She developed pedagogical exercises that converted modernist grids and letterforms into vehicles of personal expression, grounded in vernacular, rather than universal, forms. She and her students developed a model of "typography as discourse," drawing on post-structuralist literary theory, that posited the reader as an active participant in the communications process.[22] Designers at Cranbrook employed layers of texts and images to create complex, deliberately challenging compositions.

McCoy's 1980 poster "Architecture Symbol and Interpretation," created with Daniel Libeskind, shows how the theory of postmodernism that was gripping the architectural community was finding its own life in the field of graphic design. Neoclassical forms are deployed in an unsettlingly

Fig. 16-17. Katherine McCoy and Daniel Libeskind. "Architecture Symbol and Interpretation" poster, 1981. Offset lithograph. Cranbrook Art Museum, Bloomfield Hills, Michigan. *Checklist no. 151*

Surrealist manner and are titled with letters that are modernist in their individual form yet willfully disconnected in their spacing (fig. 16-17).

Many of McCoy's Cranbrook students became prominent teachers and practitioners. Lucille Tenazas, working in New York and then San Francisco, was a student at Cranbrook in the early 1980s. Her 1986 brochure for Springhill engaged neoclassical geometry, photographic imagery, and flat, decorative patterns (fig. 16-18). Nancy Skolos is a Boston-based designer whose 1987 poster "Fonts," produced with photographer Thomas Weddell, plays elaborate games with space, pattern, and dimensionality (fig. 16-19). Laurie Haycock Makela and P. Scott Makela created the poster "Sex Goddess" as a student project in 1989, revealing the turn towards more harsh, direct imagery that took place at Cranbrook at the end of the 1980s (fig. 16-20). The Makelas succeeded Katherine McCoy as co-directors of the school's two-dimensional design program in 1997. Since Scott Makela's death in 1999, Laurie Haycock Makela has filled the post on her own.

Fig. 16-18. Lucille Lozada Tenazas. Brochure and cover design for *The Third Dimension*, 1986. Offset lithograph, cardboard, and plastic. Collection of Lucille Lozada Tenazas. *Checklist no. 163*

Fig. 16-19. Nancy Skolos. "Fonts" poster, 1987. Offset lithograph. Private collection. *Checklist no. 164*

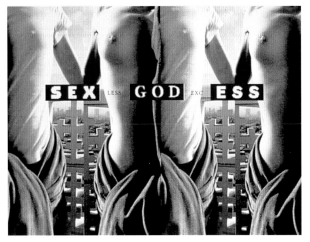

Fig. 16-20. Laurie Haycock Makela and P. Scott Makela. "Sex Goddess" poster, 1989. Silkscreen on diazo print. Student project at the Cranbrook Academy of Art, Bloomfield Hills, Michigan.

Fig. 16-21. Rebeca Méndez. "This Sentence is Weightless" poster for the Getty Center for the History of Art and the Humanities, Los Angeles, 1992. Lithograph. Collection of Rebeca Méndez. *Checklist no. 176*

Rebeca Méndez is another designer who built a remarkable career while working within an institutional setting. Born and raised in Mexico City, she studied design at the Art Center College of Design in Pasadena, California.[23] While serving as the school's design director from 1991 to 1996, she created numerous publications and posters for the school and other institutions. Méndez combines typography and photographs in delicate, permeable layers, exploiting the possibilities of digital production in ways that engage the physicality of surfaces (fig. 16-21).

In addition to their roles in schools, women occupied positions of great influence in museums during the late twentieth century. Mildred Friedman, as design director at the Walker Art Center in Minneapolis from 1970 through 1991, set an international standard for exhibitions and publications on design. In 1989 she curated the first large-scale museum survey of graphic design in the U.S., an exhibition that greatly expanded public knowledge of graphic design.[24] Among the legions of other women who have promoted design awareness through their museum work and publishing during the 1980s and 1990s were Karrie Jacobs, Dianne Pilgrim, Chee Pearlman, and several of the women contributing to this volume. Such critics and curators labored hard to raise the level of public discourse about design.

Fig. 16-22. Elaine Bass and Saul Bass. Title sequence for *The Age of Innocence* (1993, Dir. Martin Scorsese). Film excerpt. Courtesy of Columbia Pictures. *Checklist no. 185*

While the printed word provides an apt opening for discussing design in the twentieth century, the screen suggests a view to the future. Designers have produced graphics for film and television since the inception of these media, and new genres have continued to emerge with the explosion of interactive and networked technologies.

One of the great pioneers of film title design was Saul Bass, who, from the 1960s, increasingly collaborated with his wife, Elaine Bass, on film design. In the 1990s they jointly created several stunning film titles. Their opening titles for films such as Martin Scorsese's *Cape Fear* (1991), *The Age of Innocence* (1993), and *Casino* (1995) were conceived as films-within-a-film, narrative sequences that set the tone for the drama to follow, in a language that is at once set apart from the main film and compatible with it. Of the titles for *The Age of Innocence* (fig. 16-22), they commented: "The title was deliberately ambiguous and metaphorical. The kinds of notions we had in mind involved an attempt to project the romantic aura and surface of the period and still signal its submerged sensuality and hidden codes."[25] Younger designers for film include Karin Fong, an art director at Imaginary Forces in Hollywood, whose witty titles for *Dead Man on Campus* (1998) consist of a meandering pan across a page of primer-style instructions for committing suicide. Emily Oberman and Bonnie Siegler, co-founders of Number

Fig. 16-23. Margo Chase. "ESPN Billiards" logo and opening sequence for cable channel, 1995. Film. Collection of Margo Chase Design, Los Angeles. *Checklist no. 190*

Fig. 16-24. Muriel Cooper. "Information Landscapes," 1994. Film. Collection of Massachusetts Institute of Technology, Cambridge, Massachusetts, Media Lab. *Checklist no. 188*

17, a New York studio, have created numerous graphics for television, as has the Los Angeles designer Margo Chase (fig. 16-23).

A pioneer of design for digital media was Muriel Cooper, who founded the Visible Language Workshop, part of MIT's Media Lab, in 1975. Cooper worked with her students to create an electronic language for building "typographic landscapes"—complex, malleable documents in real time and three-dimensional space (fig. 16-24). Cooper gave concrete functions to such principles as layered information, simultaneous texts, and typographic texture.[26] April Greiman's film, *Inventing Flight,* carries forward some of Cooper's ideas about text as three-dimensional form (fig. 16-25).

Many women are excelling today in the fields of user-interface design and electronic media, including Red Burns, head of New York University's Interactive Technology Program; Jessica Helfand, critic and designer of interactive media; and Loretta Staples, head of U dot I, specializing in the design of graphic user interfaces (GUI). Perhaps "interface" is an electronic couterpart for realms of culture that traditionally have been feminized. Office tasks known as "women's work" often involve mediating technologies. From answering phones, transferring calls, and taking messages to typing letters and making copies, female office workers historically have formed a human link between managers and machines; women have served as bodily extensions for communications equipment. The contemporary ideal of the "user-friendly" electronic environment reflects the continued desire to humanize technology.

Fig. 16-25. April Greiman and Dale Herigstad. *Inventing Flight* film for 2003 "Century of Flight" Exposition, Dayton, Ohio, 1999-2000. Quicktime movie. Courtesy of April Greiman. *Checklist no. 220*

WOMEN PLAYED IMPORTANT ROLES in the evolution of graphic design across the twentieth century. From the re-valuation of the book spurred by the Arts and Crafts movement to the extension of typography beyond the printed page to the built environment and the luminous screen, women have found opportunities to create work of beauty and significance, shaping the field of design as well as the broader culture.

Yet despite the fantastic successes documented here, women have always been minority players. It is striking how many successful women designers in the twentieth century worked in partnership with powerful male practitioners (Elaine Bass, Zuzana Licko, Laurie Haycock Makela)—such connections to established power are not inconsequential. It is easy for young designers today to discount the importance of the pioneering women who entered a less open field; it is also easy to assume that the balance of male and female students in schools of art and design ensures an equal balance in the workplace. Although women represent a large part of the design profession, they still do not predominate at the very top, in terms of income or access to large-scale commissions. Deborah Sussman, Paula Scher, and Gael Towey are exceptional in their leadership of large businesses; more typical are the modestly scaled studios run by Lucille Tenazas, Lorraine Wild, and Rebeca Méndez.

Some comments from a 1918 portfolio of American design, published by a paper company, remain telling today. The author, after referring to the feminization of the commercial arts in the 1880s, suggested that woman's place in the world of advertising and editorial art was by now well-established. Stating that in earlier decades, women felt compelled to create work in a masculine character ("heavy masses, over-thick lines and general splash and dash"), the author asserted that the female designer was now free simply to be feminine:

> Having got what she wanted it is no longer necessary for her to assert her-
> self Being taken for granted, she is free to employ her native gifts in
> her own field, where man cannot compete; she can be delicate, subtle,
> alluring and even soft, calm in the knowledge that "a charming exterior is
> no proof of superficiality."[27]

The idea that women's place is safely guaranteed and that self-assertion is neither attractive nor necessary could provide false comfort to young women today. Although graphic design is a field that women helped to shape, there remains ample room for expanding their opportunities. May the next generation of women designers stake out new territories in the changing landscape of media and communication!

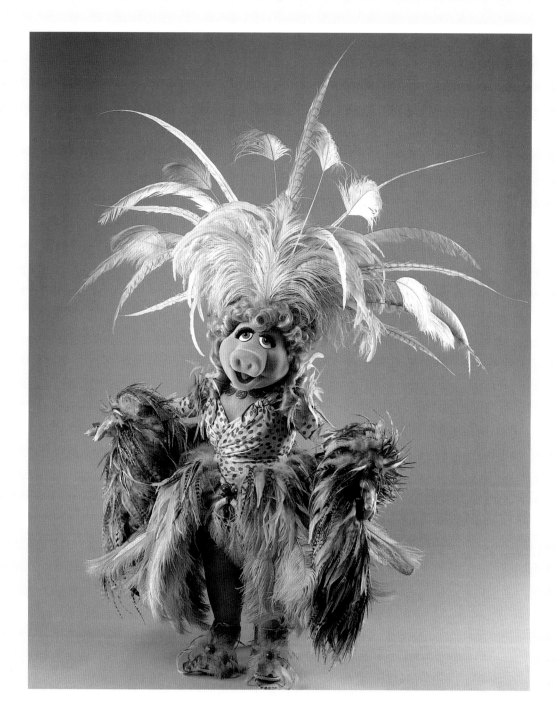

Cat. no. 189. Polly Smith.
Costume for Miss Piggy as
Benjamina Gunn in *Muppet
Treasure Island*, 1995.

Checklist of the Exhibition

The objects in the exhibition are listed below in chronological order. Life dates, where known, are included for designers. In the dimensions, height precedes width precedes depth, and abbreviations are sometimes used: L. (length), Diam. (diameter), and so on. For costume, only the overall length of the garment is given. Most film costume and production designs have been represented in the exhibtion by film excerpts. Unless otherwise noted, the film excerpts have been loaned by studios, private collections, or cinema archives.

1. MADELINE YALE WYNNE
(1847–1918)
Belt Clasp
ca. 1900
Brass
3 1/2 x 8 x 7/8 in. (8.9 x 20.3 x 2.3 cm)
Memorial Hall Museum, Pocumtuck Valley Memorial Association, Deerfield, Massachusetts, Gift of Mary Marsh (1980.80.15)

2. AMY SACKER (1876–after 1940)
Book Cover for *The Kindred of the Wild*
1902
Published by L. C. Page and Company, Boston
Die-stamped cloth binding
8 1/2 x 5 3/4 in. (21.6 x 14.6 cm)
Collection of Sandra S. Adams

3. ANNA MARIE VALENTIEN
(1862–1947)
Vase
ca. 1902
Made at Rookwood Pottery Company, Cincinnati
Glazed earthenware
H. 9 in. (22.9 cm), Diam. 4 1/2 in. (11.4 cm)
Private collection

4. BEATRIX JONES FARRAND
(1872–1959)
Garden Design for C. B. Newbold, Jenkingtown, Pennsylvania
ca. 1903
Watercolor on paper
11 1/2 x 18 1/4 in. (29.2 x 46.4 cm)
Environmental Design Archives, University of California, Berkeley, Beatrix Jones Farrand Collection (1955 2)

5. MARION MAHONY (1871–1961)
Hanging Lamp for the Church of All Souls, Evanston, Illinois
ca. 1903
Leaded stained glass
9 x 23 3/4 x 18 1/4 in. (22.9 x 60.3 x 46.4 cm)
The Mitchell Wolfson Jr. Collection, The Wolfsonian–Florida International University, Miami Beach, Florida (84.13.13.1)

6. ELLEN GATES STARR (1859–1940)
Book Cover for *Paradise Lost*
1905
Printed by Doves Press, Hammersmith, England, 1902; bound by Ellen Gates Starr at Hull House, Chicago, 1905
Moroccan leather binding, hand-tooled in gold
9 1/2 x 6 7/8 x 1 1/2 in. (24.1 x 17.5 x 3.8 cm)

The University of Chicago Library, Department of Special Collections, Gift of Helen Gunsaulus (PR 3560 1902 Rare)

7. MARY JANE COLTER (1869–1958)
Salesroom in Hopi House, Grand Canyon, Arizona
1905
Photograph for Fred Harvey Company, 1905
Courtesy of University of Arizona, Tucson, Special Collections

8. JANE CARSON BARRON
(1879–1942) and FRANCES BARNUM SMITH (1875 – after 1905)
Necklace with Cross Pendant
ca. 1905
Silver, enamel, amethyst, and pearls
Pendant: 3 3/8 x 2 3/8 in. (8.7 x 6.1 cm); *chain:* L. 15 7/8 in. (40.4 cm)
The Cleveland Museum of Art, John L. Severance Fund (1996.290)

9. JESSIE M. PRESTON (active ca. 1910–18)
Candelabrum
ca. 1905
Bronze
H. 13 1/2 x 9 7/8 x 9 7/8 in. (34.2 x 25.1 x 25.1 cm)
Collection of Rosalie Berberian

10. ZULMA STEELE (1881–1979)
Design for "Dragonfly" Wallpaper
1905–10
Watercolor, pen, and ink on paper
17 3/4 x 17 3/4 in. (45.1 x 45.1 cm)
Collection of Jean and Jim Young

11. CLARA BARCK WELLES
(1868–1965)
Bowl
ca. 1905–14
Made at The Kalo Shop, Chicago
Silver
3 x 10 1/4 x 10 1/4 in.
(7.6 x 26 x 26 cm)
Collection of Denis Gallion and
Daniel Morris, Historical Design,
New York

12. MARGARET WHITING (1860–1946)
and ELLEN MILLER (1854–1929)
"Seaweed and Dragon Flies"
Embroidery
1905–16
Made by Deerfield Society of Blue and
White Needlework, Massachusetts
Linen with linen embroidery
15 1/2 x 15 in. (39.4 x 38.1 cm)
Memorial Hall Museum, Pocumtuck
Valley Memorial Association,
Deerfield, Massachusetts (NBW-99)

13. MARY CHASE PERRY STRATTON
(1867–1961)
Vase
ca. 1907–10
Made at Pewabic Pottery, Detroit
Glazed earthenware
H. 12 3/8 in. (31.4 cm), Diam. 6 in.
(15.2 cm)
Collection of R. A. Ellison

14. ADELAIDE ALSOP ROBINEAU
(1865–1929)
Lantern
1908
Glazed porcelain
H. 8 in. (20.3 cm), Diam. 6 in.
(15.2 cm)
Everson Museum of Art, Syracuse,
New York (P.C. 16.4.5)

15. LEONA NICHOLSON (1875–1966)
Tyg (Three-handled Mug)
1908
Made at Newcomb Pottery, New
Orleans

Glazed earthenware
H. 5 1/4 in. (13.3 cm), Diam. 6 1/2 in.
(16.5 cm)
The Metropolitan Museum of Art,
New York, Purchase, Mr. and Mrs.
David Lubart Gift, in memory of
Katherine J. Lubart, 1944-1975, 1983
(1983.26)

16. MARIE DAUGHERTY WEBSTER
(1859–1956)
"Poppy" Quilt (detail shown above)
1909
Quilted and appliquéd cotton
91 1/2 x 82 1/2 in. (232.4 x 209.6 cm)
On loan to the Indianapolis Museum
of Art by Rosalind Webster Perry

17. JOSEPHINE HARTWELL SHAW
(1865–1941)
Pendant Necklace
1910
Silver, gold, and pearls
Pendant: H. 2 5/8 in. (6.7 cm); *chain:* L.
19 1/2 in. (49.5 cm)
Private collection

18. NAMPEYO (ca. 1860–1942)
Jar (Hopi Pueblo)
ca. 1910–15
Polychrome earthenware
H. 11 in. (27.9 cm), Diam. 19 in.
(48.3 cm)
School of American Research, Santa
Fe, New Mexico (IAF 1645)

19. ELSIE DE WOLFE (1865–1950)
Boudoir of Adelaide Howard Childs
Frick, Frick Mansion, New York
1913
Photographed in 1965

Courtesy of The Frick Collection,
New York

20. AGNES F. NORTHROP (1857–1953)
Design for Stained-Glass Window for
Sarah Cochran, Linden Hall,
Pittsburgh, Pennsylvania
ca. 1913
Designed for Tiffany Studios, New York
Watercolor and gouache mounted on
board
13 1/4 x 7 7/8 in. (33.7 x 20 cm)
The Metropolitan Museum of Art,
New York, Purchase, Walter Hoving
and Julia T. Weld Gifts and Dodge
Fund, 1967 (67.654.229)

21. BERTHA M. BOYÉ
(1883–after 1913)
"Votes for Women" Poster
ca. 1913
Printed by Sierra Art and Engraving
Company, San Francisco
Lithograph
Image size: 23 x 15 1/2 in.
(58.4 x 39.4 cm)
Schlesinger Library, Radcliffe
Institute, Harvard University,
Cambridge, Massachusetts
(GR-1-45)

22. ELIZABETH GRAY OVERBECK
(1875–1936) and MARY FRANCES
OVERBECK (1878–1955)
Pitcher
ca. 1914
Made at Overbeck Pottery, Cambridge
City, Indiana
Glazed earthenware
4 3/4 x 8 1/4 x 6 1/8 in.
(12 x 21 x 15.5 cm)
Collection of Stephen Gray

23. CLAIRE WEST (1893–1980)
Costume Design for *Intolerance*
(1916, Dir. D. W. Griffith,
Triangle Productions and Wark
Production Corp.)
ca. 1916
Film excerpt

24. MARIE ZIMMERMANN (1878–1972)
Candelabrum
ca. 1916
Bronze and crystal
28 1/8 x 30 7/8 x 8 5/8 in.
(71.4 x 78.4 x 22 cm)
The Mitchell Wolfson Jr. Collection,
The Wolfsonian–Florida
International University, Miami
Beach, Florida (1990.1847)

25. JESSIE FRANKLIN TURNER
(1881–ca.1942)
Afternoon Dress
ca. 1918–22
Silk crepe with silk floss embroidery
L. 59 in. (152.4 cm)
Brooklyn Museum of Art, Gift of the
estate of Mary Boocock Leavitt
(74.185.6)

26. NELLIE B. ALLEN (1869–1961)
Design for "A Persian Garden"
Dated February 17, 1919
Pencil and watercolor on paper
21 1/2 x 33 in. (54.6 x 83.8 cm)
Cornell University Library, Ithaca,
New York

27. DAT SO LA LEE (LOUISA KEYSER-
DABUDA; ca. 1850–1925)
"Bright Morning Light" Basket
(Washoe)
1921
Tule and bracken fern root
H. 8 in. (20.3 cm), Diam. 8 5/8 in.
(22 cm)
Nevada Historical Society, Reno
(LK80)

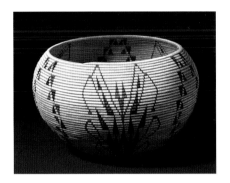

28. LENA FRANK DICK
(ca. 1889–1965)
Basket (Washoe)
1921
Willow, redbud, and bracken fern root
H. 9 1/8 in. (23.2 cm), Diam.14 1/4 in.
(36.2 cm)
Nevada State Museum, Carson City

29. NATACHA RAMBOVA (1897–1966)
Art Direction and Costume Design
for Camille (1921, Dir. Ray C.
Smallwood, Nazimova Productions)
ca. 1921
Film excerpt

30. EDITH BROWN (d. 1932)
Vase
1922
Made at Paul Revere Pottery (Saturday
Evening Girls' Club),
Boston/Brighton, Massachusetts
Glazed earthenware
H. 13 1/4 in. (33.7 cm), Diam. 8 in.
(20.3 cm)
Private collection

31. ELIZABETH ETHEL COPELAND
(1866–1957)
Box
1922
Silver, parcel gilt, painted enamels,
and cloisonne
5 x 7 x 5 1/8 in. (12.7 x 17.8 x 13 cm)
Cranbrook Educational Community,
Bloomfield Hills, Michigan, Gift of
Henry G. Booth (TH 1990.46)

32. ELLEN BIDDLE SHIPMAN
(1869–1950)
Garden Design for Estate of Mrs.
Carll Tucker, Mount Kisco, New York
ca. 1922 (with detail view)
Ink on vellum
30 1/2 x 57 in. (77.5 x 144.8 cm)
Cornell University Library, Ithaca,
New York

33. ANNA WAGNER KEICHLINE
(1889–1943)
Patent for "Kitchen Construction"
Filed January 14, 1924; issued
December 28, 1926
United States Patent and Trademark
Office, No. 1,612,730

34. WINI AUSTIN
"Log Cabin" Quilt
ca. 1925
This example pieced and sewn by Wini
Austin, ca. 1925; quilted by Roberta
Jemison (b. 1928), 1997
Cotton
85 x 76 in. (215.9 x 193 cm)

The Helen and Robert Cargo Collection of the International Quilt Study Center at the University of Nebraska, Lincoln

35. JANET PAYNE BOWLES
(1872/3–1948)
Fork
ca. 1925–29
Silver
L. 9 5/8 in. (24.5 cm), W. 3 in. (7.6 cm)
Indianapolis Museum of Art, Gift of Jan and Mira Bowles in memory of their mother, Janet Payne Bowles (68.21.98)

36. LILLIAN GISH (1893–1993) and LUCIA COULTER (ca. 1863–1936)
Costume Design for Lillian Gish as Mimi in *La Bohème* (1926, Dir. King Vidor, MGM)
ca. 1926
Film excerpt courtesy of Warner Brothers

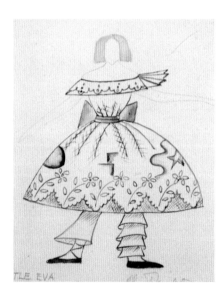

37. ALINE BERNSTEIN (1882–1955)
Costume Design for Little Eva in *Uncle Tom's Cabin*
ca. 1926–36 (Off-Broadway production)
Ink, pencil, and watercolor on board
10 x 7 in. (25.4 x 17.8 cm)
New York Public Library for the Performing Arts, Billy Rose Theatre Collection

38. JULIA MORGAN (1872–1957)
Study for Tiling to Top of Stair Tower, William Randolph Hearst Estate, San Simeon, California
1927
Graphite and colored pencil on tissue paper
13 3/4 x 10 in. (34.9 x 25.4 cm)
The Mitchell Wolfson Jr. Collection, The Wolfsonian–Florida International University, Miami Beach, Florida (TD1997.17.1)

39. MARISKA KARASZ (1898–1960)
Day Ensemble
ca. 1927
Silk and silk appliqué
Jacket: L. 31 1/2 in. (80 cm); *dress:* L. 40 1/2 in. (102.9 cm)
The Metropolitan Museum of Art, New York, Gift of Katherine J. Judson, in memory of Jeanne Wertheimer, 1977 (1977.284.2ab)

40. LOÏS MAILOU JONES (1905–98)
Design for "Totem Poles" Textile
1928
Tempera on paper
17 x 17 in. (43.2 x 43.2 cm)
Estate of Loïs Mailou Jones

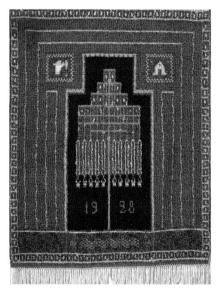

41. LOUISE (LOJA) SAARINEN
(1879–1968)
Rug No. 1
1928

Woven with Walborg Nordquist Smalley
Wool, cotton, and linen
67 x 57 in. (170.2 x 144.8 cm), excluding fringe
Cranbrook Art Museum, Bloomfield Hills, Michigan (CAM 1955.4)

42. MARJORIE SEWELL CAUTLEY
(1891–1954)
Proposed Plaza Park Plan No. 2 for City Housing Corporation, Radburn, New Jersey
1928
Ink on linen
31 1/4 x 28 in. (79.4 x 71.1 cm)
Avery Architectural and Fine Arts Library, Columbia University in the City of New York

43. ELSA TENNHARDT
Cocktail Set
ca. 1928
Manufactured by E. and J. Bass Company, New York
Silver plate, glass, and cork
Shaker: 12 x 5 3/8 x 5 3/8 in. (30.5 x 13.5 x 13.5 cm); *six glasses, each:* H. 5 in. (12.5 cm), Diam. 2 3/4 in. (7 cm); *tray:* 1 3/8 x 23 5/8 x 13 7/8 in. (3.5 x 60 x 35 cm)
Private collection, lent courtesy of Historical Design, New York

44. VALERIE (VALLY) WIESELTHIER
(1895–1945)
"Children at Play" Textile
ca. 1929
Printed by F. Schumacher and Company, New York
Linen
37 x 25 3/4 in. (94 x 65.4 cm)
F. Schumacher and Company Archives, New York

45. LUCY PARKER TELLES
(1870–1956)
Lidded Basket (Miwok Paiute)
1930
Squawgrass and maidenhair fern
H. 10 in. (25.4 cm), Diam. 20 in. (50.8 cm)
Colorado Springs Fine Arts Center, Taylor Museum, Gift of the estate of Phillip B. Stewart (TM5641)

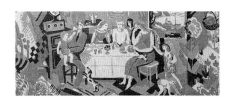

46. RUTH REEVES (1892–1966)
"American Scene" Textile (detail
shown above)
1930
Commissioned by W. and J. Sloane,
New York
Block-printed cotton
105 1/2 x 47 1/4 in. (268 x 120 cm)
Yale University Art Gallery,
New Haven, Connecticut,
The John P. Axelrod, B.A. 1968,
Collection of American Art
(1995.49.7)

47. FANNIE NAMPEYO (1860–1942)
Jar (Hopi Pueblo)
ca. 1930
Polychrome earthenware
H. 6 in. (15.2 cm), Diam. 8 in.
(20.3 cm)
The Philbrook Museum of Art, Tulsa,
Oklahoma, Gift of Clark Field
(1942.14.2199)

48. MARY HISTIA (1881–1973)
"National Recovery Act" Jar (Acoma
Pueblo)
ca. 1930
Polychrome earthenware
H. 11 in. (27.9 cm), Diam. 13 in. (33
cm)
Franklin D. Roosevelt Library-
Museum, Hyde Park, New York
(MO 55-107)

49. ILONKA KARASZ (1896–1981)
"Java" Armchair
ca. 1930
Teak and woven flax
27 1/2 x 21 5/8 x 21 5/8 in. (69.9 x 54.9
x 54.9 cm); *seat*, H. 15 5/8 in.
(39.7 cm)
The Metropolitan Museum of Art,
New York, Purchase, Theodore M.
Gamble Jr. Gift, in honor of his
mother, Mrs. Theodore Robert
Gamble, 1983 (1983.228.5)

50. MAGGIE MAZYCK (ca. 1878–1961)
Sewing Basket (shown above)
ca. 1930
Sweetgrass and palmetto leaf
H. 6 in. (15.2 cm), Diam. 10 1/4 in.
(26 cm)
Collection of Mrs. Jervey D. Royall

51. FANNIE B. SHAW
"Prosperity Is Just Around the
Corner" Quilt
1930–32
Pieced, appliquéd, and embroidered
cotton
86 x 72 in. (218.4 x 182.9 cm)
Dallas Museum of Art (1998.209)

52. ANNA RUSSELL JONES (1902–95)
Design for Carpet
ca. 1930–35
Gouache on paper
19 1/2 x 14 3/8 in. (49.5 x 36.5 cm)
The African American Museum in
Philadelphia, Anna Russell Jones
Collection (86.040)

53. RHODA KNIGHT (1890–1958)
Basket (Pomo)
1930s
Willow shoots, sedge root, and bulrush
H. 3 in. (7.5 cm), Diam. 7 1/2 in. (19
cm)
On loan to the Mendocino County
Museum, Willits, California, by
Genevieve Allen Aguilar (EA#51)

54. ELEANOR McMILLEN BROWN
(1890–1991)
Design for Drawing Room of Mrs.
Sheldon Whitehouse, Newport,
Rhode Island
1933
Designed for McMillen, Inc., New

York; maquette made by Grace Fakes
Gouache on board
3 5/8 x 7 3/4 x 9 1/2 in.
(9.2 x 19.7 x 24.1 cm)
Collection of McMillen, Inc., New
York

55. RUTH CLEMENT BOND
"Man with Crane" Tennessee Valley
Authority Wall Hanging
1934
This example made by Rose Marie
Thomas
Pieced and sewn cotton
17 1/4 x 13 5/8 in. (43.8 x 34.6 cm)
American Craft Museum, New York,
Gift of Mrs. Rosa Phillips Thomas
(1994.17.2)

56. ELIZABETH HAWES (1903–71)
Design for At-Home Negligée
1934
Watercolor and pencil on paper with
fabric swatch
12 5/8 x 9 1/2 in. (32.1 x 24.1 cm)
Brooklyn Museum of Art,
Library Collections, Fashion Sketch
Collection

57. DOROTHY DRAPER (1889–1969)
Lobby, Mark Hopkins Hotel, San
Francisco
1935
Photograph
Courtesy of Dorothy Draper and
Company, New York

58. MARIA KIPP (1900–1988)
Drapery Fabric
1935
Handwoven cotton and wool
53 x 23 in. (134.6 x 58.4 cm)
Dallas Museum of Art, The Jane R.
Van Hooser Collection, Gift of Edd
M. Van Hooser, the Stephen W. Van
Hooser family, and the Diana Jane
Shelby family (1998.19)

59. LUCILE YOUNG (1914–92)
Quilt
ca. 1935
Cotton and wool
70 x 69 in. (177.8 x 175.3 cm)
The Helen and Robert Cargo

Collection of the International Quilt Study Center at the University of Nebraska, Lincoln

60. VALENTINA (VALENTINA VON SCHLEE; 1904–89)
Evening Ensemble
ca. 1935
Silk ottoman
Jacket: L. 18 ¹/₂ in. (47 cm); *dress:* L. 63 in. (160 cm)
The Metropolitan Museum of Art, New York, Gift of Igor Kamlukin, 1995 (1995.245.5ab)

61. MARIA MARTINEZ (1886–1980) and JULIAN MARTINEZ (1885–1943)
Jar (San Ildefonso Pueblo)
ca. 1935–43
Blackware
H. 8 in. (20.3 cm), Diam. 9 in. (22.9 cm)
Institute of American Indian Arts Museum, Santa Fe, New Mexico (SILD 8)

62. MARGARET CRAVER (b. 1907)
Teapot
1936
Silver and Gabon ebony
5 ¹/₂ x 9 ³/₈ x 5 ¹/₂ in. (14 x 23.5 x 13.9 cm)
Museum of Fine Arts, Boston, Gift in Memory of Joyce Goldberg with funds provided by Mr. John P. Axelrod, Mr. and Mrs. Sidney Stoneman, Mr. Charles Devens, Mr. and Mrs. Peter S. Lynch, The Seminarians, Mr. James G. Hinckle, Jr., The MFA Council and Friends (1988.533)

63. MARGUERITE ZORACH (1887–1968)
"The Jungle" Rug
1936
Commissioned by Crawford Shops, New York
Hand-hooked wool and jute
42 x 60 in. (106.7 x 152.4 cm)
The Museum of Modern Art, New York, Gift of A. Conger Goodyear, 1937

64. BELLE KOGAN (b. 1902)
Covered Vegetable Dish
1936
Manufactured by Reed and Barton, Taunton, Massachusetts, beginning 1936; this example 1938
Silver plate
3 ³/₈ x 13 ⁵/₈ x 9 in. (8.6 x 34.6 x 22.9 cm)
Collection of Denis Gallion and Daniel Morris, Historical Design, New York

65. DOROTHY CARPENTER THORPE (active ca. 1930–68)
Table
ca. 1937
Silver-plated bronze and glass
H. 24 in. (61 cm), Diam. 21 in. (53.3 cm)
The Minneapolis Institute of Arts, The Modernism Collection, Gift of the Norwest Bank, Minnesota (L99.184.155a, b)

66. DOROTHY LIEBES (1897–1972)
"Mexican Plaid" Drapery Panel
1938–40
Wool, cotton, silk, rayon, metal laminate (tri-layered, colored film-coated foil)
108 x 50 in. (274.3 x 127 cm)
The Metropolitan Museum of Art, New York, Gift of Dorothy Liebes Design, 1973 (1973.129.2)

67. MARIA REGNIER (1901–95)
Tea Service
1939
Silver and ivory
Teapot: 6 ¹/₄ x 11 ⁷/₈ x 6 ¹/₈ in. (15.8 x 30 x 15.5 cm); *sugar:* 3 x 4 ³/₈ x 3 ⁵/₈ in. (7.5 x 11 x 9.1 cm); *creamer:* 2 ¹/₄ x 6 ⁶/₈ x 3 ¹/₂ in. (5.6 x 16.9 x 9 cm)
Museum of Fine Arts, Boston, Gift of John E. Goodman (1989.60–62)

68. CIPE PINELES (1908–91)
Proposed Cover for *Vogue*
Dated December 1, 1939
Paper collage
12 ³/₄ x 9 ³/₄ in. (32.4 x 24.8 cm)
Wallace Library, Rochester Institute of Technology, Cipe Pineles Collection, Archives and Special Collections

69. VERA WEST (d. 1947)
Costume Design for *Destry Rides Again* (1939, Dir. George Marshall, Universal Studios)
ca. 1939
Film excerpt courtesy of Universal Studios Licensing Inc.

70. FLORENCE YOCH (1890–1972) and LUCILE COUNCIL (d. 1964)
Design for Grounds of Tara Plantation in *Gone with the Wind* (1939, Dir. Victor Fleming and George Cukov, Sam Wood, Selznick International)
ca. 1939
Film excerpt courtesy of Warner Brothers

71. LILLIAN V. M. HELANDER (w. 1930–45)
Flatware
ca. 1939
Manufactured by Wm. A. Rogers, Meriden, Connecticut
Silver plate
Soup spoon: L. 7 in. (17.8 cm), W. 1 ⁷/₈ in. (4.8 cm); *teaspoon:* L. 6 ¹/₈ in. (15.6 cm), W. 1 ³/₈ in. (3.5 cm); *knife:* L. 9 ¹/₂ in. (24.1 cm), W. ⁷/₈ in. (2.3 cm); *butter knife:* L. 6 ¹/₈ in. (15.6 cm), W. ⁷/₈ in. (2.3 cm); *dinner fork:* L. 7 ¹/₂ in. (19.1 cm), W. 1 in. (2.5 cm); *salad fork:* L. 6 ¹/₈ in. (15.6 cm), W. 1 in. (2.5 cm)

The Mitchell Wolfson Jr. Collection, The Wolfsonian–Florida International University, Miami Beach, Florida (1991.476.3, 4, 6, 7, 9, 10.1)

72. MAIJA GROTELL (1899–1973)
Vase
1940
Glazed stoneware
H. 15 ½ in. (39.4 cm), Diam. 10 ½ in. (26.7 cm)
The Metropolitan Museum of Art, New York, Purchase, Edward C. Moore, Jr. Gift, 1940 (40.153.1)

73. ANNIE BURKE (1876–1962)
Basket (Pomo)
ca. 1940
Willow shoots, sedge root, and redbud
H. 6 ¾ in. (17 cm), Diam. 13 in. (33 cm)
On loan to the Mendocino County Museum, Willits, California, by Genevieve Allen Aguilar (EA#30)

74. DORIS ONDELACEY
(ca.1885–ca. 1970)
"Olla Maiden" Necklace (Zuni)
ca. 1940
Lone Mountain turquoise and silver
Pendant: 6 ½ x 4 ¾ x ⅛ in. (16.5 x 12.1 x .8 cm); chain: 14 ½ x 3 x ¼ in. (36.2 x 7.6 x 1 cm)
Collection of Tanner's Indian Art, Gallup, New Mexico

75. LILLY DACHÉ (ca. 1904–89)
Hat
1940s

Felt with beads and sequins
8 x 9 x 6 in. (20.3 x 22.9 x 15.2 cm)
The Metropolitan Museum of Art, New York, Gift of Esme O'Brien Hammond, 1977 (1977.201.36)

76. LUCY LEWIS (ca. 1895–1992)
Jar (Acoma Pueblo)
1940s
Polychrome earthenware
H. 9 ½ in. (24.1 cm), Diam. 12 in. (30.5 cm)
School of American Research, Santa Fe, New Mexico (IAF 2979)

77. NANCY McCLELLAND (1877–1959)
Wallpaper
ca. 1940–50
Block-printed by Mauny, Paris; distributed by Nancy McClelland, New York
Paper
Roll: W. 22 ¼ in. (56.5 cm)
Cooper Hewitt, National Design Museum, Smithsonian Institution, New York, Gift of the Museum at the Fashion Institute of Technology (1998-75-65)

78. VERA MAXWELL (1903–95)
"Uniform for War Work" Coverall
1942
Cotton twill
L. approx. 55 in. (139.7 cm)
The Metropolitan Museum of Art, New York, Gift of Vera Maxwell, 1947 (CI.47.60.1)

79. EVA ZEISEL (b. 1906)
"Museum" Teapot, Coffeepot, and Creamer
ca. 1942–43
Manufactured by Castleton China, Shenango Pottery, New Castle, Pennsylvania, 1945–ca. 1960
Glazed porcelain
Teapot: 5 ⅞ x 9 ⅝ x 6 ¼ in. (14.9 x 24.5 x 15.9 cm); coffeepot: 10 ¼ x 7 ½ x 5 in. (26 x 19.1 x 12.7 cm); creamer: H. 5 ⅜ in. (13.7 cm), Diam. 2 ¾ in. (7 cm)
Collection of Bernarda and Felicisimo Labaco

80. MARION DORN (1896–1964)
Headscarf
1941–43
Hand-screen-printed silk
38 ½ x 35 ½ in. (97.8 x 90.2 cm)
Philadelphia Museum of Art, Given by Mrs. John Platt (1971-042-001)

81. NINA WOLF (d. 1989)
Brooch and Earrings
ca. 1943–45
Gilded scallop shells and glass
Brooch: 2 x 2 ⅛ x ¼ in. (5.1 x 5.4 x 1 cm); earrings, each: 1 ¾ x 1 ¾ x ⅛ in. (4.5 x 4.5 x .8 cm)
The Museum of the City of New York, Costume Collection, Nina M. Wise Trust (88.74.9/10ab)

82. CLAIRE McCARDELL (1905–58)
Sports Ensemble
1944
Linen
Top: L. 11 ½ in. (29.2 cm); skirt: L. 27 in. (68.6 cm)
The Metropolitan Museum of Art, New York, Gift of Claire McCardell, 1949 (CI.49.37.30a, b)

83. LENA FRANK (1918–89)
Skirt (Big Cypress Seminole; detail shown above)
1944
Machine-stitched cotton, rayon satin, rickrack, patchwork, and appliqué
L. 37 in. (94 cm)
American Museum of Natural History, New York (50.2/6371a)

84. ANNI ALBERS (1899–1994)
"Dotted" Textile
1959
Wool
23 ¾ x 11 in. (60.3 x 27.9 cm)
Collection of Daphne Farago

85. LUTAH MARIA RIGGS (1921-80)
Production Design for *The White Cliffs of Dover* (1944, Dir. Clarence Brown, MGM)
ca. 1944
Film excerpt courtesy of Warner Brothers

86. MARGARET TAFOYA (b. 1904)
Vase (Santa Clara Pueblo)
ca. 1945–60
Blackware
H. 18 1/2 in. (47 cm), Diam. 13 in. (33 cm)
Institute of American Indian Arts Museum, Santa Fe, New Mexico (SC.37)

87. VIRGINIA LEE DEMETRIOUS (1909–68)
"Finnish Hop" Textile
1943
Manufactured by F. Schumacher and Company, New York, beginning 1946
Aralac
86 x 38 in. (218.4 x 96.5 cm)
Dallas Museum of Art, Twentieth Century Design Fund (1997.74)

88. MARGUERITE WILDENHAIN (1896–1985)
Tea Service
ca. 1946
Glazed stoneware
Teapot: 5 1/4 x 10 x 5 3/4 in. (13.3 x 25.4 x 14.6 cm); *sugar bowl:* H. 2 1/2 in. (6.4 cm), Diam. 4 1/2 in. (11.4 cm); *creamer:* 3 5¹8 x 5 1/2 x 4 in. (9.2 x 14 x 10.2); *cups, each:* H. 2 3/4 in. (7 cm), Diam. 3 3/4 in. (9.5 cm); *saucers, each:* H. 1 in. (2.5 cm), Diam. 6 in. (15.2 cm). Everson Museum of Art, Syracuse, New York (P.C. 47.515.1–13)

89. MARGARET DE PATTA (1903–64)
Brooch
ca. 1946–58
Silver, chrysoprase, and jasper
2 3/8 x 2 3/8 x 1/8 in. (6 x 6 x .5 cm)
Collection of Denis Gallion and Daniel Morris, Historical Design, New York

90. VIRGINIA CUTE CURTIN (1908–85)
Bowl
1947
Silver
H. 1 3/4 in. (4.4 cm), Diam. 7 in. (17.8 cm)
Museum of Fine Arts, Boston, Gift of David and Chelsey Remington (1999.736)

91. EVA LISA (PIPSAN) SAARINEN SWANSON (1905–79)
Glasses
1947
Manufactured by U.S. Glass Company, Tiffin, Ohio
Glass
Water goblet: H. 5 3/8 in. (13.7 cm), Diam. 3 3/4 in. (9.5 cm); *champagne glass:* H. 3 3/4 in. (9.5 cm), Diam. 4 in. (10.2 cm); *wine glass:* H. 4 in. (10.2 cm), Diam. 2 7/8 in. (7.3 cm); *sherbert glass:* H. 3 1/8 in. (7.9 cm), Diam. 3 1/4 in. (8.3 cm)
Cranbrook Art Museum, Bloomfield Hills, Michigan, Gift of Robert Saarinen Swanson and Ronald Saarinen Swanson (CAM 1981.70.a–d)

92. ESTELLE LAVERNE (1915–98)
"Fun to Run" Textile
1947–48
Silkscreen printed by Laverne Originals, New York, 1948–ca. 1965
Rayon and gold foil twill weave
83 1/2 x 46 1/4 in. (212 x 117.5 cm)
The Montreal Museum of Fine Arts/Montreal Museum of Decorative Arts, Gift of Alan Moss (D85.145.1)

93. IRENE [LENTZ] (1901–62)
Costume Design for Judy Garland in *Easter Parade*
(1948, Dir. Charles Walters, MGM)
ca. 1948
Film excerpt courtesy of Warner Brothers

94. RAY EAMES (1912–88) and CHARLES EAMES (1907–78)
"LAR" Armchair
1948–50
Manufactured by Zenith Plastics,

Gardena, California, for Herman Miller Furniture Company, Zeeland, Michigan, 1950–51, and by Herman Miller Furniture Company, ca. 1952-ca. 1972; this example ca. 1950
Polyester fiberglass composite, zinc-plated steel, and rubber
24 1/4 x 24 7/8 x 24 1/2 in. (61.6 x 63.2 x 62.2 cm)
Collection of Gansevoort Gallery, New York

95. FREDA DIAMOND (1905–98)
"Classic Crystal" Glasses
1949
Manufactured by Libbey Glass Company, Toledo
Soda lime glass
Jigger: H. 2 1/4 in. (5.7 cm), *Old Fashioned:* H. 3 3/8 in. (8.6 cm), *Collins:* H. 4 3/4 in. (12.1 cm), *Ice Tea:* H. 5 1/4 in. (13.3 cm), *Cooler:* H. 6 in. (15.2 cm)
Philadelphia Museum of Art, Gift of Libbey Glass, Toledo (1982-151-001–005)

96. BETTY COOKE (b. 1924)
Necklace
1950
Silver and leather
5 1/8 x 3 3/8 x 1/8 in. (13 x 8.5 x .8 cm)
Collection of Gansevoort Gallery, New York

97. MARY SCHEIER (b. 1908) and EDWIN SCHEIER (b. 1910)
Bowl
1951
Glazed earthenware
H. 6 3/4 in. (17.2 cm), Diam. 13 in. (33 cm)
Cranbrook Art Museum, Bloomfield Hills, Michigan, Museum Purchase with funds from the Cranbrook Foundation (CAM 1951.9)

98. GRETA VON NESSEN (ca. 1900–ca. 1978)
"Anywhere" Lamp
1951
Manufactured by Nessen Lamps, New York
Aluminum and enameled metal

14 1/2 x 14 1/2 x 14 1/2 in.
(36.8 x 36.8 x 36.8 cm)
Philadelphia Museum of Art, Gift of
Nessen Lamps, Inc., New York
(1974-057-001)

99. VERA NEUMANN (1909–93)
"Papaya" Textile
1952
Printed by F. Schumacher and
Company, New York
Cotton
66 x 38 1/8 in. (167.6 x 96.8 cm)
F. Schumacher and Company
Archives, New York

100. ESZTER HARASZTY (1921–95)
"Fibra" Textile
1953
Block-printed by Knoll Textiles, New
York, 1953–ca. 1965
Linen
81 x 52 in. (205.7 x 132.1 cm)
Dallas Museum of Art, Twentieth
Century Design Fund (1996.235)

101. RUTH ADLER SCHNEE (b. 1923)
"Seedy Weeds" Textile (detail shown
above)
1953–54
Hand-screen-printed by Adler Schnee
Associates, Detroit, ca. 1953–65
Cotton
52 3/4 x 51 5/8 in. (134 x 131 cm)
The Montreal Museum of Fine
Arts/Montreal Museum of Decorative
Arts, The Liliane and David M.
Stewart Collection (D85.148.1)

102. EDITH HEAD (1907–81)
Costume Design for To Catch a Thief

(1955, Dir. Alfred Hitchcock,
Paramount)
ca. 1955
Film excerpt courtesy of Paramount
Pictures

103. CLAIRE FALKENSTEIN (1908–97)
Brooch
ca. 1955
Brass
4 3/8 x 3 3/8 x 1 3/8 in.
(11 x 8.5 x 3.3 cm)
Collection of Sheryl Gorman

104. FLORENCE KNOLL (b. 1917)
Settee
ca. 1955
Manufactured by Knoll Associates,
East Greenville, Pennsylvania, 1955
Chrome, upholstered foam rubber,
and aluminum
30 x 56 x 31 in.
(76.2 x 142.2 x 78.7 cm)
Knoll Museum, East Greenville,
Pennsylvania

105. GERTRUD NATZLER (1908–71)
and
OTTO NATZLER (b. 1908)
Large Bowl (H331)
1956
Glazed earthenware
H. 14 1/8 in. (35.9 cm),
Diam. 18 5/8 in. (47.3 cm)
American Craft Museum, New York,
Gift of the Johnson Wax Company,
from OBJECTS: USA, 1977, Donated
to the American Craft Museum by the
American Craft Council, 1990
(1977.2.66)

106. IRENE SHARAFF (1910–93)
Costume Design for The King and I
(1956, Dir. Walter Lang, Twentieth
Century Fox)
ca. 1956
Film excerpt Twentieth Century Fox
Corporation

107. LUCIA DERESPINIS (b. 1927)
Wall Clock, Model No. 2239
1957–58
Designed for George Nelson and
Company, New York; manufactured

by Howard Miller Clock Company,
Zeeland, Michigan
Wood, brass, and painted metal
22 5/8 x 22 5/8 x 2 1/2 in.
(57.5 x 57.5 x 6.5 cm)
Collection of Gansevoort Gallery,
New York

108. HELEN ROSE (1904–85)
Costume Design for in Cat on a Hot Tin
Roof (1958, Dir. Richard Brooks,
MGM and Avon Productions)
ca. 1958
Film excerpt courtesy of Warner
Brothers

109. ANN LOWE (1898–1981)
Debutante Gown (detail shown above)
ca. 1958–60
Silk satin
L. approx. 52 in. (132.1 cm)
The Black Fashion Museum,
Washington, D.C.

110. ELAINE LUSTIG COHEN (b. 1927)
Cover for The Noble Savage 4
1959
Offset lithograph
9 x 4 3/4 in. (22.9 x 12.1 cm)
Cooper-Hewitt, National Design
Museum, Smithsonian Institution,
New York, Gift of Tamar Cohen and
Dave Slatoff (1993-31-37)

111. MARIANNE STRENGELL (1909–98)
"Taj Mahal" Automobile Upholstery
Fabric for 1959 Lincoln Continental
ca. 1958
Manufactured by Chatham
Manufacturing Company, Elkin,
North Carolina, 1959
Cotton, rayon, and metallic strands
115 3/4 x 62 3/4 in. (292.1 x 159.4 cm)

Cranbrook Art Museum, Bloomfield
Hills, Michigan, Museum Purchase
with funds from the Cranbrook
Foundation (CAM 1981.5)

112. JOYCE ANDERSON (b. 1923)
and
EDGAR ANDERSON (b. 1922)
Dictionary Stand
1960–61
Rosewood
39 1/2 x 25 1/4 x 15 in.
(100.3 x 64.1 x 38.1 cm)
Collection of Dr. and Mrs. Michael
Langan

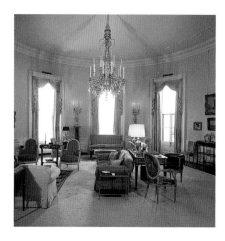

113. DOROTHY ("SISTER") PARISH
(1910–94) with JACQUELINE
KENNEDY, JAYNE WRIGHTSMAN, and
STÉPHANE BOUDIN
The Yellow Oval Room, The White
House, Washington, D.C.
ca. late 1962
Photograph
Courtesy of The John Fitzgerald
Kennedy Library and Museum,
Boston

114. JAYNE VAN ALSTYNE (b. 1923)
Patent for "Washer Unit and Dryer
Unit Combined in a Unitary Cabinet"
Filed May 15, 1962; issued July 7, 1964
United States Patent and Trademark
Office, No. 3,139,744

115. BONNIE CASHIN (1915–2000)
Suit
Fall 1964
Wool, mohair, and suede
Jacket: 22 3/4 in. (57.8 cm); *skirt:* L.
26 1/4 in. (66.7 cm)
The Metropolitan Museum of Art,
New York, Gift of Helen and Philip
Sills, Collection of Bonnie Cashin
Clothes,1979 (1979.431.51a–c)

116. SUZANNE VANDERBILT (1933–88)
Sketch for Interior Door Panel,
Panther Show Car, General Motors
Dated September 29, 1965
Charcoal and crayon on paper
17 x 24 in. (43.2 x 61 cm)
Cranbrook Archives, Bloomfield
Hills, Michigan (1998-2002)

117. DOROTHY JEAKINS (1914–95)
Costume Design for *The Sound of Music*
(1965, Dir. Robert Wise, Twentieth
Century Fox and Argyle Enterprises)
ca. 1965
Film excerpt courtesy of Twentieth
Century Fox Corporation

118. BETSEY JOHNSON (b. 1942)
Dress
ca. 1965
Designed for Paraphernalia, New York
Lurex
L. 32 in. (81.3 cm)
Collection of Lauren Sweder

119. ELSIE CRAWFORD (1913–99)
"ZIPPER" LIGHT PROTOTYPE
(Horizontal Variation)
ca. 1965
Manufactured by Morrison Imports,
San Francisco
Acrylic
H. 18 in. (45.7 cm), Diam. 26 in. (66
cm)
Collection of Peggy Gruen

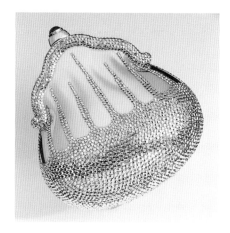

120. JUDITH LEIBER (b. 1921)
Handbag
1967
Manufactured by Judith Leiber,
New York
Vermeil with gold-covered rhinestones
4 3/4 x 4 1/2 x 2 in.
(12.1 x 11.4 x 5.1 cm)
Collection of Judith Leiber

121. FRANCES HIGGINS (b. 1912)
"Dropout" Vase
1967
Glass
7 3/4 x 7 x 7 in. (19.7 x 17.8 x 17.8 cm)
Collection of Frances Stewart Higgins

122. GERE KAVANAUGH (b. 1930)
"Chevron No. 3" Textile (detail shown
above)
1967
Manufactured by Koryo Export
Development Company Seoul, Korea,

for Isabel Scott Fabrics, New York
Silk
25 x 50 in. (63.5 x 127 cm)
Collection of Gere Kavanaugh

123. THEADORA VAN RUNKLE
(b. ca. 1940)
Costume Design for *Bonnie and Clyde*
(1967, Dir. Arthur Penn, Tatira-
Hiller)
ca. 1967
Film excerpt courtesy of Warner
Brothers

124. RAMONA SOLBERG (b. 1921)
"Shaman's Necklace"
1968
Silver, Alaskan ivory, and found
objects
L. (*overall*) 10 ¼ in. (26 cm)
American Craft Museum, New York,
Gift of the Johnson Wax Company,
from OBJECTS: USA, 1977, Donated
to the American Craft Museum by the
American Craft Council, 1990
(1978.3.8)

125. BARBARA D'ARCY (b. 1928)
Model Room, Bloomingdale's
Department Store, New York
1970
Photograph
Courtesy of Barbara D'Arcy White

126. WIN ANDERSON (b. 1922) and
JACK LENOR LARSEN (b. 1927)
"Magnum" Textile
1970–73
Produced by Aristocrat Embroidery,
Guttenberg, New Jersey, for Jack
Lenor Larsen, New York, beginning
1973
Mylar, cotton, vinyl, nylon, and
polyester
63 ½ x 51 ½ in. (161.3 x 130.8 cm)
The Minneapolis Institute of Arts,
Gift of Charles M. Senseman (85.26)

127. ELLEN LEHMAN McCLUSKEY
(1915–84)
"Peacock Alley" Lounge, Waldorf
Astoria Hotel, New York
1970
Photograph

Courtesy of Ellen McCluskey
Associates, New York

128. LELLA VIGNELLI (b. 1934)
Pitcher
1971
Manufactured by San Lorenzo s.r.l.,
Milan, Italy, beginning 1971
Silver
6 ⅞ x 4 ⅛ x 3 ⅛ in.
(17.5 x 10.5 x 7.9 cm)
Collection of Lella Vignelli

129. BEVERLY NUSOM
"Wild Banana" Textile
1971
Hand-screen-printed by The Design
Works of Bedford Stuyvesant,
Brooklyn
Cotton
126 ¼ x 50 ½ in. (320.7 x 128.3 cm)
The Metropolitan Museum of Art,
New York, Gift of The Design Works
of Bedford Stuyvesant, Brooklyn, C.
Mark Bethel, president, 1972
(1972.115.2)

130. ROSE (PIPER) RANSIER (b. 1917)
"New England Town" Textile
1971
Manufactured by Lebanon Knitting
Mills, New York
Polyester and lurex
Red: 11 ⅝ x 8 ¾ in (29.5 x 22.2 cm);
violet: 10 ¾ x 8 ¾ in (27.3 x 22.2 cm)
Collection of Rose Piper Wheeler

131. ANN ROTH (b. 1931)
Costume Design for *Klute* (1971, Dir.
Alan J. Pakula, Warner Bros.)
ca. 1971

Film excerpt courtesy of Warner
Brothers

132. ALMA EIKERMAN (1908–95)
Bracelet
1972
Silver and gold
5 ¼ x 5 x 1 ¾ in.
(13.3 x 12.7 x 4.5 cm)
Collection of Daphne Farago

133. POLLY PLATT (b. 1945)
Production Design and Costume
Design for *What's Up, Doc?* (1972, Dir.
Peter Bogdanovich, Saticoy
Productions)
ca. 1972
Film excerpt courtesy of Warner
Brothers

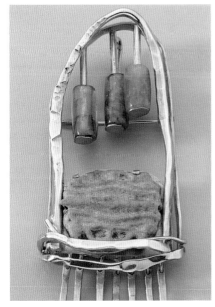

134. MIYE MATSUKATA (1922–81)
Brooch
ca. 1972
Gold, Egyptian faience, and amethyst
4 x 1 ½ in. (10.2 x 3.8 cm)
Museum of Fine Arts, Boston,
Anonymous Gift (1991.756)

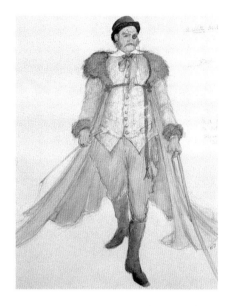

135. PATRICIA ZIPPRODT (1925-99)
Costume Design for Pozzo in *Waiting for Godot*
1973 (regional production)
Pencil and watercolor on paper with fabric swatches
24 x 18 in. (61 x 45.7 cm)
New York Public Library for the Performing Arts, Billy Rose Theatre Collection

136. EVANGELINE JULIET MONTGOMERY (b. 1933)
"Garvey Ancestral Box" also known as "Red, Black, and Green Ancestral Box"
1973
Cast silver and enamel
2 1/2 x 1 1/2 x 1 5/8 in.
(6.4 x 3.8 x 4.1 cm)
Collection of Cledie Collins Taylor

137. MARY LEE HU (b. 1943)
"Neck Piece No. 9"
1973
Silver, gold wire, and pearls
10 x 12 1/4 x 8 3/4 in.
(25.4 x 31.1 x 22.2 cm)
Museum of Fine Arts, Boston, H. E. Bolles Fund and Anonymous Gift (1996.1)

138. DORIS WHEELOCK BLUE (1905-85)
"Indian Head" Pot (Catawba)
ca. 1973
Earthenware
6 1/4 x 9 1/2 x 6 in.
(15.9 x 24.1 x 15.2 cm)
Collection of Thomas J. Blumer

139. MARY ANN SCHERR (b. 1931)
"Electronic Oxygen Belt Pendant"
1974
Silver, electronics, amber, and oxygen mask
Pendant: 12 x 4 x 1 in.
(30.5 x 10.2 x 2.5 cm)
American Craft Museum, New York, Gift of Mary Lee Hu, 1979, Donated to the American Craft Museum by the American Craft Council, 1990 (1979.2)

140. SHEILA DE BRETTEVILLE (b. 1940)
Poster for "Women in Design: The Next Decade" Conference at the Woman's Building, Los Angeles
1974
Blueprint
17 x 24 in. (43.2 x 61 cm)
Collection of Sheila Levrant de Bretteville

141. ELSA PERETTI (b. 1940)
"Bone Cuff" Bracelet
1974
Manufactured by Tiffany and Company, New York
Silver
2 1/8 x 1 3/4 x 1/4 in. (5.4 x 4.5 x 1 cm)
Collection of Tiffany and Company, New York

142. CARA CRONINGER (b. 1939)
Bracelet
1975
Polyester resin
2 3/4 x 3 x 1/4 in. (7 x 7.6 x 1 cm)
Courtesy of Julie: Artisans' Gallery, New York

143. BEATRICE WOOD (1893-1999)
Chalice
ca. 1975-83
Glazed earthenware
H. 9 5/8 in. (24.5 cm), Diam. 5 5/8 in. (14.1 cm)
Collection of Denis Gallion and Daniel Morris, Historical Design, New York

144. GRETCHEN BELLINGER (b. 1946)
"Arcadia" Textile
1976
Produced by Gretchen Bellinger, New York, 1976 to present
Wool and silk
72 5/8 x 61 5/8 in. (184.6 x 156.4 cm)
The Montreal Museum of Fine Arts/Montreal Museum of Decorative Arts, Gift of Gretchen Bellinger (D85.204.1)

145. SUSAN BILLY (b. 1951)
Feathered Basket (Pomo)
ca. 1976
Pheasant feathers, willow shoots, and sedge root
H. 1 1/4 in. (3.2 cm), Diam. 2 1/2 in. (6.4 cm)
Collection of Susan Billy

146. GEORGIA HARRIS (1905-97)
Water Jug (Catawba)
Earthenware
1979
9 7/8 x 9 x 7 1/2 in.
(25.1 x 22.9 x 19.1 cm)
Collection of Thomas J. Blumer

147. CHUNGHI CHOO (b. 1938)
Centerpiece
1979
Silver-plated copper and acrylic
11 1/8 x 18 3/4 x 6 1/4 in.
(28.3 x 47.6 x 15.9 cm)
The Metropolitan Museum of Art, New York, Gift of Jack Lenor Larson, 1980 (1980.580a, b)

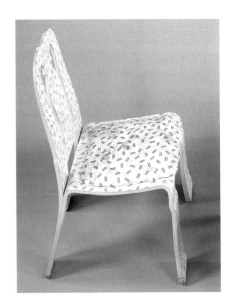

148. ROBERT VENTURI (b. 1925)
with DENISE SCOTT BROWN (b. 1931)
Project manager:
MAURICE WEINTRAUB (b. 1957)
"Queen Anne" Side Chair with
"Grandmother" Decoration
1979-84
Manufactured by Knoll International,
East Greenville, Pennsylvania,
1984-89
Plywood, plastic laminate, and rubber
38 1/2 x 26 1/2 x 23 1/2 in.
(97.8 x 67.3 x 59.7 cm)
The Metropolitan Museum of Art,
New York, Gift of Knoll
International, 1985 (1985.113.1)

149. MARTHA SCHWARTZ (b. 1950)
Plan for "The Bagel Garden," Boston,
Massachusetts
1979
Pencil on vellum
30 x 35 1/2 in. (76.2 x 90.2 cm)
Collection of Martha Schwartz,
Cambridge, Massachusetts

150. LISA KROHN (b. 1963)
Prototype of "Phonebook"
Telephone Answering Machine
1980-85
Wood, plastic, and LED
(light-emitting diode)
2 3/8 x 13 x 9 3/8 in. (6 x 33 x 23.7 cm)
Cooper-Hewitt, National Design
Museum, Smithsonian Institution,

New York, Gift of Lisa Krohn
(1994-57-1)

151. KATHERINE McCOY (b. 1945) and
DANIEL LIBESKIND (b. 1946)
"Architecture Symbol and
Interpretation" Poster
1981
Offset lithograph
28 x 22 in. (71.1 x 55.9 cm)
Cranbrook Art Museum, Bloomfield
Hills, Michigan

152. WENDY MARUYAMA (b. 1952)
Mickey Mackintosh Chair
1981
Painted maple
64 x 19 x 19 in.
(162.6 x 48.3 x 48.3 cm)
Collection of Wendy Maruyama

153. DOROTHY HAFNER (b. 1952)
"Fred Flintstone, Flash Gordon, and
Marie Antoinette" Coffee Service
Prototype with "Blue Loop with
Headdress" Decoration
1981–84
Produced by Dorothy Hafner, New
York, 1984–88, for Rosenthal Glass
and Porcelain AG, West Germany,
1988
Glazed porcelain
Coffeepot: 10 1/2 x 12 x 4 3/4 in.
(26.7 x 30.5 x 12.1 cm);
creamer: 4 1/2 x 5 3/4 x 2 3/4 in.
(11.4 x 14.6 x 7 cm);
sugar: 4 3/4 x 4 3/4 x 2 3/4 in.
(12.1 x 12.1 x 7 cm)
Collection of Dorothy Hafner

154. RUTH MORLEY (ca. 1926–91)
Costume Design for *Tootsie* (1982, Dir.
Sydney Pollack, Columbia Pictures)
ca. 1982
Film excerpt courtesy of Columbia
Pictures

155. PATRIZIA VON BRANDENSTEIN
(b. 1939)
Production Design for *Silkwood* (1983,
Dir. Mike Nichols, Twentieth Century
Fox and ABC Motion Pictures)
ca. 1983

Film excerpt courtesy of Twentieth
Century Fox Corporation

156. DEBORAH SUSSMAN (b. 1931),
Art Director
Preview Model of Environmental
Design for the XXIII Olympiad,
Los Angeles
1984
Designed by Sussman/Prejza and
Company, Culver City, California
Wood, plastic tubing, colored paper,
and paint
36 x 48 x 25 in.
(91.4 x 121.9 x 63.5 cm)
Collection of the Office of
Sussman/Prejza and Company, Culver
City, California

157. JUDY McKIE (b. 1944)
"Glass-Top Table with Dogs No. 2"
1984
Walnut, ash, and glass
34 x 60 x 18 in.
(86.4 x 152.4 x 45.7 cm)
Fuller Museum of Art, Brockton,
Massachusetts, Commissioned with
funds provided by the Massachusetts
Council on the Arts and Humanities
New Works Program

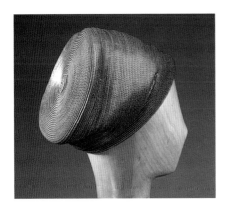

158. ANNE KRAUS (b. 1956)
"Peaceable Kingdom" Bowl
1985
Glazed porcelain
2 1/4 x 12 1/2 x 11 1/2 in.
(5.7 x 31.8 x 29.2 cm)
Everson Museum of Art, Syracuse,
New York, Gift of Garth Clark
(P.C. 85.74)

159. PATRICIA UNDERWOOD (b. 1948)
Hat
1985
Coiled leather
6 1/8 x 7 3/4 x 9 in.
(15.6 x 19.7 x 22.9 cm)
Collection of Patricia Underwood

160. LORRAINE WILD (b. 1953)
Book and Cover Design for *Mask of Medusa*
1985
Published by Rizzoli, New York, 1985
Offset lithograph
12 x 9 x 1 1/8 in.
(30.5 x 22.9 x 2.9 cm)
Private collection

161. DIANA BALMORI (b. 1936)
Design for Wintergarden, World Financial Center, New York
1985
Colored pencil on trace paper over printed paper
21 1/4 x 31 1/8 in. (54 x 79.1 cm)
Collection of Diana Balmori

162. EVA EISLER (b. 1952)
Brooch
ca. 1985
Silver and ebony
5 1/8 x 3 5/8 x 5/8 in. (13 x 9 x 1.8 cm)
Collection of Toni Wolf Greenbaum

163. LUCILLE LOZADA TENAZAS (b. 1953)
Brochure and Cover Design for *The Third Dimension*
1986
Offset lithograph, cardboard, and plastic
closed: 11 x 10 in. (27.9 x 25.4 cm)
Collection of Lucille LozadaTenazas

164. NANCY SKOLOS (b. 1955)
"Fonts" Poster
1987
Offset lithograph
44 x 33 1/4 in. (111.8 x 84.5 cm)
Private collection

165. DONNA KARAN (b. 1948)
"The Barbie Look" Playsuit
ca. 1987
Skirt: wool; *bodysuit*: crepe jersey; *hat*: felt; *gloves*: wool; *jewelry*: gold metal
Bodysuit: L. 27 in. (68.6 cm);
skirt: 33 in. (83.3 cm);
as worn: L. 51 in. (129.5 cm)
Collection of Donna Karan, New York

166. MARGARETE SEELER (1909–96)
"The Cup of '88"
1988
Silver, gold-plated silver, ivory, polychrome enamel, and gold wire
H. 6 in. (15.2 cm), Diam. 4 1/4 in. (10.8 cm)
Museum of Fine Arts, Boston, Gift in honor of Margarete Seeler (1999.135)

167. ARLINE M. FISCH (b. 1931)
Collar
1988
Copper with silver
H. 3 in. (7.6 cm); Diam. 12 1/2 in. (31.8 cm)
Collection of Hiroko Sato-Pijanowski

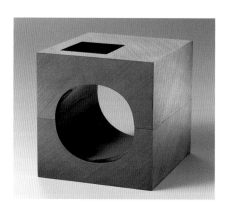

168. LISA GRALNICK (b. 1956)
Bracelet
ca. 1988
Acrylic
3 1/4 x 3 1/4 x 3 1/8 in.
(8.3 x 8.3 x 8 cm)
Collection of Sandy Grotta

169. ROSANNE SOMERSON (b. 1954)
"Earring" Cabinet
1989
Yellow poplar, maple, padauk, birch plywood, paint, and handmade paper
29 3/8 x 23 1/2 x 6 3/8 in.
(74.6 x 59.7 x 16.2 cm)
Yale University Art Gallery, New Haven, Connecticut, Bequest of Marie-Antoinette Slade, by exchange (1989.66.1)

170. JHANE BARNES (b. 1954)
"Nuance" Textile
1989
Manufactured by Knoll Textiles, New York
Cotton, rayon, silk, and polyester
120 x 54 in. (304.8 x 137.2 cm)
Courtesy of Knoll Textiles, New York

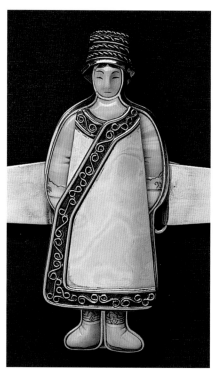

171. DENISE WALLACE (b. 1957)
"Crossroads of the Continents" Belt (Sugpiag; detail shown above)
1990
Silver, gold, semiprecious stones, and fossilized walrus tusk
L. 40 in. (101.6 cm), W. 4 in. (10.2 cm)
Collection of Denise and Samuel Wallace

172. CHERYLE WILLIAMS DENT
(b. 1952) and
KIM BRESSANT-KIBWE (b. 1953)
"Benin" Wallpaper
1991
Screen printed by African Home,
Brooklyn
Paper
Roll: W. 29 1/2 in. (75 cm)
Cooper-Hewitt, National Design
Museum, Smithsonian Institution,
New York
Gift of African Home, Brooklyn
(1993-142-1)

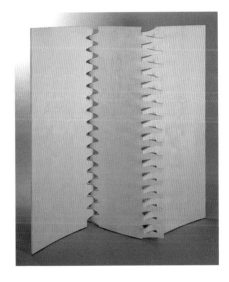

173. KATHERINE KRIZEK
"Shaker Screen"
1990–91
Manufactured by Cappellini s.p.a.,
Italy
Plywood
Each of the 3 panels: 71 1/2 x 31 x 3/4 in.
(181.6 x 78.7 x 2 cm)
Cooper-Hewitt, National Design
Museum, Smithsonian Institution,
New York, Gift of Cappellini s.p.a.,
with Assistance from Modern Age
Gallery (1993-100-3-a/c)

174. GLORIA BEGAY (b. 1970)
Moki Stripe Rug (Navajo)
1991
Wool
36 1/4 x 24 3/4 in. (92.1 x 62.9 cm)

Denver Art Museum, Gloria F. Ross
Collection (1991.742)

175. KRISTI ZEA (b. 1948)
Production Design for *Silence of the
Lambs* (1991, Dir. Jonathan Demme,
Orion)
ca. 1991
Film excerpt courtesy of MGM

176. REBECA MÉNDEZ (b. 1962)
"This Sentence Is Weightless" Poster
for the Getty Center for the History of
Art and the Humanities, Los Angeles
1992
Lithograph
33 x 18 in. (83.8 x 45.7 cm)
Collection of Rebeca Méndez

177. CHERYL RILEY (b. 1952)
"Tudor Coin-Encrusted Table"
1992
Produced by Right Angle Interiors,
San Francisco, 1993
Wood, enamel, copper leaf, coins,
brass, and gold leaf
22 1/4 x 24 x 24 in.
(56.5 x 61 x 61 cm)
Cooper-Hewitt, National Design
Museum, Smithsonian Institution,
New York, The Decorative Arts
Association Acquisitions Fund
(1993-9-1a, b)

178. RUTH CARTER (b. 1960)
Costume Design for *Malcolm X* (1992,
Dir. Spike Lee, 40 Acres & a Mule,
JVC Entertainment, and Largo
International)
ca. 1992
Film excerpt courtesy of Warner
Brothers

179. EIKO ISHIOKA (b. 1939)
Costume Design for *Bram Stoker's
"Dracula"* (1992, Dir. Francis Ford
Coppola, American Zoetrope,
Columbia Pictures, and Osiris Films)
ca. 1992
Film excerpt courtesy of Columbia
Pictures

180. CAROLE BILSON
Kodak Ektascan Imagelink™
Ultrasound System
ca. 1992
Manufactured by Eastman Kodak,
Rochester, New York
ABS Plastic
9 3/8 x 12 1/8 x 17 3/4 in.
(23.9 x 30.8 x 45.1 cm)
Collection of Eastman Kodak,
Rochester, New York

181. EDITH BONDIE (b. 1918)
Basket (Ojibwa)
ca. 1992
Black ash
H. 8 in. (20.3 cm), Diam. 8 in.
(20.3cm)
Michigan State University Museum,
East Lansing

182. KRISTINA MADSEN (b. 1955)
Dining Chair
1993
Blackened imbuya, silk, and metal
33 1/2 x 20 1/2 x 18 1/2 in.
(85.1 x 52.1 x 47 cm)
Smithsonian Institution, Washington,
D.C., The Renwick Gallery of the
National Museum of American Art,
Gift of the James Renwick Alliance
(1998.82)

183. JOYCE SCOTT (b. 1948)
"Voices" Necklace
1993
Beads, thread, chain, and synthetic
faceted disks
13 x 12 x 1/2 in. (33 x 30.5 x 1.5 cm)
American Craft Museum, New York,
Gift of the Horace W. Goldsmith
Foundation, 1994 (1994.48)

184. JILL SHURTLEFF (b. 1961)
"Sensor for Women" Razor
1993
Manufactured by the Gillette
Company, Boston, Massachusetts
Plastic, stainless steel, and aluminum
4 x 1 3/4 x 1/2 in. (10.2 x 4.5 x 1.3 cm)
Collection of the Gillette Company,
Boston

185. ELAINE BASS (b. 1927) and
SAUL BASS (1920 96)
Title Sequence for *The Age of Innocence*
(1993, Dir. Martin Scorsese,
Columbia Pictures)
ca. 1993
Film excerpt courtesy of Universal
Studios Licensing Inc.

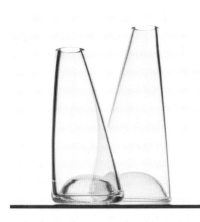

186. EMANUELA FRATTINI
MAGNUSSON (b. 1959)
Two Vases
1993–94
Manufactured by Steuben Division of
Corning Glass Works, Corning, New
York, 1994
Glass
Large: H. 18 in. (45.7 cm), Diam. 6 in.
(15.2 cm); *small:* H. 12 in. (30.5 cm),
Diam. 4 in. (10.2cm)
Collection of Emanuela Frattini
Magnusson, Principal, EFM Design,
New York

187. PHYLLIS MARIE BOWDWIN
(b. 1941)
"The Middle Passage, African
Holocaust: *Maafa*" Brooch
1993–96
Produced by Who Deserves it More
Than You?, New York
Brass and cowrie shells
2 5/8 x 4 x 1/2 in. (6.7 x 10.2 x 1.5 cm)
Cooper-Hewitt, National Design
Museum, Smithsonian Institution,
New York, Museum Purchase from
Monet Jewelry Fund (1997-3-1)

188. MURIEL COOPER (1925–94)
"Information Landscapes"
1994
Film
Collection of Massachusetts Institute
of Technology, Cambridge,
Massachusetts, Media Lab

189. POLLY SMITH (b. 1949)
Costume for Miss Piggy as Benjamina
Gunn in *Muppet Treasure Island* (1996,
Dir. Brian Henson, Walt Disney
Pictures/Jim Henson Productions,
Buena Vista)
1995
Hand-screened silk, hand-dyed
feathers, balsa wood, spandex,
seashells, wooden beads, and raffia
Approx. 66 x 53 in. (167.6 x 134.6 cm)
Collection of Jim Henson
Productions, New York

190. MARGO CHASE (b. 1959)
"ESPN Billards" Logo and Opening
Sequence for Cable Channel
1995
Film
Collection of Margo Chase Design,
Los Angeles

191. ANGELITA REANO OWEN
(b. 1946)
"Mosaic Cuff" Bracelet (Santo
Domingo Pueblo)
1995
Tiger cowrie shell, turquoise, jet, and
black epoxy
H. 2 1/8 in. (5.4 cm), Diam. 2 7/8 in.
(7.3 cm)
Museum of Fine Arts, Boston,
Museum purchase with funds donated
by Lois and Stephen Kunian and The
Seminarians (1998.57)

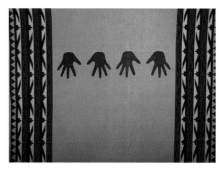

192. WENDY PONCA (b. 1960)
"Wah-Sha-She" Blanket (Osage)
1995
Manufactured by Pendleton Woolen
Mills, Oregon, for American Indian
College Fund, New York
Wool
64 x 80 in. (162.6 x 203.2 cm)
Collection of American Indian
College Fund, New York

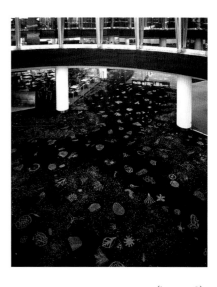

193. MICHELE OKA DONER (b. 1946)
"A Walk on the Beach" Terrazzo Floor,
Miami International Airport
(Concourse A)
1991-2000
Phase 1 completed 1995, phase 2 com-
pleted 1999 (phase 3 in progress)
Marble, granite, and mother-of-pearl
aggregate with bronze inlay
Photograph
Courtesy of Michele Oka Doner

194. CAROLYN L. MAZLOOMI
(b. 1948)
"The Ancestors Speak to Me" Quilt
1996
Reverse appliquéd and quilted cotton
and mud cloth
73 x 63 in. (185.5 x 160 cm)
Collection of Carolyn L. Mazloomi

195. DOROTHY TORIVIO (b. 1946)
Vase (Acoma Pueblo)
1995
Polychrome earthenware
H. 10 1/2 in. (26.7 cm),
Diam. 9 1/4 in. (23.5 cm)
Collection of Andrea Fisher Fine
Pottery, Santa Fe, New Mexico

196. RENÉE BEGGSMITH (b. 1963)
"Another Girl" Necklace
ca. 1995
Oxidized silver and plastic doll
7 1/4 x 5 3/8 x 1 3/4 in.
(18.3 x 13.5 x 4.3 cm)
Collection of Renée Beggsmith

197. ZUZANA LICKO (b. 1961)
Brochure with "Mrs. Eaves" Typeface
1995–96
Brochure designed by
Rudy VanderLans (b. 1955) and
printed by Peter Koch, 1996
Published by Emigré Fonts
Letterpress
Open: 8 3/4 x 11 1/2 in. (22.2 x 29.2 cm)
Private collection

198. HOLLY HAMPTON (b. 1961),
designer, and DEBORAH SUSSMAN
(b. 1931), art director
Samples of Carpet Runner for New
Jersey Performing Arts Center,
Newark
1995–96

Designed for Sussman/Prejza and
Company, Culver City, California;
manufactured by Decorative Carpets,
Incorporated, 1997
Wool
Each: 24 x 24 in. (61 x 61 cm)
Collection of Office of
Sussman/Prejza and Company, Culver
City, California

199. NANCY GOSLEE POWER (b. 1942)
Plan for Norton Simon Museum
Gardens, Pasadena, California
1995
Rendered by Doug Jameson
Watercolor on paper
31 x 40 1/2 in. (78.7 x 102.9 cm)
Collection of Nancy Goslee Power and
Associates, Santa Monica, California

200. NANCY J. PERKINS (b. 1949)
Model of "Tren Urbano" Heavy Rail
Commuter Train, San Juan, Puerto
Rico
1995–2000
High-density foam, plastic, masonite,
and paint
10 x 24 x 10 in. (25.4 x 61 x 25.4 cm)
Collection of Perkins Design Limited,
Mountain View, California, Nancy J.
Perkins FIDSA and John Gard IDSA,
Principals

201. PAULA SCHER (b. 1948)
Poster for Dancing on Her Knees at the
Public Theater, New York
1996
Silkscreen
46 x 30 in. (116.8 x 76.2 cm)
Private collection

202. COURTNEY SLOANE (b. 1962)
Office of Sha-Kim Compere, CEO,
Flavor Unit Entertainment, Jersey
City, New Jersey
1996
Photograph
Courtesy of Alternative Design, Jersey
City, New Jersey

203. MYRA MIMLITSCH-GRAY
(b. 1962)
Pendant
1996
Silver
Pendant: 1 1/4 x 1 1/4 x 1 1/8 in.
(3.2 x 3.2 x 2.8 cm);
chain: L. 34 1/4 in. (87 cm)
Collection of Myra Mimlitsch-Gray

204. SYLVIA HARRIS (b. 1953), with
TWO TWELVE ASSOCIATES, New York
Prototype for U.S. Census 2000
1996
Offset lithograph
Closed: 11 x 8 1/2 in. (27.9 x 21.6 cm)
Collection of Sylvia Harris

205. FO WILSON (b. 1955)
Brochure for African American
Design Archive, Cooper-Hewitt,
National Design Museum,
Smithsonian Institution, New York
1996
Offset lithograph
8 1/2 x 6 1/8 in. (21.6 x 15.6 cm)
Collection of Fo Wilson

206. CECIL N. HAYES (b. 1945)
Living Room in Wesley Snipes
Residence, Florida
1996
Photograph
Courtesy of Wesley Snipes and Condé
Nast Publications Inc. Photograph by
Dan Forer. © 1997 Architectural Digest,
Condé Nast Publications Inc.

207. RAE JEAN WALKING EAGLE
(b. 1955)
"Basketball Star" Quilt
(Assiniboine/Sioux)
ca. 1996
This example made by designer, 2000
Machine-pieced and hand-quilted
polyester and cotton/polyester blend
with polyester batting
77 1/2 x 87 in. (196.9 x 221 cm)
Michigan State University Museum,
East Lansing

208. VERMA NEQUATEWA
(Sonwai, b. 1949)
Bracelet (Hopi Pueblo)
1997
Gold, coral, lapis lazuli, turquoise,
and opal
3 x 2 3/8 x 3/4 in. (7.5 x 6 x 2 cm)
Collection of Marcia Docter

209. JUDITH REICHEL RILEY
(b. 1955), designer, with
KIRSTI KARPAWICH (b. 1967), project
leader, and SUSIE WATSON (b. 1952)
"Timex Rush VO²" Watch
1998
Manufactured by Timex Corporation,
Middlebury, Connecticut, 2000
Painted injection molded polycarbon-
ate case, polyurethane strap, and
internal timing mechanism
8 5/8 in. x 1 3/8 in. (22 x 3.5 cm)
Collection of Timex Corporation,
Middlebury, Connecticut

210. DEBORAH NADOOLMAN (b. 1952)

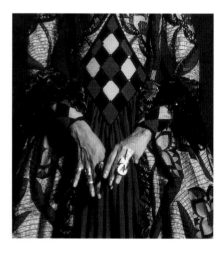

Costume for Erykah Badu as Queen
Moussette in *Blues Brothers 2000* (1998,
Dir. John Landis, Universal Pictures)
1998
African cotton batik, striped and
handpainted pieced silk, Swarovski
crystals, and glass bugle beads
L. 72 in. (182.9 cm)
Collection of Universal Studios,
Archives and Collections, Universal
City, California

211. VIVIENNE TAM (B. 1956)
Mao Coat
1998
Polyester
L. 59 in. (149.9 cm)
Collection of Vivienne Tam

212. CAROL DEVINE CARSON (b.
1944)
Dust Jacket for *Autobiography of Red*
1998
Published by Alfred A. Knopf, New
York, 1998
Offset lithograph
8 7/8 x 6 3/4 x 3/4 in. (22.5 x 17 x 2 cm)
Collection of Carol Devine Carson

213. MARILYN HENRION (b. 1932)
"Byzantium II" Quilt
1998
Machine-pieced and hand-quilted silk
66 x 68 in. (167.6 x 172.7 cm)
Collection of Marilyn Henrion

214. JEANNINE OPPEWALL (b. 1946)
Production Design for *Pleasantville*
(1998, Dir. Gary Ross, Larger Than
Life and New Line Productions, Inc.)
ca. 1998
Film excerpt courtesy of New Line
Productions, Inc.

215. MAYA LIN (b. 1959)
"Stones" Seats from "the earth is (not)
flat" Series
ca. 1998
Manufactured by Knoll, Inc.,
East Greenville, Pennsylvania
Fiberglass-reinforced concrete
Adult-size seat: 15 x 27 x 19 in.
(38.1 x 68.6 x 48.3 cm);
child-size seat: 10 x 16 x 12 in.

(25.4 x 40.6 x 30.5 cm)
Philadelphia Museum of Art,
(*adult-size seat*) Gift of COLLAB:
The Contemporary Design Group for
the Philadelphia Museum of Art
(1999-103-002); (*child-size seat*)
Gift of Knoll, Inc. (1999-104-001)

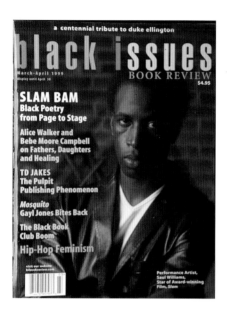

216. MICHELE Y. WASHINGTON
(b. 1953)
Book Cover for *Black Issues Book Review*
1999
Published by CMA Publishing,
March–April 1999
Photograph by George Larkins
Offset lithograph
10 7/8 x 8 in. (27.6 x 20.3 cm)
Collection of Michele Y. Washington,
Washington Design, Brooklyn

217. DOROTHY COSONAS-DEFIEBRE
(b. 1961)
"Wink" Textile
1999
Manufactured by Unika Vaev, a divi-
sion of the ICF Group, New York,
2000
Nylon, wool, polyester, rayon, and
cotton
120 x 54 in. (304.8 x 137.2 cm)
Collection of Unika Vaev, New York

218. NANCY YOUNGBLOOD LUGO
(b. 1955)
Bowl (Santa Clara Pueblo)
1999
Blackware
H. 5 ¼ in. (13.3 cm), Diam. 8 ¼ in.
(21 cm)
Collection of Natalie and Greg Fitz-
Gerald

219. AYSE BIRSEL (b. 1964)
Resolve Delta Office System Prototype
1999–2000
Designed for Herman Miller, Inc.;
previewed at Neo Con, Chicago, 1999
Extruded aluminum, plastic, coated
medium density fiberboard (MDF),
proprietary display fabric
H. approx 8 ft. (2.4 m)
Diam. approx 10 ft. (3.1 m)
Courtesy of Olive 1:1, New York

220. APRIL GREIMAN (b. 1948) and
DALE MEVICSTAD (b. 1951)
Inventing Flight Film for 2003 "Century
of Flight Exposition", Dayton, Ohio
1999–2000
Quicktime movie
Courtesy of April Greiman

221. ISABEL TOLEDO (b. 1960)
wedding dress
2000
Cotton lisle
L. 60 in. (152.4 cm)
Collection of Isabel Toledo

Endnotes

The followng short form is used: author's last name, abbreviated title, and date of publication. Full references will be found in the bibliography.

PROLOGUE: *Social Change and Changing Experience*

1. Grant, *Raising Baby by the Book* (1998).
2. Quoted in "Drop The Mop, Bless the Mess," in Baxandall and Gordon, eds., *America's Working Women* (1995): 303; Hesse-Biber and Carter, *Working Women in America* (2000): 180.
3. Hochschild, *Time Bind* (1997).
4. Weiner, *From Working Girl to Working Mother* (1985); Woloch, *Women and the American Experience* (1994): 587, table 6.
5. Hesse-Biber and Carter, *Working Women in America* (2000): 38.
6. "Domestic Service," in Baxandall and Gordon, eds., *America's Working Women* (1995): 202, interview with Mrs. Taniguchi.
7. Quoted in Epstein, et al., *Part-time Paradox* (1999), 116.
8. Costello et al., eds., *American Woman* (1998): 335, table 6-5; Sara Evans, "American Women in the New Millennium," in ibid., p. 83.
9. Quoted in "New Technology: Typists," in Baxandall and Gordon, eds., *America's Working Women* (1995): 209.
10. Guy-Sheftall, *Words of Fire* (1995); Vicki Crawford, "African American Women in the Twenty-first Century: The Continuing Challenge," in Costello et al., eds., *American Woman* (1998): 103.
11. Anderson, *Changing Woman* (1996): 142–43.
12. Ibid., pp. 40, 43–45; Hesse-Biber and Carter, *Working Women in America* (2000): 61.
13. Milkman, *Gender at Work* (1987).
14. Meyer, *Creating GI Jane* (1996).
15. Blackwelder, *Now Hiring* (1997): 179–80.
16. Ibid.; Costello et al., eds., *American Woman* (1998): 240, table 2-9; Abelson, "Push from the Top" (1999): A-1. Women were only 3.5 percent of lawyers in 1960, though they jumped to 14 percent twenty years later. Similarly they moved from 6.8 percent to 14.3 percent of physicians. For the 1990s see Hesse-

Biber and Carter, *Working Women in America* (2000): 158–59.
17. Carter and Carter, "Women's Recent Progress in the Professions" (1981): 477–504.
18. Nadine Taub, "On Becoming a Feminist/Lawyer," in DuPlessis and Snitow, eds., *Feminist Memoir Project* (1998): 308.
19. Weisberg, *Feminist Legal Theory* (1993).
20. Quoted in Anderson, *Changing Woman* (1996): 59.
21. Amott and Matthaei, *Race, Gender, and Work* (1996): 45–61; Hesse-Biber and Carter, *Working Women in America* (2000): 40, 42.
22. Quoted in Anderson, *Changing Woman* (1996): 90.
23. Ibid., p. 89.
24. Rowbotham, *Century of Women* (1997): 45, 160–61.
25. Chateauvert, *Marching Together* (1998); Gabin, *Feminism in the Labor Movement* (1990).
26. Quoted in Ruiz, *From Out of the Shadows* (1998): 85.
27. Orleck, *Common Sense and a Little Fire* (1995); Balser, *Sisterhood & Solidarity* (1987).
28. Quoted in Cobble, "'Spontaneous Loss of Enthusiasm'" (1999): 27, 29.
29. Amott and Matthaei, *Race, Gender, and Work* (1996): 309.
30. Karen Nussbaum, "Women in Labor: Always the Bridesmaid?" in Mort, ed., *Not Your Father's Union Movement*, (1998): 57.
31. As quoted in Evans, *Born For Liberty* (1989): 139.
32. Blackwelder, *Now Hiring* (1997): 36–52. Working-class boys less often attended high school, entering apprenticeship programs instead. See DeVault, *Sons and Daughters of Labor* (1990).
33. Gordon, *Gender and Higher Education* (1990): 13–51, 141–42.
34. Higginbotham, *Righteous Discontent* (1993); Gilmore, *Gender and Jim Crow* (1996).
35. Quoted in Rowbotham, *Century of Women* (1997): 156.
36. Woloch, *Women and the American Experience* (1994): 587, table 5; Blackwelder, *Now Hiring* (1997): 36–52. In 1920 women made up nearly half of all undergradu-ates, but in 1950 they were just over 30

percent. Not until 1980 did their college attendance match that of men's.
37. Quoted in Solomon, *In the Company of Educated Women* (1985): 192.
38. Costello et al., eds., *American Woman* (1998): 229-34, tables 2-1 to 2-5, fig. 2-1; Amott and Matthaei, *Race, Gender and Work* (1996): 61; Blackwelder, *Now Hiring* (1997): 114, 191–92, 207–208.
39. Woloch, *Women and the American Experience* (1994): table 5; Hesse-Biber and Carter, *Working Women in America* (2000): 105–108; Costello et al., eds., *American Woman* (1998): 240, table 2-9, 240; Kwolek-Foland, *Incorporating Women* (1998): 176.
40. Blackwelder, *Now Hiring* (1997): 93; Kwolek-Foland, *Incorporating Women* (1998): 177.
41. Quoted in Karen Nussbaum, "Women in Labor: Always the Bridesmaid?" in Mort, ed., *Not Your Father's Union Movement* (1998): 60; Coontz, *The Way We Really Are* (1997).
42. Heidi I. Hartmann, "Changes in Women's Economic and Family Roles in Post–World War II United States," in Beneria and Stimpson, eds., *Women, Households, and the Economy* (1987): 33–64.
43. Coontz, *The Way We Never Were* (1992): 23–31.
44. Meyerowitz, "Sexual Geography" (1990): 274–96; Chauncey, *Gay New York* (1994); Peiss, *Cheap Amusements* (1986).
45. Rowbotham, *Century of Women* (1997): 109–13; Rabinowitz, *Labor and Desire* (1991).
46. Rowbotham, *Century of Women* (1997): 216–18, Evans, *Born For Liberty* (1989): 200.
47. "Flora Belle Jan, Flapper and Writer," in Yung, ed., *Unbound Voices* (1999): 307–314.
48. Rowbotham, *Century of Women* (1997): 168, 171.
49. Ibid., p. 267.
50. Ibid., pp. 303, 394–95. Quoted in D'Emilio and Freedman, *Intimate Matters* (1997): 272.
51. Rubin, *Worlds of Pain* (1976).
52. Rosen, *World Split Open* (2000): 143–93; Rowbotham, *Century of Women* (1997): 467.
53. Rosen, *World Split Open* (2000): 178; Umansky, *Motherhood Reconceived* (1996): 52–77.

54. Woloch, *Women and the American Experience* (1994): 399, 585 table 2, 586 table 3; Ryan, *Womanhood in America* (1983): 330; Evans, *Born for Liberty* (1989): 291–92.

55. Ryan, *Womanhood in America* (1983): 267–69. Also see Woloch, *Women and the American Experience* (1994): 586, table 4. In 1920 there were 12 marriages and 1.6 divorces per 1,000 population. In 1990 this rate stood at 9.8 marriages and 4.7 divorces per 1,000 population.

56. Susan M. Williams and Joy Harjo, "American Indian Feminism," in Mankiller et al., eds., *Reader's Companion* (1998): 198. For African American protests, see Roberts, *Killing the Black Body* (1997).

57. Estelle B. Freedman, "Sexuality," in Mankiller et al., eds., *Reader's Companion* (1998): 536.

58. Solinger, *Wake-Up Little Susie* (1992).

59. During the same twenty-five year period, white women as household heads went from 9.4 percent to 14.1 percent. Woloch, *Women and the American Experience* (1994): 511–12; Coontz, *The Way We Never Were* (1992): 252.

60. Anderson, *Changing Woman* (1996): 78, quotation at 86.

61. Coontz, *The Way We Never Were* (1992): 232–54; Evans, *Born For Liberty* (1989): 302; Mink, *Welfare's End* (1998): 120–21.

62. Figures for 1997 are cited in Costello et al., eds., *American Woman* (1998): 358.

63. Gordon, *Pitied But Not Entitled* (1994); Cott, *Grounding of Modern Feminism* (1987).

64. Addams, "Why Women Should Vote" (1910): 22.

65. Anthony, *Feminism in Germany and Scandinavia* (1915): 6.

66. Wheeler, ed., *One Woman, One Vote* (1995).

67. Quoted in Martha Prescod Norman, "Shining in the Dark: Black Women and the Struggle for the Vote, 1955–1965," in Gordon et al., eds., *African American Women* (1997): 177.

68. Gordon et al., eds., *African American Women* (1997): passim.

69. Costello et al., eds., *American Woman* (1998): 359, table 8-1.

70. Evelyn Brooks Higginbotham, "Clubwomen and Electoral Politics in the 1920s," in Gordon et al., eds., *African American Women* (1997): 143–47.

71. Ware, *Beyond Suffrage* (1981); Weiss, *Farewell to the Party of Lincoln* (1983).

72. Andersen, *After Suffrage* (1996).

73. Susan M. Williams and Joy Harjo, "American Indian Feminism," in Mankiller et al., eds., *Reader's Companion* (1998): 199.

74. Blee, *Women of the Klan* (1991).

75. Bredbenner, *Nationality of Her Own* (1998).

76. Anderson, *Changing Woman* (1996): 83–84.

77. Kerber, *No Constitutional Right* (1998): 136, 178, 203–4.

78. Harrison, *On Account of Sex* (1988); Tobias, *Faces of Feminism* (1997); Lawrence and Matsuda, *We Won't Go Back* (1997).

79. Dorothy Sue Cobble, "Recapturing Working-Class Feminism: Union Women in the Postwar Era," in Meyerowitz, ed., *Not June Cleaver* (1994): 57–83.

80. "Myra Wolfgang rips clichés on women's rights," clipping no. S729, box 6, folder 11, Keell Center, Cornell University.

81. Vogel, *Mothers on the Job* (1993); Scharlach and Grosswall, "Family and Medical Leave Act" (1997): 335–60.

82. Sara Evans, "American Women in the New Millennium," in Costello et al., eds., *American Woman* (1998): 45–101; Friedan, *Feminine Mystique* (1963); DuPlessis and Snitow, eds., *Feminist Memoir Project* (1998).

83. As quoted by Rowbotham, *Century of Women* (1997): 378–79.

84. Redstockings, "Redstockings Manifesto," in Kolmar and Bartkowski, eds., *Feminist Theory* (2000): 178–79.

85. Quoted in Ruiz, *From Out of the Shadows* (1998): 128.

86. From Giddings, *When and Where I Enter* (1984): 345.

87. Combahee River Collective, "A Black Feminist Statement," in Kolmar and Bartkowski, eds., *Feminist Theory* (2000): 272.

88. Alice Walker, "Womanist," in Kolmar and Bartkowski, eds., *Feminist Theory* (2000): 11.

89. Boxer, *When Women Ask The Questions* (1998); Farrell, *Yours in Sisterhood* (1998).

90. Ehrenreich, "Doing it for Ourselves" (1999): 11.

91. Faludi, *Blacklash* (1991); for a negative assessment of feminism's turn to the family, see Berry, *Politics of Parenthood* (1993): 147–70; Sara Evans, "American Women in the New Millennium," in Costello et al., eds., *American Woman* (1998): 96–97.

92. For current efforts, the Women's Committee of 100/Project 2002, author's personal participation.

CHAPTER 1: *Diversity and Difference*

Acknowledgments: We would like to thank Cheryl Buckley, Paul Dobbs, Sue Hanson, Ella Howard, Ron Labaco, Ellen Leopold, Scott Perkins, Joan Rothschild, Beverley Skeggs, Mary Ann Stankewicz, and Steve Walker for their help with this chapter. —PK and LW

1. Besides common usage of the words *diversity* ("variety" and "the condition of being different") and *difference* ("the characteristics which distinguish one person or thing from another or the general"), the terms here refer to feminist and postmodern discourses on difference, "race," and multiculturalism (definitions from *Webster's Third New International Dictionary*). We consider socially constructed categories of difference in and through the practice of design, acknowledging that "Difference is not essential but understood as a social structure which positions male and female people asymmetrically in relation to language, to social and economic power and meaning" (Pollack, *Vision and Difference* [1988]: 56). The text draws attention to differences among and between women and to the intersections of gender with "race," class, employment, domestic situation, sexuality, and other historically specific locations in which women find and place themselves.

The emphasis on difference was a response to assumptions about "women" as a homogenous category (questioned from the earliest days of the Women's Movement by women of color, lesbians, and Marxists). For a discussion of this and the deconstruction of the term *woman*, see Riley, "'Am I That Name?'" (1988); Alcoff, "Cultural Feminism" (1988): 405–36; hooks, *Ain't I a Woman* (1981); and idem, *Talking Back* (1989). For difference as a "crucial strength," see Audre Lorde, "The Master's Tools Will Never Dismantle the Master's House," in *Sister Outsider* (1984).

For different feminisms trying to make sense of difference, see Segal, *Why Feminism?* (1999). For a summary of difference (as sexual difference), particularly in relation to design and feminism, see Rendell, et al., *Gender, Space, Architecture* (2000): 18, which includes a discussion of Luce Irigaray,

Helene Cixous, and Julia Kristeva's "new ways of thinking the construction of female subject from a position of difference." For the shift of emphasis from "race" equality to "race" and multicultural difference see Maynard and Afsar, *Dynamics of Race and Gender* (1994); and for a transnational perspective on feminist multiculturalism and its intersectionalities, see Shohat, ed., *Talking Visions* (1998).

2. See chaps. 3 and 4 in this volume.

3. The term is taken from Rowbotham, *Hidden from History* (1973).

4. Often combined with more structured design teaching and practical experience, travel was an important component of design education from 1900, particularly travel to England, France, Italy, and Germany, and later farther afield. Design students and practitioners were greatly assisted by grants and other subventions for travel and study abroad, ranging from textiles to interior design. The Widener Design Fellowship, for example, was awarded at the Philadelphia School of Design for Women. Parsons School of Design's outpost in Paris, established in 1920 had a substantial impact; Claire McCardell, for example, spent her sophomore year there and many other young designers also studied there (noted in other chapters in this volume).

5. See, e.g., Mather, *Second Report of the Royal Commissioners* (1884); and Clarke, *Art and Industry* (1885–98).

6. The National Academy of Design in New York, founded in 1825, opened its School of the Antique to women in 1831 (Internet: www.nationalacademy.org/schoolhx.htm [cited 14 June 2000]). This date, however, has also been given as 1841 (see Chalmers, *Women in the Nineteenth-Century Art World* [1998]: 78). Drawing lessons were readily available to girls from affluent—and even relatively modest—families. By 1900, in elementary and secondary schools, subjects related to design, such as drawing, were widely taught, often as required by law.

7. Chalmers, *Women in the Nineteenth-Century Art World* (1998): 110–15.

8. British models included the Normal School of Design, London (founded 1837); the Female School of Design, London (1842); and the National Art Training Schools in London and the provinces (1844). From 1863, the National Art Training Schools were affiliated with the South Kensington Museum (now the Victoria and Albert Museum), London.

9. Callen, *Angel in the Studio* (1979): 27–47; Wendy Kaplan, "Spreading the Crafts: The Role of the Schools," in *"Art That Is Life"* (1987/1998): 302; and Chalmers, *Women in the Nineteenth-Century Art World* (1998): 85 and 102.

10. Smith, *Masterpieces of the Centennial Exhibition* (1877): 95–96, as quoted in Thomson, "Alms for Oblivion" (1994): 44. See also Diana Korzenik, "The Art Education of Working Women 1873–1903," in Faxon and Moore, eds., *Pilgrims and Pioneers* (1987): 33–42. Our thanks to Paul Dobbs, Archivist, Massachusetts College of Art, for this reference and for his generous assistance, and special thanks to Ellen Leopold who introduced us to him and supplied other valuable material on education.

11. Mary Ann Stankewicz, Pennsylvania State University, letters to the authors, April 2000. We are very grateful for her comments and for her review of the design education section of this chapter.

12. Chalmers, *Women in the Nineteenth-Century Art World* (1998): 80; Sarah Peter's other involvement in education—as one of the founders of the Ladies Academy of Fine Arts in Cincinnati (active 1854–56)—was directed more toward affluent art students. Also see Callen, *Angel in the Studio* (1979). The St. Louis School of Design for Women, conceived on the South Kensington model, had a brief life (ca.1877).

13. Chalmers, *Women in the Nineteenth-Century Art World* (1998): 79.

14. We are grateful to Sue Hanson, Special Collections, Smith Library, Case Western University, for this information. In Boston, two institutions with similar roots seem to have had less impact and longevity, perhaps because of the establishment of the School of the Museum of Fine Art. The schools were The New England School of Design for Women (founded 1851), modeled on the Philadelphia school, and the School of Carving and Modeling for Women (1877) established by the Women's Education Association (Chalmers, *Women in the Nineteenth-Century Art World* [1998]: 79 and 92n14).

15. Florence C. Ives, "Report of the Board of Women Managers," in Lyon, *Report of the . . . World's Columbian Exposition* (1894): 156 and 160.

16. Ibid., p. 162.

17. "Catalogue of the New Exhibits in the Woman's Building," in ibid., pp. 192–194; and Ives, "Report of the Board of Women Managers," in ibid., pp. 160 and 179. There was even a model kitchen garden planned by a Miss Huntington with a budget of $2,500.

18. Weimann, *Fair Women* (1981): 353–92; and Van Slyck, "Lady and the Library Loafer" (1996): 230–35.

19. Sanborn, "Report on the New York Indian Exhibit," in Lyon, *Report of the . . . World's Columbian Exposition* (1894): 485–91, 498, and 500.

20. Ives, "Report of the Board of Women Managers," in Lyon, *Report of the . . . World's Columbian Exposition* (1894): 176–77; and "Catalogue," in ibid., pp. 196–97 and illus. opp. 208. The exhibit also included examples of African American decorative painting, bookbinding, and macramé basketmaking.

21. For abstraction in design and its importance for Newcomb, as well as other significant curriculum developments, see Poesch, *Newcomb Pottery* (1984): 21–28. See also Kaplan, "Spreading the Crafts," in *"Art That Is Life"* (1987/1998): 298–307.

22. Gillian Moss in Kaplan, ed., *"Art That Is Life"* (1987/1998): 308. For philanthropy and the Saturday Evening Girls' Club, see chap. 2 in this volume and Meyer, et al., *Inspiring Reform* (1997): 64.

23. Knauff, *Training for the Useful* (1922): 37, cited in Chalmers, *Women in the Nineteenth-Century Art World* (1998): 123n26. Knauff lists alumni occupations and numbers for each design area.

24. Catalogue, Parsons School of Design, 1952, quoting the 1925 prospectus. The Parsons School of Design in New York succeeded the Chase School for painters and sculptors (founded 1896). In 1902 it was incorporated as the New York School of Art; in 1909 it reincorporated as the New York School of Fine and Applied Art; in 1941 it was renamed Parsons School of Design; and in 1970 it became part of the New School for Social Research (now New School University). See *One College Three Cities* (1985).

25. Other West Coast schools include

California School of Design (founded 1874 with a fine arts curriculum; renamed the Mark Hopkins Institute; now the San Francisco Art Institute); California College of Arts and Crafts in Berkeley and Oakland (founded 1906), which was introduced to Arthur Wesley Dow's principles of abstraction by Isabelle Percy West (Kaplan, "Spreading the Crafts," in *"Art That Is Life"* [1987/1998]: 305); and Otis College of Art and Design, Los Angeles (founded 1918). The ceramist Edith Heath (see chap. 15 in this volume) and painter and furniture decorator Lucia Kleinhans (Mathews; see chap. 12 in this volume) attended the California School of Design. Several Hollywood designers attended this or the other West Coast schools (see chap. 10 in this volume).

26. Land grants were made through the Morrill Acts of 1862 and 1890 (which included an extension to separate "colored" colleges) and the Amendment of 1907; they produced revenue from "public lands [donated] to the several States and Territories which may provide colleges for the benefit of agriculture and the mechanic arts in order to promote the liberal and practical education of the industrial classes" (Morrill Act, 1862).

27. Kaplan, "Spreading the Crafts," in *"Art that is Life"* (1987/1998): 302.

28. Harris, *Federal Art* (1995); Melosh, *Engendering Culture* (1991); and Carlton-Smith, "New Deal for Women" (1990).

29. See chap.5 in this volume, n23; and Harris, *Federal Art* (1995): 8.

30. Harris, *Federal Art* (1995): 89, 91, 95, and 189n2.

31. Winifred Owens-Hart, "Ceramics: From Africa to America," in Kardon, ed., *Revivals!* (1994): 118.

32. Carlton-Smith, "New Deal for Women" (1990): 160 and 196. In her time, Augusta Savage was considered the "most influential artist in Harlem." See Bibby, *Augusta Savage* (1988): 8. A leader in two other WPA-supported art programs—the Harlem Art Workshop and the Harlem Artists Guild—Savage had first opened the Savage Studio of Arts and Crafts in the early 1930s with a subvention from the Carnegie Corporation. See Patton, *African-American Art* (1998): 145–48; see also chap. 15 in this volume.

33. Melosh, *Engendering Culture* (1991) 3.

34. Ibid., p. x.

35. Schrader, *Indian Arts* (1983): 5. In 1900 the school at Hampton took both Native American and African American students. For representations of Native Americans in material culture around this time, see Cromley, "Masculine/Indian" (1996): 265–80.

36. Howard R. Lamar, "An Overview of American Expansion," in Truettner, ed., *The West as America* (1991): 19.

37. Schrader, *Indian Arts* (1983): 79–80 and 121–22. In 1935, the US Department of the Interior's Indian Arts and Crafts Board (IACB) was established to promote arts and crafts organizations, set standards, and monitor sales and marketing partly through exhibitions and museums of Native American culture, with rare interventions into the training of Native American arts and crafts (Indian Arts and Crafts Board Act, 27 August 1935; amended 1990). See also chap. 4 in this volume.

38. Harris, *Arts at Black Mountain* (1987); Aldersey-Williams, et al., *Cranbrook Design* (1991); and Clark et, ed., *Design in America* (1983).

39. Makela and Lupton, "Underground Matriarchy" (1994): 43.

40. Katherine McCoy and Michael McCoy, "The New Discourse," in Aldersey-Williams, et al., *Cranbrook Design* (1991): 14-16. Katherine McCoy "allowed some of the first debates about deconstruction to surface in critiques of graphic design" and readily took "the heat and the glory for staking out the potentially unbeautiful aesthetic manifestations" (Makela and Lupton, "Underground Matriarchy" [1994]: 44).

41. Lesko, "Industrial Design at Carnegie" (1997): 269; and Pulos, *American Design Ethic* (1983).

42. This topic is discussed in many of the other chapters in this volume.

43. Clegg and Mayfield, "Gendered by Design" (1999): 4 and 6–7.

44. Braznell in Kaplan, ed., *"Art That Is Life"* (1987/1998): 264.

45. See chap. 11 in this volume.

46. For DeRespinis see Carpenter, "STATEMENT" (1964): 72–74; for Kavanaugh see Ella Howard, "Design 'Adventure' of Gere Kavanaugh" (2000/2001). Other women designers have similar histories: Marion Weeber, who designed metalware, jewelry, and giftware in the 1930s, credited her father, a "pioneer" automotive and aeronautical inventor, as a major influence. In 1923, he encouraged her to abandon her art studies to join him in developing a helicopter rescue craft. She recalled, "He put me in overalls in the machine shop where he taught me to think and create and draw factory drafts which were sent to his patent attorneys" ("Marion Weeber" [1998]: 82]. Marie Kirkpatrick, daughter of Arthur Kirkpatrick, "the Dean of Grand Rapids furniture designers," was one of the few women designers to work in the Grand Rapids furniture industry during the entire century. For five years, from about 1918 to 1923, she trained in her father's design studio, learning not only to design but also to make full working drawings. We are grateful to James Beebe for this reference.

47. For Cashin see Iverson, "'Early' Bonnie Cashin" (2000/2001). Isabel Toledo, conversation with Pat Kirkham, 2 December 1999. See also chap. 7 in this volume.

48. For Lowe, see chaps. 4 and 7 in this volume. Furniture designer Cheryl Riley's mother was a fashion show consultant who enrolled in a BFA course in the 1950s. The young Riley was exposed "to the tools and fruits of [my mother's] art classes as she filled our home with her own furniture and wall designs" (Cheryl Riley file, African-American Design Archive, Cooper-Hewitt, National Museum of Design, Smithsonian Institution, New York).

49. Peterson, *Living Tradition of Maria Martinez* (1977): 83.

50. Ibid. Although Peterson and others have pointed to "matriarchies" within Native American pottery and basket making, the direct transmission of design and craft traditions often went through other relatives, male as well as female.

51. E.g., film costume designer Ruth Carter relocated to take advice from her graphic designer brother when she had her first big break—designing costumes for a Spike Lee movie (see chaps. 4 and 10 in this volume). Interior designer Frances Elkins was greatly influenced by her elder brother David Adler, an architect, whom she followed to Paris while he was studying there and with whom she later collaborated (see chap. 13 in this volume).

52. See chap. 2. Raymond Loewy employed another sister-team, Virginia and Nancy Spence, in the early 1940s to work on the South Bend Studebaker

commission (Lamm and Hollis, *Century of Automotive Style* [1997]: 192).

53. See chap. 8 in this volume. They were apprenticed to their uncle Charles Loloma.

54. Mariska Karasz used her sister's textile designs for dresses to her own designs; in turn, Ilonka designed flyers and invitations for Mariska's fashion shows. Although they had much in common, Ilonka designed furniture and graphics as well as textiles, whereas Mariska moved from fabrics to clothing design and embroidery (see Brown, "Ilonka Karasz" [2000–2001]). Textiles also linked the work of the Hampton sisters: Karen designs woven and stitched textiles; graphic designer Holly applied her skills to carpet designs inspired in part by her sister's work and by African American patterns (see chap. 4 in this volume).

55. Florence Knoll Bassett recently commented, "Rachel was a wonderful role model. It was so rare then for a woman to be an architect, and to have one as one's high school teacher and mentor was extraordinary" (Florence Knoll Bassett, interview with Pat Kirkham, 18 February 1999). I am grateful to Mitchell Wolfson Jr. for arranging the introduction and for other courtesies while I was a fellow at the The Wolfsonian-Florida International University, Miami Beach, Florida. — PK

56. Sussman's parents supported her endeavors: her father was a commercial (or graphic) artist and her mother was an accomplished linguist, and at age ten Deborah broadcast, in French, on wartime radio to "the children of France" (Deborah Sussman, in conversation with Pat Kirkham, 19 January 2000).

57. Sparke, *As Long as It's Pink* (1995): 73.

58. McNeil, "Designing Women" (1994): 639. Parsons sought to reclaim interior design as "masculine" immediately after Elsie de Wolfe categorized it as "feminine" (*House In Good Taste* [1913]). See Parsons, *Interior Decoration* (1915).

59. As far as employers were concerned, women's labor was cheaper than that of men. However, there are surprisingly few statistics available for comparable wages paid to male and female designers doing roughly equal work, in terms of experience, type of product, status of the area of work, and status of the firm. This is further evidence of the need for studies of design and designers to use what are generally regarded as "business" archives.

60. "Ten on the Edge" (1988): 64. The stories of young women wanting to be architects only to be advised to be interior designers are as legion as those of young women aspiring to be doctors being encouraged to enter nursing. Today, though much has changed, the channeling of girls and young women into particular fields of work remains central to the continuation of gender divisions in design.

61. See chaps. 9 and 12 in this volume. The gender divisions within furniture making date to the Middle Ages. See Pat Kirkham, "'If You Have no Sons': Furniture Making in Britain," in Attfield and Kirkham, eds., *View from the Interior* (1989): 109–30.

62. See ibid.

63. For markers of masculinity, see Pat Kirkham and Janet Thumim, "You Tarzan," in Kirkham and Thumim, *You Tarzan* (1993): 11–26.

64. See chap. 11 in this volume.

65. Commonwealth of Massachusetts, *Massachusetts Normal Art School . . . 1915–1916* (1915): 17; and idem, *Massachusetts Normal Art School . . . 1923–1924* (1923): 16. We are grateful to Paul Dobbs for this information.

66. Atypically, architect Lutah Maria Riggs worked as an art director on a few Hollywood movies during the war (see chap 10 in this volume). Some wartime activities expanded the repertoires of certain women designers and enhanced the recognition given to them. For example, Nina Wolf, jewelry designer, organized a handicraft program for the physical rehabilitation of wounded veterans, complete with kits and instructions (Staggs-Flinchim, "An Innovative Fashioner" [1996–97]: 104). Fashion designers Muriel King and Vera Maxwell designed coordinates for aircraft workers and a "coverall" jumpsuit for workers at Sperry Gyroscope (see fig. 7-13), respectively. Elizabeth Hawes came out of retirement to design the uniform of the Red Cross Volunteers. Maxwell, Bonnie Cashin, Clare McCardell, and Helen Cookman all designed women's Civilian Defense uniforms which were worn with hats designed by Sally Victor and Lilly Daché. See Iverson, "'Early' Bonnie Cashin" (2000–2001): 40, and figs. 67 and 68. For Daché see checklist no. 75 in this volume.

67. Kirkham, *Charles and Ray Eames* (1995): 212–14.

68. See chap. 4 in this volume.

69. Anita Stewart Bach, interview with Pat Kirkham and Ella Howard, 7 October 1998. Bach discussed the engineering drawing and machine design at the Illinois Institute of Technology, Chicago. Parsons School of Design also offered engineering drawing and illustration courses (see fig. 1-29).

70. Ibid.

71. Belle Kogan, Ray Eames, Margaret de Patta, Bonnie Cashin, Patricia Zipprodt, and Deborah Sussman are among notable women designers who did/do not have children. Elsie de Wolfe rose to fame while living in what was euphemistically termed a "Boston marriage"—a lesbian relationship. Industrial designer Kogan determined not to marry or have children when forced to leave the Pratt Institute in the late 1920s — after only one semester — because she had to care for seven siblings and the family home (see chap. 11 in this volume).

72. Tankard, *Gardens of Ellen Biddle Shipman* (1996): 5 and 26–28.

73. Zeisel's mother, Laura Polyani Stricker, was a femininst who had been a political activist in Hungary in the early 1900s and had run an experimental school for young children. See Eidelberg, et al., *Eva Zeisel* (1984): 13.

74. For Bowers Rice see Doering, Switzky, and Welz, eds., *Goddess in the Details* (1994): 11 and for Wolf see Staggs-Flinchim, "An Innovative Fashioner" (1996–97): 104.

75. Kirkham and Seiler, "Lella Vignelli" (2000–2001). Deborah Nadoolman, a film costume designer for over twenty years, recently decided to shift career (to design historian, no less) because of the heavy tolls of location work, excessive hours, and holding together "family life."

76. Collaborations are discussed in many chapters in this volume. Also see part 2 of this chapter.

77. Smithson cited in Kirkham, *Charles and Ray Eames* (1995): 70. "Telepathy" was mentioned by several speakers at the "Heirs of Modernism: Partners in Design" conference, 1999, organized by the Cooper-Hewitt National Design Museum. Attitudes toward the recognition of women within such partnerships is changing. The couples featured were

designers Nancy Green and Michael Donovan, Katherine McCoy and Michael McCoy, and Jessica Helfand and William Drenttel, as well as architects Billie Tsien and Tod Williams and architects/exhibition/set designers Hsing-Ming Fung and Craig Hodgetts. For "couple" collaborations see also Chadwick and de Courtivron, *Significant Others* (1993); Kirkham, *Charles and Ray Eames* (1995): 1–8, 61–96, and 364–81; Walker, *Drawing on Diversity* (1997): 20–26 and 34–36; Filler, "Constructing Couples" (1998): 114–17, 122; and Kirkham, "Looking for the Simple Idea" (1994): 16–20.

78. In 1991 British designer and architect Alison Smithson commented, "It was and is extremely hard for anyone to stomach the fact that there can be two people of equal talent in a partnership. Someone always says that one must be being carried, and—if it is a woman—then she must be really tied to the kitchen sink, that they wouldn't be working with her if they were not married and all that sort of thing. People still can't face the fact of women being equal, of women being good designers. If there is a woman involved the assumptions are that the male is the leading partner" (quoted in Kirkham, *Charles and Ray Eames* [1995]: 81).

79. The number unearthed during research for this project suggests that working with a husband was an even more common route for women to take to practice as designers than has previously been supposed.

80. Wexman, *Creating the Couple* (1993): 12–13.

81. See part 2 of this chapter.

82. "Faithful Helpmates" (1945): 53–54.

83. Kirkham, *Charles and Ray Eames* (1995): 83.

84. For an account of her early years working with Massimo Vignelli, see Kirkham and Seiler, "Lella Vignelli" (2000–2001). Heilbrun draws attention not only to the sanitizing tendencies of biographies, but also to women's own self-censorship in terms of expressing frustrations, disappointments, and bitterness (*Writing a Woman's Life* [1988]). Too many accounts of women designers fail to deal with such topics.

85. See, e.g., Battersby, *Gender and Genius* (1989).

86. For a model in-depth interview, see interview with Scott Brown in Gabor, *Einstein's Wife* (1995): 157–231.

87. Ibid. For the first published co-attribution of Denise Scott Brown and Robert Venturi for the "Queen Anne" dining chair, manufactured for Knoll, see Eidelberg, ed., *Designed for Delight* (1997): 200.

88. Denise Scott Brown, interviewed by Pat Kirkham, 30 November 1999. Scott Brown stated, "I only spent months and months on the project whereas Bob spent years." See also Denise Scott Brown, "Room at the Top? Sexism and the Star System in Architecture," in Berkeley and McQuaid, eds., *Architecture* (1989): 237–46.

89. She was constantly informed by her parents that her brother Eero Saarinen was a "genius." We are grateful to Mark Coir, Director, Cranbook Archives and Cultural Properties and to Karen P. Swanson for this information.

90. Susan Peterson has suggested that it was because he was talented while she outstanding. This may have been the case, but, when Charles Rennie Mackintosh argued that about Margaret McDonald Mackintosh, he was considered to be merely gallant.

91. See chaps. 3, 4, and 5. If history were a complete science, or if one had a retrospective crystal ball, one could theoretically know the name of every member of every textile design studio, full-time or freelance. Scholars undoubtedly will continue to identify and research women currently considered "anonymous."

92. Mainardi, "Quilts" (1973): 1, 18–23. Particular biases and poor scholarship have certainly added greatly to the ranks of "anonymous," but the "recovery" of women designers "hidden from history" will never be complete.

93. Peterson, "Nampeyo of Hano," in *Pottery by American Indian Women* (1997): 54–57. Today, the Indian Arts and Crafts Board regards stamps and signatures less as a means to recognition for designer-makers than as guaranteeing "authentic" Native American work. See Public Law 101-644, The Indian Arts and Crafts Act, 1990 (an addendum to legislation of 1935 establishing the IACB).

94. Peterson, "Martina Martinez," in ibid., pp. 62–65. See also Peterson, *Living Tradition of Maria Martinez* (1977): 71–118.

95. Quoted in Benjamin, *Life and Art of Loïs Mailou Jones* (1994): 7. For Jones, see also chaps. 4 and 5 in this volume.

96. For Jones and Ransier, see chap. 4 in this volume.

97. Even in the textile industry, it was possible to become a "star"—the term used to describe Dorothy Liebes in a Goodall Fabrics advertisement. For this and another reference to her as "First Lady of the Loom," see chap. 5 in this volume.

98. Lucia DeRespinis, in conversation with Pat Kirkham, 11 March 2000.

99. We now expect lengthy credits at the end of a movie, but rolling credits are difficult to fit onto a dress label. Nor do they sit easily in industries and marketing geared towards "boutique culture," "star" names, and volume sales (see chaps. 5 and 7 in this volume). Although Donna Karan is one of the best-known women designers working in the United States today, she was not a household name until she established her own firm and the DKNY label in the mid-1980s. She recalled that "nobody knew anything about me" when she worked for Anne Klein, just as Klein had been "anonymous" when she worked for Varden Petites (1938–40) and for Maurice Rentner (1940–47), and just as Karan's own staff designers are today. Morris and Walz, *Fashion Makers* (1978): 133.

100. See chap. 4 in this volume.

101. Paul Gilroy quoted in Jaggi, "Gifted, Black . . . and Gone" (2000): 16.

102. Although product designers Belle Kogan, Suzanne Vanderbilt (fig. 1-43), and Ray Eames all appeared on the small screen in the 1950s, television appearances by designers has been relatively rare. By 2000, magazines and journals remained the most important media vehicles for designer recognition.

103. Cynthia Henthorn and Nicole Demerin, "Women and Design Education: A Contemporary Survey," unpublished paper, New York, 1999. Their data were taken from statistics compiled by the National Association of Schools of Art and Design (NASAD), a US accrediting agency founded in 1944 for institutions, colleges, and universities with art and design programs or departments.

104. Ibid. In 1998–99 the percentages of women students were: textiles/fiber 89 percent, interior design 87 percent, jewelry and metalwork 85 percent, and fashion 81 percent.

105. Ibid. In 1997–98 only 8.5 percent of

the students studying transportation design were women. Other industrial design courses were grouped with product design, making it impossible to separate out particular areas. Women accounted for 38 percent of all undergraduates in this broad category. The Industrial Designers Society of America reported that women accounted for only 1 percent of its membership in 1974 whereas at the end of the century the figure had risen to 19 percent (see chap. 11 in this volume). It remains to be seen how secure that toehold will prove if there is a serious downturn in the economy.

106. Ibid. Women comprised over 50 percent of craft-based wood and furniture courses at the end of the century. We are grateful to the staff at the Savannah College of Art and Design (where women account for approximately 40 percent of furniture students in a department that encourages them to use machinery as well as craft techniques) for providing detailed information about their course.

107. Ibid. At undergraduate level (1998–99) 63 percent of graphics students were women—with roughly equal numbers in "New Media, Computer Art and Communication." Of the current 15,000 AIGA (American Institute of Graphic Arts) members, 55 percent are women. We are grateful to Alice Twemlow for this information.

108. Ibid. Women accounted for approximately 55 percent of art and design undergraduates in 1998–99. Of these, 82 percent were European American, with 9.5 percent Asian American, 4.5 percent Hispanic, 3.25 percent African American, and 0.6 percent Native American. Of the total female population at the same date, "White, Not Hispanic" women accounted for approximately 72 percent; "Asian and Pacific Islander, Not Hispanic" for just under 4 percent, "Hispanic Origin" for just over 11 percent, "Black, Not Hispanic" for approximately 12 percent, and "American Indian, Eskimo, and Aleut, Not Hispanic" for approximately 0.7 percent (taken from Population Estimates Program, Population Division, United States Census Bureau, Washington, D.C., Internet [cited 24 May 2000].

109. See chaps. 14 and 16 in this volume. In 1995, a report published under the auspices of the American Society of Landscape Architects Women and the Profession, *Glass Ceilings and Bottom Lines*, commented on continuing inequalities within the profession. See also Anne Komara, "Glass Wall" (2000–2001).

110. Eva Zeisel, conversations with Pat Kirkham, January–March 2000. See also Eidelberg, et al., *Eva Zeisel* (1984), and Labaco, "'Playful Search for Beauty'" (2000–2001).

111. For postmodernism, see Jameson, *Postmodernism* (1991); Huyssen, *After the Great Divide* (1986); Harvey, *Condition of Post-modernity* (1989); Callinicos, *Against Postmodernism* (1989); and Skeggs, "Postmodernism" (1991): 255–67. For modernist suppression of the decorative, the domestic, and the "feminine," see Sparke, *As Long as It's Pink* (1995): 222–36; and Sharon Haar and Christopher Reed, "Coming Home: A Postscript on Postmodernism," in Reed, ed., *Suppression of Domesticity* (1996): 253–73. For reviews of feminist scholarship on design, see Howard, "Feminist Writings" (2000–2001). Joan Rothschild and Victoria Rosner, "Feminism and Design: Review Essay," in Rothschild, ed., *Design and Feminism* (1999); Whitely, "Feminist Perspectives," in *Design for Society* (1993); and Haar and Reed, "Coming Home," in Reed, ed., *Suppression of Domesticity* (1996): 253–73. For reappraisals of craft, see Elinor, ed., *Women and Craft* (1987); Kardon, ed., *Revivals!* (1994); Dormer, *Design Since 1945* (1993); idem, *Arts of the Maker* (1994); Harrod, *Crafts in Britain* (1999): 369-410; and *Journal of Design History* 11 (1998). For the relationship of feminism to postmodernism, see Wolf and Nicholson, eds., *Feminism/Postmodernism* (1990); Flax, *Thinking Fragments* (1990); Benhabib, "Feminism" (1994); and Weedon, *Feminist Practice* (1987).

112. For instance, see Winifred Owens-Hart, "Ceramics: From Africa to America," in Kardon, ed., *Revivals!* (1994): 114–18; Alexander, *Blacks in...Fashion* (1982); White, *Style Noir* (1998); Michele Wallace, "French Connection," in Cameron, ed., *Dancing at the Louvre* (1998); Benberry, *Always There* (1992); Harris, "What It Is?" (1996): 38–42; and Wilson, *Visual Perceptions* (1991).

113. As important as the Harlem Renaissance in its historical significance, this movement awaits sustained analysis.

114. Gail Tremblay questions the concept of authenticity in her essay, "Cultural Survival and Innovation: Native American Aesthetics," in Kardon, ed., *Revivals!* (1994): 77–83.

115. The issue of "messy vitality" also relates to "messy" versus "neat" history. See Scotford, "Toward an Expanded View of Women in Graphic Design" (1994): 368–88; Skeggs, *Feminist Cultural Theory* (1995): 8–9; and Pat Kirkham, "The Personal, the Professional, and the Partner(ship)," in ibid., especially p. 209.

116. Mainardi, "Quilts" (1973): 1, 18–23. For reactions to *The Dinner Party* by Judy Chicago, see Jones, ed., *Sexual Politics* (1996): 24. For a history of feminist art and some design, see Broude and Garrard, eds., *Power of Feminist Art* (1995).

117. Mainardi, "Quilts" (1973): 18.

118. See Parker, "Word for Embroidery"(1975): 41–45 and idem, *Subversive Stitch* (1989): 5; for Edward Worst's contribution to hand-loom weaving see Gillian Moss's catalogue entry in Kaplan, ed., *"Art That Is Life'"*(1987/1998): 332; and for men and quilting, see chap. 6 in this volume.

119. Buckley, "Made in Patriarchy" (1986): 3–14.

120. Lucy Lippard questioned the importance placed on innovation in art in *From the Center* (1976). Buckley, "Made in Patriarchy" (1986) and Attfield and Kirkham, *View from the Interior* (1989) were written in part as responses to Isabelle Anscombe, *Women's Touch* (1984), which was critiqued as unproblematically adding women to an unproblematized design history.

121. By the late 1950s Pevsner was one of the first to argue for the appreciation of Victorian design—which led to a new focus on eclecticism, accumulation, "clutter," and associative and emotive aspects of design, too often only associated with postmodernism. For examples of later scholarship, which privileged modernism and industrial design, see Heskett, *Industrial Design* (1980); Sparke, *Consultant Design* (1983); and Woodham, *Industrial Designer* (1983).

122. Chapman-Huston, *Lamp of Memory* (1949): 127, cited in Kirkham, *Charles and Ray Eames* (1995): 81.

123. Howarth, *Charles Rennie Mackintosh* (1952): 145. For a feminist analysis of the Mackintoshes' collaboration see Helland, "Critics and the Arts and

Crafts" (1994): 209–27; for genius and gender see Battersby, *Gender and Genius* (1989).

124. Parker and Pollock's *Old Mistresses* (1981) sought to "explore women's place in the history of art" (p. *xvii*) and to look at the specific ways women made art under various constraints at different periods (ibid., p. *xix*). See also Nevins, "Eileen Gray" (1981): 68–71; and Deitsch, "Lilly Reich" (1981): 73-76. Both essays were in the same issue of *Heresies*; after its publication women designers and academics could never again be so in awe of male modernist heroes, to say nothing of their biased chroniclers.

125. See, e.g., Lynne Walker, "The Arts and Crafts Alternative," in Attfield and Kirkham, eds., *View from the Interior* (1989): 163–73; and Cheryl Robertson, "From Cult to Profession: Domestic Women in Search of Equality," in Martinez and Ames, *Material Culture of Gender* (1997): 75–109.

126. Buckley, "Women Designers in the English Pottery Industry"(1985): 11–15; idem, "Pottery Women: A Comparative Study of Susan Vera Cooper and Millicent Jane Taplin", in Attfield and Kirkham, eds., *View from the Interior* (1989): 71-89; idem, *Potters and Paintresses* (1990); and idem, "'Noblesse of the Banks'"(1989/1990): 257–73.

127. See also Torre, ed., *Women in American Architecture* (1977).

128. See also Feldman, "Women in Architecture" (1991): 10–11; and Dixon, "White Gentleman's Profession?" (1994): 55–61.

129. *Drawing on Diversity* accompanied an exhibition at Heinz Gallery, Royal Institute of British Architects (RIBA), 5 June–26 July 1997.

130. See also Cowan, *More Work for Mother* (1983).

131. For the work of Cynthia Cockburn on gender and technology, see Joan Rothschild and Victoria Rosner, "Feminisms and Design: Review Essay," in Rothschild, ed., *Design and Feminism* (1999): 24. See also Lupton, *Mechanical Brides* (1993).

132. The exhibition was held at the Pratt Manhattan Gallery, 14 January–17 February 1994.

133. Perry, ed., *Gender and Art* (1999): 24.

134. Pat Kirkham's 1995 discussions of the designer Ray Eames, which focused on aspects of her work previously thought insignificant and which refused to place her within the binary oppositions of modernist design history, helped establish this approach within design history. See Kirkham, *Charles and Ray Eames* (1995); and idem, "Humanizing Modernism" (1998): 15–29.

135. See also Helland, "Critics and the Arts and Crafts" (1994): 209–27; and idem *Studios of Frances and Margaret Macdonald* (1996).

136. Contributors writing on women designers included Liz Arthur, Liz Bird, Anne Ellis, Janice Helland, Timothy Neat, and Pamela Robertson.

137. See especially Lee Wright, "Objectifying Gender: The Stiletto Heel," in Attfield and Kirkham, *View form the Interior* (1989): 7–20; Angela Partington, "Designer Housewife in the 1950s," in ibid., pp. 206–14; and Attfield, "Inside Pram Town: A Case Study of Harlow House Interiors, 1951-1961," in ibid., pp. 215–38.

138. The quotation is from Hillel Schwartz, "Hearing Aids: Sweet Nothings, or an Ear for an Ear," in Kirkham, ed., *Gendered Object* (1996): 57.

139. See also Cheryl Robertson, "House and Home in the Arts and Crafts Era," in Kaplan, ed., *"Art That Is Life"* (1987/1998): 336–57; and Foy and Schlereth, eds., *American Home Life* (1992).

140. The special issue includes Beverly Gordon, "Woman's Domestic Body: The Conceptual Conflation of Women and Interiors in the Industrial Age" (pp. 281–301); Elizabeth Cromley, "Masculine/Indian" (pp. 265–80); and Jan Jennings, "Controlling Passion: The Turn-of-the-Century Wallpaper Dilemma" (pp. 243–64). Other publications in the field include *Material Culture* and *Material History Review*. For gendered interiors, see Girouard, *Victorian Country House* (1973); Franklin, *Gentleman's Country House* (1981); and Juliet Kinchin, "Interiors: Nineteenth-Century Essays on the 'Masculine' and the 'Feminine' Room," in Kirkham, ed., *The Gendered Object* (1996): 12–29.

141. By contrast, Jennifer Craik's *Face of Fashion: Cultural Studies in Fashion* (1994) took a more ethnographic approach.

142. Colomina, ed., *Sexuality and Space* (1992); and Wigley, *White Walls Designer Dresses* (1995).

143. Elizabeth Wilson, "Fashion and the Postmodern Body," in Ash and Wilson, eds., *Chic Thrills* (1992): 5.

CHAPTER 2: *Arts and Crafts*

Acknowledgments: I am grateful to the Winterthur Museum, Garden and Library for granting a residential fellowship that enabled me to complete the research for this chapter.—WK

1. Day, "Woman's Part in Interior Decoration" (1881), reprinted in *Late Victorians* (1986): 208.

2. William Morris, preface to *Nature of Gothic* by John Ruskin (1892 ed.), quoted in Lambourne, *Utopian Craftsman* (1980): 13.

3. A few paragraphs of this essay have been drawn from some of my other essays in publications on the Arts and Crafts movement. See Kaplan, *Leading "The Simple Life"* (1999): 12, 14; and idem, *"Art that is Life"* (1987 / 1998): 304–5; used by permission.

4. For the only book solely on women in the Arts and Crafts movement, see Callen, *Angel in the Studio* (1979). The text focuses on England, however, and the author's assessment, repeated even more vehemently in an article she wrote ten years later, is fairly negative. She asserted: "Although the Arts and Crafts movement was in many ways socially and artistically radical, at the same time it in fact reproduced, perpetuated and thus reinforced dominant Victorian patriarchal ideology. It recreated in microcosm traditional divisions between male and female roles" (Callen, "Sexual Division of Labour in the Arts and Crafts Movement," in Kirkham and Attfield, eds., *View from the Interior* [1989]: 151). An alternative view, posited by scholars such as Lynne Walker, is that "the Arts and Crafts movement provided women with alternative roles, institutions and structures...," which served to enhance "women's position and status in society in a much more fundamental way than has been conceded." (Kirkham and Attfield, eds., *View from the Interior* [1989]: 165). For the best overall description of women's participation in the American Arts and Crafts movement, see Boris, *Art and Labor* (1986), especially chaps. 5-7.

5. These categories are developed from the four posited by Callen ("Sexual Division of Labour in the Arts and Crafts Movement," in Kirkham and Attfield, eds., *View from the Interior* [1989]: 155–56).

6. Books by Candace Wheeler include *How to Make Rugs* (1902), *Principles of Home Decoration* (1903), and her memoir *Yesterdays in a Busy Life* (1918). I am grateful to Amelia Peck for her kindness in reviewing the section on Wheeler and sharing her expertise.

7. Wheeler, *Yesterdays in a Busy Life* (1918): 211, 213.

8. Quoted in Callen, *Angel in the Studio* (1979): 129.

9. Wheeler, *Development of Embroidery* (1921): 107.

10. Also modeled on British precedent, the Exchange sold goods of quality, including baking, but these home wares did not meet the rigorous aesthetic standards of the Society of Decorative Arts.

11. For example, the Boston Society of Decorative Art was modeled after its New York predecessor and the Women's Industrial and Educational Union in Boston after Wheeler's Women's Exchange. See Boris, *Art and Labor* (1986): 115.

12. M. Nichols Storer, *Bulletin* 11 (June 1932): 158 (excerpts from a brochure written in 1895 and published in Paris in 1919). Quoted in Evans, *Art Pottery* (1974): 255.

13. Triggs, *Chapters* (1902): 161.

14. Evans, *Art Pottery* (1974): 4.

15. The firm closed in 1913.

16. After about 1916, the focus of the magazine shifted from china painting to art pottery.

17. Weiss, ed., *Adelaide Alsop Robineau* (1981): 73.

18. Perry, "Adventures in Ceramics" (1930s): 55–56, 67, 75. Original manuscript is located in the archives of the Pewabic Pottery, Detroit, Michigan; copy also at the Winterthur Museum Library, Winterthur, Delaware.

19. Ibid., p. 66.

20. Binns, "Education in Clay" (June 1903): 160.

21. Dow, *Composition* (1899; 1913 edition): 76.

22. Quoted in Jessie Poesch, "The Art Program at Newcomb College and Newcomb Pottery, 1886–1940," in *Southern Arts and Crafts* (1996): 63.

23. Ibid., p. 64. For a more complete account of the Newcomb Pottery, see Poesch, *Newcomb Pottery* (1994).

24. Jessie Poesch discussed this point in her lecture on Newcomb at the conference, "The Arts and Crafts Movement in America, 1875–1920" held at New York University, June 1999. See also Poesch,

"Art Program at Newcomb," *Southern Arts and Crafts* (1996): 64, 65, and 70.

25. Darling, *Chicago Metalsmiths* (1977): 45.

26. Ibid., p. 53.

27. Sargent, "Successful Pursuit of an Art-Industry" (August 1905): 1233. Sargent was also the editor of the most influential Arts and Crafts magazine, Gustav Stickley's *Craftsman*.

28. Ibid., pp. 1233, 1236.

29. [New York] *Evening Sun*, 12 January 1916. I am grateful to Rosalie Berberian for her generosity in sharing her research files on Zimmermann and on Carson and Barnum.

30. Much of the information in this section on settlement house work in the South was derived from *Southern Arts and Crafts* (1996): see especially 34–41.

31. Slocum, "'Hearthside Loom'" (July 1908): 18–19.

32. Margaret Whiting, speech given after 1926, folder 7, box 4, p. 3, in the Deerfield Town Papers, Memorial Hall Museum, Pocumtuck Valley Memorial Association Library, Deerfield, Massachusetts.

33. Both Whiting and Miller studied at the Academy of Design in New York; Miller also studied at the Art Students League.

34. Whiting, "Colonial Embroidery," 1931, p. 45, in the Pocumtuck Valley Memorial Association Library, Deerfield, Massachusetts.

35. Margaret Whiting, manuscript, ca. 1901, in the Pocumtuck Valley Memorial Association Library, Deerfield, Massachusetts. I am grateful to Suzanne L. Flynt for providing a copy of the manuscript, and for her review of my text about Deerfield.

36. See Ellen Gates Starr, "Art and Labor," in *Hull-House Maps and Papers* (1895). For Starr's beliefs, see Kahler, "Art and Life" (1986).

37. Quoted in Kahler, "Art and Life" (1986): 140.

38. Quoted in Tracy et al., *Nineteenth-Century American* (1970): cat. no. 210.

39. Brigham, *Box Furniture* (1909 / 1919): preface, unpaginated. The only modern scholarship about Brigham is Neville Thompson, "Louise Brigham: Developer of Box Furniture," in Denker, ed., *Substance of Style* (1996): 199–211.

40. *Illustrated Lectures by Louise Brigham, Author of "Box Furniture,"* pamphlet (n.d.): unpaginated. This pamphlet was inserted into Brigham's annotated copy of *Box*

Furniture, Winterthur Library, Winterthur, Delaware.

41. "Industrial Art Fancy Work," *Craftsman* 10 (August 1906), p. 683.

CHAPTER 3: *Native American*

1. Bullboats are a kind of spherical workboat. Bullboats and bullboat frames were depicted in paintings of Hidatsa earthlodge communities in 1832 by artist George Catlin who visited and painted in several communities located along the upper Missouri river. See McCracken, *George Catlin* (1959), and Gilman and Schneider, *Way to Independence* (1987): 125, 184.

2. Nabokov, ed., *Native American Testimony* (1992): 182.

3. Powell, "The Enduring Beauty" (July 1973): 4–11.

4. Gilman and Schneider, *Way to Independence* (1987): 116.

5. For an example of shared designs, see Maxwell Museum of Anthropology, *Seven Families* (1974): 52.

6. Smith-Ferri, "Development of the Commercial Market" (1998): 15–22.

7. Sullivan and Pardue, "Introducing America" (Fall/Winter 1995): 58–64. The system of authentication he established by working with the Field Museum of Chicago's curator George Dorsey and other ethnographers was continued by Harvey's daughter and other traders such as J. L. Hubbell.

8. Patterson, "Change and Continuity" (1998): 13–14.

9. McLendon, "Pomo Basket Weavers" (1998): 34–47.

10. Ibid., pp. 44–45.

11. Abel-Vidor, Brovarney and Billy, *Remember Your Relations* (1996): 33.

12. Ibid., p. 10.

13. Remarks by Susan Billy at the symposium, "Pomo Indian Basket Makers: Past, Present and Future," held at the Smithsonian Institution, National Museum of the American Indian, Heye Center, New York City, 7 May 1999.

14. Small baskets require less time to make. Billy has stated: "When people ask me if this is a craft, I say no, it's a spiritual path. It's certainly not about money. People think you can make money on Pomo baskets. I think non-Indian art dealers make money on Pomo baskets. It's not true for the weavers themselves" (Thompson, "Susan Billy" [March/April 1999]: 11).

15. Billy also works to protect the gathering sites for plants used in weaving and in transplanting efforts.

16. For an overview, see Bates and Lee, *Tradition and Innovation* (1990).

17. Ibid., pp. 168–71.

18. Marvin Cohodas, "Washoe Innovators and Their Patrons," in Wade, ed., *Arts of the North American Indian* (1986): 208.

19. Gretchen Ronnow, "Dat-So-La-Lee," in *Native American Women* (1993): 71–72.

20. Cohodas, "Washoe Innovators" (1986): 208.

21. Ibid.

22. Ibid.

23. Tohono O'odham Basketweavers Organization, "Native Baskets" (Winter 1999): 42–45.

24. For an overview, see Feest, *Beadwork and Textiles* (1984) and Densmore, *Chippewa Customs* (1929/1979).

25. Dow, "Native Baskets" (1998): 44.

26. Project Indian PRIDE, *Baskets* (n.d.): 1.

27. Both the Akwesasne Museum in Hogansburg, New York, and Michigan State University Museum Gift Shop in East Lansing, Michigan, promote the sale of Northeastern Native basketry.

28. Dow, "Native Baskets" (1998): 46.

29. Hudson, *Southeastern Indians* (1994): 384.

30. Ibid., p. 387.

31. Navajo technique was adapted from that of male Pueblo weavers living nearby. Pueblo men wove cotton and yucca garments before Spaniards introduced European sheep to the region in the sixteenth century. By the late eighteenth century, Pueblos were producing high-quality woolen blankets. See Marc Simmons, "History of Pueblo-Spanish Relations," in Alfonso Ortiz, ed., *Southwest*, vol. 9 of Sturtevant., ed., *Handbook of North American Indians* (1979): 190.

32. See Rodee, "Spider Woman's Art" (1982): 10.

33. Ibid., p. 11.

34. Penney and Longfish, *Native American Art* (1994): 159.

35. Sullivan and Pardue, "Introducing America" (Fall/Winter 1995): 60.

36. Ibid., p. 58. Harvey publications such as *First Families of the Southwest* and *The Great Southwest* were designed for tourists.

37. Rodee, "Spider Woman's Art" (1982): 12.

38. She was referred to by name in magazines such as *Arizona Highways* (50, no. 7). Hedlund, *Reflections of the Weaver's World* (1992): 48.

39. Ibid.

40. Mimbres pots were created ca. 900–1200 in southern New Mexico. See Paul S. Marlin, "Prehistory: Mogollon," in Alfonso Ortiz, ed., *Southwest*, vol. 9 of Sturtevant., ed., *Handbook of North American Indians* (1979): 70.

41. For Sakiestewa see Emily Drabanski, "Dream Weaver" (August 1996): 56, 58; Steinberg, "Hectic Pace" (31 July 1994): arts section, 61, 63; and *Women of Sweetgrass* (1985).

42. Begay used money made from weaving rugs to study computer science at a nearby community college See Hedlund, *Reflections of the Weaver's World* (1992): 32.

43. Lesso's role in painting was minimal compared with that of their daughter, Annie. See Kramer, *Nampeyo* (1996): 162–63; and Peterson, *Pottery* (1997): 54–61.

44. See John Anson Warner, "The Individual in Native American Art: A Sociological View," in Wade, ed., *Arts of the North American Indian* (1986): 183; and Wade, "Native American Pottery" (1991): 178.

45. See Warner, "Individual," in Wade, ed., *Arts of the North American Indian* (1986): 183; and Sullivan and Pardue, "Introducing America" (Fall/Winter 1995): 63.

46. Warner, "Individual," in Wade, ed., *Arts of the North American Indian* (1986): 182.

47. Ibid., 183.

48. Fannie Nampeyo's work displays the same high standards established by her mother. See, e.g., Blair and Blair, *Legacy of a Master Potter* (1999): 135, 207–219; Peterson, *Pottery* (1997): 110–15.

49. Dorothy K. Washburn, "Pueblo Ceramics," in Washburn, ed., *Elkus Collection* (1984): 17.

50. Conn, *Native American Art* (1979): 211.

51. See, e.g., Maxwell Museum of Anthropology, *Seven Families* (1974): 22–38; Dillingham, *Fourteen Families* (1994): 14.

52. Potters sold their work directly to tourists brought to Pueblo villages in automobiles by the Fred Harvey Company during the 1920s. See Kramer, *Nampeyo* (1996): 130–32.

53. Maxwell, *Seven Families* (1974): 22.

54. Barbara Babcock, "Martinez, Maria Montoya," in Bataille, ed., *Native American Women* (1993): 165.

55. Maxwell, *Seven Families* (1974): 85.

56. During the 1930s Lewis, with children in hand, sold her pottery at a roadside stand set up on U.S. Highway 66. See Peterson, *Lucy Lewis* (1984): 105.

57. Maxwell Museum of Anthropology, *Seven Families* (1974): 9.

58. Blumer, "Eastern Woodland" (February 1979): 16. According to Catawba lore, people have always made pots. See Fewkes, "Catawba Pottery-Making" (July 1944): 72, 109.

59. Blumer, "Eastern Woodland" (February 1979): 17.

60. Anna Mitchell, telephone conversation with author, January 2000. See also Mitchell, "Our People" (Fall 1998).

61. Each year she takes her pottery line to the Santa Fe Market for sale, as well as serving collectors with whom she conducts mail-order business.

62. Heth, ed., *Native American Dance* (1992): 16. Jingle dresses are specifically "danced" to hear or to maintain one's health.

63. Blackard, *Patchwork* (1990): 45.

64. Palmetto roofs feature the spines of leaves folded back on themselves. See Nabokov and Easton, *Native American Architecture* (1989): 121.

65. See, e.g., Downs, *Art of the Florida Seminole* (1995): 103; Nabokov and Easton, *Native American Architecture* (1989): 110.

66. Downs, *Art of the Florida Seminole* (1995): 90.

67. Ibid., p. 99.

68. Dorothy Downs acted as intermediary between clients and designer for both projects. See ibid., p. 117.

69. *Hope Series* (n.d.). The program benefited thirty tribal colleges throughout the United States.

70. Designs by Tony Abeyta (Navajo), Arthur Amiotte (Lakota Sioux), George Hunt, Jr. (Kwakiutl), and Wendy Ponca (Osage) comprise "The Hope Series." See Lohrmann, "Weaving" (Spring 1998): 26–32.

71. Ibid., 32.

72. Burns, *Symbolic and Decorative Art* (1994): 31.

73. Ibid., pp. 28–33.

74. Wendy Ponca, telephone conversation with Pat Kirkham, May 1999.

75. Teters, "Jeweler Denise Wallace" (Summer 1997): 27.

76. White, "Layered with Significance" (September 1992): 29.

77. Denise Wallace, letter to Ron Labaco, Bard Graduate Center, New York, 7 February 2000. The exhibition opened in New York in December 1989. The belt took 2,500 hours to make. The

Wallace family's move to Hawaii may result in designs connecting Native American traditions with those of Hawaii.

78. *New Mexican* (15–21 June 1990): 14; see also White, "Layered with Significance" (1992): 28.

79. Rubinstein, *American Women Artists* (1982): 6.

80. Powell, "Enduring Beauty of Cheyenne Art" (July 1973): 4–5.

81. See T. J. Brasser, "Early Indian-European Contacts," in Bruce G. Trigger, ed., *Northeast*, vol. 14 of Sturtevant, ed., *Handbook of North American Indians* (1978): 70, 87.

82. The recent exhibition, *Beadwork From the Four Directions* (American Indian Community House Gallery/Museum, New York City, 22 January–26 March 2000), featured fine art beadwork of Melanie Printup Hope (Tuscarora), Marcus Amerman (Choctaw), George Blackwood (Cherokee), Jose Baker (Delaware), and Maynard Lavadour (Nez Perce/Cayuse).

83. *Beads* (1977): 16.

84. See, e.g., Hammond, *Aptuczet* (1920); and Leavitt and Francis, eds., *Wampum Records* (1990): 23.

85. See, e.g. Shaw, *Quilts* (1995): 231; and Powers, *Oglala Women* (1986): 138.

86. MacDowell and Dewhurst, eds., *To Honor and Comfort* (1997): 154.

87. Shaw, *Quilts* (1995): 234.

88. Ibid., p. 232.

89. MacDowell and Dewhurst document "Star" quilts among the Sioux as early as 1908, while Powers notes that girls among the Lakota at the end of the nineteenth century might have learned this particular design at school. See MacDowell and Dewhurst, eds., *To Honor and Comfort* (1997): 130; and Powers, *Oglala Women* (1986): 138.

90. MacDowell and Dewhurst, eds., *To Honor and Comfort* (1997): 38. Powers also notes that the "Star" pattern may have been popular among the Oglala because it echoes traditional patterns related to older craft techniques. Powers, *Oglala Women* (1986): 139.

91. MacDowell and Dewhurst, eds, *To Honor and Comfort* (1997): 166, and Powers, *Oglala Women* (1986): 139.

92. Powers, *Oglala Women* (1986): 139.

93. Ibid., p. 137.

94. MacDowell and Dewhurst, eds., *To Honor and Comfort* (1997): 130.

95. Ibid., p. 135.

96. Ibid., p. 131. Rae Jean Walking Eagle, telephone conversations with the author, June 1999 and January 2000.

97. Shaw, *Quilts* (1995): 233.

CHAPTER 4: *African American*

Acknowledgments: Our many thanks to all the designers and curators who have helped us with this project, and to all their assistants. There is not space to thank everyone individually, but special mention must go to David Rice, Bill Brown, Joyce Bailey (The Black Fashion Museum), Michele Black Smith, Mike Orgill, Scott Perkins, Victor Margolin Emily Miller, and all the members of the Organization of Black Designers (OBD).
—PK and SS

1. "A Wonderful Life" (1987): 2.

2. Florence C. Ives, "Report of the Board of Women Managers," in Lyon, *Report of the World's Columbian Exposition* (1894): 164, 176–77.

3. For the New Negro Movement, see Hutchinson, *Harlem Renaissance* (1995): 170–208; and *Rhapsodies in Black* (1997).

4. Guzman, "Social Contributions" (1948): 86–94; originally delivered as an address to the Association for the Study of Negro Life and History at Oklahoma City, 26 October 1947. Guzman, head of the Tuskegee Institute's Department of Records and Research, covered women's achievements in art, music, education, war service, screen and radio, literature, journalism, political activity, the legal challenging of discrimination, and social work.

5. Barbara J. Richberg, "Anna R. Jones, 92, Pioneer in Many Fields" (obituary), *Philadelphia Inquirer* (5 April 1995).

6. "A Wonderful Life" (1987): 2.

7. Ibid. The designs were for a rug, wallpaper, and cover the design school's catalogue.

8. Richberg, "Anna R. Jones" (5 April 1995).

9. *Anna Russell Jones: Praisesong for a Pioneering Spirit.*, prod. Marlene G. Patterson; dir. Nadine Patterson, 26 mins., Harmony Image Productions, 1993, videocassette.

10. Employment in the building trades fell by 63 percent between 1924 and 1933, and even such promising young designer-architects as Charles Eames found work scarce; in 1933 Eames drifted around Mexico for several months (Kirkham, *Charles and Ray Eames* [1995]: 14 and 16–18).

11. Janet McMillan, "Success Against the Odds," *Philadelphia Inquirer* (23 (November 23, 1986): sec. 1, 8.

12. "A Wonderful Life" (1987): 2.

13. Bearden and Henderson, *History of African-American Art* (1993), 381. See also Bowles, "Loïs Mailou Jones" (3 July 1977): 4–23.

14. Benjamin, *Life and Art of Loïs Mailou Jones* (1994): 26. See also Hoover, "Meta Vaux Warrick Fuller" (1977): 678–81.

15. Russell, *Black Genius* (1998): 89.

16. Benjamin, *Life and Art of Loïs Mailou Jones* (1994): 6. The curriculum there was broad and she studied book design with Alice J. Morse, a noted practitioner and leading authority on that subject.

17. Ibid., p. 7. The well-known German textile designer Ludwig Frank offered her the scholarship. Quote from Bearden and Henderson, *History of African-American Art* (1993): 383.

18. Benjamin, *Life and Art of Loïs Mailou Jones* (1994): 7 and 125. While she was a student some of her textile designs were exhibited at La Boheme Tea Room in Greenwich Village under the sponsorship of a patron, Mrs. J. Mardo Brown. Also see Bearden and Henderson, *History of African-American Art* (1993): 383.

19. Bowles, "Loïs Mailou Jones" (3 July 1977): 7.

20. See chap. 5 in this volume. Native American and Eskimo references are cited in work of 1934, years after "Totem Poles." See Bearden and Henderson, *History of African-American Art* (1993).

21. Ibid., pp. 383–84.

22. For influence of the pottery of the Nigerian village of Ipetumodu on Owens-Hart, see Owens-Hart, "Traditions: Ipetumodu" (1994): 58–66; and Owens-Hart files, African American Design Archive, Cooper-Hewitt National Museum of Design, Smithsonian Institution. For African American pottery as a male domain, see Wragg Chase, *Afro-American Art* (1971): 130. In Africa pottery was often a female occupation. See also Owens-Hart, "Ceramics: From Africa to America," in Kardon, *Revivals!* (1994): 114–18.

23. See Candace Wheeler, "Applied Arts in the Woman's Building," in Elliott, *Art and Handicraft* (1893): 59–67.

24. Interview with Lucas's daughter Helen Lyles, cited in Owens-Hart, "Ceramics," in Kardon, *Revials!* (1994): 115–16. The pots were subsequently

fired. Lucas used a kerosene-heated kiln in her living room to fire her lusterwork.

25. Ibid., p. 116.

26. Bearden and Henderson, *History of African-American Art* (1993): 383.

27. For the first two quotes see Bowles, "Loïs Mailou Jones" (3 July 1977): 7; and Benjamin, *Life and Art of Loïs Mailou Jones* (1994): 7. See also Ken Oda, "Loïs Mailou Jones on the Joys and Frustrations of Recognition Deferred" [cited September 21, 1999], available from http://www.cais.net/koan/loisjone.html; and Mint Museum of Art (Charlotte, NC), "Loïs Mailou Jones and Her Former Students: An American Legacy" [cited August 19, 1999], available from http://www.tfaoi.com/newsmu/nmus74c.htm. Prompted by such experiences Mailou Jones later concealed her race when submitting paintings to galleries in the 1930s and 1940s. She commented "I floated incognito for quite a long time before I made my niche" (ibid.)

28. Alexander, *Blacks in the History of Fashion* (1982): 47. In later years Mailou Jones came to regard her beautician mother as an "artist" because of her skills at designing and making hats during the 1920s and 30s (Bearden and Henderson, *History of African-American Art* [1993]: 381).

29. Michele Wallace, "The French Collection," in Cameron, *Dancing at the Louvre* (1998): 16. Wallace is Ringgold's daughter and Posey's granddaughter.

30. Ringgold, *We Flew over the Bridge* (1995): 73. Ringgold is Posey's daughter.

31. The cultural significance of a new dress for a Saturday night out or for a wedding has been much neglected by historians of material culture. For a discussion of "special dresses" see Kirkham, "Dress" (1995): 195–214.

32. Ringgold, *We Flew over the Bridge* (1995): 72.

33. Susan Taylor, Preface in Alexander, *Blacks in the History of Fashion* (1982): 9–10. In 1979 Alexander established the Black Fashion Museum (BFM) to encourage collecting and conserving the work of African American designers.

34. Ibid., pp. 26–29, 35 and 49, illus. p. 40 (suit designed by Mrs. Sutton of Los Angeles and worn by famed model Dorothea Towles).

35. Ibid., p. 49.

36. Ibid., p. 50.

37. White, *Style Noir* (1998): 26.

38. Sones, "Found Exclusively at Ann Lowe Gowns" (1999): 32 and 34. In 1966 in an article in *Ebony* Lowe, commented "I love my clothes and I'm particular about who wears them. I am not interested in sewing for café society or social climbers. I do not cater to Mary and Sue. I sew for the families of the Social Register" (quoted in "Anne Lowe," press release, 1999, Black Fashion Museum, Washington, D. C.). We are grateful to Joyce Bailey of the Black Fashion Museum for this information.

39. Statement made in 1966, quoted in Sones, "Found Exclusively at Ann Lowe Gowns" (1999): 34.

40. Ibid.

41. Statement made in 1965, quoted in ibid., p. 38.

42. According to Lowe, Jacqueline Bouvier told her "I want a tremendous dress, a typical Ann Lowe dress," and Lowe drew upon her memories of the ball gowns her mother had fashioned in Alabama and on French couture wedding and evening gowns ("Anne Lowe," press release, 1999, Black Fashion Museum, Washington, D. C.). Years later Kennedy never refuted disparaging remarks about the dress, and her daughter Caroline confirmed that her mother "really didn't like the dress that much" (Sones, "Found Exclusively at Ann Lowe Gowns" [1999]: 32). But by the time such remarks were made, the romanticism of the 1950s had disappeared. There is no evidence that Jacqueline Kennedy was not pleased at the time of her wedding. In fact, her own mother (for a second marriage) and her half-sister had worn Lowe wedding dresses, and her sister and half-sister had also worn Lowe debutante gowns (ibid., p. 34). Lowe actually took a loss on the commission because a flood destroyed the bridal gown and those of the five bridesmaids only five days before the wedding and it took heroic efforts on the part of Lowe and her staff to remake them.

43. Sones, "Found Exclusively at Ann Lowe Gowns" (1999): 39. Upon closing, a $12,800 IRS bill was paid by an anonymous donor—reputedly Jacqueline Kennedy. Other former clients and friends also sent Lowe checks.

44. Ibid. She remained very active, and in 1976 at age seventy-eight, despite failing eyesight she was still exploring new ideas, dictated to a sketcher ("Anne Lowe," press release, 1999, Black Fashion Museum, Washington, D. C.).

45. Jackie Peters, interviewed by Pat Kirkham, 12 January 2000.

46. Ibid. An advertisement in the *New York Times* led to her "working in a tiny outfit run from someone's home."

47. Clippings in Jackie Peters' scrapbook. We are grateful to the designer for sharing this with us.

48. "Fashion's Flower Child" (1968): 56–62. Her salary was cited as "upwards of $15,000 a year."

49. Jackie Peters, interviewed by Pat Kirkham, 31 January 2000.

50. Rose Ransier Piper, interviewed by Pat Kirkham, 15 February 2000.

51. Ibid.

52. We are grateful to Jackie Peters for information on Cheryl Nero, and to Jane Adlin of the Metropolitan Museum of Art for information on Beverly Nusom.

53. Michelle Hill, interviewed by Pat Kirkham, 16 March 2000. She received her BFA in textile design from the Rhode Island School of Design (1977), MFA in printmaking from Howard University (1982), and studied CAD at Parsons School of Design. She organized an exhibition (held 14 September to 7 October 1995) and seminar (30 September 1995), which included Anna Russell Jones, Ruth Ransier Piper, and Jackie Peters.

54. See Benberry, *Always There* (1992) for more information.

55. Ibid., p. 61. Telfair made three "Freedom" quilts, the first in 1975 for a Bicentennial exhibition sponsored by the Georgia Council for the Arts and Humanities.

56. Wahlman, *Signs and Symbols* (1993): 28–43. Wahlman has argued that quilts meeting these criteria express African traditions passed down through generations and substantiate a unique African American quilt tradition, while Benberry points to a great diversity of African American—made quilts and maintains that those focused on by Wahlman and others tell only part of the story (*Always There* [1992]). Although the issue is posed around what we feel is a false dichotomy, Benberry's point about the African American contribution to and shaping of the "mainstream" is important.

57. Benberry, *Always There* (1992): 28–29.

58. The "reinterpretations of standard forms" by African American women were as numerous as those who devised

them.; see Vlach, *Afro-American Tradition* (1978): 73.

59. Benberry, *Always There* (1992): 64. A "self-taught" designer, Mazloomi was inspired by the use of negative space in lino-cuts of African American artist Bill Williams. See also Freeman, *Communion of the Spirits* (1996): 269–75.

60. Richard J. Powell, "Re/Birth of a Nation," in Powell, et al., *Rhapsodies in Black* (1997): 17–18.

61. Ibid., p. 18. Black people were not considered part of the "machine age" and were stereotyped as resisting modernity. The new movement sought to alter that.

62. Ibid., pp. 16–17.

63. Benjamin, *Life and Art of Loïs Mailou Jones* (1994): 6 and 125.

64. April Kingsley, "Ruth Clement Bond and the TVA Quilts" in Kardon, *Revivals!* (1994): 119. She came from a middle-class home committed to social justice. Her Methodist bishop father was co-chair of the Inter-Racial Commission of the Federal Council of Churches; her mother the first African American to be named "Mother of the Year." See also Waldvogel, *Soft Covers* (1990): 78–80.

65. Waldvogel, *Soft Covers* (1990): 78.

66. Kingsley, "Ruth Clement Bond" in Kardon, *Revivals!* (1994): 119. Today, someone with Bond's activist credentials would likely encourage the women's own design repertoires.

67. Ringgold, *We Flew over the Bridge* (1995): 76. Viewpoints have changed greatly since 1980; the so-called lack of "culture," of modernity, of cutting-edge design sensibility of black design and its associations with "folk" and craft, once criticized as stereotypical, are now celebrated and explored.

68. Bond's focus on the black working man ties her work to the "revival of black folk traditions and the iconography of black labor" that evolved during the Depression of the 1930s; see Harris, "What It Is?" (1996): 40. This was also the period of Zora Neale Hurston's stories and the Works Progress Administration's oral histories of slavery—folk images fused with those of Social Realism in radical magazines and pamphlets.

69. Hutchinson, *Harlem Renaissance* (1995): 49; for illustrations, see Powell et al., *Rhapsodies in Black* (1997): 19, 22, 26, 74–80.

70. Kingsley, "Ruth Clement Bond" in Kardon, *Revivals!* (1994): 121.

71. Waldvogel, *Soft Covers* (1990): 80.

72. Kingsley, "Ruth Clement Bond" in Kardon, *Revivals!* (1994): 119–20.

73. For mention of Mason as a "famed jewelry maker," see *Ebony* (July 1946). Constance Ramsey, another African American jeweler, who worked in mainstream modernist mode, has also been difficult to trace. For mention of her as a member of the Connecticut Society of Craftsmen and for illustrations of her work, see Wragg Chase, *Afro-American Art* (1971): 135.

74. Arthur Smith and James L. de Jongh, "Arthur Smith, an Autobiography," in *Arthur Smith* (1990).

75. Lewis, *African American Art* (1994): 238; see also Lewis and Waddy, *Black Artists* (1969): 86. In 1973 Montgomery was awarded a National Endowment for the Arts grant to research black artists.

76. Victor Margolin, "African American Designers in Chicago: Themes and Issues" (paper presented at the symposium, African-American Designers: The Chicago Experience Then and Now, University of Illinois at Chicago, 5 February 2000).

77. Elizabeth Morcom, "Sculptor/Designer Creates 'Plastic' Beauty," *Mobile Press Register* (11 July 1982): sec. D, 4.

78. Ibid.

79. "Graphic Viewpoints" (1971): 60.

80. Ibid.

81. The exhibition was held at Gallery 303, New York, 9 January through 20 February 1970. When interviewed in *Idea* (January 1971), Hayes commented, "this exhibit represents my background, my present, and my hope for the future." See also "Black Artists in Graphic Communication" (October 1970): 18–19; and "Exhibition by Black Artists"(May 1970): 98–107. Diane Dillon and Leo Dillon shared credit for a poster design for Ground Zero Coffee Shop and Gallery in Brooklyn.

82. Harris, "What It Is?" (1996): 38–42. A commited educator, Harris teaches graduate-level public information design and graphic design research at the Yale University School of Art. Before 1980 she was a graphic designer at the Architects Collaborative, Cambridge, Mass. and later a graphic design manager at the Boston architecture office of Skidmore, Owings and Merrill. She recently advised the General Services Administration in New York City on the design of the African Burial Ground Interpretive Center.

83. Sylvia Harris, interviewed by Shauna Stallworth, 20 March 2000, and Pat Kirkham, 3 March 2000. She was also a founding member of the Organization of Black Designers (OBD) and is a well-known speaker on "design for diversity."

84. Fo Wilson, interviewed by Pat Kirkham, 29 March 2000.

85. Ibid., and correspondence dated 27 March 2000. Wilson is an active member of the American Institute of Graphic Arts (AIGA), of which she has been a national board member (1993–96), and Society of Publication Designers (SPD; 1992–95). She has taught communication design at Parsons School of Design (1989–92) and developed the curriculum for the first design component at New York University's Publishing Institute (1990–92).

86. Information is taken from resumes, press clippings, and other material in the files of the Organization of Black Designers, hereafter cited as "OBD Files." A founding member of Black Women in Publishing and an active member of OBD and AIGA, Washington writes and lectures on the history of African American graphic designers and has been published in *CHICAIGA* (AIGA's Journal on New Media), *International Review of African American Art*, *Designing Pioneers*, and *Print Magazine*.

87. OBD Files. The exhibition toured for two years and funded a scholarship at Parsons in the name of New York's first black art director, Georg Olden. She is currently writing a book and developing an interactive media program on the history and achievements of twentieth-century African American graphic designers.

88. Joseph Giovannini, "African-Inspired Decor Illuminates Newark Arts Center," *New York Times* (27 August 1998): sec. F, 10.

89. She is presently the project manager for the design of a new identity and environmental graphics program for Pioneer Place retail center, Portland, Ore., and for the renovation of the historic Barnsdall Park for the City of Los Angeles.

90. OBD Files. Lynch is a former art director at Warner Brothers Records, director of design at Elektra Records,

and a vice-president at GRP Records. The name of her firm—Negerkunst Digital Design Studio, New York—reflects her concern for her cultural heritage. She has designed opening title sequences for films and computer games and participated in the Little Rock Designers' Roundtable convened by the Clinton/Gore Presidential Transition Team. One of the first recipients of a fellowship in Computer Arts awarded by the New York Foundation for the Arts, Harvey is the creative director and founder of entropy8 Digital Arts and is committed to emphasizing the communicative "human" aspects of online culture. Staples (Yale University and Rhode Island School of Design) most recently taught graphic and interaction design at the University of Michigan's School of Art and Design. She lectures and writes widely on digital technology and design. Hill has worked for high-tech companies such as Surgical Laser Technologies, Hayes Microcomputer Products, and is currently design manager at U.S. South Communications and the principal of Positive Propaganda, whose campaigns include the National Black Arts Festival and the "Spirit and Splendor" program for the High Museum of Art, Atlanta. Jones combines design and business acumen, for such clients as Delta Air Lines, AT&T, Coca-Cola, and The Centers for Disease Control.

91. "The AD 100" (January 2000): 66. Other articles on the firm can be found in such publications as *Florida Design, The Magazine of South Florida, Florida Design Quarterly,* and *Ebony* magazines, in addition to *The Sun Sentinel* and *The Miami Herald* (press clippings, company archive, Cecil's Designers Unlimited).

92. *The Power of Creativity: Cecil's Designers Unlimited Inc.,* promotional brochure, 2000.

93. OBD Files. Other articles appeared in *Washington Post, Vibe, Metropolitan Home,* and *Contract Design.*

94. Moline, "Courtney Rocks" (September 1999): 75.

95. Courtney Sloane, interviewed by Pat Kirkham, 8 March 2000.

96. Alternative Design, promotional brochure 1999; and OBD Files.

97. Ibid.

98. Ibid. Currently benefit chair of the African American Design Archive, Cooper-Hewitt National Design Museum, Smithsonian Institution, Sloane has also participated in numerous Design Industries Foundation Fighting Aids (DIFFA) events.

99. She also occasionally designs interiors, such as the public lobby of Bayview (California) Police Station (1991–97).

100. Museum collections include those of the Cooper-Hewitt National Design Museum, New York ("Coin-Encrusted Tudor Table," nos. 2 and 3); San Francisco Museum of Modern Art ("Zulu Renaissance Writing Table for a Lady" and "Hunter's Screen"); Oakland Museum ("d'Medici" cabinet); and the Mint Museum of Art ("Babuka Griffin" dining table).

101. Riley's recent commissions include a desk for Susan Taylor, publishing director of *Essence,* and an installation for the San Francisco Zoo. For a detailed discussion of "Zulu Renaissance Writing Table for a Lady," see Miller, "Evolution of a Design" (June 1998): 32–38. Riley is active in the Kentucky Arts Council, the Furniture Society, OBD, and the American Craft Museum.

102. O'Keefe, "Celebrating Roots" (1993):36. See also Yanick Rice Lamb, "Wall to Wall, the Inspiration of Africa," *New York Times* (29 October 1992); and Style Beat, *House Beautiful* (November 1993): 32.

103. OBD Files. The portfolio of Sheila Bridges Design consists of Fortune 500 companies, financial institutions, law firms, architectural and engineering firms, nonprofit organizations, healthcare, and educational institutions. Bridges, who moved to New York City in 1986, has also lived and worked in Italy (while studying Decorative Arts at Polimoda in Florence).

104. Deborah Nadoolman Landis in conversation with Pat Kirkham, 4 December 1999. See chap. 10 in this volume.

105. "Catalogue of New York Exhibits in the Woman's Building," in Lyon *Report of the World's Columbian Exposition* (1894): 197. In 1893 a pastry fork designed and patented by a black woman designer was shown in "The Afro-American Exhibit" in the New York State exhibit at the 1893 World's Columbian Exposition held in Chicago.

106. Carole Bilson, interview with Ella Howard, 31 January 2000. She credits Alan Samuels to this day, not least because he established contacts for her within the industry.

107. Ruth Carter, interview with Pat Kirkham, 4 February 2000.

CHAPTER 5: *Textiles*

Acknowledgments: We would like to thank the authors of the unpublished theses cited below for giving permission to consult them. We would also like to thank: Lynn Felsher, for generous access to her research files; Win Anderson, Gretchen Bellinger, Dorothy Cosonas-de Fiebre, Patrice George, and Mitzi Mills, for interviews granted and information provided; Lotus Stack, curator of textiles, and Diane Charbonneau, curator, Musée des Arts Décoratifs, Montreal, for information and assistance; and the Fashion and Textiles Department of Central Saint Martins College of Art and Design, London, which has partly funded Schoeser's contribution to this essay through their research fellowship program.—MS and WB

1. Manufacturers openly admitted to sending their representatives to Paris or Lyon to purchase, sometimes to steal, designs that were either copied outright or simplified for the home market. For discussion of industrial competition and nationalism, 1900–25, see Schoeser, *Fabrics and Wallpapers* (1986): 16–58.

2. "Prizes for Silk Designs" (June 1905): 42.

3. *Design for Women* (1968): 62. Textile design students of the early to mid-1920s included Marie Casey, Emma Lint, Esther Snavely, Grace Larer, Camille Cronk, Margaret Freshwater, Emmy Lou Spinner, Katherine Abbott, and Anna Rachel Russell Jones (for Russell Jones, see chap. 4, in this volume).

4. The designs were called "Bird and Wisteria" and "Chinese Panel"; see Morris, *Liberty Design* (1989): 30. Butterfield taught textile design at the Central School of Arts and Crafts, London, 1916–34.

5. King, "War, Women and American Clothes" (November 1917): 592–93. King's estimates were based on the manufacturing censuses of 1909 and 1913.

6. To a certain extent their concerns were to be justified. Fewer ships made the crossing. Many of the great textile mills of Northern France closed for the duration, never to reopen. Handweavers hid their pattern books from

the invading Germans and disabled or dismantled their looms.

7. Culin was curator of ethnology at the Brooklyn Museum; Spinden was assistant curator of anthropology at the American Museum of Natural History, and Crawford was design editor for *Women's Wear* and honorary research associate at the Museum of National History. See Whitley, "Morris de Camp Crawford" (September 1994).

8. *Scientific American* called it "a new departure in museum research, destined to afford the basis for a typical school of American design": "Modern Design from Ancient Fabrics" (February 1918): 148.

9. For further discussion see Whitney Blausen, "The Search for a National Style," in Schoeser and Boydell, eds., *Disentangling Textiles* (forthcoming).

10. As early as 1905, the New York School of Applied Design for Women had staged an end-of-term show for its students, inviting manufacturers to view and possibly purchase the work of its graduates. "Prizes for Silk Designs" (June 1905): 42.

11. Crawford, *Heritage of Cotton* (1924): 203.

12. Ibid., pp. 202–3.

13. For Dorn (Poor), see Boydell, *Architect of Floors* (1996); and "Women Textile Designers in the 1920s and 1930s: Marion Dorn, a Case Study," in Attfield and Kirkham, *View from the Interior* (1989): 57–70. For Karasz see Brown, "Ilonka Karasz" (Fall–Winter 2000–2001); and idem, "Ilonka Karasz" (1998). For Reeves see Blausen, "Textiles Designed by Ruth Reeve," (1993); for Zorach see Patterson, *Companions in Art* (1991) and Nicola J. Shilliam, "Emerging Identity: American Textile Artists in the Early Twentieth Century," in Carlano and Shilliam, eds., *Early Modern Textiles* (1995): 28–44.

14. For example, in the mid-1920s, the Stehli Silk Company's "Americana Prints" series included designs by the tennis idol Helen Wills Moody, the cartoonist John Held Jr., the photographer Edward Steichen, and such painters and illustrators as Neysa McMein, Katherine Sturgis, and her husband Clayton Knight; see Boardman, *All that Jazz* (1998). The same mixture of credentials also benefited designers who gained notice through other avenues, such as Lydia Bush-Brown, who had studied at the Pratt

Institute and traveled widely.

15. For further discussion of this and other related exhibitions, see Whitley, "Morris de Camp Crawford" (September 1994); and Blausen, "Search for a National Style," in Schoeser and Boydell, eds., *Disentangling Textiles* (forthcoming).

16. "Exhibition of Textile Designs" (December 1922): 59.

17.. *McCall Needlework and Decorative Arts* (Spring 1926): 16.

18. Although the impetus for the development of screen-process printing came from posters, labels, and related printed ephemera, serigraphs (limited-edition art prints on paper) were less rapidly accepted; the first solo show of serigraphs, by Guy McCoy, was at the Contemporary Art Gallery, New York, in 1938. See Schwalbach and Schwalbach, *Screen-process Printing* (1970): 14.

19. Naylor, "Textiles Derived from Paintings" (February 1932): 214–19; "As the Modernist Sees the Hudson" (September 1934): 87; Hillyer, "Scenic Fabrics Revived" (May 1934): 8; and Blausen, "Ruth Reeves" (Winter 1995): 5–6, 32.

20. "Distinctive American Art" (9 May 1931): 29; Sprackling, "Modern Art in the Textile Field" (April 1929): 522–26; *Bulletin of the Museum of Fine Arts, Boston* (30 October 1930): 99; and *Exhibition of Contemporary Textiles* (1930), unpaginated.

21. Susman, *Culture as History* (1984): 154.

22. Numerous examples of such patterns exist; see Boardman, *All that Jazz* (1998); and Leonard and Glassgold, eds., *Annual of American Design* (1930); Mary Schoeser, "Textiles: Surface, Structure and Serial Production," in Kardon, ed., *Craft in the Machine Age* (1995): 110–21, but note that the frequent references to makers, designers, architects, and craftspeople as "artists" was a decision of the editor and not the author.

23. Among the Federal Art Project initiatives were the Design Laboratory, a free school that taught all kinds of design for production and in which Ruth Reeves and Gilbert Rhode were prime movers (see Rhode, "Design Laboratory" [October 1936]: 636–43, 686); and the Educational Alliance Art School, where federal art workers taught screen printing to children and some of the resulting designs were sold

to industry (see Joanne C. Dolan, "The 'New Deal' Child Artist: Textiles from the Educational Alliance Art School," in *Creating Textiles* [1998]: 390–99).

24. "Art Moderne Rugs" (September 1928): 142; among her students and assistants were Emily Reist and Ann Hatfield.

25. "Vally Wieselthier" (January 1930): 145–47.

26. For Hoffmann, see "Art Moderne Rugs" (September 1928): 140, 143; the illustrated rugs were hand-hooked in North Carolina.

27. This was as true for the women considered above as it was for many prominent male industrial designers: e.g., Donald Deskey was initially a painter; Russell Wright and Norman Bel Geddes were theater designers, Raymond Loewy was a fashion illustrator, Walter Dorwin Teague was an advertising illustrator, and Henry Dreyfus a theater and graphic designer. Like the textile designers working with screen printing, such industrial designers were working in a relatively new field that by the 1930s had instituted specialist training for designers.

28. Ruth Reeves's papers, microfilm reel 136, frame 3, gift of Judith Baker Katzman, Archives of American Art, Smithsonian Institution.

29. Leonard and Glassgold, eds., *Annual of American Design* (1930). The introduction to the textile sections (pp. 47–64) was written by Crawford; of the twenty-three designers illustrated, fourteen are women: Karasz (and her sister, Mariska), Reeves, Reiss, and Wieselthier, together with Mary Bendelari, Alice Donaldson, Helen Dryden, Jennie Greene, Ellen M. Kern, Teresa Kilham, Marguerita Mergentime, Lydia Rahlson, and Dorothy Trout.

30. Musicant, "Maria Kipp" (Fall–Winter 2000–2001); Puffer, "Hand and the Loom" (May 1949): 8–9,25; and Howell, "Maria Kipp" (November–December 1961): 5–9; Maria Kipp files, Cooper-Hewitt National Museum of Design, Smithsonian Institution.

31. Adrian was more than a costume designer: he also had a ready-to-wear and custom salon in California from 1942 to 1952 and a boutique in New York City in 1948; from 1952 to 1958 he was in brief retirement in Brazil. For seven of these years he was ordering

fabric from Stout.

32. Stout, "Education in Fashion" (Summer 1965): 6–9.

33. Weber and Asbaghi, *Anni Albers* (1999).

34. Christa C. Meyer Thurman, "Textiles," in Clark, ed., *Design in America* (1983): 173–212.

35. See "Marli Ehrman" (Spring 1960): 25–26, 57; Ehrman designed prototypes for the Herman Miller Furniture Company, among others. The Institute of Design (popularly known as the "New Bauhaus") later became the School of Design, Chicago.

36. Dorn, who resided in England from 1923 to 1940 but was also known in America through exhibitions and imports, was represented by one of the largest number of items shown by an individual designer.

37. In 1939 the Krolls were weaving prototypes for Cromwell. See *Arts and Decoration* (August 1938): 31, for examples of their designs. which are described as "Modern in feeling . . . and their textures are unusually interesting."

38. Over one-third of the California women were members of the San Francisco Society of Women Artists (the subject of ongoing research by Schoeser).

39. Liebes, *Decorative Arts* (1939): 92.

40. This division echoes a characteristic identified with the later years of the Bauhaus, where in the "widening polarization between industry and craft . . . women were identified with the latter. As mechanization and industrialization increased, the role of the designer gained in status and attracted males. Women lost ground" (Weltge, *Bauhaus Textiles* [1993]: 98–99).

41. "Handwoven Fabrics in the S.S. *United States*" (Winter 1952–53): 15–17, 63; a "modern appliquéd quilted fabric" was supplied by Marion Cheever Whiteside.

42. *Design Quarterly*, no. 48–49 (Walker Art Gallery, Minneapolis, Spring 1960). This volume contains brief biographies of weavers, including Albers, Lili Blumenau, Trude Guermonprez, Else Regensteiner, Kay Sekimachi, Strengell, and Lenore Tawney.

43. Booth, *E. McKnight Kauffer* (1979): 82.

44. Ruth Reeves to Henry Allen Moe (director of the Guggenheim Foundation), 29 June 1942 and 28 August 1943, Ruth Reeves papers, the John Simon Guggenheim Foundation, New York.

45. See *Design by the Yard* (1956), in which the some two dozen women designers of prints issued between 1946 and 1956 were outnumbered two-to-one by male designers. See also Lustig, "Modern Printed Fabrics" (Winter 1951–52): 61–73, on the new cult of the personality and the preference for commissioning well-known architects ("or their wives"), furniture, graphic, or interior designers, or painters and sculptors. Lustig referred to such people as "outsiders" because they were trained in and had made their names in fields other than textiles. He erroneously dates the influence of outsiders to the postwar period, presumably because this later incursion was dominated by men.

46. For further information see Dilys Blum, "Painting by the Yard: American Artist Designed Textiles 1947–57," in Schoeser and Boydell, eds., *Disentangling Textiles* (forthcoming).

47. In their 1947 venture only two of six artists were women: Gladys Rockmore Davis and Doris Rosenthal. None produced designs. Instead, paintings selected by Onondaga president Philip Vogelman were reinterpreted by staff designers for production. Thirteen well-known New York dress designers, including Netti Rosenstein and Jo Copeland, were then given yardage. The paintings, designs, silks, and garments toured as a group to museums and department stores across the country; a film was also produced. See Lund, "Art and Textile Design" (1993).

48. Blum, "Painting by the Yard," in Schoeser and Boydell, eds., *Disentangling Textiles* (forthcoming).

49. "Application of the Fine Arts in Apparel Textiles" (Summer, 1952): 92–94.

50. Blum, "Painting by the Yard," in Schoeser and Boydell, eds., *Disentangling Textiles* (forthcoming).

51. *Dorothy Liebes* (1970); clients included DuPont, the Bigelow-Sanford carpet company, and even, at the end of her career, Sears Roebuck and Company. See also *Interiors* (October 1942): 40; and ibid. (November 1944): 30, for examples of Goodall Fabrics' advertisements.

52. Perhaps the most famous such partnership today is the firm founded by Laura Ashley and her husband, Bernard, but there are others (see note 74).

53. Their teachers included Wolfgang Hoffmann and William Zorach, the husbands of Pola and Marguerite, respectively.

54. Several of her early designs have recently been reissued by Unika Vaev as weaves. In addition, she and Mitzi Mills, president of Anzea Textiles, Texas, began collaborating on printed textiles in 1995; she is currently designing a line for Anzea's tenth anniversary collection.

55. C.L., "Vera" (Winter/Spring 1964): 88.

56. "Vera Neumann" (obituary), *New York Times* (17 June 1993): [page number varies with edition].

57. Tillet and Tillet, "Plain Print Talk" (1947): 71.

58. C.L., "Vera..."(Winter/Spring 1964): 88.

59. Company press release, n.d., courtesy of the Museum at the Fashion Institute of Technology, New York.

60. Patrice George interviewed by Whitney Blausen, 21 July 1999.

61. Rubin, "Jhane Barnes" (Summer, 1999): 145–53; and Sano, "Jhane Barnes" (June 1999): 132–34, 198, 202.

62. Nepodal had been a designer at Cheney, which was taken over by Greeff in 1952; see *American Fabrics and Fashions*, no.115 (Spring 1979): 82.

63. These included the Mitchell-David Company, M. H. Kimball and Company, which printed hundreds of her handkerchief designs exclusively for Lord and Taylor, and Golding Decorative Fabrics, who screen-printed furnishing fabrics and home textiles.

64. Information courtesy of Lynn Felsher, from material compiled for the exhibition, *A Woman's Hand: Designing Textiles in America, 1945–1969*, 17 October 2000 – 15 January 2001, Museum at the Fashion Institute of Technology, New York.

65. Erb, "Get Out Your Handkerchiefs" (April/May 2000): 60–63, 72.

66. Blake, "Eszter" (February 1995): 29–30.

67. Knoll publicized the work of other women, including freelancers Strengell and Evelyn Hill, and Haraszty's former assistant and successor from 1955 to 1963, Suzanne Huguenin.

68. She remained able to garner publicity and continued to be alert to new trends. E.g., in May 1966 *House Beautiful* featured Haraszty's "flower power" California home; and she later co-authored books on embroidery: E.

Haraszty and B. D. Colen, *Needlepainting: A Garden of Stitches* (New York: Liveright, 1974), and *The Embroiderer's Portfolio of Flower Designs* (New York: Liveright, ca.1981).

69. "Tiger, Tiger Everywhere" (17 August 1967): 15; and see *American Home* 70, no.5 (June 1967).

70. Larson, *Jack Lenor Larson* (1998): passim.

71. Win Anderson, interviewed by Mary Schoeser, 10 March 2000; n.b., only severe arthritis induced her to leave the company in 1977.

72.. Weitzner press release, 1997, from the Musée des Beaux Arts, Montreal.

73.. "Interior Design Market: Weitzner" (September 1993): 118.

74. Danish-born and Cranbrook-trained, Pearson started her own company ca.1991; she designs and her husband, Art, runs the business.

75. Dorothy Cosonas-de Fiebre interviewed by Mary Schoeser, 14 March 2000.

76. Ibid.

77.. For example, Neopodal did not become a vice president of Greeff until 1979.

78. *Design for Women* (1968): 62. This characterization was used at least as late as 1969, when it was recommended to Schoeser, then a student.

CHAPTER 6: *Quilts*

Acknowledgments: The author wishes to thank the following women for their generous sharing of information and ideas in the preparation of this article: Karen Berkenfeld, Marilyn Henrion, Niloo Imami-Payder, Drunell Levinson, Paula Nadelstern, Phyllis Tepper, Merikay Waldvogel, and Shelly Zegart. I would also like to acknowledge the thousands of women, known and unknown, who have contributed their creativity and skills to quilt design over the years.—JMA

1. *Godey's Lady's Book* (February 1860): 163. This nineteenth-century quote applies equally well to twentieth-century quiltmakers, such as the anonymous maker of the "Broken Dishes" quilt (fig. 6-1).

2. Patricia Mainardi, "Quilts: The Great American Art," in Broude and Garrard, eds., *Feminism and Art History* (1982): 332.

3. Cheryl Buckley, "Made in Patriarchy," in Margolin, ed., *Design Discourse* (1989): 255. When quilts are discussed, the more common use of "pattern" rather than "design" for the images seen in them is an indication of the marginal-ization that quilt design has received.

4. Mainardi, "Quilts,"in Broude and Garrard, eds., *Feminism and Art History* (1982): 343.

5. Less than one percent of the estimated 15 million quilters are men (author's estimate).

6. Orlofsky and Orlofsky, *Quilts in America* (1992): 79.

7. As quoted in McMorris and Kile, *Art Quilt* (1996): 27.

8. Ibid., p. 27.

9. As quoted in Jeannette Lasansky, "Colonial Revival and Quilts" in Lasansky, ed., *Pieced by Mother* (1988): 101.

10. Gunn, "Quilts for Milady's Boudoir" (1990): 82.

11. Hall and Kretsinger, *Romance of the Patchwork Quilt* (1935): 15.

12. Ibid., p. 29.

13. Ibid. Although aspects of the Colonial Revival in home decoration reverberated in many directions, its full extent had, in fact, come to represent a "physical and social exclusivity" for the well-to-do. See Celia Betsky, "In the Past: The Interior and the Colonial Revival in American Art and Literature, 1860–1914," in Axelrod, ed., *Colonial Revival in America* (1985): 261.

14. As quoted in Lasansky, *Pieced by Mother* (1988): 101.

15. McMorris and Kile, *Art Quilt* (1996): 28. The authors note that Belle Gary of Gates Mills, Ohio, made two quilts based on the Parrish design, which appeared in *Ladies Home Journal* (March 1905).

16. Niloo Imami-Paydar, "Marie Webster Quilts: A Retrospective," in *American Quilt Renaissance* (1997): 17. Many of Webster's quilts are now owned by the Indianapolis Museum of Art.

17. Gordon, "Spinning Wheels" (1998): 182.

18. Webster, *Quilts, Their Story* (1915; 1990).

19. Some quilt designers are known by name, while others remain anonymous. Many companies that sold quilt supplies also offered patterns for quilt designs. They traded on the concept of the Colonial Revival by attributing the designs to "old-fashioned" names such as Laura Wheeler, Aunt Martha, Aunt Ellen, Nancy Cabot, Grandma Dexter, and Grandmother Clark (to name only a few), meant to recall colonial times. Ongoing research, however, is slowly exposing the real identities of the contemporary artists who created these designs. See, for example, n. 44, below.

20. Filo, "Ruby Short McKim" (1997): 75.

21. Ibid., p. 88, and McMorris and Kile, *Art Quilt* (1996): 36.

22. Virginia Gunn states that Americans had adopted the "Art Deco" look by 1914. See Gunn, "Quilts for Milady's Boudoir" (1990): 81.

23. McMorris and Kile, *Art Quilt* (1996): 36.

24. Waldvogel, "Marketing of Anne Orr's Quilts" (1991): 11.

25. Ibid., p. 12.

26. Finley, *Old Patchwork Quilts* (1929; 1992).

27. Barbara Brackman, introduction to Finley, *Old Patchwork Quilts* (1929; 1992): 12. Brackman notes that some of Finley's early newspaper articles dealt with the difficult conditions of working women.

28. Ibid., p. 13.

29. Carol Shankel, "Rose Kretsinger," in *American Quilt Renaissance* (1997): 74.

30. Hall and Kretsinger, *Romance of the Patchwork Quilt* (1935): 15.

31. Ibid., p. 269.

32. Ibid., p. 262; also see Shankel, "Carrie A. Hall" in *American Quilt Renaissance* (1997): 92.

33. Kentucky women especially benefited; they had achieved almost legendary fame as expert needleworkers because of Eliza Calvert Hall's novel, *Aunt Jane of Kentucky* (1907; Lexington: The University Press of Kentucky, reprint 1995). For information on Kentucky quilters, see Cuesta Benberry, "Quilt Cottage Industries: A Chronicle," in Horton, ed., *Quiltmaking in America* (1994); and Zegart, *Kentucky Quilts* (1998).

34. Merikay Waldvogel, "Quilt Design Explosion of the Great Depression," in Lasansky, ed., *On the Cutting Edge* (1988): 91.

35. Waldvogel and Brackman, *Patchwork Souvenirs* (1993): 42.

36. Ibid., p. 42.

37. Bingham, "Val-Kill Industries" (2000): 3.

38. Woodard and Greenstein, *Twentieth-Century Quilts* (1988): iv.

39. Waldvogel, *Soft Covers for Hard Times* (1990): 78–79. See also April Kingsley, "Ruth Clement Bond and the TVA Quilts," in Kardon, ed., *Revivals!* (1995): 119–21.

40. Waldvogel, *Soft Covers* (1990): 82.

41. Woodard and Greenstein, *Twentieth-Century Quilts* (1988): 34.

42. Joyce Gross, "Four Twentieth-Century Quilters," in Horton, ed., *Quiltmaking in America* (1994): 173–74.

43. As quoted in Austin, ed., *Twentieth Century's Best American Quilts* (1999): 94.

44. Recent research by Merikay Waldvogel has brought to light some of the designers who worked for Mountain Mist. See Waldvogel, "Origin of Mountain Mist R Patterns" (1996): 95–138.

45. Ramsey, "Art and Quilts" (1994): 16.

46. Ibid., p. 22.

47. Jean Ray Laury, as quoted in Shaw, *Quilts* (1995): 250.

48. Ramsey, "Art and Quilts" (1994): 11.

49. Judith Stein, "Collaboration," in Broude and Gerrard, eds., *Power of Feminist Art* (1994): 237.

50. Lucy R. Lippard, "Up, Down, and Across: A New Frame for New Quilts," in Robinson, ed., *Artist and the Quilt* (1983): 33.

51. Miriam Shapiro, "Geometry and Flowers," in Robinson, ed., *Artist and the Quilt* (1983): 31.

52. Chadwick, *Women, Art, and Society* (1996): 364.

53. Robinson, ed., *Artist and the Quilt* (1983): 104.

54. Wahlman, *Signs and Symbols* (1993): 115.

55. Benberry, *Always There* (1992): 62.

56. Ibid., p. 19. Also see chap. 4 in this volume.

57. McMorris and Kile, *Art Quilt* (1996): 43.

58. Benberry, *Always There* (1992): 15.

59. Warren and Eisenstat, *Glorious American Quilts* (1996): 114.

60. Ibid., p. 131. It remains to be seen whether the design tradition that made Amish quilts so distinctive can be maintained or whether it will gradually be taken over by mainstream quilting.

61. Warren and Eisenstat, *Glorious American Quilts* (1996): 131.

62. Shaw, *Quilts: A Living Tradition* (1995): 213.

63. Ibid., pp. 215–17.

64. Holstein, *American Pieced Quilts* (1972): 14.

65. *Quilter's Newsletter Magazine* (September 1971): 3.

66. Warren and Eisenstat, *Glorious American Quilts* (1996): 140.

67. Shaw, *Quilts: A Living Tradition* (1995): 251.

68. Ibid., p. 252.

69. Austin, ed., *Twentieth Century's Best American Quilts* (1999): 32. Myers-Newbury dyes fabric herself for her quilt designs and works with other women in piecing and quilting her large works.

70. Shaw, *Quilts: A Living Tradition* (1995): 253.

71. According to a 1995 survey, quilters spend some $1.554 billion annually on quilt-related purchases. The survey identified a subgroup of "dedicated" quilters—5.4% of all quilters—who spend some $400 or more annually on fabric (survey sponsored by International Quilt Market & Festival [divisions of Quilts, Inc.] and *Quilter's Newsletter Magazine* [division of Leman Publications], 1995).

72. Paula Nadelstern, conversation with author, 29 October 1999.

73. Survey sponsored by International Quilt Market & Festival (divisions of Quilts, Inc.) and *Quilter's Newsletter Magazine* (division of Leman Publications), 1995.

CHAPTER 7: *Fashion*

1. Steele, *Women of Fashion* (1991): 24.

2. Ibid., p. 25. Traditionally, dressmakers tended to be working-class women who served an elite clientele. A print by Mary Cassatt, for example, shows a dressmaker kneeling at her client's feet, pinning the hem of her dress. The design of the dress resulted from a collaboration between client and dressmaker.

3. Wilson and Taylor, *Through the Looking Glass* (1989): 33–38.

4. There were four sisters: Marie Callot Gerber, Marthe Callot Berrand, Regina Callot Tennyson-Chantrell, and Josephine Callot Crimont.

5. Valerie Steele, "Chanel in Context," in Ash and Wilson, eds., *Chic Thrills* (1992): 118–26.

6. Milbank, *New York Fashion* (1989): 66.

7. Ibid.

8. Ibid., p. 59.

9. Steele, *Paris Fashion* (1988): 6–7, 260–62.

10. Milbank, *New York Fashion* (1989): 70, 72, 86. See also Steele, *Women of Fashion* (1991). 101.

11. Milbank, *New York Fashion* (1989): 18

12. Ross, *Crusades and Crinolines* (1963): especially 20–38.

13. Joy Emery, director of the Commercial Pattern Archive, University of Rhode Island Library, Special Collections, communication with author, 23 October 1999. I am indebted to Ms. Emory for information on Mme Demorest and pattern-making. She commented that Demorest had "invented the commercial pattern industry."

14. Milbank, *New York Fashion* (1989): 100.

15. Ibid., p. 86.

16. Williams, *Fashion is Our Business* (1945): 52–68.

17. Steele, *Women of Fashion* (1991): 116. See also Williams, *Fashion is Our Business* (1945): 9–14.

18. Keller, "Men Are Designing, Too," *World Telegram* (n.d. [late 1930s]), in the Costume Designers scrapbook, Special Collections, The Fashion Institute of Technology Library, New York. In contrast the French regarded couture not just as "artistic" (and therefore "feminine"), but also as a real "art," which men could also pursue.

19. Buckley, "On the Margins" (November, 1998).

20. Williams, *Fashion is Our Business* (1945): 116–28.

21. Ibid., p. 127.

22. Gould, *Mommy Dressing* (1998).

23. "*Vogue*'s Gallery of American Designers" (1 September 1933).

24. "Valentina," *Current Biography* (1946): 607.

25. Milbank, *New York Fashion* (1989): 86–89.

26. "Valentina," *Current Biography* (1946): 607.

27. Ballard, *In My Fashion* (1962): 165.

28. Ibid.

29. Berch, *Radical by Design* (1988): 13.

30. Steele, *Women of Fashion* (1991): 92.

31. Elizabeth Hawes, *Why Women Cry or Wenches with Wrenches*, quoted in Steele, *Women of Fashion* (1991): 93.

32. Hawes, *Fashion is Spinach* (1938).

33. Steele, *Women of Fashion* (1991): 92–96; see also Berch, *Radical by Design* (1988). She closed her business in 1940 and worked in the education department of the United Auto Workers Union during World War II.

34. Hawes, *Fashion is Spinach* (1938): 181.

35. Yohannan and Nolf, *Claire McCardell* (1998): 50.

36. Valerie Steele, "McCardell's American Look," in ibid., pp. 8–13. See also Martin, *American Ingenuity* (1998): 17, 90–91.

37. Yohannan and Nolf, *Claire McCardell* (1998): 15–22.

38. "In the American Grain" (October 1944): 89.

39. "The American Look" (2 May 1955): 85.

40. "Women Designers Set New Fashions" (14 January 1946): 87.

41. Milbank, *New York Fashion* (1989): 158, 196.

42. Ibid., p. 162.

43. Martin, *American Ingenuity* (1998): 85–86.

44. Williams, *Young Faces* (1956): 131, 138–39. For Cashin see also Iverson, "'Early' Bonnie Cashin" (Fall/Winter, 2000/2001).

45. Williams, *Young Faces* (1956): 142.

46. Ibid., pp. 143, 146, 148.

47. Bonnie Cashin, interview with author, December 1990, New York.

48. All quotations in this paragraph are from Hope Johnson, "Are Men Best Fashion Designers?" *World Telegram and Sun* (New York, January 18, 1954), n.p. In the designer file of the library at the Costume Institute, The Metropolitan Museum of Art, New York.

49. See chap. 4. Little has been published about the lives and work of African American clothes designers and dressmakers. However, there is a long history of dressmaking within the community, and the profession provided a respectable living for many black women. Abraham Lincoln's wife, for example, is known to have employed a black dressmaker. See Wares, "Dress of African-American Women" (1981). The participation of Asian and Hispanic women in the American fashion industry is also under-researched, although they clearly make up a significant percentage of the labor force in the garment industry, replacing earlier generations of Italian and Jewish garment workers.

50. Williams, *Young Faces* (1956): 12.

51. Vera Maxwell quoted in Fashion Group, *Your Future in Fashion Design* (1966): 52.

52. Anne Klein quoted in Fashion Group, *Your Future in Fashion Design* (1966): 39–40. Although she does not say so specifically, the image that she conjures up here may be based on a composite of famous figures, such as film costume designer Edith Head and "society" interior decorators Elsie de Wolfe and Dorothy Draper.

53. Fashion Group, *Your Future in Fashion Design* (1966): 41.

54. Wohlfert-Wihlborg, "Label Is Anne Klein" (29 March 1982).

55. "Liz Claiborne," in McDowell, *McDowell's Dictionary of 20th-Century Fashion* (1985): 107.

56. Pierre, *Looking Good* (1976): 248.

57. Mansfield, "Prima Donna" (August 1989): 291.

58. Voight, "Scene Dining" (November/December 1987): 28.

59. Weir, "Closing the Gender Gap," (30 June 1985): 44.

60. Steele and Major, *China Chic* (1999): 90–94; Martin, "Yeohlee" (September 1998): 287–94.

61. Hastreiter, Steele, et al., *Ruben and Isabel Toledo* (1998), n.p.

62. Hochswender, "AIDS and the Fashion World" (11 February 1990): 1, 42.

63. Martin, "Emperors of New Clothes" (1990): 31.

CHAPTER 8: *Jewelry*

1. Adair, *Navajo and Pueblo Silversmiths* (1944): 6, 122; Frank, *Indian Silver Jewelry* (1978): 6.

2. Adair, *Navajo and Pueblo Silversmiths* (1944): 164.

3. Ibid., pp. 9, 88–89, 164.

4. Ibid., pp. 25–27; Bedinger, *Indian Silver* (1973): 115. See also Babcock and Weigle, eds., *Great Southwest* (1996).

5. Adair, *Navajo and Pueblo Silversmiths* (1944): 9.

6. Ibid., p. 88.

7. "Interview with C.G. Wallace" (*Arizona Highways*), reprinted in *C. G. Wallace Collection* (1975): unpaginated.

8. Cited in Adair, *Navajo and Pueblo Silversmiths* (1944): 9–10.

9. Ibid., p. 161. Ceremonial offices were an integral part of Zuni culture. Della Casa Appa belonged to the Ant fraternity.

10. Joe Tanner, Interviewed by Toni Greenbaum, 5 November 1999.

11. Adair, *Navajo and Pueblo Silversmiths* (1944): 164.

12. Ibid, pp. 203 and 206. By 1975 approximately three-quarters of all Zuni jewelry was made by women. See "Interview with C.G. Wallace" (*Arizona Highways*), reprinted in *C. G. Wallace Collection* (1975): unpaginated.

13. Fales, *Jewelry in America* (1995): 158, 274, 289, 298. In the early nineteenth century, a small percentage of women worked in the trade, as burnishers, enamelists, and engravers, but despite huge expansion, by 1870 only 1500 of the 10,000 workers were women. By 1875 of the 323 manufacturing jewelry firms on record in New York City only one, Martha Seckendorf, was run by a woman.

14. Aymer Vallance, "Modern British Jewellery and Fans," in Holme, ed., *Modern Design* (1901–2): 5.

15. W Scott Braznell, "Metalsmithing and Jewelrymaking, 1900–1920," in Kardon, ed., *Ideal Home* (1993): 55, 61.

16. Ibid., p. 55.

17. Ibid., pp. 55–57.

18. Ibid., p. 57.

19. Ibid., p. 63. See also W. Scott Braznell in Wendy Kaplan, ed., *"Art That Is Life"* (1987): 267–68.

20. Tara Leigh Tappert, "Artists and Advocates," in Kardon, ed., *Craft In The Machine Age* (1995): 232, 249. Smith and Barron won a medal at the Louisiana Purchase Exposition, 1904.

21. She married Frederick Shaw, silversmith and sculptor. Ibid., p. 248.

22. Sharon S. Darling, "From 'New Woman' to Metalsmith: A Voyage of Self Discovery," in Shifman, ed., *Arts and Crafts Metalwork* (1993): 38.

23. "This Being a Feminist Age, the Village Smithy Is a Studio and the Smith a Comely Young Woman," *Evening Sun* (12 January 1916). We are grateful to Rosalie Berberian for this information.

24. See Barron, ed., *Exiles and Emigrés* (1997).

25. For "male" modernism see Sparke, *As Long As It's Pink* (1995)

26. "Costume Jewelry" (1946): 144.

27. "Labels for Modern Jewelry Design 1946–47," n.p., n.d., Library of the Museum of Modern Art, New York.

28. She studied at the Academy of Fine Arts, San Diego; the California School of Fine Arts, San Francisco, and the Art Students League, New York. Wallance, *Shaping America's Products* (1956): 164.

29. Ibid.

30. Ibid.

31. "De Patta" (April 1947): 30.

32. Wallance, *Shaping America's Products* (1956): 165.

33. "De Patta" (April 1947): 30.

34. "Labels for Modern Jewelry Design 1946–47," n.p., n.d., Library of the Museum of Modern Art, New York.

35. Wallance, *Shaping America's Products* (1956): 165

36. Ibid., p. 163.

37. Ibid.

38. Elaine Rosenfeld, conversation with Pat Kirkham, May 1999. Her uncle, artist Edward Rosenfeld, was a neighbor of Cooke, with whom he exchanged work.

39. "Jewelry Designed By Betty Cooke" (April 1949): 32.

40. Smith and de Jongh, *Arthur Smith* (1990): unpaginated.

41. Morrison, "Twilight for Greenwich

Village"(January 1949): 30.

42. *Ebony* (July 1946): 23, 29.

43. Smith and de Jongh, *Arthur Smith* (1990): unpaginated.

44. Toni Greenbaum, catalogue entry in Eidelberg, ed., *Messengers of Modernism* (1996): 132–33.

45. See Wolf, "Claire Falkenstein's Never-Ending Universe" (1991): 26–31; also *Claire Falkenstein* (1989).

46. Toni Greenbaum, catalogue entry in Eidelberg, ed., *Messengers of Modernism* (1996): 108–11. See also Brynner, *Jewelry* (1979).

47. Wallance, *Shaping America's Products* (1956): 165.

48. "Costume Jewelry" (1946): 142.

49. Cera, *Jewels of Fantasy* (1992): 211.

50. Martin, ed., *Contemporary Fashion* (1995): 85.

51. Ball, *Costume Jewelers* (1997): 16.

52. Cera, *Jewels of Miriam Haskell* (1997): 13.

53. Ibid., pp. 37–38.

54. Ibid., 8, 17–19, 24–25, and passim. Frank Hess, a former window dresser for Macy's department store, was Haskell's principal designer until 1960, when Clark took over. He left in 1967.

55. Staggs-Flinchum, "Innovative Fashioner" (1996–97): 104.

56. Ibid.

57. Ibid.

58. Ibid.

59. Ibid.

60. The precedent was set slightly earlier in Europe by designers such as Emmy Van Leersum and Lam de Wolf in the Netherlands, and Julia Manheim, Susanna Heron, and Caroline Broadhead in England.

61. Greenberg, "Mary Ann Scherr" (Spring 1991): 30.

62. Proddow and Healy, *American Jewelry* (1987): 186; Proddow, Healy, and Fasel, *Hollywood Jewels* (1992): 187.

63. Frank Acaro, Tiffany and Company, facsimile transmission to Toni Greenbaum, 29 November 1999. Peretti's silver jewelry is mostly stamped out by steel tools or dies, in several sheets, which are then soldered together. This process gives the pieces an enhanced three-dimensional quality and smooth surface not available through casting.

64. Greenbaum, "Luminous Plastic Jewelry" (1992): 18, 56–59.

65. Lois Allan, "Ramona Solberg Jewelry," in Nichols, ed., *Northwest Originals* (1990): 109. She had served in the Women's Army Corps and studied under the G.I. Bill.

66. Fisch, *Textile Techniques* (1997).

67. Benesh, "Mary Lee Hu"(March 1983): 2–5.

68. Liotta, "Architectonic Ornamentation" (January/February 1997): 52. Also Greenbaum, "Constructivism" (1998–99): 88–89.

69. Osburn, "Verma Nequatewa (Sonwai)" (Spring 1998): 40.

70. Ibid.

71. Ibid.

72. Ibid., p. 39.

73. Cirillo, "Back to the Past" (Spring 1988): 48.

74. Cirillo, *Southwestern Indian Jewelry* (1992): 195.

75. Ibid.

76. In Native American fetish carvings, especially masks, "doors" open to reveal several layers of meaning. A face, for example, might open to reveal another face symbolizing an inner spirit. Some of Wallace's figures open to reveal not only symbols of landscapes, daily life, or legends, but also removable elements, such as earrings or smaller pendants.

77. See Dubin, *North American Indian Jewelry* (1999): 21–24.

78. The pin, along with Bowdwin's entire line of thematic jewelry, is manufactured by her Bronx-based company, Who Needs It More Than You?

79. Phyllis Bowdwin, interviewed by Toni Greenbaum, 17 December 1999.

80. Joyce Scott, "Artist Statement 1," n.d. We are grateful to Joyce Scott for sending us a copy of this document.

81. She most often uses "peyote stitch," referring to Native American implements, covered in a twilled pattern of beads, which were used in religious rituals involving the peyote cactus. See Dubin, *North American Indian Jewelry* (1999): 232, 590.

82. Renée Beggsmith, interviewed by Toni Greenbaum, 19 December 1999.

83. Ibid.

CHAPTER 9: *Metalwork*

Acknowledgments: I am grateful to Gerry W. R. Ward for his early reading of this manuscript, and to Claire Sanford, Marjorie Schick, Myra Mimlitsch Gray, Cynthia Eid, and Deborah Todd Wheeler for sharing their points of view from the field. —JF

1. NB. The terms *metalworking*, *metalsmith*, *goldsmith*, and *silversmith* are interchangeable for the purposes of this essay. Recent scholarship has demonstrated that in England, women from the seventeenth through the nineteenth centuries served as both silversmiths and business partners of larger workshops. With minor exceptions, no such evidence has come to light about comparable women in the United States. For British and Irish women, see Glanville and Goldsborough, *Women Silversmiths* (1990).

2. Statistics drawn from Úlehla, comp. and ed., *Society of Arts and Crafts* (1981).

3. In the absence of statistical data, this observation is drawn from discussions with independent craftspeople and academics.

4. For a thoughtful review of the reasons why women entered the field of metalsmithing, see Darling, "From 'New Woman' to Metalsmith: A Voyage of Self Discovery" in Shifman et al., *Arts and Crafts Metalwork* (1993): 27–32.

5. Quotation from "Woman Is Training To Be Silversmith," *Boston Post* (8 December 1913); "Test Student Recommends Silversmithing for Women" [ca. 1914], scrapbook, vol. 6, p. 20, School of the Museum of Fine Arts, Boston.

6. "This Being a Feminist Age, the Village Smithy is a Studio and the Smith is a Comely Young Woman," *The* [New York] *Evening Sun* (12 January 1916). I am grateful to Rosalie Berberian for this reference.

7. News of Women, *New York Sun* (29 August 1945); Today's Woman, *Christian Science Monitor* (November 1945); Women's Section, *Atlanta Constitution* (16 October 1959). Kaufmann was Regnier's married name. Regnier expressed her irritation with the press to the author on numerous occasions.

8. Howard Derrickson, "Maria Regnier Opens Artists' Guild Show," *St. Louis Post-Dispatch*, [January] 1953. Between 1900 and 1965, and many times since then, women's first names, rather than their surnames, have been frequently used in local and national publications. Even if one assumes good intentions on the part of the writer, this attitude toward women in the press indicates a tendency to trivialize women through a lack of respect and formality that is rarely found in comparable articles on men.

9. Rosemary Moore, "Kansas-Born Girl

Silversmith Wins Rare Swedish Honor" [ca. 1951], artist clipping files, Archives of American Art, Smithsonian Institution.

10. Austin, *June Schwarcz* (1998): 5, 86. For Wynne see Beels, "'I hate pretty work'" (1995): 24–31. For Bowles, see "Janet Payne Bowles and the Arts & Crafts Movement in Indianapolis," in Shifman et al., *Arts and Crafts Metalwork* (1993): 12. For Bowles and Welles see Darling, "From 'New Woman' to Metalsmith: A Voyage of Self Discovery" in Shifman et al., *Arts and Crafts Metalwork* (1993): 29–30. Many sources do not mention the marital status of other women metalworkers.

11. Darling, "From 'New Woman' to Metalsmith: A Voyage of Self Discovery" in Shifman et al., *Arts and Crafts Metalwork* (1993): 31.

12. Quoted in Shifman et al., *Arts and Crafts Metalwork* (1993): 13–14.

13. Ibid.

14. Yale Wynne tutored the wealthy Chicago socialite Frances M. Glessner, who fashioned silver for her own use and as gifts for her husband, International Harvester manufacturer John J. Glessner. See Darling, *Chicago Metalsmiths* (1977): 63–67.

15. For more information on manual education programs, later called vocational or technical courses, see Wygant, *Art in American Schools* (1973); and Korzenik, *Drawn to Art* (1985).

16. Shifman et al., *Arts and Crafts Metalwork* (1993): 16, 22. Pack's publications include *Jewelry and Enameling* (1941); *Chains and Beads* (1951); *Jewelry Making for the Beginning Craftsman* (1957); Davis and Pack, *Mexican Jewelry* (1963); Pack, *Jewelry Making* (1968).

17. Many of Pack's students are recorded in issues of *The Metal Crafts*, an occasional publication produced by Augustus Rose of Providence, Rhode Island. See *Metal Crafts: Things In and about Metal* 4 (June 1936): 4, ill.

18. Grace V. Kelly, "Mildred Watkins Outstanding Artist in making Jewelry and in the Art of Silversmithing," [Cleveland] *Plain Dealer* (28 January 1934): no page number. The Society of Arts and Crafts, Boston, awarded Watkins its highest honor in 1940. As late as 1948, she was featured in an America House exhibit entitled *Beauty in Enamels*. See "News of the Councils," *Craft Horizons* 8, no. 20 (February 1948): 30.

19. The program was officially known as the National Silversmithing Workshop Conference for Teachers.

20. Falino, "Metalsmithing at Midcentury," in *Sculptural Concerns* (1993): 10–27.

21. The May Show was formally known as *Exhibition of Work by Artists and Craftsmen of the Western Reserve*. See Kardon, *Craft in the Machine Age* (1995): 252–53. The Wichita Art Association produced *The Decorative Art and Ceramics Exhibition* from 1946 to 1962. Since that time, there have been intermittent exhibitions and various titles, most of which have included the words "Wichita Nationals," hence its popular name. Thanks to Pamela Kingsbury for clarifying Wichita exhibition dates and titles.

22. The Cowles Art School, established by the painter Frank Cowles (1839–1928), was founded in 1883 and closed about 1900. Harrington, "Cowles Art School" (1993).

23. Book designer and illustrator Amy Sacker taught first at the Cowles School in Boston and later in her own academy, called the School of Miss Amy Sacker. Sacker offered courses in bookbinding, interior decoration, and decorative design that embraced all media, including metal, wood, and fabric. Meyer, *Inspiring Reform* (1997): 231–32.

24. *Official Catalogue of Exhibits* (1904), Department B, Art, cat. nos. 729–32. None of these items, nor any other metalwork by Sears, has yet been located.

25. Sargent, "Worker in Enamel," *Keystone* (February 1906): 195.

26. Meyer, *Inspiring Reform* (1997): 210.

27. W. Scott Braznell, in Kaplan, *"Art That Is Life"* (1987/1998): 268, cat. no. 129.

28. Consigner records, Society of Arts and Crafts, Boston, Archives of American Art, Smithsonian Institution; Úlehla, comp. and ed., *Society of Arts and Crafts* (1981): 59.

29. Archives, Massachusetts College of Art; *School of the Museum of Fine Arts, Twenty-Fourth Annual Report 1900–1901*, pp. 18–19. *Thirtieth Annual Report*, p. 10; *Museum of Fine Arts Twenty-Sixth Annual Report of the School*, p. 16. Watkins and Barron's jointly fashioned works were included in several exhibitions; see Art Institute of Chicago, *Annual Exhibition of Original Designs for Decorations and Examples of Art Crafts Having Distinct Artistic Merit* (1906): 18, nos. 103–11; idem (1907): 21, nos. 139–54; *Arts and Crafts Exhibition* (Cleveland: Cleveland Decorative Arts Club, 1908):

unpaginated, nos. 56–90.

30. "Hand Wrought Silver by Woman on Show," *Boston Post*, March 27, 1915, Úlehla, comp. and ed., *Society of Arts and Crafts* (1981): 85. Consigner records, Society of Arts and Crafts, Boston, Archives of American Art, Smithsonian Institution. After 1919, Foster returned her family home in Sharon, Massachusetts, and later moved to New Haven, Connecticut, and New York City. Society records note that although she retained her membership until 1927, Foster was "inactive since going into business at the time of the World War." For Handicraft Shop see W. Scott Braznell, in Kaplan, *"Art That Is Life"* (1987/1998): 272–73, cat. no. 134.

31. Consigner records, Society of Arts and Crafts, Boston, Archives of American Art, Smithsonian Institution.. For contemporaneous accounts regarding the additional time and expense involved in Pratt's work, see W. Scott Braznell, in Kaplan, *"Art That Is Life"* (1987/1998): 180, cat. no. 66.

32. Scrapbook, vol. 8, p. 25, School of the Museum of Fine Arts, Boston; Katharine Pratt records, Archives of American Art, Smithsonian Institution; Jenny Perry, "Women Silversmith Continues to Learn," *Santa Barbara News-Press* (4 July 1967). Pratt was a member of the jury and on the Craftsman Advisory Board at the Society of Arts and Crafts, Boston.

33. "Idealism at 'The Handicraft Shop'" *Providence* [Rhode Island] *Sunday Journal* (25 June 1905). For Dennett, see "Mrs. Mary Ware Dennett," *Tennessee American* (31 May 1914), scrapbook, vol. 6, p. 125, School of the Museum of Fine Arts, Boston.

34. For the shop practices of Arthur Stone, see Chickering and Ross, *Arthur J. Stone* (1994): 26. For Ashbee, see Crawford, *C. R. Ashbee* (1985); Kaplan, "Lamp of British Precedent: An Introduction to the Arts and Crafts Movement," in *"Art That Is Life"* (1987/1998): 56.

35. In the 1904 St. Louis exposition, Knight was listed as designer and Seth Ek as collaborator in a "large and small 'tooled' silver plate and a small enamelled silver bowl" (*Official Catalogue of Exhibits* [1904]: 81, cat. nos. 299–301). In the same exhibition Knight paired with Karl Leinonen to produce flatware, a child's mug, and salt cellars (ibid., cat. nos. 302–11). In the following year, she participated in an exhibi-

tion at the Detroit Museum of Art as "designer and maker" (*Second Annual Exhibiton of Applied Arts* [1905]: 11). At the annual exhibitions in Chicago, she was listed alone as the maker of an assortment of bowls, chocolate pots, syrup pitchers, and spoons. See Art Institute of Chicago, *Annual Exhibition* (1908): nos. 372–77; ibid. (1910): nos. 702–5; ibid. (1911): nos. 387–90.

36. Darling, *Chicago Metalsmiths* (1977): 45–55.

37. Trapp, et al., *Arts and Crafts Movement in California* (1993): 145–47, 273, 284.

38. City directories list Gaw in Chicago as an interior decorator in 1913 and a designer in 1914; in San Jose, California, as a designer, 1915–19; in Carmel as an interior designer in 1933; in New York City as an interior decorator in 1933–34. See Trapp (1993): 273.

39. Trapp, et al., *Arts and Crafts Movement in California* (1993): 189 91.

40. Mrs. Stone, whose first husband had left her with a comfortable inheritance, provided financial backing for the workshop and freed Stone to concentrate on the design and execution of silver. As business grew, she served as his agent, managing the photography of the completed commissions, handling correspondence, and keeping accounts. That the couple was united in their aesthetic and professional goals is evident from Elizabeth Stone's prominent role as lecturer and author of articles that were published in *Handicraft* magazine. Chickering and Ross, *Arthur J. Stone* (1994): 9–10, 19.

41. Charlotte Bone to Elenita Chickering, 27 May 1991. I am grateful to Elenita Chickering for sharing this letter with me.

42. Chickering and Ross, *Arthur J. Stone* (1994): 174, cat 203. The vessel may be the same exhibited at the Brooklyn Museum in 1937, along with several other vessels and a fish server. See *Contemporary Industrial and Handwrought Silver* (1937): unpaginated. Bone exhibited a "mantlepiece bowl with lapis lazuli, chased and with mounted leaves" in the Brooklyn exhibition. Exhibition correspondence, The Brooklyn Museum. A similarly described bowl by Bone appeared at The Metropolitan Museum of Art; see *Silver* (1937). I am grateful to Jewel Stern for kindly sharing her resources on the Metropolitan Museum exhibition.

43. Mangan, "Marie Zimmermann" (Winter 1986)1:48. Zimmermann joined the National Arts Club in 1901, but it is not certain how soon afterwards she established her studio.

44. Saatchi, "Precious Metals" (June 1989): 170.

45. Kogan's employer was Scottish-born James W. Jennings, formerly employed by the Gorham Silver Company, and a German immigrant named Mr. Stone. For Kogan's personal story of achievement see Rice, "Belle Kogan Remembers" (Spring 1994): 33–39.

46. *Creative Design in Home Furnishings*, 1 (Fall 1936) 9:34–5.

47. *Contemporary Industrial and Handwrought Silver* (1937): unpaginated.

48. U.S. Patent 1928, Des. 75,939; see also Diane M. VanderBeke, "Cubistic Cocktails," student paper, 1987, files of the Department of Decorative Arts, Brooklyn Museum. Table accessories including triangular salts were also produced by E and J. Bass Company, New York. Kevin Stayton of the Brooklyn Museum kindly provided information on Tennhardt.

49. *Decorative Arts, Official Catalog . . . San Francisco* (1939): 82, cat. 808; U.S. Patents: 81,219; 81,316; 81,368; 81,569; 94,688; 95,683; 121,160; 140,749; and 142,714. The flatware pattern, later stamped with the name and symbols of the New York World's Fair, was submitted on 8 March 1938, granted on 21 March 1939, and assigned patent number 113866. I am grateful to Jewel Stern for sharing her discovery of and early research on this designer.

50. Karasz's education at the Royal School of Arts and Crafts in Budapest served her well in the United States. See Davies, *At Home in Manhattan* (1983): 42–43, 66, 86, 90–91; biographical entry, *Craft in the Machine Age* (1995): 237.

51. "Modern Design in Metal" (April 1929) 7:51–2.

52. Falino, "MFA Boston acquires Craver Silver Teapot" (16 February 1990): 50; Falino and Markowitz, "Margret Craver" (1996–97): 8–23.

53. Yolande Gwin, "A Rare Smith—A Woman Smith," *Atlanta Constitution* (16 October 1952): Women's Section.

54. For an article she published for beginner jewelers, see Husted-Anderson, "Setting Up shop . . . the jeweler"(Summer 1949) 2:13–15. Husted-Anderson was among senior

metalsmiths who recalled their experiences at a research conference that was held by the Archives of American Art in 1983. For a review see "American Metalsmithing" (February/March 1983) 1:86–87.

55. For more on the Handy and Harman conferences, see Falino, "Metalsmithing at Midcentury," in *Sculptural Concerns* (1993): 14–15; Falino and Markowitz, "Margret Craver" (1996–97): 15.

56. Quotation from an unpublished artist's statement, ca. 1990–91, departmental files, Art of the Americas, Museum of Fine Arts, Boston.

57. Bowen and Solley, eds., *Tribute to Alma Eikerman* (1985): passim.

58. Ibid. For relevant images of work by Eikerman's students, see ibid., pp. 62, 64, 81, 87, 90.

59. "Germantown Woman Famous for Unique Work in Silver Featured in New York Show," *Germantown Courier* (9 February 1950). Artist resumé, departmental files, Art of the Americas, Museum of Fine Arts, Boston. Her resumé does not say where or when she studied with Husted-Anderson, but it was probably at the Craft Students League.

60. Falino, "Metalsmithing at Midcentury," in *Sculptural Concerns* (1993): 19–20; artist files, Art of the Americas, Museum of Fine Arts, Boston.

61. Charron, *Modern Pewter* (1973). Charron's book is based upon the work and techniques of Felten, whose pewter is illustrated throughout; Seeler's enamels are also found in this volume.

62. Frances Felten, pewterer, and Margarete Seeler, enameler, *Cannister*, pewter with *plique-à-jour* (1968); published in Nordness, *Objects: USA*, (1970): 184.

63. Falino, *Silver of the Americas* (forthcoming).

64. Seeler, "Cup of '88" (June 1990) 3:52–55; Seeler, *Enamel* (1997). Seeler later moved to Kennebunkport, Maine, where this cup was fashioned.

65. For a look at the inventive work made in the late 1980s by an exciting group of young furniture makers, see Cooke, *New American Furniture* (1989), passim, For jewelers working without precious metals, see *Good as Gold* (1981).

66. Heisinger and Marcus, eds., *Design Since 1945* (1983): 162, 172; Doering, Switzky, and Welz, eds., *Goddess in the Details* (1994): 50; Russell, *Women of*

Design, Contemporary American Interiors (1992): 126–27.

67. This new series of work by the artist can be seen in [Myra Mimlitsch Gray], *Magnification* (self-published, October 1998).

CHAPTER 10: *Hollywood*

Acknowledgments: We would like to thank the following for their help in preparing this chapter: John Landis, Sharon Dolin, Jim Cook, Mike Hammond, Terry Geesker, Stephanie Day Iverson, and Scott Perkins. —DN and PK

1. At first films were made on the streets; there were no studios, only crude laboratories behind business offices. For the early history see Musser, *Emergence of Cinema* (1990); and Bowser, *Transformation Of Cinema* (1990).

2. Slide, *Silent Feminists* (1996): vi–viii, and Acker, *Reel Women* (1991): xvii.

3. Acker, *Reel Women* (1991): xvii; see also Gish with Pinchot, *Movies* (1969): 275 and Finlar, *Hollywood Story* (1988): passim.

4. The extent of women's involvement with the graphic design of opening and intertitle sequences in "silent cinema" is not known but title design, which became a specialist aspect of filmmaking in the 1950s, has been, until recently, a largely male world.

5. Arvidson [Griffith], *When the Movies Were Young* (1969): 56 and 71–74.

6. Ibid, pp. 71–72. Jeanie Macpherson and Gloria Swanson were among those whose beautiful clothes helped them get their first parts. In 1908, Macpherson "got her first movie job on the strength of a pale blue crèpe-de-chine evening gown" (ibid., p. 71). Swanson's autobiography indicates that she was always immaculately turned out as a teenager (*Swanson* [1980]: 26–27). In 1921 aspiring actresses were still advised to own a full screen wardrobe of contemporary clothes, including at least one evening dress. See Emerson and Loos, *Breaking into Movies* (1921): 23, cited in Jane Gaines "Costume and Narrative" in Gaines and Herzog, *Fabrications* (1990): 182, 184.

7. Peter Morris, "Nell Shipman in the Context of her Times," in Shipman *Silent Screen* (1987): 213, cited in Acker, *Reel Women* (1991): 24. The average film budget was approximately $500 in the early 1910s; a decade later "quality" features cost $200,000, with some epics exceeding that.

8. Chierichetti, *Hollywood Costume* (1976): 46.

9. Young, "Dressing for the Movies" (1915):117, cited in Jane Gaines, "Costume and Narrative" in Gaines and Herzog, *Fabrications* (1990): 181, 268.

10. Gish's actress mother had made the clothes for her and her sister Dorothy when they were child stage actresses. See Gish with Pinchot, *Movies* (1969): 6, 17. For the cinematic qualities of costume and early cinema see Howard, "How I Teach My Gowns to Act" (1916):92, cited in Jane Gaines, "Costume and Narrative" in Gaines and Herzog, *Fabrications* (1990): 182 and 184. In 1916 Marguerite Courtot rejected a particular orchid gown because it had insufficient variation of tone, too little contrast, and "ineffectual" draperies.

11. Gish with Pinchot, *Movies* (1969): 138. For *Captain Macklin* (1915), it was Gish who decided on a long, hooded coat based on one belonging to a friend, and on a dress of "pink taffeta, black velvet and ermine" made by Madame Frances, probably with advice from Gish (Gish, *Dorothy and Lillian* [1973]: 48). Of *Remodelling Her Husband* (1920), which she directed, she later commented, "I saw to the costumes (we had no designers then)" (ibid., p. 94).

12. Gish, *Dorothy and Lillian* (1973): 97; and Leese, *Costume Design* (1991): 14. The items included nightdress, negligee, and ballgown.

13. Gish with Pinchot, *Movies* (1969): 243.

14. Ibid., and Gish, *Dorothy and Lillian* (1973): 109.

15. Ibid., pp. 243 and 141, respectively.

16. Gish, *Dorothy and Lillian* (1973): 141; and Chierichetti, *Hollywood Costume* (1976): 12. See also Barthes, *Erté* (1972): 38, cited in Gaines and Herzog, *Fabrications* (1990): 22.

17. Walker, "Dressing the Movies" (1921): 24.

18. Gish with Pinchot, *Movies* (1969): 275. Gish recalled that by 1925 "the whole structure of film making had changed" and that Hollywood actors and actresses mostly "had nothing to say about the choice of costume."

19. West has been credited with the costume designs commissioned by Griffith for *The Birth of a Nation*. See Chierichetti, *Hollywood Costume* (1976): 187; Acker, *Reel Women* (1991): 264–65; and Leese, *Costume Design* (1991): 124.

20. Chierichetti notes that Hamilton, whom he states began working for the Triangle company in the summer of 1918, "was very probably the first [costume designer] to be put under contract at any studio" (*Hollywood Costume* [1976]: 12), but he later writes that Claire West "was already well-established at Paramount by the summer of 1918"(ibid., p. 46).

21. Leese, *Costume Design* (1991): 124. Howard Greer took over as chief designer after West left.

22. Chierichetti, *Hollywood Costume* (1976): 14, 46; and Slide, *Silent Feminists* (1996): 128–30. Valentino himself designed costumes: riding outfits for Dorothy and Lillian Gish (Gish with Pinchot, *Movies* [1969]: 211).

23. Slide, *Silent Feminists* (1996): 128–29.

24. Ibid., p. 128.

25. Heiser, *Hollywood Art* (1990): 46. United Artists refused to renew Valentino's contract if he continued to insist on Rambova as designer.

26. Swanson, *Swanson on Swanson* (1980):117; and Chierichetti, *Hollywood Costume* (1976): 63–66, 165–66.

27. See Leese, *Costume Design* (1991):passim; and Chierichetti, *Hollywood Costume* (1976): passim.

28. Such jobs usually included a supervisory role.

29. Leese, *Costume Design* (1991): 121; and Chierichetti, *Hollywood Costume* (1976): 187.

30. Chierichetti, *Hollywood Costume* (1976): 32.

31. Ibid., p. 186; and Leese, *Costume Design* (1991): 115.

32. Ibid., pp. 189 and 124, respectively.

33. Chierichetti, *Hollywood Costume* (1976): 163. A "period" movie, *Back Street* (1932 version), heavily referenced contemporary fashions whereas the later version aimed at greater "authenticity".

34. See Leese, *Costume Design* (1991): 66–67; and Chierichetti, *Hollywood Costume* (1976): 158, 163. For Columbia's first technicolor film, the "fashion movie" *Cover Girl* (1943, dir. Charles Vidor), for example, Travis Banton designed Rita Hayworth's outfits, Gwen Wakeling designed those in a flashback sequence, and King designed costumes for the major supporting roles as well as coordinating "all the purchased clothes for the endless parade of fashionable women."

35. Chiericetti, *Hollywood Costume* (1976): 58.

36. For Head, see Barbara Cavaliere, "Edith Head," in Pendergast, *Contemporary Designers* (1997): 351–53. See also Head and Calistro, *Edith Head's Hollywood* (1983); Head with Ardmore, *The Dress Doctor* (1959); and Head with Hyams, *How to Dress for Success* (1967).

37. Leese, *Costume Design* (1991): 57–58; and Chierichetti, *Hollywood Costume* (1976): 32.

38. Ibid. She had a boutique in Bullocks department store, Wilshire Boulevard, Los Angeles.

39. Chierichetti, *Hollywood Costume* (1976): 32. Although taken directly from old engravings, the designs were not considered appropriate for the movie.

40. Ibid.

41. Leese, *Costume Design* (1991): 92.

42. Ibid.; and Chierichetti, *Hollywood Costume* (1976): 41–42.

43. Rose, *Glamorous World* (1983): 27; for the Kelly/Rainier wedding, see Rose, *Just Make Them Beautiful* (1976). 151. Rose commented, "I loved that period. Grace was beautiful and in love with the prince and life was divine. I have always been extremely proud that Grace chose me to design her wedding gown as practically every designer in the world vied for this honor."

44. Cashin left school at age sixteen in 1931 to work for Fanchon and Marco, whereas Helen Rose studied at the Chicago Academy of Fine Arts before joining the troupe later in the decade. For Cashin see Iverson, "'Early' Bonnie Cashin" (2000–2001).

45. Chierichetti, *Hollywood Costume* (1976): 120.

46. Bonnie Cashin converation with Stephanie Day Iverson, 12 September 1998. See Iverson, "'Early' Bonnie Cashin" (2000–2001).

47. Chierichetti, *Hollywood Costume* (1976): 106.

48. Leese, *Costume Design* (1991): 87.

49. Ibid., pp. 59 60.

50. Ibid. Lamarr requested Jenssen as designer for *Dishonored Lady*, but they quarreled over the designs, and the results may incorporate some of Lamarr's ideas. For *Samson and Delilah*, Jennsen designed a range of male costumes. For a photograph of Cecil B. De Mille, Jenssen, and her sketches for the latter film, see ibid., p. 60, top right. In the 1950s Jenssen designed costumes for television's *I Love Lucy*, starring Lucille Ball.

51. Chierichetti, *Hollywood Costume* (1976): 158.

52. Ibid., p. 85.

53. Ibid., p. 86.

54. Leese, *Costume Design* (1991): 98, 102.

55. Ibid. Often praised for their "authenticity," Sharaff's designs for *Meet Me in St. Louis* are now seen as an early marker of Hollywood's version of the "New Look"; some costumes for the film were by Irene. See Maureen Turim, "Designing Women: The Emergence of the New Sweetheart Line," in Gaines and Herzog, *Fabrications* (1990): 215. Sharaff's first film was the historical drama *Madame Curie* (1943, dir. Mervyn LeRoy) starring Greer Garson and Walter Pidgeon.

56. Leese, *Costume Design* (1991): 102.

57. Ibid., pp. 98 and 102. Sharaff is also remembered for Barbra Streisand's costumes as Fanny Brice in *Funny Girl* (1968, dir. William Wyler) and Dolly Levi in *Hello Dolly* (1969, dir. Gene Kelly).

58. Chierichetti, *Hollywood Costume* (1976): 129 ("eye"); and Audrey Hepburn, "The Costumes Make the Actors," in Engelmeier and Engelmeier, *Fashion in Film* (1990):11 ("genius").

59. Oscars for Best Costume from 1948 to 1966 were given for both color and black-and-white films. Women, who vastly outnumbered their male colleagues, only marginally outdid them as winners during those years.

60. *Costume Designers Guild Directory* (1999): 2.

61. Toeplitz, *Hollywood And After* (1975): 17–40.

62. LaVine, *In a Glamorous Fashion* (1980): 153.

63. Ibid., p. 148.

64. Ibid., p. 150. Paramount spent many thousands of dollars touring the costumes from *The Great Gatsby*.

65. Morley's traumatic childhood, which included being sent out of Germany on a *Kindertransport* organized to save children from the Holocaust, was the subject of a film directed by her daughter, *My Knees were Jumping: Remembering the Kindertransports* (1998, dir. Melissa Hacker).

66. Roth has an exceptional support team in Gary Jones and Gene Kelly's daughter Bridget Kelly.

67. Her 1996 Oscar for *The English Patient* (1996, dir. Anthony Minghella) was in no small way a career achievement award. In 2000 the indefatigable Roth was again nominated, with codesigner Gary Jones, for *The Talented Mr. Ripley* (1999, dir. Anthony Minghella). That these costumes were copied by fashion houses testifies to Roth's enduring talent.

68. Sometimes directors were aware of this; sometimes not. Tailoring a unique "modern" or "vintage" costume for a particular actor sometimes not only furthered characterization and narrative but also conserved time and money. All too often, novice independent directors and producers trusted the "designer labels" with which they themselves were familiar, or in which they could more easily imagine characters, rather than the sketches of an unknown film costume designer. There are many "off the record" tales from costume designers about sewing "hot" designer labels into clothing they had designed and made in order to ensure approval by actors and directors. For reasons of confidentiality the sources remain "off the record."

69. Costumers belong to Motion Picture Costumers No.705. There are no rules to force a producer or director to hire a costume designer.

70. Ellen Mirojnick, "In-Person Presentation," program notes and comments made at the symposium, "Designing Dreams: Production and Costume Design In Film Today," held at the Walter Reade Theater, New York, 7 March 1999.

71. Judiana Makovsky interviewed by Deborah Nadoolman, 18 February 2000. Makovsky expressed a fear prevalent among late-twentieth-century costume designers that "no matter what you do, someone else is going to take credit for your work."

72. Panel discussion at the symposium, "Designing Dreams: Production and Costume Design In Film Today," held at the Walter Reade Theater, New York, 7 March 1999. Parker also gave costume designer Kristi Zea her first position as art director.

73. Eiko Ishioka, "In-Person Presentation," program notes to the symposium, "Designing Dreams: Production and Costume Design In Film Today," held at the Walter Reade Theater, New York, 7 March 1999.

74. Ruth Carter interviewed by Pat Kirkham, 4 December 1999. See also chap. 4 in this volume.

75. Balio, *Hollywood* (1990): 211.

76. Brouwer and Wright, *Working in Hollywood* (1990): 179.
77. Albrecht, *Designing Dreams* (1986): 32–34.
78. Gish, *Dorothy and Lillian* (1973): 94.
79. Ibid.
80. Everson, *American Silent Film* (1998): 315.
81. Grace, "Interior Design Influence" (1942): 45.
82. This was their last involvement with film. For Yoch and Council see J. Y. Yoch, *Landscaping the American Dream* (1989); see also chap. 14 in this volume.
83. Ibid., pp. 104–107.
84. Ibid., p. 104.
85. We are grateful to the United Scenic Artists Local 829 in New York City for this information.
86. Sharaff, *Broadway and Hollywood* (1976): 67. Gladys Calthrop also joined in the early 1930s.
87. Sennett, *Setting the Scene* (1994):78. The production cost $2,723,903, of which $542,000 was for the final ballet. See Halliwell, *Halliwell's Film Guide* (1991): 35.
88. Linda Berger, telephone conversation with Deborah Nadoolman, February 2000.
89. Gebhard, *Lutah Maria Riggs* (1992): 117.
90. Ibid., p. 91.
91. She won an Emmy as production designer for *Eleanor and Franklin,* which she shared with Antony Mondello, the set decorator. For movie information, see Internet Movie Database, http://www.imdb.com [cited 28 May, 2000].
92. LoBrutto, *By Design* (1992): 156–57.
93. McBride, *Filmakers on Filmaking* (1983): 132, cited in Webb, *Happy Birthday* (1987): 102.
94. Brouwer and Wright, *Working in Hollywood* (1990): 189.
95. Ibid., p. 188.
96. Patrizia von Brandenstein, "In-Person Presentation" at the symposium, "Designing Dreams: Production and Costume Design In Film Today," held at the Walter Reade Theater, New York, 7 March 1999.
97. LoBrutto, *By Design* (1992): 181. See also Heisner, *Production Design* (1997): 155–58.
98. Jeannine Oppewall interviewed by Pat Kirkham, 18 July 1991. See also Kirkham, *Charles and Ray Eames* (1995): 89.
99. Jeannine Oppewall, conversation with Deborah Nadoolman, September 1999. Oppewall added that she "never had a problem or lack of respect from carpenters or painters" she worked with.
100. Ibid.
101. Finnigan, "Designing Woman" (1989): 64.
102. Press kits for *Ghost* (1990, dir. Jerry Zucker) and *Raising Arizona* (1987, dir. Joel Coen); for an interview with Jane Musky, see *Back Stage* (29 March 1991).
103. Shaw, "Cameos: Lilly Kilvert" (1990): 33.

CHAPTER 11: *Industrial Design*

Acknowledgments: We are grateful to Terrance Keenan, George Arents Research Library for Special Collections, Syracuse University Library; Nancy Perkins (for providing us with information on Anna Keichline); Matt Kester at General Motors; and Bernard A. Banet (for allowing access to his Belle Kogan archives; hereafter referred to as Banet Collection).—EH and ES

1. See Pulos, *American Design Adventure* (1988); and Votolato, *American Design* (1998).
2. Anna Wagner Keichline, "Bed for Apartments," patent no. 1,736,653 (19 November 1929); "Kitchen Construction," patent no. 1,612,730 (28 December 1926).
3. The figure for 1900 is based on United States Patent and Trademarks Office records, and for 1995 is from *Buttons to Biotech* (1998).
4. Viola E. Kent, "Design for a Meat or Vegetable Chopper," patent no. 33,328 (9 October 1900); Hermena Kessler, "Design for a Kitchen-Bin," patent no. 37,689 (21 November 1905); Martha H. Solms, "Design for Linoleum, Oilcloth, or Floor-covering," patent no. 47,346 (11 May 1915); Sarah Lord Murphy, ""Design for a Telephone Appliance," patent no. 48,444 (11 January 1916); Charlotte S. Kohler, "Pedestal," patent no. 37,542; (12 September 1905), assigned to J. M. Kohler and Sons.
5. "Charlotte S. Kohler" [obituary], *Kohler of Kohler News* (March 1947); and biographical sketch, Kohler Corporate Archives, Kohler, Wisconsin.
6. See Davies, *At Home in Manhattan* (1983): 10–12, 27.
7. Ibid., p. 90.
8. Glassgold, "Some Modern Furniture Designers" (February 1930): 214.
9. Stanford, "International Exhibit of Modern Art"(July 1928): 19, cited in Brown, "Ilonka Karasz" (2000–2001): n. 38. See also Storey, "Latest Art-In-Industry Exhibition" (27 May 1928): 19.
10. Tachau, "Modern Ideas" (Septempter 1935): 292.
11. Anderson, "Contemporary American Designers" (December 1935): 87.
12. Heskett, *Industrial Design* (1980): 105.
13. Meikle, *Twentieth Century Limited* (1979): esp. chap. 3. Quotation from "The New Industrial Designers," in *Belle Kogan Design, 1930–1972: Retrospective Exhibition* (Israel: The Center for Technological Education, [1972]): unpaginated, Banet Collection.
14. "New Industrial Designers" [1972]: unpaginated, Banet Collection.
15. Rice, "Belle Kogan Remembers" (1994): 33.
16. Ibid., p. 36.
17. Babbitt, "As a Woman Sees Design" (1935): 14.
18. Jane Corby, "Smart Girls," *Brooklyn Eagle* (26 July 1939): page unknown, Banet Collection.
19. *Belle Kogan Design* [1972]: unpaginated, Banet Collection.
20. Rice, "Belle Kogan Remembers" (1994): 39.
21. Jane Corby, "Smart Girls," *Brooklyn Eagle* (26 July 1939): page unknown, Banet.Collection. In 1933 Kogan had hired her first design-trained employee, Madeline Masters ("Belle Kogan Remembers" [1994]: 39). Kogan was later cited as one of the few industrial designers to have employed an African American designer; see "Is Industrial Design Color Blind?" (1963): 83–84.
22. Belle Kogan Associates brochure, mid-1960s, Banet Collection.
23. Rice, "Belle Kogan Remembers" (1994): 34–35; and remarks at IDSA awards ceremony, Henry Ford Museum, Dearborn, Michigan, 17 August 1994, transcribed by Bernard A. Banet, Banet Collection.
24. *Anne Swainson* (1994).
25. Women designers at Chase included Helen Bishop Dennis, Sarah Lieberman, and Ruth Gerth, about whom little is known. See Johnson *Chase Complete* (1999): 27–29.
26. Cheney and Cheney, *Art and the Machine* (1936/1992): 250.
27. Ellen Manderfield, "Summary of Professional Activities," 13 April 1978, p. I, in the Manderfield file, Industrial Design Archive, George Arents

Research Library for Special Collections, Syracuse University Library.

28. Ellen Manderfield, "Design Contributions," January 1983, p. 1–5, typescript, in ibid.

29. Manderfield, "Summary of Professional Activities" (1978): 3, in ibid.

30. "Ellen Manderfield" (1999–2000): 6.

31. Information about Carnegie graduates is taken from Lesko, "Industrial Design at Carnegie Institute" (1997): 269–92; and for interview with Maud Bowers, see ibid., pp. 274–79.

32. Goddess in the Details (1994): 11; for Bowers's water heater, see Lesko, "Industrial Design at Carnegie Institute" (1997): 276.

33. R. Craig Miller, "Interior Design and Furniture," in Clark, ed., Design in America (1983): 273, 306n.73

34. Fedderson, Scandinavians in Michigan, vol. 1 (1968): 85, 86–87.

35. Ibid., p. 89.

36. For Schust Knoll biography see Oedekoven-Gerischer et al., Frauen im Design (1989): 132; and "Biographies of the Artists," in Clark, ed., Design in America (1983): 270.

37. Larrabee and Vignelli, Knoll Design (1981): 19.

38. Ibid., p. 77.

39. Cliff, "Gallery 4," (1961): 66, 71.

40. "Eight Solutions" (1948): 108–11.

41. Arguably the defining moments of midcentury modern design, the Good Design exhibitions sponsored by the Museum of Modern Art and the Merchandise Mart of Chicago from 1950 to 1954 featured "a selection of the best progressive design in home furnishings newly available during the year to the American consuming public." See Terence Riley and Edward Eigen, "Between the Museum and the Marketplace: Selling Good Design," in Elderfield, ed., Museum of Modern Art (1994): 150–79.

42. R. Craig Miller, "Interior Design and Furniture," in Clark, ed., Design in America (1983): 134. The "Parallel Bar" system was being publicized by 1956; see, e.g., Art and Architecture (March 1956): 36.

43. Janet Chusmir, "Florence Bassett's World on Display," Miami Herald (12 March 1972): sec. 8L.

44. R. Craig Miller, "Interior Design and Furniture," in Clark, ed., Design in America (1983): 122.

45. Neuhart, Neuhart, and Eames, Eames Design (1989): 22–23; Eidelberg, ed., What Modern Was (1991): 371.

46. R. Craig Miller, "Interior Design and Furniture," in Clark, ed., Design in America (1983): 108, 268.

47. Eidelberg, ed., What Modern Was (1991): 371.

48. The year 1946 also saw the introduction of the "DCW" (a dining-chair version of the "LCW"), the "LCM" and "DCM" (metal-framed variations on the "LCW" and "DCW"), the "FSW" (a folding screen in wood), and a variety of plywood tables; see Neuhart, Neuhart, and Eames, Eames Design (1989): 72–80.

49. Kirkham, Charles and Ray Eames (1995): 83.

50. Quotation from ibid., p. 82.

51. "Designer for Everybody" (April 1954): 69; Musselman, "Designing Woman" (1995): 30.

52. Josephine Di Lorenzo, "Clever Gal Has Design to Thank for Her Living," [New York] Sunday News (25 February 1951): M10; Musselman, "Designing Woman" (1995): 27.

53. Musselman, "Designing Woman" (1995): 27.

54. Josephine Di Lorenzo, "Clever Gal Has Design to Thank for Her Living," [New York] Sunday News (25 February 1951): M10.

55. Diamond, "Coordination Starts at Home" (October 1946): 45.

56. "Libbey Studies Post-War Designs" (November 1944): 48.

57. "In Memoriam . . . Freda Diamond" [obituary], Society of Glass and Ceramic Decorators Newsletter (February 1998): 8.

58. People, Interiors (August 1945): 98.

59. "Designs for Living in America" (February 1958): 43.

60. Clipping from Furnishings Merchandising (February 1945), Company Scrapbook, Freda Diamond Collection, National Museum of American History, Smithsonian Institution.

61. "Designer for Everybody" (April 1954): 69.

62. Hiesinger and Marcus, Design Since 1945 (1983): 224.

63. Furniture Forum 4, no. 1 (February 1953): unpaginated.

64. Hiesinger and Marcus, Design Since 1945 (1983): 224; for other examples of her winning designs, see also the Good Design exhibition catalogues produced by the Museum of Modern Art, New York, 1950–54.

65. Biographical details from Henderson, "Swedish Furniture Designer" (1951): 55; "Newsreel" Interiors (November 1943): 54.

66. Henderson, "Swedish Furniture Designer" (1951): 54.

67. Ibid., pp. 55–57.

68. See, e.g., "Furniture and Lamps by Greta Magnusson Grossman" (1950): 30.

69. Society of Industrial Designers, U.S. Industrial Design (1951); "Faithful Helpmates" (1945): 56–57.

70. Carpenter, "Statement: The Designing Women" (1964): 72.

71. Ibid., p. 73.

72. Ellen Manderfield, "Summary of Professional Activities," 13 April 1978, p. 1, in the Manderfield file, Industrial Design Archive, George Arents Research Library for Special Collections, Syracuse University Library.

73. "Woman of the Month," Today's Woman (25 January 1946), clipping in the Banet Collection.

74. Linz, Art Deco Chrome (1999), Another early woman auto designer was Betty Thatcher, who joined Hudson in 1939. See Lamm and Holls, Century of Automotive Style (1997): 192–93.

75. Earl quoted in "Women Play Prominent Part in GM Car Styling," New Center News, 27 May 1957, clipping in the Van Alstyne Collection, Cranbrook Academy of Art Archives. See also Goddess in the Details (1994): 14–21.

76. Suzanne Vanderbilt interviewed by Dave Crippin, Edsel B. Ford Design History Center, 22 April 1986, West Bloomfield, Michigan, transcript in the Vanderbilt Collection, Cranbrook Academy of Art Archives.

77. Ibid.

78. Goddess in the Details (1994): 18–19.

79. Erika Doering, "Dagmar Arnold" [obituary] (1999): 14. Also see Goddess in the Details (1994): 20–21.

80. Vanderbilt interviewed by Dave Crippin, 22 April 1986.

81. Once, while visiting New York, Vanderbilt purchased a coat made of the new fabric Ultrasuede and sent a sample back to the studio for consultation. On several occasions, rather than employing fabrics specially designed for automobiles, Vanderbilt used furniture fabrics as initial concepts, exploring interpretations of the fabrics as automotive textiles (ibid.).

82. Lucia DeRespinis interviewed by Cheryl Buckley, 7 October 1999.

83. *Goddess in the Details* (1994): 30.

84. Peggy Gruen interviewed by Eric Setliff, 14 March 2000; *California Design 8* (Pasadena: Pasadena Art Museum, 1962): 80–81; *Goddess in the Details* (1994): 30.

85. *California Design 9* (1965): 18–19.

86. *California Design 10* (1968): 91; *California Design 11* (1971): 94; Peggy Gruen interviewed by Eric Setliff, 14 March 2000; quotation from *Goddess in the Details* (1994): 30.

87. "Artistry in Glass," *Pittsburgh People* (August 1953): 19.

88. Johnson, *Higgins* (1997): 51, quotation from p. 11.

89. Seiler and Kirkham, "Lella Vignelli" (2000–2001).

90. Lisa Krohn interviewed by Ella Howard, 19 January 2000.

91. Nancy Perkins interviewed by Ella Howard, 17 December 1999.

92. Ibid.

93. "Is Industrial Design Color Blind?" (1963): 83–84.

94. Carole Bilson interviewed by Ella Howard, 31 January 2000.

95. Ibid.

96. Jill Shurtleff interviewed by Ella Howard, 14 December 1999.

97. It is estimated that more than half the "Sensor for Women" sales have been to women who formerly used disposable razors. Shurtleff, "Finally!" (1993): 33–35.

98. Jill Shurtleff interviewed by Ella Howard, 14 December 1999.

99. Judy Reichel Riley interviewed by Pat Kirkham and Ella Howard, 2 February 2000.

100. Birsel was featured on the covers of *Interiors* (September 1999) and *Metropolis* (November 1999).

101. Birsel quoted in Schwartz, "120 Degrees of Separation" (1999): 51.

102. All three statistics are minimum figures (IDSA members are not required to declare their sex): statistic for 1974 from interview with Nancy Perkins; for 1986 from Krohn, "Against the Odds" (1986): 38; for 1999 from Gigi Thompson, IDSA, conversation with Ella Howard, 24 March 2000.

103. Erika Doering, correspondence with the authors, March 2000.

104. Ellen Manderfield, "Summary of Professional Activities," 13 April 1978, p. 4, in the Manderfield file, Industrial Design Archive, George Arents Research Library for Special Collections, Syracuse University Library.

CHAPTER 12: *Furniture*

Acknowledgments: For their helpful comments, I would like to thank Pat Kirkham and Glenn Adamson, who read an early version of this article.—ESC

1. On the notion of traditional feminine craft pursuits, see *Heresies* 4 (Winter 1978). Glenn Adamson kindly brought this volume to my attention. Particularly relevant articles in this special issue, subtitled "Women's Traditional Arts, The Politics of Aesthetics," are two articles: Linda Nochlin, "Women and the Decorative Arts" (p. 43); and Mary Garrard, "Feminism: Has It Changed Art History" (pp. 59–60). For a helpful introduction to the necessity of recovering feminine histories of artistic production see Pollock, *Vision and Difference* (1988): esp. 1–17. Early efforts to examine the role of women furniture makers include Pat Kirkham, "'If You Have No Sons': Furniture-Making in Britain," in Attfield and Kirkham, eds., *View from the Interior* (1989): 109–30; Stritzler, *Pioneer and Pioneering 20th-Century Women Furniture Designers* (1988); and Noll, "Finding Your Own Voice" (Spring 1989): 36–41.

2. On the role of women in the American Arts and Crafts movement, see chap. 2 in this volume. See also Boris, *Art and Labor* (1986): 99–138; and Marcia Anderson, "Art for Life's Sake: The Handicraft Guild of Minneapolis," in Conforti, ed., *Art and Life* (1994): 122–23.

3. The standard American studies celebrate the few works by individual heroic women such as Adelaide Robineau and the more numerous works of relatively anonymous girls at several potteries such as Grueby, Rookwood, and Paul Revere, but do not press the interpretive issue of gender and its role in production. See Clark, *Arts and Crafts Movement* (1972); Kaplan, ed., *"Art That is Life"* (1987); Bowman, *American Arts and Crafts* (1990); Eileen Boris, "Crossing Boundaries: The Gendered Meaning of the Arts and Crafts," in Kardon, ed., *Ideal Home* (1993): 32–45; and Sharon Darling, "From 'New Woman' to Metalsmith: A Voyage of Self Discovery," in Shifman, *Arts and Crafts Metalwork* (1993): 27–45. A suggestive investigation into the interrelationship between two marginalized groups—women and immigrants—is R. Tripp Evans's study of the Kalo Shop in Chicago ("A Profitable Partnership" [Summer 1995]: 5–21). British scholars have probed the complexities more satisfactorily: Callen, *Women Artists* (1979); Anthea Callen, "Sexual Division of Labor in the Arts and Crafts Movement," in Attfield and Kirkham, eds., *View from the Interior* (1989): 151–64; and Lynne Walker, "The Arts and Crafts Alternative," in ibid., pp. 165–73.

4. *Museum of Fine Arts* [Boston], *School of Drawing and Painting: Ninth Annual Report* (1885): 7. Another period publication that underscores the notion of decorative design is Sturgis, *Interdependence of the Arts* (1905).

5. For the School of the Museum of Fine Arts, Boston, see, e.g., Pierce, *History of the School* (1930); Sheehan, "Boston Museum School" (1983); and the school's annual reports. On Millet, see Darling, *Chicago Ceramics* (1979): 104–8. Many of the graduates of these schools went on to design books, wallpaper, and jewelry.

6. Varnum originally published his work in 1915 and 1916 as a series of articles in *Industrial-Arts Magazine*, but compiled them into a single volume in 1916: Varnum, *Industrial Arts Design* (1916/1995). For a biography of Varnum, see *Industrial-Arts Magazine* 3, no. 1 (January 1915): 5.

7. On Nowell, see Knight, *Artists of Winchester* (1992): 8; *Affirmation and Rediscovery* (1997): 33; and Meyer, ed., *Inspiring Reform* (1997): 56.

8. On Lucia Kleinhans Mathews, see Jones, *Mathews* (1972); and Trapp, ed., *Arts and Crafts Movement* (1993): 137–40 and 280–81.

9. For Molly Coolidge Perkins, see Meyer, *Inspiring Reform* (1997): 55–56 and 227.

10. On Wheelock, see Kaplan, *"Art That is Life"* (1987/1998): 321.

11. Adolf Loos wrote "Ornament and Crime" in 1908. For a reprint, see Conrads, ed., *Programmes and Manifestoes* (1970): 19–24. For insightful feminist perspectives on Loos's and Karl Scheffler's contempt for ornament, see Jenny Anger, "Forgotten Ties: The Suppression of the Decorative in

German Art and Theory, 1900–1915," in Reed, ed., *Not at Home* (1996): 130–46.

12. On the rise of industrial design, see Meikle, *Twentieth-Century Limited* (1979); Davies, *At Home in Manhattan* (1983); and Nina Stritzler, "Design Moves On: The Ascendancy of American Design in the Decade of Recovery," in *Merchandising Interior Design* (1991): 63–75; and Smith, *Making the Modern* (1993): 353–404.

13. For more on Karasz, Schaefer, Connor, and Knoll, see chaps. 11 and 13 in this volume.

14. On Eames, see Kirkham, *Charles and Ray Eames* (1995).

15. The change from manual arts and industrial arts to vocational education is discussed in Edward S. Cooke Jr., "From Manual Training to Freewheeling Craft: The Transformation of Wood Turning, 1900–1976," in *Across the Grain* (2001).

16. For the context of this period and the rise of designer-craftsmen, see ibid.; and Sussman, "Did Success Spoil the United States? Dual Representations in Postwar America," in May, ed., *Recasting America* (1989): 19–37; and Jackson Lears, "A Matter of Taste: Corporate Cultural Hegemony in a Mass-Consumption Society," in ibid., pp. 38–57; *Designer Craftsmen* (1953). The term "gentle revolutionaries" is derived from Emery, *Craftsman Lifestyle* (1976).

17. Harris, *Arts at Black Mountain College* (1987): 86.

18. Gregory, manuscript written by her in the late 1960s (in possession of Molly Gregory); and Gregory, interviews with the author, October 1989 and March 2000; see also Cooke, "Coming of Age" (December 1989/January 1990): 10–13 and 49.

19. Stone, "Partners in Craftsmanship" (June/July 1983): 6.

20. For more on Anderson, see Cooke, "From Manual Training to Freewheeling Craft." Another prominent woman designer-craftsman making furniture at this time was Jean Russum of Monkton, Maryland, who showed work in *Furniture by Craftsmen*, an important 1957 exhibition at the Museum of Contemporary Crafts, New York, that also included work by Joyce and Edgar Anderson, Richard Artschwager, Wharton Esherick, Tage Frid, Sam Maloof, George Nakashima, and Walker Weed.

21. On the growth of the field, see Cooke, *New American Furniture* (1989): 10–31; and Edward S. Cooke, Jr., "Defining the Field," in Kelsey and Mastelli, eds., *Furniture Studio* (1999): 8–11. In *New Handmade Furniture*, the pioneering 1979 exhibition at the American Craft Museum, New York, only two of the thirty-seven featured makers were women. Suggestive studies on professionalization and the lure of the term *studio* are Upton, "Pattern Books" (1984): 107–50; and Jones, *Machine in the Studio* (1996).

22. Sources of information on McKie include Cooke, *New American Furniture* (1989): 80–83; Cooke, "Coming of Age" (December 1989/January 1990); Belz, *Todd McKie and Judy McKie* (1990); *Furniture Art of Judy Kensley McKie* (1994); and *Judy Kensley McKie* (1997).

23. Cooke, *New American Furniture* (1989): 68–71; Olsen, "Kristina Madsen" (Summer 1991): 38–42; and Noll, "Return of the Native" (June 1998): 20–27.

24. *Rosanne Somerson* (1993): 4.

25. Cooke, *New American Furniture* (1989): 116–19.

26. Ibid., pp. 72–75; Cooke, *Wendy Maruyama* (1991); and Noll, "Finding Your Own Voice" (Spring 1989): 39–40.

27. Noll, "Finding Your Own Voice" (Spring 1989): 37–39; Spenger, "Meanwhile Back at the Ranch" (June 1997): 70–75; and Donnelly, "Furniture as Art" (February 1993): 58–60.

CHAPTER 13: *Interiors*

Abbreviations: AIA (American Insititute of Architects), AID (American Institute of Decorators), ASID (American Society of Interior Designers), FIDER (Foundation for Interior Design Education and Research), NCIDQ (National Council for Interior Design Qualification), NSID (National Society of Interior Designers).

PART I

1. Kirkham, "London Furniture Trade" (1988): 66.

2. For the sake of clarity readers are asked to consider the terms as interchangeable.

3. George Leland Hunter was a published expert on the subject of antique tapestries; see Hunter, *Tapestries* (1912). Some architects also undertook interior decoration. For example, McKim, Mead, and White collaborated directly with furniture manufacturers, such as the prestigious Herter Brothers. See Katherine S. Howe, Alice Cooney Frelinghuysen, and Catherine Hoover Voorsanger, introduction to Museum of Fine Arts, Houston, *Herter Brothers* (1994): 14 and 238–239.

4. "Decorative Art Study" (1885): 22, quoted Cheryl Robertson, "From Cult to Profession," in Martinez and Ames, eds., *Material Culture of Gender* (1997): 98. See also Clark, *American Family Home* (1986): 106.

5. Wheeler, "Interior Decoration," part 1 (6 April 1895): 559–60; part 2 (20 April 1895): 649.

6. Forsslund, "Woman's Influence" (May 1906): 499.

7. Ibid., p. 497.

8. Marcia G. Anderson, "Art for Life's Sake: The Handicraft Guild of Minneapolis," in Conforti, ed., *Minnesota* (1994): 166.

9. Cheryl Robertson, "From Cult to Profession," in Martinez and Ames, eds., *Material Culture of Gender* (1997): 102. See also Forsslund, "Woman's Influence" (May 1906): 499.

10. Ibid., pp. 99 and 496, respectively. Robertson (p. 99) also mentions Henrietta Keith, who advertised as an independent interior decorator and worked in that capacity for a mail-order housing business run by her family.

11. Lamoureux, *Arts and Crafts Studio of Dirk van Erp* (1989): 16. Gaw studied at the Guild of Handicraft in England and the School of the Art Institute of Chicago.

12. Pregliasco, "Life and Work of Marion Mahony Griffin" (1995): 165. For further information, see Hines, "Portrait: Marion Mahony Griffin (1995): 28–40.

13. Pregliasco, "Life and Work of Marion Mahony Griffin" (1995): 170–71.

14. Grattan, *Mary Colter* (1992): 3–5. While studying design, Colter apprenticed at the office of a local architect. For more information on Colter's work, see *House Made of Dawn*, 1996, videocassette, based on Momaday, *House Made of Dawn* (1968/1989).

15. Grattan, *Mary Colter* (1992): 10.

16. Ibid., p. 94. She took advice from Guy Cowan, a ceramic sculptor, on this project. She nonetheless rejected the first samples because the designs were too even and the colors not sufficiently

authentic. See Luckin, *Dining on Rails* (1983): 92.

17. Loe, *Hearst Castle* (1994): 7, 12, 37, 47, 64, 68, 70, and 77.

18. Smith, *Elsie de Wolfe* (1982): 102. De Wolfe had already decided to abandon the theater in 1904 and was looking for a way of financing her new interior decorating enterprise when the commission for the Colony Club came along.

19. Ibid., pp. 24 and 118–19. De Wolfe and Marbury lived together in Irving House, the former home of Washington Irving at Gramercy Park in New York. The house was redecorated by de Wolfe in a manner that impressed guests, such as Stanford White, who regularly attended their Sunday social events.

20. De Wolfe published articles in the *Delineator* between October 1911 and May 1912 and in *Good Housekeeping* between May 1912 and June 1913.

21. Commissions arising from the Colony Club project included work on New Place outside San Francisco for Mrs. William Crocker (1907); Mellody Farm in Lake Forest for Mrs. Ogden Armour (1907); Shoremond on Long Island for Mrs. Ormond G. Smith (1910/12); and Mirador in New Jersey for Mrs. C.W. Harkness (1907).

22. Banham, ed., *Encyclopedia of Interior Design* (1997): 376.

23. Ibid., p. 1317.

24. Salny, "Frances Elkins" (January 2000): 164–67; Rowlands, "Frances Elkins" (September 1988): 146–56; and Platt, *David Adler* (1970): 4, 6, 25–27, 201.

25. Rose Cumming, "A Door Always Open" in Tweed, ed., *Finest Rooms* (1964), 44.

26. See Cumming's New York apartment for Mrs. Cowan: "New Expression of Modern"(August 1937): 10–11.

27. Tapert, "Rose Cumming" (January 2000): 147.

28. Cumming, "A Door Always Open" in Tweed, ed., *Finest Rooms* (1964), 44.

29. Petkanas, *Parish Hadley* (1995): 23.

30. Ibid., pp. 122–31. See also Heyman, *Woman Named Jackie* (1989): 253–54; for Parish and the White House project see Abbott and Rice, *Designing Camelot* (1998).

31. Petkanas, *Parish Hadley* (1995): 12.

32. Banham, ed., *Encyclopedia of Interior Design* (1997): 930.

33. Petkanas, *Parish Hadley* (1995): 39.

34. Brown, *Sixty Years of American Design* (1982): 15–17.

35. Banham, ed., *Encyclopedia of Interior Design* (1997): 765.

36. *Decorative Arts: Official Catalog* (1939): 12–18. The eleven men included Kem Weber, Marcel Breuer, William Haines, William Pahlmann, and Gilbert Rhode.

37. Brown, *Sixty Years of American Design* (1982): 32.

38. McNeil, "Designing Women" (December 1994): 639. See also Parsons, *Interior Decoration* (1915): vii.

39. "The Women Decorators' Exhibit" (March 15, 1927): 119.

40. Richardson, "Founding of the American Institute of Decorators" (January 1941): 24.

41. Cited in Cheryl Robertson, "From Cult to Profession,"in Martinez and Ames, eds., *Material Culture of Gender* (1997): 102.

42. "Radio News" (March 1934): 17.

43. "A.I.D. Board of Governors Hold Quarterly Meeting," *Decorators Digest* (January 1934): 25.

44. For McClure, see "Portraits of Presidents" (August 1934): 9 and cover (illus.). For Weisskopf, see "Portraits of Presidents" (January 1936): 52 and 78.

45. A series of editorials in *Decorators Digest* focused on the two terms and featured readers' responses to the debate. See Anderson, "Interior Designers" (November 1936): 27. Anderson wrote, "You don't decorate or interior decorate; that is the function of the painter or paper hanger. You design and create interiors; therefore you should term yourself an Interior Designer, and the field you serve, Interior Design." See also "Reader Reaction" (December 1936): 25. *Decorators Digest* appended its title with a subheading, "Interior Design and Decoration," on most of its 1936 issues. According to New York Public Library records, the journal was titled *Decorators Digest* from 1932 to 1936 and *Interior Design and Decoration* from 1937 to 1950.

46. Moore, "Why not Publicize A.I.D.?" (November 1934): 29.

47. Anderson, "Decorators Of Tomorrow" (April 1935): 27.

48. Ibid.

49. Banham, ed., *Encyclopedia of Interior Design* (1997): 93.

50. McNeil, "Designing Women" (December 1994): 637–38.

51. Anderson, "Transition"(November 1937): 35.

52. McClelland, "A.I.D. News" (November 1940): 37.

53. Ibid., p. 37.

54. Banham, ed., *Encyclopedia of Interior Design* (1997): 385.

55. Ibid., p. 386.

56. Forsslund, "Woman's Influence" (May 1906): 499.

57. Brown, *Backgrounds for Modern Living* (1999.

58. For Schamberg see "Crossing the Bar" (January 1934): 27.

59. For Ryan see "The 'Little Things'" (1935): 26–27; for Hunn see "Department of Plastics" (October 1941): 42–43; for Higbie see "Interior Design in Public Work"(January 1941): 39; for Urquardt, Smyth, and Marckwald see "Interior Design Aboard the S.S.*America*" (September 1940): 30; 74–76; for Colter see Grattan, *Mary Colter* (1992): 95; and *House Made of Dawn*, 1996, videocassette, based on Momaday, *House Made of Dawn* (1968/1989).

60. For Warren see "At the Washington National Airport" (November 1941): 53–55; for Draper see Banham, ed., *Encyclopedia of Interior Design* (1997): 387; for Schaefer see "Paintings and Light Used in Design" (May 1937): 46; and for Connor see "Style Created by These Famous Designers" (January 1940): 77; and "Three-dimensional Arrangements" (July 1941): 44 and 51.

61. Cliff, "Gallery 4: Florence Knoll"(April 1961): 68.

62. Larrabee and Vignelli, *Knoll Design* (1989): 17; and Clark, ed., *Design in America* (1983): 33.

PART 2

Acknowledgments: For their assistance in compiling the statistical information for this chapter, I am grateful to X. Theodore Barber, archivist, the Anna-Marie and Stephen Kellan Archives, Parsons School of Design, New York; Misti Cook, NCIDQ; and Douglas Doe, assistant archivist, Rhode Island School of Design (RISD), Providence; Paul Glassman, director of the library, New York School of Interior Design; Holly Mattison, FIDER; and the staffs of the research department at *Interior Design* and the membership and government affairs offices at ASID. — JG

63. Yankelovich, Clancy, Shulman, *Interior Design Universe Study* (1995).

64. McCluskey, quoted by Barbara Ettore in "Designer's Inside Story"(28 August 1977): section 3, 1.

65. These statistics are based on figures

provided by X. Theodore Barber, Parsons School of Design, memorandum to author, 21 October 1999; Douglas Doe, RISD, memorandum to author, 16 December 1999; Paul Glassman, NYSID, memorandum and telephone conversation with author, 12 October 1999.

66. In a 1968 survey conducted by NCIDQ, 72 percent of the respondents were female, a figure the organization takes to reflect the balance of the profession overall (survey cited in "NCIDQ Information: Executive Summary," 1998, p, 1, NCIDQ National Headquarters, Washington, D.C.).

67. "Past Presidents" roster, ASID Headquarters, Washington, D.C.

68. See, for example, Lella Vignelli's description of her experiences in the 1960s in Seiler and Kirkham, "Vignelli" (2000–2001).

69. Betty Sherrill, interview by author, 15 October 1999, New York City. McMillen, Inc. was founded two years before Mrs. Henry Parish's firm, the successor to which, Parish-Hadley, closed its doors at the end of 1999. See Banham, ed., Encyclopedia of Interior Design, vol. 2 (1997): 930.

70. Ethel Smith, telephone conversation with author, 16 January 2000.

71. Varney, Draper Touch (1988); Smith and Tate, Interior Design (1986).

72. Aberbrombie, "Century of Design" (December 1999): 170.

73. "Ellen McCluskey Long Dies," obituary, New York Times (23 October 1984): section A, 30.

74. "Designer's Inside Story (28 August 1977): section 3, 1, 4; "Designer in the News" (October 1982): 32; Richard Dillon, former publicist for E. L. McCluskey Associates, telephone conversation with author, 6 January 2000.

75. Dolores Engle, telephone conversation with author, 26 January 2000.

76. Emily Malino Scheuer, telephone conversation with author, 6 January 2000. Malino would later concentrate on hospital design, heading divisions of architectural firms Perkins and Will and then HOK.

77. Russell, Women of Design (1992): passim.

78. Margo Grant Walsh, interview by author, 14 October 1999.

79. Ibid.

80. "100 Interior Design Giants" (January 1999): 74–94.

81. Seiler and Kirkham, "Vignelli" (2000/2001).

82. Even though many architects considered interiors of less importance than buildings, they frequently designed them, especially after the recessions of 1974 and 1981, when new construction ceased. See Russell, Women of Design (1992): 11.

83. Their efforts included traveling exhibitions of award-winning designs which were seen by more than a million visitors (Frances, "20 Years" [April 1951]: 131).

84. Gueft, "Past as Prologue" (1980): 6. Disagreement on nomenclature (decorator versus designer), on admission of candidates, and on a single slate for AID elections caused the schism. Shortly after the breakup, AID modified its name to American Institute of Interior Designers.

85. Foundation for Interior Design Education and Research, FIDER Accreditation Manual (1996): 2. There are presently 538 college-level interior design programs, of which 133 were FIDER accredited as of January 2000 (information provided by FIDER office, 17 January 2000).

86. "NCIDQ Information: Executive Summary," October 1998, NCIDQ Headquarters, Washington, D.C. NCIDQ members now also include Interior Designers of Canada (IDC), International Interior Design Association (IIDA), and Interior Design Educators Council (IDEC).

87. Ruth Lynford, telephone conversation with author, 20 January 2000. See also Russell, Women of Design (1992): 12.

88. Figures supplied by the government affairs office, ASID National Headquarters, Washington, D.C., telephone conversation with author, 17 January 2000.

89. "Now, clients feel they can do it themselves, if they want to take the time" (Paige Rense, interview by author, 26 October 1999).

90. Recognizing the importance of this exposure, Interior Design made Rense the recipient of a special Hall of Fame Award in 1985.

91. D'Arcy's contributions were recognized with awards from both ASID and Interior Design: Elsie de Wolfe Award (ASID, 1979), Designer of Distinction Award (ASID, 1981; she was the first woman recipient), and Hall of Fame Award (Interior Design, 1983). Interior Design research department memorandum to author, 9 September 1999; official biography ("Barbara D'Arcy White"), ca. 1985.

92. "Hall of Fame Members," list provided by Interior Design research department, December 1999.

93. Interiors (June 1999).

94. ASID membership office, telephone conversation with author, November 1999.

95. Beatrice Rivas Sanchez, "Women in Art and Design," Innovation (Winter 1995): 17.

96. Seiler and Kirkham, "Vignelli" (2000/2001).

97. Janet Schirn, telephone conversation with author, 17 July 1999.

98. Margo Grant Walsh, telephone conversation with author, 6 January 2000.

99. Yankelovich, Clancy, Shulman, Interior Design Universe Study (1995). ASID represents less than half of these, but its gender breakdown is similar: a 1988 AIA report noted that 72 percent of ASID members were women (Russell, Women of Design [1992]:12). As of January 2000 the figure is closer to 80 percent (ASID National Headquarters, Washington, D.C., telephone conversation with author, 17 January 2000).

100. This is partly because of increased numbers of women graduating as architects and partly the result of the expansion of the curriculum to include interior design. In 1992, Russell criticized interior design education as "no match for the intellectually layered postgraduate degrees in architecture," noting that interior design was still considered "unmasculine" by architects (Russell, introduction to Women of Design [1992]: 12). Partly to counter this, and to indicate their broader scope, many interior design programs have been renamed interior architecture or environmental design.

101. For Hayes and Sloane see chap. 4 in this volume. For Falkener see Kips Bay Decorator Showhouse program, 1978.

CHAPTER 14: Landscape

1. Beecher and Stowe, American Woman's Home (1869).

2. See Loudon, Gardening for Ladies (1840); Thaxter, Island Garden (1894); Johnson, Every Woman Her Own Flower Gardener (1889); and Van Rensselaer, Art Out-of-Doors (1893).

3. Shelton, Beautiful Gardens (1915).

4. See Balmori, McGuire, and

McPeck, *Beatrix Farrand's American Landscapes* (1985); and Tankard, *Gardens of Ellen Biddle Shipman* (1996).

5. For a general discussion of the history of women in the professions, see Chafe, *American Woman* (1972); and Solomon, *In the Company of Educated Women* (1985).

6. Solomon, *In the Company* (1985), p. 63.

7. Beverly Seaton, "Elizabeth Lawrence" in Mainiero, ed., *American Women Writers* (1980): 524–26.

8. See Leslie Rose Close, "Annette Hoyt Flanders," in Mackay, Baker, and Traynor, eds., *Long Island Country Houses* (1997): 169–70; and Yoch, *Landscaping the American Dream* (1989); and Rutz, "Michigan Women's Contribution to the Landscape," in *Landscapes and Gardens* (June 1987): 29–34.

9. Alternative schools included Pennsylvania School of Horticulture for Women, at Ambler; the Lowthorpe School in Groton, Massachusetts; and the Cambridge School of Architecture and Landscape Architecture for Women. See Frost and Sears, *Women in Architecture* (1928).

10. See Anderson, *Women, Design and the Cambridge School* (1980); Knight, "Examination of the History of the Lowthorpe School" (1986).

11. Knight, "Examination of the History of the Lowthorpe School" (1986).

12. When accredited by the American Society of Landscape Architects in the 1930s, Lowthorpe was one of only thirteen accredited schools of landscape architecture. Lowthorpe affiliated with Simmons College from 1928 to 1934, granting both bachelors' and masters' degrees, and became part of the Rhode Island School of Design in 1945 (see ibid.).

13. Then known as Olmsted Brothers and located in Brookline, Massachusetts. See Newton, *Design on the Land* (1971): 429–30, 475–77; and Beveridge et al., *Master List* (1987).

14. Tripp, "Lowthorpe School" (1912–13): 14–18.

15. Anderson, *Women, Design and the Cambridge School* (1980).

16. Ibid.

17. Quoted in ibid., p. 76.

18. Ibid., p. 98.

19. Helphand and Rottle, "Cultivating Charm"(Autumn 1988): 3, 26–33.

20. See Ethel Howes, introduction to *Women in Architecture* (1928); and Cole, *From Tipi to Skyscraper* (1973): 83.

21. See Leslie Rose Close, "A History of Women in Landscape Architecture," introduction to Tankard, *Gardens of Ellen Biddle Shipman* (1996): xvi.

22. Ibid.

23. Anderson, *Women, Design and the Cambridge School* (1980): 142.

24. In 1942, twenty-eight women enrolled as degree candidates at Harvard (ibid., p. 236).

25. Ibid., p. 151.

26. This is a frequently published remark. It is quoted, e.g., in Anderson, *Women, Design and the Cambridge School* (1980): 20.

27. Peterson, "Women Take the Lead in Landscape Art" (13 March 1938): D5.

28. Knight "Examination of the History of the Lowthorpe School" (1986): 146.

29. See Darwina Neal, introduction to Anderson, *Women, Design and the Cambridge School* (1980): xv.

30. "Marian Coffin Designed Estates" (obituary), *New York Times* (4 February 1957); and Jeanne Marie Teutonico, "Marian C. Coffin, 1876–1957," in MacKay, Baker, and Traynor, eds., *Long Island Country Houses* (1997): 116–18.

31. See Tankard, *Gardens of Ellen Biddle Shipman* (1996): 76.

32. See McGuire and Fern, eds., *Beatrix Jones Farrand* (1982): 106–8.

33. See Yoch, *Landscaping the American Dream* (1989): 20.

34. Brown, "Women in the Land: (1979).

34A. Cambridge students who went into practice together include: Mary Parsons Cunningham and Edith Cochran; Helene Bliss Warner and Priscilla Eddy. Lowthorpe students similarly include Jessie and Alice Bourquin, who were partners; and Grace Campbell Wing and Edith Henderson.

35. See, e.g., Browne, "Status of Women" (1993).

36. Newton, *Design on the Land* (1971).

37. See Close, *Portrait of An Era* (1980): unpaginated.

38. Forty-ninth Annual Exhibition (1934).

39. Newton, *Design on the Land* (1971): 445. Newton cites designers Eckbo, Halprin, and Church among those who successfully moved toward public work.

40. Ibid., p. 424.

41. See Cutler, *Public Landscape* (1985).

42. "Garden Design Contest" (July 1933): 25–26.

43. See Cutler, *Public Landscape* (1985).

44. Anderson, *Women, Design and the Cambridge School* (1980): 35, 105.

45. Cutler, *Public Landscape* (1985): 123–28.

46. See Cautley, "Planting at Radburn" (October 1930): 23–29; and Nell Walker, "Marjorie Sewell Cautley," in Birnbaum and Crowder, eds., *Pioneers* (1993): 23.

47. Peterson, "Women Take the Lead in Landscape Art" (13 March 1938): D5.

48. See ibid.; and Brown, ed., "Women in The Land" (1979): unpaginated.

49. As founder of the Women's National Farm and Garden Association and founder/vice president of the Garden Club of America, King promoted women in farm and garden vocations and emphasized their capacity for physical work, two vanguard positions for a woman of her time and class. She also featured the work of Elizabeth Leonard Strang and Isabella Pendelton in her book, *The Little Garden* (1921). See Beverly Seaton, "Louisa Yeoman King," in Mainiero, ed., *American Women Writers* (1980): 459–60.

50. See Close, *Portrait of an Era* (1980); and idem, "American Women and Gardens" (1981).

51. For Dean, see Eve F. W. Linn, "Ruth Bramley Dean," in Birnbaum and Fix, *Pioneers* (1995); for Coffin see Libby, *Marian Cruger Coffin* (1986); for Flanders see Leslie Rose Close, "Annette Hoyt Flanders," in Mackay, Baker, and Traynor, eds., *Long Island Country Houses* (1997): 169, 170.

52. Chafe, *American Woman* (1972).

53. New York University, "Landscape

Architecture" (1944).

54. From 1932 to 1937 there was a federal prohibition of more than one member of each family employed by the civil service. Chafe, *American Woman* (1972): 108.

55. Anderson, *Women, Design and the Cambridge School* (1980): 19.

56. Heekin, "Beyond the Rose Garden" (June 1985): 51.

57. Ryan, *Womanhood in America* (1975): 319.

58. Walker and Simo, *Invisible Gardens* (1994): 290.

59. McPeck, "Education's Role Examined" (1995): 42.

60. Miriam Easton Rutz, Council of Education in Landscape Architecture Education (1975)

61. See McPeck, "Education's Role Examined" (1995): 43.

62. Ibid

63. Krauss, "Sculpture in the Expanded Field" (Spring 1979).

64. In addition to the women discussed in this essay, others who have contributed to the expanding field include: Cecile Abish, Alice Aycock, Betty Beaumont, Harriet Feigenbaum, Jackie Ferrara, Nancy Holt, Mary Miss, Beverly Pepper, Jody Pinto, Michelle Stuart, and Elyn Zimmerman.

65. See Sherry Ortner, "Is Female to Male as Nature is to Culture?," in Rosaldo and Lamphere, eds., *Women, Culture and Society* (1974); and Lippard, *Overlay* (1983).

66. See Matilsky, "Mierle Laderman Ukeles: Reclaiming Waste," in *Fragile Ecologies* (1992): 74.

67. Johnson and Frankel, *Modern Landscape Architecture* (1991): 82.

68. Lippard, *Overlay* (1983): 45; and Matilsky, *Fragile Ecologies* (1992): 33.

69. For a collaboration with Newton Harrison, see Matilsky, *Fragile Ecologies* (1992): 66–73 ("The Lagoon Cycle: From the Book of the Seven Lagoons," 1972–82).

70. For a collaboration with Patricia Johanson, see ibid., pp. 60–64 ("Habitat Gardens," 1981–86).

71. Ibid., p. 51.

72. Meyer, *Martha Schwartz* (1997): 5.

73. See Treib, ed., *Modern Landscape Architecture* (1993): 264.

74. See *Diana Balmori* (1998).

75. For Lin, see Johnson and Frankel, *Modern Landscape Architecture* (1991): 218–25.

76. A 1992 survey of female ASLA members cited the glass ceiling for women in male-owned firms as the reason so many women opened their own firms. This leads to a confusing statistically high percentage of women as heads of their own firms, when, in reality, it is a default phenomenon. See Browne, "Status of Women in Landscape Architecture" (Fall 1994): 102–5.

77. See Fleming, "In the Public Interest" (May 1995): 47.

78. See Walker and Simo, *Invisible Gardens* (1994): 158–60.

79. See Moorhead, ed., *Landscape Architecture* (1997): 106–11.

80. In responding to a 1973 ASLA questionnaire regarding prevailing attitudes toward women in landscape architectural offices, men articulated the belief that the presence of women was disruptive to an (all male) office; and it was the enduring opinion among male respondents that men, especially in construction crews, would simply not take direction from a woman. See Darwina Neal, introduction to Anderson, *Women, Design and the Cambridge School* (1980): xv.

81. Browne, "Status of Women in Landscape Architecture" (1993): 11–46.

CHAPTER 15: *Ceramics*

Acknowledgments: For their advice and assistance in preparing this text I am grateful to Garth Clark, Janet Kardon, Lucia DeRespinis, Dorothy Hafner, Eva Zeisel, Ellen Denker, Ella Howard, Ron Labaco, Pat Kirkham, Lynne Walker, Joan Rothschild, Regina Lee Blaszczyk, Nancy Perkins, and Ellen Leopold.—CB

1. Address by C. W. Franzheim, president of the United States Potters' Association, quoted in "Report of meeting" (February 1900): 23.

2. A few writers and academics deal with the issue of gender in relation to ceramics. See Barbara Perry, "American Ceramics 1920–1950," in Perry, ed., *American Ceramics* (1989): 121–97; Ulysses Dietz, "Art Pottery 1880–1920," in ibid.; Brandimarte, "Somebody's Aunt" (1988); and Blaszczyk, *Imagining Consumers* (2000).

Blaszczyk deals with the interconnected themes of production, consumption, and gender in relation to the American ceramics and glass industries. Ramsey, *American Potters* (1939).

4. Ibid., p. 79.

5. Women's dominance in the decoration of pottery was evident in the art potteries at the end of the nineteenth century, as well as in industrial pottery production: "It is a startling fact that in virtually every case the role of men and women in American art pottery can be very clearly divided: women were china painters and decorators and men were chemists and potters." Ulysses Dietz, "Art Pottery" in Perry, *American Ceramics* (1989): 63. A division of labor based on gender was also described in the American pottery industry in which women were primarily decorators of pottery and men were mainly makers of pottery shapes. See *Crockery and Glass Journal* 52 (December 13, 1900). This was remarkably similar to that found in the English potteries of North Staffordshire, although not exactly the same. For example, men were wedgers and throwers with either girl or boy assistants, but men also worked as jigger operators (a job taken by women in England). Women primarily decorated, but men would put gold "lines" on wares (a practice sometimes found in England). Women were also burnishers. As we will see, women challenged these divisions during the twentieth century, in both studio pottery and in industrial ceramics.

6. See chap. 3 in this volume.

7. See, e.g., Poesch, *Newcomb Pottery* (1984).

8. See Perry, "Grueby Potteries" (1900); and Stratton, "Pewabic Records" (15 October 1946).

9. Horace J. Caulkins (1850–1918) designed and manufactured the Revelation kilns in many sizes to meet individual needs; they were economical, safe, and clean: "these kilns were highly endorsed by the leading potteries at that time, and by individual potters across the country" (Pear, *Pewabic Pottery* [1976]: 19).

10. Ibid.

11. After visiting the United States in 1893 to oversee the Royal Worcester Porcelain exhibit at the Columbian Exposition in Chicago, Binns moved permanently in 1897 to work for the Ceramic Art Company in Trenton

(after 1906 known as Lenox, Inc.). In 1898 the Trenton School of Technical Science and Art was founded with Binns as its head. In 1900 he was made professor of ceramics at Alfred University in the New York State School of Clay-working and Ceramics, a position he held until his retirement 1931. Only one other college, Ohio State, Columbus, had inaugurated a department of ceramic engineering to support its clay industry by this date. See Bernstein, *Art and Design* (1986), and Carney, *Charles Fergus Binns* (1998).

12. For further discussion see the extensive literature on art pottery and studio pottery in the United States, e.g., Perry, *American Ceramics* (1989).

13. Architectural tiles were developed by the pottery after Stratton had designed tiles for her new home, for which William Stratton, her husband since 1918, was architect.

14. See Marcia Yockey Manhart, "Charting a New Educational Vision," in Kardon, ed., *Craft in the Machine Age* (1995). Manhart describes how Savage developed a WPA/FAP program at the Savage Studio of Arts and Crafts in a basement apartment on West 143rd Street in Harlem. She writes, "Some fifteen hundred people of all ages participated in the Savage Studio's weaving, pottery-making, and quilting workshops" (p. 67).

15. Patton, *African-American Art* (1998): 145–48.

16. See Bassett and Naumann, *Cowan Pottery* (1997).

17. Perry, ed., *American Ceramics* (1989): 135.

18. Kardon, ed., *Craft in the Machine Age* (1995): 106, 107, 233; and Clark, *American Ceramics* (1987): 263.

19. Kardon, ed., *Craft in the Machine Age* (1995): 107.

20. Ibid., p. 67.

21. "Sense of Line" (February/March 1988): 24. Mary Scheier was director of two FAP galleries at Abingdon and Big Stone Gap, Virginia. She studied in New York (1928–30) at the Grand Central School of Art and at the Art Students League, and at the New York School of Fine Art, followed by a year of study in Paris. The Big Stone Gap and Abingdon art centers were the first FAP art centers in Virginia, and Scheier was an administrator and teacher of painting and modeling. See Komanecky, *American Potters* (1993): 32, 37–38.

22. Edwin Scheier worked for the Viennese ceramicist Vally Wieselthier; for further information on him see "Mary Goldsmith Scheier, 1910– / Edwin Scheier, 1910–" in *American Studio Ceramics* (1988): **61–71**; Komanecky, *American Potters* (1993); and "Sense of Line" (February/March 1988).

23. For further information on this aspect of Mary Scheier's life and work see "Mary Goldsmith Scheier, 1910– / Edwin Scheier, 1910–" in *American Studio Ceramics* (1988): 61–71; Komanecky, *American Potters* (1993).

24. Ceramics, particularly heat-resistant hard-paste porcelain, were used industrially as insulators in the electrical switch-gear industry. The research laboratory at the TVA was attempting to produce a high-quality American porcelain of indigenous materials. "Sense of Line" (February/March 1988): 28.

25. "Mary Goldsmith Scheier, 1910– / Edwin Scheier, 1910–" in *American Studio Ceramics* (1988): 61.

26. Komanecky, *American Potters* (1993): 43. They also drew on Edwin's previous experience as FAP Field Supervisor in Virginia when he had been required to check local clays for their suitability for modeling and potting to provide basic knowledge of the properties of different clays.

27. Sgraffito is a method of decoration whereby the ceramic body is covered with slip or glaze which is then scratched through to reveal the original, contrasting clay body underneath. Sprigging is a form of low relief decoration added to the surface of ware, made either by hand or in a mold and then stuck on.

28. "Mary Goldsmith Scheier, 1910– / Edwin Scheier, 1910–" in *American Studio Ceramics* (1988): 65.

29. For information on Jugtown see Kovel and Kovel, *Kovel's American Art Pottery* (1993): 72.

30. Ibid., p. 73.

31. For an interesting discussion of gender divisions within Pueblo pottery making see Moira Vincentelli, "Gender Identities in Pueblo Pottery," in Harrod, ed., *Obscure Objects of Desire* (1997): 239–46.

32. See Peterson, *Pottery by American Indian Women* (1997); and idem., *Living Tradition of Maria Martinez* (1977). See also chap. 3 in this volume.

33. Press and Weihs, *Marguerite* (1980).

34. See "An Open Letter to Bernard Leach from Marguerite Wildenhain" (May/June 1953): 43–44 (letter dated 23 March 1953). In a private letter from 1950 Wildenhain earlier thanks Leach for sending her two of his pots. Papers from the Don Wallace Collection, Cooper-Hewitt, National Design Museum, Smithsonian Institute.

35. Ibid., p. 43.

36. Wildenhain, letter to Bernard Leach, Autumn 1950, p. 2.

37. Wildenhain, *Pottery* (1959; see also idem., "Pottery," *Art & Architecture* 3 (1947): 29.

38. Wildenhain, letter to Bernard Leach, Autumn 1950, p. 2.

39. *Pâte-sur-pâte* is a method of decorating by painting a clay body with layers of slip of different colors to build up light and shade.

40. For further information on Grotell's work see "Maija Grotell, 1899–1973," in *American Studio Ceramics* (1988): 1–11; Clark, *Design in America* (1983); Schlanger and Takaezu, *Maija Grotell* (1996).

41. For an interesting discussion of this see Reed, *Not At Home* (1996).

42. Clark, *American Ceramics* (1987): 84.

43. Perry, *American Ceramics* (1989): 127.

44. Los Angeles County Museum of Art, *Clay Today* (1990): 33.

45. Bernstein, *Art and Design at Alfred* (1986): 52–77.

46. For further information see Smyth and Weightman, *International Ceramic Tableware* (1984).

47. See also *Goddess in the Details* (1994).

48. See Reiss, *Red Wing* (Chicago: Property, 1996).

49. Kogan, "Are Today's Design-Standards Slipping?" (December 1952): 96.

50. Reiss, *Red Wing* (1996): 106. Kogan was sent to Germany by her employer, Quaker Silver, Attleboro, Massachusetts, to take a course at the Pforzheim Kunstgewerbeschule and also to survey silver and glass factories in Germany, Czechoslovakia, and France.

51. For Zeisel's career see Eidelberg, *Eva Zeisel* (1984).

52. Whitmyer and Whitmyer, *Collector's Encyclopedia* (1989): 102.

53. Labaco, "Playful Search for Beauty" (2000–2001).

54. Eidelberg, *Eva Zeisel* (1984): 36.

55. Holly Finn, "By the Bay," *Financial Times* (12–13 February 2000): 11.

56. "Pottery and Dinnerware" (1949): 38.

57. See Dintenfass, "Old Hands" (September/October 1994): 5049–52.

58. Edith Heath, interviewed by CeCe Landoli, 1999.

59. See advertisements in the industry trade journals, particularly the *Crockery and Glass Journal*.

60. Lucia DeRespinis, interviewed by the author, New York, 7 October 1999. See also chap. 11 in this volume.

61. "Gertrud Amon Natzler, 1908–1971 / Otto Natzler, 1908–" in *American Studio Ceramics* (1988): 39. The division of labor between the Natzlers is described as "strict." See also Spurey, "Gertrud and Otto Natzler" (February 1995): 10.

62. Garth Clark, "Luster: The Art of Ceramic Light," in *Beatrice Wood* (1997): 2.

63. Report in *Crockery and Glass Journal* 126 (November 1940): 25. The ceramic national competition was established in memory of Adelaide Robineau in 1932.

64. Galbraith, *Affluent Society* (1958/1984).

65. For further information see Clark and Hughto, *Century of Ceramics* (1979), Clark, *American Ceramics* (1987); and Dormer, *New Ceramics: Trends* (1994).

66. Clark and Watson, *American Potters* (1986): 12.

67. Los Angeles County Museum of Art, *Clay Today* (1990): 89.

68. "Karen Karnes" (October/November 1998): 64; Clark, *American Ceramics* (1987): 274; Nordness, *Objects* (1970).

69. For Arbuckle, see *American Craft* (June/July 1992): 55; for Shankin and Sikora see Ullrich, "Vessels That Pour" (August/September 1998): 64–69.

70. Ullrich, "Vessels That Pour" (1998): 65.

71. See Garth Clark, "Luster: The Art of Ceramic Light," in *Beatrice Wood* (1997): 1–4; Moro, "Beatrice Wood" (Summer 1998): 56–86; Wood, *I Shock Myself* (1985).

72. Garth Clark, "Luster: The Art of Ceramic Light," in *Beatrice Wood* (1997): p2.

73. A particularly influential book in the context of this debate was Parker and Pollock, *Old Mistresses* (1981): especially chap. 2.

74. Dormer, *New Ceramics* (1994): 127.

75. Ibid., p. 43.

76. Johnson, *Joyce Kozloff* (1986): 1.

77. For more discussion of the Pattern and Decoration movement see Chadwick, *Women, Art and Society* (1990): 332–34.

78. Johnson, *Joyce Kozloff* (1986): 8.

79. Clark, *American Ceramics* (1987): 209.

80. Dormer, *New Ceramics* (1994): 18.

81. Los Angeles County Museum of Art, *Clay Today* (1990): 164–65.

82. Clark, *Anne Krauss* (1998).

83. Dorothy Hafner, interviewed by Cheryl Buckley and Pat Kirkham, 14 October 1999.

84. For further information see Wechsler, "New American Ceramics" (May/June 1985): 22–25; Margolies, "Crafts Cross Over" (May/June 1987): 56–59; Perreault, "Functional Glamour" (1991): 36–40.

85. "Rosenthal Commission" (October 1984): 61–62.

CHAPTER 16: *Graphic Design*

Acknowledgments: To Mary Jane Lupton, a great writer, teacher, mother, grandmother, and feminist.—EL

1. VanderLans, Licko, and Gray, *Emigre* (1994). See also Licko and VanderLans, "The New Primitives," *I.D.* (1988): 60.

2. Thomson, "Alms for Oblivion" (1994).

3. Morris, *Ideal Book* (1982).

4. Thomson, "Alms for Oblivion" (1994): 38, 45.

5. Finlay, "A Millennium in Bookmaking: The Book Arts in Boston," in Meyer, ed., *Inspiring Reform: Boston's Arts and Crafts Movement* (1997): 116–131. See also Kaplan, *"Art that is Life"* (1987/1998).

6. Smith, "Sarah de St. Prix Wyman Whitman" (1999): 46–64. I am grateful to Pat Kirkham for this reference.

7. Wild, "Europeans in America," in Friedman, ed., *Graphic Design in America* (1989): 153–69.

8. Elaine Lustig Cohen, interviewed by Ellen Lupton, 1994. See also Lupton, "Archive: Elaine Lustig Cohen" (1995): 8–9. Cohen was the subject of a one-person exhibition at Cooper-Hewitt, National Design Museum, Smithsonian Institution in 1995.

9. On Louise Fili and Carin Goldberg, see Meggs, "The Women Who Saved New York!" (1989). 61–71. See also Lupton, *Mixing Messages: Graphic Design in Contemporary Culture* (1996): 116–19.

10. Makela and Lupton, "Underground Matriarchy" (1994): 42–4. See also Lupton, *Mixing Messages* (1996): 118–19.

11. Scotford, *Cipe Pineles* (1999).

12. For advertisments created by Estelle Ellis and Helen Federico, see Lupton, *Mechanical Brides* (1993): 54. In the advertising field, women may have found easier access to fashion promotion than to other areas. Among the women featured in the 1935 Annual of the Art Directors Club of New York, most were associated with department stores and cosmetics companies. See *Fourteenth Annual of Advertising Art* (1935).

13. Friedl, Ott, and Stein, *Typography* (1998): 217–18.

14. Brady, "Inside the Growing Empire of Martha Inc.," (2000): 63–68. See also Albrecht, Lupton, and Holt, *Design Culture Now* (2000): 162–63.

15. Paula Hays Harper, "Votes for Women?" in Millon and Nochlin, eds., *Art and Architecture in the Service of Politics* (1978): 150–61.

16. For an extensively illustrated, international survey of feminist graphics, see McQuiston, *Suffragettes to She-Devils* (1997).

17. De Bretteville, "Feminist Design" (1983): 98–103. For an account of women's representation in the design fields and their assessment of their roles, see Dreyfus, "Women's Lib and Women Designers" (1970): 29–35.

18. On the Women's Action Coalition, see McQuiston, *Suffragettes to She-Devils* (1997): 158–59. See also Lupton, *Mixing Messages* (1996): 104.

19. Klein, "Designing the L.A. Olympics" (1984): 28–43; and Heller, "Mickey in the Clover" (1992): 53–59.

20. Lupton, *Mixing Messages* (1996): 92–93, 172.

21. Rand, "Confusion and Chaos" (1992): 1-2. See also Brumfield, "The Changing of the Guard" (1991): 30–35.

22. McCoy, "American Graphic Design" (1991): 4–22. See also Aldersey-Williams et al., *Cranbrook Design* (1991); and Lupton, "Academy of Deconstructed Design" (1991): 44–52.

23. Vienne, "Designing from Skin to Screen: Rebeca Méndez" (1996): 46–57.

24. See Friedman, ed., *Graphic Design in America* (1989).

25. On film title design, see Hall, "Title Wave" (1999): 60–64 For title designs by Elaine Bass and Saul Bass, see Kirkham, "Looking for the Simple Idea" (1994): 16–20.

26. Makela and Lupton, "Underground Matriarchy" (1994). See also Owen, "Design in the Age of Digital Reproduction" (1994): 26–41.

27. *Some Examples of the Work of American Designers* (1918): unpaginated. I am grateful to Pat Kirkham for this reference.

Bibliography

Abbott, James A., and Elaine M. Rice. *Designing Camelot: The Kennedy White HFouse Restoration.* New York: Van Nostrand Reinhold, 1998.

Abel-Vidor, Suzanne, Dot Brovarney, and Susan Billy. *Remember Your Relations, The Elsie Allen Baskets, Family & Friends.* Berkeley: Heyday Books, 1996.

Abelson, Reed. "A Push from the Top Shatters a Glass Ceiling." *New York Times,* 22 August 1999, A-1.

Abercrombie, Stanley. "A Century of Design." *Interior Design* (December 1999): 170.

Acker, Ally. *Reel Women: Pioneers of the Cinema, 1896 to the Present.* New York: Continuum, 1991.

Across the Grain: North American Wood Turning Since 1900. New Haven: Yale University Art Gallery, 2001.

"The A.D. 100," *Architectural Digest* 57 (January 2000): 66.

Adair, John. *The Navajo and Pueblo Silversmiths.* Norman, Okla.: University of Oklahoma Press, 1944).

Addams, Jane. "Why Women Should Vote." *The Ladies Home Journal* 27 (January 1910): 22.

Affirmation and Rediscovery: Objects from the Society of Arts and Crafts Boston. Boston: JMW Gallery, 1997.

"A.I.D. Board of Governors Hold Quarterly Meeting." *The Decorators Digest* (January 1934): 25.

Albers, Anni. *On Designing.* New Haven: Pellango Press, 1959.

———. *On Weaving.* Middletown, Conn.: Wesleyan University Press, 1965.

Albrecht, Donald, *Designing Dreams: Modern Architecture in the Movies.* New York: Harper and Row, 1986.

Albrecht, Donald, Ellen Lupton, and Steven Holt. *Design Culture Now: National Design Triennial.* New York: Princeton Architectural Press and Cooper-Hewitt, National Design Museum, Smithsonian Institution, 2000.

Alcoff, Linda. "Cultural Feminism versus Post-structuralism: The Identity Crisis in Feminist Theory." *Signs* 13 (1988): 405–36.

Aldersey-Williams, Hugh, et al. *Cranbrook Design: The New Discourse.* New York: Rizzoli, 1991.

Alexander, Lois K. *Blacks in the History of Fashion.*

New York: Harlem Institute of Fashion, 1982.

Alvin Lustig, "Modern Printed Fabrics", *American Fabrics* no.20 (winter 1951–52), 61–73.

"The American Look," *Time* (2 May 1955): 85.

"American Metalsmithing in the 1940's and 50's." *American Craft* 43 (February/March 1983) 1: 86–87.

American Quilt Renaissance: Three Women who Influenced Quiltmaking in the Early 20th Century. Exhib. cat. Tokyo: Kokusai Art, 1997.

American Studio Ceramics, 1920–1950. Exhib. cat. Minneapolis: University Art Museum, University of Minnesota, 1988.

Amott, Teresa, and Julie Matthaei. *Race, Gender, and Work.* Boston: South End Press, 1996.

Andersen, Kristi. *After Suffrage.* Chicago: University of Chicago, 1996.

Anderson, Dorothy May. *Women, Design and the Cambridge School.* West Lafayette, Indiana: PDA Publishers, 1980.

Anderson, Harry V. "Decorators of Tomorrow." *Decorators Digest* (April 1935): 27.

———. "Contemporary American Designers." *Decorators Digest* (December 1935): 87.

———. "Interior Designers." *Decorators Digest: Interior Design and Decoration* (November 1936): 27

———. "Transition." *Decorators Digest* (November 1937): 35

Anderson, Karen. *Changing Woman: A History of Racial Ethnic Women in Modern America.* New York: Oxford University Press, 1996.

Anne Swainson, Master Designer: Montgomery Ward's Bureau of Design, 1931–1955." Exhib. cat. Chicago: Chicago Atheneum, 1994.

Anscombe, Isabelle. *A Women's Touch: Women in Design from 1860 to the Present Day.* London: Virago, 1984.

Anthony, Katherine S. *Feminism in Germany and Scandinavia.* New York: Henry Holt, 1915.

"Application of the Fine Arts in Apparel Textiles." *American Fabrics* 22 (Summer 1952): 92–94.

Art Institute of Chicago. *Annual Exhibition of Original Designs for Decorations and Examples of Art Crafts Having Distinct Artistic Merit.* Chicago: Art Institute of Chicago, 1906–11.

"Art Moderne Rugs to the Fore . . . Prominent Artists Design Rugs." *Good Furniture Magazine* (September, 1928): 142

Arts and Crafts Exhibition. Cleveland: Cleveland Decorative Arts Club, 1908.

Arvidson, Linda [Mrs. D. W. Griffith]. *When the Movies Were Young.* New York: E. P. Dutton, 1925. Reprint, New York: Dover, 1969.

"As the Modernist Sees the Hudson." *House & Garden* (September 1934): 87.

Ash, Juliet, and Elizabeth Wilson, eds. *Chic Thrills: A Fashion Reader.* London: Pandora, 1992.

"At the Washington National Airport." *Interior Design and Decoration* (November 1941): 53–55.

Attfield, Judy, and Pat Kirkham, eds.. *A View form the Interior: Feminism, Women, and Design.* London: Women's Press, 1989.

Austin, Carole. *June Schwarcz: Forty Years Forty Pieces.* Exhib. cat. San Francisco: San Francisco Craft and Folk Art Museum, 1998.

Austin, Mary Leman, ed. *The Twentieth Century's Best American Quilts.* Golden, Colo.: Primedia Special Interest Publications, 1999.

Axelrod, Alan, ed. *The Colonial Revival in America.* New York: W. W. Norton, 1985.

Babbitt, Marcy. "As A Woman Sees Design: An Interview with Belle Kogan." *Modern Plastics* (December 1935): 14.

Babcock, Barbara, and Marta Weigle, eds. *The Great Southwest of the Fred Harvey Company and the Santa Fe Railway.* Exhib. cat. Phoenix: Heard Museum, 1996.

Balio, Tino. *Hollywood as a Modern Business Enterprise, 1930–1939.* Vol. 5 of History of the American Cinema, edited by Charles Harpole. New York: Scribner, 1990.

Ball, Joanne Dubbs. *Costume Jewelers: The Golden Age of Design.* 2d ed. Atglen, Pa.: Schiffer, 1997.

Ballard, Bettina. *In My Fashion.* New York: David McKay, 1962.

Balmori, Diana, Diane Kostial McGuire, and Eleanor McPeck, *Beatrix Farrand's American Landscapes, Her Gardens and Campuses.* New York: Sagapress/Wave Hill, 1985.

Balser, Diane. *Sisterhood and Solidarity.* Boston: South End Press, 1987.

Banham, Joanna, ed. *Encyclopedia of Interior Design.* London and Chicago: Fitzroy Dearborn, 1997.

Barron, Stephanie, ed. *Exiles and Emigrés: The*

Flight of European Artists from Hitler. Exhib. cat. Los Angeles: Los Angeles County Museum of Art and Harry N. Abrams, 1997.

Barthes, Roland. *Erté.* Translated by William Weaver. Palma: Franco Maria Ricci, 1972.

Bassett, Mark, and Victoria Naumann. *Cowan Pottery and The Cleveland School.* Atglen, Pa.: Schiffer Publishing, 1997.

Bataille, Gretchen M., ed. *Native American Women, A Biographical Dictionary.* New York: Garland Publishing, 1993.

Bates, Craig D., and Martha J. Lee. *Tradition and Innovation: A Basket History of the Indians of the Yosemite—Mono Lake Area.* Yosemite: Yosemite Association, 1990.

Battersby, Christine. *Gender and Genius: Towards a Feminist Aesthetics.* London: The Women's Press, 1989.

Baxandall, Rosalyn, and Linda Gordon, eds. *America's Working Women: A Documentary History.* New York: W. W. Norton, 1995.

Beads: Their Use By Upper Great Lakes Indians. Grand Rapids: Grand Rapids Public Museum and the Cranbrook Academy of Art Museum, 1977.

Bearden, Romare, and H. A. Henderson. *A History of African-American Art from 1792 to the Present.* New York: Pantheon, 1993.

Beatrice Wood. Exhib. cat. New York: American Craft Museum, 1997.

Bedinger, Margery. *Indian Silver: Navajo and Pueblo Jewelers.* Albuquerque: University of New Mexico Press, 1973.

Beecher, Catherine, and Harriet Beecher Stowe. *The American Woman's Home* New York: J. B. Ford and Company, 1869.

Beels, Jesseca H. "'I hate pretty work': Madeline Yale Wynne and the American Craft Revival." Master's thesis, University of Delaware, 1995.

Belle Kogan Design, 1930–1972: Retrospective Exhibition. Exhib. cat. Israel, The Center for Technological Education, [1972].

Belz, Carl. *Todd McKie and Judy McKie.* Exhib. cat. Waltham, Mass.: Rose Art Museum, 1990.

Benberry, Cuesta.. *Always There: The African American Presence in American Quilts.* Louisville, Ky.: Kentucky Quilt Project, 1992.

Beneria, Lourdes, and Catharine R. Stimpson, eds. *Women, Households, and the Economy.* New Brunswick: Rutgers University Press, 1987.

Benesh, Caroline L. E. "Mary Lee Hu." *Ornament* 6 (March 1983): 2–5.

Benhabib, Seyla. "Feminism and the Queston of Postmodernism." In *The Polity Reader in Gender Studies.* Cambridge: Polity Press, 1994.

Benjamin, Tritobia Hayes. *The Life and Art of Loïs Mailou Jones.* San Francisco: Pomegranate, 1994.

Berch, Bettina. *Radical by Design: The Life and Work of Elizabeth Hawes.* New York: E. P. Dutton, 1988.

Berkeley, Ellen Perry, and Matilda McQuaid, eds. *Architecture: A Place for Women.* Washington, D.C.: Smithsonian Institution Press, 1989.

Bernstein, Melvin H. *Art and Design at Alfred: A Chronicle of a Ceramics College.* Philadelphia: The Art Alliance Press / London and Toronto: Associated University Press, 1986.

Berry, Mary Frances. *The Politics of Parenthood: Child Care, Women's Rights, and the Myth of the Good Mother.* New York: Viking Press, 1993.

Beveridge, Charles E., et al. *The Master List of Design Projects of the Olmsted Firm: 1857–1950.* Boston: National Association for Olmsted Parks, 1987.

Bibby, Deirdre L. *Augusta Savage and the Art Schools of Harlem.* Exhib. cat. New York: The New York Public Library, 1988.

Bingham, Lisa A. "The Val-Kill Industries: An Analysis of their Founding, Context, and Dissolution." Master's thesis, Bard Graduate Center for Studies in the Decorative Arts, 2000.

Binns, Charles. "Education in Clay." *Craftsman* 4 (June 1903): 160.

Birnbaum, Charles, and Lisa E. Crowder. *Pioneers of American Landscape Design.* Vol. 1. Washington, D. C.: National Park Service, 1993.

Birnbaum, Charles A., and Julie K. Fix. *Pioneers of American Landscape Design.* Vol. 2. Washington, D.C.: National Park Service, 1995.

"Black Artists in Graphic Communication: A Taste from the Vast Reservoir of Underused Talent." *Contact* 2 (October 1970): 18–19

Blackard, David. *Patchwork and Palmettos: Seminole/Miccosukee Folk Art Since 1820.* Fort Lauderdale: Fort Lauderdale Historical Society, 1990.

Blackwelder, Julia Kirk. *Now Hiring: The Feminization of Work in the United States, 1900–1995.* College Station: Texas A & M

Press, 1997.

Blair, Mary Ellen, and Laurence Blair. *The Legacy of a Master Potter Nampeyo and Her Descendants.* Tucson: Treasure Chest Books, 1999).

Blake, Peter. "Eszter." *Interior Design* (February 1995): 29–30.

Blaszczyk, Regina Lee. *Imagining Consumers: Designs and Innovation from Wedgwood to Corning.* Baltimore and London: Johns Hopkins Press, 2000.

Blausen, Whitney. "Textiles Designed by Ruth Reeves." Master's thesis, State University of New York, Fashion Institute of Technology, 1993

————. "Ruth Reeves: A Pioneer in American Design." *Surface Design Journal* (Winter 1995): 5–6, 32.

Blee, Kathleen M. *Women of the Klan.* Berkeley: University of California Press, 1991.

Blum, Dilys. "Painting by the Yard: American Artist Designed Textiles, 1947–57." *Disentangling Textiles: Interdisciplinary Techniques in the Study of Designed Objects.* London: Middlesex University Press, 2001.

Blumer, Thomas J. "Eastern Woodland Indians Continue Pottery Tradition." *The Indian Trader* (February 1979): 16.

Boardman, Michelle. *All that Jazz: Printed Fashion Silks of the '20s and '30s.* Allentown, Pa.: Allentown Art Museum, 1998.

Booth, Mark Hayward. *E. McKnight Kauffer and his Public.* London: Gordon Fraser, 1979.

Boris, Eileen. *Art and Labor: Ruskin, Morris, and the Craftsman Ideal in America.* Philadelphia: Temple University Press, 1986.

Bowen, Constance L., and Thomas T. Solley. *A Tribute to Alma Eikerman Master Craftsman: A Retrospective Exhibition of the Jewelry and Metalsmithing of Alm Eikerman and Forty Indiana University Alumni Metal-Artists.* Bloomingdale, Ind.: Indiana University Art Museum, 1985.

Bowles, Juliette H. "Loïs Mailou Jones: Portrait of an Artist." *New Directions* (Howard University) 4 (3 July 1977): 4–23.

Bowman, Leslie Greene. *American Arts and Crafts: Virtue in Design.* Boston: Bulfinch Press, 1990.

Bowser, Eileen. *The Transformation of Cinema, 1907–1915.* Vol. 2 of History of the American Cinema, edited by Charles Harpole. New York: Scribner, 1990.

Boxer, Marilyn Jacoby. *When Women Ask The*

Questions: Creating Women's Studies in America. Baltimore: Johns Hopkins University Press, 1998.

Boydell, Christine. *The Architect of Floors: Modernism, Art and Marion Dorn Designs.* Coggeshall, Essex. Eng.: Schoeser, 1996.

Brady, Diane. "Inside the Growing Empire of Martha Inc." *Business Week* (17 January 2000): 63–68.

Brandimarte, Cynthia. "Somebody's Aunt and Nobody's Mother: The American China Painter and Her Work, 1870–1920." *Winterthur Portfolio* 23 (1988).

Bredbenner, Candice Lewis. *A Nationality of Her Own: Women, Marriage, and the Law of Citizenship.* Berkeley: University of California Press, 1998.

Brigham, Louise. *Box Furniture: How to Make a Hundred Useful Objects for the Home.* New York: The Century Company, 1909 and 1919.

Broude, Norma, and Mary D. Garrard, eds. *Feminism and Art History: Questioning the Litany.* New York: Harper and Row, 1982.

———. *The Power of Feminist Art: The American Movement of the 1970s, History and Impact.* New York: Harry N. Abrams, 1995.

Brouwer, Alexandra, and Thomas Lee Wright. *Working in Hollywood.* New York: Crown, 1990.

Brown, Ashley. "Ilonka Karasz (1896–1981), Twentieth-Century American Designer." Master's thesis, Cooper-Hewitt, National Design Museum and Parsons School of Design, 1998.

———. *Backgrounds for Modern Living: Furniture, Textile, and Fashion Designs by Pipsan Saarinen Swanson.* Bloomfield Hills, Mich.: Cranbrook Art Museum, 1999.

———. "Ilonka Karasz: Rediscovering a Modernist Pioneer." *Studies in the Decorative Arts* 8, no. 1 (Fall–Winter 2000–2001).

Brown, Catherine R., ed. "Women in the Land: A Biographical Survey of Women Who Have Contributed to the Development of Landscape Architecture in the United States." Morgan State University, Baltimore, Maryland, 1979.

Brown, Erica. *Sixty Years of American Design: The World of McMillen.* New York: Viking Press, 1982.

Browne, Charlene. "The Status of Women in Landscape Architecture: Findings, Perspectives and Strategies for the Future." *Landscape Journal* 13, no. 2 (Fall 1994): 102–5.

———. "The Status of Women in Landscape Architecture: Results from a National Survey of Women in American Society of Landscape Architects." *Women in Landscape Architecture, Open Committee of the Women in Landscape Architecture Newsletter* 1

(Winter/Spring, 1993): 11–46.

Brumfield, Paul. "The Changing of the Guard at Yale: Sheila Levrant de Bretteville." *Graphis* 47 (March/April 1991): 30–35.

Brynner, Irena. *Jewelry as an Art Form.* New York: Van Nostrand Reinhold, 1979.

Buckley, Cheryl. "Women Designers in the English Pottery Industry, 1919–1939." *Woman's Art Journal* (Fall 1984/Winter 1985): 11–15.

———. "Made in Patriarchy: Toward a Feminist Analysis of Women and Design." *Design Issues* 3 (1986): 3–14.

———. "'The Noblesse of the Banks': Craft Hierarchies, Gender Divisions, and the Roles of Women Paintresses and Designers in the British Pottery Industry, 1890–1939." *Journal of Design History* 2 (December 1989/January 1990): 257–73.

———. *Potters and Paintresses: Women Designers in the Pottery Industry 1870–1955.* London: The Women's Press, 1990.

———. "On the Margins: Theorizing the History and Significance of Making and Designing Clothes at Home." *Journal of Design History* 11, no. 2 (November 1998).

Burkhauser, Jude, ed. *Glasgow Girls: Women in Art and Design, 1880–1920.* Edinburgh: Canongate, 1990.

Burns, Louis. *Symbolic and Decorative Art of the Osage People.* Fallbrook, California: Ciga Press, 1994.

Bussel, Abby. "Women in Architecture: Leveling the Playing Field." *Progressive Architecture* (November 1995): 45–49, 86.

Buttons to Biotech: US Patenting by Women, 1977 to 1996: 1996 Update Report. Washington, D.C.: USPTO, 1998.

The C. G. Wallace Collection of American Indian Art. Auction cat., 14–16 November 1975. Phoenix and New York: Sotheby–Parke Bernet, 1975.

C. L. "Vera: Textile Designer for a Sophisticated Mass Market." *American Fabrics,* no. 63 (Winter/Spring 1964): 87–90.

California Design. Vols. 8–11. Pasadena: Pasadena Art Museum, 1962–71.

Callen, Anthea. *Angel in the Studio: Women in the Arts and Crafts Movement 1870–1914.* London: Astragal Books, 1979.

———. *Women Artists of the Arts and Crafts Movement, 1870–1914.* New York: Pantheon, 1979.

Callinicos, Alex. *Against Postmodernism: A Marxist Critique.* London: Polity Press, 1989.

Cameron, Dan, ed. *Dancing at the Louvre: Faith Ringgold's French Collection and Other Story Quilts.* New York: New Museum of

Contemporary Art, 1998.

Carlano, M., and N. J. Shilliam, eds. *Early Modern Textiles.* Boston: Museum of Fine Arts, 1995.

Carlton-Smith, Kimn. "A New Deal for Women: Women Artists and the Federal Arts Project, 1935–1939." Ph.D. diss., Rutgers University, 1990.

Carney, Margaret. *Charles Fergus Binns: The Father of American Studio Ceramics.* New York: Hudson Hills Press, 1998.

Carpenter, Edward. "Statement: The Designing Women." *I.D.* (June 1964): 72.

Carter, Michael J., and Susan Boslego Carter. "Women's Recent Progress in the Professions or, Women Get a Ticket to Ride After the Gravy Train Has Left the Station." *Feminist Studies* 7 (Fall 1981), 477–504.

Cautley, Marjorie Sewell. "Planting at Radburn." *Landscape Architecture Magazine* (October 1930): 23–29.

Cera, Deanna Farneti. *Jewels of Fantasy: Costume Jewelry of the 20th Century.* New York: Harry N. Abrams, 1992.

———. *The Jewels of Miriam Haskell.* Woodbridge, Suffolk, Eng.: Antique Collectors' Club, 1997.

Chadwick, Whitney. *Women, Art, and Society.* 1990. Rev. ed. New York: Thames and Hudson, 1996.

Chadwick, Whitney, and Isabelle de Courtivron. *Significant Others: Creativity and Intimate Partnership.* London: Thames and Hudson, 1993.

Chafe, William H. *The American Woman: Her Changing Social, Political and Economic Roles.* London: Oxford University Press, 1972.

Chalmers, F. Graeme. *Women in the Nineteenth-Century Art World: Schools of Art and Design for Women in London and Philadelphia.* Westport, Conn.: Greenwood Press, 1998.

Chapman-Huston, Desmond. *The Lamp of Memory.* London, 1949.

"Charlotte S. Kohler" [obituary]. *Kohler of Kohler News* (March 1947): n.p. In Kohler Corporate Archives, Kohler, Wisc.

Charron, Shirley. *Modern Pewter Design and Techniques.* New York: Van Nostrand Reinhold, 1973.

Chateauvert, Melinda. *Marching Together: Women of the Brotherhood of Sleeping Car Porters.* Urbana: University of Illinois Press, 1998.

Chauncey, George. *Gay New York.* New York: Basic Books, 1994.

Cheney, Sheldon, and Martha Cheney. *Art and the Machine: An Account of Industrial Design in 20th-century America.* 1936. Reprint. New York: Acanthus Press, 1992.

Chicago, Judy. *Embroidering our Heritage: The Dinner Party Needlework.* Garden City, N.Y.:

Anchor Books, 1980.

Chickering, Elenita C., and Sarah Morgan Ross. *Arthur J. Stone, 1857–1938: Designer and Silversmith*. Boston: Boston Athenaeum, 1994.

Chierichetti, David. *Hollywood Costume Design*. New York: Harmony Books, 1976.

Cirillo, Dexter. "Back to the Past: Tradition and Change in Contemporary Pueblo Jewelry." *American Indian Artist* 13 (Spring 1988): 48.

——. *Southwestern Indian Jewelry*. New York: Abbeville Press, 1992.

Claire Falkenstein, Chance and Choice. Exhib. cat. Los Angeles: Jack Rutberg Fine Arts, 1989.

Clark, Clifford E., Jr. *The American Family Home, 1880–1960*. Chapel Hill and London: The University of North Carolina Press, 1986.

Clark, Garth. *American Ceramics, 1876 to the present*. London: Booth-Clibborn Editions, 1987.

——. *Anne Krauss: A Survey*. New York and Los Angeles: Garth Clark Gallery, 1998.

Clark, Garth, and Margie Hughto. *A Century of Ceramics*. New York: E. P. Dutton, 1979.

Clark, Garth, and Oliver Watson. *American Potters Today*. New York: Abbeville, 1986.

Clark, Robert Judson. *The Arts and Crafts Movement in America, 1876–1916*, Princeton: Princeton University Press, 1972.

——, ed. *Design in America: The Cranbrook Vision, 1925–1950*. New York: Harry N. Abrams, 1983.

Clarke, Isaac Edwards. *Art and Industry: Education in the Industrial and Fine Arts in the United States*. 4 vols. Washington, D.C.: U.S. Department of the Interior, Bureau of Education, 1885–98.

Clegg, Sue, and Wendy Mayfield. "Gendered by Design: How Women's Place in Design is Still Defined by Gender." *Design Issues* 15 (Autumn 1999): 4 and 6–7.

Cliff, Ursula. "Gallery 4, Florence Knoll." *I.D.* (April 1961): 66–71.

Close, Leslie Rose. *Portrait of an Era in Landscape Architecture: The Photographs of Mattie Edwards Hewitt*. Exhib. cat. New York: Wave Hill, 1980.

——. "American Women and Gardens, 1915–1945: A Brief History." Paper presented at the conference, Women and Gardens, 1915–1945, Wave Hill, New York 1981.

Cobble, Dorothy Sue. "'A Spontaneous Loss of Enthusiasm': Workplace Feminism and the Transformation of Women's Service Jobs in the 1970s." *International Labor and Working-Class History* 56 (Fall 1999): 27, 29.

Cole, Doris. *From Tipi to Skyscraper: A History of Women in Architecture*. Boston: I press, 1973.

Colomina, Beatriz, ed. *Sexuality and Space*. Princeton Papers on Architecture. New York: Princeton University Press, 1992.

Commonwealth of Massachusetts Board of Education. *Massachusetts Normal Art School Circular and Catalogue for the Forty-Third Year, 1915–1916*. Boston: Wright and Potter Printing Company, 1915.

——. *Massachusetts Normal Art School Fiftieth Annual Catalog, 1923–1924*. Boston: Commonwealth of Massachusetts Commission on Administration and Finance, 1923.

Conforti, Michael. ed. *Art and Life on the Upper Mississippi, 1890–1915*. Newark: University of Delaware Press, 1994.

Conn, Richard. *Native American Art in the Denver Art Museum*. Denver: Denver Art Museum, 1979.

Conrads, Ulrich, ed. *Programmes and Manifestoes on 20th-Century Architecture* London: Lund Humphries, 1970.

Contemporary Industrial and Handwrought Silver. Exhib. cat. Brooklyn: The Brooklyn Museum, 1937.

Cooke, Edward S., Jr. *New American Furniture: The Second Generation of Studio Furnituremakers*. Boston: Museum of Fine Arts, 1989.

——. "Coming of Age in Boston." *Art New England* 11, no. 1 (December 1989/January 1990): 10–13, 49.

——. *Wendy Maruyama: Form and Function*. Boston: Gallery NAGA, 1991.

Coontz, Stephanie. *The Way We Never Were: American Families and the Nostalgia Trap*. New York: Basic Books, 1992.

——. *The Way We Really Are: Coming to Terms with America's Changing Families*. New York: Basic Books, 1997.

Costello, Cynthia B., et al., eds. *The American Woman, 1999–2000*. New York: W. W. Norton, 1998.

Costume Designers Guild Directory of Members. Sherman Oaks, Calif.: Costume Designers Guild, 1999.

"Costume Jewelry," *Fortune* 34 (December 1946): 144.

Cott, Nancy. *The Grounding of Modern Feminism*. New Haven: Yale University Press, 1987.

Cowan, Ruth Schwartz. "The 'Industrial Revolution' in the Home: Household Technology and Social Change in the Twentieth Century." *Technology and Culture* 17 (January 1976): 1–23.

——. *More Work for Mother: The Ironies of Household Technology from the Open Hearth to the Microwave*. New York: Basic Books, 1983.

Craik, Jennifer. *The Face of Fashion: Cultural Studies in Fashion*. London: Routledge, 1994.

Crawford, Alan. *C. R. Ashbee: Architect, Designer and Romantic Socialist*. New Haven and

London: Yale University Press, 1985.

Crawford, M. D. C. *The Heritage of Cotton*. New York: Grosset and Dunlap, 1924.

Creating Textiles: Makers, Methods, Markets. Proceedings of the Sixth Biennial Symposium of the Textile Society of America. Earleville, MD: Textile Society of America, 1998.

Cromley, Elizabeth. "Masculine/Indian." *Winterthur Portfolio* 31 (Winter 1996): 265–80.

"Crossing the Bar: à la Mode." *The Decorators Digest* (January 1934): 27.

Cutler, Phoebe. *The Public Landscape of the New Deal*. New Haven: Yale University Press, 1985.

D'Emilio, John, and Estelle B. Freedman. *Intimate Matters: A History of Sexuality in America*. Chicago: University of Chicago Press, 1997.

Darling, Sharon S. *Chicago Metalsmiths*. Chicago: Chicago Historical Society, 1977.

——. *Chicago Ceramics and Glass*. Chicago: Chicago Historical Society, 1979.

Davies, Karen. *At Home in Manhattan: Modern Decorative Arts, 1925 to the Depression*. New Haven: Yale University Art Gallery, 1983.

Davis, Mary L., and Greta Pack. *Mexican Jewelry*. Austin, Tx.: University of Texas Press, 1963.

Day, Lewis F. "The Woman's Part in Interior Decoration." *The Magazine of Art* (1881). Reprinted in *The Late Victorians: Art, Design and Society, 1852–1910: A Documentary History of Taste in Britain*. London and New York: Longman, 1986.

de Bretteville, Sheila. "Feminist Design." *Space and Society/Spazio e Societa* 6 (June 1983): 98–103.

Decorative Arts, Official Catalog: Department of Fine Arts Division of Decorative Arts, Golden Gate International Exposition, San Francisco, 1939. Exhib. cat. San Francisco: Golden Gate International Exposition, 1939.

"Decorative Art Study for Women," *Decorator and Furnisher* 7 (October 1885): 22.

Deutsch, Deborah. "Lilly Reich." *Heresies* 3, no.3 (1981) 73–76.

Denker, Bert, ed. *The Substance of Style: Perspectives on the American Arts and Crafts Movement*. Papers from the 1990 Winterthur Conference. Winterthur, Delaware: The Henry Francis du Pont Winterthur Museum, 1996.

Densmore, Frances. *Chippewa Customs*. 1929. Reprint. Saint Paul: Minnesota Historical Society, 1979.

"De Patta." *Arts & Architecture* (April 1947): 30.

"Department of Plastics." *Interior Design and*

Decoration (October 1941): 42–43.

Design by the Yard: Textile Printing from 800 to 1956. New York: The Cooper Union Museum for the Arts of Decoration, 1956.

Designer Craftsmen U. S. A. 1953. New York: American Craftsmen's Educational Council, 1953.

"Designer for Everybody: Millions of U.S. Homes Profit by her Good Taste." *Life* 5 (April 1954): 69.

"Designer in the News." *Interiors* (October 1982): 32.

"Designs for Living in America." *Crockery and Glass Journal* (February 1958): 43.

DeVault, Ileen A. *Sons and Daughters of Labor: Class and Clerical Work in Turn-of-the-Century Pittsburgh.* Ithaca: Cornell University Press, 1990.

de Wolfe, Elsie. *The House in Good Taste.* New York: The Century Company, 1913.

Diamond, Freda. "Coordination Starts at Home." *Home Furnishings* (October 1946): 45.

Diana Balmori, Landscape Works. Monograph 133 of the Process Architecture Series, edited by Masahiro Soma and Jun Mitsui. Tokyo: Prot Galaxy, 1998.

Dillingham, Rick. *Fourteen Families in Pueblo Pottery.* Albuquerque: University of New Mexico Press, 1994.

Dintenfass, Susan Subtle. "Old Hands at Molding the Earth." *Metropolitan Home* (September/October 1994): 5049–52.

"Distinctive American Art Takes Leadership in Textile Field." *Textile World* 79 (9 May 1931): 29.

Dixon, John. "A White Gentleman's Profession?" *Progressive Architecture* (November 1994): 55–61.

Doering, Erika. "Dagmar Arnold" [obituary]. *Association of Women Industrial Designers Newsletter* 3, no. 1 (Winter/Spring 1999): 14.

Doering, Erika, Rachel Switzky, and Rebecca Welz. *Goddess in the Details: Product Design by Women.* New York: Association of Women Industrial Designers, 1994.

Donnelly, David. "Furniture as Art." *Furniture Magazine* 2 (February 1993): 58-60.

Dormer, Peter. *Design Since 1945.* New York: Thames and Hudson, 1993.

———. *The Arts of the Maker.* New York: Thames and Hudson, 1994.

———. *The New Ceramics: Trends and Traditions.* London: Thames and Hudson, 1994.

Dorothy Liebes. Exhib. cat. New York: Museum of Contemporary Crafts of the American Crafts Council, 1970.

Dow, Sue Ellen. "Native Baskets of the Northeast." *Indian Artist* 4, no. 3 (Summer 1998): 44.

Dow, Arthur Wesley. *Composition: A Series of Exercises in Art Structure for the Use of Students and Teachers.* 1899. 7th ed.. Revised and expanded. New York: Doubleday, Page, 1913.

Downs, Dorothy. *Art of the Florida Seminole and Miccosukee Indians.* Gainesville: University Press of Florida, 1995.

Drabanski, Emily. "Dream Weaver," *New Mexico Magazine* (August 1996): 56, 58.

Dreyfus, Patricia Allen. "Women's Lib and Women Designers." *Print* 24, no. 3 (1970): 29–35.

Dubin, Lois Scherr. *North American Indian Jewelry and Adornment from Pre-history to the Present.* New York: Harry N. Abrams, 1999.

DuPlessis, Rachel Blau, and Ann Snitow. *The Feminist Memoir Project.* New York: Three Rivers Press, 1998.

Ehrenreich, Barbara. "Doing it for Ourselves: Can Feminism Survive Class Polarization?" *In These Times* (28 November 1999): 11.

Eidelberg, Martin P., ed. *Eva Zeisel: Designer For Industry.* Chicago: University of Chicago Press, in association with the Musée des Arts Décoratifs de Montreal, 1984.

———. *Messengers of Modernism American Studio Jewelry, 1940–1960.* Exhib. cat. Montreal and Paris: Montreal Museum of Decorative Arts and Flammarian, 1996.

———. *Designed for Delight: Alternative Aspects of Twentieth-century Decorative Arts.* Paris and New York: Flammarion, 1997.

"Eight Solutions to Merchandise Display." *Interiors* (October 1948): 108–11.

Elderfield, John, ed. *The Museum of Modern Art at Mid-Century: At Home and Abroad.* Vol 4 of Studies in Modern Art. New York: Harry N. Abrams, 1994.

Elinor, Gillian, ed. *Women and Craft.* London: Virago, 1987.

"Ellen Manderfield, L/IDSA, 1916–1999." *Innovation* (December 1999–January 2000): 6.

Elliott, Maud Howe, ed. *Art and Handicraft in the Woman's Building of the World's Columbian Exposition, Chicago, 1893.* Paris and New York: Boussod, Valadon, 1893.

Emerson, John, and Anita Loos. *Breaking into Movies.* New York: McCann, 1921.

Emery, Olivia. *Craftsman Lifestyle: The Gentle Revolution.* Pasadena: California Design Publications, 1976.

Engelmeier, Regine, and Peter W. Engelmeier, eds. *Fashion in Film.* Translated by Eileen Martin. English edition edited by Barbara Einzig. New York, Prestel, 1997.

Epstein, Cynthia Fuchs, et al. *The Part-time Paradox: Time Norms, Professional Lives, Family, and Gender.* New York: Routledge, 1999.

Erb, Phoebe Ann. "Get Out Your Handkerchiefs." *American Craft* 60, no. 2 (April–May 2000): 60–63, 72.

Evans, Paul. *Art Pottery of the United States.* New York: Charles Scribner's Sons, 1974.

Evans, R. Tripp. "A Profitable Partnership." *Chicago History* 24, no. 2 (Summer 1995): 5–21.

Evans, Sara M. *Born For Liberty: A History of Women in America.* New York: Free Press, 1989.

Everson, William K. *American Silent Film.* New York: DeCapo Press, 1998.

"An Exhibition by Black Artists." *Communication Arts Magazine* (May 1970): 98–107.

Exhibition of Contemporary Textiles. New York: W.& J. Sloane, 1930.

"Exhibition of Textile Designs." *American Silk Journal* (December 1922): 59.

"Faithful Helpmates: Interior Designers' Working Wives." *Interiors* (July 1945): 53–54.

Fales, Martha Gandy. *Jewelry in America 1600–1900.* Woodbridge, Suffolk, Eng.: Antique Collectors' Club, 1995.

Falino, Jeannine. "MFA Boston acquires Craver Silver Teapot." *Antiques and the Arts,* (16 February 1990): 50.

———. *Silver of the Americas.* Exhib. cat. Boston: Museum of Fine Arts, Boston, forthcoming.

Falino, Jeannine, and Yvonne Markowitz. "Margret Craver: A Foremost 20th Century Jeweler and Educator." *Jewelry: Journal of the American Society of Jewelry Historians* I (1996–97): 8–23.

Faludi, Susan. *Blacklash: The Undeclared War Against American Women.* New York: Crown Publishers, 1991.

Farrell, Amy Erdman. *Yours in Sisterhood: Ms. Magazine and the Promise of Popular Feminism.* Chapel Hill: University of North Carolina Press, 1998.

Fashion Group. *Your Future in Fashion Design.* New York: Richard Rosen Press, 1966.

"Fashion's Flower Child." *Ebony* (March 1968): 56–62.

Faxon, Alicia, and Sylvia Moore, eds. *Pilgrims and Pioneers: New England Women in the Arts.* New York: Midmarch Arts Press, 1987.

Fedderson, Christian T. *Scandinavians in Michigan: With Special Reference to Detroit Environs.* Romeo, Michigan: Christian T. Fedderson, 1968.

Feest, Christian F. *Beadwork & Textiles of the Ottawa.* Harbor Springs: Harbor Springs Historical Commission, 1984.

Feldman, Roberta. "Women in Architecture:

Fitting in or Making a Difference." *Chicago Architecture* 9 (1991): 10–11.

Fewkes, Vladimir J. "Catawba Pottery-Making, with Notes on Pamunkey Pottery-Making, Cherokee Pottery-Making, and Coiling." *Proceedings of the American Philosophical Society* 88, no. 3 (July 1944): 72, 109.

Filler, Martin. "Constructing Couples." *House Beautiful* (November 1998): 114–17, 122.

Filo, Jill Sutton. "Ruby Short McKim: The Formative Years," *Uncoverings 1996* 16 (1997): 75.

Finlar, Joel W. *The Hollywood Story.* New York: Crown, 1988.

Finley, Ruth E. *Old Patchwork Quilts.* 1929. Reprint. McLean, Va.: EPM Publications, 1992.

Finnigan, Joseph. "Designing Woman." *Emmy* 11 (May/June 1989): 64.

Fisch, Arlene M. *Textile Techniques in Metal.* 2d ed. London: Robert Hale, 1997.

Flax, Janet. *Thinking Fragments: Psychoanalysis, Feminism, and Postmodernism in the Contemporary West.* Berkeley: University of California, 1990.

Fleming, Lee. "In the Public Interest." *Landscape Architecture Magazine* (May 1995): 47.

Forsslund, Louise. "Woman's Influence in House Decoration." *Good Housekeeping* (May 1906): 499.

Forty-ninth Annual Exhibition, Architectural League. Yearbook. New York: Architectural League of New York, 1934.

Foundation for Interior Design Education and Research, *FIDER Accreditation Manual.* Grand Rapids, Michigan: FIDER, 1996.

Fourteenth Annual of Advertising Art. New York: The Book Service Company, 1935.

Foy, Jessica H., and Thomas J. Schlereth, eds. *American Home Life, 1880–1930.* Knoxville: University of Tennessee Press, 1992.

Fragile Ecologies: Contemporary Artists' Interpretations and Solutions. New York: Rizzoli, 1992.

Frances, Evan. "20 Years: A History." *Interior Design* 110, no. 9 (April, 1951): 131.

Frank, L. *Indian Silver Jewelry of the Southwest, 1868–1930.* New York, Graphic Society, 1978.

Franklin, Jill. *The Gentleman's Country House and Its Plan, 1835–1914.* London: Routledge and Kegan Paul, 1981.

Freeman, Roland L. *A Communion of the Spirits.* Nashville: Rutledge Hill Press, 1996.

Friedan, Betty. *The Feminine Mystique.* New York: W. W. Norton, 1963.

Friedl, Friedrich, Nicolaus Ott, and Bernard Stein. *Typography: An Encyclopedic Survey of Type Design and Techniques Throughout History.* New York: Black Dog and Leventha, 1998.

Friedman, Mildred, ed. *Graphic Design in America: A Visual Language History.* Minneapolis: Walker Art Center, 1989.

Frost, Henry Atherton, and William R. Sears. *Women in Architecture and Landscape Architecture.* Northampton, Mass.: Institute for the Co-Ordination of Women's Interests, Smith College, 1928.

"Furniture and Lamps by Greta Magnusson Grossman." *Art & Architecture* (January 1950): 30.

The Furniture Art of Judy Kensley McKie. Exhib. cat. East Hampton, N.Y.: Pritam and Eames, 1994.

Gabin, Nancy F. *Feminism in the Labor Movement: Women and the United Auto Workers, 1935–1975.* Ithaca, N.Y.: Cornell University Press, 1990.

Gabor, Andrea. *Einstein's Wife: Work and Marriage in the Lives of Five Great Twentieth-century Women.* New York: Penguin, 1995.

Gaines, Jane, and Charlotte Herzog, eds. *Fabrications: Costume and the Female Body.* New York. Routledge, 1990.

Galbraith, John Kenneth. *The Affluent Society.* 1958. Reprint. London: Penguin, 1984.

Garber, Marjorie. *Vested Interests: Cross-dressing and Cultural Anxiety.* New York: Routledge, 1992.

"Garden Design Contest." *Bulletin of the Garden Club of America* 4 (July 1933): 25–26.

Garrard, Mary. "Feminism: Has It Changed Art History." *Heresies* 4 (Winter 1978): 59–60.

Gebhard, David. *Lutah Maria Riggs: A Woman in Architecture, 1921–1980.* Santa Barbara: Capra Press in association with the Santa Barbara Museum of Art, 1992.

Giddings, Paula. *When and Where I Enter.* New York: Morrow, 1984.

Gilman, Carolyn, and Mary Jane Schneider. *The Way to Independence: Memories of a Hidatsa Indian Family, 1840–1920.* St. Paul: Minnesota Historical Society Press, 1987.

Gilmore, Glenda E. *Gender and Jim Crow.* Chapel Hill: University of North Carolina Press, 1996.

Giovannini, Joseph. "African Inspired Decor Illuminates Newark Arts Center." *New York Times* (27 August 1998): sec. F, 10.

Girouard, Mark. *The Victorian Country House.* 2d ed. Oxford: Claredon, 1973.

Gish, Lillian. *Dorothy and Lillian Gish.* Edited by James E. Frasher. New York: Charles Scribner's, 1973.

Gish, Lillian, with Ann Pinchot. *The Movies, Mr. Griffith. and Me.* San Francisco: Mercury House, 1969.

Glanville, Phillippa, and Jennifer Faulds

Goldsborough. *Women Silversmiths, 1686–1845: Works from the Collection of the National Museum of Women in the Arts.* Washington, D.C.: The National Museum of Women in the Arts and Thames and Hudson, 1990.

Glassgold, C. Adolf. "Some Modern Furniture Designers." *House Beautiful* (February 1930): 214.

Good as Gold: Alternative Materials in American Jewelry. Exhib. cat. Washington, D.C.: Smithsonian Institution Traveling Exhibition Service, 1981.

Gordon, Ann D., et al., eds. *African American Women and the Vote, 1837–1965.* Amherst: University of Massachusetts Press, 1997.

Gordon, Beverly. "Woman's Domestic Body: The Conceptual Conflation of Women and Interiors in the Industrial Age." *Winterthur Portfolio* 31 (Winter 1996): 281–301.

———. "Spinning Wheels, Samplers, and the Modern Priscilla: The Images and Paradoxes of Colonial Revival Needlework." *Winterthur Portfolio* 33 (1998): 182.

Gordon, Linda. *Pitied But Not Entitled.* New York: Free Press, 1994.

Gordon, Lynn D. *Gender and Higher Education in the Progressive Era.* New Haven: Yale University Press, 1990.

Gould, Lois. *Mommy Dressing: A Love Story.* New York: Anchor Books, 1998.

Grace, Henry W. "The Interior Design Influence In The Motion Picture Industry." *Interiors* (January 1942): 22–28, 44–49, 56.

Grant, Julia. *Raising Baby by the Book: the Education of American Mothers.* New Haven: Yale University Press, 1998.

"Graphic Viewpoints." *Industrial Design* 18 (January/February 1971): 60.

Grattan, Virginia L. *Mary Colter: Builder upon the Red Earth.* Grand Canyon, Ariz.: Grand Canyon Natural History Association, 1992.

Greenbaum, Toni. "Luminous Plastic Jewelry: Cara Croninger." *Ornament* 15, no. 4 (Summer 1992): 18, 56–59.

———. "Constructivism and American Studio Jewelry, 1940 to the Present." *Studies in the Decorative Arts* 6 (Fall–Winter 1998–99): 88–89.

Greenberg, Blue. "Mary Ann Scherr, A Designer/Jeweler's Route of Investigation, Learning, Change, Discovery." *Metalsmith* 11 (Spring 1991): 30.

Gueft, Olga. "The Past as Prologue: The First 50 Years." In *ASID Annual Report, 1980.* Washington, D.C.: ASID, 1980.

Gunn, Virginia. "Quilts for Milady's

Boudoir." *Uncoverings 1989* 10 (1990): 82.

Guy-Sheftall, Beverly. *Words of Fire: An Anthology of African-American Feminist Thought.* New York: The New Press, 1995.

Guzman, Jessie. "The Social Contributions Of The Negro Woman Since 1940." *The Negro History Bulletin* (January 1948): 86–94;

Hall, Carrie A., and Rose G. Kretsinger. *The Romance of the Patchwork Quilt in America.* New York: Bonanza Books, 1935.

Hall, Peter. "Title Wave." *I.D.* 46, no. 2 (March/April 1999): 60–64.

Halliwell, Leslie. *Halliwell's Film Guide.* 8th ed. Edited by John Walker. London: Harper Collins, 1991.

Hammond, Eleanor A. *Aptuczet Trading Post Museum.* Bourne, Massachusetts: Bourne Historical Society, 1920.

"Handwoven Fabrics in the S.S. United States: An Old Art Is at Home in a Modern Setting." *Handweaver & Craftsman* 4, no.1 (Winter 1952–53): 15–17, 63

Harrington, Mary. "The Cowles Art School, Boston, 1883–1900." Undergraduate paper, Massachusetts College of Art, 1993.

Harris, Mary Emma. *The Arts at Black Mountain College.* Cambridge, Mass.: M.I.T. Press, 1987.

Harris, Jonathan. *Federal Art and National Culture: The Politics of Identity in New Deal America.* Cambridge, Eng.: Cambridge University Press, 1995.

Harris, Sylvia. "What It Is? Searching for a Black Aesthetic in American Graphic Design." *The International Review of African American Art* 13 (1996): 38–42.

Harrison, Cynthia. *On Account of Sex.* Berkeley: University of California Press, 1988.

Harrod, Tanya. *The Crafts in Britain in the Twentieth Century.* New Haven: Yale University Press, in association with the Bard Graduate Center for Studies in the Decorative Arts, New York, 1999.

——, ed. *Obscure Objects of Desire: Reviewing the Crafts in the Twentieth Century.* London: The Crafts Council, 1997.

Harvey, David. *The Condition of Post-modernity.* Oxford, Eng.: Blackwells, 1989.

Hastreiter, Kim, Valerie Steele, et al. *Ruben and Isabel Toledo: A Marriage of Art and Fashion.* Tokyo: Kodansha, 1998.

Hawes, Elizabeth. *Fashion is Spinach.* New York: Random House, 1938.

Hayden, Dolores. *The Grand Domestic Revolution: A History of Feminist Designs for American Homes, Neighborhoods, and Cities.* Cambridge, Mass.: M.I.T. Press, 1981.

——. *The Power of Place: Urban Landscapes as Public History.* Cambridge, Mass.:

M.I.T. Press, 1995.

Head, Edith, with Jane Kesner Ardmore. *The Dress Doctor.* Boston: Little Brown, 1959.

Head, Edith, and Paddy Calistro. *Edith Head's Hollywood.* New York: Dutton, 1983.

Head, Edith, with Joe Hyams. *How to Dress for Success.* New York: Random House, 1967.

Heekin, Elizabeth. "Beyond the Rose Garden." *Garten + Landschaft* (June 1985): 51.

Heilbrun, Carolyn G. *Writing a Woman's Life.* New York: Ballatine, 1988.

Heiser, Beverly. *Hollywood Art: Art Direction in the Days of the Great Studios.* Jefferson, N.C.: McFarland and Company, 1990.

——. *Production Design in the Contemporary American Film: A Critical Study of Twenty-three Movies and Their Designers.* Jefferson, N.C., McFarland and Company, 1997.

Heisinger, Kathryn B., and George H. Marcus, eds. *Design Since 1945.* Exhib. cat. Philadelphia: Philadelphia Museum of Art, 1983.

Helland, Janice. "The Critics and the Arts and Crafts: The Instance of Margaret Macdonald and Charles Rennie Mackintosh." *Art History* 117, no. 2 (June 1994): 209–27.

——. *The Studios of Frances and Margaret Macdonald.* Manchester and New York: Manchester University Press, 1996.

Heller, Steven. "Mickey in the Clover: The Prime of Walt Disney World." *Print* 44 (September/October 1992): 53–59.

Helphand, Kenneth, and Nancy D. Rottle. "Cultivating Charm." *Garden Design* 7 (Autumn 1988): 3, 26–33.

Henderson, Rose. "A Swedish Furniture Designer in America." *American Artist* (December 1951): 55.

Heskett, John. *Industrial Design.* London: Thames and Hudson, 1980.

Hess, Joan. "Domestic Interiors in Northern New Mexico," *Heresies* 3 no. 3 (1981): 30–33.

Hesse-Biber, Sharlene, and Gregg Lee Carter. *Working Women in America: Split Dreams.* New York: Oxford University Press, 2000.

Heth, Charlotte, ed. *Native American Dance.* Washington: Smithsonian Institution with Starwood Publishing, 1992.

Heyman, C. David. *A Woman Named Jackie.* New York: Carol Communications, 1989.

Higginbotham, Evelyn Brooks. *Righteous Discontent: The Women's Movement in the Black Baptist Church, 1880–1920.* Cambridge: Harvard University Press, 1993.

Hillyer, Elinor. "Scenic Fabrics Revived." *Arts and Decoration* (May 1934): 8.

Hines, Thomas S. "Portrait: Marion Mahony

Griffin, Drafting a Role for Women in Architecture." *Architectural Digest* (March 1995): 28–40.

Hochschild, Arlie Russell. *The Time Bind.* New York: Metropolitan Books, 1997.

Holme, Charles, ed. *Modern Design in Jewellery and Fans.* London: The Studio, 1901–2.

Holstein, Jonathan. *American Pieced Quilts.* Washington, D.C.: Smithsonian Institution, 1972.

Hooks, bell. *Ain't I a Woman: Black Women and Feminism.* Boston: South End Press, 1981.

——. *Talking Back: Thinking Feminist, Thinking Black.* Boston: South End Press, 1989.

Hoover, Velma J. "Meta Vaux Warrick Fuller: Her Life and Art." *Negro Hostory Bulletin* 40 (March/April 1977): 678–81.

The Hope Series. Pamphlet. New York: American Indian College Fund, n.d.

Horton, Laurel, ed. *Quiltmaking in America: Beyond the Myths.* Nashville, Tenn.: Rutledge Hill Press, 1994.

Howard, Ella. "Feminist Writings on Twentieth-Century Design History, 1970–1995: Furniture, Interiors, Fashion." *Studies in the Decorative Arts* 8, no. 1 (Fall–Winter 2000–2001).

——. "The Design 'Adventure' of Gere Kavanaugh." *Studies in the Decorative Arts* 8, no. 1 (Fall–Winter 2000–2001).

Howard, Louise. "How I Teach My Gowns to Act." *Photoplay* 9 (February 1916): 92.

Howarth, Thomas. *Charles Rennie Mackintosh and the Modern Movement.* London: Routledge and Kegan Paul, 1952.

Howell, Betje. "Maria Kipp." *Creative Crafts* 2 no.4 (November–December, 1961): 5–9.

Howes, Ethel. *Women in Architecture and Landscape Architecture.* Study for the Institute for Co-ordination of Women's Interests, Publication No. 7. Northampton, Mass.: Smith College, 1928.

Hudson, Charles. *The Southeastern Indians.* Knoxville: The University of Tennessee Press, 1994.

Hull-House Maps and Papers. New York: Thomas Y. Crowell, 1895.

Husted-Anderson, Adda. "Setting Up Shop . . . the jeweler." *Craft Horizons* 9 (Summer 1949) 2: 13–15.

Hutchinson, George. *The Harlem Renaissance in Black and White* (Cambridge, Mass.: Belknap Press, Harvard University, 1995).

Huyssen, Andreas. *After the Great Divide: Modernism, Mass Culture, Postmodernism.* Bloomington, Ind.: Indiana University Press, 1986.

Illustrated Lectures by Louise Brigham, Author of "Box Furniture." Pamphlet. N.p., N.d.

Winterthur Library, Winterthur, Delaware.

"In Memoriam . . . Freda Diamond" [obituary]. *Society of Glass and Ceramic Decorators Newsletter* (February 1998): 8.

"In the American Grain." *Harper's Bazaar* (October 1944): 89.

"Industrial Art Fancy Work." *Craftsman* 10 (August 1906): 683.

"Interior Design Aboard the S.S. *America*." *Interior Design and Decoration* (September 1940), 30, 74–76.

"Interior Design in Public Work." *Interior Design and Decoration* (January 1941): 39.

"Interior Design Market: Weitzner for Larsen." *Interior Design* (September 1993): 118.

"Is Industrial Design Color Blind?" *I.D.* (November 1963): 83–84.

Iverson, Stephanie Day. "'Early' Bonnie Cashin, before Bonnie Cashin Designs, Inc." *Studies in the Decorative Arts* 8, no. 1 (Fall–Winter 2000–2001).

Jaggi, Maya. "Gifted, Black . . . and gone." *Guardian* (30 May 2000): 16.

Jameson, Frederic. *Postmodernism, or, The Cultural Logic of Late Capitalism.* London: Verso, 1991.

Jennings, Jan. "Controlling Passion: The Turn-of-the-Century Wallpaper Dilemma." *Winterthur Portfolio* 31 (Winter 1996): 243–64.

"Jewelry Designed By Betty Cooke." *Arts & Architecture* (April 1949): 32.

Johnson, Donald-Brian. *Higgins.* Vol. 9 of Adventures in Glass. Atglen, Pa.: Schiffer Publishing, 1997.

———. *Chase Complete: Deco Specialities of the Chase Brass and Copper Company.* Atglen, Pa.: Schiffer Publishing, 1999.

Johnson, Louisa. *Every Woman Her Own Flower Gardener.* 7th ed. New York : Ralph H. Waggoner, 1889.

Johnson, Jory, and Felice Frankel. *Modern Landscape Architecture: Redefining the Garden.* New York: Abbeville Press, 1991.

Johnson, Patricia. *Joyce Kozloff: Visionary Ornament.* Boston: Boston University Art Gallery, 1986.

Jones, Amelia, ed. *Sexual Politics: Judy Chicago's Dinner Party in Feminist Art History.* Los Angeles: UCLA in association with the University of California Press, Berkeley, 1996.

Jones, Caroline A. *Machine in the Studio: Constructing the Postwar American Artist.* Chicago: University of Chicago Press, 1996.

Jones, Harvey. *Matthews: Masterpieces of the California Decorative Style.* Oakland: Oakland Museum Art Department, 1972.

Judy Kensley McKie. Exhib. cat. East Hampton, N.Y.: Pritam and Eames, 1997.

Kahler, Bruce Robert. "Art and Life: The Arts and Crafts Movement in Chicago, 1897–1910." Ph.D. diss. Ann Arbor, Michigan: University Microfilms, 1986.

Kaplan, Wendy, ed. *"The Art That Is Life": The Arts and Crafts Movement in America, 1875–1920.* Exhib. cat. Boston: Museum of Fine Arts, 1987. Reprint, Boston: Bulfinch Press, 1998.

———. *Leading "The Simple Life": The Arts and Crafts Movement in Britain, 1880–1920.* Miami Beach: The Wolfsonian–Florida International University, 1999.

Karasz, Mariska. *Adventures in Stitching: A New Art of Embroidery.* New York: Funk and Wagnalls Company, 1949.

Kardon, Janet, ed. *The Ideal Home, 1900–1920.* Exhib. cat. New York: Harry N. Abrams in association with the American Craft Museum, 1993.

———. *Revivals! Diverse Traditions, 1920–1945: The History of Twentieth-century American Craft.* New York: Harry N. Abrams in association with The American Craft Museum, 1994.

———. *Craft in the Machine Age, 1920–1945: The History of Twentieth-Century Craft.* Exhib. cat. Harry N. Abrams in association with the American Craft Museum, New York, 1995.

"Karen Karnes." *American Craft* (October/November 1998): 64;

Kelsey, John, and Rick Mastelli, eds. *Furniture Studio: The Heart of the Decorative Arts.* Free Union, Va.: The Furniture Society, 1999.

Kerber, Linda K. *No Constitutional Right to be Ladies.* New York: Hill and Wang, 1998.

King, Elizabeth Miner, "War, Women and American Clothes: Dress, the Money Maker." *Scribner's Magazine* (November 1917): 592–98.

King, Louisa Yeoman. *The Little Garden.* Boston: Atlantic Monthly Press: 1921.

Kirkham, Pat. "The London Furniture Trade, 1700–1870." *Furniture History* 24 (1988): 66.

———. "Looking for the Simple Idea." *Sight and Sound* 4 (February 1994): 16–20.

———. *Charles and Ray Eames: Designers of the Twentieth Century* Cambridge, Mass.: M.I.T. Press, 1995.

———. "Dress, Dance, Dreams, and Desire: Fashion and Fantasy in *Dance Hall*," *Journal of Design History* 8 (1995): 195–214.

———. "Humanizing Modernism: The Crafts, 'Functioning Decoration,' and the Eameses." *Journal of Design History* 11 (1998): 15–29.

———, ed. *The Gendered Object.* Manchester and New York: Manchester University Press/ St Martin's Press, 1996.

Kirkham, Pat, and Janet Thumim. *You Tarzan: Masculinity, Movies, and Men.* New York: St. Martin's Press, 1993.

Klein, L. "Designing the L.A. Olympics." *Communication Arts* 25 (January/February 1984): 28–43.

Knauff, Theodore C. *Training for the Useful and the Beautiful.* Philadelphia: Philadelphia School of Design for Women, 1922.

Knight, Ellen. *Artists of Winchester, Massachusetts, 1850–1950.* Winchester, Mass.: Winchester Historical Society, 1992.

Knight, Jane Alison. "An Examination of the History of the Lowthorpe School of Landscape Architecture for Women, Groton, Massachusetts, 1901–1945." Master's thesis, Cornell University, 1986.

Kogan, Belle. "Are Today's Design-Standards Slipping?" *Crockery and Glass Journal* 151 (December 1952): 96.

Kolmar, Wendy, and Frances Bartkowski, eds. *Feminist Theory: A Reader.* Mountain View: Mayfield Publishers, 2000.

Komara, Anne. "The Glass Wall: Gendering the American Society of Landscape Architects." *Studies in the Decorative Arts* 8, no. 1 (Fall–Winter 2000–2001).

Komanecky, Michael K. *American Potters: Mary and Edwin Scheier.* Manchester, N. H.: Currier Gallery of Art, 1993.

Korzenik, Diana. *Drawn to Art: A Nineteenth-Century American Dream.* Hanover, N. H.: University Press of New England, 1985.

Kovel, Ralph, and Terry Kovel. *Kovel's American Art Pottery.* New York: Crown Publishers, 1993.

Kramer, Barbara. *Nampeyo and Her Pottery.* Albuquerque: University of New Mexico Press, 1996.

Krauss, Rosalind. "Sculpture in the Expanded Field." *October* 8 (Spring 1979).

Krohn, Lisa. "Against the Odds: Five Top Designers Discuss the Challenges Unique to Women in Design." *Innovation* (September/October 1986): 38.

Kwolek-Foland, Angel. *Incorporating Women: A History of Women and Business in the United States.* New York: Twayne, 1998.

Labaco, Ronald T. "'The Playful Search for Beauty': Eva Zeisel's Life in Design." *Studies in the Decorative Arts* 8, no. 1 (Fall–Winter 2000–2001).

Lamb, Yanick Rice. "Wall to Wall, the Inspiration of Africa." *New York Times* (29 October 1992)

Lambourne, Lionel. *Utopian Craftsman.* London: Astragal Books, 1980.

Lamm, Michael, and Dave Holls. *A Century of Automotive Style: 100 Years of American Car Design*. Stockton, Calif.: Lamm-Morada Publishing, 1997.

Lamoureux, Dorothy. *The Arts and Crafts Studio of Dirk van Erp*. Exhib. cat. San Francisco: San Francisco Craft and Folk Art Museum, 1989.

Landscapes and Gardens: Women Who Made a Difference. Proceedings of Conference at Michigan State University, East Lansing, Mich., June 1987.

Larrabee, Eric, and Massimo Vignelli. *Knoll Design*. 1981. Rev. ed. New York, Harry N. Abrams, 1989.

Larson, Jack Lenor. *Jack Lenor Larson—A Weaver's Memoir*. New York, Harry N. Abrams, 1998.

Lasansky, Jeannette. "The Colonial Revival and Quilts." *Pieced by Mother: Symposium Papers*. Lewisburg, Pa.: Oral traditions Project, 1988.

———, ed. *On the Cutting Edge: Textile Collectors, Collections, and Traditions*. Lewisburg, Pa.: Oral Traditions Project, 1988.

LaVine, W. Robert. *In a Glamorous Fashion: The Fabulous Years of Hollywood Costume Design*. New York: Scribner, 1980.

Lawrence III, Charles R., and Mari J. Matsuda. *We Won't Go Back: Making the Case for Affirmative Action*. New York: Houghton Mifflin, 1997.

Leavitt, Robert M., and David A. Francis, eds. *The Wampum Records: Wabanaki Traditional Laws*. Fredericton: Micmac-Maliseet Institute, University of New Brunswick, 1990.

Leese, Elizabeth. *Costume Design in the Movies*. New York: Dover, 1991.

Leonard, R. L., and C. A. Glassgold, eds. *Annual of American Design 1931*. New York: Ives Washburn , 1930.

Lesko, Jim. "Industrial Design at Carnegie Institute of Technology, 1934–1967." *Journal of Design History* 10 (1997): 269.

———. "Interview with Maud Bowers." *Journal of Design History* 10, no. 3 (1997): 274–79.

Lewis, Samella. *African American Art and Artists*. Berkeley: University of California Press, 1994.

Lewis, Samella S., and Ruth G. Waddy. *Black Artists on Art*. Vol. 1. Los Angeles: Contemporary Crafts Publishers, 1969.

"Libbey Studies Post-War Designs." *Crockery and Glass Journal* (November 1944): 48.

Libby, Valencia. *Marian Cruger Coffin, 1876–1957: The Landscape Architect and the Lady*. Roslyn, New York: Nassau County Museum of Fine Art, 1986.

Licko, Zuzana, and Rudy VanderLans. "The New Primitives." *I.D.* 35, no. 2 (March/April 1988): 60.

Liebes, Dorothy. *Decorative Arts: Official catalog*. San Francisco: Department of Fine Arts Division of Decorative Arts, Golden Gate International Exposition, 1939.

Linz, James R. *Art Deco Chrome*. Atglen, Pa.: Schiffer Publishing, 1999.

Liotta, Christine. "Architectonic Ornamentation." *Metropolis* 16 (January–February 1997): 52.

Lippard, Lucy. *From the Center: Feminist Essays on Women's Art*. New York: Dutton, 1976.

———. *Overlay: Contemporary Art and the Art of Pre-History*. New York: Pantheon Books, 1983.

"The 'Little Things'." *The Upholsterer and Interior Decorator* 94, no. 1 (1935): 26–27.

LoBrutto, Vincent. *By Design: Interviews with Film Production Designers*. Westport, Conn.: Praeger, 1992.

Loe, Nancy E. *Hearst Castle: An Interpretive History of W. R. Hearst's San Simeon Estate*. Santa Barbara, Calif.: Companion Press, 1994.

Lohrmann, Charles J. "Weaving New Traditions." *Native Peoples* 11, no. 3 (Spring 1998): 26–32.

Lorde, Audre. "The Master's Tools Will Never Dismantle the Master's House." In *Sister Outsider: Essays and Speeches*. Freedom, CA: The Crossing Press, 1984.

Los Angeles County Museum of Art. *Clay Today: Contemporary Ceramicists and Their Work*. San Francisco: Chronicle Books, 1990.

Loudon, Jane. *Gardening for Ladies*. Edited by A. J. Downing. New York: John Wiley, 1840.

Lund, Amy. "Art and Textile Design: The Onondaga Silk Company's 'American Artist Print Series' of 1947." Master's thesis, University of Rhode Island, 1993.

Lupton, Ellen. "The Academy of Deconstructed Design." *Eye* 1, no. 3 (Winter 1991): 44–52.

———. *Mechanical Brides: Women and Machines from Home to Office*. New York: Cooper- Hewitt, National Museum of Design, Smithsonian Institution / Princeton Architectural Press, 1993.

———. "Archive: Elaine Lustig Cohen." *Eye* 5, no. 17 (Summer 1995): 8–9.

———. *Mixing Messages: Graphic Design in Contemporary Culture*. New York: Princeton Architectural Press and Cooper-Hewitt, National Design Museum, Smithsonian Institution, 1996.

MacDowell, Marsha L., and C. Kurt Dewhurst, eds. *To Honor and Comfort: Native Quilting Traditions*. Santa Fe: Museum of New Mexico Press and Michigan State University, 1997.

Mackay, Robert B., Anthony K. Baker, and Carol A. Traynor, eds. *Long Island Country Houses and Their Architects, 1860–1940*. New York: Norton, 1997.

Madeline, Jeanne. *The Fair Women*. Chicago: Academy, 1981.

Mainardi, Patricia. "Quilts: The Great American Art." *The Feminist Art Journal* 2, no. 1 (Winter 1973): 1, 18–23.

Mainiero, Lina, ed. *American Women Writers: A Critical Reference Guide from Colonial Times to the Present*. New York: Ungar Publishing, 1980.

Makela, Laurie Haycock, and Ellen Lupton. "Underground Matriarchy." *Eye* 14 (Autumn 1994): 42–47.

Manderfield, Ellen. Papers. Industrial Design Archive, George Arents Research Library for Special Collections, Syracuse University Library.

Mangan, Kathleen Nugent. "Marie Zimmermann: Art and Craft in Metal, The Metropolitan Museum of Art, July 2-September 8, 1985." *Metalsmith* 6 (Winter 1986): 48.

Mankiller, Wilma, Gloria Steinem, et al., eds. *The Reader's Companion to U.S. Women's History*. New York: Houghton Mifflin, 1998.

Mansfield, Stephanie. "Prima Donna." *Vogue* (August 1989): 291.

"Marion Weeber—Industrial Designer." *Antiques and The Arts Weekly* (March 6, 1998): 82.

Margolies, Jane. "Crafts Cross Over." *Industrial Design* (May/June 1987): 56–59.

Margolin, Victor. "African American Designers in Chicago: Themes and Issues." Paper presented at "African-American Designers: The Chicago Experience Then and Now," University of Illinois at Chicago, 5 February 2000.

———, ed. *Design Discourse: History/Theory/Criticism*. Chicago: The University of Chicago Press, 1989.

"Marli Ehrman." *Handweaver & Craftsman* 11, no.2 (Spring 1960): 25–26, 57.

Martin, Richard. "The Emperors of New Clothes." *Textile and Text* 12, no. 4 (1990): 31.

———. *American Ingenuity: Sportswear 1930s–1990s*. New York: The Metropolitan Museum of Art, 1998.

———. "Yeohlee: Energetics: Clothes and Enclosures." *Fashion Theory* 2, no. 3 (September 1998): 287–94.

———, ed. *Contemporary Fashion*. New York: St. James Press, 1995.

Martinez, Katharine A., and Kenneth L. Ames. *The Material Culture of Gender, the Gender of Material Culture*. Winterthur, Del.: The Henry Francis du Pont Winterthur

Museum, 1997.

Mather, Sir William. *Second Report of the Royal Commissioners on Technical Instruction: Report on Technical Education in the United States of America and Canada*. Vol. 2. London: Eyre and Spottiswoode, 1884.

Maxwell Museum of Anthropology, *Seven Families in Pueblo Pottery*. Albuquerque: University of New Mexico Press, 1974.

May, Lary, ed. *Recasting America: Culture and Politics in the Age of Cold War* Chicago: University of Chicago Press, 1989.

Maynard, Mary, and Haleh Afsar. *Dynamics of Race and Gender*. London: Taylor and Francis, 1994.

Mazloomi, Carolyn. *Spirits of the Cloth: Contemporary African-American Quilts*. New York: Clarkson Potter Publishers, 1998.

McBride, Joseph. *Filmmakers on Filmmaking*. Vol I. Los Angeles: J. P. Tarcher, 1983.

McClelland, Nancy V. "A.I.D. News." *Interior Design and Decoration* (November 1940): 37.

McCoy, Katherine. "American Graphic Design Expression." *Design Quarterly* 148 (1990): 4–22.

McCracken, Harold. *Ccorge Catlin and the Old Frontier*. New York: The Dial Press, 1959.

McDowell, Colin. *McDowell's Dictionary of 20th-Century Fashion*. Englewood Cliffs: Prentice-Hall, 1985.

McGuire, Diane Drotial, and Lois Fern, eds. *Beatrix Jones Farrand (1872–1959): Fifty Years of American Landscape Architecture*. Dumbarton Oaks Colloquium on the History of Landscape Architecture. Washington, D.C.: Dumbarton Oaks, 1982.

McLendon, Sally. "Pomo Basket Weavers in the University of Pennsylvania Museum Collections." *Expedition* 40, no. 1 (1998): 34–47.

McMillan, Janet. "Success Against the Odds." [Philadelphia] *Inquirer* (23 November 1986): sec. 1, 8.

McMorris, Penny, and Michael Kile. *The Art Quilt*. Lincolnwood, Ill.: Quilt Digest Press, 1986, 1996.

McNeil, Peter. "Designing Women: Gender, Sexuality and the Interior Decorator, c. 1890–1940." *Art History* 17 (December 1994): 639.

McPeck, Eleanor. "Education's Role Examined." *Landscape Architecture Magazine* 85 (May 1995): 42.

McQuiston, Liz. *Suffragettes to She-Devils: Women's Liberation and Beyond*. London: Phaidon, 1997.

Meggs, Philip B. "The Women Who Saved New York!" *Print* 49, no. 3 (May/June 1989): 61–71.

Meikle, Jeffrey L. *Twentieth Century Limited: Industrial Design in America, 1925–1939*.

Philadelphia: Temple University Press, 1979.

Melosh, Barbara. *Engendering Culture: Manhood and Womanhood in New Deal Public Art and Theater*. Washington: Smithsonian Institution Press, 1991.

Merchandising Interior Design: Methods of Furniture Fabrication in America Between the Two World Wars. Proceedings of a symposium. New Haven: Yale University School of Architecture, 1991.

Meyer, Elizabeth K. *Martha Schwartz: Transfiguration of the Commonplace*. Edited by Heidi Landecker. Washington, D.C.: Spacemaker Press, 1997.

Meyer, Leisa D. *Creating GI Jane: Sexuality and Power in the Women's Army Corps During World War II*. New York: Columbia University Press, 1996.

Meyer, Marilee Boyd, et al. *Inspiring Reform: Boston's Arts and Crafts Movement*. Exhib. cat. New York: Harry N. Abrams in association with the Davis Museum, Wellesley, 1997.

Meyerowitz, Joanne. "Sexual Geography and Gender Economy: The Furnished Room Districts of Chicago, 1890–1930." *Gender and History* 2 (Autumn 1990): 274–96.

———, ed. *Not June Cleaver*. Philadelphia: Temple University Press, 1994.

Milbank, Caroline Reynolds. *New York Fashion: The Evolution of American Style*. New York: Harry Abrams, 1989.

Milkman, Ruth. *Gender at Work: The Dynamics of Job Segregation by Sex during World War II*. Urbana: University of Illinois Press, 1987.

Miller, Alicia. " Evolution of a Design." *Woodwork* 51 (June 1998): 32–38.

Millon, Henry A., and Linda Nochlin. *Art and Architecture in the Service of Politics*. Cambridge and London: M.I.T. Press, 1978.

[Mimlitsch-Gray, Myra.] *Magnification: 500x The Work of Myra Mimlitsch-Gray*. N.p., 1998.

Mink, Gwendolyn. *Welfare's End*. Ithaca, N.Y.: Cornell University Press, 1998.

Mitchell, Anna. "Our People, Anna Belle Sixkiller Mitchell, 1969." *Cherokee Quarterly* (Fall 1998).

"Modern Design from Ancient Fabrics." *Scientific American* 16 (February, 1918). 148–49.

"Modern Design in Metal." *The Museum* 2 (April 1929)7: 51–52.

Moline, Julie. "Courtney Rocks." *Interiors* (September 1999): 75.

Momaday. N. Scott. *House Made of Dawn*. New York: Perennial, 1968; reprint 1989.

Moore, William R. "Why not Publicize A.I.D.?" *Decorators Digest* (November 1934): 29.

Moore College of Art. *Design for Women: A History of Moore College of Art*. Wynnewood, Pa.: Livingston Publishing Company, 1968.

Moorhead, Steven, ed. *Landscape Architecture*. Gloucester, Mass.: Rockport Press, 1997.

Morcom, Elizabeth. "Sculptor/Designer Creates 'Plastic' Beauty." *Mobile Press Register* (11 July 1982): sec. D, 4.

Moro, Ginger. "Beatrice Wood: The Last of the Red Hot Mamas of Dada." *Echoes* 7, no. 1 (Summer 1998): 56–86;

Morris, Barbara. *Liberty Design, 1874–1914*. Secaucus, N.J.: Chartwell Books, 1989.

Morris, William. *The Ideal Book: Essays and Lectures on the Arts of the Book* Edited by William S. Peterson. Berkeley: University of California Press, 1982.

Morrison, Allan. "Twilight for Greenwich Village." *Negro Digest* 7 (January 1949): 30.

Mort, Jo-Ann, ed. *Not Your Father's Union Movement*. New York: Verso, 1998.

Museum of Fine Arts, Houston, *Herter Brothers: Furniture and Interiors for a Gilded Age*. Exhib. cat. New York: Harry N. Abrams, 1994.

Museum of Fine Arts, School of Drawing and Painting: Ninth Annual Report. Boston, Museum of Fine Arts, 1885.

Musicant, Marlyn R. "Maria Kipp: Autobiography of a Hand Weaver." *Studies in the Decorative Arts* 8, no. 1 (Fall–Winter 2000–2001).

Musselman, Mike. "Designing Woman." *Screen Graphics* (January–February 1995): 30.

Musser, Charles. *The Emergence of Cinema: The American Screen to 1907*. Vol. 1 of History of the American Cinema, edited by Charles Harpole. New York: Scribner, 1990.

Nabokov, Peter, ed. *Native American Testimony*. New York: Penguin Books, 1992.

Nabokov, Peter, and Robert Easton. *Native American Architecture*. New York: Oxford University Press, 1989.

Naylor, Blanche. "Textiles Derived from Paintings." *Design* 33 (February 1932): 214–19.

Neuhart, John, Marilyn Neuhart, and Ray Eames. *Eames Design: The Work of the Office of Charles and Ray Eames*. New York: Harry N. Abrams, 1989.

Nevins, Deborah F. "Eileen Gray." *Heresies* 3, no. 3 (1981): 68–71.

"A New Expression of Modern." *Arts and Decoration* 44, no. 6 (August 1937): 10–11.

New York University. "Landscape Architecture." Occupational Abstract No. 9, 1944.

Newton, Norman. *Design on the Land: The Development of Landscape Architecture*. Cambridge, Mass.: Belknap Press of

Harvard University Press, 1971.

Nichols, Ellen, ed. *Northwest Originals: Washington Women and Their Art*. Portland, Ore.: Matri Media, 1990.

Nochlin, Linda. "Women and the Decorative Arts." *Heresies* 4 (Winter 1978): 43.

Noll, Terrie. "Finding Your Own Voice." *Woodwork* 1 (Spring 1989): 36–41.

———. "Return of the Native: Kristina Madsen Revisited." *Woodwork* 51 (June 1998): 20–27.

Nordness, Lee. *Objects: USA.* New York: The Viking Press, 1970.

O'Keefe, Linda. "Celebrating Roots." *Elle Décor* 4 (August/September 1993): 36.

Oedekoven-Gerischer, Angela, et al., eds. *Frauen im Design / Women in Design*. Exhib. cat. Stuttgart: Design Center Stuttgart, 1989.

Official Catalogue of Exhibits, Universal Exposition, St. Louis, U.S.A., Department B, Art. St. Louis, Mo.: Official Catalogue Company, 1904.

Olsen, Andrea. "Kristina Madsen: Textures With A Touch of Class." *Woodwork* 10 (Summer 1991): 38–42;

One College Three Cities: Parson's School of Design Portfolio and Catalogue, 1984–85. New York: Parsons, 1985.

"One Hundred Interior Design Giants." *Interior Design* (January 1999): 74–94.

"An Open Letter to Bernard Leach from Marguerite Wildenhain." *Craft Horizons* 13 (May/June 1953): 43–44

Orleck, Annelise. *Common Sense and a Little Fire: Women and Working-Class Politics in the United States, 1900–1965*. Chapel Hill: University of North Carolina Press, 1995.

Orlofsky, Patsy, and Myron Orlofsky. *Quilts in America*. New York: Abbeville Press, 1992.

Osburn, Annie. "Verma Nequatewa (Sonwai)." *Indian Artist* (Spring 1998): 40.

Owen, William. "Design in the Age of Digital Reproduction." *Eye* 4, no. 14 (Autumn 1994): 26–41.

Owens-Hart, Winifred. "Traditions: Ipetumodu." *International Review of African American Art*, 11, no. 2 (1994): 58–66

Pack, Greta. *Jewelry and Enameling*. New York: D. Van Nostrand Company, 1941.

———. *Chains and Beads*. New York: Van Nostrand, 1951.

———. *Jewelry Making for the Beginning Craftsman*. New York: Van Nostrand, 1957.

———. *Jewelry Making by the Lost Wax Process*. New York: Van Nostrand Reinhold, 1968.

"Paintings and Light Used in Design." *Interior Design and Decoration* (May 1937): 46.

Parker, Rozsika. "The Word for Embroidery

was WORK." *Spare Rib* 37 (July 1975): 41–45

———. *The Subversive Stitch: Embroidery and the Making of the Feminine*. New York, Routledge, 1989.

Parker, Rozsika, and Griselda Pollock. *Old Mistresses: Women, Art and Ideology*. London: Routledge and Kegan Paul, 1981.

Parsons, Frank. *Interior Decoration: Its Principles and Practice*. Garden City, N.Y.: Doubleday, 1915.

Patterson, Victoria. "Change and Continuity: Transformations of Pomo Life." *Expedition* 40, no. 1 (1998): 13–14.

Patterson, Vivian. *Companions in Art: William and Marguerite Zorach*. Williamstown, Mass.: Williams College Museum of Art, 1991.

Patton, Sharon F. *African-American Art*. New York: Oxford University Press, 1998.

Pear, Lillian Myers. *The Pewabic Pottery: A History of Its Products and Its People* Des Moines, Iowa: Wallace-Homestead Book Company, 1976.

Peiss, Kathy. *Cheap Amusements: Working Women and Leisure in Turn-of-the-Century New York*. Philadelphia: Temple University Press, 1986.

Pendergast, Sara. ed., Contemporary Designers. Detroit: St. James Press, 1997.

Penney, David, and George Longfish. *Native American Art*. Hong Kong: Hugh Lauter Levin Associates, 1994.

Perreault, John. "Functional Glamour." *Crafts Arts*, no. 21 (1991): 36–40.

Perry, Barbara. *American Ceramics: The Collection of the Everson Museum of Art* New York: Rizzoli, 1989.

Perry, Gill, ed. *Gender and Art*. New Haven: Yale University Press in association with the Open University, 1999.

Perry, Mary Chase. "Grueby Potteries." *Keramik Studio* 2 (1900).

———. "Adventures in Ceramics: The Story of Mary Chase Perry and The Pewabic Pottery." Typescript, [1930s]. Archives of the Pewabic Pottery, Detroit, Michigan; copy also at the Winterthur Museum Library, Winterthur, Delaware.

Perry (Stratton), Mary Chase. "Pewabic Records." *American Ceramic Society Bulletin* 25 (15 October 1946).

Peterson, Ann. "Women Take Lead in Landscape Art; Field Dominated by a Group of Brillian Designers of Horticultural Vistas." *New York Times* (13 March 1938): D5.

Peterson, Susan. *The Living Tradition of Maria Martinez*. Tokyo: Kodansha International, 1977.

———. *Lucy Lewis, American Indian Potter*. Tokyo: Kodansha International, 1984.

———. *Pottery by American Indian Women: The Legacy of*

Generations. Exhib. cat. National Museum of Women in the Arts, Washington, D.C., and Abbeville Press, New York, 1997.

Petkanas, Christopher. *Parish Hadley: The First Sixty Years*. Boston: Little, Brown and Company, 1995.

Pevsner, Nikolaus. *Pioneers of Modern Design from William Morris to Walter Gropius*. 1937. Revised ed. New York: Museum of Modern Art, 1949.

Pierce, H. Winthrop. *The History of the School of the Museum of Fine Arts, Boston, 1877–1927*. Boston: Museum of Fine Arts, 1930.

Pierre, Clara. *Looking Good: The Liberation of Fashion*. New York: Reader's Digest Press, 1976.

Platt, Richard. *David Adler*. New York: M. Evans, 1970.

Poesch, Jessie J. *Newcomb Pottery: An Enterprise for Southern Women, 1895–1940*. Exton, Pa..: Schiffer Publishing, 1984.

Pollack, Griselda. *Vision and Difference: Femininity, Feminism, and the Histories of Art*. New York and London: Routledge, 1988.

"Portraits of Presidents." *The Decorators Digest* (August 1934): 9.

"Pottery and Dinnerware by Edith Heath." *Art & Architecture* 9 (1949): 38.

Powers, Marla N. *Oglala Women: Myth, Ritual, Reality*. Chicago: University of Chicago Press, 1986.

Powell, Peter J. "The Enduring Beauty of Cheyenne Art." *The American West* 10, no. 4 (July 1973): 4–11.

Powell, Richard J., et al. *Rhapsodies in Black: Art of the Harlem Renaissance*. Exhib. cat. Berkeley, Calif.: University of California Press, 1997.

Pregliasco, Janice. "The Life and Work of Marion Mahony Griffin." *Museum Studies*. Chicago: The Art Institute of Chicago, 1995.

Press, Nancy, and Terry F. A.Weihs. *Marguerite: A Retrospective Exhibition of the Work of a Master Potter*. Exhib. cat. Ithaca, N.Y.: Cornell University/Herbert F. Johnson Museum of Art, 1980.

"Prizes for Silk Designs," *American Silk Journal* (June 1905): 42.

Proddow, Penny, and Debra Healy. *American Jewelry: Glamour and Tradition*. New York: Rizzoli, 1987.

Proddow, Penny, Debra Healy, and Marion Fasel. *Hollywood Jewels*. New York: Harry N. Abrams, 1992.

Project Indian PRIDE. *Baskets of the Dawnland People*. Calais, Maine: Project Indian PRIDE, n.d.

Puffer, Harriett. "The Hand and the Loom." *Western Fabrics, Curtains and Draperies* (May 1949): 8–9, 25.

Pulos, Arthur J. *American Design Ethic: A History of Industrial Design to 1940* Cambridge, Mass.: M.I.T. Press, 1983.

———. *The American Design Adventure, 1940–1975.* Cambridge, Mass.: M.I.T. Press, 1988.

Rabinowitz, Paula. *Labor and Desire.* Chapel Hill: University of North Carolina Press, 1991.

"Radio News, From the Educational Committee." *The Decorators Digest* (March 1934): 17.

Ramsey, Bets. "Art and Quilts: 1950–1970." *Uncoverings 1993* (1994): 16.

Ramsey, John. *American Potters and Pottery.* Boston: Hale, Cushman and Flint, 1939.

Rand, Paul. "Confusion and Chaos: The Seduction of Graphic Design." *AIGA Journal of Graphic Design* 10, no. 2 (1992): 1–2.

"Reader Reaction." *Decorators Digest: Interior Design and Decoration* (December 1936): 25.

Reed, Christopher, ed. *Not At Home: The Suppression of Domesticity in Modern Art and Architecture.* New York: Thames and Hudson, 1996.

———. *The Suppression of Domesticity in Modern Art and Architecture.* London: Thames and Hudson, 1996.

Reiss, Ray. *Red Wing Art Pottery.* Chicago: Property, 1996.

Rendell, Jane, et al. *Gender, Space, Architecture.* London: Routledge, 2000.

"Report of meeting of the United States Potters' Association, address by the President, C.W. Franzheim." *Crockery and Glass Journal* 51, no. 5 (February 1900): 23.

Report of the Board of General Managers of the Exhibit of the State of New York at the World's Columbian Exposition. Albany: James B. Lyon, State Printer, 1894.

Rhode, Gilbert. "The Design Laboratory." *The American Magazine of Art* (October 1936): 636–643, 686.

Rice, Helen M. "Belle Kogan Remembers/A Journey to Design." *Innovation* (Spring 1994): 33–39.

Richardson, Frank W. "The Founding of the American Institute of Decorators." *Interiors* (January 1941): 24.

Richberg, Barbara J. "Anna R. Jones, 92, Pioneer in Many Fields" [obituary]. [Philadelphia] *Inquirer* (5 April 1995).

Riley, Denise. "'Am I That Name?' Feminism and the Category of 'Women'." In *History.* London: MacMillen Press, 1988.

Ringgold, Faith. *We Flew over the Bridge: The Memoirs of Faith Ringgold.* Boston: Bulfinch Press, 1995.

Roberts, Dorothy. *Killing the Black Body: Race, Reproduction, and the Meaning of Liberty.* New York: Vintage, 1997.

Robinson, Charlotte, ed. *The Artist and the Quilt.* New York: Alfred A. Knopf, 1983.

Rodee, Marian. "Spider Woman's Art: A Brief History of Navajo Weaving." *New America, Women Artists and Writers of the Southwest* 4, no. 3 (1982): 10.

Rosaldo, Michelle Z., and Louise Lamphere, eds. *Women, Culture and Society* Stanford, Calif.: Stanford University Press, 1974.

Rosanne Somerson: Earthly Delights. Exhib. cat. New York: Peter Joseph Gallery, 1993.

Rose, Helen. *Just Make Them Beautiful: The Many Worlds of a Designing Woman.* Santa Monica: Dennis-Landman Publishers, 1976.

———. *The Glamorous World of Helen Rose.* Palm Springs, Calif.: Helen Rose, 1983.

Rosen, Ruth. *The World Split Open: How the Modern Women's Movement Changed America.* New York: Viking, 2000.

"Rosenthal Commission." *Ceramics Monthly* 32 (October 1984): 61–62.

Ross, Isabel. *Crusades and Crinolines: The Life and Times of Ellen Curtis Demorest and William Jennings Demorest.* New York, Evanston and London: Harper & Row, 1963..

Rothschild, Joan. *Women, Technology, and Innovation.* New York: Pergamon Press, 1982.

———, ed. *Machina ex dea: Feminist Perspectives on Technology.* New York: Pergamon Press, 1983.

———, ed. *Design and Feminism: Re-Visioning Spaces, Places, and Everyday Things.* New Brunswick, N.J.: Rutgers University, 1999.

Rowbotham, Sheila. *Hidden from History: Three Hundred Years of Women's Oppression and the Fight Against It.* London: Pluto Press, 1973.

———. *A Century of Women: The History of Women in Britain and the United States.* New York: Viking Press, 1997.

Rowlands, Penelope. "Frances Elkins: The Influential California Decorator's House in Monterey." *Architectural Digest* (September 1988): 146–56.

Rubin, Christopher. "Jhane Barnes." *Ritz Carlton Magazine* (Summer 1999): 145–53.

Rubin, Lillian B. *Worlds of Pain.* New York: Basic Books, 1976.

Rubinstein, Charlotte. *American Women Artists from Early Indian Times to the Present.* New York: Avon Books, 1982.

Ruiz, Vicki L. *From Out of the Shadows: Mexican Women in Twentieth-Century America.* New York: Oxford University Press, 1998.

Ruskin, John. *The Nature of Gothic.* Hammersmith, Eng.: Kelmscott Press, 1892.

Russell, Beverly. *Women of Design.* New York: Rizzoli International, 1992.

Russell, Dick. *Black Genius.* New York: Carroll and Graf, 1998.

Ryan, Mary. *Womanhood in America: From Colonial Times to the Present.* New York: New Viewpoints, 1975. 3rd ed., New York: Franklin Watts, 1983.

Saatchi, Doris. "Precious Metals: The Work of Marie Zimmermann is Rediscovered." *House and Garden* (June 1989): 170.

Salny, Stephen M. "Frances Elkins: A Forward-Looking Icon of European Chic and American Style." *Architectural Digest* (January 2000): 164–167.

Sanchez, Beatrice Rivas. "Women in Art and Design." *Innovation* (Winter 1995): 17.

Sane, Michael. "Jhane Barnes, Fashion Nerd." *Wired* (June 1999): 132–34, 198, 202.

Sargent, Irene. "The Successful Pursuit of an Art-Industry." *The Keystone* 20 (August 1905).

———. "The Worker in Enamel, With Special Reference to Miss Elizabeth Copeland." *The Keystone* (February 1906): 195.

Scharlach, Andrew E., and Blanche Grosswall. "The Family and Medical Leave Act of 1993." *Social Service Review* 71 (September 1997), 335–60.

Schlanger, Jeff, and Toshiko Takaezu. *Maija Grotell: Works Which Grow From Belief.* Vermont: Studio Potter Books, 1996.

Schoeser, Mary. *Fabrics and Wallpapers.* New York: E.P. Dutton, 1986.

Schoeser, Mary, and Chritine Boydell, eds. *Disentangling Textiles: Interdisciplinary techniques in the study of designed objects.* London: Middlesex University Press, forthcoming.

Schrader, Robert Fay. *The Indian Arts and Crafts Board: An Aspect of New Deal Indian Policy.* Albuquerque: University of New Mexico Press, 1983.

Schwalbach, M., and J. Schwalbach. *Screen-process Printing.* New York: Van Nostrand Reinhold, 1970.

Schwartz, Bonnie. "120 Degrees of Separation." *Interiors* (September 1999): 51.

Scotford, Martha. "Toward an Expanded View of Women in Graphic Design: Messy History vs. Neat History." *Visible Language* (Fall 1994): 368–88.

———. *Cipe Pineles: A Life of Design.* New York: W. W. Norton, 1999.

Sculptural Concerns: Contemporary American Metalworking. Exhib. cat. Fort Wayne, Ind., and Cincinnati: Fort Wayne Museum of Art and The Contemporary Arts Center, 1993.

Second Annual Exhibiton of Applied Arts. Detroit:

Detroit Museum of Art, 1905.

Seeler, Margarete. "The Cup of '88." *Glass on Metal* 9 (June 1990) 3: 52–55;

———. *Enamel Medium for Fine Art.* Pittsburgh, Pa.: Dorrance Publishing, 1997.

Segal, Lynne. *Why Feminism?: Gender, Psychology, Politics.* Cambridge: Polity Press, 1999.

Seiler, Molly, and Pat Kirkham. "Lella Vignelli on Vignelli: Design History, Concepts, and Collaboration." *Studies in the Decorative Arts* 8, no. 1 (Fall–Winter 2000–2001).

Sennett, Robert S. *Setting the Scene: The Great Hollywood Art Directors.* New York: Harry N. Abrams, 1994.

"A Sense of Line." *American Crafts* (February/March 1988): 24.

Sharaff, Irene. *Broadway and Hollywood: Costumes Designed by Irene Sharaff.* New York: Van Nostrand Reinhold, 1976.

Shaw, Diana. "Cameos: Lilly Kilvert." *Premiere* (May 1990): 33.

Shaw, Robert. *Quilts: A Living Tradition.* New York: Hugh Lauter Levin, 1995.

Sheehan, Roberta. "Boston Museum School: A Centennial History, 1876–1976" Ph.D. diss., Boston College, 1983.

Shelton, Louise. *Beautiful Gardens in America.* New York: Charles Scribner's Sons, 1915.

Shifman, Barry, et al. *The Arts and Crafts Metalwork of Janet Payne Bowles.* Indianapolis: Indianapolis Museum of Art and University of Indiana Press, 1993.

Shipman, Nell. *The Silent Screen and My Talking Heart.* Hemingway Western Studies Series. Boise, Idaho: Boise State University, 1987.

Shohat, Ella, ed. *Talking Visions: Multicultural Feminism in a Transnational Age* Cambridge, Mass.: M.I.T. Press, 1998.

Shurtleff, Jill. "Finally! A Razor Worth Holding Onto." *Innovation* (Fall 1993): 33–35.

Silver: An Exhibition of Contemporary American Design by Manufacturers, Designers, and Craftsmen. Exhib. cat. New York: The Metropolitan Museum of Art, 1937.

Skeggs, Beverly. "Postmodernism: What is All the Fuss About?" *British Journal of Sociology of Education* 12 (1991): 255–67.

———. *Feminist Cultural Theory: Process and Production* (Manchester, Eng.: Manchester University Press, 1995.

Slide, Anthony. *The Silent Feminists.* Lanham, Md., and London: The Scarecrow Press, 1996.

Slocum, Grace L. "'The Hearthside Loom' Domestic Industry Near Providence, R.I." *House Beautiful* 24 (July 1908): 18–19.

Smith, Terry. *Making the Modern: Industry, Art, and Design in America.* Chicago: University of

Chicago Press, 1993.

Smith, Arthur, and James L. de Jongh. *Arthur Smith: A Jeweler's Retrospective.* New York: Jamaica Arts Center, 1990.

Smith, Betty S. "Sarah de St. Prix Wyman Whitman." *Old-Time New England* 77, no. 266 (Spring/Summer 1999): 46–64.

Smith, C. Ray, and Allen Tate. *Interior Design in the 20th Century.* New York: Harper and Row, 1986.

Smith, Jane S. *Elsie de Wolfe: A Life in High Style.* New York: Atheneum, 1982.

Smith, Walter. *The Masterpieces of the Centennial Exhibition Illustrated.* Vol. 2. Philadelphia: Gebbie and Barrie, 1877.

Smith-Ferri, Sherrie. "The Development of the Commercial Market for Pomo Indian Baskets." *Expedition* 40, no. 1 (1998): 15–22.

Smyth, R. L., and R. S. Weightman. *The International Ceramic Tableware Industry.* Beckenham, U.K.: Croom Helm, 1984.

Society of Industrial Designers. *U. S. Industrial Design, 1951.* New York: Studio Publications, 1951.

Solinger, Rickie. *Wake-Up Little Susie.* New York: Routledge, 1992.

Solomon, Barbara Miller. *In the Company of Educated Women.* New Haven: Yale University Press, 1985.

Some Examples of the Work of American Designers. Philadelphia, New York, and Boston: Dill & Collins Co. Papermakers, 1918.

Sones, Melissa. "Found Exclusively at Ann Lowe Gowns." *American Legacy* (Winter 1999): 32, 34.

Southern Arts and Crafts, 1890–1940. Charlotte, N. C.: The Mint Museum of Art, 1996.

Sparke, Penny. *Consultant Design: The History and Practice of the Designer in History.* London: Pembridge, 1983.

———. *As Long as It's Pink: The Sexual Politics of Taste.* London: Pandora, 1995.

Spenger, Polly. "Meanwhile Back at the Ranch" *Woodwork* 45 (June 1997): 70–75.

Sprackling, Helen. "Modern Art in the Textile Field." *House Beautiful* (April 1929): 522–26.

Spurey, Kurt. "Gertrud and Otto Natzler Retrospective." *Ceramics Monthly* (February 1995): 10.

Staggs-Flinchim, Janis L. "An Innovative Fashioner of Non-precious Jewelry." *Jewelry: The Journal of the Society of Jewelry Historians* 1 (1996–97): 104.

Stanford, C. "An International Exhibit of Modern Art." *Good Furniture Magazine* (July 1928): 19.

Stanley, Autumn. *Mothers and Daughters of Invention: Notes for a Revised History of Technology.*

Metuchen, N.J.: Scarecrow Press, 1993.

Steele, Valerie. *Fashion and Eroticism: The Ideals of Feminie Beauty from the Victorian Era to the Jazz Age.* New York: Oxford University Press, 1985.

———. *Paris Fashion: A Cultural History.* New York: Oxford University Press, 1988.

———. *Women of Fashion: 20th-Century Designers.* New York: Rizzoli, 1991.

Steele, Valerie, and John S. Major. *China Chic: East Meets West.* New Haven and London: Yale University Press, 1999.

Steinberg, David. "Hectic Pace Taps Artist Sakiestewa's Creativity," *Albuquerque Journal* (31 July 1994): arts, 61, 63;

Stone, Michael. "Partners in Craftsmanship." *American Craft* 43, no. 3 (June/July 1983): 6.

Storey, Rendell. "The Latest Art-In-Industry Exhibition." *New York Times Magazine* (27 May 1928): 19.

Stout, Pola. "Education in Fashion and Fabrics: Program at the Fashion Institute of Technology." *Handweaver & Craftsman* (Summer 1965): 6–9.

Stritzler, Nina. *Pioneer and Pioneering 20th-Century Women Furniture Designers and Furniture Designers/Makers.* New York: Bernice Steinbaum Gallery, 1988.

Sturgis, Russell. *The Interdependence of the Arts of Design.* Chicago: A. C. McClurg, 1905.

Sturtevant, William C., ed. *Handbook of North American Indians.* 17 vols. to date. Washington: Smithsonian Institution 1978–.

"Style Created by These Famous Designers." *Interior Design and Decoration* (January 1940): 77.

Sullivan, Martin, and Diana Pardue. "Introducing America to Americans." *Native Peoples* 9, no. 1 (Fall/Winter 1995): 58–64.

Susman, Walter. *Culture as History.* New York: Pantheon Books, 1984.

Swanson, Gloria. *Swanson on Swanson: An Autobiography.* New York: Pocket Books, 1980.

Tachau, Hanna. "Modern Ideas for Very Young Moderns." *American Home* (Septempter 1935): 292.

Tankard, Judith B. *The Gardens of Ellen Biddle Shipman.* Sagaponack, NY: Sagapress in association with the Library of American Landscape History, 1996.

Thomson, Ellen Mazur. "Alms for Oblivion: The History of Women in Early American Graphic Design." *Design Issues* 10 (Summer 1994): 44.

Tapert, Annette. "Rose Cumming: Eccentric Glamour Marks an Original Talent of

Lasting Influence." *Architectural Digest* (January 2000): 147.

"Ten on the Edge," *I.D.* (March/April 1988): 64.

Teters, Charlene. "Jeweler Denise Wallace, Sugpiag." *Indian Artist* 3, no. 3 (Summer 1997): 27.

Thaxter, Celia. *An Island Garden.* Boston and New York: Houghton Mifflin, 1894.

Thompson, Sandy. "Susan Billy: Spirit Drawn to Weave a Legacy." *Arts and Entertainment* 25, 2 (March/April 1999): 11.

Thomson, Ellen Mazur. "Alms for Oblivion: The History of Women in Early American Graphic Design." *Design Issues* 10, no. 2 (Summer 1994): 27–48.

"Three-dimensional Arrangements." *Interior Design and Decoration* (July 1941): 44, 51.

"Tiger, Tiger Everywhere." *Home Furnishing Design* (17 August 1967): 15.

Tillet, d.d., and Leslie Tillet. "Plain Print Talk: Two Young American Fabric Designers Make a Plea for Better Design." *American Fabrics*, no. 3 (1947): 71.

Tobias, Shelia. *Faces of Feminism.* Boulder: Westview Press, 1997.

Toeplitz, Jerzy. *Hollywood and After: The Changing Face of Movies in America.* Translated by Boleslaw Sulik. Chicago, Henry Regnery Company, 1975.

Tohono O'odham Basketweavers Organization. "Native Baskets of the Southwest." *Indian Artist* 5, no. 1 (Winter 1999): 42–45.

Torre, Susana, ed. *Women in American Architecture: A Historic and Contemporary Perspective.* New York: Watson-Guptill Publications, 1977.

Tracy, Berry B., et al. *Nineteenth-Century American Furniture and other Decorative Arts.* Exhib. cat. New York: Metropolitan Museum of Art, 1970.

Trapp, Kenneth, et al. *The Arts and Crafts Movement in California: Living the Good Life.* New York: Abbeville Press and The Oakland Museum, 1993.

Treib, Marc, ed. *Modern Landscape Architecture: A Critical Review.* Cambridge, Mass.: M.I.T. Press, 1993.

Triggs, Oscar Lovell. *Chapters in the History of the Arts and Crafts Movement.* Chicago: Bohemian Guild of the Industrial Art League, 1902.

Tripp, A. F. "Lowthorpe School of Landscape Architecture, Gardening and Horticulture for Women." *Landscape Architecture* 3 (1912–13): 14–18.

Truettner, William H., ed. *The West as America: Reinterpreting Images of the Frontier, 1820–1920.* Washington, D.C.: Smithsonian Institution Press, 1991.

Tweed, Katherine, ed. *The Finest Rooms by America's Greatest Decorators.* New York: Viking Press, 1964.

Úlehla, Karen Evans, comp. and ed. *The Society of Arts and Crafts, Boston: Exhibition Record, 1987–1927.* Boston: Boston Public Library, 1981.

Umansky, Lauri. *Motherhood Reconceived: Feminism and the Legacies of the Sixties.* New York: New York University Press, 1996.

Upton, Dell. "Pattern Books and Professionalism: Aspects of the Transformation of Domestic Architecture in America, 1800–1860." *Winterthur Portfolio* 19, nos. 2/3 (Autumn/Summer 1984): 107–50;

Ullrich, Polly. "Vessels That Pour." *American Craft* (August/September 1998): 64–69.

"Valentina." *Current Biography.* New York: H. H. Wilson, 1946.

"Vally Wieselthier: Modern Fabric Designing." *Design* 31 (January 1930): 145–47.

Van Alstyne, Jayne. Papers. Van Alstyne Collection, Cranbrook Academy of Art Archives, Bloomfield, Michigan.

VanderBeke, Diane M. "Cubistic Cocktails." Student paper, 1987. Departmental files, Department of Decorative Arts, Brooklyn Museum.

Vanderbilt, Suzanne. Papers. Vanderbilt Collection, Cranbrook Academy of Art Archives, Bloomfield, Michigan.

VanderLans, Rudy, Zuzana Licko, and Mary E. Gray. *Emigre: Graphic Design in the Digital Realm.* New York: Van Nostrand Reinhold, 1994.

Van Rensselaer, Marina. *Art Out-of-Doors: Hints on Good Taste in Gardening.* New York: Charles Scribner's Sons, 1893.

Van Slyck, Abigail A. "The Lady and the Library Loafer: Gender and Public Space in Victorian America." *Winterthur Portfolio* 31 (1996): 230–35.

Varney, Carleton. *The Draper Touch.* New York: Shannongrove Press, 1988.

Varnum, William [Biographical sketch.] *Industrial-Arts Magazine* 3, no. 1 (January 1915): 5.

Varnum, William. *Industrial Arts Design: A Textbook of Practical Methods for Students, Teachers, and Craftsmen.* Milwaukee: Bruce Publishing Company, 1916. Reprinted as *Arts and Crafts Design.* Salt Lake City: Gibbs-Smith, 1995.

Venturi, Robert. *Complexity and Contradiction in Architecture.* New York: Museum of Modern Art, 1966.

Venturi, Robert, Denise Scott Brown, and Steve Izenour. *Learning from Las Vegas : The Forgotten Symbolism of Architectural Form.* Cambridge, Mass.: M.I.T. Press, 1977.

"Vera Neumann" [obituary], *New York Times* (17 June 1993): page number varies with edition.

Vienne, Veronique. "Designing from Skin to Screen: Rebeca Méndez." *Graphis* 52 (November/December 1996): 46–57.

Vlach, John Michael. *The Afro-American Tradition in the Decorative Arts.* Cleveland: The Cleveland Museum of Art, 1978).

Vogel, Lise. *Mothers on the Job.* New Brunswick: Rutgers University Press, 1993.

"Vogue's Gallery of American Designers," *Vogue* (1 September 1933).

Voight, Rebecca. "Scene Dining." *Accent: The Magazine of Paris Style* (November/December 1987): 28.

Votolato, Gregory. *American Design in the Twentieth Century.* Manchester, Eng.: Manchester University Press, 1998.

Wade, Edwin L., ed., *The Arts of the North American Indian: Native Traditions in Evolution.* New York: Hudson Hills Press, 1986.

———. "Native American Pottery and Basketry." In *The Philbrook Museum of Art: A Handbook to the Collections.* Tulsa: The Philbrook Museum of Art, 1991.

Wahlman, Maude Southwell. *Signs and Symbols: African Images in African-American Quilts.* New York. Penguin Studio Books in association with the Museum of American Folk Art, 1993.

Waldvogel, Merikay. *Soft Covers for Hard Times: Quiltmaking and the Great Depression.* Nashville, Tenn.: Rutledge Hill Press, 1990.

———. "The Marketing of Anne Orr's Quilts." *Uncoverings 1990* 11 (1991): 11.

———. "The Origin of Mountain Mist R Patterns," *Uncoverings 1995* (1996): 95–138.

Waldvogel, Merikay, and Barbara Brackman. *Patchwork Souvenirs of the 1933 World's Fair.* Nashville, Tenn.: Rutledge Hill Press, 1993.

Walker, Lynne. *Drawing on Diversity: Women, Architecture, and Practice.* London: RIBA Heinz Gallery: 1997.

———, ed. *Women Architects: Their Work.* London : Sorella Press, 1984.

Walker, Anne. "Dressing the Movies." *Woman's Home Companion* (May 1921): 24.

Walker, Peter, and Melanie Simo. *Invisible Gardens: The Search for Modernism in American Landscape.* Cambridge, Mass.: M.I.T. Press, 1994.

Wallance, Donald A. *Shaping America's Products.* New York: Van Nostrand Reinhold, 1956.

Ware, Susan. *Beyond Suffrage: Women in the New Deal.* Cambridge: Harvard University Press, 1981.

Wares, L. J. "Dress of African-American Women in Slavery and Freedom: 1500–1935." Ph. D. diss., Purdue University, 1981.

Warren, Elizabeth V., and Sharon L. Eisenstat. *Glorious American Quilts: The Quilt Collection of the Museum of American Folk Art.* New York: Penguin—Studio Books in association with the Museum of American Folk Art, 1996.

Washburn, Dorothy K., ed. "Pueblo Ceramics." *The Elkus Collection.* Seattle: University of Washington Press for the California Academy of Sciences, 1984.

Webb, Michael. *Happy Birthday, Hollywood: One Hundred Years of Magic, 1887–1987.* Hollywood: Motion Picture and Television Fund, 1987.

Weber, Nicholas Fox, and Pandora Tabatabai Asbaghi. *Anni Albers.* New York: The Solomon R. Guggenheim Foundation, 1999.

Webster, Marie D. *Quilts, Their Story and How to Make to Them.* 1915. Reprint. Santa Barbara, Calif.: Practical Patchwork, 1990.

Wechsler, Susan. "The New American Ceramics." *Industrial Design* (May/June 1985): 22–25.

Weedon, Chris. *Feminist Practice and Poststructuralist Theory.* Oxford, Eng.: Blackwell, 1987.

Weimann, Jeanne Madeline. *The Fair Women: The Story of the Woman's Building, World's Columbian Exposition, Chicago 1893.* Chicago: Academy, 1981.

Weiner, Lynn Y. *From Working Girl to Working Mother.* Chapel Hill: University of North Carolina Press, 1985.

Wei, June. "Closing the Gender Gap." *New York Times Magazine* (30 June 1985): 44.

Weisberg, D. Kelly. *Feminist Legal Theory.* Philadelphia: Temple Univ. Press, 1993.

Weiss, Nancy J. *Farewell to the Party of Lincoln.* Princeton: Princeton University Press, 1983.

Weiss, Peg, ed. *Adelaide Alsop Robineau: Glory in Porcelain.* Syracuse: Syracuse University Press, 1981.

Weltge, Sigrid Wortmann. *Bauhaus Textiles.* San Francisco: Chronicle Books, 1993.

Wexman, Virginia Wright. *Creating the Couple: Love, Marriage, and Hollywood Performance.* Princeton: Princeton University Press, 1993.

Wheeler, Candace. "Interior Decoration as a Profession for Women." Parts 1 and 2. *The Outlook: A Family Paper* (6 April 1895): 559–60; (20 April 1895): 649.

————. *How to Make Rugs.* New York: Doubleday, Page and Company, 1902.

————. *Principles of Home Decoration, with Practical Examples.* New York: Doubleday, Page and Company, 1908.

————. *Yesterdays in a Busy Life.* New York: Harper and Brothers, 1918.

————. *The Development of Embroidery in America.* New York: Harper and Brothers, 1921.

Wheeler, Marjorie Spruill, ed. *One Woman, One Vote: Rediscovering the Woman Suffrage Movement.* Troutdale, Oregon: New Sage Press, 1995.

White, Constance C. R. *Style Noir: The First How-to Guide to Fashion Written with Black Women in Mind.* New York: Berkley Publishing Group, 1998.

White, Fran. "Layered with Significance." *Lapidary Journal,* (September 1992): 29.

Whiteley, Nigel. *Design for Society.* London: Reaktion, 1993.

Whiting, Margaret. "Colonial Embroidery" [1931]. Pocumtuck Valley Memorial Association Library, Deerfield, Massachusetts.

Whitley, Lauren. "Morris de Camp Crawford and American Textile Design, 1916–1921." Master's thesis, State University of New York, Fashion Institute of Technology, 1994.

Whitmyer, Margaret, and Kenn Whitmyer. *The Collector's Encyclopedia of Hall China.* Paducah, Ky.: Collector's Books, 1989.

Wildenhain, Marguerite. "Pottery." *Art & Architecture* 3 (1947): 29.

————. *Pottery: Form and Expression.* New York: American Craftsmen's Council, 1959.

Wigley, Mark. *White Walls, Designer Dresses: The Fashioning of Modern Architecture.* Cambridge, Mass.: M.I.T. Press, 1995.

Williams, Beryl. *Fashion is Our Business.* Philadelphia and New York: J. B. Lippincott, 1945.

————. *Young Faces in Fashion.* Philadelphia and New York: J.B.Lippincott, 1956.

Wilson, Elizabeth . *Adorned in Dreams.* London: Virago, 1985.

Wilson, Elizabeth, and Lou Taylor. *Through the Looking Glass: A History of Dress from 1860 to the Present Day.* London: BBC Books, 1989.

Wilson, Fo. *Visual Perceptions: Twenty-one African American Designers Challenge Modern Stereotypes.* New York: Parsons School of Design, 1991.

Wohlfert-Wihlborg, Lee. "The Label Is Anne Klein, But the Name That Keeps It Going Belongs to Donna Karan." *People* (29 March 1982).

Wolf, Janet, and Linda Nicholson, eds., *Feminism/Postmodernism* (London: Routledge, 1990);

Wolf, Toni Lesser. "Claire Falkenstein's Never-Ending Universe." *Metalsmith* 11, no. 3 (Summer 1991): 26–31.

Woloch, Nancy. *Women and the American Experience.* 2d ed. New York: McGraw-Hill, 1994.

"The Women Decorators' Exhibit." *Interiors* 78 (15 March 1927): 119.

"Women Designers Set New Fashions," *Life* (14 January 1946): 87.

"Women in Landscape Architecture Education: A Report by the ASLA Task Force Council on Education, June 1975." Chaired by Miriam Rutz. *ASLA Bulletin* 15, no. 237 (December 1975): n.p.

Women of Sweetgrass and Sage. Exhib. cat. New York: Gallery of the American Indian Community House, 1985.

Wood, Beatrice. *I Shock Myself: The Autobiography of Beatrice Wood.* San Francisco: Chronicle Books, 1985.

Woodard, Thomas K., and Blanche Greenstein. *Twentieth-Century Quilts, 1900–1950.* New York: E. P. Dutton, 1988.

Woodham, Jonathan. *The Industrial Designer and the Public.* London: Pembridge, 1983.

"A Wonderful Life—A Difficult Path." *Moore College of Art Magazine* (Spring 1987): 2.

Wragg Chase, Judith. *Afro-American Art and Craft.* New York: Van Nostrand Reinhold Company, 1971.

Wygant, Foster. *Art in American Schools in the Nineteenth Century.* Cincinnati: Interwood Press, 1973.

Yankelovich, Clancy, Shulman Associates, *Interior Design Universe Study.* New York: Interior Design/Cahners Publications, 1995.

Yoch, James. *Landscaping the American Dream: The Gardens and Film Sets of Florence Yoch, 1890–1972.* New York: Harry N. Abrams/Sagapress, 1989.

Yohannan, Kohle, and Nancy Nolf. *Claire McCardell: Redefining Modernism.* New York: Harry N. Abrams, 1998.

Young, Clare Kimball, "Dressing for the Movies." *Photoplay* 7 (January 1915): 117.

Yung, Judy, ed. *Unbound Voices: A Documentary History of Chinese Women in San Francisco.* Berkeley: University of California Press, 1999.

Zegart, Shelly. *Kentucky Quilts: Roots and Wings.* Exhib. cat. Morehead, Ky.: Kentucky Folk Art Center, 1998.

Index

The index is intended primarily as an index of persons, but important design training centers, collectives, competitions, exhibitions, and cultural movements are included on a selective basis. Life dates are given for the designers in the exhibition as well as many others mentioned in the text. Page numbers in *italics* refer to illustrations.

Photographic credits

Unless noted below, photographs are credited to the collectors, designers, museums, and other organizations listed in the captions and the Context Line, or to the photographic services of the Bard Graduate Center. Individual photographers, where known, are acknowledged below. Every effort has been made to contact copyright holders. Any errors or omissions brought to the publisher's attention will be corrected in future editions.

Peter Aaron/ESTO, for Tom Lee, Inc.: Fig. 13-23. Academy of Motion Picture Arts and Sciences, Figs. 10-2, 10-3, 10-4, 10-5, 10-7, 10-9, 10-10, 10-11, 10-12, 10-15, 10-17, 10-19, 10-21, 10-24, 10-25, 14-3, 16-22. Ruven Afanador: Fig. 7-19. The African American Museum in Philadelphia, Gift of Anna Russell Jones (86.040): Fig. 1-48. Dugan Aguilar: Figs. 3-3, 3-5 David Allison: Figs. 3-18, 4-1, 4-2, 4-8, 8-18, 8-19, 8-21, 8-22, 8-25, 11-25, 15-13, 15-17; Cat. no. 130. America Hurrah Archive, New York: Fig. 3-32. American Museum of Natural History Library / R. Mickens: Fig. 3-26; Cat. no. 83. The Art Institute of Chicago; Fig. 13-1. Art Resource / Cooper-Hewitt, National Design Museum, Smithsonian Institution, New York: Figs. 16-5, 13-11, 13-16, 13-17, 13-20 (Horst); Cat. no. 173. Daniel Aubry / Clodagh Designs: Fig. 13-32. Bernard Banet: Fig. 11-4. Karen Bell: Figs. 6-19, 6-22. Eugene Bielawski: Fig 1-44. Bison Archive: Fig. 10-1. The Black Fashion Museum, Washington, D.C.: Fig. 4-4. Talisman Brolin: Fig. 1-45. Wil Brown / Philadelphia Museum of Art: Fig. 11-13. Bonnie Cashin: Fig. 7-9. Michael Cavanaugh/ Kevin Montague: Fig. 9-24. Chicago Athenaeum Archives, Gift of Ellen Manderfield: Figs. 1-26 (Walter G. Manderfield), 11-5. Chicago Historical Society: Fig. 1-4. Chitimacha Tribe of Louisiana: Fig. 3-11. Cincinnati Museum Center: Fig. 15-1. Andrea Claire: Figs. 7-2, 7-7, 7-12, 7-14; Cat. nos. 37, 135. Communication Arts Magazine: Fig 1-24. Condé Nast Publications, © House & Garden: Fig. 1-30. Harold Haliday Constain / Rose Cumming, Inc.: Fig. 13-10. Cooper Union Library, New York: Figs. 1-20, 1-21. Cranbrook Archives, Bloomfield Hills, Michigan: Figs. 1-A, 1-17, 1-43. Geoge Cserna / Vignelli Associates: Fig. 13-30. D.C. Moore Gallery, New York: Fig. 15-18. Agnes

Denes: Fig. 14-9. Dorothy Draper and Company: Fig. 13-18. Dorothy Downs: Fig. 3-27. © Lucia Eames d.b.a. Eames Office: Figs. 1-36, 5-11. Eastman Kodak: Fig. 4-27. © Ebony: Fig. 4-7. EFM Design: Cat. no. 186. Ellen McCluskey Associates: Fig. 13-22. Lisa Erramouspe: Fig. 8-3. F. Schumacher and Company: Figs. 5-4, 5-14. Lee Fatherree: Fig. 9-22. Phil Fein / Dorothy Draper and Company: Fig. 13-19. Florence Knoll Collection: Fig. 11-9. Matt Flynn / Cooper-Hewitt, National Design Museum, Smithsonian Institution, New York: Figs. 4-A, 4-26, 8-23, 11-21. Dan Forer / Condé Nast Publications, *Architectural Digest*: Fig. 4-23. Frick Collection, New York: Fig. 13-8. Fuller Museum of Art, Brockton, Massachusetts: Fig. 12-9. Gallery 1021:Lill Street, Chicago: Fig. 15-16. General Motors Media Archives: Figs. 1-25, 11-16. Richard P. Goodbody / Montreal Museum of Decorative Arts: Figs. 1-38, 6-12, 6-13. Janis Hall: Fig. 14-14. Holly Hampton: Fig. 1-14. Karen Hampton: Fig. 1-15. Peter Harholdt / The Mitchell Wolfson Jr. Collection, The Wolfsonian-Florida International University, Miami Beach, Florida: Figs. 9-10, 13-6. Hearst Castle, Hearst San Simeon State Historical Monument / A. Wisdom: Fig. 13-5. Hedrich-Blessing Photographers: Fig. 13-26; Cat. no. 193. Greg Heins, Boston: Fig. 12-4. R. H. Hensleigh / Cranbrook Art Museum: Figs. 5-8, 9-3, 11-7; Cat. no. 41. Mattie Edwards Hewitt / Cornell University Library: Fig. 14-5. Eva Heyd: Fig. 11-10; Cat. no. 159. Eva Heyd / American Craft Museum: Figs. 8-11, 8-15, 8-16, 8-24, 15-14. Melanie Printup Hope: Fig. 3-31. Jerry Howard: Fig. 14-15. Hub Willson Photography / Knoll Associates: Fig. 11-8. Hugh Tifft Photography: Figs. 2-4, 15-5, 15-19. Indiana University Art Museum / Michael Cavanagh and Kevin Montague: Fig. 9-15. JMW Gallery, Boston: Fig. 12-2. Joe Salem Photography / Bishop Museum: Fig. 6-15. John Elder Gallery: Fig. 12-14. John F. Kennedy Library, Boston: Fig. 4-6; Cat. no. 113. Karen Karnes: 15-21. Carl Kaufman / Yale University Art Gallery: Fig. 12-12. Elliott Kaufman / Daroff Design: Fig. 13-25. Kent State University News Service: 8-10. Scott Klette / Nevada State Museum: Cat. no. 28. Knoll Associates: Fig. 13-24; Cat. no. 215. Jean Ray Laury: Fig. 6-11. Judith Leiber: Cat. no. 120. Library of Congress, Prints and Photographs Division (ca. 1905): Fig. 1-39. Tom Liden:

Fig. 3-4. Los Angeles County Museum of Art: Fig. 11-A. Herbert Lotz: Fig. 3-19. Nancy Youngblood Lugo: Fig. 3-21. Mellisa Karlin Mahoney: Figs. 6-12, 6-16 (courtesy of Primedia Special Interest Publications). Paul Margolies: Fig. 6-21. Maris Photo / Vignelli Associates: Fig. 1-35. Mark Twain Memorial, Hartford, Connecticut: Fig. 1-2, 1-3, 2-2 Santana Martinez: Fig. 1-10. Massachusetts College of Art, College Archives, Morton R. Godine Library: Figs. 1-7, 1-27. Peter Mauss / ESTO: Fig. 14-13. Scott McCue / Pritam & Eames: Fig. 12-10. McMillen, Inc., New York: Figs. 13-14, 13-15. Luis Medina, © Peter S. Reed: Fig. 13-9. Steve Hall / Hedrich-Blessing: Fig. 13-31. The Metropolitan Museum of Art, New York: Fig. 7-10. Michigan State University Museum/Pearl Yee Wong: Fig. 3-8. J. T. Miller: Fig. 1-37. Moore College of Art and Design, Philadelphia: Fig. 1-6. Museum of the City of New York: Fig. 13-7. Museum of Modern Art Stills Archive: Figs. 10-6, 10-8, 10-13, 10-14, 10-16, 10-18, 10-20, 10-22, 10-23. Museum of New Mexico: Frasher: Fig. 8-1. Naomi Leff and Associates: Fig. 13-28. New York Public Library: Fig. 4-5. Mary E. Nichols / J. Robert Scott, Inc.: Fig. 13-27. North Carolina State Archives: Figs. 12-6, 12-7. The Oakland Museum: Figs. 9-5, 9-6. Parsons School of Design, New York, The Anna-Maria and Stephen Kellen Archives: Fig. 1-22, 1-23, 1-29. Nancy Perkins: Fig. 1-8, 1-9, 11-1. Pewabic Pottery, Detroit: 15-2. Leslie Piña: Fig. 11-19. Gary Pollmiller: Fig. 9-16. Tim Street Porter: Fig. 14-18. Richard Quinn: Fig. 11-14. Marvin Rand, © Lucia Eames d.b.a. Eames Office: Fig. 11-11. Ray Reiss Photography: 15-8. Cheryl Riley, Fig. 1-44a. Faith Ringgold: Figs. 4-3, 4-14. Sharon Risedorph: Fig. 6-18. Giles Rivest / Montreal Museum of Decorative Arts: Fig. 8-7. Robert Cargo Folk Art Gallery, Figs. 4-11, 4-12. Chris Roberts: Fig. 3-25. Lynn Rosenthal / Philadelphia Museum of Art: Fig. 5-9. Sakiestewa Textiles: Fig. 3-13. F. Sarin / University of Pennsylvania: Fig. 3-2. Nora Scarlett: Figs. 13-A, 13-11. Sears Archives, Chicago: Fig. 6-8. Owen Seumptewa: Fig. 1-42. Helen Shirk: Fig. 9-25. Ilonka Sigmund: Fig. 1-11. Jim Simmons / Annette Del Zoppo: Figs. 4-21, 4-22, 16-14; Cat. no. 198. Irving Solero / Museum at the Fashion Institute of Technology, New York:

Figs. 5-15, 5-19. Spannierman Gallery:
Fig. 4-10. Sussman/Prejza & Company:
Figs. 1-16, 1-18, 1-19, 16-15. Ezra Stoller /
ESTO: Fig. 13-29. Nancy Ellen A. Streeter:
Fig. 1-33. Syracuse China Company:
Fig. 13-4. Time Inc., © *Life Magazine*: Fig. 1-31,
1-32. University City Public Library, Univer-
sity City, Missouri: Fig. 1-7a. University of
Arizona Library, Special Collections:
Fig. 1-40. Vandouris Photo, San Francisco:
Fig. 12-15. G. W. Vance / University of
Arizona Library, Special Collections:
Fig. 13-3. Vignelli Associates: Figs. 9-19,
11-20. Peter Vitale / McMillen, Inc.,
New York: Fig. 13-21. Merikay Waldvogel:
Figs. 4-15, 6-2, 6-6, 6-7, 6-10. Richard
Walker / American Quilters Society, Paducah,
Kentucky: Fig. 6-13. Denise Wallace:
Fig. 3-29 and detail; Cat. no. 171. Alan Ward:
Figs. 14-1, 14-11. Barbara D'Arcy White:
Fig. 13-33. Bruce White: Halftitle page;
Figs. 2-A, 2-3, 2-5, 2-6, 2-7, 2-11, 2-13,
3-22, 3-23, 3-30, 5-16, 7-15, 8-5, 8-6, 8-8,
8-12, 11-18, 11-23, 12-A, 12-8,13-13, 15-9,
15-11, 15-20; Cat. nos. 189, 168. Timothy
White: Fig. 10-A; Cat. no. 210. Gavin
Wilson: Figs. 4-19, 4-28, 14-12, 16-1, 16-2,
16-3, 16-7, 16-16, 16-19. Graydon Wood /
Philadelphia Museum of Art: Fig. 11-12.
Woodard and Greenstein American Antiques,
New York: Fig. 6-4. Yale Collection of Amer-
ican Literature, Beinecke Rare Book and
Manuscript Library, New Haven: Fig. 4-16.
Yeohlee Teng: Fig. 7-18 (taken at the installa-
tion of "Intimate Architecture: Contempo-
rary Clothing Design," Hayden Gallery,
M.I.T., May–June, 1982). Eva Zeisel:
Fig. 1-34.

Film copyrights, all rights reserved:
© Buena Vista International, Burbank:
Fig. 10-22. © Columbia Pictures, Culver
City: Figs. 10-13, 10-15, 16-22.
© Dreamworks Skg, Universal City:
Figs. 4-28, 10-25. MGM-Pathé Communica-
tions Co., Santa Monica: Fig. 10-24
[© 1991]. New Line Productions, Inc.,
New York / Photo by Ralph Nelson:
Fig. 10-23 [© 1998]. Orion Pictures Corpo-
ration: Context line, still from *Thelma and Louise*
[© 1991]. Paramount Pictures, Hollywood:
Fig. 10-6 [© 2000]. Twentieth Century Fox
Film Corporation: Fig. 10-9 [© 1944];
10-10 [© 1956]; 10-11 [© 1965]. © Universal

Studios Licensing Inc., Universal City:
Figs. 10-5, 10-17. © Warner Bros., Burbank:
Figs. 10-2, 10-7, 10-8, 10-12, 10-14, 10-16,
10-19, 10-20, 10-21, 14-2.